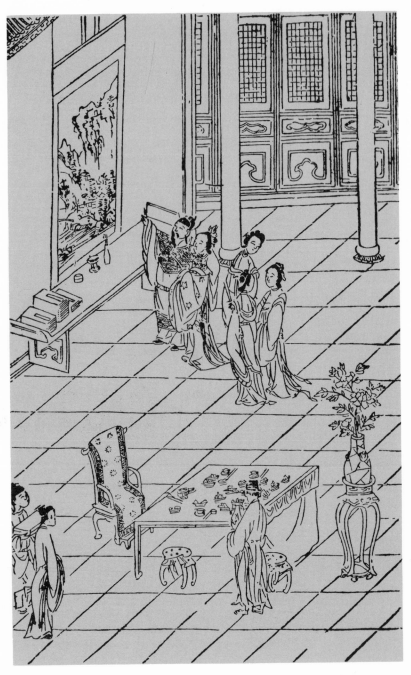

VIEWING A LANDSCAPE SCROLL IN THE MAIN HALL
MING WOODPRINT

R. H. van GULIK

# CHINESE PICTORIAL ART
## AS VIEWED BY THE CONNOISSEUR

# 書畫鑑賞彙編
# CHINESE PICTORIAL ART

## AS VIEWED BY THE CONNOISSEUR

NOTES ON THE MEANS AND METHODS OF TRADITIONAL
CHINESE CONNOISSEURSHIP OF PICTORIAL ART, BASED
UPON A STUDY OF THE ART OF MOUNTING SCROLLS
IN CHINA AND JAPAN

BY

R. H. VAN GULIK

HACKER ART BOOKS · NEW YORK · 1981

First published 1958 Rome, Italy
Reissued 1981 by Hacker Art Books, Inc. New York

Library of Congress Catalogue Card Number 79-91820
International Standard Book Number 0-87817-264-5

*Printed in the United States of America*

" For certainly not by intuition or opinions derived from a general or vague knowledge of art can we hope to reach the goal, but only by the most absorbed method of research consulting the views, traditions and sentiments of those people who created the monuments which we desire to understand ".

BERTHOLD LAUFER, in his *Jade, a study in Chinese archaeology and religion,* reprint of 1946, page 20.

DEDICATED TO

# GIUSEPPE TUCCI

AS A TOKEN OF OUR LONG FRIENDSHIP

# CONTENTS

# PREFACE

CHINESE PAINTING and Chinese ceramics are two subjects about which a great deal has been written in Western languages. There is, however, a marked difference in the state of our knowledge about the two; it cannot be denied that our studies of the former are lagging far behind. This disparity appeared already at the beginning of this century. When in 1905 the Sinologues H. A. Giles and F. Hirth published the first two serious monographs on Chinese pictorial art [1] they could do little more than reconnoitre the field. But in 1899 S. W. Bushell had already published a monumental work on Chinese ceramics that gave a balanced survey of the entire subject, including Chinese literary sources, potter's technique, ornamental designs, glazes, pigments etc. [2] In the ensuing fifty years much has been written about Chinese painting and much progress has been made, but the arrears have not yet been made up for.

These arrears in Western studies of Chinese pictorial art are caused by various reasons; some of these were beyond our control, others consist of impediments of our own making.

Among the former one should mention the fact that the Chinese have always been much more jealous of their pictures than of their porcelain. They considered — not without reason — that painting and calligraphy represent the essence of their culture, hallowed by the association with great statesmen and scholars who made national history. Ceramics they viewed as part of the

---

1) H. A. GILES, *An Introduction to the History of Chinese Pictorial Art*, one illustrated vol., London 1905; FRIEDRICH HIRTH, *Scraps from a Collector's Notebook*, one illustrated vol., Leiden 1905.

2) S. W. BUSHELL, *Oriental Ceramic Art* (collection of W. T. Watters), one vol. and portfolio of plates, New York 1899.

furnishing of their house — often of exquisite beauty but definitely belonging to the sphere of the artisan rather than that of the artist.

Thus Chinese paintings became known in the West at a comparatively late date. Chinese collectors and antique dealers did not gladly show superior scrolls to foreigners, and they were loath to see good specimens leave China where moreover there was — until recent years — a better market for them than abroad. Not one good scroll is mentioned in the bills of lading of the old Canton trade while excellent ceramic wares figure there largely. During more than two hundred years good Ch'ien-lung and Yung-chêng wares were a familiar sight in Western interiors while of Chinese pictorial art the West knew only painted wallpaper and " rice-paper pictures ", made for export.

Further, Chinese literature on ceramics is limited to a few dozen books and essays written in a matter-of-fact language that offers few problems to a Western student schooled in Chinese. But works on painting and calligraphy run into the thousands and are often couched in a nearly esoteric language. Chinese texts on pictorial art ask for a specialized study, even experienced Sinologues have to make a concentrated effort to understand them. And until the last twenty years few felt called upon to make this effort.

Then, when Chinese pictorial art had become somewhat better known in Europe and America, Western art lovers and art historians set to work and developed great activity when the Sinologues remained idle; they published book after book while most of the latter confined themselves to the writing of a few articles. Art historians unfamiliar with the Chinese language and the problems of Sinology did much to acquaint the general public with the esthetic aspects of Chinese pictorial art. They were especially attracted by the philosophical background and artistic theory, including the Six Canons of Hsieh Ho. They published numerous large, well-written and profusely illustrated books on Chinese painting that do credit to their enthusiasm for the subject.

However, these sumptuous works were based on flimsy foundations. The Chinese pictures used were of mixed quality, many being late copies or fakes. The majority emanated from the more accessible Japanese private and public collections and thus gave the student a rather one-sided view of Chinese painting. Chinese artistic literature remained largely unexplored and the great

collections in China — including that of the Imperial Palace — remained closed to foreigners. Thus it could hardly be avoided that Chinese pictorial art was presented measured by Western standards; there came into being a hybrid conception of that art, a curious mixture of Taoist speculations, esthetic theories of the Japanese tea–masters, and Western principles of art history. This roughly represents the state of affairs in Western studies of Chinese pictorial art during the Twenties.

Thereafter great strides were made. There arose a new type of Western student of Chinese art, sinologically trained, who made a beginning with a reconsideration of the entire subject. At the same time the development of collotype printing in China made many superior Chinese scrolls in collections in China available for study, and more and more good specimens found their way directly from China to the West.

During the last ten years work was started on some of the basic old Chinese texts on pictorial art; the road to a critical examination of Chinese collector's catalogues was opened up; there appeared several lists of technical terms, and special studies on individual Chinese artists; also indexes of artists and their works, and of the seals they used. [1] Most important of all, the theory — dear to Western art historians of the Twenties — that Chinese calligraphy is a subject beyond the grasp of Western students has now been definitely abandoned by all serious workers in the field.

Although it cannot be denied that there are still a number of unfortunate gaps in our equipment it can yet be assumed that at present we have arrived at the stage of independent research in Chinese pictorial art, including a critical reconsideration of Chinese and Japanese literary sources and a re–evaluation of the scrolls contained in the great collections in China. It would seem that our stage of apprenticeship has nearly been completed and that Western workers will soon be in a position to make original contributions to Chinese and Japanese studies in this field.

However, " if one aims at performing a task well one must first sharpen one's tools ". It seems to the present writer that thus far we have ignored a set of the most useful tools, namely those supplied by traditional Chinese connoisseurship.

---

1) Cf. the publications by W. R. B. Acker, Victoria Contag, John C. Ferguson, B. March, B. Rowland and A. C. Soper mentioned in Appendix I.

Chinese connoisseurship of pictorial art has the experience of nearly two thousand years behind it. Although as a matter of course lacking the aids evolved by modern science it has developed an advanced technique of its own, eminently suited to the appraisal of antique paintings and specimens of calligraphy. It is true that this tradition is not without its weak points. Modern Chinese connoisseurs concede that for instance the old esthetic classification of pictures in the three groups *shên-miao-nêng* is futile, and that with regard to decisions on authenticity there has always existed in China a tendency to attach more importance to the social and scholarly standing of the man who made the decision than to the actual merits of the case. Taken all in all, however, traditional connoisseurship provides many sound data and we cannot afford to ignore it.

It should be realized, however, that the study of Chinese connoisseurship is far from easy. It is true that its methods and terminology have been placed on record and that much additional information may be gathered from the oral tradition that still lives on in China. However, before one can digest and utilize these data one must first acquire a considerable amount of specialized knowledge that, although part and parcel of the education of scholars in China, lies outside Sinological curricula in Western universities and about which little is available in Western literature.

Daily contact with artistic and literary activities has made every Chinese connoisseur familiar with the working methods of the artist and the media he has at his disposal. The various brush techniques and their application, ink, ink stone, pigments, paper and silk and the peculiar properties of these materials — all this is as familiar to him as fountain pen and note paper are to us. But those Western students who have not resided for a longer period in China will find it difficult to acquire this knowledge, because detailed information on these subjects is lacking in Western books on Chinese pictorial art. Despite the fact that nearly all Western writers are for instance agreed that the brush stroke is the basis of Chinese pictorial art, none of them has given an adequate description of the brush and its construction, and the way it functions.

Further, every Chinese connoisseur knows how scrolls are mounted and repaired, and not a few of them — for example the T'ang collector Chang Yen-yüan and the Sung collectors Su Shih and Mi Fu — could even do this work themselves. The art of mounting scrolls is so important to the appraising

of antique scrolls that its terminology occupies a predominant position in artistic literature. But neither the process nor its terminology have ever been properly explained in Western literature.

Moreover, a Chinese connoisseur grows up and lives among specimens of pictorial art. His critical appreciation of antique scrolls is narrowly connected with the place they occupy in his daily life. If one does not know how the connoisseur enjoys his scrolls and how he uses them for the embellishment of his surroundings, one will be unable to gauge the import of his decisions and opinions in artistic matters.

Finally, next to the difficulties caused by the scarcity of Western literature on the special subjects mentioned above, there is the fact that the Chinese connoisseur's knowledge of them is rather haphazard and unmethodical. He rarely feels the necessity of coordinating the amazing quantity of facts he has at his finger tips, or of seeing them in their historical setting. Yet a systematic survey of these data is far from superfluous. The Chinese scholars who wrote on artistic matters have always taken it for granted that the future reader would be as familiar with the subject matter as they themselves; but they forgot that although they were right in assuming that the language they used would undergo few changes, the objects themselves were liable to change completely in later times. One often notices that a connoisseur of for instance the 18th century gives a mistaken interpretation of a process or object described by a writer of for instance the Sung period.

Therefore the Western student can not deem his task completed when he has acquired a general idea of the special knowledge possessed by the Chinese connoisseur. For then there still remains the critical examination of these data, their coordination with Japanese material and recent archeological discoveries, and the systematic rearrangement of this vast and varied source-material.

The present book is offered as a first attempt at filling in some of the lacunae in Western literature by supplying some elementary information on the means and methods of traditional Chinese connoisseurship of pictorial art. The aim was to arrange the main data available more or less methodically and set up a few guide-posts so as to facilitate the task of those who wish to explore this field further.

Some readers may think that the aspect of Chinese pictorial art dealt with in this book is rather dull and prosaic; little is said about the beauty of Chinese scrolls and the profound philosophical background. However, esthetic

aspects and Chinese artistic theory have already been so eloquently described by former writers that it will not be out of place to view " the art of the brush " for once from a more technical and matter-of-fact angle.

The best approach to Chinese connoisseurship is to take as starting point the art of mounting scrolls, an old handicraft peculiar to China, Korea and Japan. This may be explained by a few words about the scope of this art and about how the present author came to realize its importance.

The mounting of a Chinese scroll can in no way be compared with the frame of a Western picture. With us, the frame is an incidental, easily detachable accessory that can be omitted or changed without in any way damaging the picture. But a newly painted, unmounted Chinese picture is just a wrinkled piece of silk or paper, only when mounted can a scroll display its beauty. And the changing of the mounting of an antique scroll is a delicate operation that may either enhance its artistic value considerably or ruin it forever.

The art of mounting has a double purpose, practical and esthetic. It aims on the one hand at strengthening the frail canvas of pictures and calligraphic specimens by providing them with a tough backing, and protecting them by borders consisting of broad strips of mounting; if properly mounted a scroll will last for several centuries without need of repair. On the other hand the mounting also serves to bring out the beauty of the brushwork and deepen the tone of ink and colours, and at the same time to bring the scroll in harmony with its surroundings and — in the case of hanging scrolls — adapt it to interior decoration.

Moreover, knowledge of the technique of the art of mounting supplies the Chinese connoisseur with valuable criteria for deciding whether an antique specimen is genuine or not. It teaches him the possibilities for tampering with a scroll that may be — and indeed often are — utilized by the forger. This technical knowledge provides tangible clues that are an indispensable supplement to more subtle — and more debatable! — criteria connected with style, brushwork etc.

Information about the technical aspects of this art must be obtained mainly in the mounter's workshop; data on its role in Chinese connoisseurship must be culled from heterogeneous notes scattered over old and new Chinese literature.

The present author became interested in these subjects primarily as a collector of Chinese pictures and specimens of calligraphy. Having started

collecting in a small way during his student days in Holland, the study of Chinese scrolls became his favourite pastime after his arrival in the Far East. Through this study he came into contact with Chinese and Japanese mounters and was fascinated by their skill. He made it a point to frequent the workshop of his mounter whenever an item from his collection was being repaired or remounted, following the work in its successive stages and occasionally himself trying his hand at it. This practical experience roused his curiosity concerning the history of this craft. Hence he started to keep note of passages referring to the art of mounting during his Chinese and Japanese reading, at the same time checking whenever possible the data thus obtained with the connoisseurs with whom it was his good fortune to associate during his various terms of office in Far Eastern capitals.

Thus the author came to realize that the study of scroll mounting has a much wider application than merely helping the collector to buy with discretion and to keep his scrolls in good repair, and that it is an indispensable aid to research-work in Chinese pictorial art and its history.

He found that knowledge of the technique of mounting acquaints the student with a special vocabulary that constitutes the link between Western and Chinese art criticism, and without which there is no common ground for an exchange of views between Western and Chinese art historians. Further, an investigation into the beginnings and evolution of this technique and its terminology focusses attention on some lesser known aspects of the history of Chinese painting and calligraphy and brings to light several points connected with the development of art-collecting and of Chinese interior decoration. These facts open a new approach to the appreciation of antique Chinese scrolls, not only as regards their authenticity but also as to their artistic qualities. The author arrived at the conclusion that the art of mounting is the gate to Chinese connoisseurship.

It was these findings that led the author to the belief that it might serve a useful purpose to assemble and re-write his notes on the subject, for publication in book form.

While making the manuscript ready for the press the main problem was how to arrange this mass of miscellaneous data into a more or less logical sequence and how to place them in a chronological frame work so as to show the historical development. There could be little doubt that the art of

mounting and its history should serve as the thread of the argument. But there still remained the problem of selection. The subject is wide and varied and connected directly or indirectly with nearly every aspect of Chinese culture. It proved difficult to decide where and how to begin, and it was as difficult to know where and how to end.

Also, the question arose what place to assign to Japanese data and how much space should be allotted to them. The Japanese took over the Chinese art of mounting at an early date, and Japanese connoisseurship of Chinese scrolls can boast of a long history. In many cases Japanese data fill in lacunae in the Chinese material, in others they provide instructive parallels. The problem was how to include this Japanese material without breaking the unity of a book primarily concerned with Chinese pictorial art. After much reflection the author decided to coordinate Chinese and Japanese data throughout. It is true that this arrangement requires the reader to change his bearings every time the argument shifts from China to Japan and vice-versa; but he will find that this effort will clarify more than one historical issue that remains obscure if viewed from either the Chinese or the Japanese angle alone.

The book is divided into two parts, the first roughly representing the means, and the second the methods of traditional Chinese connoisseurship. The discussions in the First Part centre round the art of mounting and its history, while the Second Part deals mainly with the methods for judging antique scrolls. The following summary of the contents will acquaint the reader with the general plan of this book.

The First Part starts with an introductory chapter that sketches the approach to the subject, meant to orientate the reader in a general manner on the scope of the art of mounting. It discusses the different kinds of canvas at the disposal of painters and calligraphers, and how these are mounted; the place the mounted scroll occupies in the Chinese and Japanese interior and in artistic life in general, and how scrolls are enjoyed by the connoisseur.

Chapter II, entitled " The Technique of Mounting ", is a detailed account of the work done in the mounter's workshop. The first half of this chapter describes the technique of mounting new scrolls and rubbings; the second half is devoted to the remounting and repairing of antique scrolls. Chinese and Japanese mounting techniques are treated side by side, and various practices of copyists and forgers are discussed in some detail. Here it must be remarked that also in the subsequent chapters it proved necessary to allot much space

to the tricks of professional forgers and unscrupulous dealers. The author wishes to state here once and for all that those passages are in no way meant as a reflection on the honesty of present-day curio dealers in China and Japan; he found them on the average as honest as can reasonably be expected of persons who depend for their living on a trade that involves great risks and sharply fluctuating profits.

Chapter III bears the title " The History of Mounting ". The first half traces the beginnings of the art of mounting in China and its development till the end of the Sung dynasty; in this section much space is given to the origin and evolution of the hanging scroll mounting, and an attempt is made to present an outline of the early development of the Chinese dwelling house and the decoration of its interior. The second half begins with a continuation of the history of Chinese mounting till the end of the Yüan dynasty. Then follows a survey of the early history of mounting in Japan. This account is broken off at the end of the Ashikaga period, to be followed by a description of the Chinese art of mounting during the Ming dynasty, with special emphasis on the new trends in interior decoration that became popular towards the end of that era. Returning to Japan, there follows a discussion of the art of mounting and of interior decoration during the Tokugawa and Meiji periods, and a few notes on modern Japanese scroll mountings. This historical part closes with a survey of the development of the art of mounting during the Ch'ing dynasty, and modern Chinese mounting. The author would have preferred to give consecutive accounts of the history of Chinese and Japanese scroll mounting separately, but the subject itself invited the division into parallel periods.

Chapter IV, " The Books of Mounting " is entirely devoted to the Chinese text material. It contains a complete translation of the two existing special treatises on the art of mounting. Its first half gives the *Chuang-huang-chih* " Book of Mounting " written by the late-Ming scholar Chou Chia-chou. The second half deals with the *Shang-yen-su-hsin-lu* " Records of Prolonged Gratification of the Simple Heart ", compiled by the Ch'ing collector Chou Erh-hsüeh. Both texts are here reprinted, punctuated and arranged in such a way as to be easily compared with the translation. It is hoped that the notes added will facilitate an understanding of these two rather technical texts and assist the reader in following the arguments brought forward.

The Second Part consists of three chapters, each of which forms a unity in itself.

Chapter I, entitled " The Judging of Antique Scrolls " is a review of the traditional methods employed by the Chinese connoisseur. It begins with an analysis of the brush stroke, based upon an examination of the structure of the Chinese brush and of the special properties of Chinese ink and ink stone. Then follows a survey of the general principles for judging antique scrolls and a discussion of the value of colophons and superscriptions attached to antique specimens and of the seals they bear; and finally a description of collector's catalogues. The reader will also find there some observations on the delicate problem of copies, and on the importance of studying the provenance of antique scrolls including a detailed account of the history of Chinese scrolls in Japan.

Chapter II, " The Connoisseurship of Seals ", presents a succinct account of the history of the Chinese and Japanese seal, of the art of seal carving, the artistic appreciation of the seal, the interpretation of seal legends, and of how seals are used by artists and collectors. It is hoped that this survey of the " art of the iron brush " will bring this little known aspect of pictorial art within the orbit of Western students.

Chapter III, entitled " The Collecting of Scrolls " is a kind of postscript. It consists of miscellaneous notes on some practical aspects of the collecting of scrolls in old and modern times, together with such items of information on the antique trade in China and Japan as were thought to be of interest to fellow collectors.

After a perusal of the above list of contents the reader will ask: " Granted that the study of these subjects contributes something to our knowledge of Chinese material culture, how effectual are the traditional methods of the Chinese connoisseur, and does their practical value justify such a detailed investigation ? " In answer thereto here follows an appraisal of the working methods of the Chinese connoisseur.

To begin with, the Chinese connoisseur sees an antique scroll as it were from the inside, while observers who lack his special knowledge see it only from the outside. The experienced connoisseur has stored in his visual memory the images of countless old and new pictures and autographs seen and studied, and he has in his fingers an intuitive response to the brushwork of

the artist. His prodigious visual memory enables him to see any scroll he is confronted with as one of a class or group, while the layman sees it more or less as a unity in itself; and the Chinese connoisseur visualizes as it were automatically the moving hand of the artist when he was putting down the strokes, while the observer who is unfamiliar with the handling of the brush can only guess at the technique used.

At the same time the connoisseur's wide knowledge of technical details connected with artistic media; his appreciation of signatures, inscriptions and seals; his familiarity with material and style of different types of mounting, together with his natural affinity to the mental attitude of the artist, will enable him to eliminate at once the obvious and unessential features of the scroll and to concentrate his attention on those that matter. Although as a rule none of these features is conclusive in itself, their sum total will convey to the connoisseur a fairly accurate general impression of date and quality.

This total impression can be compared to what physicians are wont to call the syndrome, that is the total of signs and symptoms occurring together in a patient and on the basis of which the doctor formulates for himself the provisional diagnosis. Where the layman sees merely a sick person, the trained physician sees a lung patient, a cardiac case or a man who just suffers from a bad cold. The layman sees the patient from the outside while the doctor sees him, as it were, from the inside. Finally, clinical tests will have to confirm the doctor's first impression; but in nine out of ten cases an experienced practitioner will prove to have made the right diagnosis.

The same applies to the judgement of the Chinese connoisseur. The general opinion derived from his total impression of a scroll can in many cases be assumed to be correct. After having obtained the total impression, he can subsequently make a few simple tests to verify some special points; such as examining the picture against a strong light in order to check old defects and to locate retouchings; daubing ink and colours with a cotton pad soaked in a detergent in order to test their condition; or checking a doubtful date or signature by referring to literary sources. But to all practical purposes the parallel with medical science does not go further than the total impression; the traditional methods of the Chinese connoisseur do not extend to decisive " clinical tests ".

The final tests that will confirm or invalidate the opinions placed on record by old and later Chinese connoisseurs will only be possible at some future date

when Chinese art–literature will have been systematically re–examined, when all the more important antique scrolls preserved will have been subjected to a close comparative study, and when the application of chemical and other scientific aids — including microphotography — will have been perfected.

Until then, any attempt on our part to find a short–cut that bypasses Chinese materials and Chinese methods must remain a waste of time and labour. But every effort, how small and limited in scope it be, made along the lines suggested here, will bring us one step nearer to the ultimate goal, namely the establishing of a critical method that will allow us to judge antique Chinese pictures and autographs with a reasonable degree of certitude.

This book is written in the first place for the student of Chinese pictorial art. It is hoped, however, that at the same time it will be of some use also to the collector. He might first read the Introduction, then Chapters I and III of the Second Part, and use the rest of the book as material for reference. These notes will, perhaps, show the collector some ways along which he may arrive by himself at the formulation of the principles that answer his own particular requirements and assist him in deciding where he can trust his own eyes and where he had better ask the advice of a Sinologue.

Throughout this book various kinds of Chinese and Japanese silk and paper are mentioned; being used by both artists and mounters, a general knowledge of these materials is indispensable to the student of Chinese pictorial art. To give in words a satisfactory description of the properties of these varieties is wellnigh impossible. Therefore in Appendix V there has been added a small collection of forty–two actual samples of old and new paper and silk commonly used in China and Japan. The author had the text of this Appendix printed ten years ago when he was serving in Chungking. The selecting and pasting in of the samples provided a welcome occupation during the frequent spells of compulsory inactivity imposed by the air–raid warnings in China's war–capital.

It is not possible to mention here all those who, in one way or another, contributed material to this book. Any attempt at completeness would entail omissions.

The author should be ungrateful, however, were he not to mention the late John C. Ferguson who, twenty years ago, directed in Peking his attention to

the traditional Chinese methods for judging antique scrolls. Dr. Wang Shih-chieh 王世杰 who in Chungking never grudged his advice on various technical problems and moreover gave the author free access to his own valuable collection of antique pictures. Professor Ma Hêng 馬衡, formerly Director of the Old Palace Museum in Peking who let the author profit by his wide experience as a connoisseur of Chinese art, and the Hon. Shên Yin-mo 沈尹默, the eminent calligrapher and expert on antique autographs who was always ready for protracted discussions on problems of authenticity.

In pre-war Japan the author learned much from the two Japanese authorities on Chinese pictorial art, the late Nagao Uzan 長尾雨山 and the late Kawai Senro 河井荃廬, both of them eminent artists themselves and "gentlemen-scholars" in the best sense of the word. In post-war Tōkyō the author wishes to mention especially his old friend the Sinologue, poet and tea-master Hosono Endai 細野燕臺, who soon will be celebrating his 90th birthday, his experience in the judging and collecting of Chinese scrolls covering the Meiji, Taishō and Shōwa eras.

During the war the author's entire collection of scrolls, books and other antiques was destroyed. Although thereafter he started on a second collection, several unique items formerly purchased expressly for illustrating the present publication were irrevocably lost. It is thanks to the generous help received from Mr. A. G. Wenley of the Freer Gallery of Art and Dr. A. W. Hummel of the Library of Congress in Washington, and Mr. Basil Gray of the British Museum that the references could be completed and gaps in the illustrative material supplemented.

Finally, it is the author's pleasant duty to express his gratitude to the mounters who honoured him with their friendship. Among the Chinese experts in this subtle art he wishes to mention the master of the Shang-ku-chai 尙古齋, in the opinion of many connoisseurs the best mounter in Peking. Among those of Japan he mentions Hara Kiyohiro 原清曠, well known to all collectors of antique scrolls in Tōkyō. And in Seoul, Han Sangyong 韓祥鎔, master of the Susong-dang 壽松堂, perhaps the last mounter of antique scrolls in Korea's war-torn capital.

The greater part of the present essay was written in China and Japan during the turbulent late Thirties and early Forties, in spare hours left over from exacting official duties. The author realizes that what is given here are but

the rudiments of the science of the Chinese connoisseur. Almost every paragraph should be considerably enlarged and numerous problems pursued farther, while doubtless not a few errors have crept in.

The author also realizes that here and there he touches upon controversial matters. Nothing is farther from him than the wish to impose his own opinions upon his readers. Such passages should be viewed in a critical spirit, they are meant only to provide the reader with material for comparison with his own opinions, and to focus attention on problems that stand in need of further discussion.

The author thus hopes that his fellow students in this field will correct and complete what is given here. There is still a long road ahead and much more spade-work remains to be done.

Next to the desire to contribute his share to this work there was also an other motive that prompted the author to publish these notes, elementary and incomplete as they are. It was that while placing on record the technique of scroll mounting he was more than once struck by the unhappy thought that he was writing about a vanishing art. In the halcyon early Thirties there were in Peking nearly half a dozen mounters who could remount and repair antique scrolls; when the author revisited Peking in 1938–39 four of them had already changed to other occupations. At that time mounters in Soochow — the age-old centre of this art — were complaining about the difficulty of finding apprentices and feared that their tradition was about to be broken off. When after the war, in 1946, the author returned to the old centres of the art of mounting mentioned, there were altogether only three mounters left. Thus he feared that those coming after him might find that there was no opportunity any more for studying this art.

But perhaps this is too pessimistic a view. Perhaps it is better to assume that there will always be at least some great mounters as long as there will be understanding collectors who patronize them. And it is as difficult to imagine that Chinese pictorial art will ever die as to think that there will come a time in China when there are no collectors and connoisseurs who cherish this art.

The present writer would not gladly have missed either the joys or sorrows that came his way during twenty years of collecting. Some of the happiest times of his stays in the Far East were spent in the hospitable houses of connoisseurs and collectors and in the shops of art dealers in China, Korea

and Japan.  Not to forget the hours passed in the study of favourite pictures and specimens of calligraphy.  It was those that brought to mind the poet's word that " apart from this world there is another one that is not of man ",[1] a thought that swept away the weariness of the days that went and the anxiety of the days to come.

And then, too, it would not have been well to have missed the sorrows caused by the parting from beauty.  For it is perhaps those very sorrows that in the end may teach us resignation — a valuable lesson for this floating life.

*The Hague, Summer 1955*

R. H. v. G.

---

[1] Li T'ai-po: 桃花流川杳然去。別有天地非人間。

# ENGLISH RENDERINGS OF CHINESE AND JAPANESE TERMS

*shu–hua* 書畫, Japanese *sho–ga*: translated "scroll". This compound, when used as a substantive, means literally "specimens of calligraphy, and paintings". *Shu* when used singly is for the sake of brevity rendered as "autograph"; it refers to a specimen of handwriting the value of which lies in the quality of the calligraphy rather than in the content of the text written out.

*ming–hua* 名畫, Japanese *mei–ga*; translated "superior picture". This term means literally "famous picture". It is applied to good specimens of the work of well known masters. After the beginning of the Ming dynasty it usually implies also that the picture has been preserved in good condition.

*kua–fu* 掛幅, Japanese *kake–mono* 縣物: translated "hanging scroll".

*shou–chuan* 手卷, Japanese *maki–mono* 卷物: translated "hand scroll". It should be noted that *kake–mono* and *maki–mono* are typical Japanese terms that should be used exclusively for *Japanese* scrolls. It is difficult to understand why numerous Western writers persist in using these Japanese terms while speaking about Chinese scrolls. That both *kake–mono* and *maki–mono* are listed in dictionaries of the English language can not be adduced as an excuse; this fact only goes to prove that early Western studies of Chinese pictorial art were mainly based on Japanese data — a situation that now belongs to the past.

*chieh* 揭 "to dismount". This seems the simplest rendering of the term, which refers to the removing of the front mounting and backings of a mounted scroll, or the removing of the ribs and backing of a fan. While "unmounted picture (c. q. fan)" means a picture or fan that has never been mounted before, "dismounted" ditto means a picture or fan the mounting or ribs of which have been removed.

*kai–shu* 楷書, Japanese *kai–sho*: translated "regular script".

*chuan–shu* 篆書, Japanese *ten–sho*: translated "seal script".

*li–shu* 隸書, Japanese *rei–sho*: translated "chancery script".

*ts'ao–shu* 草書, Japanese *sō–sho*: translated "draft script". *Ts'ao* means literally "grass", hence *ts'ao–shu* is often rendered "grass script". Although some Chinese writers may occasionally have interpreted the term in this sense because the flowing strokes of the script reminded them of grass leaves in the wind, there can be no doubt that in this compound *ts'ao* means "draft", and that *ts'ao–shu* means the cursive style of writing used when drawing up drafts of official documents.

# ABBREVIATIONS

B. D. = H. A. GILES, *A Chinese Biographical Dictionary*, London and Shanghai 1898; reprinted Peking 1939.

E. C. = *Eminent Chinese of the Ch'ing Period*, edited by Arthur W. Hummel, Library of Congress; vol. I, Washington 1943; vol. II, ibid. 1944.

FREER GALLERY OF ART = The Freer Gallery of Art, Washington D. C. The Director kindly allowed me to select from the Gallery's stock the specimens reproduced here; it should be stressed that the choice was determined solely by the quality of the *mounting* of the scrolls and its suitability to photographic reproduction; the quality of the painting itself was not taken into consideration.

IMPERIAL CATALOGUE = *Szŭ-k'u-ch'üan-shu-tsung-mu* 四庫全書總目, edition of 1930 in 10 volumes, published in Shanghai by the Ta-tung-shu-chü.

K. B. S. = *Kokusai-bunka-shinkōkai* 國際文化振興會, " Japanese Society for the Promotion of International Cultural Relations ", which kindly supplied several photographs of Japanese interiors.

OLD PALACE COLLECTION (Ku-kung-po-wu-yüan 故宮博物院); the collection of antiques that formerly belonged to the Ch'ing Imperial House. After the establishment of the Chinese Republic the collection was transformed into a National Museum, part of the objects being stored in Peking and part in Shanghai. During the Sino-Japanese conflict a great number of the most valuable items were removed to Free China and, when the People's Government took over, part of these objects were transferred by the National Government to Formosa. Therefore at the time of writing (1955) it is difficult to say where the scrolls from this Collection described in the present publication actually are.

# MEASUREMENTS

All measures are given in the decimal system in order to avoid English " foot " being confused with Chinese *ch'ih* 尺. For the same reason *chang* 丈 " ten feet ", *ts'un* 寸 " inch " and *fên* 分 " one tenth of an inch " are left unchanged in the translations from the Chinese. In China the value of these measures differs considerably according to period and locality. Those interested are referred to John C. Ferguson's article *Chinese Foot Measure*, in " Monumenta Serica ", vol. VI, Peking 1941.

# TABLE OF CONTENTS

## FIRST PART

### CHAPTER I. – INTRODUCTION

### CHAPTER II. – THE TECHNIQUE OF MOUNTING

## CHAPTER III. – THE HISTORY OF MOUNTING

### Chapter IV. – THE BOOKS OF MOUNTING

# SECOND PART

### Chapter I. – THE JUDGING OF ANTIQUE SCROLLS

### Chapter II. – THE CONNOISSEURSHIP OF SEALS

### Chapter III. – THE COLLECTING OF SCROLLS

## APPENDICES

# LIST OF ILLUSTRATIONS

## IN THE TEXT

## ON SEPARATE PAGES

# CHINESE PICTORIAL ART
## AS VIEWED BY THE CONNOISSEUR

# FIRST PART

CHAPTER I

# INTRODUCTION

Influence of the seasons on Chinese artistic life.

I N THE FAR EAST the rhythm of the seasons influences the life of the cultured classes much more than in Western countries. Seasonal feasts are more regularly observed and have retained more of their original significance. It is not only those people who by their occupation are in close contact with cosmic changes such as the farmer and the villager, but also the leisured classes and the townspeople in general who deeply experience the eternal circular movement of nature.

This susceptibility to the changes of nature has had a far–reaching influence on Chinese and Japanese art. Not only did this susceptibility bring into prominence a number of seasonal subjects which tradition has fixed as most suitable for artistic treatment — such as plum blossoms in early spring, wild geese in autumn — but it also greatly influenced the manner in which works of art were shown and appreciated. For in both China and Japan it is an old–established custom to harmonize as much as possible the interior decoration with the constantly changing condition of nature outside.

Scrolls exposed only temporarily, and in accordance with the seasons.

This adaptation of the individual to seasonal changes was doubtless the origin of the custom, common to both China and Japan, of never exposing the same scroll picture for a long time on end: after the lapse of a week or so it is taken down and rolled up again, to be stored away and replaced by another.

It is true that various artistic and practical considerations contributed to the maintenance of this custom throughout the centuries. The Sung connoisseur Chao Hsi–ku observes:

" Having selected some paintings by famous artists you should not suspend more than three or four in one room. After having enjoyed these to the full, every three or four days you should change them for other good pictures. In such a way you will (in course of time) see all your scrolls and they will never suffer damage by draughts or sunrays. Moreover, if you thus display them in turns they will not get soiled, and by continually changing the works by one or two masters you will never tire of them. " [1]

This thought is echoed by T'u Lung, a 16th century collector, who says:

" Superior paintings ordinarily used for hanging in your room should be changed every four or five days. Then you will never get tired of them and moreover they will not be soiled by dust and dampness. " [2]

---

[1] Cf. Chinese text on page 197 below.

[2] K'ao–p'an–yü–shih (cf. Appendix I, no. 29), ch. 2:　平 時 張 掛 名 畫。須 三 五 日 一 易。則 不 厭 觀。不 令 惹 塵 濕。

3

Similar statements may be found in literary sources of old and modern times. However, the origin of the custom of frequently changing the exposed scrolls must be sought for in the Chinese manner of life rather than in considerations of expediency.

Superior scrolls, whether pictorial or calligraphic, seldom form a permanent part of the room. In China, permanent interior decoration is confined to carved wooden panels, wall paintings, and painted beams and ceilings. In Japan, this decoration consists of rare and beautifully grained woodwork, carved frames over the sliding doors and, in the old lordly mansions and in temples, of painted wooden panels. To this permanent decoration the mounted scroll is added as a temporary embellishment.

The choice of scrolls to be displayed on a particular time or occasion depends largely on individual taste and preference. In course of time, however, there gradually developed certain traditions fixing what policy should be adopted by a gentleman of refined taste for displaying his scrolls.

It was chiefly during the Ming period — which in the opinion of many represents the heyday of Chinese culture — that connoisseurs and collectors tried to formulate these traditional rules so as to codify the results of centuries of artistic experience.

A Ming calendar for the displaying of scrolls.

A typical example of such an attempt is a "Calendar for the displaying of scrolls" drawn up by Wên Chên–hêng, a prominent artist and connoisseur of the Ming period. His ideas on the use of hanging scrolls in interior decoration may be taken as representative for those prevailing in literary circles during the later part of that dynasty. Since this seems to be the only document of the kind that has been preserved in its entirety it is translated here in full.

" On New Year's morning you should display Sung paintings of the Gods of Happiness and images of the Sages of olden times. Round the 15th of the first moon you should suspend on your wall paintings showing the Lantern Festival or marionette performances. [1] In the second moon there should be representations of ladies enjoying spring walks, of plum blossoms, apricots, camellia, orchids, and peach and pear blossoms. On the third day of the third moon there should be shown Sung pictures of the Dark Warrior [2] while round the time of the Ch'ing-ming Festival [3] there should be shown pictures of peonies and *paeonia albiflora*. On the eighth day of the fourth moon, the birthday of Buddha, you should display representations of Buddha by Sung and Yüan artists, or Buddhist pictures woven in silk dating from the Sung period. On the fourteenth day of that moon you should show images of Lü Tung-pin, [4] also painted by

---

1) Looking at processions of people carrying gaily painted lanterns of silk and paper and seeing marionette performances are favourite pastimes during the holidays of the first moon.

2) *Hsüan-wu* 玄武 is a mythical being that symbolizes the North; it is represented as a tortoise with a snake coiling around it. Later it was incorporated in the Taoist pantheon under the name of *Chên-wu-ta-ti* 眞武大帝;

hsüan was replaced by chên because the former character occurred in the name of the T'ang Emperor Hsüan-tsung and hence became taboo.

3) One of the 24 Chinese yearly festivals; on this occasion one goes to visit the family tombs.

4) Lü Tung-pin 呂洞賓 is a Taoist fairy, one of the Eight Immortals; he is said to have been born on this date. Also known as Ch'un-yang-tzŭ 純陽子 or Lü-tsu 呂祖.

artists of the Sung dynasty.   On the fifth day of the fifth moon there should be charms written by Taoist masters and calligraphic specimens by famous men of the Sung and Yüan dynasties; further scrolls depicting the Tuan–yang Festival, the Dragon Boat races, tigers made of artemisia and the Five Poisonous Creatures. [1]

"During the sixth moon there should be displayed large Sung or Yüan pictures of towers and palaces, of forests and rocks, of high mountain peaks, of parties gathering lotus flowers, of summer resorts, and similar scrolls.   On the seventh evening of the seventh moon there should be displayed pictures of girls praying for skill in needle work, of the Goddess of Weaving, [2] of towers and palaces, of banana trees, of noble ladies, and suchlike representations.   During the eighth moon you should use pictures of old cassia trees, or of libraries fragrant with incense.   During the ninth and tenth moon there should be shown pictures of chrysanthemums, hibiscus, or rivers and mountains in autumn, of maple forests [3] and similar scrolls, while during the eleventh moon there should be paintings of snow landscapes, winter plum trees, water lilies, Yang Kuei–fei indulging in wine, [4] and suchlike pictures.   During the twelfth moon there should be scrolls showing Chung K'uei inviting good luck and chasing away devils or of Chung K'uei marrying off his sister. [5]   On the twentyfifth of that same moon you should suspend on the wall pictures of the Jade Emperor riding on coloured clouds [6] or similar scrolls.

"Further, on the occasion of changing your abode you may display pictures like that of Ko Hung moving to the Lo–fou Mountain, [7] while on the occasion of an anniversary there should be shown images of the God of Longevity by artists of the Sung Imperial Academy [8] or representations of the Queen of the Western Paradise. [9]   If you are praying for clear weather, hang on your wall an image of the Sun God, and when praying for rain, pictures of transcendental dragons sporting in wind and rain, of the spring thunder awakening the hibernating insects, or similar scrolls.   For the beginn-

[1] On the occasion of the Tuan–yang festival rowing races are held with boats showing the shape of a dragon.   At that time the houses are lavishly decorated with garlands of *Artemisia moxa*, a plant supposed to be a powerful antidote against poison and to ward off evil influences.   Its roots are burnt in front of the house and its leaves are plaited in the shape of a tiger, as an emblem of good luck.   The "five poisonous creatures" are viper, scorpion, centipede, toad and spider; these also act as a charm against evil and are often found embroidered on the jackets of small children.

[2] *Chih–nü*, the Goddess of Weaving — also called T'ien–sun — is supposed to grant girls and women skill in needle work; cf. the story referred to on page 291 below, note 1.   She resides in Lyra and is the spouse of Niu–lang 牛郎, the Cowherd, viz. the patron of agriculture who resides in Capricorn.   Chinese popular belief has it that once the two were happily married but afterwards separated by the Milky Way.   Only once a year, on the 7th of the 7th moon, magpies form a bridge across the Milky Way and thus permit the lovers to meet.

[3] It is in autumn that the maple leaves turn red and

yellow and offer a charming colour scheme that is much appreciated both in China and Japan.

[4] The famous consort of the T'ang Emperor Hsüan–tsung.

[5] Chung K'uei is the well known Taoist devil–queller depicted as a bearded warrior of terrifying appearance.   It is said that when he died he left an unmarried younger sister behind; his soul returned to earth and he succeeded in arranging a suitable marriage for her.   He often appears in pictorial art as conducting his sister to her new home, riding at the head of a procession composed of domesticated devils of all shapes and sizes who meekly carry the trousseau.

[6] Yü–ti or Yü–huang 玉皇 is the supreme god of the Taoist pantheon.

[7] The philosopher Ko Hung 葛洪 who lived round 300 A. D. is said to have become an Immortal after he had moved his abode to the Lo–fou Mountain 羅浮山.

[8] Cf. below, page 191, note 2.

[9] Hsi–wang–mu 西王母 presides over the Western Paradise, where waxes a peach tree, the fruits of which contain the Elixir of Immortality.

5

ing of spring paintings showing the God of Spring or the Great Monad personified [1] are most suitable.

"Thus all scrolls should be displayed according to the season so as to indicate the time of the year and the various calendar festivals. If, however, you show large scrolls of various deities, or pictures of apricot blossoms and swallows, or plum blossoms as depicted on paper mosquito nets, or scrolls showing plum branches growing over a wall; or again pictures showing pine and cedar together or similar pictures directly referring to long life, then such will give your house a vulgar appearance; therefore such scrolls should never be used. [2] On the other hand small landscapes of the Sung and Yüan periods, pictures of old trees, of bamboo and rocks, or four scrolls showing together one continuous large landscape, [3] these can be displayed without reference to time or seasons." [4]

As a matter of course it are not many who possess such an extensive collection of paintings that they can afford to be so particular about harmonizing the scrolls exposed in their houses with seasonal changes. Moreover these rules were drafted by a man

1) Tung-huang, the "Eastern Emperor", since ancient times considered as the god of spring. *T'ai-i*, the Great Monad, split into the Positive and Negative Principles, from these there developed the five elements, and thus the universe came into being; in the Taoist pantheon this philosophical idea is personified as an old man with a long beard and a jade scepter.

2) Wên Chên-hêng's objections are based on various reasons. Large scrolls with religious representations are meant to be displayed in temples, where people can burn incense and pray to them, they should not be used for decorating the interior of a private house. Second, "apricots and swallows" are a very popular allusion to success in official life. Compare, for instance, the well known auspicious phrase *hsing-lin-ch'un-yen* 杏林春燕, which often appears on brushes, ink stones, and other paraphernalia of the scholar's library. The first half of this phrase refers to the examination for the degree of *chin-shih*, which was held in the second moon, when the apricot is in bloom; the second half refers to the fact that the successfull candidates are treated to a banquet, *yen* 宴, a homonym of *yen* 燕 "swallow". This phrase is often expressed in a picture, showing a swallow alighting on a flowering apricot sprig. The author considers this representation too common to serve as decoration of a scholar's library. Third, especially during the Ming dynasty, paper bed-curtains, painted with plum blossoms, were fashionable (for the sexual associations of the plum blossom, cf. my book *The Lore of the Chinese Lute*, page 141 sq.); suggesting fertility and the intimacies of the wedded couch, this motive is not suited for public display. These curtains were popular already in the Sung period; cf. the article *Mei-hua-chih-chang* 梅花紙帳 in the *Shan-chia-ch'ing-shih* 山家清事, a brief treatise by the Sung scholar Lin Hung 林洪. Plum blossoms growing over a garden wall

are vaguely connected with illicit relationships. Finally, pine and cedar, cranes and deer are so popular as emblems of longevity and prosperity, that Wên Chên-hêng deems them too vulgar to be used by a man of taste.

3) *Szǔ-fu ta-ching*, presumably the same types as the *t'ung-ching* described on page 20 below.

4) *Chang-wu-chih* (cf. Appendix I, no. 30), ch. 5: 縣名二桃像。日四符五幅避織古菊宜二十移有東雷等若過俗木論古正蘭武八十玉虎大蓮孫宜宜月十二如則有春乙序及儡玉眞月像人艾閣探天月月一圖梅落枯序神傀茶畫四佛眞像八十十等時紙小以福燈山宋藥繡宜龍舟樓山巧八十等妹圖祈雨東歲子之元當書看杏宜芍宋五景元幅鍼等圖九圖妃嫁等圖祈雨東歲宋宜梅日丹及端陽宋大雲乞圖等楊魅車等圖風有見燕意宋不宋後宜女三牡佛像端陽宜士屋林醉驅雲居等畫則以花壽如又宜梅日丹宜石士屋楓仙福色移母古春掛杏鹿至景朝前士月畫陽月樹夕蕉書山水迎五仙王有立時懸及鶴懸大宵遊三後人純名六密七芭香秋梅尴帝葛星則圖時圖柏宜幅大歲元春屬前元畫元類蒙圖閣天蓉臘鍾玉有壽雨等隨神松不四令元宵宜之明宋宋之水等樓或芙景宜則畫蟄皆幅梅斷石月像元之明宜宋宋之水等樓或芙景宜則畫蟄皆幅梅斷石。書賢月李清宜及毒山暑女桂花雪月五家院君起圖大墻套竹也。

6

living in a fastidious artistic milieu and at a time when there was attached the greatest importance to all matters related to esthetics and good taste.

Yet even nowadays and in ordinary interiors preference for some fixed subjects during a certain season is often noticeable. During the cold days of late winter one likes to see in one's house paintings of the plum blossom, because these flowers coming forth from the gnarled branches of a black, seemingly dead tree, suggest the presence of the living spirit that has been gathering during winter and will presently become manifest in its full glory with the coming of spring. In the hot days of summer one prefers representations of the bamboo because its fresh rustling leaves suggest cool shade and gentle breeze; or rubbings from stone inscriptions, their white design on a black ground reminding one of the moss–covered stone tablets in temple courts cool in the shadow of old cypress trees. And in autumn the observation of a painting of wild geese flying high in a limpid sky will deepen the mood of expectation and sad longing proper to that season.

This applies equally to pictorial and calligraphic scrolls. As a rule one will choose for the latter a scroll with a poem, a brief essay or a few large characters the contents of which allude to the aspect of nature outdoors.

The frequent changing of the scrolls exposed has exercised considerable influence on the evolution of the art of mounting. And the art of mounting, in its turn, contributed to the preservation of this ancient custom.

Influence of the changing of scrolls on the art of mounting; brief survey of the history of this art.

Originally the main features of a mounted scroll were conditioned by practical reasons. Until well into the fifth century narrow horizontal strips of silk or paper, rarely more than about one–and–a–half feet broad but often measuring scores of feet in length, served as the canvas of both the painter and the calligrapher. The archaic art of mounting aimed at making these frail materials more durable and easier to handle. Thus a backing of some tough material was added and, as a further protection, borders on all four sides, and the scrolls were stored away rolled around a wooden stick. These early scrolls could not be suspended on the wall and were not meant to be used in any way for the purpose of interior decoration. If one wished to look at them they were unrolled on the floor or a desk. Pictorial art did figure largely in interior decoration but only as expressed in murals and paintings executed on wooden screens, beams and parts of the ceiling.

The hanging scroll became popular only at a comparatively late date, approximately during the 11th century, under Buddhist influence; this will be discussed in greater detail in the historical part of the present essay. When the mounted scroll had become part of interior decoration special attention was given to the esthetic possibilities of the hanging scroll mounting: choice brocades were employed for the borders, and the rollers at the bottom of the scroll were provided with ornamental knobs. However, just as it was practical considerations that determined the character of the early mountings, so for the same reason the main features of the process of mounting remained unchanged throughout the centuries. Scrolls being only temporarily exposed it was natural that stiff mountings were avoided and scrolls mounted in such a way as to be easily stored away

7

in as little space as possible. The archaic way of mounting proved the most suitable, answering as it did both practical and esthetic requirements. Thus up to the present day both in China and in Japan most paintings and calligraphic specimens are mounted in either one of two forms: as horizontal hand scrolls or as vertical hanging scrolls. Although there are also found scrolls mounted on wooden frames, as screens or as albums, these forms of mounting constitute a small minority.

In Chinese daily life hand scrolls and albums occupy the same place as rare books and manuscripts. Literati and art lovers keep them on their shelves or carefully locked away; they are taken out only when one wishes to look at them. The hanging scroll, on the other hand, forms part of the interior decoration of every house, from the humble abode of a poor school teacher to the sumptuous mansions of the rich. Antique paintings by famous masters mounted with silk and silver-plated knobs will further enhance the elegant atmosphere of the spacious halls in the residences of ranking scholar-officials. But pictures and autographs by friends or relatives with cheap paper mountings will in no lesser degree give a touch of literary refinement to the otherwise bare room of a poor student.

Importance of the art of mounting for the preservation of scrolls, and its artistic possibilities.
The art of mounting has two main aspects. First, the mounting of new scrolls that have never been mounted before, and second, the remounting and repairing of antique scrolls.

Literary works left by Chinese artists and connoisseurs usually discuss only the art of remounting. They take it for granted that any qualified artisan will be able to mount a new scroll and therefore pass over this aspect of the art of mounting in silence.

This fact, however, should not make one overlook the importance of the process of mounting new scrolls. It is the quality of the first mounting that decides the length of a picture's life. A good first mounting will hold for several hundred years preserving the scroll in its full glory. A clumsily applied first mounting, on the other hand, will soon warp, become loose or cause wrinkles to appear on the surface of the picture and thus definitely spoil its beauty. It is for this reason that the Ming scholar Chou Chia-chou justly calls the mounter " the arbiter of the destiny of scrolls ". [1] The longer the first mounting lasts, the better it is for the scroll. For remounting, even if done by an expert in the restoration of antique specimens, always implies the risk that the picture will lose something of its original charm. Or, as the great artist and connoisseur of the Sung period Mi Fu tersely puts it: " A painting is damaged everytime its backing is changed. " [2]

Further, already at the time when a picture is mounted for the first time there are many opportunities for the forger to practise his tricks. Knowledge of the mounting of new pictures has put the connoisseur on the alert for various possibilities for tamper-

---

[1] Quoted from Chou Chia-chou's own preface to his *Chuang-huang-chih*.

[2] *Hua-shih* (cf. Appendix I, n. 37); full quotation given below, page 191.

8

ing with pictures that will never even be suspected by the outsider unfamiliar with the technicalities of the process.

It goes without saying, however, that the remounting and repairing of antique scrolls is the more difficult task, one that can be satisfactorily performed only by an experienced mounter who has specialized in this art and who couples great technical skill with sound artistic judgement. In practically every town in China and Japan one will find mounters who can mount new scrolls; but those qualified to remount antique specimens are found only in some of the more important cultural centres.

Moreover, it is during the process of remounting antique scrolls that the forger finds most opportunities for effecting his ingenious falsifications.

One need not wonder therefore that old and modern Chinese writers devote so much attention to the art of remounting and repairing antique specimens: it is of decisive importance to the conservation and the preservation of works of art. The Ming scholar Chou Chia–chou observes:

" Great scholars and talented men have exerted themselves to express the essence of their wisdom in writings and paintings. The transmission of these, however, entirely depends upon paper and silk. Now paper and silk are frail materials. They are menaced by all kinds of calamities: as when falling into the hands of the wrong people, being destroyed by disasters of war and fire, becoming grimy, torn and worm–eaten, or being stolen and bartered away for gain. Because of these evils but one–hundredth part of them is preserved. If the scrolls constituting this one–hundredth part that survives are mounted by the wrong people they will be spoilt beyond repair. This truly is a cause for great indignation. " [1]

Lu Shih–hua, a Ch'ing collector of antique scrolls has the following to say on the subject:

" If you cannot obtain the service of a good mounter for remounting your scrolls, even if they should be badly damaged you had better (leave them as they are, and) wrap them up well and keep them in a box, putting no heavy articles on top of them. You should not be in a hurry and entrust such scrolls to a clumsy mounter. For if you give a scroll to a clumsy mounter then this is tantamount to destroying the scroll. Clumsy mounters are therefore often referred to as 'Executioners of scrolls'. On the other hand present-day Soochow mounters like Chang Yü–jui, expert in repairing antique paper scrolls, and Shên Ying–wên, expert in repairing antique silk scrolls, in their art truly surpass the mounters of old, and the future will not produce their equals. They can be likened to great sages or meritorious statesmen. " [2]

1) Again quoted from the preface to the *Chuang-huang-chih*.

2) *Shu–hua–shuo–ling* (cf. Appendix I, no. 47), ch. 23:
書畫不遇名手裝池。雖破爛不堪。寧包好藏之匣中。不可壓以他物。性急而付拙工。是滅其蹟也。今吳中張玉瑞之治破紙本。沈文迎為名賢之功臣。實超前絕後之技。拙工謂之治破絹本。拙工謂之殺紙本。沈後之絕前超。拙工創本。

From the above it will be clear that a mounter bears a heavy responsibility: the fate of scrolls, both old and new, is laid in his hands.

As to the esthetic importance of the art of mounting, this has been wittily explained by the Ch'ing writer Chang Ch'ao in the following words:

" The mounting is to a scroll what make–up is to a handsome woman. Even when a beautiful woman is gifted with natural charm, if all day she walks about in coarse attire and with tousled hair, although it will not entirely destroy her charm, yet it will make her look insignificant. But if she powders herself and paints her eyebrows and daintlty adds some spots of rouge; if she cuts her garments from gauze fine like a mist and fashions her sleeves out of crystalline silk, shall not then her beauty be increased and her charm enhanced ? " [1]

<div style="float:left; width:20%;">The qualities characterizing a good mounting.</div>

To sum up, a good mounting must combine practical and esthetic features. The mounting must embellish the scroll and at the same time offer it effective protection.

In the first place, a mounting should be perfect from the technical point of view. The mounted scroll must be smooth and supple so that one can roll and unroll it easily, without its getting askew. Yet, at the same time, it may not be so loose as to get warped when suspended on the wall nor so stiff as to develop creases when rolled up quickly. A scroll is said to have been perfectly mounted if when being partially unrolled on the table it stays that way when one lets it go, neither curling up on its own account nor rolling out further.

Then, a mounting must meet artistic requirements without being so strikingly beautiful as to divert attention from the picture itself. The mounting must detach the picture from its surroundings but at the same time it must not give the impression of clamping it in a rigid frame. The mounting should harmonize in colour and design with the picture yet it on no account blend into it. The mounting should separate the picture from its surroundings yet not be so prominent a framing as to strike the eye of the observer before he has noticed the picture itself.

The mounting should frame the scroll in an unobtrusive way; the observer should, as it were, notice the mounting only subconsciously. At the same time the mounting should form a strong and efficient protection for the scroll, guarding it both when it is exposed and when it is rolled up.

When one adds to these requirements the manifold and complicated problems posed by the removing of former mountings from antique pictures and by their repairing and retouching, it will be evident that the mounter's task is far from easy. But a tradition of many centuries coupled with deft hands and sensitive eyes have enabled the mounter to overcome these difficulties and solve the problems of the art of mounting in an admirable way.

[1] Quoted from Chang Ch'ao's preface to the *Chuang-huang-chih*.

Mounted scrolls are so typical an expression of the spirit of Chinese and Japanese culture that it is difficult to arrive at a full appreciation of their artistic significance if one considers them divorced from the surroundings of their homeland.

It is true that the qualities of superior Chinese and Japanese paintings are such that their beauty will be apparent regardless of how and when they are shown. But it cannot be gainsaid that these works of art are at their best when seen — or imagined — in their proper environment.

The charm of a large Chinese landscape painting will be enhanced if one sees it hanging in the library of a connoisseur amidst the noble simplicity of antique Chinese furniture. And what setting could show to greater advantage a Japanese hanging scroll than the tea room with its quiet sifted light filtering through the paper windows? Anyone who aspires at seeing these scrolls through the eyes of the Chinese and Japanese connoisseur must know what place they occupy in their daily life and surroundings.

Therefore, after the description of the scope of the art of mounting given above, we shall now briefly review the main features of the Chinese and Japanese interior and explore how and to what extent the mounted scroll figures in its appointments.

It is hoped that this description will on the one hand broaden the reader's appreciation of the artistic significance of the mounted scroll, and on the other serve as an introduction to the historical part of the present publication. The 19th century Chinese and Japanese interiors described below resulted from an evolution that began more than a thousand years ago. This evolution will be discussed further in Chapter III here after, together with an account of how indoor architecture influenced the art of mounting and how this art in its turn affected the development of interior decoration. Here the facts are stated without historical comment.

We shall begin with a description of the floor plan and interior of a Chinese upper middle class house of the 19th century. [1]

---

1) Although there exist many books in Western languages on Chinese temples and palaces, walls and ramparts, few has been written about the Chinese dwelling house and its history; and it is precisely the evolution of the Chinese upper middle class interior that has had a decisive influence on the history of the mounted scroll. In the present publication, therefore, an attempt is made at supplementing this gap. Next to the sketch of the Ch'ing dwelling house given here, the reader will find in subsequent chapters further data on its development during the preceding dynasties; the pertinent passages may be located by consulting the General Index. Needless to say that the present publication treats this complicated subject only cursorily, its many problems being dealt with in a simplistic way. Those interested may find more material in the sources listed below.

The credit of having published the first somewhat detailed account of the upper middle class Chinese house and its decoration goes to William Chambers (1724-1796); in his book *Designs of Chinese buildings, furniture, dresses, machines and utensils* (London 1757, French edition Paris 1776) he describes a dwelling house in Canton, illustrated with some fairly accurate sketches (cf. especially Plates VIII and IX). A good source for the study of Chinese interiors is a collection of pictures dating from the Ch'ien-lung period, and preserved in the *Cabinet des Estampes*, of the Bibliothèque Nationale, in Paris; these are described by ELEANOR VON ERDBERG, *Chinese influence on European garden structures* (Harvard University Press, Cambridge 1936). Six of these pictures were published by G. ECKE, in his article *Sechs Schaubilder Pekinger Innerraume des Achtzehnten Jahrhunderts* (in "Bulletin of the Catholic University of Peking", Nov. 1934). It is hoped that some day the entire collection will be made available in reproduction.

A series of fine picture of 17th century Chinese dwelling houses in Central and South China is to be found in the Japanese book *Shinzoku-kibun* (清俗紀聞, blockprint publ. 1799, 13 ch. in 6 vls.); this is an amazingly detailed

It goes without saying that houses in various parts of China show differences in floor plan and architectural details, differences caused by climatic conditions, local tradition and individual taste. Yet such is the degree of integration achieved by Chinese culture that a description of a fairly opulent house in Peking will, *mutatis mutandis*, apply to houses of this class in cultural centres all over China.

The floor plan reproduced on Plate **1** belongs to an upper middle class house in Peking. As is usual in the North, this house is a *p'ing-fang* 平房, that is to say it has only one storey. In Central and South China most houses of this class are built as *lou-fang* 樓房, viz. with one or more storeys added. But the general principle of the floor plan of both *p'ing-fang* and *lou-fang* is the same.

account of daily life of the Chinese, drawn up by Nakagawa Chūei 中川忠英 on the basis of material gathered from the Chinese residents at Nagasaki, while he was serving in that town as a government official. The illustrations were drawn by Japanese painters and Chinese artists staying in Nagasaki. The *Shinzoku-kibun* was used as source book by PAUL CARUS, who in his *Chinese Life and Customs* (Chicago 1907) reproduced a number of selected pictures, with brief explanatory notes.

As regards modern literature, as far as I know the only Western book on the history of the Chinese dwelling house is R. KELLING, *Das Chinesische Wohnhaus* (Supplement band XIII, of "Mitteilungen der Deutschen Gesellschaft für Natur- und Völkerkunde Ostasiens", Tokyo 1935); unfortunately the author had to work with second-hand sources, and the illustrations are poor. The second part, treating of the early history of the Chinese house, was written by Bruno Schindler, on the basis of material collected by the late Prof. Conrady. A brief, but accurate description of the main hall in a Chinese house, illustrated with pictures and diagrams, is to be found in Father SIMON KIONG, *Quelques mots sur la politesse chinoise* ("Variétés Sinologiques", No. 25, Shanghai 1906, p. 37 sq.). Another brief description of a Chinese middle class dwelling house, with a floor plan, is given by FLORENCE AYSCOUGH, in her article *Chinese poetry and its connotations* ("Journal of the North China Branch of the Royal Asiatic Society", vol. LI, 1920).

As to Chinese sources, many data will be found scattered over the various publications of the Chinese association for the study of architecture, *Chung-kuo-ying-tsao-hsüeh-shê* 中國營造學社, sine many years ably directed by Prof. Liang Szŭ-ch'êng 梁思成. A scholarly study of the Chinese house, with particular reference to its garden, is *Tsao-yüan-hsüeh-kai-lun* 造園學概論, by Ch'ên Chih 陳植, Shanghai 1935; see especially the detailed ground plan of the famous Liu Garden in Soochow, facing p. 26. Further an article on Chinese houses and gardens during the Wei and Ch'in periods, 魏晉風流與私家園林, by Wu Shih-ch'ang 吳世昌, published in the periodical *Hsüeh-wên-yüeh-k'an* 學文月刊, vol. I, no. 2; for an English abstract see GRACE M. BOYNTON, *Notes on the origin of Chinese private gardens*, in "The China Journal", vol. XXIII, no. 1, Shanghai 1935.

The best Japanese work on the subject is *Shina-kenchiku-sōshoku* 支那建築裝飾, English title "Architectural decoration in China", 5 illustrated folio volumes, published in 1941 in Tokyo by the *Tōhō-bunka-gakuin* 東方文化學院: this magnificent work was written by Itō Chūta 伊藤重太, the well known Japanese expert on Chinese architecture. Although mainly concerned with palaces and temples this book pays due attention also to the Chinese dwelling house. The Japanese text is accompanied by an English translation; unfortunately the war prevented publication of the sixth and concluding volume. A Japanese study specially devoted to the Chinese dwelling house is *Shina-jūtaku-shi* 支那住宅志 one illustrated volume, published in 1932 by the *Manshu-bunka-kyōkai* 滿洲文化協會 in Dairen and compiled by Kijima Katsumi 貴島克己; here the differences among dwelling houses in various parts of China are discussed at some length. Profusely illustrated with floor plans and photographs, this scholarly publication deserves more attention than it has hitherto received.

Finally, for good pictures of Chinese upper middle class houses, illustrating the role played by the mounted hanging scroll in interior decoration, I refer the reader to the following publications. Excellent photographs are given in the folio work *Chinese houses and gardens* (one vol., Honolulu 1940). The Chinese subtitle of this book is *Yüan-ting-hua-tsui* 園庭畫萃, and it was edited by Henry Inn 阮勉初; unfortunately the accompanying text by Li Shao-ch'ang 李紹昌 is written in a rather popular vein. An attractive book is *In the Chinese Garden*, published by Florence Lee Powell (one vol., New York 1943). This book contains good photographs of two famous old Soochow residences, the *Liu-yüan* 留園 and the *Shih-tzŭ-lin* 獅子林; a general introduction has been added, and each plate is accompanied by a brief explanation. A few mistakes on page 23, where the history of the Liu-yuan is discussed, should be corrected. "Shang Taotai" is the well known statesman Shêng Hsüan-huai (盛宣懷, 1849-1916) who restored the house and its garden, and gave it the name of Liu-yüan 留園; originally it belonged to the Liu 劉 family, and was called Han-pi-chuang 寒碧莊.

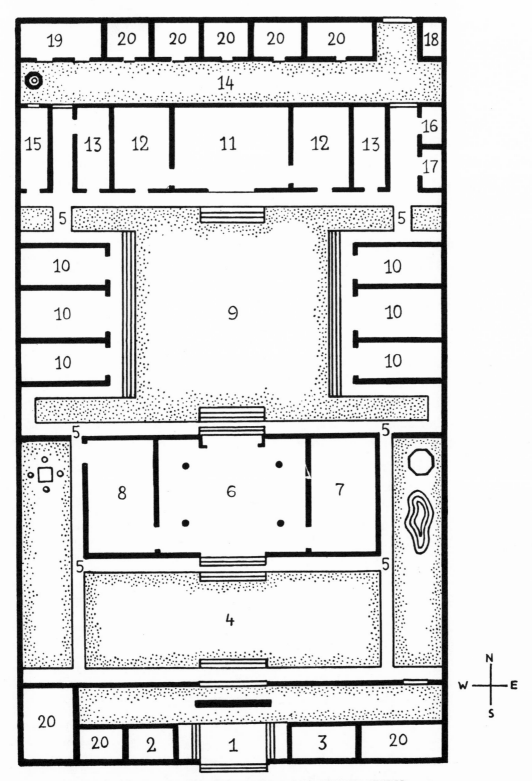

I. – FLOOR PLAN OF AN UPPER MIDDLE CLASS HOUSE IN PEKING

(1) main entrance – (2) porter's lodge – (3) room for sedan chair – (4) front courtyard – (5) open corridors – (6) main hall – (7) library – (8) sitting room – (9) central courtyard – (10) side rooms – (11) t'ang-wu – (12) chêng-fang – (13) t'ao-chien – (14) back-yard – (15) store room – (16) privy – (17) bathroom – (18) servant's privy – (19) kitchen – (20) servant rooms.

This floor plan shows a rectangular shape, the compound being on all four sides enclosed by a high wall. This is the ideal shape that corresponds to that of ancient palaces and temples. As a matter of course the limited space available in crowded cities rarely allows an architect to build a house that shows such a symmetrical pattern.

The floor plan. One enters the compound by the large main gate, *ta–mên* 大門 (1) flanked on both sides by the high wall that surrounds the entire lot. This gate has a double door of heavy wood, usually lacquered red and hence commonly referred to as *chu–ch'i-men* 朱漆門 "Red Lacquer Gate". The laws of the Ch'ing dynasty dictated what officials were entitled by their rank to have their main gates lacquered red, but since the establishment of the Republic these rules have become obsolete.

On left of this gate there is a porter's lodge, *mên–fang* 門房 (2) and two rooms for male servants (20). On right a *ch'ê–fang* 車房 (3), that is to say a room for storing sedan chairs and rickshaws, and another servant room (20). These rooms form together one architectural unit that might be referred to as the "gate house".

This front section is separated from the rest of the compound by a solid wall that has one larger doorway in the middle and a smaller one on the right. The former is used by members of the family, guests and the more important servants; the latter by the lower servants and tradesmen and messengers. The central doorway is screened off by a narrow brick wall called *chao–pi* 照壁; it is decorated on the front side by a large character for "happiness" or some other auspicious legend, written on the plaster or inlaid in mosaic, over a basin for goldfish or a stone bench with potted flowers. This wall is supposed to prevent evil spirits from entering the house since ghosts and goblins can only move forward in one straight line. The central doorway in the dividing wall often takes the shape of an ornamental archway of wrought iron which is called *ch'ui–hua–mên* 垂花門.

This gate gives upon the front courtyard, *ch'ien–yüan* 前院 (4); here one finds flower beds, artificial rocks or other garden embellishments. In summer this front courtyard is usually covered by a temporary roof of matting stretched over high bamboo poles and called *p'êng* 棚. Covered passages, the so–called *tsou–lang* 走廊 (5) lead to the main building of the compound and, farther on, connect all other buildings with each other. These *tsou–lang* often have floors of coloured tiles and low, carved balustrades. When they follow an irregular course they are called *ch'ü–lang* 曲廊, "crooked corridors".

The empty wall space of the garden wall and the ceilings and beams of the *tsou–lang* are frequently decorated with paintings. These, however, are executed directly on the wood or plaster and have no connection with the art of mounting. Moreover, they are mostly done by artisans and can hardly be considered as belonging to the domain of fine art.

In the main hall of the house, the *ta–t'ing* 大廳 (6) one finds a display of scrolls of various descriptions. In this hall the family gathers on solemn occasions and it is here that important visitors are entertained. This hall shall be discussed in greater detail below.

Continuing our survey of the floor plan we find on either side of the main hall a smaller room. The one on the right (7) is most often used as the library of the master of the house and hence designated as *shu-chai* 書齋 or *shu-fang* 書房. Part of its walls are covered with book shelves, a large writing desk is standing in front of the window, flanked by some easy chairs. In this study the master will hang a few larger and smaller scrolls and display some bronze vessels or other antiques. Here he reads and writes and receives his friends. The room on the left of the main hall (8) bears a more intimate character; it serves as rest room for the master when he takes his afternoon nap and here he will take one or two bosom friends for a confidential talk. It also serves as his spare bedroom if he comes home late or prefers the quiet of this part of the compound to the more noisy family quarters at the back. The back part of this room is usually taken up by a broad couch or heated stone bench (*k'ang* 炕), while in front of the window there stands a tea table and a set of chairs. The wall space is utilized for hanging a few selected scrolls that are particularly dear to the owner.

Much thought is given to the outlay of the two smaller gardens on either side of this main part of the compound. In the present case the garden on the left has a rustic stone table for drinking tea or playing chess in summer, while in the garden on the right stands an octagonal tea pavilion in the shadow of some trees and with an artificial lotus pond in front. The *tsou-lang* running along these gardens often take the shape of broader verandahs where one may find racks with potted plants protected against the rain by the protruding eaves overhead.

The above completes the description of the public part of the compound. Except members of the family and servants practically no male person, not even the closest friends of the master of the house, ever penetrate beyond this.

The *tsou-lang* now lead farther to the central courtyard, called *chêng-yüan* 正院 or *szû-ho-yüan* 四合院 (9). Where the *tsou-lang* run along the wall one will often find a mural painting, or an engraved slab of stone inserted in the plaster. These murals are as a rule rather crudely drawn coloured pictures of birds and flowers or simple landscapes. They disappear everytime the house is repainted and are thereafter drawn anew by artisans. The stone slabs, however, often have historical and artistic value and are a permanent feature of the house. Especially in residences belonging to old–established families of scholars or collectors such slabs are valuable antiques engraved with exact replica of autographs or pictures by famous artists and from which the owner may take " rubbings " for publication or for presentation to his friends.

The central courtyard is usually decorated with raised flowerbeds or clusters of bamboo and smaller trees. On the right and left are the " side rooms ", *hsiang* 廂 (10) built in sets of three, the room in the middle being slightly larger than the two adjoining it. These side rooms serve as living quarters of the concubines, married sons or other close relatives.

At the back of the central courtyard stands a building consisting of five rooms. These are the living quarters of the master of the house and his first wife. The large room in

the middle (11), called *t'ang-wu* 堂屋 often contains the ancestral altar and serves as a kind of family shrine. The rooms adjoining this central room are called *chêng-fang* 正房 (12); the smaller rooms at the end, called *t'ao-chien* 套間 (13), are used as store rooms. Another store room is the small building on the left (15), called *ts'ang-fang* 倉房.

The side rooms and the rooms of the building back of the central courtyard are all decorated with hanging scrolls of various descriptions, according to the individual taste of the people who live there.

Finally one comes to the back courtyard, *hou-yüan* 後院 (14), which is a plain yard of stamped earth or stone flags. Here the water well is located and near to it the kitchen, the rooms of female servants, etc.

The residences of high officials and wealthy people have a floor plan where the present one is duplicated or triplicated. Side gates lead to other courtyards and gardens belonging to the compound. Mansions built on such a large scale mostly have a second, larger reception hall in a separate compound, called *hua-t'ing* 花廳. It is used for receiving important guests. Often it faces a raised terrace for private theatrical performances.

One courtyard together with the buildings surrounding it is designated by the term *chin* 進, the unit used for indicating the size of a mansion. [1] The present floor plan counts three " chin " 三進, but compounds of six or seven chin are by no means rare. Smaller houses, on the contrary, consist of only the back half of the floor plan given here, that is to say the central courtyard and the *hou-yüan*. The dwelling house of the lower classes is represented by the family quarters of a larger house, viz. *t'ang-wu* and adjoining rooms, all on a smaller scale.

As regards the general location of a house, ancient geomantic considerations are adhered to as closely as circumstances permit. If possible the compound is facing South, the ideal situation is when at the back of the house there is a hill or a higher building and in front of it a watercourse.

The decoration of the main hall.

We now return to a closer inspection of the main hall. Plate **2** gives a detailed floorplan of the hall and Plate **3** a general view of its interior.

Having crossed the front courtyard one ascends a few stone steps and enters the hall through a broad doorway, usually consisting of six or more narrow and high panels decorated with delicate openwork carving. In the backwall opposite there is a door similar in size but made of solid wood. This backdoor which gives on an open porch is nearly always kept closed, one goes in and out through the two narrow side doors. The main hall further has two door openings on the left and the right leading to the adjoining library and rest room described above.

From the architectural point of view the prominent feature of the hall is constituted by the four heavy wooden pillars that support the roof, two in front and two at the back.

---

[1] Curiously enough this special meaning of *chin* is not given in any of the Western standard dictionaries of the Chinese language which I consulted.

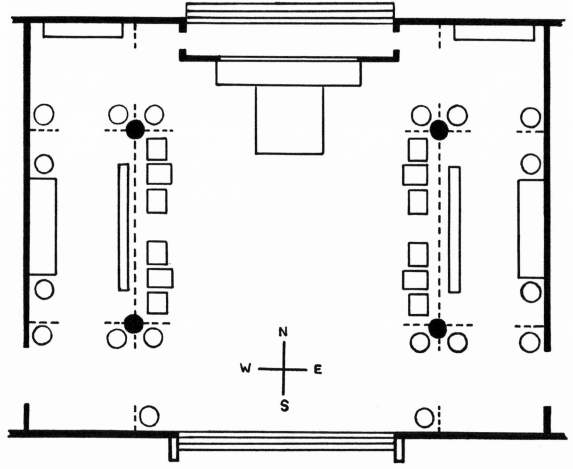

2. – FLOOR PLAN OF THE MAIN HALL IN A CHINESE HOUSE

These pillars serve as guideposts for the location of the most important pieces of furniture and, corresponding therewith, for the distribution of the mounted scrolls over the wall space available. These pillars supply a pattern of interior decoration that is uniform for the halls of upper middle class houses all over China.

Against the closed back door there is placed a narrow, high table called *t'iao-chi* 條 几 or *ch'ang-cho* 長 桌; a special Southern term is *chiao-t'ai* 橋臺. Directly in front of this high table there stands a lower, square-topped one, known as *pa-hsien-cho* 八 仙 桌 " Eight Immortals Table ".

Above these tables, against the backwall, one hangs a large-size scroll of good quality; scrolls exposed in this particular place are called *t'ang-hua* 堂 畫 " Hall Pictures " or *chung-t'ang* 中 堂 " Centre pieces ". A *t'ang-hua* occupies the most conspicuous position in the hall.

*T'ang-hua* show a simple form of hanging scroll mounting. As indicated on Plate **4**, the picture itself is surrounded by a square frame of dark-coloured silk. On top there is a broad strip of silk of a lighter colour, and below a strip of the same material but not

so broad as the upper one. The strip on top is crossed by two vertical bands of darker silk. A thin stave at the top and a thicker roller with protruding knobs at the bottom complete the mounting.

As will be seen below, medium size and smaller hanging scrolls often have more elaborate mountings, including extra strips of silk running across the breadth of the scroll, and thin strips of coloured brocade directly above and below the picture itself. Such elaborate mountings, however, are not considered suitable for the larger *t'ang-hua*.

On the narrow table below the *t'ang-hua* one will find some flower vases or antique bronze vessels, an incense burner, a miniature screen of carved jade or some other ornaments. Properly the objects placed there should accentuate the atmosphere intended to be conveyed to the observer by the *t'ang-hua* they accompany. During the Ming period and during the earlier part of the Ch'ing dynasty such additional decorations were carefully chosen and kept severely simple in order not to divert the attention of the observer from the *t'ang-hua* itself. Later some high officials and wealthy people started to accumulate on this table a mass of heterogeneous objects, such as inscribed silver vases, mirrors, branches of red coral in jade vases, highly coloured statues of gods and fairies etc. This custom is not in accordance with Chinese artistic tradition and has often excited the just ire of discerning Chinese connoisseurs.

In many parts of China the location of the *t'ang-hua* has also a religious significance. In smaller houses one often finds against the back wall of the main hall instead of a *t'ang-hua* the family altar with the soul tablets of the ancestors, *p'ai-wei* 牌位, or the portraits of the recently deceased known as *ming-hsiang* 冥像. In larger houses this family altar is usually found in the *t'ang-wu* further back in the compound, or in a side room especially reserved for it and called *tsu-hsien-t'ang* 祖先堂 "Ancestral Hall".

The religious significance of the place occupied by the *t'ang-hua* finds it expression in the custom, observed all over China, to suspend during domestic ceremonies or private religious services instead on the *t'ang-hua* another hanging scroll with a picture appropriate for the occasion. This custom is referred to in the "Calendar for the displaying of scrolls" translated above. When, for instance, a birthday is being celebrated, a large picture of the God of Longevity replaces the *t'ang-hua*, and incense is burnt on the table below.

The *t'ang-hua* is generally considered as the hanging scroll *par excellence*, and mounted scrolls that qualify as such are designated in catalogues and other works on pictorial art by this special term.

Hanging scrolls in general are called *kua-fu* 掛幅, *chih-fu* 直幅 or *li-chou* 立軸. Next to the *t'ang-hua* mounting there exist several other types each of which has its own technical appellation. These other hanging scrolls are discussed below in the order in which they are found displayed in the main hall.

The *t'ang-hua* is usually flanked on either side by one or more long, narrow hanging scrolls. These accessory scrolls always go in pairs and are therefore called *tui-fu* 對幅,

18

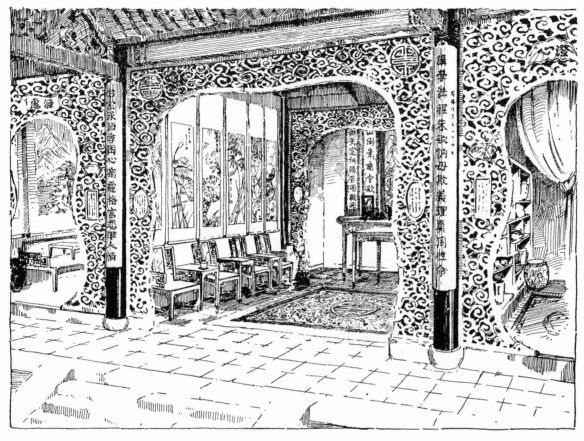

3. — GENERAL VIEW OF THE MAIN HALL IN A CHINESE HOUSE
Drawn by the Chinese architect Tai Nien–tz'û 戴 念 慈

*tui–lien* 對 聯 or more popularly *tui–tzû* 對 子, all of which mean " corresponding scrolls "; in the mounter's jargon they are called *t'ang–i* 堂 翼 " wings of the *t'ang–hua* ".

*Tui–fu* accompanying the *t'ang–hua* show calligraphic specimens, usually antithetical couplets, each line counting five, six, seven or more characters. These *lien–chü* 聯 句 " parallel phrases " generally consist of a quotation from the Classics or from the verses of some celebrated poet, written out in large characters by a well known calligrapher. Since the main hall is more or less of a public place one prefers to display there texts of a non–committal and conservative character. To suspend there texts referring to the personal affairs of the owner of the house is considered indiscreet and in bad taste.

Each half of a *tui–fu* shows the most simple style of hanging scroll mounting, that is to say a margin of a few inches on top and bottom, and a narrow strip of mounting on left and right; see Plate **105** C.

A large pictorial representation in the middle flanked by two narrow calligraphic scrolls in the most common decoration of the back wall in the main hall of a Chinese house (Plate **5**).

Hêng-fu, "horizontal hanging scrolls".

P'ing-fu, "sets of vertical hanging scrolls".

4. – SIMPLE TYPE OF HANGING–
SCROLL MOUNTING (T'ANG-HUA)

It is not unusual to find against the back wall instead of a vertical *t'ang-hua* a large horizontal scroll the breadth of which exceeds its height. This type of hanging scroll is called *hêng-fu* 橫 幅 or *hêng-pi* 橫 披.

*Hêng-fu* are mounted less elaborately than vertical *t'ang-hua*. The picture is surrounded by a one–coloured "frame" of silk or paper, with a thin roller on the right and left (see Plate **6**). In the middle of the scroll, on top and bottom, there is added a small triangular slip; these slips are nailed to the wall in order to prevent the scroll from sagging.

These horizontal hanging scrolls are especially suited as canvas for large landscapes where breadth is accentuated more than depth. Tradition has it that such pictures meant to be mounted as *hêng-fu* were painted for the first time by the "Two Mi", viz. the famous Sung artist Mi Fu and his son Mi Yu–jên. [1]

Instead of one large *t'ang-hua* one may also find against the back wall two, three or more vertical hanging scrolls of equal size and identical mounting, hung side by side. Such sets of scrolls represent subjects that artistic convention has pronounced fit for being shown in combination. The general appellation of these sets is *p'ing-lien* 屏 聯, *p'ing-fu* 屏 幅, or *p'ing-t'iao* 屏 條; the character *p'ing* is sometimes also written 軿. When there are two, such a pair is called *shuang-fu* 雙 幅, *shuang-p'ing-kua-fu* 雙 屏 掛 幅, *p'ei-fu* 配 幅, *p'ei-chou* 配 軸, or also *tui-fu* 對 幅; as a rule, however, the last term is used exclusively for narrow antithetical scrolls with calligraphic specimens.

When they go in pairs one will find, for instance, two landscapes painted in the same style, or a dragon on right and a tiger on left; or bamboo and pine tree on right and plum blossoms and orchids on left, etc. When there are three scrolls they may represent three kinds of flowers, three historical personages, three famous scenic spots, or some other acknowledged trio. Four scrolls will often show the four seasons or the four literary pastimes: lute playing, composing poetry, practising calligraphy and playing chess.

Sometimes a set of two or more vertical hanging scrolls will form one continuous composition, usually a large landscape; such a set is known as *t'ung-ching* 同 景. In the same way a set of calligraphic hanging scrolls may show one continuous literary text; this is common in China but rarely seen in Japan.

[1] *Tung-t'ien-ch'ing-lu-chi* (cf. Appendix I, no. 27), ch. 10: "The horizontal hanging scroll was first used by the two Mi, father and son: this is not the antique style" 橫 披 始 於 米 氏 父 子。非 古 制 也。

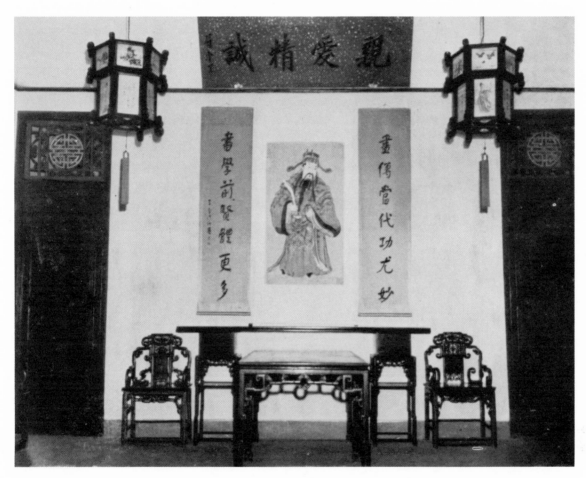

5. — THE DECORATION OF THE BACK WALL

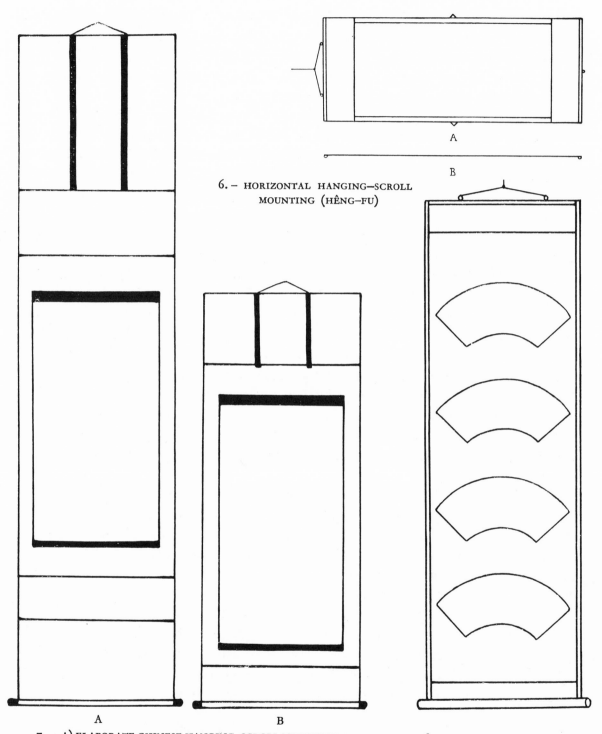

6. – HORIZONTAL HANGING–SCROLL
MOUNTING (HÊNG–FU)

7. – A) ELABORATE CHINESE HANGING–SCROLL MOUNTING;
B) ELABORATE JAPANESE HANGING–SCROLL MOUNTING

8. – FOUR FANS MOUNTED TO-
GETHER AS A HANGING SCROLL

21

Scrolls composing sets have the ordinary broad strips of mounting along top and bottom and narrower ones along the sides; they rarely have the two thin vertical bands crossing the upper margin that were mentioned in the description of the *t'ang-hua* mounting. Sets of the *t'ung-ching* type have either very thin side margins or none at all, in order not to break the unity of the picture or the literary text.

Other hanging scrolls exposed in the main hall.

Besides the *t'ang-hua* there are displayed in the main hall a number of other scrolls which, although occupying a secondary position, also have their fixed place and are an indispensable factor in the decoration of the hall.

If one refers again to the floor plan given on Plate **2**, one will find against the back wall on either side of the *t'iao-chi* another table of the same style but slightly lower. On these tables are placed some smaller antiques while on the wall above there is hung a medium size hanging scroll, called *chung-t'iao* 中 條, often accompanied by a set of *tui-fu* just as the *t'ang-hua*. *Chung-t'iao* are usually mounted in the most elaborate manner, as indicated by the schematic drawing on Plate **7** A. On top and bottom of the picture itself there is a narrow strip of multicoloured brocade. Then follows the " frame ", with a horizontal strip of mounting material above and below. Finally there is added a very broad strip at the top and the bottom, the upper one crossed by two vertical bands. It is a fixed rule that every horizontal strip above the painting should be broader than the corresponding one below, the proportion being roughly 2 : 1. The background of this rule will be discussed in the historical part of the present essay. Here I mention only that the excessive length of the mounting of medium-size hanging scrolls was dictated by the necessity of adapting such pictures to the high walls of the Chinese house.

On the left and right side of the hall are placed two sets of carved wooden chairs and tea tables facing each other. Each set, known as *pan-t'ang* 半 堂 " half a hall ", consists of six pieces arranged in a fixed order, viz. chair–table–chair, chair–table–chair. The chairs often have marble slabs with an interesting natural design inlaid in the seats and the backs, while the same material is used for the tops of the tea tables. In winter the seats and backs of the chairs are covered with cushions of embroidered silk.

Against the walls on the right and left one will find a low, broad couch of carved wood with on either side a small tea table. The wall space above these couches serves for the display of more hanging scrolls. Usually one sees there *p'ing-fu*, sets of four or more hanging scrolls as were described above. It is a fixed custom to hang calligraphic scrolls on the wall on right, and pictorial scrolls on the left wall.

Ying-lien, scrolls on pillars and doorposts.

Further, narrow antithetical scrolls may be hung against pillars or doorposts. These are technically called *ying-lien* 楹 聯 or *ying-t'ieh* 楹 帖; since *ying* means " pillar " this term should properly be reserved for such scrolls only. But the term *ying-lien* is often loosely employed in the general sense of a narrow vertical scroll, irrespective where it is hung, and thus becomes a synonym of *tui-lien*.

**22**

*Ying–lien* are mounted in the same way as *tui–fu*. In the mounter's jargon they are called *hsiao–i* 小 翼 " small wings ".

There also exist wooden *ying–lien*, narrow boards engraved with gilt or coloured letters. Sometimes the texts are carved directly in the surface of the pillar or doorpost itself.

The above is a description of the main hall in a middle class house. In larger mansions the hall is divided into seven or more parts by means of the so–called *lo–ti–chao* 落 地 罩. These are a kind of thin wooden partitions of intricate openwork carving that connect the four pillars with each other and with the walls. On Plate **2** the *lo–ti–chao* are indicated by dotted lines. <span style="float:right">The lo-ti-chao.</span>

Behind the rows of chairs and tables on the left and right of the hall the *lo–ti–chao* are real partitions forming a wall–screen that reaches from the floor upward to a few feet from the ceiling. Between the two frontal pillars and between the two pillars at the back, and where the *lo–ti–chao* connect these pillars with the walls, they form open archways in fanciful shapes, a kind of elaborate spandrels. These are shown on Plate **3**.

The partitions behind the chairs provide extra wall–space for more hanging scrolls. These are selected according to the same rules as apply to the scrolls hung on the side walls of a hall that lacks the *lo–ti–chao*; that is to say a set of pictorial scrolls on the left, and calligraphic scrolls on the right.

Some people prefer to hang against these partitions sets of four or more scrolls each of which shows a number of fans detached from their ribs (*shan–mien* 扇 面), and mounted together one above the other, as may be seen on Plate **8**. Such a set of scrolls with mounted fans on one side of the hall must be accompanied by a similar set on the wall or partition opposite. The rule that pictorial representations must be hung on the left and calligraphic ones on the right does not apply to such sets of fan–scrolls. But tradition demands that the fans on each single scroll should alternately show a picture and a calligraphic specimen.

On the other side of the partition, opposite the couch placed against the wall, one often finds a high, narrow cabinet of carved wood, used for displaying smaller antiques, or rare books and manuscripts in sumptuous brocade covers.

Finally, the blank circles in the floor plan of Plate **2** indicate the places where one will find large ornamental vases on carved wooden stands, or the well–known *ku–i* 鼓 椅 or *tz'ŭ–ku–têng* 磁 鼓 櫈, barrel–shaped porcelain seats.

Spread among the arabesque–like designs of the open–work carving the *lo–ti–chao* have a number of frames in fanciful forms; some are round, others square, octagonal or show the outline of fans, gourds, vases etc. In these frames are inserted the so–called *t'ieh–lo* 貼 落, small pictures or calligraphic specimens on silk or paper. In older mansions the *t'ieh–lo* are not seldom works of art of great value which are carefully preserved by the successive owners of the house. When one has them replaced, the old *t'ieh–lo* are often remounted as hanging scrolls, or united together in an album. <span style="float:right">The t'ieh-lo.</span>

On Plate **3** one sees that each of the two front pillars is flanked by an oval and a square *t'ieh–lo* showing specimens of calligraphy.

This concludes the description of the place occupied by the mounted hanging scroll in the main hall of the Chinese house.

While tradition has more or less fixed the distribution of hanging scrolls in the main hall, there exist no rules for the decoration of the rest of the house. Hanging scrolls of all types and sizes are found practically everywhere where there is a suitable blank space on the wall.

As a general rule, however, the back wall of any given room has an arrangement that reproduces on a smaller scale that of the *t'ang–hua* and its accompanying scrolls. That is to say one somewhat larger scroll in the middle, flanked by one or more pairs of *tui–fu*.

Above couches and broad benches one will find a set of scrolls or one large *hêng–fu*.

*Tui–fu* are found by the side of windows and doors while sometimes such a pair is used also as the central decoration of a wall. In that case both scrolls are hung close together, the right side of the one on the left touching the left side of the scroll on the right.

The *tui–fu* in the main hall give stern admonitions from the Classics. Those in the adjoining library and rest room, however, bear texts of a more informal and personal character. The couplets chosen for such *tui–fu* will give a shrewd observer an idea of his host's interests. If he is a scholar with Taoist leanings he will prefer quotations from the Tao–tê–ching or Chuang–tzû while a person interested in Buddhism will select an appropriate couplet from his favourite *sûtra*.

In the literary works left by Chinese connoisseurs one often finds remarks on the way hanging scrolls should be displayed in one's house.

Above there were already quoted a few passages relating to the necessity of frequently changing the scrolls hung on the wall. Here it may be added that — except in the houses of great collectors — the *t'ang–hua* is not changed as often as other hanging scrolls. Few people have the required number of large pictures that qualify as *t'ang–hua* but most upper middle class families possess sufficient medium and smaller scrolls for changing at regular times those exposed in other parts of the house.

Generally speaking Chinese tradition leaves ample latitude for individual taste and preference in the selection of the scrolls to be used in interior decoration, and of the place where they should be hung. Occasionally, however, there arose among connoisseurs controversies regarding some minor points.

For instance, it seems that many Ming scholars did not like to hang in their libraries single, medium–size hanging scrolls; such scrolls are technically called *tan–t'iao* 單條, *fang–t'iao* 房條, *ku–chou* 孤軸, or *tu–chou* 獨軸. Those scholars preferred for their libraries pairs of scrolls, or sets of three, four and more. This custom is severely criticized by T'u Lung, a late Ming scholar. He observes:

24

" In a spacious library or a refined studio there should be displayed only one scroll. A pair of scrolls will lessen the elegant atmosphere, not to speak of four or five. Moreover, highminded artists painted only when inspired, therefore their works are treasured during succeeding generations. How could such paintings be adequately paired? The present-day people do not like single scrolls. With such persons one can not talk about painting. " [1]

The Ming connoisseur Wên Chên-hêng has the following to say:

" Paintings should be suspended high on the wall, and in one's library there should be exposed only one scroll at the time. To hang scrolls on two walls facing each other or hanging scrolls in pairs is a most vulgar custom. One long hanging scroll should be suspended on the wall of a high room, one should not cover such a wall with a number of scrolls hung close together like bamboo stems. On the table standing below the scroll one may place a stone of interesting shape, some flowers in season, a miniature tray-landscape etc.; but garish objects like red lacquer work should be avoided. In the main hall of the house should be hung a large horizontal scroll, while in one's library there should be one smaller landscape painting, or a picture of birds and flowers. If one hangs there narrow single pictures, mounted fans, square miniature pictures, sets of scrolls etc., then all such will give one's studio a vulgar appearance. " [2]

The Ch'ing collector Lu Shih-hua says:

" Scrolls should be displayed in their proper surroundings. A beautiful landscape garden is the most appropriate place. Further a rustic pleasaunce or the simple abode of a retired scholar, if clean and tidy, will always provide the right atmosphere. Spacious halls and large courts will be found to diminish by their luxurious appointments the beauty of the scrolls exposed there. If in such a place one suspends a fine painting, hanging by its side red scrolls [3] or antithetical couplets written in vulgar characters referring to official honours and signed by persons of influence and authority; or if one places on the table underneath artificially-aged bronze vessels, fans of peacock feathers or foreign-made striking clocks — then such surroundings must be pronounced a grievous locality for a good scroll to find itself in. " [4]

---

1) *K'ao-p'an-yü-shih* (cf. Appendix I, no. 29), ch. 2:
高齋精室。宜掛單條。若對軸即少
雅致。況四五軸乎。且高人之畫。適
與偶作數筆。人即寶傳。何能有對
乎。今人以孤軸爲嫌。不足與言畫
矣。

2) *Chang-wu-chih* (cf. Appendix I, no. 30), ch. 10:
懸畫宜高。齋中僅可置一軸於上。
若懸兩壁及左右對列。最俗。長畫
可掛高壁。不可用挨畫竹。畫桌可
置奇石。或時花盆景之屬。忌設朱
紅漆等俗。堂中宜掛大幅。齋中宜
小景山水。或花鳥一幅。若橫披、扇
面、斗方、掛屏之類。俱不雅觀。

3) Complimentary scrolls and those written on special festive occasions are usually written on red paper; cf. the samples in Appendix V, nos. 14 and 16. Such scrolls should be displayed on only one or two days, and then stored away as souvenirs. They are not considered as works of art and should, therefore, not be exposed together with an antique painting.

4) *Shu-hua-shuo-ling* (cf. Appendix I, no. 47), ch. 27:
書畫必位置得宜。山水園林最稱。不可
即竹籬茅舍。打掃潔淨。亦無減色。如聯
高堂華廈。金碧輝煌。反俗字對聯赫弈貨
中懸名繪。旁列篸冠斑。名孔雀毛扇洋
句則堂皇出銅。名孔雀毛扇阨境也。
兼佐以燒斑等物。此書畫之
時鳴鐘等物。此書畫即高中句兼時

Further, the Ming scholar T'u Lung maintained that one should never hang a landscape scroll in a room the windows of which give on some fine scenery. " You should not ", he says, " suspend a scroll on a wall facing a beautiful view, for an image can never compete with reality. " [1]   Other Ming scholars, however, dismissed this theory as irrelevant.   Wên Chên–hêng, for instance, states: " That a painting should not be hung opposite a scenic view, this also is a mistaken theory. " [2]

Finally, since olden times there has existed in China a prejudice against the displaying of Buddhist — and to a certain extent also Taoist — religious pictures in secular interiors.   The Sung connoisseur Kuo Jo-hsü says:

" Sometimes people are heard to observe that one should not collect pictures of Buddhist and Taoist saints since it is feared that one can hardly display such scrolls regularly without (inadvertently) showing lack of respect for them or letting them become soiled.   I for one disagree with this view.   When people of standing and education gather for the enjoyment of viewing scrolls they will as a matter of course select a quiet and clean abode.   Since they are concerned only with the critical appreciation of their artistic qualities, they will view such pictures of the past in the proper reverent spirit.   How could such persons ever be guilty of a disrespectful attitude ? " [3]

Despite Kuo Jo-hsü's observations, however, the prejudice persisted.   Even nowadays Chinese collectors often show a disinclination to display Buddhist scrolls in their houses and connoisseurs are not very keen on collecting them.   Next to the idea that sacred images would be defiled if shown outside temples and monasteries, many are also of the opinion that such pictures remind the observer too much of funeral ceremonies and services for the dead and therefore are an inauspicious decoration for one's daily surroundings.

On the Chinese market antique Buddhist scrolls fetch less than for instance landscapes or flower pieces of the same period and quality.   Also in Japan one notices a marked aversion to the display of Buddhist pictures in private houses.   However, good Buddhist scrolls still fetch high prices: they are bought by devout Japanese Buddhists for the express purpose of presenting them to a temple as votive gifts.

The survey given above describes the place which the mounted hanging scroll occupies in the Chinese dwelling house.   Scrolls mounted of this type form indeed the main factor in Chinese interior decoration.   Before going on to a discussion of other types of Chinese mounted scrolls, hereunder follows first an account of the hanging scroll in the Japanese interior.

---

1) *K'ao-p'an-yü-shih* (cf. Appendix I, no. 29), ch. 2: 對 景 不 宜 掛 畫。以 偽 不 勝 眞 也。

2) *Chang-wu-chih* (cf. Appendix I, no. 30); ch. 10: 畫 不 對 景。其 言 亦 謬。

3) *T'u-hua-chien-wên-chih* (Appendix I, no. 36), section *Lun-shou-tsang-shêng-hsiang* 論 收 藏 聖 像:論

者 或 曰。不 宜 收 藏 佛 道 聖 像。恐 其
藝 慢 葷 穢。難 可 時 展 玩。愚 謂 爲 不 適
然。凡 士 君 子。相 與 觀 閱 書 畫 能 遺
則 必 處 閑 靜。但 鑒 賞 精 瞻 崇
像。惡 有 藝 慢 之 心 哉。

26

Japanese houses seem at first sight completely different from those in China. While in China the dwelling house is a solid construction with massive brick walls, stone floors and heavy wooden beams and pillars, Japanese houses on the contrary are fragile constructions of light wood and paper with wooden floors covered with rush mats.

Further, the Chinese house is divided into separate rooms each of which is an individual architectural unit so that there is much wall space available. The Japanese house, on the other hand, has hardly any walls at all. Most of the slender uprights are filled in with thin paper sliding doors; when all of those have been taken out the house is nothing but one large, open hall.

As a matter of fact Chinese and Japanese domestic architecture developed from fundamentally different origins. [1]   Yet so great was the influence of Chinese culture in Japan that on closer inspection the traditional Japanese dwelling house will be found to have faithfully preserved many features of Chinese houses of the earlier periods. Even in the modern Japanese house of to-day one will find some of the principles that since centuries have ruled the Chinese floor plan.

For a review of the main features of an upper middle class Japanese dwelling house we take as example the Edo mansion of a minor Japanese feudal lord of the 19th century; its floor plan is sketched on Plate **9**. For our present purpose such a Japanese mansion can be taken as roughly corresponding to the Chinese house described in the above. Towards the end of the 19th century there developed in Japan a new style of native architecture that is less suitable for an over-all comparison with counterparts in China.

One enters the compound through a gate house (1) built with plaster walls, on the outside covered with tiles. The double gate is made of heavy wood adorned with bronze plates. During the Tokugawa Shogunate the style and ornamentation of this gate was

---

1) While the Chinese dwelling house has received little attention from Western writers, about Japanese domestic architecture there exist some excellent treatises.

Josiah Conder, who during the Eighties was professor of architecture in Tōkyō, published in the Sessional Papers of the Royal Institute of British Architects three lectures on this subject, viz. *Notes on Japanese Architecture* (1878), *Further Notes on Japanese Architecture* (1886), and *Domestic Architecture in Japan* (1887); despite their date, these articles, profusely illustrated with photographs, sketches and diagrams, are highly recommended.

In 1886 EDWARD S. MORSE published in Boston his *Japanese Homes and their Surroundings*. This fine example of scholarly research is still the Western standard work on the Japanese dwelling house. During his protracted stay in Japan the author, a shrewd observer and a clever draughtsman, studied the subject on the spot, and made an amazing number of sketches, which illustrate this volume.

Additional information about the Japanese dwelling house in the beginning of the 20th century is to be found in R. ADAMS CRAM, *Impressions of Japanese Architecture*

(London 1906), which contains good photographs of upper middle class interiors. More recent publications are BRUNO TAUT, *Houses and People of Japan* (Tōkyō 1937), written in a more or less popular vein, A. L. SADLER's, *A Short History of Japanese Architecture* (London 1941), which treats of palaces, temples and dwelling houses together, and A. DREXLER, *Japanese Architecture*, New-York 1955.

Japanese old and new books and periodicals on the subject are legio. The reader is referred to such modern works as *Nihon no jū-taku*, "The Japanese Dwelling house" (日 本 住 宅, by Fujii Kōji 藤 井 浩 二, Tōkyō 1928), *Nihon-kenchiku-shi*, "History of Japanese Architecture" (日 本 建 築 史, by Satō Tasuku 佐 藤 助, Tōkyō 1926), *Kinsei-nihon-kenchiku-shi*, "History of Japanese Architecture in recent times" (i. e. from the middle of the Tokugawa period till the present) (近 世 日 本 建 築 史, by Takahashi Jin 高 橋 仁, Tōkyō 1930), etc. Japanese books which deal especially with the history of the *toko-no-ma* and interior decoration are listed in Appendix I of the present publication.

regulated by strict laws in accordance with the official rank of the owner which reminds one of the Chinese rules regarding the use of red–lacquered gates. The gate house is flanked by the quarters of the guards and other armed retainers. These rooms are called together *naga–ya* 長屋; in larger mansions the *naga–ya* is built all along the outer wall. In a corner of the compound is a watch tower (2), called *yagura* 櫓.

The gate house is together with the fire–proof store house the only solid construction found in a Japanese compound.

The house itself is raised on a stone foundation and surrounded on three sides by an *en–gawa* 緣側, a broad open verandah. On entering the house by the main entrance one finds an anteroom (4). Here stands a stiff, single panel screen called *tsui–tate* 衝立 which prevents people outside from looking into the house. This screen is doubtless a counterpart of the *chao–pi*, the "screen–wall" of Chinese house; but its original significance of guard against evil influences has been forgotten in Japan.

A wooden hallway, *rō–ka* 廊下 (5) gives on to a smaller "inner garden" (6) called *naka–tsubo* 中坪 where one will find some charming landscape gardening.

The four main rooms of the house are located around this inner garden, each room having on one or two sides a broad corridor with a mat–covered floor, the so–called *iri–kawa* 入側. On the left there are two large ceremonial rooms, called respectively *jō–dan* 上段 (8) and *ge–dan* 下段 (9). The floors of these two rooms are covered with mats and raised a few inches above the level of the rest of the house.

In the back wall of the *jō–dan*, the room where the lord of the house sits in state on official occasions, one sees a recess of about two feet deep. This is the *toko–no–ma* 床の間, the base of which is raised an inch or so above the floor of the room. The *toko–no–ma* occupies about half of the breadth of the wall; the other half usually shows two or more shelves where one can place some smaller objets d'art. In this architectural style peculiar to the residences of samurai and known as *shoin–zukuri* 書院造, the *toko–no–ma* is usually accompanied by a "window recess" at a right angle with the back wall. Plate **10** shows part of the *Kuro–shoin* 黑書院, the "Black Library" in the Nishi Honganji 西本願寺, a temple in Kyōto; this particular section was built in 1656. In the centre one sees the "window recess"; its base is about two feet high and serves as desk, the writer kneeling in front of it.

An age–old tradition has designated the *toko–no–ma* as the proper place for displaying hanging scrolls, suspended against its back wall.

On the present floor plan there is, next to the *jō–dan*, but one other room that has a *toko–no–ma*, viz. the so–called "upper room", *kami–no–ma* 上間 (10), the hind one of the two larger rooms on the right of the "inner garden". The adjoining room, called *tsugi–no–ma* 次間 (11) has no *toko–no–ma*; but over the sliding doors on the right one may find a shelf for a Buddhist or Shintō house altar.

In the right corner of the same wing is a large bathroom (12), the *yu–dono* 湯殿, and next to it a dressing room called *agari–ba* 上場 (13). The other rooms are used for storage or as quarters for the servants. I mention the *nan–do* 納戶 (17) and the

28

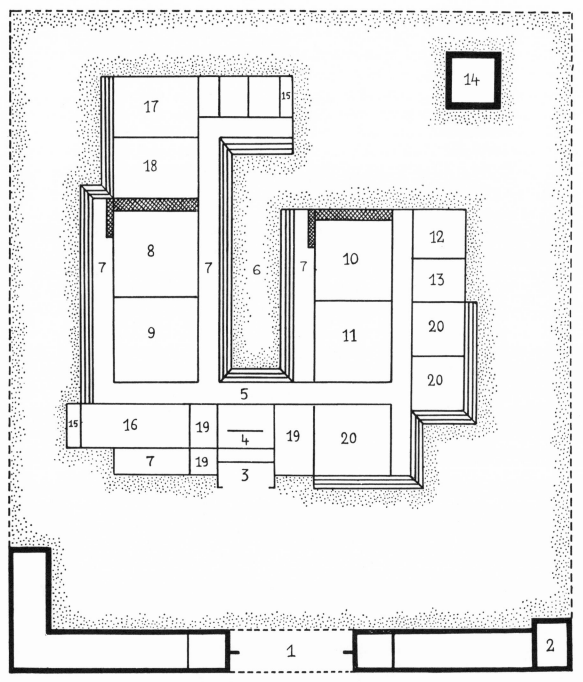

9. – FLOOR PLAN OF A JAPANESE FEUDAL MANSION

(1) gatehouse – (2) outlook – (3) main entrance – (4) anteroom with tsui–tate – (5) hallway – (6) inner garden – (7) matted corridors – (8) jō–dan – (9) ge–dan – (10) kami–no–ma – (11) tsugi–no–ma – (12) bathroom – (13) dressing room – (14) fireproof storehouse – (15) privies – (16) parlour – (17) store room – (18) dressing and store room – (19) anterooms for guards and servants – (20) rooms for personal servants, also used as store rooms. – Diapered space: location of toko–no–ma and "window recess".

*keshō–no–ma* 化粧間 (18) which are used as dressing room or store room, and the *tamari* 溜 (20), rooms for personal servants that are used at the same time for storage.

In Japanese houses there is no distinction between living rooms and bedrooms. The bedding consists of quilts spread directly on the floormats; during the daytime these quilts are rolled up and stored away in cupboards. Thus any room can be converted at short notice into a bedroom. Since the mats are kept scrupulously clean and footgear left outside on entering the house, any room can be used as guest room or dining room.

The kitchen is located in a separate building somewhere in the backyard. There one will also find the *kura*, written 倉 or 土藏 (14), the store house. This is a fire-proof building, usually of two storeys. Its wooden walls are covered with several thick coats of plaster and the windows provided with iron shutters.

Since the only two places where hanging scrolls can be displayed are the *toko–no–ma* in the *jō–dan* and in the *kami–no–ma*, it is this *kura* that contains the bulk of the owner's collection of scrolls and other antiques. It is true that in a residence like the one describ-ed here the sliding doors were often lavishly decorated with paintings and horizontal tablets suspendend over door openings, while painted folding screens were freely used in the larger rooms. But this does not alter the fact that the display of hanging scrolls remained restricted to the *toko–no–ma*. This fact has had a decisive influence on the development of hanging scroll mounting in Japan.

Towards the end of the 19th century when the feudal way of life was gradually being relinquished such large residences were abandoned as dwelling houses. Ever since even wealthy Japanese have lived as a rule in much smaller houses. If more room space is necessary one erects one or more similar structures standing somewhat apart, rather than expanding the original building itself. It has become customary in upper middle class houses to add at least one foreign–style room. The *toko–no–ma* in the main room is still the only place where hanging scrolls are displayed. However, as will be seen below, persons of elegant tastes often erect a special pavilion in their garden for leisurely artistic enjoyment.

The Japanese hanging scroll.

Hanging scrolls in general are called in Japan *kake–mono* 懸物, *kake–jiku* 懸軸 or *kake–ji* 懸字.[1] If the breadth of a scroll exceeds its height it is called *yoko–mono* 横物.

Since hanging scrolls are displayed only in the *toko–no–ma* it follows that their size must be adapted to the height of this recess. Therefore the Japanese prefer medium and small pictures, and Japanese mountings are made much shorter than the Chinese ones. The type most commonly met with in Japan is a kind of miniature *t'ang–hua* mounting, the type depicted on Plate **4**. Japanese hanging scroll mountings do not have the two extra horizontal strips at the top and bottom of the " frame " of elaborate Chinese moun-

---

1) The term *kake–ji* should properly be used for only *calligraphic* specimens mounted as hanging scrolls. In Ja-panese usage, however, it is commonly used as an equivalent of *kake–mono*.

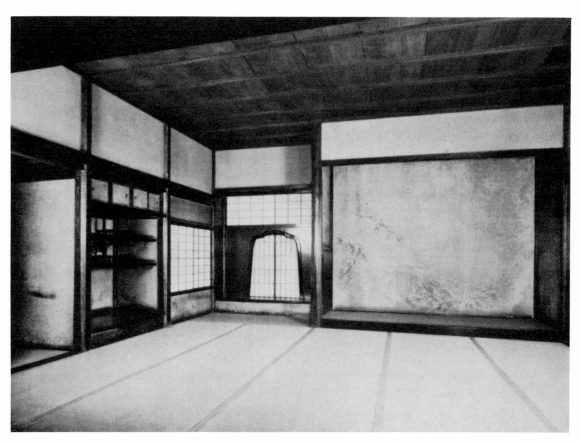

10. – THE " BLACK LIBRARY " AT KYOTO
(Photograph supplied by K. B. S.)

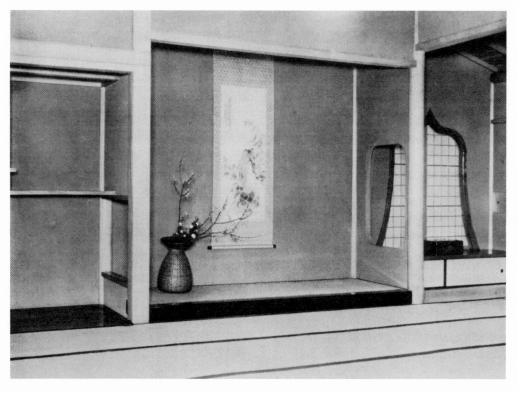

11. – JAPANESE INTERIOR WITH TOKO–NO–MA
(Photograph supplied by K. B. S.)

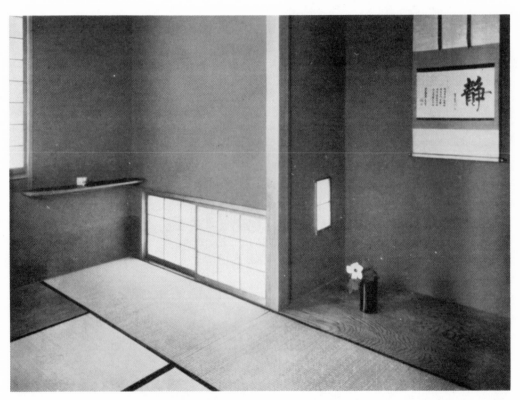

12. – JAPANESE ROOM FOR THE TEA CEREMONY (CHA–SHITSU)
(Photograph supplied by K.B.S.)

tings (cf. Plate **7** A), and the uppermost and lowest horizontal strips are much narrower, as shown on Plate **7** B.

A distinctive feature of all Japanese hanging scroll mountings is that the two vertical bands that are pasted down across the upper part of the mounting are left hanging loose. Further, while since the last three or four centuries the Chinese prefer plain, light-coloured thin silk for their hanging scroll mountings, the Japanese have retained the heavy, multicoloured brocade of the earlier Chinese types.

The Chinese rule that the colour of the various strips of mounting should become lighter the farther they are removed from the picture itself is not observed in Japan. But the Japanese do follow the Chinese custom of making all strips above the " frame " broader than those below.

The *toko–no–ma* is in many ways the centre of the house. Its backwall can be compared to the backwall of the main hall of a Chinese house: it is here that the master of the house displays valuable scrolls by famous masters, for his own enjoyment and the delectation of his guests.

The toko-no-ma.

Just as in China the *t'ang–hua* is often accompanied by a few antique objects placed on the table below, so in Japan there are displayed in the *toko–no–ma* some ornaments, placed on the floor of the niche, under the hanging scroll. One may find there an incense burner, a flower arrangement, a small statue or some other work of art that is not too large and that harmonizes with the scroll exposed (see Plate **11**). A purely Japanese feature is that the owner of the house will often place in the *toko–no–ma* some objects that reflect his individual taste or personal interests, as an additional decoration. A musician will place in the *toko–no–ma* his favourite cither or flute, a fencer his swords, and a lover of the old–style theatre some wooden dolls representing well–known histrionic figures. Just as in China one may obtain an insight into the inclinations of the master of the house by reading the texts hung in his library, so in Japan one may come to know the disposition of the host by examining the arrangement in the *toko–no–ma*.

In a smaller *toko–no–ma* one suspends as a rule only one vertical hanging scroll; the technical term for such a scroll is *tan–fuku* 單 幅. In larger ones one may see a pair of pictorial scrolls, *sō–fuku* 雙 幅 or *tsui–ren* 對 聯, or also sets of three, *sampuku–tsui* 三 幅 對, or four scrolls, *shifuku–tsui* 四 幅 對.

A single scroll shows either a pictorial representation or a specimen of calligraphy. For the latter, if in Chinese, a single line of five or seven characters is preferred. If in Japanese, the scroll may show anything from a poem of seventeen syllables to a longer inscription of several hundred words.

A set of three scrolls often shows in the middle a human figure, for instance a famous saint or hero of antiquity or a well–known courtezan, flanked by two landscapes or flower paintings. Such a combination would seem to be peculiarly Japanese, for I have not yet met with it in Chinese interiors. On the other hand one never sees in Japan a

pictorial representation flanked by a pair of calligraphic *tui-fu*, a combination which is so common all over China.

The Japanese tendency to fix the various ways of artistic expression by traditional rules extends also to the arrangement of the *toko-no-ma*. Detailed regulations dictate what scrolls should be shown on special occasions, their size and their style of mounting, the distance separating them from the floor; and in case several scrolls are suspended there at the same time, in what sequence they should be hung and how far apart from each other. The *cha-jin* 茶人, "tea masters", the experts on the tea ceremony who have had so great an influence on Japanese artistic life, are invested with supreme authority also with regard to the displaying of scrolls. These rigid regulations prescribing every detail of interior decoration often had a salutory influence on artistic development. They compelled people to avoid ostentatious effects and to concentrate on the beauty of simple forms. On the other hand, however, the strict rules frequently stifled individual initiative and degenerated from well-tested canons of artistic refinement into mere futilities.

Apart from the *toko-no-ma* a Japanese room has no other possibilities for displaying hanging scrolls. The sparing use of hanging scrolls in the Japanese house goes back to the influence of the Chinese priests who visited Japan in the 12th century. It is the esthetic ideals of those Sung priests that to the present day constitute the foundation of the rules for Japanese interior decoration.

The Japanese tea-room.

The influence of the Chinese priests lingers on especially in the *cha-shitsu* 茶室, the "tea-room".

Men of scholarly and artistic inclinations were not satisfied with the limited space for the display of hanging scrolls provided in their dwellings. They needed a place that offered the privacy lacking in the house itself, a place where they could perform the tea ceremony in the required atmosphere, and study their pictures, albums and other art-treasures.

The rulers of the land and the great feudal lords built for that purpose elaborate tea pavilions in spacious landscape gardens, or on a small island in the middle of an artificial lake. Old and modern art lovers of modest means, however, have reached the same result by building their tea pavilions on a miniature scale. For them a patch of twenty feet square or less in a corner of their garden was sufficient. There they built a thatched hut of two rooms. One, provided with a *toko-no-ma*, was used for performing the tea ceremony, the second served as a rest room. In the appointments of these two rooms all spectacular effects are avoided, the aim is to achieve an inobtrusive, simple natural beauty, expressed mainly by carefully selected woodwork and harmonious proportions (see Plate **12**).

A tuft of bamboo or a diminutive rock garden in front of the pavilion, crossed by a winding stone path, separates the *cha-shitsu* from the main building, marking this domain off as a small world in itself. A narrow door in a rustic fence further accentuates its atmosphere of seclusion.

The *cha-shitsu* of a Japanese house can be compared with the master's restroom in a Chinese residence. Official callers and visitors in general are received in the main room of the house. But only intimate friends are admitted into the *cha-shitsu*.

It is customary to hang in the *toko-no-ma* of the tea-room but one single scroll. But that scroll is chosen with meticulous care. Next to its intrinsic artistic qualities such a scroll must also be in harmony with the spirit of the tea ceremony. Landscapes and flower pieces painted in full colours, mounted with glittering brocade can be displayed in the *toko-no-ma* of the dwelling house; but they should never be shown in the tea-room.

For this abode of reflection and unworldly esthetic enjoyment one prefers smaller ink-paintings on paper, or specimens of the calligraphy of a famous tea master of days gone by. And such a scroll should be mounted in a special way. Its front mounting should be made of antique brocade, the original bright colours of which have faded and become mellow with age; or of old silk of subdued colouring. A scroll that answers these requirements is called a *cha-gake* 茶掛 "scroll fit for being suspended in the tea room". In Japanese curio shops and on sales a *cha-gake* can be spotted as easily as a *t'ang-hua* on sales in China.

\* \* \*

In the above we have discussed only the mounted hanging scroll since it is this form of mounting that is most familiar to Western readers; it is also the type of mounting that plays a preponderant role in Chinese and Japanese interior decoration.

Besides hanging scrolls, however, both pictures and specimens of calligraphy may also be mounted in other ways that make them a minor but at the same time more permanent part of interior decoration.

In China a few large characters written horizontally on paper or silk by an expert hand are often mounted on a stiff wooden frame. Such tablet-like mountings, called *ê* 額, *hêng-ê* 橫額 or *pien-ê* 匾額, are frequently seen suspended over a door, against a beam in the ceiling, or high up on the wall. If the legend of such a tablet represents the special name of the room, or if it was written by some exalted person, it may be hung against the back wall of the main hall, over the *t'ang-hua*; such an arrangement is shown on Plate **5**. Although these *pien-ê* are occasionally taken down and replaced by others, they are as a rule more permanent than the hanging scroll.

The same may be said of the small paintings and calligraphic specimens inserted in frames in the *lo-ti-chao* described above. These are usually changed only when the house is taken over by a new owner.

Further, the Chinese mount larger pictures and specimens of calligraphy often on movable screens, called generally *p'ing-fêng* 屏風, *p'ing-mên* 屏門 or *p'ing-chang* 屏障.

The simplest form of such a screen-mounting is the so-called *yen-chang* 掩障 or *chang-tzŭ* 障子, a stiff screen consisting of one panel and kept upright by a heavy

13.– CHINESE ONE–PANEL SCREEN

ornamental foot; such a screen is depicted on Plate **13**. In olden days both paintings and calligraphic specimens were often mounted in the form of such single–panel screens. The thin paper or silk of the original was stretched tight over a wooden frame, and this frame fitted into a larger one of blackwood or rosewood, elaborately carved. Since the beginning of the Ch'ing period, however, these single–panel screens are either made entirely of solid carved wood, or of boards inlaid with plaques of painted porcelain, coloured stone or jade.

Folding screens consisting of three, four or more panels are used for mounting pictorial and calligraphic scrolls, according to the same technique as that applied in the case of single panel screens.

Folding screens of three panels often show the same trio commonly found on the walls, that is to say the central panel of the screen showing a picture and the panels flanking it antithetical phrases. Such a screen is reproduced on Plate **14**. Folding screens of more panels (Plate **15**) show a continuous picture or some longer literary text.

Since the later years of the Ch'ing dynasty folding screens are also mostly made of solid wood with intricate relief carving or inlaid with jade and porcelain plaques, just like the single panel screens. Such screens are made by artisans rather than by artists.

In old–fashioned Chinese houses one will find both single–panel and folding screens. Large ones are used to partition off temporarily one or more sections in the main hall or for covering an open doorway. Smaller screens are used in the living quarters of the family for various purposes.

Japanese tablet mountings and screens.

In Japan the horizontal tablet mounting is as popular as it is in China. In Japanese these tablets are called *gaku* 額. Mounted with plain or lacquered wooden frames they are hung against the open transom over the sliding doors; also, but less frequently, on a high space on the solid wall. *Gaku* are also found over the main entrance of the house, on the inside, or against the back wall of the anteroom so that the *gaku* faces the entrance.

In China horizontal tablet mountings are almost invariably calligraphic but in Japan calligraphic and pictorial *gaku* are found in equal numbers. In the Japanese house *gaku* are used as sparingly as hanging scrolls: seldom does one find more than one in a room.

Movable folding screens, *byō–bu* 屏 風, and movable single panel screens, *tsui–tate* 衝立 are well–known also in Japan; their structure is shown on Plate **16** and **17** respectively. The Chinese usually first paint a picture or write a text on silk or paper, and

34

then mount these on the screen. In Japan, however, most artists and scholars paint and write directly on the surface of a screen already mounted with blank silk or paper panels. Further, while Chinese screens have heavy frames of hardwood supported on solid wooden feet, Japanese screens are of a much lighter construction. Their frames are made of thin wooden staves, lacquered or left in the natural colour, and with the exception of the *tsui-tate*, they have no feet. The feet of the *tsui-tate* are made of very light wood. This different construction is to be explained by the difference between Chinese and Japanese floors. Chinese houses have floors of stone-flags; but the floor of a Japanese house consists of soft mats which would suffer damage if heavy pieces of furniture were placed on them.

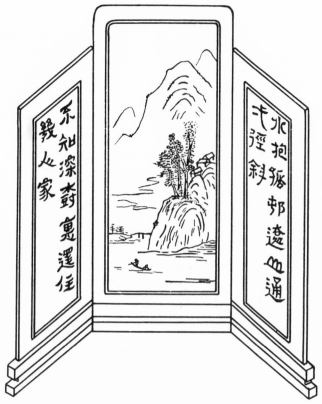

14. – CHINESE FOLDING SCREEN OF THREE PANELS

Formerly both *byō-bu* and *tsui-tate* were widely used in Japanese interior decoration. Today they are found most often in temples and tea-houses — that incongruous pair of fortresses where the old Japanese artistic tradition has most successfully entrenched itself against foreign influence.

A *byō-bu* may be placed anywhere but a *tsui-tate* is used only for screening a door opening. It is most commonly found in the anteroom, directly opposite the main entrance of the house.

Chinese and Japanese fans.

A survey of the various types of mounted scrolls that form part of interior decoration would not be complete without mentioning the fan, that charming companion during hot summer days which in its various shapes is so graceful an addition to a Chinese or Japanese room.

Chinese fans can be divided into two categories, stiff fans and folding ones. The stiff fan, *t'uan-shan* 團扇, represents the oldest type. The specimen reproduced on Plate **18** consists of a piece of silk stretched over a round frame of lacquered wood and is provided with a handle of the same material. A miniature landscape is painted on the front side, the reverse shows a central rib for strengthening the frame; often a poem or essay is inscribed there. Stiff fans are usually round but one finds also specimens of oblong or square shape. These fans were popular already during the Sui and T'ang periods.

15. — CHINESE FOLDING SCREEN OF FOUR PANELS

16. — JAPANESE FOLDING SCREEN (BYŌ—BU)

36

The folding fan, in Chinese called *chê-shan* 摺扇 (see Plate **18**) was introduced in the Ming dynasty from Japan, probably via Korea. Folding fans have usually a picture on the front side and a text on the reverse, exactly like the stiff fans; but one often sees also folding fans covered on both sides with specimens of calligraphy. The ribs of folding fans consist of carved bamboo, ivory, or some fragrant wood. [1]

17. – JAPANESE ONE-PANEL SCREEN (TSUI-TATE)

Japanese folding fans, called *sen-su* 扇子 or *ōgi* 扇, and the stiff fans called *uchiwa* 團扇 are smaller than the Chinese but the same care is spent on their decoration. In Japan larger fans are used on the stage and for ceremonial dances.

A peculiar Japanese variety of the folding fan is the so-called *tes-sen* 鐵扇 "iron fan"; the ribs of these are made of tempered steel painted so as to resemble wood. As it was customary that guests left their swords at the front gate these fans often proved useful for warding off an unexpected blow and when used as bludgeons were effective weapons of attack.

Both in China and Japan the greatest masters of the brush chose the limited surface of the fan as canvas. Dismounted antique fans are therefore highly valued and as carefully preserved as other antique scrolls. Although the work of the artisan who attaches the ribs to a fan is a craft in itself, it is the mounter who transforms one or more dismounted fans into a hanging scroll, or mounts them together on the leaves of an album. Such mounted fans are included in collectors' catalogues, and handbooks for the painter and the calligrapher devote as a rule a special section to them.

In China folding fans are often carried about in cases of embroidered silk, the so-called *shan-t'ao* 扇套 or *shan-tai* 扇袋. In Japan these never became popular.

Finally, in the scholar's library one will often see "natural fans" of rustic appearance, namely dried palm or banana leaves inscribed with a few lines of poetry. Sometimes these are mounted as hanging scrolls and suspended on the wall.

\* \* \*

The above description of the function of the mounted scroll in interior decoration will have made clear that neither in China nor Japan one finds in the houses of collectors anything resembling our Western picture galleries. Scrolls that do not happen to be

The Chinese hand scroll.

---

1) An interesting account of Chinese fans may be found in H. A. GILES, *Historic China and other Sketches* (London 1882), section "On Chinese Fans" (pp. 294 sq.). M. von BRANDT published an illustrated essay on Chinese fans under the title of *Der Chinesische Fächer*, in "Orientalisches Archiv", vol. I (1910–11), Leipzig, p. 87 sq. In 1938 there was published in Peking a Chinese monograph on fans, entitled *Chiao-ch'uang-hua-shan* 蕉窗話扇, compiled by Po Wên-kuei 白文貴, who gives an extensive list of quotations from older Chinese sources. For further information the reader is referred to these publications.

exposed are rolled up and carefully stored away. In China one uses for this purpose solid wooden cupboards or chests, in Japan the *kura*, the fireproof storehouse standing at some distance from the fragile, inflammable living quarters.

It is not only hanging scrolls that are thus stored away but also those scrolls that are not intended ever to be suspended on the wall, viz. the so–called hand scrolls. These are pictures or specimens of calligraphy mounted as long, horizontal rolls. They are meant to be viewed while being gradually unrolled on the desk of the connoisseur. Plate **19** shows such a hand scroll partially unrolled.

In colloquial Chinese scrolls mounted in this way are called *shou–chüan* 手卷. Literally translated this term means " hand scroll " which constitutes a very apt English rendering [1] since these scrolls can unfold their beauty only when passing through the loving hands of the observer: while his left hand unrolls it he loosely rolls it up with his right. Thus one never sees more than one section at a time, a part only a few feet in length. Hand scrolls are meant to be seen in this way, from right to left and section by section, and this is also the way they are painted by the artist. If a hand scroll is shown unrolled full length its artistic effect will as a rule not be seen to the full.

In China hand scrolls are also called *chüan–tzû* 卷子, *hêng–chüan* 橫卷, *chüan–chou* 卷軸 or simply *chüan* 卷. Hand scroll pictures cover a wide range of subjects. Landscapes are perhaps most commonly met with since by their very nature they are most suited for presentation as one continuous picture on a long, narrow roll. Sometimes these dreamy compositions give an impression as if traveling in a leisurely way down a river. First low drifting mists conceal the landscape from the eye; but gradually as the scroll is unrolled the haze lifts and a cluster of trees with a few houses nestling beneath them are revealed, while occasionally the massive shape of a mountain looms in the distance. Here a temple appears, there a boat is moored to the rocky shore; further on a lonely fisherman is casting his nets in the stream. After having thus traveled for mile after mile through this imaginary landscape finally a light haze again blurs the view and the roll ends with distant mountains melting into a sky that at the very end one finds to be nothing but the untouched paper.

Often these panoramas are pictures of actual scenery. The most famous of these is one of the earliest known landscape paintings in hand scroll form, the *Wang–ch'uan–t'u* 輞川圖. Here the great T'ang artist Wang Wei (王維, 699–759) depicted the scenery surrounding his favourite summer retreat. Although preserved only in rubbings these still suffice to give some idea of the exquisite brushwork of this master of poetic expression. Another famous hand scroll painting representing an actual site is the *Lung–mien–shan–chuang–t'u* 龍眠山莊圖 where the famous Sung painter Li Kung–lin 李公麟 drew his mountain retreat. Further, it is said that the great tenth century landscape painter Tung Yüan 董源 nearly always derived his inspiration from actual scenery. Mostly, however, the artist chose entirely imaginery landscapes for his subject. Among these horizontal landscape scrolls are some of the finest examples of Chinese pictorial art.

---

1) As far as I know this translation was first proposed by Benjamin March (cf. Appendix I, no. 8).

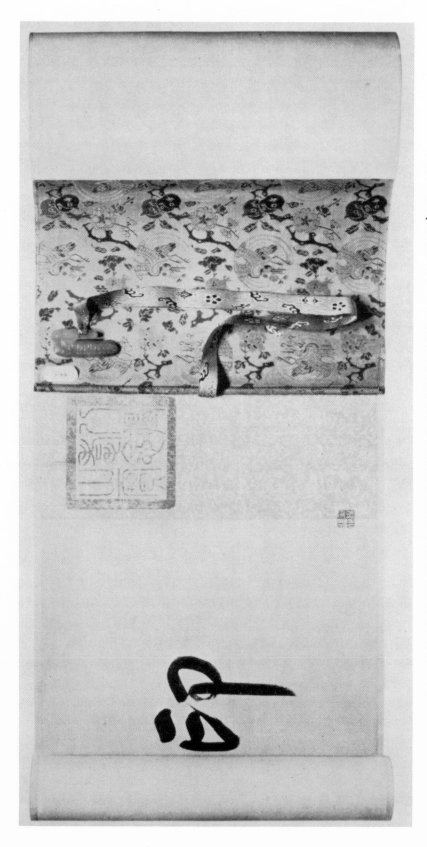

19. — CHINESE HAND SCROLL, PARTIALLY UNROLLED; CHINESE MOUNTING OF THE CH'ING PERIOD

Note the protecting flap of heavy brocade and the band for winding round the scroll when rolled up. The first vertical strip of mounting and the first character of the superscription are just visible. The large seal reading *Pa-chêng-mao-nien-chih-pao* 八徵耄念之寶 is one of the seals of the Emperor Ch'ien-lung. Note the small "seal astride the seam" below. (Freer Gallery of Art)

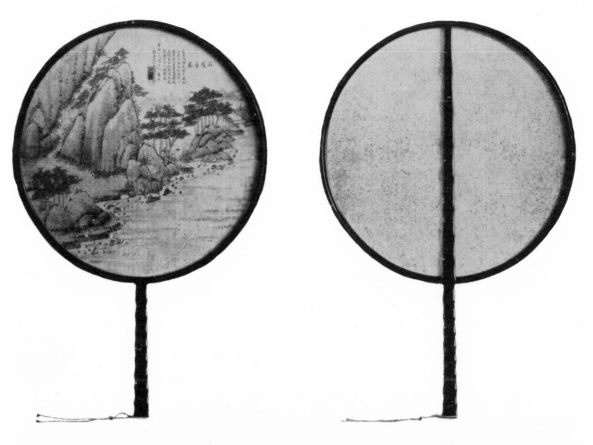

18. – CHINESE FANS. A) STIFF FAN, FRONT AND REVERSE; B) FOLDING FAN

However, besides the landscape many artists selected other themes. Such as the gnarled bough of a plum tree that in a sequence of bold brush strokes stretches itself over the entire length of the scroll, the ruggedness of its outline agreeably contrasted by a shower of white and pink blossoms. Or the scroll may unfold a procession of celestial beings or historical personages, or vast halls and terraces populated by minute people, [1] or again it may show the flight of a flock of wild geese.

Calligraphic hand scrolls may show a stately row of large characters in archaic writing or some text in flowing " grass characters " made with rapid brush strokes. But whatever the subject of a hand scroll, whether pictorial or calligraphic, there is always a sentient, powerful rhythm pervading it that compells sustained attention on the part of the observer from beginning to end. A hand scroll that one lays aside when only partially unrolled is never a great work of art.

The Chinese hand scroll has here been described in some detail because in most Western books on Chinese art this form of scroll is as a rule but cursorily treated; Western collectors generally seem to be more interested in the hanging scroll. Chinese connoisseurs, on the contrary, value hand scrolls more than hanging scrolls. This preference is to be explained partly by the fact that the hand scroll is the oldest known canvas used already by the early masters of the brush. And partly because hand scrolls have usually appended to them a great number of commentaries and appreciative remarks that enhance their value as antiques. The Chinese connoisseur has most exacting standards: it is not enough for him when a scroll is beautiful in itself, it must also whet his antiquarian interest. He wants to study the past history of the scroll, he wants to know the opinions of former collectors and compare his own impressions with theirs. Such material is supplied by the colophons and superscriptions attached to hand scrolls but in the case of hanging scrolls they are usually lacking. One need not wonder, therefore, that those collectors' catalogues where the items are arranged according to the type of their mounting, always begin with the hand scroll.

Hand scrolls are also very popular in Japan. The earliest specimens brought over from China were rolls with Buddhist texts, the so-called *kyō-kan* 經卷. These hand scrolls represent the beginning of the art of mounting in Japan. In China such Buddhist texts are mostly mounted as folding books whereas in Japan they have largely retained the archaic hand scroll form.

In Japanese hand scrolls in general are called *maki-mono* 卷物. There the most common type is that called *e-maki-mono* 繪卷物 viz. horizontal pictures or literary

The Japanese hand scroll.

1) A remarkable specimen of a long hand scroll of this kind is the picture *Han-kung-ch'un-hsiao* 漢宮春曉 " Spring Morn in the Han Palace ", painted by four artists of the 18th century, and preserved in the Old Palace Collection, Peking. The scroll is nearly twenty meters long, and represents in full colours an idealized version of an ancient Imperial Palace, with all its gates, towers, halls, terraces and gardens, painted with painstaking care, and populated by hosts of countless courtiers, ladies and noblemen, some so small that one needs a magnifying glass for examining the details. Although this painting lacks the qualities that mark a great artistic work, it shows what heights can be reached by the Chinese miniature painter.

texts interspersed with illustrations. Purely calligraphic hand scrolls are less popular than in China chiefly because Japanese calligraphy is used to the greatest artistic effect in brief verses written on separate leaves of about one foot square. Such a few lines, capturing the mood of the moment, are often exquisite works of art while longer Japanese texts even if written by great calligraphers usually give an impression of skill rather than of artistic quality.

Since the early feudal period illustrated hand scrolls of a narrative character were greatly in vogue. A favourite religious subject was the *en-gi* 緣起, the semi-historical account of the founding of some famous sanctuary. Secular scrolls either illustrated court life or depicted the tempestuous career of some well known warrior.

In these narrative scrolls the Japanese artistic genius finds full expression. Especially noteworthy is the clever spacing. A hand scroll depicting a battle scene may start with a few isolated warriors locked in combat; unrolling the scroll farther one is gradually led on to the centre of the fight where one finds the space filled to overflowing with a solid mass of struggling figures. Then slowly the scene assumes a quieter character, the fight dissolves into sparse groups, and finally the scroll " tapers off like a cadence in music ". [1]

Japanese hand scrolls are mounted according to the same principles as the Chinese ones. But whereas in China it is by no means rare to find pictorial hand scrolls of twenty feet or longer most Japanese horizontal pictures are of a more modest length. Another difference is that Japanese *maki-mono* are as a rule not accompanied by superscriptions and longer colophons.

*Chinese and Japanese albums.*

Among the types of mounted scrolls that do not figure in interior decoration mention must be made of the album, in China called *ts'ê* 冊 or *ts'ê-yeh* 冊葉.

This type of mounting represents the transition from hand scroll to book. One cannot look up a special section of a long hand scroll without much rolling up and unrolling. Especially in the case of hand scrolls containing literary texts this was felt as an inconvenience. Therefore the long strip instead of being rolled up was folded accordion-wise in leaves of uniform size. Later such albums were cut along the folds and the loose leaves thuse obtained were sewn together; thus the well known Chinese stitched books originated.

The accordion-album is to-day still used for mounting together a number of smaller calligraphic specimens; for instance single leaves inscribed with poetry, brief essays, or collections of letters by famous people. Rubbings taken from stone tablets, if cut and re-arranged are also often mounted in album form. Such calligraphic albums are known as *shu-t'ieh* 書帖, *tzŭ-t'ieh* 字帖, *tzŭ-ts'ê* 字冊 or, in the case of standard calligraphic specimens, *fa-t'ieh* 法帖 " model writings ".

---

[1] This felicitous phrase is quoted from FENOLLOSA, *Epochs of Chinese and Japanese Art*, vol. I (London 1933), page 192.

The album also is the best type of mounting for smaller pictures. When painted on pieces of silk or paper of two feet square or less such miniature pictures are called *t'ou-fang* 斗方 or *p'ing-fang* 平方; when the canvas is round their name is *t'uan-fang* 團方. Such pictures as a matter of course are not meant to be displayed on the wall. They should be viewed on one's desk, just as hand scrolls. Since they are usually painted in sets of eight, ten or twelve, their being mounted together in one album will ensure the set remaining unbroken.

Very popular are albums the leaves of which show alternately a picture and a specimen of calligraphy — the latter mostly a brief poem describing the picture it faces. Such albums are called *shu-hua-tui-yeh* 書畫對葉 or *shu-hua-shuang-pi* 書畫雙壁.

Often a number of dismounted fans are mounted together in album form, one fan on each leaf. The technical name of such an album is *shan-mien-chi-ts'ê* 扇面集冊.

In Japan albums contain either pictures or calligraphic specimens; the Japanese do not like to mount both together in one album, as is so often done in China. Calligraphic albums are called *hō-chō* 法帖, and those containing pictures *ga-chō* 畫帖. The latter term is a peculiarly Japanese expression that is not used in China.

<p style="text-align:center">* * *</p>

All the various types of mounted scrolls described above have their appointed place in Chinese artistic life.

How the Chinese connoisseur enjoys his scrolls.

The *t'ang-hua*, the large scroll hung against the back wall of the reception room is chosen with particular care. The owner sees it every time he passes through the hall, therefore it must be a painting of fair quality and undoubted authenticity. It hangs in the most conspicuous place where not only members of the family but also visitors will regularly see it. While sipping tea with his guests the *t'ang-hua* serves as a convenient topic of conversation when the customary polite enquiries after health and family have been exhausted while it is yet too early to broach the real purpose of the visit.

At the same time the *t'ang-hua* should bear a more or less impersonal character. A real art lover does not like to expose his cherished scrolls to the eyes of all and sundry who pass through his hall. This also runs counter to the Chinese feeling of reserve that is reflected also in the choice of the literary quotations figuring on the calligraphic scrolls hung in the main hall. As was remarked already above, texts displayed there are mostly non-committal quotations from the Classics. To expose there couplets from one's favourite authors or lines composed by one's friends is not only a sign of bad taste but also dangerous. The Chinese literary language is so rich in nuances that lines of lesser-known authors can easily be endowed with political implications. Enemies may interpret such couplets in a sense derogatory to those in authority and denounce the unfortunate owner. Old and modern Chinese historical records cite numerous cases of men who lost their life on the execution ground because of an indiscreet sentence displayed on their wall. A well-worn classical dictum obviates such risks since its meaning is clearly established by the standard commentaries.

Another reason for selecting as *t'ang–hua* mediocre works of art is that light conditions in the main hall are not favourable for a close inspection of the scrolls exposed there. During daytime the hall is filled with a screened, diffuse light coming through the papered front windows or the open work carving of the door panels, while at night it is dimly lit by lanterns of silk or thin cowhorn, or of painted glass. This peculiar lighting has the advantage of softening bright colours and harmoniously blending together the mounted scrolls with their surroundings; strong, direct light would too much accentuate details and rob the interior of the desired quiet atmosphere. But it goes without saying that the dim light is not very suitable for a close examination of works of art. [1]

Therefore discerning connoisseurs use as *t'ang–hua* preferably landscape scrolls painted in a free style or pictures of birds and flowers drawn life–size. Generally scrolls painted by artists who though well known are not classed among the great masters.

The frontispiece of the present essay shows a hall in a Chinese palace where one sees suspended on the wall a large landscape painting as *t'ang–hua*. The person standing in front of it points out its merits to his ladies. Note the typical long, narrow table below the picture. One sees there an incense burner accompanied by a round box containing powdered incense, and a flower vase. On the left are three sets of books.

The restrictions mentioned with regard to the *t'ang–hua* do not apply to the hanging scrolls displayed in the library and the rest room.

In his studio the owner can hang some valuable pictures or specimens of calligraphy that will brighten his spirit when, seated at his desk, he is pondering over some difficult problem. In the rest room he will hang those scrolls that are particularly dear to him. There he usually has a cupboard or a few chests which contain his cherished scrolls and albums, items he likes to take out on quiet evenings, either alone or together with one or two intimate friends who share his tastes. Here they can linger undisturbed over each single picture examining its every detail. In daytime the scroll will be taken near the window and at night they can study it by the light of strong candles or oil lamps. The delights of such contemplative hours passed by " the transparent window and the quiet desk " 明 窓 靜 几 have often been praised by Chinese poets.

Thus both scrolls and guests are graded in the same manner as to their relation to the master of the house. A formal visitor is received in the main hall, and there one displays formal pictures. Friends and relations one sees in the library where there are exposed scrolls of a more personal character. The rest room is the inner sanctum where one enjoys one's best scrolls together with a few bosom friends.

The ladies of the house can also enjoy looking at pictures, in their own quarters. Such an occasion is shown on Plate **20**. A lady of rank, seated in a comfortable armchair is examining a picture of flowers, temporarily hung on the doorpost. Three other ladies

[1] In this connection I mention that when exhibiting Buddhist paintings and statuary it should be remembered that in China and Japan such works of art are displayed in the main hall or the side chapels of temples which are rather dark even during the daytime, being at the best lighted by a few altar lamps. It is to such lighting conditions that the vivid colouring of Buddhist paintings is adapted; if viewed in a strong, direct light they will often seem too gaudy.

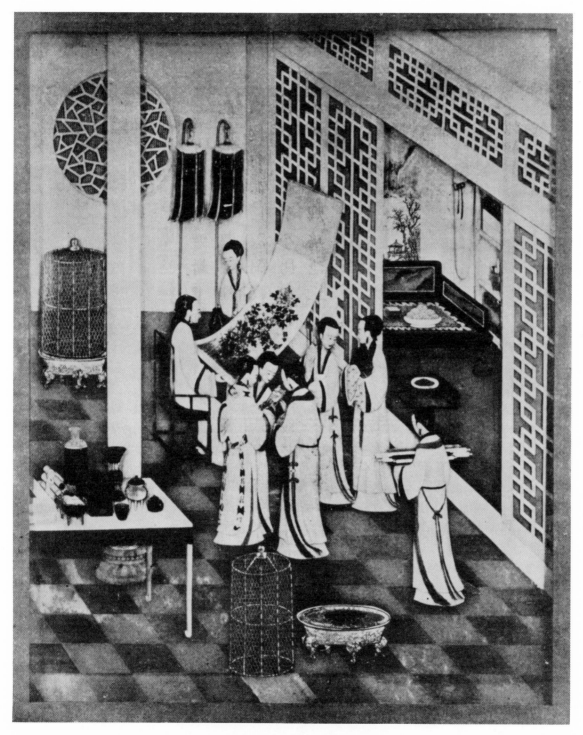

20. – PALACE LADIES VIEWING ANTIQUES

One leaf of an album consisting of twelve ivory plaques carved in relief and representing the elegant pastimes
for each month of the year.

Ch'ien–lung period. (Old Palace Museum, Peking)

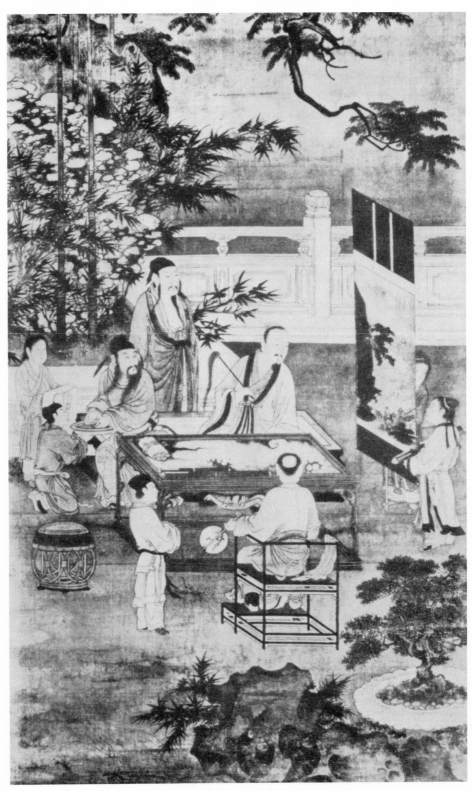

**22.** – ARTISTIC GATHERING IN THE OPEN
Anonymous Ming painting. (Old Palace Museum, Peking)

21. – SHOWING PICTURES TO A FRIEND
(From the Wu–ju–yu–hua–pao, cf. Appendix I, no. 42)

are discussing a jade incense burner, the one on the right is carrying an armful of rolled up hanging scrolls.   On the table one sees some other antiques.   Through the doorway one can just see part of a larger hanging scroll suspended on the back wall of the adjoining room, over a broad couch.   Since this is the tenth moon the weather is chilly and the room is therefore heated by two braziers with glowing coals.   The high coops of copper thread are meant to prevent one's trailing robe to get scorched by the fire when passing by the brazier.

If the weather permits a connoisseur may show his scrolls also outside, under the eaves of the main hall, or on a verandah or terrace in front of the library or the rest room. Plate **21** depicts such a scene.   A boy servant holds up the top of a hanging scroll and the guest looks at it while letting the lower roller revolve in his hands.   As is clearly seen

in the position of his left hand he does not hold the scroll by the knobs of the roller, but lets part of the roller itself rest in his hand. This is the correct method; for if one should hold the scroll only by the knobs these may come off and the scroll will drop down and get torn or soiled. The book rack in the background is loaded with books in brocade covers and title labels stuck between the leaves. A page is rolling up a hand scroll. On the table one sees other scrolls and a pile of four albums.

The above applies to amateurs of pictorial art who have a modest collection of scrolls. Great collectors and wealthy connoisseurs who are the happy owners of hundreds of antique pictures have to make more elaborate arrangements. The main part of their collection is kept in securely locked cupboards or heavy wooden chests and three or four pages are specially charged with the care of these. The connoisseur will select a few items from his catalogue and has them brought out to his library or to an open verandah or terrace of his mansion. There the scrolls are one by one unrolled on a table or suspended on a convenient post or pillar. The scrolls are hung up with a special scroll hanger, a stick ending in a fork to hook under the suspension loop of the scroll, and called *hua-ch'a* 畫叉.

Connoisseurs are very particular with regard to such scroll hangers. For the stick they choose some rare kind of speckled bamboo and for the fork white or green jade or some ancient bronze article of suitable shape. The 11th century collector Kuo Jo-hsü mentions already an elaborate scroll hanger and they are described by more than one later connoisseur. [1]

The long days of summer are said to be particularly suited for the viewing of scrolls. Thus this favourite pursuit of the collector may be suggested by the term *hsiao-hsia* 銷夏 " to while away the summer ". Some famous collectors actually employed this term in the titles of the catalogues of their scrolls. The archeologist and art collector Wu Jung-kuang (吳榮光 1773-1843) compiled the catalogue of his scrolls entitled *Hsin-ch'ou-hsiao-hsia-chi* (see Appendix I, no. 48) " Records of whiling away the summer of 1841 " when in that year he had to confine himself to his house in his native village, partly because of illness and partly in order to escape the political confusion caused by the Opium War.

A connoisseur will only occasionally take out his most valued scrolls. The frequent rolling and unrolling is liable to cause wrinkles in the paper or silk, make fragments of the surface peel off, loosen the borders of the mounting or otherwise damage the scroll. Thus not seldom it happens that an antique scroll that had the good fortune during many centuries to remain in one and the same family or always was transmitted from one connoisseur directly to another, looks as new as if it had been painted yesterday although it dates from the Yüan period. As a matter of fact superior scrolls are less liable to acquire the antique appearance of many an inferior specimen that was painted much later.

If a collector decides to take out his treasures it is often made a special occasion to which he invites a number of friends of similar interests. These gatherings in many

1) Cf. below, pages 179 and 334.

44

ways resemble a kind of religious rite. First all present will wash their hands in large brass bowls offered to them by boy servants. This introductory ceremony has given its name to the class of pictures that represents a gathering of connoisseurs viewing art treasures: such pictures are technically called *hsi-shou-t'u* 洗手圖 "hand-washing pictures". Rare incense is burned to intensify the mood of exalted enjoyment of beauty. And although wine is drunk on most literary occasions, while enjoying scrolls one should be content with sipping only a cup of fragrant tea.

On Plate **22** one sees how a former artist depicted such a gathering of four art lovers on a terrace in the open air, in summer. Three of them are seated at a wooden table with a marble top, the fourth remains standing in a leisurely pose. One of the gentlemen sitting on the low couch is washing his hands in a basin offered to him by a kneeling page, while a second boy servant is standing by with a clean towel. Even while he is washing his hands this guest can not take his eyes off the hanging scroll, a landscape painting that is being shown suspended on a scroll hanger by the page on the right. The central person is also engrossed in the observation of this picture. In his right hand he carries a fly-whisk, the traditional symbol of leisurely conversation. The scholar seen from behind sitting in an armchair carries a stiff, round fan in his left hand. The boy servant standing by his side is also looking at the scroll. The page on the right is carrying another rolled up hanging scroll that will be displayed next. On the table one sees a number of rolled up scrolls tied together.

A similar occasion, this time in winter, is shown on Plate **23**, a reproduction of an anonymous Ming painting in the Old Palace Collection in Peking. Three gentlemen are sitting at a marble-topped table on the open porch of a large residence. The one at the back — obviously a person of rank — points out to the others some feature of a large landscape painting suspended from a roof beam. A boy servant holds the picture to prevent it from swaying while another is waiting by his side carrying more scrolls in his arms. On the table one sees an incense burner and a vase. In the foreground the host is welcoming a newly arrived guest. The latter is accompanied by two servants carrying some boxes, presumably containing paintings or other antiques to be submitted to the judgement of this distinguished gathering. On the left another guest is standing on a tabouret and chooses blossoming sprigs from the plum tree in the courtyard. He hands these sprigs to a servant who will presently arrange them in the vase standing ready by his side. When placed on the table this vase with "winter plum blossoms" will contribute to the mood of refined enjoyment of this gathering.

On the pictures described above hanging scrolls are viewed while being suspended. Some Ming writers, however, recommend that when viewing hanging scrolls one should unroll them on the desk. They maintain that this is the correct way to enjoy such pictures to the full since one then sees them from exactly the same angle as the artist when he painted them. Fastidious connoisseurs use for this purpose a special narrow, high table made of blackwood, the so-called *hua-chi* 畫几 or *hua-an* 畫案. By its side there may be standing the *hua-kang* 畫缸, a large porcelain jar with wide mouth.

In this jar one can stack a number of rolled up scrolls ready for being taken out and unrolled on the table. *Hua-chi* and *hua-kang* were much in vogue during the Ming dynasty but at present one finds them only in the houses of scholars with antiquarian interest.

Hand scrolls and albums are looked at while being opened or unrolled on the desk. Plate **24** shows a lady examining an album by the window of a luxuriously appointed library. The painter did not indicate the content of this album; probably the dark leaf on the right represents a painting. Two rolled up hand scrolls are lying ready for being inspected next. Further one sees on the table a block of jade of interesting shape and a vase with flowers. In the background stands a beautifully carved bookcase with books in brocade covers and a few antique bronze vessels on the top shelf. A seven-stringed lute is suspended on the wall.

Chinese opinions on the enjoying of scrolls.

Chinese amateurs of pictorial art are wont to stress that one can enjoy the pictures and calligraphic specimens in one's collection only when looking at them either alone or in the company of real connoisseurs; they should never be shown to people devoid of taste and understanding.

The great Ch'ing collector Lu Shih-hua tersely observes: " With rank outsiders you must not debate questions of authenticity (of antique scrolls) for such discussions are only a waste of lips and tongue ". [1]

And elsewhere he says:

" Some people lock their scrolls away carefully, never showing them to others and even themselves never taking them out. This is like burying a great treasure in a deep well and a wholly irrational attitude. On the other hand, however, you should neither be too liberal in showing your treasures. If your guest has not the slightest understanding for art and only listlessly unrolls and rolls up the paintings even touching them with greasy fingers or moistening them with spittle while talking, then this only brings harm and no gain ". [2]

The " touching with greasy fingers " mentioned here has come to stand in Chinese art literature as symbolic for the damage scrolls suffer when handled by careless and incompetent persons. It refers to the famous story about the 4th century statesman and art collector Huan Hsüan (see below, page 141). Once he had organized a large scroll-viewing gathering where he showed all his best paintings and autographs. First, however, he had served fried cakes and some of his guests handled his scrolls without having washed their hands; thus they spoilt not a few scrolls, to Huan Hsüan's great mortification. [3] This sad occurrence has never ceased to horrify collectors and connoisseurs

---

1) *Shu-hua-shuo-ling* (cf. Appendix I, no. 47), ch. 29:
勿 與 外 人 爭 眞 僞。徒 費 唇 舌。
2) Ibid., ch. 25: 書 畫 祕 密 而 藏。不 與
人 看。自 亦 不 看。如 以 大 寶 沉 之 深
淵。最 不 可 解。然 輕 與 人 觀。亦 非 也。
其 人 全 然 不 董。徒 勞 卷 舒。反 以 油
手 指 點 吐 沫 噴 濺。有 損 無 益。

3) This story is related in T'ang works like the *Li-tai-ming-hua-chi* (see Appendix I, no. 33), and the *Shu-tuan* 書 斷, by Chang Huai-kuan 張 懷 瓘. The " fried cakes " of this story are indicated by the term *han-chü* 寒 具, which is explained as meaning round flour cakes fried in fat, not unlike the modern Chinese *san-tzŭ* 饊 子.

46

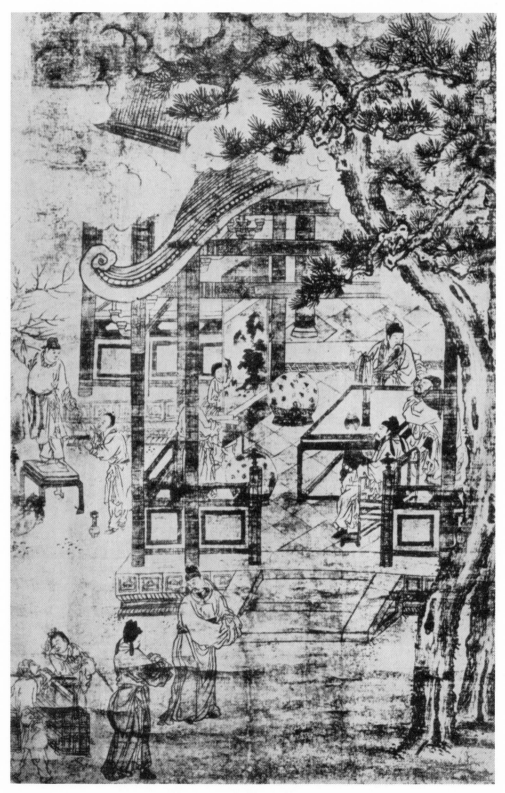

**23. – ARTISTIC GATHERING**
Anonymous Ming painting. (Old Palace Museum, Peking)

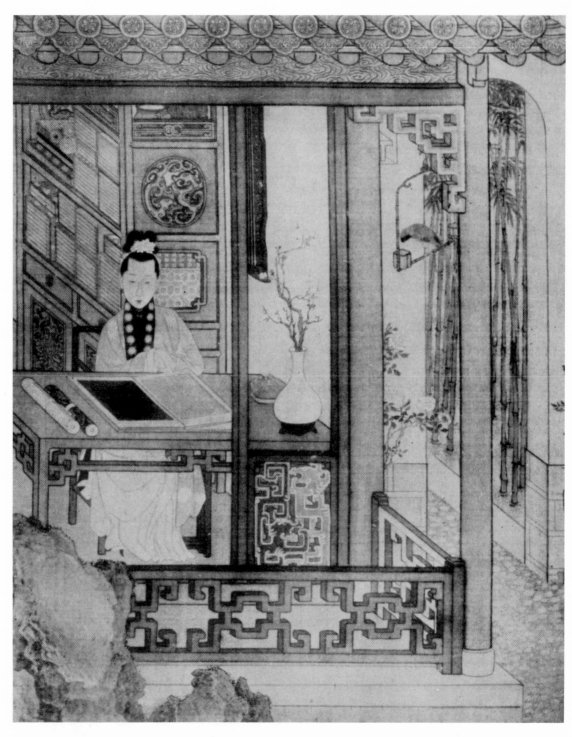

24. – CHINESE LADY LOOKING AT AN ALBUM
From an album with pictures of elegant family life, in the Old Palace Museum, Peking

of the succeeding centuries; it is referred to in nearly every later work dealing with the collecting of antique scrolls.

The Ming scholar T'u Lung has the following to say:

" Antique paintings should never be taken out and shown to vulgar people. Not knowing the correct manner of viewing scrolls they will lift parts of the painting up on their hand to see better, and then the silk will tear. Or they will even carelessly let the scroll drop on the floor so that it is spoilt beyond repair ". [1]

Further the following amusing passage from Lu Shih–hua may be quoted:

" The likes and dislikes of people are different. If I look at superior scrolls together with some one who says: ' This one is refined. This one is inspired. And this one is wonderful ', everytime expressing exactly what was in my own mind and exactly reproducing my own feelings, then this indeed is a great joy. If, on the other hand, such a person idly chatters away all the time, proving not only that he is absolutely impervious to the beauty that is displayed in front of him, but on top of that in his talk confuses the sequence of the dynasties, and while reading out in a loud voice the inscriptions on the scrolls always scans the text wrongly and makes mistakes in the most elementary characters, then this is truly a tremendous nuisance ". [2]

The portrait of the gentleman drawn so vividly in the second part of this passage is evidently based upon many a galling personal experience.

Finally, this section on the enjoyment of scrolls would not be complete without the famous passage from the *Li–tai–ming–hua–chi* by the T'ang scholar Chang Yen–yüan (see Appendix I, no. 33), where he gives us an intimate glimpse of the delights of the connoisseur's studio.

" Since my youth I have devoted myself day and night to the collecting of rare antique scrolls, studying them, enjoying them and devising means for their repair and preservation. Everytime I obtain a scroll I will work on it with loving care, treasuring and enjoying it for whole days. If I find (a valuable scroll) that can be had I sell my clothes and economize on my food (in order to assemble funds for purchasing it). My wife, my children and my servants often scathingly deride me saying: ' The whole day doing useless things, what is the good of that? ' But I then answer with a sigh: ' If one does not do useless things, how could one ever enjoy this limited life? '

" Thus my love of scrolls went ever increasing and now has grown to be a veritable passion. Always when on a clear morning I sit peacefully enjoying beautiful scenery, by my bamboo–overgrown window or in my pavilion under the pines, I find that all worldly glory is vain and I tire of the care for the daily bowl of rice. For among all those outer

1) *K'ao–p'an–yü–shih* (Appendix I, no. 29), ch. 2: 古
書不可出示俗人。不知看法。以手
托起書背就觀。絹素隨拆。或忽慢
墮地。損裂莫補。

2) *Shu–hua–shuo–ling* (cf. Appendix I, no. 47), ch. 8:
人之好惡不同。與人共觀名蹟。其

人云此妙事。或朝辭魯
是快所論題魚
此品。是意不前破句。
種與妄代以非大煞風景。
方余論以非大
逸品。此一不後。
品。中休。以認識
是符不後字。
神合。著作面。盡
品。眞痛前。
此大卷。朗屬

things that bother us there is none that possesses real value; [1] there are only these anti-
que scrolls that never pall on me.   Completely absorbed by them I forget speech, I go
on looking at them in a mood of perfect serenity. " [2]

How the Japanese
connoisseur enjoys his
scrolls.

In Japan a connoisseur suspends his scrolls one by one in the *toko-no-ma* and
together with his friends studies them while kneeling on the floormats in front.

As was remarked already above, Japanese collectors prefer the tea room for showing
their scrolls.   Its austere beauty together with its atmosphere of quiet reflection make
this room an ideal place for this enjoyment.   First the leisurely tea ceremony is perform-
ed so as to bring the gathering in the proper mood.   People of elegant taste will per-
form the Chinese-style tea ceremony, *sen-cha* 煎茶 [3] when Chinese scrolls are going
to be shown, and the *cha-no-yu* 茶の湯 or Japanese version of the old Chinese tea
ceremony when purely Japanese scrolls are to be displayed.

Japanese connoisseurs make elaborate preparations for such meetings.   They will
use choice utensils for the tea ceremony, and each of these is examined by the guests
with the same interest and care as will be bestowed after the tea ceremony on the scroll
displayed in the *toko-no-ma* and on the antique or the flower arrangement accompa-
nying it.   Detailed records are kept of such gatherings, including lists of the objects
displayed, copies of the poems composed by those who took part in it, their views on
the scrolls shown, and so on.   Since the end of the Tokugawa period tea masters
and collectors often published illustrated collections of such records.   Such books
contain valuable material that has thus far escaped the notice of most students of
pictorial art.

Plate **25** is a picture taken from such a publication.   It shows the arrangement of the
tea room prior to the arrival of the guests.   A hanging scroll is suspended in the *toko-
no-ma* and below it is placed an incense burner on a lacquered tray.   In the foreground
one sees the utensils for *sen-cha*, including a portable stove for boiling the water, tea cups
etc.   In the centre of the room stands a tobacco box and a basket of fresh fruit, surround-
ed by five cushions for seating the guests.

1) *Chang-wu* 長物 literally means "superfluous
things".   In my opinion, however, there can be no doubt
that, especially when used by art lovers, this term has no
derogatory sense.   In such passages it stands, on the con-
trary, for all those things that, although considered super-
fluous by the man in the street, are of supreme importance
to the art lover and the connoisseur.   It was therefore that
the Ming scholar Wên Chên-hêng chose this term as title
for his book on the surroundings of the elegant scholar
(*Chang-wu-chih*, listed in Appendix I, no. 30).

2) *Li-tai-ming-hua-chi* (cf. Appendix I, no. 33),
last section of the second chapter: 余自弱年。鳩
集遺失。鑒玩裝理。晝夜精勤。每獲
一卷。遇一幅。必孜孜葺綴。竟日寶
玩。可致者必貨弊衣。減糲食。妻子

童僕。切竟何益之好。笑。或既則安近以千之累。既閱。
之事。無以景。為書。猶然以觀。

日而歎曰有癖每乘且無頦然以忘
終日曰成於以之情。忘

為若涯之清輕物。以忘言。

益不生晨一書。又

3) Japanese *sen-cha* is an exact copy of the tea cere-
mony as it was practised in China during the Ming dynasty.
It is well worth a closer study by Sinologues, for most of
its technical terms, now obsolete in China and lacking in
Chinese dictionaries, were still in current use in the China
of the Ming dynasty.

25. – JAPANESE TEA ROOM WITH PREPARATIONS FOR THE *SEN-CHA* CEREMONY
Blockprint from a 19th century Japanese collector's catalogue

The *toko-no-ma* is a most suitable place for showing hanging scrolls. It focusses the attention on the picture displayed there and sets it apart from the rest of the room. A drawback is that in the ordinary Japanese dwelling house, and more especially in the tea-room, the *toko-no-ma* is rather low so that it cannot accomodate larger scrolls. It is mainly for this reason that larger pictures have always been unpopular in Japan: they can be displayed only in temples or the old lordly mansions. Since scrolls in the *toko-no-ma* are hanging close to the floor one should not remain standing while looking at them but sit down on the mats. Otherwise one cannot see the scroll from the right angle.

In Japan hand scrolls and albums are viewed on low tables or also on the floormats. Connoisseurs first spread out on the mats a felt pad, the so-called *mō-sen* 毛氈. This is done in order to show respect to the scrolls rather than out of fear that they might become soiled, for the mats are kept scrupulously clean. *Mō-sen* are also used for spreading out the paper or silk on when one is painting or writing characters.

49

<div align="center">* * *</div>

Finally the literary sources utilized in writing the present essay may be briefly reviewed.

Until recent years there did not exist in China "histories" of pictorial art in our sense of the word. [1]

In their dynastic histories the Chinese concentrated on the actions of prominent men and the resulting political events rather than on the broader issues that influenced men's behaviour and on the general trends of an era that gave events their shape and determined their import. Chinese historical records bear therefore a pronounced factual character; if the compilers drew any conclusions at all such were concerned with moral considerations, they were not aimed at historical interpretation as we understand it.

The Chinese followed largely the same method in their accounts of the history of pictorial art. These books record the biographies of eminent artists and descriptions of the works they created. The biographies are usually arranged in chronological order while occasionally they state for instance that a certain style of painting was first introduced by X., or that Y. followed the technique of Z. But the writers refrained from attempts at formulating general artistic trends as determined by historical and cultural evolution. They limited the expression of their individual views to a grading in traditional classes of the ability of the artists and the quality of their works.

This strictly factual character of Chinese accounts of pictorial art makes them into useful source-books for our present subject. The detailed notes on the individual traits of artists and collectors, describing how the former created their works and how the latter had them mounted and how they preserved them — all such data are liable to be passed over in silence in histories of art devoted to broader issues of artistic development. As a matter of fact the modern Chinese and Japanese histories of pictorial art, although ably written and useful for general orientation, proved of slight help in the compilation of the present essay while random notes as for instance those left by the Sung artist Mi Fu in his *Hua-shih* and *Shu-shih* supplied valuable data.

Hence in the following pages T'ang sources like Chang Yen-yüan's *Li-tai-ming-hua-chi* and Sung works like Kuo Jo-hsü's *T'u-hua-chien-wên-chih* are quoted extensively. For details about these texts the reader is referred to Appendix I. "Literary Sources". Books of minor importance are described in the footnotes to the pages where they are quoted.

Here I confine myself to describing three lesser-known classes of books that proved useful as sources on the methods of the Chinese connoisseur.

---

[1] The first Chinese history of Chinese painting written on modern principles is apparently *Chung-kuo-hua-hsüeh-ch'üan-shih* 中國畫學全史, by Chêng Ch'ang 鄭昶; one foreign volume, published Shanghai 1929. The contents are well arranged and the sources quoted in full while justice is done to the historical and cultural background of each period. Collectors will find Appendix IV of special interest; there are listed many modern Chinese painters with their literary designations and particulars about their life and work.

Books on the surroundings of the refined scholar.

Copious material relating to Chinese connoisseurship and the history of the art of mounting can be extracted from books of a special genre, viz. compilations meant as guide-books for the scholar of elegant taste.

Such books describe the interior in which the refined lover of art and literature likes to live. They deal with the furniture of his library, the brushes and paper, ink and incense he prefers, the art treasures he likes to contemplate and the books he likes to read. They discuss in detail how pictures and specimens of calligraphy should be mounted, how they should be appraised and how one should display them in his house.

The oldest book of this class extant is the *Tung-t'ien-ch'ing-lu-chi* written by the Sung collector Chao Hsi-ku. The genre continued to be popular till the end of the Ming dynasty, thereafter interest in the subject declined. A number of these treatises have been preserved in China itself while some of the rarer items survive in Japanese reprints or manuscript copies.

The men who compiled these handbooks borrowed freely from each other, quoting *verbatim* entire passages. Since such passages are as a rule not marked, one can locate them only by a careful comparison of the texts preserved. This labour is often rewarded. Usually a writer who incorporated a statement made by one of his predecessors in the field would make slight changes in the wording so as to make the passage agree with his own argument. Thus a comparison of the various versions of a statement on some esthetic principle will bring to light controversial points that else would have remained unnoticed. An example is given on page 26 hereabove.

Some representative books of this genre are described together in Appendix I, nos. 27–31.

Encyclopedias of material culture.

It is not without interest to compare the handbooks of the surroundings of the refined scholar with another class of source-books that deserve special mention, namely the encyclopedias of material culture. These books might be classified as the *ko-chih* 格致 variety, a term which often occurs in their titles.

The compound *ko-chih* is taken from a passage in the *Ta-hsüeh* 大學, chapter 8, where it is said: " The perfecting of knowledge depends upon the investigation of things " 致知在格物者. While the works by Chao Hsi-ku and his successors describe things as they are, the books of the *ko-chih* class aim at tracing the origin of things and following their evolution in the course of the centuries. The oldest work of this kind would seem to be the *Shih-shih-ch'i-yüan* 事始起原 by the Sung scholar Kao Ch'êng 高承. Better known are the *Ko-ku-yao-lun* 格古要論 written in 1388 by Ts'ao Chao 曹昭 and the *Ko-chih-ching-yüan* 格致鏡原, published in 1735.

These encyclopedias must be handled with much caution. The people who compiled these books, although professing to follow historical principles, were in fact more interested in terms than in the objects those terms stand for; they preferred quoting a famous literary quip to the recording of an exact description. The authors did not reckon with the fact that the literary language remained the same while Chinese material

culture changed and developed. Writers would continue to use one term fixed by tradition for indicating an object or a process although in the mean time the object had changed completely in structure and appearance while the process had split up into two or more different ones. The colloquial language adapted itself to such changes and created new terms but the literary language disdained such newly–coined expressions.

For instance, the *Ko–chih–ching–yüan* mentioned above gives in ch. 37 first a section on books, then one on specimens of calligraphy, and lastly one on pictures. To each of three sections there is appended an article entitled *chuang–huang* 裝 潢, a term that originally referred exclusively to providing scrolls with a backing of a yellow material. But the author of the *Ko–chih–ching–yüan* uses this term in three different meanings, viz. in the first case as " book binding ", in the second as " binding and mounting ", and in the third as " scroll mounting ". In the colloquial each of these three processess has its proper term. " Book binding " is referred to as *chuang–ting* 裝 釘 " to provide with (paper) nails ", i. e. to fasten the loose pages together by means of two paper spills passing through holes along the inner margin, prior to sewing the volume together with its outer covers. Calligraphic specimens may either be bound in the same way or inserted between loose covers; the latter process is called *chuang–chêng* 裝 幀 " to provide with covers ". Finally, the mounting of scrolls is properly referred to as *piao–pei* 裱 褙 " to provide (a picture) with a front mounting and a backing ".

In the literary language each of the three colloquial terms *chuang–ting*, *chuang–cheng* and *piao–pei* can be rendered by the ancient expression *chuang–huang*, as is done in the *Ko–chih–ching–yüan*. In this particular case its meaning can be easily derived from the context; but it is evident that when such literary terms as *chuang–huang* are used without further comment it is often difficult to ascertain what process the writer had in mind.

This point should be remembered when one is working on older texts which are directly or indirectly concerned with material culture. If, therefore, one is translating a Sung text on for instance lacquer ware, one will do well to study at the same time as many actual specimens of Sung lacquer as one can find in musea or private collections. For if one depends exclusively on literary data such as later commentaries and the meanings of technical terms as given in later dictionaries and other works of reference, one will be liable to make awkward mistakes. [1]

I have dwelt on this point at some length because it is of primary importance for our present subject. As will be seen in the historical part of this essay not a few technical terms relating to Chinese connoisseurship and the art of mounting scrolls had different connotations in various older periods. It is only by a careful examination of antique

---

1) The study of material culture is necessary also for Chinese textual criticism. If, for instance, a Ming scholar while editing a T'ang text found there a term for a utensil that had become obsolete in his own time, he would often replace it by another word for a similar object familiar to him, taking it for granted that that was the thing the T'ang writer had in mind. If the modern student of this " emendated " text is unfamiliar with the material culture of the T'ang period then the correction by the Ming editor will lead him completely astray. Students of sinology would do well to visit the Chinese collections in museums accessible to them as regularly as Sinological libraries.

mountings and a study of the terminology preserved in Japanese sources that the original meanings can be reconstructed.

In this respect the " handbooks on the surroundings of the scholar " supply more reliable information than the *ko–chih* encyclopedias. The men who wrote the handbooks tried to record accurate descriptions of the objects as they actually saw them, the *ko–chih* authors merely assembled literary synonyms and flowery expressions for objects they often even had never seen themselves. [1]

Another source of useful information are the older and newer collector's catalogues. <span>Collector's catalogues.</span>

These catalogues are of great importance for the study of Chinese pictorial art in general. They are constantly consulted by Chinese connoisseurs who consider a thorough knowledge of at least some standard catalogues as indispensable to the art student and collector. It is proposed, therefore, to discuss this special genre of Chinese art literature in some detail.

When a Chinese connoisseur has assembled a large collection of scrolls he will sooner or later compile a descriptive catalogue of all the more important items. Those who possessed the necessary means often published their catalogue, others were printed by their friends or relatives, sometimes posthumously. The first private catalogues were compiled during the T'ang dynasty, while the first official catalogues date from the Sung period. During the Ming dynasty the number of private catalogues waxed and by the end of the Ch'ing period ran into the hundreds.

These catalogues are not hastily written: their contents are based upon the notes made by the compiler during years of patient study and more often than not represent the experience of a life time. Although not as a rule illustrated the descriptions given in these catalogues are so detailed that the lack of reproductions is not felt so grave a shortcoming as one would imagine.

The scrolls described are as a rule arranged chronologically according to the dynasties during which the artists lived, and each section is usually subdivided according to the type of mounting of the scrolls; first hand scrolls, then hanging scrolls and finally albums.

Each item is headed by the title of the scroll and the name of the artist. Then follows the type of mounting, and the measurements of the picture or calligraphic specimen itself, and the canvas the artist used. Further the style of the work is recorded: of paintings whether monochrome or coloured while of specimens of calligraphy the type of writing is further defined. In the case of pictures there follows a minute description of the subject represented, stressing those points that in the opinion of the writer deserve special notice. In the case of calligraphic specimens the entire text is reprinted; it is noted into how many columns the writing is divided and how many characters each column

---

[1] It should be remembered that the writers of most encyclopedias and rhyming dictionaries did not intend to supply material for historical and philological research; their primary aim was to provide poets and essayists with synonyms and flowery expressions.

counts, together with its height and width. If the text is not an original composition but a copy of some famous poem or essay, only the first and last lines are quoted.

Additional notes and comments written on the scroll by former owners are copied out with scrupulous care and artists' and collector's seals are reproduced in facsimile or described.

Finally the compiler of the catalogue usually adds a critical note of his own, discussing the authenticity of the scroll, comparing it with scrolls by the same artist in other collections; giving details about the life of the artist or of a former owner, or stating when and where the item was obtained.

These compiler's notes in particular are mines of information from which one may gather valuable data not only on the critical methods of the Chinese connoisseur, on the assembling and dispersion of famous old collections and on the lives of lesser-known artists and literati, but also on subjects of general historical importance.

In addition to his own scrolls a conscientious connoisseur often includes in his catalogue descriptions of the scrolls he saw in the houses of friends and acquaintances or in the shops of curio dealers.

As a rule these catalogues of private collections are more reliable than those of the scrolls preserved in the Palace drawn up by Imperial command. The scholars charged with compiling the Palace Catalogues of the various dynasties were mostly diffident in recording their candid opinion on the authenticity of the items listed, fearing lest they might incur the august displeasure.

The way of using these catalogues will be discussed in Chapter I of the Second Part of the present publication. A list of the more important ones will be found in Appendix I, nos. 44–52.

Special treatises on
the art of mounting. Incidental remarks on the art of mounting and remounting scrolls are easily located in the literary sources enumerated above. It is more difficult to find longer accounts of this art.

As will be discussed further in the following pages, Chinese writers in general took it for granted that collectors were familiar with the technique of mounting; moreover, this art was deemed to belong to the sphere of the artisan rather than to that of the artist and hence a subject unsuited for being included in literary works.

Apparently there were only two scholars who thought it worth while to write a longer treatise specially devoted to the art of mounting. The one lived during the last years of the Ming dynasty, the other in the middle of the Ch'ing period.

The earlier of these two studies is the *Chuang-huang-chih* 裝潢志 "The Book of Mounting". It was written by Chou Chia-chou 周嘉冑, a scholar of Nanking, the old Ming capital. This book consisting of fifty-two brief chapters, is a systematic account of this complicated subject, written in a fluent style and testifying to the sound judgement and artistic sensitivity of the author. Although Chou Chia-chou was not prominent in political life, there are indications that he belonged to one of the most distinguished

circles of art lovers in Nanking. Moreover, since Kiangsu Province, then as now, was famous for the skill of its mounters, he was in an excellent position for gathering material on his subject *in situ*.

The other treatise, written about one hundred years later, is entitled *Shang-yen-su-hsin-lu* 賞 延 素 心 錄, " Records of prolonged gratification of the Simple Heart ". Its author was Chou Erh-hsüeh 周 二 學, a comparatively obscure collector who flourished about 1730. Although both in style and contents this book is inferior to the *Chuang-huang-chih*, yet it throws new light on some problems connected with the art of mounting and interior decoration, while occasionally supplementing remarks made by Chou Chia-chou. In Chapter IV here after both the *Chuang-huang-chih* and the *Shang-yen-su-hsin-lu* will be found in complete translations.

It must be stressed that both these books are concerned only with the art of remounting and repairing antique scrolls. In the prefaces both Chou Chia-chou and Chou Erh-hsüeh state clearly that their aim was to ensure by timely advice that valuable antiques scrolls are preserved with due care and not damaged by clumsy mounters. They assumed that their readers knew how *new* scrolls should be mounted. Since, however, the arts of mounting and remounting are closely connected, most of their observations apply equally to both. Moreover, the first half of Chapter II following here after contains a detailed description of the mounting of new scrolls and thus supplements what is lacking in the Chinese texts translated in Chapter IV.

Modern Chinese scholars have written little about the art of scroll mounting and about connoisseurship of antique scrolls. I know of only two articles on this subject; those are listed in Appendix I, nos. 58 and 59.

In Japanese literature much information on Japanese connoisseurship of Chinese pictorial art is contained in the works left by the tea masters. Such sources devote ample space also to the way Japanese connoisseurs and Sinologues enjoyed the Chinese scrolls in their collections while these records supply at the same time a wealth of data on scroll mounting. <span style="float:right">Japanese literary sources.</span>

Additional information on these subjects may be gathered from Tokugawa collections of miscellaneous notes on topics of literary and archeological interest. These books belong to the class of *zui-hitsu* 隨 筆, a genre that in Japan became even more popular than in China.

In recent years there appeared a few special studies in Japanese on the art of mounting scrolls as it is practised in Japan. Besides giving accurate descriptions of the technique of this craft these books also reprint references collected from older Japanese literary sources. Moreover the guild of Japanese mounters published in 1939-40 its own periodical containing interesting articles on technical and historical problems connected with the art of mounting, written by well known mounters or art-historians. A shortcoming all these Japanese publications have in common is that they either ignore or treat only superficially the Chinese material and thus fail to place the facts against their proper historical background.

Details about the old and new Japanese sources that were utilized for the present essay will be found in Appendix I, section C.

\* \* \*

The sources enumerated above, if studied in connection with each other, will enable the reader to obtain an insight into the means at the disposal of the Chinese connoisseur and to form a general idea about the art of mounting. Such studies, however, can never be complete if the theoretical information gathered is not tested by observation of the actual mounter's craft as it is at present still practised in China and Japan, in accordance with the principles transmitted during many centuries.

Let us therefore now visit the mounter in his atelier and watch him at his work.

CHAPTER II

# THE TECHNIQUE OF MOUNTING

## 1 – THE MOUNTING OF NEW SCROLLS AND RUBBINGS

SINCE olden times those Chinese connoisseurs who wrote on the art of mounting confined their discussions to the remounting and repairing of antique scrolls and did not refer to the mounting of new pictures or calligraphic specimens, or of those that had never been mounted before.  As was explained already above the reason for this one–sided treatment of the technique of scroll mounting is that it was always taken for granted that every art lover would be thoroughly conversant with the mounting of new scrolls. Literary sources silent on the art of mounting new scrolls

However, since the technique of mounting new scrolls has never been adequately described in Western sources, it must be feared that most Western readers are unfamiliar with its details.  Yet knowledge of such details is indispensable for an understanding of the problems involved in the repairing and remounting of antique specimens.  Hence we shall here first describe the process of mounting scrolls that have never been mounted before, reserving the second half of this chapter for a discussion of the technique of remounting.

For more than a thousand years, ever since the decline of mural painting, silk and paper have been the favourite canvas of Chinese and Japanese painters and writers. In what state the mounter receives a newly–painted scroll, and the scope of his work.

When the artist has finished his picture or autograph it is left on the table to dry, kept more or less flat by rulers or paper weights; or it is lightly attached to a blank paper roll by means of a few gummed paper slips at the four corners.

Such an unmounted picture or autograph does not look very attractive.  The paper or silk is all crumpled up by the wrinkles that develop there where ink or colours were heavily applied, and the canvas seems too thin to lend body to the brush stroke.  It needs the art of the mounter to show its beauty.  One need not wonder therefore that in antique shops or in the houses of collectors one hardly ever finds an unmounted picture or autograph; such are seen only in the ateliers of living artists, and even they will as a rule immediately pass on their work to the mounter as soon as it has dried.

When the scroll has been properly mounted all the wrinkles will have disappeared, the ink shows a deep black tone, the colours have become more substantial and the picture is fittingly framed by assorted strips of coloured paper and silk cut to harmonious proportions.  Suspended on the wall such a scroll will appear to its full advantage and gladden the eye of the observer, and when rolled up it will take up little space and can be stored away safely, being well protected by several layers of silk and paper against dust, mould and dampness.

In order to effect this astonishing transformation the mounter needs but few tools. The secret of his art does not lie in a complicated technical outfit but in a sharp and experienced eye, an innate feeling for colour and proportion, nimble fingers and, above all, a highly developed sensitivity for the individual properties of each variety of paper and silk, and for the various degrees of viscosity of the paste.

The Chinese mounter and his workshop.

In China a mounter is called *piao-hua-shih* 裱畫師 " Master who mounts pictures ", or *chuang-huang-shih* 裝潢師 " Master who provides (scrolls with) a backing ". These two terms designate a highly skilled mounter who is an expert in the repairing and remounting of antique pictures and calligraphic specimens.

More popular terms are *piao-hu-chiang* 裱糊匠 " Artisan who pasts mountings ", and *piao-kung-chiang* 裱工匠 " Artisan who does mounting work ". These refer usually to craftsmen who mount new scrolls only and undertake also other work connected with paste and paper, such as the papering of windows and ceilings.

Mounter's workshops go by the name of *piao-chuang* 裱莊 or *chuang-piao-tien* 裝裱店. In the larger cities all over China one often meets the appellation *Su-piao-chuang* 蘇裱莊 " Soochow mounting shop ". This does not mean that the owner of the shop is a native of Soochow but rather that he practises the methods evolved by the mounters of Soochow, throughout the centuries famous for their skill in this art. Further, both the mounter and his shop are occasionally referred to as *chuang-ch'ih* 裝池; this curious term is discussed on page 70 herebelow.

Mounting shops as a rule do not have any striking front decoration for attracting the eye of prospective customers. Occasionally, however, they use a shop sign consisting of a rectangular wooden board with a picture of a rolled up scroll and the name of the shop. [1]

Upon entering the mounter's atelier the first object that catches the eye is an enormous flat-topped table, known as *ta-an* 大案 (see Plate **26**). The top is usually covered with a coat of red lacquer that by long use has acquired a beautiful dull shine, *t'ui-kuang* 退光, which makes old mounter's tables valuable antiques. Since olden times this table has formed the essential part of the mounter's outfit; it is mentioned already in a work of the T'ang period where it is called *t'ai-p'ing-an* 太平案 (see below, page 149).

In the capacious drawers the mounter keeps knives of various sizes used for cutting paper, an assortment of large and small brushes, ivory and bamboo spatulas and some heavy zinc or iron rulers; the latter are used for guiding the knife when cutting silk or paper and serve at the same time as paper weights. Also large and small scissors and a few conch shells used for polishing the mounted scroll, and small boxes with ingredients for making pigments, including cakes of glue. In a corner one will notice a sealed jar with paste, and a portable stove with glowing coals for filling the pan-shaped flat iron.

---

1) Cf. the picture of a mounter's signboard in: LOUISE CRANE, *China in Sign and Symbol*, London and Shanghai 1927, figure 54 facing page 89.

The larger are brushes used for applying the paste and for moistening the scroll with water and are counted among the mounter's most precious possessions. Through continuous use they have " grown to his hand " and enable him to moisten the paper and silk to exactly the right degree; to apply the paste evenly and to stick several layers of mounting material securely together without a single wrinkle making its appearance. An 18th century mounter is quoted as having said: " The (hairs of) new paste brushes are hard and uneven, those of old ones are brittle and often fall out. The best brushes are those that are neither too new nor too old " (see below, page 332).

The small brushes — varying in size from an ordinary writing brush to extremely fine ones consisting of only a few hairs — are used for the delicate work of retouching damaged pictures and autographs.

Against the walls of the workshop are hung a number of large boards, collectively called *pi* 壁 " the wall " and singly *chuang-pan* 裝板 " mounting boards ". It are light wooden frames covered with thick paper treated with persimmon juice which gives the paper an oily appearance and prevents it from being affected by moisture. These boards play a very important role in the mounting process: it is on them that the mounted scroll is left to dry, often for weeks on end, without warping or developing wrinkles (see Plates **26, 27, 33** and **34**).

The mounter's stocks of silk, brocade and various kinds of white and coloured paper are kept in solid cupboards or in heavy wooden chests. Every mounter must have a good knowledge of these materials so as to be able to select the right kind of paper for backing a scroll, and suitable silk and brocade for its front mounting. Chapters XXXIV and XXXV of the *Chuang-huang-chih* give a detailed discussion of various kinds of paper and silk used for mounting scrolls. Actual samples of material commonly used by Chinese and Japanese mounters will be found in Appendix V of the present publication.

The most valued possession of a mounter is his supply of paste, *hu* 糊 or *chiang-hu* 漿糊; the success of a mounting depends chiefly on the paste used. Even the best silk and paper will in course of time become loose or develop wrinkles if not attached with the proper paste.

The best mounter's paste is very thin and has a remarkable degree of viscosity. When applied to silk or paper it will penetrate into it and when dried never solidifies into stiff cakes. It is by virtue of the special qualities of the paste that a mounted scroll — actually consisting of three or more layers of silk and paper pasted together — obtains its wonderful plasticity. Such a scroll can be rolled and unrolled smoothly and when suspended it will hang down perfectly straight, as faultless as though it were pasted on an iron board.

Since the paste is of such supreme importance, the *Chuang-huang-chih* devotes a special chapter to its manufacture (op. cit. Ch. XXXII); in my commentary on that passage the reader will find references to recipes from the T'ang, Sung, Ming and Ch'ing periods, together with a description of the paste used by Japanese mounters.

59

The Chinese mounter keeps his paste in large earthenware jars, securely sealed and stored away in a dark and cool corner, or even on occasion buried underground. All sources are agreed that only old paste, *ch'ên-hu* 陳糊, should be used; new paste will cause the mounted scroll to warp and moreover attracts insects by its smell. Most mounters use paste that is more than ten years old. Before using it the mounter strains it (*chi-hu* 擠糊) till it has obtained the degree of fluidity required in each special case. The straining of the paste is shown on Plate **27**.

These are all the instruments a Chinese mounter needs. [1]

In Japan a mounter is called *kyōji-ya* 經師屋 or *hyōgu-shi* 表具師. The former term which means literally "Master of the Sûtras" is the oldest one; it referred originally to the Buddhist monks who provided sûtra-rolls with a backing. As will be discussed in greater detail in Chapter III, it was this work that constituted the beginning of the art of mounting in Japan. At present, however, the term *kyōji-ya* denotes a mounter of new scrolls who at the same time will paper sliding doors, screens and windows, and engage in other pasting work. The term *hyōgu-shi* "Master of mounting" designates a skilled mounter who specializes in the remounting and repairing of antique scrolls.

A mounter's shop is called in Japanese *hyōgu-ten* 表具店, *hyōgu-ya* 表具屋 or *hyōsō-ten* 表裝店. Old-established shops often have beautiful signboards, usually a weather-worn piece of wood with interesting grain and irregular edges, where the word *hyōgu-shi* is engraved in large characters after the handwriting of a well known scholar or connoisseur.

The outfit of a Japanese mounter is essentially the same as that of his Chinese colleague, the only difference being that it is adapted to the Japanese interior.

The main feature also of a Japanese mounter's workshop is a large table, called *ō-ita* 大板, made of unpainted *hinoki* 檜 wood. As shown on Plate **28**, it rests on trestles of about one foot high so as to permit the mounter to use it while kneeling down on the floor mats. On the same photograph one notices the drying boards, in Japan called *kari-bari* 借張, suspended on the wall or standing against it. Often they are also hung on beams of the ceiling, as shown on Plate **29**. These boards are constructed in the same way as those used by the Chinese mounter.

---

1) Here it may be added that mounters, just as most other Chinese craftsmen, have their own peculiar system of writing numerals. Since figures written in this way are occasionally found on the title labels or on the reverse of mounted scrolls (for indicating the sequence of the items in a set etc.) and might puzzle the collector, they are listed herebelow.

1. *i* 意
2. *p'ai* 排
3. *ch'ang* 昌
4. *su* 肅
5. *wei* 爲
6. *lung* 龍
7. *hsi* 細
8. *tui* 對
9. *ch'ien* 欠
10. *p'ing* 平

These "code numbers" used by Chinese artisans ought to be made the subject of a special study by ethnologists; they contain many clues to popular beliefs and folklore. Here it may suffice to draw attention to the fact that *lung* "dragon" meaning "six" occurs also in the jargon of Chinese actors, copper and pewter artisans, cotton dealers and fishmongers.

26. — CHINESE MOUNTER AT WORK (PEKING)

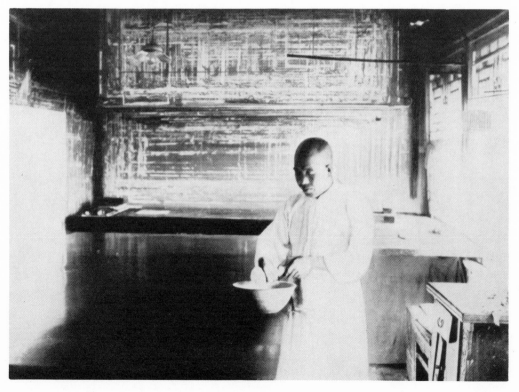

27. — STRAINING THE PASTE

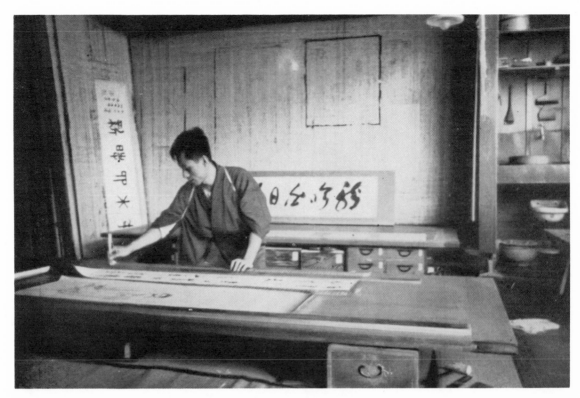

28. – JAPANESE MOUNTER AT WORK (TOKYO)

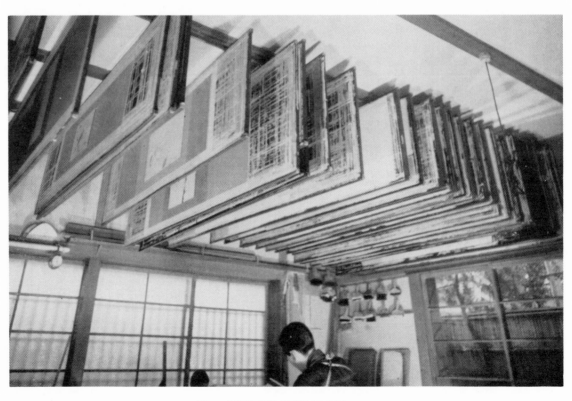

29. – JAPANESE DRYING BOARDS
(Photograph supplied by K. B. S.)

Next to the large table the Japanese mounter uses a smaller one made of *itchō* 銀杏 wood and called *nori–ita* 糊盤 " pasting board "; as indicated by its name this smaller table is used especially for applying paste to silk and paper. Finally the Japanese mounter uses the same assortment of knives, rulers, brushes etc. as his Chinese colleague.

Both Chinese and Japanese mounters prefer for their workshop a well–lit and airy room, devoid of humidity and facing South.

The Korean mounter and his workshop.

At present the most common Korean terms for " mounter " are *p'yogu-sa* 表具師 or *p'yochang-sa* 表裝士, which evidently have been borrowed from Japanese. An older, more elegant term is *changhwang-sa* 裝潢師, a Chinese literary expression. All three words indicate a skilled mounter who specializes in the repairing of antique scrolls.

Mounters who undertake only the mounting of new scrolls and also paper walls, doors and windows are called *tobyok* 塗壁.

Korean mounters use one and the same large table for both cutting and pasting, just as the Chinese mounter; this table is called *paep'an* 褙板, literally " board for backing scrolls ". It is placed on low trestles so that the mounter can use it while sitting on the floor; in this the Korean mounter resembles his Japanese confrere. The drying boards, in Korean called *changch'op-p'an* 裝接板, are made in the same way as in China and Japan, and suspended from the ceiling.

A mounter's workshop is called *p'yogu-jom* 表具店, also borrowed from Japanese. In Korean literary language the old Chinese terms are used.

\* \* \*

The technical terminology of mounting.

It is impossible to describe the process of mounting without using a certain number of technical terms. Since most of these refer to objects or processes that have no counterpart in the West they can not be translated and so we have perforce to use the Chinese and Japanese terms.

Most of the Chinese technical terms are not listed in Chinese dictionaries, though they occur regularly in old and modern books on pictorial art — including collector's catalogues — and though even at present they are used everyday by mounters and connoisseurs. A closer examination of the literary sources shows that not a few of these terms had different connotations at various times, while others have become obsolete so that their meaning must be reconstructed from the context or from a comparison with Japanese data.

As regards those terms that are still used in the mounter's workshop, even these are not without their problems. Chinese mounters are most efficient in all practical aspects of their craft, but they have of course but scant knowledge of literary matters. Thus, when questioned about the origin of the technical terms they use daily or about the characters these are written with, they often confess not to know or give explanations obviously made up on the spur of the moment, or produce characters that are mere phonetic renderings.

61

It is worth while to make an attempt at establishing the meaning of the Chinese mounter's terminology, not only for a correct interpretation of literary texts but also because the terms in themselves often contain clues to the history of the art of mounting. Before describing the technique of mounting we shall, therefore, first try to analyze the Chinese terminology of this craft.

In this work much help is derived from Japanese data. In Japan the problem of establishing the exact meaning of the terminology of mounting does not arise because it was standardized four or five centuries ago when the tea masters started taking an interest in this art. Since the art of mounting was originally introduced into Japan by Buddhist priests it was from the beginning closely connected with religious matters and, later, especially with the Ch'an (禪, Japanese: Zen) school, the doctrine that since early times provided the philosophical background of the tea ceremony. The tea masters recorded in their writings all technical terms of mounting introduced by the immigrant priests and also carefully noted down those Japanese terms that had come into general use among their own mounters. A study of the terms used in Japan proves that in the Japanese mounter's jargon there have been preserved numerous terms that now are absolete in China, or the meaning of which has become subject to doubt.

Finally, the older Korean terminology of mounting supplies some clues to the development of this handicraft in China. Until the end of the 19th century Korean mounters employed Chinese terms. After the Japanese annexation of the peninsula these were gradually replaced by Japanese ones, many of the old Sino–Korean terms falling into oblivion; since they were never placed on record most of these are now lost beyond recovery. The mounter's jargon found in Korea to–day is a curious mixture of archaic Chinese, and modern Japanese terms.

The lists given below represent an attempt at coordinating Chinese and Japanese data; wherever possible the Korean equivalents have been added. [1] Because of the above–mentioned difficulties these lists necessarily bear a tentative character, and lay no claim to either finality or completeness.

Terminology of the Chinese hanging scroll with Japanese and Korean equivalents.
A picture mounted as a hanging scroll is referred to in Chinese as *hua–chou* 畫軸, and an autograph thus mounted as *tzŭ–chou* 字軸.

It should be noted that in China, contrary to Japan, there exist only a few general terms for indicating the various types of hanging scroll mounting. All different types are divided into three broad categories, named after the material of the mounting, viz.:

*ling–piao* 綾褾 " with a front mounting of thin silk "; or *yün–ch'ên* 雲襯 " mounted (with thin silk) with a cloud pattern ".

*chüan–piao* 絹褾 " with a front mounting of ordinary silk "; or *wên–ch'ên* 文襯 " mounted with figured silk ".

---

1) I regret that I never had an opportunity of visiting the workshops of Indo–Chinese mounters. I am told that in Tonking scrolls are mounted in a manner resembling that practised in China; a study of the local mounter's jargon might bring to light interesting data.

62

*chih-piao* 紙 裱 " with a front mounting of paper "; or *pên-ch'ên* 本 襯 " mounted in the basic manner ".

Each of the component parts of the mounting, however, has its special technical name. Plate **30** is a schematic drawing of a hanging scroll mounted in elaborate style. A. gives the front, B. the side view with the front turned to the left, and C. the reverse of the mounted scroll.

The black space in the centre represents the picture itself, in China called *hua-hsin* 畫 心, *hua-shên* 畫 身 or *pên-shên* 本 身. The Japanese apellation is *honshi* 本 紙 or *honzon* 本 尊; the latter term should properly be used only with regard to Buddhist pictures. Korean: *hwabon* 畫 本.

Pictures done on silk are referred to as *chüan-pên* 絹 本 c. q. *ling-pên* 綾 本, those on satin are called *tuan-pên* 緞 本, and those on paper *chih-pên* 紙 本. In collector's catalogues these general terms are mostly further defined, for instance *hsüan-tê-ling-pên* 宣 德 綾 本 " picture on thin silk of the Hsüan-tê era (1426-1435) ", *kao-li-chih-pên* 高 麗 紙 本 " picture on Korean paper ", etc.

The subject represented may either be pictorial, *hua* 畫, or calligraphic, *shu* 書. Pictorial representations are further defined by terms like *shui-mo-hua* 水 墨 畫, or *mo-pi* 墨 筆 " monochrome ink painting ", *shê-sê-hua* 設 色 畫 or *cho-sê-hua* 著 色 畫 " painting in colours ", *ch'ing-lü-hua* 青 綠 畫 " blue-green painting " indicating a picture where much use is made of mineral green and blue, *tan-sê* 淡 色 " shallow colour " meaning that though the picture is primarily a monochrome ink painting, light patches of colour are added here and there, and *mu-ku* 沒 骨 painting in colours only, without ink contours.

To these terms there is again added some indication of the style of the painting. Free and impressionistic pictures are called *hsieh-i* 寫 意, more realistic ones *hsieh-shêng* 寫 生 and elaborate ones *kung-pi* 工 筆. Nuances are indicated by combinations of the terms mentioned, e. g. *chien-kung-tai-hsieh* 兼 工 帶 寫 " elaborate style, with a touch of the impressionistic ".

The style of calligraphic specimens is described by adding a further qualification of the script used, for instance " chancery script ", " draft script " etc., accompanied by an indication of the text written out, e. g. *chuan-shu-ku-shih-i-shou* 篆 書 古 詩 一 首 " One poem in the old style, written in seal script ", *li-shu-szŭ-ta-tzŭ* 隸 書 四 大 字 " four large characters in chancery script ", and so on. Often the arrangement of the text is indicated also; e. g. *pa-hang-mei-êrh-shih-tzŭ* 八 行 每 二 十 字 " eight columns of twenty characters each ".

The above terms defining the picture or autograph itself are also used in Japan. The Japanese only add some purely Japanese terms as for instance *goku-zaishiki* 極 彩 色 " highly coloured ", indicating the brightly coloured paintings of the Tosa and Yamato schools.

We now proceed to the terms for various parts of the mounting. On Plate **30** each strip has been numbered for easy reference.

63

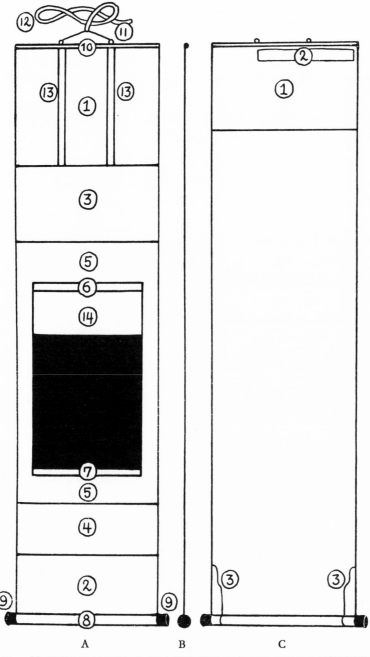

We shall begin with the front mounting (Plate **30** A), in Chinese called *piao* 標, 褾, 表, in Japanese *omote* 表.

1) Chinese: *t'ien* 天 "heaven"; older term *shang-piao* 上標. Japanese: *ten* 天, *jō* 上 or *jō-jidai* 上地題. Korean: *ch'on* 天.

A broad strip of light-coloured paper or thin monochrome silk, usually plain white; also light blue, ivory colour, pink and sometimes black.

While in China since the later half of the Ming dynasty the kinds of silk and paper to be used for the various parts of the front mounting are more or less fixed by custom, Japanese mounters are free to make their choice from as many varieties of silk, cloth, brocade and paper as the country produces. Here, therefore, only the material of the Chinese mounting is indicated.

2) Chinese: *ti* 地 "earth"; older term *hsia-piao* 下標. Japanese: *chi* 地, *ge* 下 or *ge-jidai* 下地題. Korean: *chi* 地.

30. – SCHEMATIC DRAWING OF A CHINESE HANGING SCROLL MOUNTED IN ELABORATE STYLE. A) FRONT; B) SIDE VIEW; C) REVERSE

A strip of identical colour and material as (1), but about half as narrow.

3) Chinese: *chieh-ling* 界綾, *ko-chieh* 隔界, or *ko-shui-ling* 隔水綾; older term *yin-shou* 引首. In Japanese called *naka-no-suji* 中肋, but only very rarely found in Japanese mountings. Korean: *sangson* 上璿; 璿 is probably a fanciful way of writing *son* 線 "thread".

A strip of silk — sometimes also plain white paper — of a slightly deeper colour than (1) and (2).

64

4) Chinese: *hsia* 下*–chieh–ling*, *hsia-ko-chieh*, or *hsia-ko-shui-ling*.　Japanese: same as (3).　Korean: *hason* 下 瑄.

Same remark as sub (2).

5) Chinese: *szŭ-pien* 四 邊, *szŭ-hsiang* 四 鑲; colloquial: *ch'üan* 圈.　Japanese: *chū-beri* 中 緣 or *chū-mawashi* 中 迴; the left and right side may be called separately *hashira* 柱.　Korean: *kwŏn* 圈; the top strip separately is called *sangt'ae* 上 台, the bottom strip *hat'ae* 下 台, and the side strips *pyŏnt'ae* 邊 台.

This is a rectangular "frame" surrounding the picture on all four sides and made of silk of a darker tinge than the preceding items.　One prefers silk with a pattern of clouds and Phoenix birds known as *yün-luan-ling* 雲 鸞 綾; cf. the sample in Appendix V, no. 4.　If the pattern is large, this silk is called *ta* 大 *yün-luan-ling*, if small *hsiao* 小 *yün-luan-ling*.　The "frame" is made from four strips; the seams are indicated by dotted lines.

In the case of smaller pictures this "frame" may be cut from one piece of silk; the technical name is *wa-ch'ien-pien* 挖 嵌 邊 "scooped-out frame".　The bottom strip of the "frame" is always narrower than the top one.

6) Chinese: *ya-tzŭ* 牙 子 "teeth", or *yang-chü* 養 局.　Japanese: *ichi-monji* 一 文 字.

A narrow strip of dark silk or brocade, occasionally also gaudy old brocade with gold and silver patterns; very common is a silver "thunder pattern" *lei-wên* 雷 紋 on a black ground.

7) Same as (6), but more narrow.

8) Chinese: *chou* 軸, *ti-kan* 地 杆, or *kan* 杆, 桿.　Japanese: *jiku-gi* 軸 木.　Korean: *ch'uk-pong* 軸 棒.

Wooden roller attached to the bottom of the scroll.　This roller has three functions.　When the scroll is hanging on the wall it serves as stretcher and at the same time prevents it from touching the wall; too close proximity to the wall might cause mould to form on the scroll.　And when the scroll is rolled up it can be wound the roller evenly without getting askew or developing creases.

9) Chinese: *chou* 軸, *chou-t'ou* 軸 頭 or *chou-shou* 軸 首.　Japanese: *jiku* 軸.　Korean: *ch'uktu* 軸 頭.

Knobs of wood, ivory etc. attached to either end of the roller.　It should be noted that in China both roller and knob together, or roller and knob each·separately, may all be indicated by the one character *chou* 軸.　The Sung artist Mi Fu uses *chou* mostly as meaning "knob"; that this is the original meaning would seem to be indicated by the Japanese usage.

10) Chinese: *t'ien-kan* 天 杆 or *t'ieh-chu* 貼 竹; older term *ta-ya-chu* 打 壓 竹.　Japanese: *hassō*, written 八 宗, 發 宗 or 八 相; *hyō-moku* 標 木; *maki-ita* 卷 板.　Older Japanese terms *hyōshi-take* 標 紙 竹 (often spelt 打 壓 竹) and *osae-dake* 押 竹.　Korean: *panwol* 半 月 "half moon".

Upper stave made of wood, flat on one side and shaped like a half moon on the other; cf. profile on Plate **30**, B.

5

11) Chinese: *huan* 鐶.    Japanese: *kan* 釻 or *za-gane* 座金.

Round eyes of copper, often provided with an ornamental clamp of copper plate.

12) Chinese: *tiao* 綤.    Japanese: *taku-boku* 啄木.    Korean: *tae* 帶.

Suspension loop.    In China made of plain silk cord, in Japan of white ribbon speckled with small blue, green or black dots.    In China there is attached to the suspension loop a narrow strip of soft silk–paper, called *tai* 縖 and used for winding round the scroll when it has been rolled up.    In Japan it is called *himo* 紐 and made of the same material as the suspension loop.

13) Chinese: *ching-tai* 經帶, *ch'ui-tai* 垂帶, *fêng-tai* 風帶, *ching-yen* 驚燕, *fu-yen* 拂燕,    or    *shou-tai* 壽帶.    Japanese: *fū-tai* 風帶.    Korean: *p'ung dae*.

Two narrow strips across the *t'ien* running from upper stave till the upper rim of the *ko-chieh*.    In China these two strips are nowadays always pasted down on the *t'ien*; same colour and material as the " frame ".    Sometimes merely indicated by drawing across the *t'ien* two pairs of vertical ink lines.

In Japan these two strips are not pasted down but, being sewn to the upper stave, left dangling free across the *t'ien*.    They may be referred to as *sage-būtai* 垂風帶 if one wishes to distinguish them from *haritsuke-fūtai* 張附風帶 which are stuck down like the Chinese ones; the latter type, however, is extremely rare in Japan and occurs only in some types of mountings made entirely of paper.

Japanese *fū-tai* are made of identical material as (6) and (7), their breadth being exactly the same as that of (7), the lower *ichi-monji*; hence also called *ichi-monji fūtai* 一文字風帶.    It is customary to make tiny wisps of white silk floss protrude on either side of the lower tips of these strips; these are called *tsuyu*, written 露 or 露花.    When the scroll is being rolled up the *fūtai* must be folded over and laid along the upper stave so that they will hang down straight when the scroll is unrolled and suspended on the wall.    *Haritsuke–fūtai* are made of the same material as the " frame " (chū–mawashi) and hence also called *chū–fūtai* 中風帶.

14) Chinese: *shih–t'ang* 詩堂 " poetry hall ".    Japanese: *dai–ji* 題字.

A piece of silk or ornamental paper, mounted directly above the picture, intended to be inscribed by friends of the artist or by collectors and connoisseurs. Fairly common in China, but rarely found in Japan.

Plate **30** B, shows the mounted scroll in profile, with the front side turned to the left.
C. gives the reverse of the scroll, in Chinese called *pei* 背, *li* 裏 or *hou-mien* 後面; in Japanese called *ura* 裏.

At the top is a broad strip of thin but tough silk of a dark colour which will protect the scroll when it has been rolled up; here it is marked (1).    In Chinese this strip is called *pao-shou* 包首, in Japanese *maki-ginu* 卷絹.

The title label (2) pasted along the upper stave is called in Chinese: *piao* 標, *ch'ien* 簽, *chien* 簽, 檢, *t'i-chien* 題簽.    In Japanese: *ge-dai* 外題 or *hyō-dai* 表題.

66

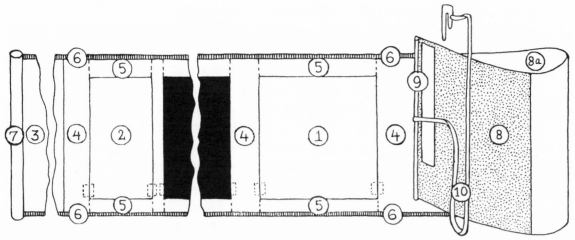

31. – SCHEMATIC DRAWING OF A CHINESE MOUNTED HAND SCROLL

Further we see on the reverse of the scroll two strips of silk, usually of the same colour and material as the protecting flap; they are pasted round the roller and then run up a few inches along the edge of the scroll. These strips are meant to reinforce the lower corners where the roller is attached, as the mounting is liable to tear in these places. In Chinese these strips are called *chüeh* 角 or *chüeh-p'an* 角畔, in Japanese *jiku-tasuke* 軸助.

The rest of the back consists of the white paper with which the mounting has been lined.

Construction and terminology of the mounting vary slightly in the case of a hand scroll. A picture mounted as a hand scroll is referred to in Chinese as *hua–chüan* 畫卷, an autograph mounted in this manner as *tzŭ–chüan* 字卷; a hand scroll containing pictures and autographs mounted together is called *shu–hua–chüan* 書畫卷, *shu–hua–chi–chin* 書畫集錦, or *shu–hua–shuang–pi* 書畫雙璧.

Terminology of the Chinese hand scroll, with Japanese equivalents.

Plate **31** gives a schematic drawing of a hand scroll unrolled full length. To save space, the drawing has been broken in two places; actually the roll should have been about ten times longer than represented.

The structural difference between a hanging scroll and a hand scroll mounting consists of the fact that while the former is mounted all in one piece, the latter is mounted in two parts, viz. the protecting flap — on Plate **31** marked (8) and shown partially curled up — and the rest of the scroll; these two parts are joined together when their mounting has been completed. Further, in the case of excessively long hand scrolls, the body of the scroll may also be mounted in three or four separate parts; when the mounting of each part has been completed they are joined together so as to form one long continuous roll.

On plate **31** the black space in the centre represents the picture itself. Only the beginning and end of the picture are drawn here. The component parts of the mounting are marked by numbers.

1) Chinese: *t'i* 題, Japanese: *dai–ji* 題字.

A sheet of silk or ornamental paper, to be inscribed with the title of the scroll in large characters, or some appropriate quotation. The terms *t'i* and *dai–ji* refer to both the inscription and the space reserved for writing it in. The space itself is called *ch'ien–ê* 前額 or *yin–shou* 弓首; in Japanese *in–shu* 弓首.

2) Chinese: *po* 跋 (colloquial: *pa*), or *po–wên* 跋文. Japanese: *batsu* 跋 or *oku–tsuke* 奧附.

A sheet of paper or silk following after the picture and destined for writing colophons and other comments. Plate **31** has only one sheet reserved for this purpose, but actually antique pictures or autographs by well known artists often have as many as ten or twenty colophons attached to them.

The space itself is called in Chinese *po–chih* 跋紙, in Japanese *bi–shi* 尾紙. Sometimes the colophons are written on a sheet of paper directly adjoining the picture, without an intervening strip of mounting; in catalogues such colophons are referred to as *chieh–chih–po* 接紙跋. In most cases, however, the colophons are written on separate sheets of paper, as indicated on the Plate; these are called *ling–chih–po* 另紙跋.

3) Chinese: *t'o–chih* 拖紙 or *t'o–wei–chih* 拖尾紙. Japanese: *bi–shi* 尾紙.

A very long strip of ordinary blank paper which is not unrolled when the scroll is looked at. Its purpose is to prevent that the picture itself is damaged when the scroll is rolled up too tightly and in too small a compass round the roller attached to its extreme left. In Japan this strip is much shorter than in China, it usually does not measure more than one or two decimeter; this is to be explained by the fact that the custom of adding colophons at the end of hand scrolls never became popular in Japan.

4) Chinese: *chieh–ling* 界綾, *ko–chieh* 隔界 or *ko–shui–ling* 隔水綾. Japanese: *kaku–sui–ryō* 隔水綾.

Vertical strips of silk or paper separating the picture from the superscription and the colophons. If one wishes to distinguish between these strips, the former may be called *ch'ien–chieh–ling* 前界綾 and the latter *hou–chieh–ling* 後界綾.

The small dotted squares across the seams represent impressions of collector's seals, the so–called *ch'i–fêng–chang* 騎縫章 " seals astride the seams "; more details about these will be found on page 133 below.

5–6) Chinese: *t'ien–ti* 天地 or *hsiang–pien* 鑲邊. Japanese: *ten–chi* 天地 or *heri* 緣.

Upper and lower border of silk, usually of the same colour as (4). Along the outer edges these borders are reinforced by a thin seam of darker silk or tough brown paper called *chê–pien* 折邊 " folded border " marked (6). The broad, silk borders begin where the protecting flap is attached to the scroll and end where the *t'o–chih* begins; but the *chê–pien* run on till the very end of the entire roll.

7) Chinese: *chou* 軸 or *chou–hsin* 軸心. Japanese: *jiku* 軸.

Wooden roller. Chinese hand scrolls now usually have no protruding knobs; the ends of the roller are covered with a thin round plaque of jade or ivory level with the scroll. Japanese hand scrolls, however, have usually protruding knobs, the old Chinese style.

68

8) Chinese: *pao–shou* 包首. Japanese: *hyō–shi* 標紙.

  The protecting flap. In Chinese the inside of this flap, marked 8 *a*, is called *li* 裏, the outside *piao* 表. In Japanese the former is called *mi–kaeshi* 見返 or *futokoro* 懷, the latter *omote* 表.

  In both China and Japan the inside is usually made of ornamental paper sprinkled with gold or silver, or of thin, coloured silk; the outside consists of heavy embroidered silk or multi–coloured brocade.

9) Stave, same names as those applied to the upper stave of a hanging scroll.

  A thin stave attached to the flap, to keep it straight. The title label of the scroll is pasted along this stave.

10) Chinese: *tai* 縧帶. Japanese: *himo* 紐 or *obi* 帶.

  A band sewn on to the stave and used for winding round the scroll when rolled up. In China this band usually ends in a flat fastening pin made of ivory, bone or jade, often elaborately carved (cf. Plates **19** and **61**). Purely Japanese hand scrolls lack such a pin, the band being tied in a bow (cf. Plate **44**).

Two ambiguous terms: *yü-ch'ih* and *tan.*

Here we must deal with two terms that regularly occur in older texts but the meaning of which is differently interpreted by different Chinese authors and which, therefore, could not be included in the lists given hereabove. These terms are *yü–ch'ih* 玉池 and *tan* 賮.

  The *Chuang–huang–chih* uses the term *yü–ch'ih* as a synonym of *ko–chieh* (Plate **30** A, 3–4); this is proved beyond doubt by the context in Chapter XIII. However, Sung texts use this term in a different sense.

  The Sung scholar Li Chai 李廌 says in his *Hua–p'in* 畫品: "Collectors of autographs call the strip of silk pasted on at the head of a hand scroll *tan*, or also *yü–ch'ih*. At present mounters use the term *yü–ch'ih* for the vertical strips that divide the various parts of a hand scroll" 藏書家卷首貼綾。謂之賮。又謂之玉池。今裝潢家以卷縫罅處謂玉池。

  The *K'ang–hsi–tzŭ–tien* 康熙字典 says *sub voce tan*: "*Tan* is the strip of silk pasted on at the head of a hand scroll; it is also called *yü–ch'ih*" 賮。卷首帖綾。又謂之玉池。 This is evidently a paraphrase of Li Chai's statement.

  The Sung document *Szŭ–ling–shu–hua–chi* (see below, page 204) does not mention *yü–ch'ih*; but there *tan* is frequently used for indicating the vertical strips of a hand scroll mounting. The Ming scholar Yang Shên (楊愼, 1488–1599) says in his *Chin–hu–lu* 菫戶錄: "In the case of old mounted hand scrolls the strip of silk pasted on after the *yin–shou* (i. e. the space for the superscription. Transl.) is called *tan*; the people of the T'ang period called this strip *yü–ch'ih*" 古裝裱卷軸引首後以綾黏者曰賮。唐人謂之玉池。

  Further, there has been preserved in Japan a style of mounting hand scrolls said to have been introduced into Japan by Sung priests and therefore called *Sō–chō–shiki* 宋朝

式 "Sung dynasty type". The upper and lower border of this type of hand scroll is called *gyoku-chi* 玉 池.

The above data lead to the conclusion that *ch'ih* 池 in the compound *yü-ch'ih* must be taken in its rare sense of "seam" or "border"; this meaning is not given in the *K'ang-hsi-tzŭ-tien*, but recorded in the modern dictionary *Tz'ŭ-hai* 辭 海. Thus *yü-ch'ih* might be translated as "precious (or: ornamental) border", and taken to mean generally any kind of silk strip that is used in scroll mounting, and the same applies to the term *tan*.

It should be noted, however, that in some collector's catalogues the compound *tan-ch'ih* 賾 池 is used to indicate the *shih-t'ang* (Plate **30** A, no. 14) of hanging scrolls, and the *yin-shou* (Plate **31**, 4) of hand scrolls. Here *ch'ih* is used in the sense of "a small, limited space". The early-Ch'ing scholar Fang I-chih 方 以 智 says in the *T'ung-ya* 通 雅, a small encyclopedia composed by him, *sub voce* chuang-huang: "*Huang* means *ch'ih*; if along the edges of a scroll one adds borders, then the space enclosed by these borders is the *ch'ih* 潢 猶 池 也。外 加 緣 則 內 爲 池.

That in terms relating to mounting *ch'ih* should be translated as "border" is attested by the compound *chuang-ch'ih* 裝 池, an old term meaning "to mount a scroll"; in literal translation this compound would mean "to provide with borders". However, in later times this original meaning was forgotten. Since the beginning of the Ch'ing period *chuang-ch'ih* is often used for "mounter", occasionally also for "mounter's workshop". In the former case *chuang-ch'ih* would seem to be an erroneous abbreviation of *chuang-ch'ih-chê* 裝 池 者 or *chuang-ch'ih-shih* 裝 池 師 "the man who provides scrolls with borders", while the latter usage is either an abbreviation of *chuang-ch'ih-tien* 裝 池 店 or rests on a fanciful interpretation of *ch'ih* in the sense of "abode".

Since Chinese sources use the terms *yü-ch'ih* and *tan* rather indiscriminately, in each separate case the meaning must be derived from the context. Generally the meaning "strip of mounting" will prove to meet the case.

Conclusions drawn from a comparison of Chinese and Japanese terminology. A comparison of the Chinese and Japanese technical terms throws some interesting sidelights on the history of mounting. It appears that while the Japanese largely retainep the old Chinese terminology for parts of the *hand scroll* (cf. *tenchi, kakusui-ryō, inshu, hyōshi-take, gyoku-chi*), with regard to the *hanging scroll* they mostly coined new, purely Japanese terms (cf. *hassō, ichimonji, chūberi, jōjidai, hashira*).

This shows that although during the past centuries the mounting of Japanese hand scrolls remained the same, the Japanese hanging scroll on the contrary developed its own, independent new types. This is to be explained by the fact that the hanging scroll had to be adapted to the requirements of the Japanese interior, while for the hand scroll which did not form part of interior decoration the old Chinese Sung and Yüan styles were preserved intact.

Summary of the differences of Chinese and Japanese mountings. Since it is useful for the connoisseur to be able to tell Chinese and Japanese scroll mountings apart at a glance, the differences between the two are summarized below.

*Hanging scrolls*:

1) A mounted Chinese hanging scroll is from $1^1/_2$ to 2 times longer than a Japanese one. This difference in length is caused by Japanese mounters omitting the two *ko–chieh* and by their making *t'ien* and *ti* much narrower than in China; cf. Plate **7**, A and B.

2) The *ching–tai* of Chinese hanging scrolls are always stuck down on the *t'ien*, in Japan they are as a rule dangling free.

3) In China silk cord is used for the suspension loop, in Japan the typical speckled bands.

4) Chinese mounters either attach protruding knobs to the ends of the lower roller, or just cover the ends with a piece of brocade so that they are level with the edge of the scroll. Japanese mounters invariably add protruding knobs to the roller.

5) Since the middle of the Ming period Chinese mounters use thin monochrome silk or paper for the front mounting of hanging scrolls. Japanese mounters, on the contrary, prefer thick, gaudy brocade, multicoloured silk, or various kinds of coloured Japanese paper.

6) Because of this difference in the materials used, a Chinese hanging scroll is appreciably thinner than one mounted in Japan.

*Hand scrolls*:

1) The roller of a Chinese hand scroll as a rule has no protruding knobs, but Japanese hand scrolls nearly always have them.

2) The band for winding round a Chinese hand scroll is usually provided with a fastening pin, Japanese bands are mostly left without.

3) Chinese mounters add at the end of a hand scroll several meters of *t'o–chih*, Japanese mounters a strip of only a few decimeters.

4) Chinese hand scrolls as a rule have a broad upper and lower border, Japanese ones show only a very narrow " folded border ".

\* \* \*

We may now proceed to a description of the actual process of mounting. It must be stated at once, however, that although in its essential features this process is every where the same, in details it often shows differences determined by local customs and the personal views of individual mounters. The following is therefore only a summary of my personal observations in mounter's workshops in China and Japan.

As a first example I propose to consider a comparatively simple work: the mounting of a new hanging scroll, a picture that has recently left the hands of the artist, and has consequently never before been mounted.

When the owner brings such a picture to the mounting shop the mounter will start by observing it carefully, fixing in his mind all its special features. He then takes out his stocks of silk and paper and selects what he considers suitable materials for

The actual process of mounting.

The mounting of a hanging scroll. First stage: preliminary examination and alum treatment.

mounting the picture. If the owner himself is a connoisseur, the mounter will be glad to have his advice, and together they decide what materials should be used and what style of mounting is most suited to this particular item. An agreement on these points having been reached, the patron must thereafter entrust his picture unconditionally to the mounter: he will not see it again until the process of mounting has been completed. For it is an unwritten rule amongst all Chinese and Japanese mounters on no account to show a scroll to its owner while the mounting is still in progress.

The mounter first studies the canvas, to decide what preliminary work is needed before he can commence the actual mounting process.

Pictures and calligraphic specimens done on silk can generally be mounted as they are, but there are some kinds of paper that need preliminary treatment.

Most laminated papers, although preferred by painters and calligraphers, are not very popular with mounters. When such papers, in China called *chia–chih* 夾 紙 (see the actual samples in Appendix V, nos. 9–12) are moistened — and the process of mounting includes the thorough moistening of the scroll more than once — the various layers of which they are composed may become loosened in places, with the result that wrinkles appear which distort the design of the picture. In such cases, therefore, a Chinese mounter starts with taking off two or three layers from the back of the scroll. This is done in the following way. The picture is spread out face downwards on the mounting table. Then the mounter takes a very soft, large brush and moistens the picture thoroughly with clean water; after the lapse of some time the layers can then be peeled off one by one with a bamboo or ivory spatula. It should be noted that while Chinese mounters are accustomed to peel off some of the layers, the Japanese mounter as a rule will take off all save the uppermost one.

It goes without saying that this peeling off is a laborious process, involving continuous care, as one false move will seriously damage the scroll; hence the unpopularity of laminated papers with mounters.

Single papers, Chinese *tan–chih* 單 紙 (see the samples in Appendix V, nos. 5 and 6) are the easiest to handle, for they can be mounted as they are.

As a second preliminary, the mounter must investigate the colouring of the picture, in order to discover whether it shows spots where ink or colours have been laid on thickly; for later on when the scroll is moistened such heavily coloured portions may run.

Works done on un–sized paper (*shêng–chih* 生 紙) in particular are exposed to this danger, especially multi–coloured landscapes and calligraphic specimens written with thick ink. Monochrome ink paintings, even when done on un–sized paper, are rather safe, because they do not usually show heavy ink blotches.

Sized paper and silk (*shu–chih* 熟 紙, *shu–chüan* 熟 絹) will hold ink and colours much better, but even when such sized material is used some of the thicker pigments will often run.

To avoid this evil, which may definitely ruin a work of art, the mounter applies an alum treatment to the picture previous to mounting it.

A famous Chinese handbook for painters says: " If on a silk ground thick pigments like mineral blue or vermilion are applied, there is a risk that these colours will run when the painting is mounted. Such spots, therefore, should be previously treated with a thin alum solution (Chinese *fan-shui* 礬 水, Japanese *dosa*). This should be done by painting over the spots lightly with a brush dipped in the solution; you should not let tarry the brush for one single moment, for then (when the painting has dried) traces of the brush will show ". [1] Another painter's handbook gives the following indications for preparing the alum solution: " One should take a large lump of alum and place it in a clean saucer; then moisten it with water until it has dissolved. One should not try to hasten this process by heating the alum, for should it become warm it will lose its force. In summer it will be sufficient to moisten the alum for a short time, but in winter one should let it soak quite a while. For testing whether the solution is of the right thickness, moisten your brush with it and taste it on the tip of the tongue; if it is acrid to the taste, it is fit for use ". [2]

With this solution the mounter first paints over all the dangerous spots on the front side of the painting, and when they have thoroughly dried, the spots are treated in the same way on the reverse side. This treatment of the reverse is especially necessary in case of the occurrence of *ch'ên-ch'ing-lü* 櫬 青 綠, i. e. where the artist has applied mineral blue or green on the back of the silk, in order to give more depth to these colours on the surface. Seals impressed on the scroll are treated in the same way, i. e. they are painted over with the alum solution on both front side and reverse.

As indicated by the handbook quoted above this alum treatment must be applied with considerable care: if the solution is put on too thinly, it will not be effective, and if put on too thickly, after the lapse of some time brownish rings will appear round the spots treated.

This work completes the preliminary stage of the mounting process, and the mounter may then commence the second stage, with which the real process of mounting begins.

After this preliminary treatment the appearance of the picture has not been improved: is more crumpled than ever. To give it an even, smooth surface and to reinforce its frail material the picture is now provided with a backing.

The process of backing a picture is called in Chinese *pei* 背, in Japanese *ura* 裏 *wo utsu* 打 or *ura-uchi* 裏 打 *suru*.

Second stage: adding the first backing.

The first backing of a picture is called in Chinese *t'o-hsin* 托 心 or *hsiao-t'o* 小 托; for this the mounter uses a thin but tough paper.

---

1) *Chieh-tzǔ-yüan-hua-chuan* (cf. Appendix I, no. 41):
絹 書 上 如 用 青 綠 硃 砂 厚 重 之 色。
恐 裱 時 脫 落 顏 色。須 於 未 下 手 時。
上 輕 礬 水 … 礬 時 用 筆 輕 過。不 可
使 其 停 滯。反 增 痕 跡 耳。

2) *Hui-shih-hsiao-yen* (繪 事 瑣 言, a work by the scholar-artist Tso Lang 迮 郎, who flourished dur-

ing the Ch'ien-lung period): 取 大 塊 礬。置 淨
碟 內。以 水 浸 之。俟 其 自 化。不 可 火
烘。烘 熱 則 礬 無 力 矣。夏 日 浸 一 飯 以
之 頃。冬 日 須 浸 半 日。水 之 濃 淡。已
筆 蘸 水。點 於 舌 尖。嘗 之 澀 舌。即
可 用。

73

A superior material is the so-called *mien-lien* (綿連; *mien* is also written 棉), a sample of which is found in Appendix V, no. 5. This paper is made from the bark of the mulberry tree (*ch'u* 楮, *Broussonetia papyrifera*) and produced in Anhui Province, and more especially in Hsüan-ch'êng 宣城 the famous centre of paper manufacture in that Province; hence *mien-lien* and similar papers are often collectively referred to as *hsüan-chih* 宣紙 "Paper from Hsüan-ch'êng". In chapters XV and XLII of the *Chuang-huang-chih* this paper is recommended as the best material for backing scrolls.

For cheaper mountings many mounters use *chu-lien* 竹連, a paper made from bamboo pulp; a sample is given in Appendix V, no. 6. Some mounters prefer for the backing of pictures on silk a thicker variety of *mien-lien*, others insist that especially for silk scrolls extremely thin paper is the most suitable. All are agreed, however, that one should use exclusively unsized paper; this fact is stressed already by the Sung connoisseur Mi Fu, as will be seen on page 188 below.

Both Chinese and Japanese papers have an obverse, *chêng-mien* 正面, and a reverse, *fan-mien* 反面. The former is smooth and, in the case of sized papers, has a dull lustre; the latter is rough and shows various imperfections that do not appear on the obverse. Painters and calligraphers as a matter of course always use the obverse. Mounters also use paper in this way: they apply the paste only to the obverse of the sheets used for backing scrolls.

In Japan the first backing of a picture is called *hada-ura* 肌裏. The Japanese mounter uses for this purpose either *misu-gami* 美栖紙 (cf. Appendix V, no. 32) or *yotsuban-shi* (四判紙, cf. ibid., no. 33). Since both these papers although thin and of fairly loose texture are very tough, Japanese mounters maintain that they "grip" the material of the picture better than the *hsüan-chih* used by Chinese mounters. It is true that it is more difficult to remove the backings from Japanese-mounted pictures than from those mounted in China; on the other hand this implies that Japanese-mounted paintings are more liable to become damaged during the process of remounting. Therefore it is not easy to decide which of the two methods is the best.

The mounter begins by spreading the picture out on the mounting table, face downwards, and moistening it by going over it repeatedly with a large soft-haired brush dipped in clean water, *shui-shua* 水刷. Then all wrinkles will disappear, the picture looks as if it were stuck down to the table.

Thereafter he takes a sheet of backing paper that is cut to a size one inch broader and longer than the picture, and places that on the table by the side of the picture. When he judges that the picture has exactly the right degree of moistness, he quickly covers it with a very thin layer of paste applied with a broad pasting brush. Then he takes the sheet of backing paper and smoothes it out over the picture in such a way that the backing protrudes for one centimeter or so along all four edges of the picture. Finally he glues picture and backing firmly together by softly tapping the backing over and over again with a stiff-haired brush; in China this brush is called *tsung-p'i-shua* 棕皮刷

74

"coir hair brush", in Japanese *uchi-bake* 打刷毛 or *tataki-bake* 叩刷毛, both of which mean "tapping brush".

When one sees a mounter do this work it seems very easy indeed. The process is completed in a few minutes and when the backed painting has dried it has a beautifully smooth surface, all creases and wrinkles have disappeared and the ink and colours have obtained clarity and depth. Actually this is an extremely difficult work which calls for long and assiduous practice.

In the first place the application of the paste is a very delicate undertaking. If one brushes too hard or with too moist a brush the picture will become damaged; if too softly with too dry a brush the paste will not be evenly spread. The spreading of the paste is of the utmost importance. A beginner will always lay on the paste in streaks; afterwards, when the backing has been added and the scroll dried, these streaks will appear on the surface of the picture and give it a striated look which destroys its beauty.

Further, if the backing is not smoothed out expertly over the picture, bubbles of air will make their appearance between the two sheets; when tapped with the brush these bubbles burst and cause damage to both picture and backing. Finally, the material of both picture and backing exhibit a treacherous tendency to develop creases; these will show clearly when the scroll has dried, distorting the drawing and spoiling the picture completely.

Plate **26** shows a Chinese mounter while applying the paste to the reverse of a scroll, and on Plate **32** one sees a Japanese mounter demonstrating how the paste brush is grasped.

Since in the case of larger pictures it is difficult to paste on evenly one large sheet of backing, the mounter uses several smaller sheets of backing paper which are pasted on to the scroll one by one, each overlapping the preceding one by a few millimeters. As a rule the mounter cuts these sheets in such a way that when pasted on their fibration does not run parallel: if the fibre of the first strip runs horizontally, that of the second must run vertically, that of the third again horizontally, and so on. This alternation is said to ensure a firmer backing.

The sheets that compose the backing must be joined in such a way that their seams do not run across important parts of the picture and they should be judiciously spaced. The T'ang writer Chang Yen-yüan observes that the spacing should be such that when the scroll is rolled up there are no places where two seams rub against each other, for the friction of two hard seams may cause damage to the scroll (cf. page 149 below). In chapter XXV of the *Chuang-huang-chih* a similar warning is given.

A Chinese mounter when backing a scroll will use only his large table. The Japanese mounter, however, for covering the backing with paste uses the *nori-ita*, and the large table only for the tapping process.

After the painting has been backed, it is left on the table to dry thoroughly. As a rule the mounter will consider one backing insufficient, and he usually adds a second one (Chinese *fu-pei* 復背, Japanese *mashi-ura* 増裏). For this second backing he uses

the same material as for the first, and it is attached in the same way. It must be noted that the second backing is cut about half a centimeter larger than the first, so that the edge of the backing protruding beyond the borders of the painting gradually grows broader.

Adding the front mounting.

In the mean time the mounter has cut to measure the various strips of silk that are to form the front mounting of the scroll; in Chinese this process is called *tsai-pien* 裁邊, in Japanese *kiri-tsugi* 切次. Beginning with those directly attached to the painting, these strips are: the two *ya-tzŭ* (Plate **30**, nos. 6 and 7), the " frame " (ibid., no. 5), the two *ko-chieh* (ibid., nos. 3 and 4), and *t'ien* and *ti*. The cutting is done on the large table, with the aid of long, heavy rulers and sharp knives (see Plate **33**). When all the strips have been cut to measure they are backed with paper, in the same way as the backing was added to the original. The backings of these strips of silk are also made to protrude for about half a centimeter beyond the borders. The extra margins are important, for it is by means of these that presently the various parts that compose the front mounting will be attached to the scroll. In case of a front mounting of paper, one backing will be sufficient. But if heavy silk is used a second backing will be necessary, while to the thick brocade of some Japanese mountings one more backing is sometimes added.

When both the backed painting and the backed strips of silk destined for the front mounting have dried thoroughly, the mounter may start joining them together. First he will add to the picture upper and lower *ya-tzŭ* (Plate **30** A, nos. 6 and 7). He cuts off the protruding margin of the backing along one of the sides of the strip, covers the extra margin of backing that appears along the top of the painting with paste, and there attaches the upper *ya-tzŭ*, in such a way that it fits exactly together with the edge of the painting itself. When the lower *ya-tzŭ* has also been added, the mounter proceeds to paste on the right and left parts of the " frame ". This is done according to the same method as that used for adding the *ya-tzŭ*, viz. by utilizing the extra margins of backing that protrude beyond the sides of the painting itself, and of the strips of mounting silk. Thereafter the upper and lower part of the " frame " are also added; subsequently both *ko-chieh*, and finally *t'ien* and *ti*, all these being joined together by using the extra margins of their backings.

For covering these narrow margins with paste, the mounter uses a special kind of paste brush, Chinese *hu-shua* 糊刷, Japanese *nori-bake* 糊刷毛, which is very broad and thin, and has short hairs.

It should be noticed that along the upper border of *t'ien* and the lower border of *ti* there occurs a generous extra margin, marked off by drawing a groove along the silk with a spatula; this margin will serve later for attaching the upper stave and the lower roller to the scroll. The mounter also draws a groove right along the right and left side of the entire front mounting, marking off a narrow margin of about half a centimeter. Later this margin is folded over backwards, thus seaming off the sides of the scroll with the so-called " folded borders ", *chê-pien* 折邊.

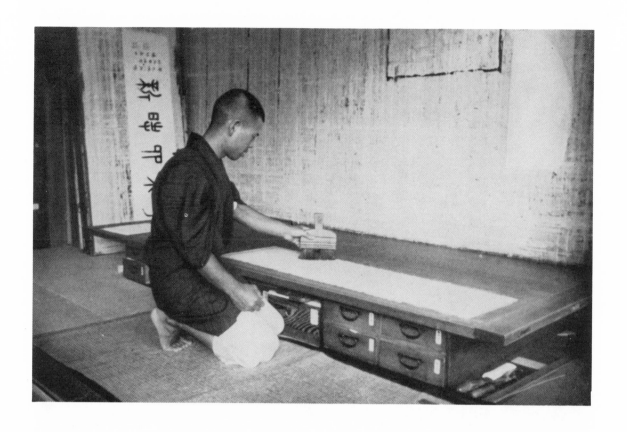

32. — JAPANESE MOUNTER DEMONSTRATING HOW THE PASTE BRUSH IS HELD

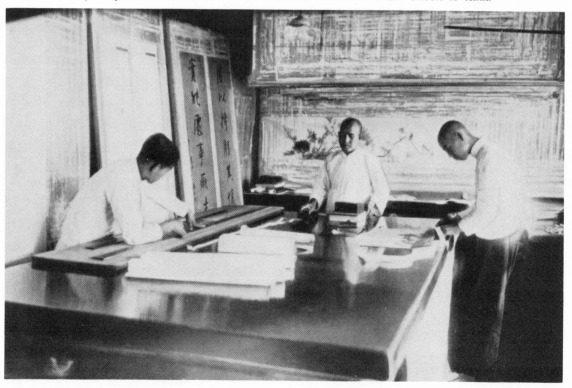

33. — CHINESE MOUNTER CUTTING THE STRIPS OF THE FRONT MOUNTING

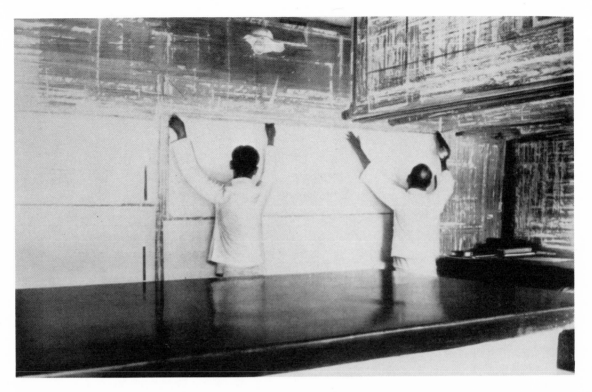

34. – CHINESE MOUNTER AND ASSISTANT PUTTING THE SCROLL ON THE BOARD

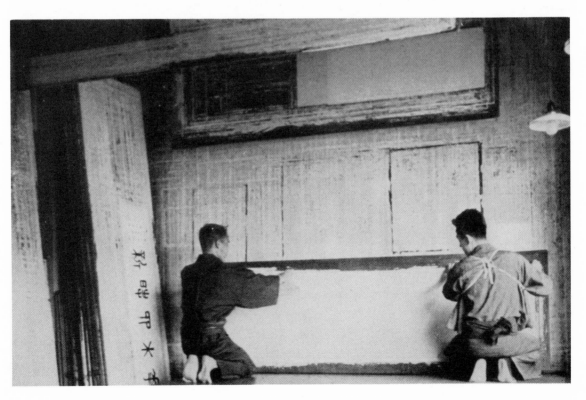

35. – JAPANESE MOUNTER AND ASSISTANT PUTTING THE SCROLL ON THE BOARD

Finally, Chinese mounters now paste the two *ching–tai* (Plate **30** A, no. 13) on to the *t'ien*. If these consist of very thin material they may be pasted directly on to the silk; if they are made of thicker paper or silk, the mounter first cuts out two strips of the *t'ien*, and there inlays the *ching–tai*. It should be noted that the loose *ching–tai* of Japanese mountings are added only during the very last stage of the mounting process, after the upper stave has been added to the scroll (see page 79 below): they are sewn on to the upper edge of the mounting with thin silk thread.

The picture together with its newly attached front mounting is now left lying on the table do dry, kept flat by heavy rulers.

It goes without saying that the mounted scroll in this condition is a rather weak construction. All its component parts are kept together only by the narrow pasted margins of backing–paper; and although it presents a smooth surface, if left to dry in this stage the mounting will develop a tendency to warp. Soon afterwards, therefore, when the paste has had time to penetrate well into the paper but has not yet dried thoroughly, the scroll must be taken from the table and transferred to the boards on the wall. In Chinese this process is called *shang–pi* 上 壁, in Japanese *hari–komi* 張 込.

Third stage: putting the scroll on the board.

The mounter takes the mounted scroll from the table and smoothes it out on the board, taking great care that it is spread out absolutely flat. Then he lightly moistens the edges of the backing protruding beyond the four sides of the mounting with water, so that these edges will adhere to the board and keep the scroll stretched flat. Two scrolls — a pair of *tui–fu* — in this stage are seen on Plate **33**, stuck to the drying board standing in the corner; a Japanese horizontal specimen of calligraphy in seal script in this stage of the mounting process can be seen on Plate **28**, stuck to the drying board standing of the left. Chinese mounters often moisten not only the extra margins but drench the entire scroll by going over it repeatedly with a large soft–haired brush dipped in clean water. Thus the paste merges completely with the materials it is applied to; moreover this method ensures that the scroll is spread out flat over the board. Since Chinese mountings are very thin it is indeed advisable to moisten the entire scroll; but in the case of the thicker Japanese mountings this second soaking is not necessary. In Japan, therefore, as a rule only the protruding margins are made to adhere to the board.

The *Chuang–huang–chih* devotes a special chapter to this stage of the mounting process (Chapter XVI), in which it is pointed out that for putting the scroll on the board one should choose a damp day, for then the moistened paper and silk will retain their full elasticity. If some portions of the mounted scroll happen to have dried before it has been put on the board it will prove impossible to spread out the scroll smoothly.

When the scroll has been put on the board there intervenes a long pause in the mounting process: the scroll is left there to dry for a week or longer. Thus the paste has time to work out completely and gradually the last trace of humidity will disappear. In this connection the *Chuang–huang–chih* remarks: " The longer you leave the scroll on the board, the better; thus its capacity for warping will become entirely exhausted ". It

is in fact during this period that a mounted scroll acquires its remarkable qualities; its solid construction, its smooth surface and, above all, its plasticity. As a Chinese mounter once said to me: " A good mounting is not made by the mounter, but by the board ".

Fourth stage: adding the last backing. The scroll is taken down from the board only when the mounter is convinced that it has completely dried. It follows that while moist weather is the right time for putting up a scroll on the board, it may on no account be taken down on a rainy day. The *Chuang-huang-chih* aptly formulates this important principle as follows: " When putting the scroll on the board it should be moist, the degree of its humidity being of great importance. When taken off the board the scroll should be dry, then afterwards it will not warp. *The successful mounting of a scroll depends entirely on whether or not one strikes the exact degree of both dryness and humidity* (op. cit., Chapter XVII).

Having spread out the scroll face downwards on the table the mounter now adds to it the last backing (Chinese *t'o-pei* 托褙, Japanese *sō-ura* 總裏). Chinese mounters use for this last backing the same material as that employed for backing the picture itself, and the various parts of the front mounting. In Japan, however, for this purpose a special kind of tough paper is used, the so-called *uda-gami* (宇陀紙, see the sample in Appendix V, no. 34).

The last backing consists of several square sheets of paper which are pasted on to the reverse of the mounted scroll one by one, with overlapping margins, in the same way as the first backing is added to a large painting. Each sheet of backing is securely glued to the scroll by vigorous tapping with the coir brush. With a magnifying glass it is easy to locate the traces of this brush on the backing of even antique scrolls (see various samples in Appendix V). When the last backing has been added, the scroll is again put on the board face downwards (see Plate **34**), being kept stretched out smoothly by the margins of this last backing. As there is now no longer any danger that it may warp, these margins suffice to make the scroll stay smooth: it should not again be moistened.

When the scroll has dried it is taken down for the last time. Having spread it out on the table, the mounter attaches on the reverse strips of a tough kind of paper, along the extra margins of *t'ien* and *ti* indicated by the groove drawn over the front mounting. These strips are pasted down along one side over the groove; the rest is left free, so that it forms together with the extra margin of the front mounting a kind of flap. These flaps will later be utilized for attaching stave and roller to the scroll. The flap at the bottom is on both sides reinforced by pasting on to it two narrow strips of backed silk (Plate **30** C, no. 3). Then the protecting flap (ibid., no. 1) is pasted on to the backing, and on this flap the title label (ibid., no. 2) is added. This completes the fourth stage of the mounting process.

Fifth and last stage: adding stave and roller, suspension loop, etc. The mounter can now start with the fifth and last stage of the mounting process, viz. the addition of the stave, roller, and suspension loop.

78

The roller is a stick of turned pine wood, perfectly round, and made to the exact measure of the scroll. On each end there are protruding pegs for attaching the knobs. If no knobs are added these pegs are of course not necessary; both ends of the roller are cut off level with the edges of the scroll and a small piece of coloured silk is pasted over them.

36. – ADDING THE LOWER ROLLER TO A HANGING SCROLL

The ends of the upper stave are finished off according to the same method: they are covered with silk or coloured paper. Neither in China nor Japan do the ends of the upper stave ever protrude, and never are knobs attached to them.

Before attaching stave and roller to the scroll the mounter, as a finishing touch, polishes the entire backing of the scroll. The scroll is laid on the table face downwards and lightly sprinkled with talc; then it is burnished by rubbing the entire backing with a large polishing shell, the so-called *ya-lo* 研螺, till it shines like a mirror. Japanese mounters usually polish the scroll by rubbing it with a wooden rosary, using the palm of the hand. The burnished backing facilitates the rolling and unrolling of the scroll and at the same time enhances its beauty.

Both in China and Japan the scroll is thereafter often turned front upwards, and gone over with a flat-iron, the seams of the various parts of the front mounting receiving special attention. This practice has a long history, it is already mentioned in a source from the fifth century; cf. page 137 below.

When the roller is inserted in the flap at the bottom of the scroll, a heavy ruler is placed over it to prevent it from moving, and then the extra margin of the *ti* is glued round it (see Plate **36**). This is done in such a way that the half of the roller showing in front is covered by the silk of the front mounting, while its back is covered by the paper of the backing. For attaching the roller the mounter uses glue instead of paste.

The upper stave is attached to the scroll in the same way, and eyes are screwed in at the proper place, i. e. directly above the right edge of the right *ching-tai*, and above the left edge of the left *ching-tai*. Ordinarily only one pair of eyes is used. But in the case of large scrolls a second pair of eyes is added, about half-way between the first pair and the end of the stave; after having passed through the inner pair, the ends of the suspension loop are fastened to the outer pair. In China the suspension loop is made of silk cord, and the band attached to it (for winding round the scroll when it is rolled up) is made of silk ribbon. In Japan both loop and band are usually made of the same material, white silk with greenish-blue spots; cf. Plate **39** where one can just see part of

79

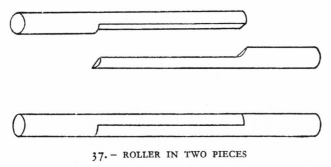

37. – ROLLER IN TWO PIECES

the speckled band wound round the scroll marked with my square seal. The technical name of the loop, *taku–boku* 啄 木 " pecked wood ", is said to refer to the fact that such a spotted band resembles a piece of wood that shows the traces of the wood–pecker's bill.

The work of the mounter is now finished. When the owner has received back his scroll he will take his favourite brush, and in graceful characters write on the label the title of the scroll, eventually adding the name of the artist or an impression of his own seal. He can now enjoy his work of art at leisure. Suspended on the wall the scroll will beautify his library, and when, having taken in all its details, he takes it down again and stores it away, he can feel assured that his children and grandchildren will also be able to enjoy it: for a good mounting will easily last several centuries.

\* \* \*

Description of some minor details of Chinese and Japanese hanging scrolls.

In order not to interrupt unduly the description of the mounting process, the roller, knobs and bands of a mounted hanging scroll have so far been but briefly described. Since olden times, however, Chinese connoisseurs have given much attention to these details. The loving care with they studied such minor questions is evinced by their writings: the great Sung artist Mi Fu often refers to the correct use of bands and rollers, and the *Chuang–huang–chih* devotes a special chapter to the knobs of hanging scrolls (Chapter XXXVI). Now we shall consider these minor details of Chinese and Japanese mounted hanging scrolls in greater detail.

The roller.

As was stated above, the roller of a hanging scroll is usually made of pine wood (Chinese *shan* 杉, Japanese *sugi*). The mounter may also use other kinds of wood, provided it is old; for new wood will easily warp, and moreover by its smell attract insects. The roller must of course be perfectly rounded else it will be impossible to roll up the scroll evenly.

Next to serving for rolling up the scroll, the roller also functions as a stretcher; its weight will make the scroll hang straight when it is suspended on the wall. In the case of large scrolls sometimes both ends of the roller are hollowed out and molted lead is poured in to add extra weight. Mi Fu, however, objects to heavy rollers, as by their excessive weight they may cause the mounting to tear. He, on the contrary, advises to make the rollers lighter, instead of adding extra weight; see below, page 185.

Some mounters prefer to make up the roller out of two separate pieces of wood, as a further guard against warping (see Plate **37**).

80

In former times Japanese mounters often wrote their name or impressed their seal on the roller before attaching it to the scroll, while sometimes the owner of the scroll also had his name recorded there, together with the title of the scroll, or the name of the artist. In mounting shops I have occasionally seen such inscribed and dated rollers taken off antique scrolls that were being remounted, and in old Japanese literature there are a few passages that refer to this custom. One occurs for instance in the *Kokon-chomon-shū* 古今著聞集, a collection of miscellaneous notes on various subjects, written in 1254 by Tachibana Narisue 橘成季 and published in 1690; it relates how the dispute about the authenticity of a scroll was settled by taking off the roller, and examining the inscription that appeared on it. At present a few Japanese mounters still follow this custom, but as yet I have found no evidence that this custom was ever observed in China.

The knobs are fastened to the roller with lime, and before the roller is attached to the scroll. The knobs are provided with holes that fit into the protruding pegs at the ends of the roller. Rollers without knobs are cut off level with the mounting, and covered by pasting a piece of coloured paper or brocade over both ends (see Plate **38**, the two scrolls on the left); such rollers are in Chinese called *kuo-t'ou* 裹頭, "wrapped up heads", or *p'ing-chou* 平軸 "level heads", and in Japan (where they are very rarely used) *kurumi-jiku* 包軸.

Both Chinese and Japanese sources are most explicit on the subject of the knobs of mounted scrolls.

The knobs of Chinese mountings.

It appears that during the Period of the Six Kingdoms (3–6th century), and also during the T'ang dynasty, when most scrolls were still mounted as horizontal hand scrolls, the protruding knobs were often decorated with all kinds of precious materials. Some people objected to this custom, as it might cause scrolls to be stolen by ignorant robbers, who would throw away the pictures, and keep only their valuable knobs. But the T'ang connoisseur Chang Yen-yüan protests against this, saying: "Mounting them (i. e. your scrolls) with rare and beautiful materials, wrapping them up in costly brocade, refined and elegant in every respect, this is the only right way" (cf. page 150). The Sung connoisseur Mi Fu, on the other hand, calls the decorating of scroll knobs with gold and silver a vulgar habit. He advises to make the knobs of sandal or sapan wood, or, best of all, of rhinoceros horn; see below, page 185.

The various kinds of knobs attached to the scrolls in the Palace collection during the Southern Sung period are described in great detail in a contemporary document (see page 201 below); from this source it appears that these knobs bore a very ornate character: carved sandal wood, jade, ivory, and amber were the most common materials.

The *Chuang-huang-chih* in Chapter XXXVI mentions knobs made of jade, rhinoceros horn, carved ivory, sandal wood, bamboo, and gold or silver lacquer. This text does not mention porcelain knobs, but these are often seen in China, while they were also popular in Japan, being especially favoured by the tea masters. The Ch'ing collector Chou Êrh-hsüeh mentions knobs of crackled Sung porcelain, or Ming ware with a blue

pattern on a white ground. In China till the present day white porcelain knobs with a blue design are most often met with (see Plate **38**, third scroll from left). Occasionally one may also find knobs of monochrome porcelain, mostly dark blue and grey, rarely also red and violet.

A few years ago I purchased in Shanghai a scroll from the Ming period, a painting of a vase with a few blossoming branches of the plum tree. This scroll was mounted with light blue porcelain knobs, showing in relief delicately modeled white designs of plum blossoms. These knobs were doubtless ordered especially for this scroll by a former collector. Unfortunately, they proved too fragile to be practical; when I obtained this scroll the knobs were damaged beyond repair.

For more details on knobs of the T'ang, Sung, Ming and Ch'ing periods the reader is referred to the General Index, s. v. *knobs*.

It remains to add that the writers quoted above were all enthusiastic connoisseurs who spent great care on the mounting of their scrolls, and who lived in former times when a tendency prevailed to embellish the mountings of scrolls as much as possible. During the later years of the Ch'ing dynasty and in recent times, in Chinese mounting more severe styles are aimed at, so that nowadays scrolls with elaborate knobs are not often met with. The greater part of the hanging scrolls one sees nowadays in China are mounted with knobs made of plain blackwood, rose wood or some other varieties of hard wood, turned in simple shape; see Plate **38**, fourth scroll from left.

Japanese knobs.

In Japan where many features of older styles of Chinese mounting have been preserved, even to-day the knobs of hanging scrolls show great variety in material and design. On Plate **39** one sees on top, from left to right, a knob made of bamboo, and two of blackwood; below, a knob of grey porcelain decorated with blue and red bands, a knob covered with copper plate, a sexagonal crystal knob, and one of old ivory.

Simple, undecorated wooden knobs are used for mounting paintings in Chinese style (especially monochrome landscapes), and for calligraphic specimens in Chinese. For such scrolls lacquered knobs are never used, these being reserved for Buddhist representations and scrolls to be displayed in the tea room. For Buddhist pictures red–lacquered knobs are preferred, while large Buddhist scrolls are often provided with wooden knobs covered with chased copper plate. Further, rare Buddhist scrolls may be mounted with crystal knobs, encased in silver or gold filigree, showing a design of lotus flowers or some other Buddhist motif (see Plate **41**, the knob on top, left).

Superior scrolls are often mounted with knobs of old ivory (*ge–jiku* 牙 軸); such knobs as do not show the kernel of the ivory (so–called *shintori–gejiku* 心 取 牙 軸) are especially valued. Next to ivory, horn (*tsuno* 角) is also found, preferably deer horn (in the mounter's jargon called *kasuga* 春 日, referring to the famous deer at Nara); these horn knobs may be polished smooth so as to resemble ivory, but often they are left with their original rough surface, especially if this shows an interesting pattern (see Plate **41**, upper row, fourth from left). Horn knobs may not be used for Shintō and Buddhist scrolls.

82

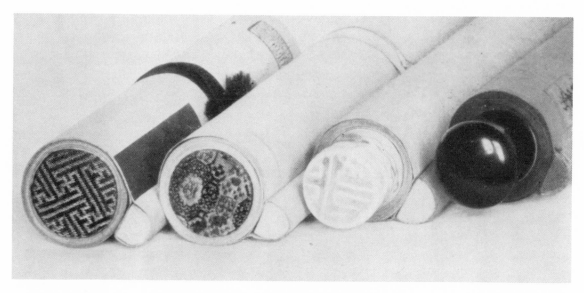

38. – KNOBS OF CHINESE HANGING SCROLLS

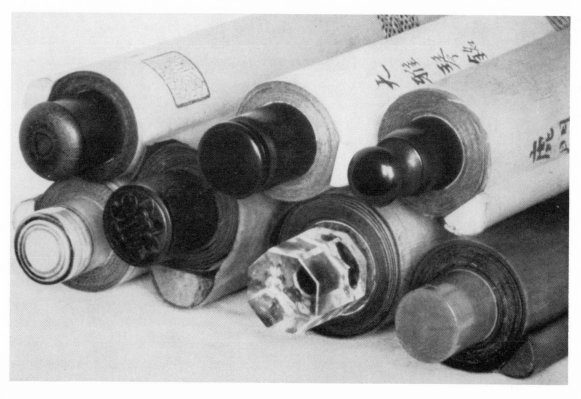

39. – KNOBS OF JAPANESE HANGING SCROLLS

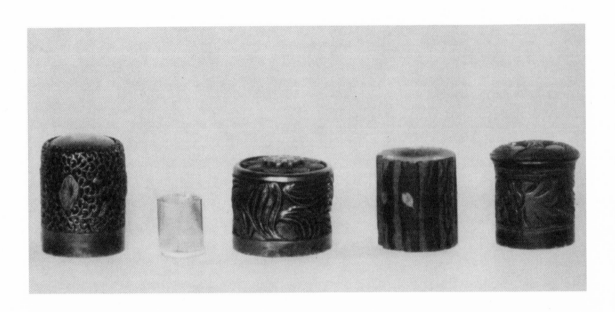

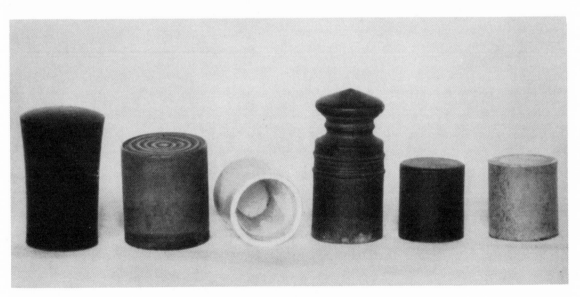

41. – DETACHED KNOBS OF JAPANESE SCROLLS

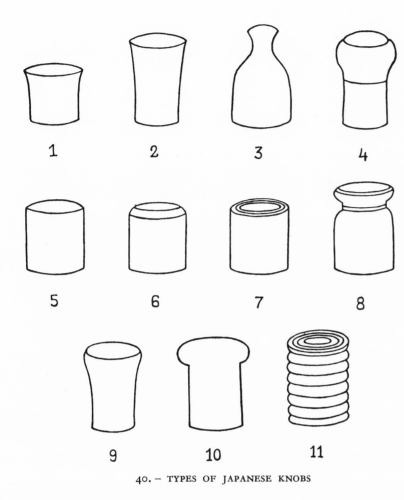

40. – TYPES OF JAPANESE KNOBS

Knobs covered with gold or silver lacquer are reserved for scrolls with poems in Japanese.

Further materials in common use in Japan are various kinds of bamboo, crystal and porcelain. White porcelain knobs with a blue design are preferably used for calligraphic specimens in Chinese style, while one–coloured porcelain knobs are used for purely Japanese scrolls.

Wooden knobs are turned in various models, many of which are connected with the name of some ancient tea master who especially favoured such and such a particular shape. Eleven common models are depicted on

Plate **40**. Nos 1–3 represent the *hachi* 鉢 " pot-type "; (1) is simply called *hachi*, (2) *chōsen–bachi* 朝鮮鉢 " Korean pot ", and (3) *naga–bachi* 長鉢 " long pot ". The *naga–bachi* type is said to have been specially favoured by the famous tea master Rikyū; often a round plaque of ivory is inlaid in the top. No. (4) is called *nagara–chō* for which no Chinese characters are given; this type of knob also has often a round plaque of ivory inlaid in the top. No. (5) is a very common type called *atama–giri* 頭切 or also *kiri–jiku* 切軸; if the sharp rim on top is cut down one gets the type known as *men–tori* 面取 (6). No. (7) is called *in–ka* 印可 because it resembles a round seal. No. (8) is said to have been invented by Rikyū, and (9) is ascribed to Rikyū's grandson, the tea master Sen Sōtan. No. (10) was favoured by another famous tea master, Kobori Enshū. Finally, No. (11) is the type called *uzu–maki* 渦 or *sandan–maki* 三段巻.

Plate **41** shows detached Japanese knobs representing some of the types described above, and a few other models.

Top row, from left to right: Ornamental knob of a Buddhist scroll, of crystal encased in silver filigree – Plain crystal – Copper plate – Deer horn decorated with small leaves, laid on in gold lacquer – Carved red lacquer.

83

Below: *Chōsen–bachi* of blackwood – *In–ka* of rosewood – Ivory knob seen from the inside – Copper knob of a Buddhist scroll, in the form of the knobs on balustrades of Buddhist temples – *Men–tori* of blackwood – Ivory.

The " wind guards "
of Japanese hanging
scrolls.

In connection with the knobs of Japanese hanging scrolls mention must also be made of the *fū–chin* 風 鎮 " wind guards " commonly used in Japan.

*Fū–chin* are weights made of porcelain, crystal, stone, metal or some other heavy material which are hung on a silk cord over either knob of the scroll when it is suspended on the wall; they are decorated with long tassels of coloured silk. These weights make the scroll hang straight and prevent it from being swayed by currents of air. The weights usually take the shape of large round beads, but countless variations occur; a few common shapes are represented on Plate **42**.

I have never seen *fū–chin* in China but it would seem that in former times they were not unknown. As will be seen on page 186 below, the Sung connoisseur Mi Fu mentions *fū–chin* consisting of heavy bronze coins; such are still used occasionally in Japan. The reason why " wind guards " became obsolete in China while remaining popular in Japan is probably that Japanese houses — as all of us who lived in them know only too well! — are much exposed to draughts so that *fū–chin* are necessary to prevent a scroll from clattering against the wall.

Western collectors will find it useful to keep a dozen or so of various *fū–chin* in stock for in some climates scrolls will only hang down straight if weighted, while they are moreover a graceful addition to interior decoration. The *fū–chin* must of course harmonize in shape and colour with the scroll they are attached to. For antique landscape scrolls in colours I use *fū–chin* of rock crystal and for monochrome ink landscapes ones made of white and blue porcelain. Old bronze coins go very well with specimens of calligraphy.

\* \* \*

The mounting of
hand scrolls.

The above description of how a new painting is mounted in the form of a hanging scroll applies *mutatis mutandis* also to the mounting of hand scrolls.

The excessive length of most hand scrolls presents no difficulty, since they can be mounted in three or four sections which are subsequently joined together.

For mounting hand scrolls the same materials are used as for hanging scrolls. It should be noted, however, that even to–day hand scrolls are mounted in a more conservative style than hanging scrolls; the outside of the protecting flap consists of heavy brocade or figured silk, as was popular already during the Sung dynasty. But since the Ming period the ornamental knobs added to the rollers of antique hand scrolls are usually omitted; the ends of the roller are cut off flush with the scroll and the mounter adds there a thin round disc of jade or some other material. In Japan, however, the ancient protruding knobs have been preserved till the present day.

Plate **43** shows on the left a Chinese hand scroll mounted with a protecting flap of black and silver brocade; a flat disc of green jade is stuck to the end of the roller. In the

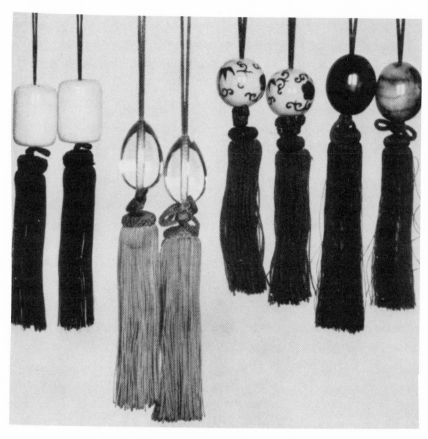

42. — JAPANESE "WIND GUARDS"

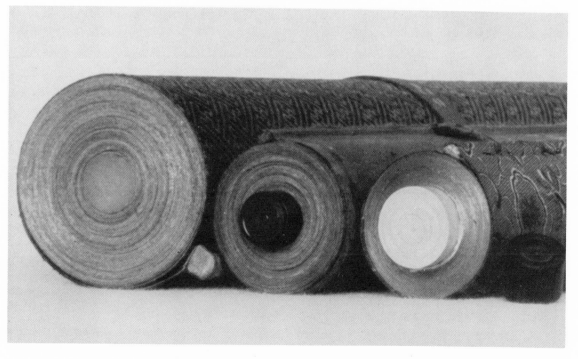

43. — KNOBS OF CHINESE AND JAPANESE HAND SCROLLS

middle a Japanese hand scroll with a protruding knob of blackwood. On the right another Japanese hand scroll with a protecting flap of gorgeous brocade and an ivory knob. On the extreme right a detached wooden knob of a Japanese hand scroll.

The Ch'ing collector Chou Erh–hsüeh has the following to say on the knobs of hand scrolls:

"For the knobs (of hand scrolls) white jade or a variety of greenish jadeite is the best. Occasionally one may also use rhinoceros horn, provided it is well carved, in order to have also this variety represented in one's collection. But such knobs should be inlaid into the ends of the roller, then it is easy to roll and unroll the scroll. You should not imitate the ancient fashion, and let the knobs protrude" (see below, page 331).

In China the band for winding round the hand scroll is made of silk or brocade and it usually ends in an ivory or jade fastening pin. Hand scrolls in the Palace Collection have large ornamental pins the front side of which is carved with designs borrowed from Han bronzes; on the reverse one often finds the name of the Emperor who inspected the scroll, its title, and the date it was entered into the collection, engraved in small characters. Such pins are valuable antiques in themselves and eagerly sought for by connoisseurs who attach them to hand scrolls in their own collection.

Chou Erh–hsüeh says on pins of hand scrolls:

"Pins of old jade are beautiful, but in course of time they will leave their impression on the roll; this depression may grow deeper till it reaches the painting itself, causing no small damage. It is better, therefore, to use broad bands of old brocade, which should be would round the scroll very loosely" (see below, page 331).

The last half of this quotation seems to have been inspired by the following discussion found in Mi Fu's *Hua–shih*:

"Chao Shu–ang (see below, page 325) says: 'You must weave (編; the text has 褊 which must be a mistake. Transl.) a silk band of half a finger broad, using fine and flossy silk. If you wind this band round your scroll it will never (wear down the brocade of the protecting flap and make it) hairy. You should make a small cut in the mounting (of the protecting flap) with a knife, making a hole between two strands of the silk, and there attach the band. Afterwards, when winding this band round the scroll, you should not do so right in the middle so as to prevent causing damage to the picture itself (inside the rolled up scroll), and so as not to leave an impression of the band (by winding it always round the scroll in the same spot). That paintings often become damaged in the middle must be ascribed to the fact that the bands were wound round them too tight, and the same applies to calligraphic specimens. These bands should therefore be wound very loosely without using force". [1]

1) Hua–shih (cf. Appendix I, no. 37): 盎者。作絲縷在畫省損者。縛之。烏用力。尋常畫多損亦然。書多
云書間套掛縹。線褊不生毛。以刀刺縹中開絲即縛之。又不在畫趙权綿細如絲。半指潤條褊生心中略略縛書。無摺破故也。帶隱痕。書多腰損

85

44. – THREE WAYS OF TYING THE BANDS OF JAPANESE HAND SCROLLS

As was stated above, the bands of Japanese hand scrolls are not as a rule provided with fastening pins but tied into bows. In Japan these bands were formerly made of brocade (*kambata* 綺), in imitation of Chinese models. Since the Tokugawa period, however, bands of *sawada-himo* 澤田紐 "ribbed silk" are preferred. *Taku-boku* bands (see page 80) are as a rule not used for hand scrolls but only for hanging scrolls.

Japanese tea masters are most fastidious as to the manner these bands should be tied. Plate **44** shows three common styles. A is the conventional way of tying the band of a Buddhist scroll, B shows the way of tying the band of a scroll displayed on a special low stand, and C shows an old fashioned style of tying the bow. Moreover, in the case of sets of three or more scrolls the tea masters insist that their sequence be indicated by differently tied bows.

\* \* \*

The mounting of rubbings.

A very special aspect of the mounter's work is the transformation of " rubbings " into hanging scrolls, hand scrolls or albums.

The mounting of " rubbings " has its own peculiar problems and the *Chuang-huang-chih* quite properly devotes a special chapter (XXVIII) to this subject. Chinese writers take it for granted that the reader is familiar with the characteristics of " rubbings " and the methods of making them. Before we describe the process of mounting " rubbings " we shall therefore first discuss the general aspects of this subject.

In Western literature [1] " rubbings " are also referred to as " ink squeezes ". In Chinese they are usually called *t'a-pên* 搨 (拓) 本; other terms are *ta-pên* 打 本, *mo-*

---

[1] The earliest Western description of Chinese rubbings is probably the note by MATTEO RICCI; cf. "China in the Sixteenth Century: The Journals of Matthew Ricci 1583–1610 ", translated from the Latin by Louis J. Gallagher, S. J., New York 1953, page 21. Further, A. STANLEY has given a brief note on the subject in his article " The method of making ink rubbings ", publ. in Journal of the N. China Branch of the R. A. S., vol. XLVIII, 1917, pp. 83–84. Cf. also TH. F. CARTER, " The invention of the art of printing in China and its spread westward ", New York 1931, page 12; reprint of 1955, p. 19.

As to the Chinese sources, a succinct but authoritative account of the subject is to be found in the *Chin-shih-hui-mu-fên-pien* 金石彙目分編, by the great Ch'ing archeologist Wu Shih-fên (吳式芬, 1796–1856); this note chiefly treats of taking rubbings from stone tablets. A detailed essay on taking rubbings from bronze vessels and similar objects has been written by Ch'ên Chieh-chi (陳介祺, lit. name Fu-chai 簠齋, 1813–1884), another famed Chinese archeologist. This essay, entitled *Ch'uan-ku-pieh-lu* 傳古別錄, is to be found in the *Mei-shu-ts'ung-shu* (美術叢書, the well known modern collection of reprints of works on artistic subjects), and in the *Yeh-shih-ts'un-ku-ts'ung-k'o* 葉氏存古叢刻. Moreover the editor of the Japanese monthly *Sho-en* 書菀 obtained a manuscript copy of this essay, which is much more complete than the versions printed in China; this enlarged text was published in *Sho-en*, vol. I (1937). The most detailed modern account in Chinese of the taking of rubbings in general is the article *Mo-t'a-shu* 墨拓術 " The art of taking rubbings ", by Chiang Hsüan-i 蔣玄詒, published in the periodical *Shuo-wên-yüeh-k'an* 說文月刊, Chungking 1940.

For a full description of the value of rubbings for archeological and epigraphical studies, the reader is referred to Yeh Ch'ang-shih's excellent work *Yü-shih* (see Appendix I, no. 60).

*pên* 墨本, *shua-pên* 刷本 and *k'o-pên* 刻本. In Japanese they are called *taku-hon* 拓本 or *ishi-zuri* 石摺.

A rubbing is an imprint on paper taken from an inscription or picture incised in stone, wood, jade or some other material, made by spreading the paper over the surface one wishes to reproduce and then applying ink to it; the design will then appear in white on a black ground. The principle is simple, but the methods vary greatly according to the material one has to work on and the ink and paper used. To make a good rubbing is an art in itself.

Various methods for taking rubbings. "Wet rubbings".

The method most commonly practised in China and Japan is the so-called "wet method". This is applied to memorial stone tablets, *pei* 碑, if new or well preserved, to carved wooden boards and to practically every kind of surface that is comparatively smooth, has a clear-cut design and is not covered with paint, lacquer or gilding.

Wet rubbings are taken in the following way. A sheet of tough white paper is cut to the size of the surface to be reproduced and lightly moistened with an agar-agar solution whereby its plasticity is enhanced. Then the paper is spread out over the surface and tapped with a mallet covered with soft leather or with a stiff-haired brush, forcing the paper into all the incisions and cavities of the surface. When it has dried one takes a tampon made of a pad of wool tied up in a piece of silk — the so-called *mo-pao* 墨包 — moistens it with thick ink and then inks the entire surface by lightly tapping it with this tampon. When the ink has dried the paper can easily be peeled off. As will be seen from the actual sample in Appendix V, no. 22 the design appears in white while also the grain of the surrounding surface is faithfully reproduced.

Variations of the "wet process". A. Wu-chin rubbings.

There exist some variations of the "wet process", made by using special kinds of paper and ink.

If the surface to be reproduced is exceptionally smooth and the design deeply incised, a spectacular result can be obtained by applying the method called *wu-chin-t'a* 烏金搨 "black gold rubbing".[1] For such rubbings one uses a thicker, sized paper, and very superior ink. Before applying it to the surface the paper is held over a bowl of boiling water, so as to make it soft and plastic without becoming too moist. It is then hung over the surface to be reproduced and tapped in the usual way with a stiff brush till it is securely glued on to it. Thereafter the surface is inked with a tampon, well soaked in thick ink. Because the paper is thicker than that ordinarily used for rubbings, it will not sag or tear even if the ink is applied heavily. When thoroughly dry the paper is taken off and burnished with a polishing shell. Such a rubbing will show a beautiful black shine which contrasts pleasantly with the white design.

---

1) The term *wu-chin* properly belongs to metallurgy where it stands for a mixture of about 9 parts copper and 1 part gold, which is said to have a dark, purplish lustre. Hence the term is used also with reference to the lustre of good ink. With ceramics it indicates a brilliant black glaze invented during the K'ang-hsi period.

The *Chuang–huang–chih* also mentions another variation of the " wet method ", viz. *hsüeh–hua–t'a* 雪花搨 " snow flake rubbing ". This method is used in case the surface to be reproduced is rather rough. Ink and paper are the same as employed for *wu–chin* rubbings, but instead of being soaked, the tampon is only lightly moistened with ink. Thus not only the incised design but also the grain of the surface will be reproduced on the rubbing. When such a rubbing has been properly polished it will obtain a shine exceeding even that of *wu–chin* rubbings. The appellation *hsüeh–hua* would seem to be derived from the fact that the black ground is enlivened by a number of tiny white spots (caused by small holes in the rough surface from which the rubbing was taken), thus making it appear as if the white design were seen in a drift of snow flakes.

I add a description of another variation of the " wet method " which, although not specially mentioned in the *Chuang–huang–chih*, has since olden times been popular in both China and Japan; this is *chu–t'a* 朱搨, taking rubbings with vermilion (Chinese *chu* 硃, Japanese *shu–zumi* 朱墨).

For making red rubbings one should use the best quality of vermilion made from a mixture of mercury and sulphur; because of the greater quantity of mercury they contain, superior cakes of vermilion are much heavier than those of inferior quality. If, while preparing ink from such a cake the white of an egg is added, the rubbings made with it will acquire a beautiful shine. Cheap vermilion made from ochre should not be used. The *Yü–shih* (cf. page 86, note 1) says that vermilion rubbings attract insects and that therefore such rubbings should never be stored away together with ordinary ones. This statement applies only to inferior rubbings made with ochre. Real vermilion acts as a poison, and will frighten away book worms and other insects. Hence the custom of publishers in South China of inserting one leaf covered with vermilion at the beginning of a book.

When the engraving of a stone tablet has been completed, it is customary to take the first few rubbings with vermilion. Red rubbings are also preferably used for reproducing rare or especially valued antiques.

Red rubbings are very effective from an artistic point of view, especially when reproducing surfaces where the design appears in relief instead of in intaglio; they are therefore often used for reproducing Buddhist reliefs in stone. As good vermilion cakes are expensive, red rubbings sell at a higher price than black ones.

For very rough and irregular surfaces, for instance an inscribed stone tablet that is damaged and weather–beaten by long exposure, the " dry method " is advisable. For this method one should use very thin but tough paper.

One starts with scrubbing the surface with a stiff–haired brush using soap and warm water, in order to cleanse it of the moss, dust and other refuse that in the course of the years is liable to accumulate on old stone tablets standing in the open air. The cleaned surface should then be studied carefully. It is advisable to draw a rough sketch

of it where one can mark damaged spots and half–effaced or missing characters. Only if the main features of the surface have thus been fixed in the mind, may one proceed with cutting the paper to measure, leaving a generous extra margin on all four sides. The paper is stretched over the tablet by fixing it at the corners with gummed slips of paper. Then the paper is pressed on to the stone with the palm of the hand; it is so thin that the warmth of the hand alone suffices to make it cling to the surface as though it were glued on to it. This work takes considerable time but it must be done thoroughly, otherwise a satisfactory rubbing cannot be obtained.

When the entire surface has thus been gone over with the palm of the hand, the inking may be commenced. Chinese and Japanese stationers sell ink cakes specially made for taking dry rubbings. In China this ink is usually sold in thick, round disks; in Japan these cakes show a small model of a temple bell and are therefore known as *tsuri–gane–zumi* 釣鐘墨 " hanging–bell ink cakes ". They are considerably softer than ordinary ink cakes so that the ink comes off easily. With such a cake the paper is gently rubbed, as a result of which the design to be reproduced will gradually come to life. The background of the design will be a light grey, showing all the irregularities of the original surface, thus giving the rubbing an antique flavour that harmonizes agreeably with the worn appearance of the stone. Experts will handle the ink cake much in the same way as a brush: damaged spots are clearly marked so that they will not be confused with the design, and missing strokes are completed with the sharp edge of the cake.

Technically the " dry method " is more difficult than the wet one. All depends on the skilful handling of the cake of ink: if pressed too hard, the thin paper will tear; if too soft, the design will not show at all. [1]

The Chinese use for dry rubbings often a very white thin paper sprinkled with mica and sized with a solution of alum, to which an unusually large quantity of glue has been added. This paper is known as *ch'an–i–chih* 蟬翼 (衣) 紙 " cicada wing paper ". It is this paper that has given its name to the variation of the " dry process " for which it is used, viz. *ch'an–i–t'a* 蟬翼搨 " cicada wing rubbing ". [2] The *Chuang–huang–chih* refers to this process as *ch'an–ch'ih–t'a* 蟬翅搨.

Ch'an–i rubbings.

1) In the antique trade are obtainable ink cakes made for producing dry rubbings that have a lustre comparable to that of *hsüeh–hua* specimens; these cakes contain a large quantity of wax.

2) The Sung source *Tung–t'ien–ch'ing–lu–chi* (cf. Appendix I, no. 27) says the following about the *wu–chin* and *ch'an–i* technique: " In the North they make paper with transverse moulds; it is loose and thick and does not absorb the ink to a marked degree. When inked (in order to make a rubbing on it) its surface looks like thin clouds sailing across the sky: everywhere the white of the paper appears in tiny spots. All rubbings made in the North have this feature, while they can also be recognized by the fact that the ink contains no oil or wax. In the North ink cakes are usually made from pine soot, hence the ink produced by them has a greenish tinge; moreover the paste (made from the soot) was steamed twice which further increased the green colour. In the South they use lampblack made from oil for manufacturing ink cakes, hence that ink has a pure black colour while it can further be recognized by the fact that it contains oil and wax " 北 紙 用 橫 簾。其 質 鬆 而 厚。不 甚 滲 墨。以 墨 拂 之。如 薄 雲 之 過 靑 天。猶 隱 隱 見 紙 白 處 也。凡 北 碑 皆 然。且 不 用 油 蠟 可 辨。北 墨 多

89

*Ch'an–i* rubbings are especially suited for reproducing the designs of bronze vessels and jade ornaments. Further, they should always be used for coloured surfaces, for if the "wet method" is employed for these the colours of the original may come off; and if the ordinary "dry method" is used the surface may become damaged by too vigorous rubbing.

The "dry method" should always be used for taking rubbings of inscribed wooden boards. The board itself is often lacquered and the incised characters gilded or coloured; if on such boards one should apply the "wet method", the water may affect the colours or the lacquer and cause considerable damage.

45. – SCHEMATIC DRAWING, SHOWING THE CHARACTER "ONE", CARVED ACCORDING TO THE U, V AND W TECHNIQUE

Before taking a rubbing of an inscribed board due attention must be given to the technique followed by the engraver who incised the characters in its surface. The three most common varieties of this technique may be conveniently indicated by the three letters U, V and W, if one takes it that the form of each of these letters roughly reproduces the profile of the engraved board cut right through (see Plate **45**). The U–technique is the easiest to execute: in cutting characters according to this technique the strokes are simply gouged out with a rounded gouge. This method may be applied to very large and very small characters alike. In the V–technique each stroke of a character is reproduced by chiseling in the wood a V–shaped groove; this technique is used exclusively for small characters, such as those of seal impressions or signatures. The W–technique is especially suited to larger characters. First the outlines of each stroke are indicated by incising a V–shaped groove, then the remaining wood in between is chiseled off so as to create a bulging surface. The W–technique is the most difficult to execute but on the other hand it produces the best results; it enables a skilful carver to reproduce exactly the movement of the brush.

用 松 烟。故 色 青 黑 更 經 蒸 潤。則 愈 青 矣。南 墨 用 油 烟。故 墨 純 黑。且 有 油 蠟 可 辨。 The Ming treatise *Chang–wu–chih* (cf. Appendix I, no. 30) says: "Formerly the paper produced in the North had transverse mould marks; it was loose but thick and did not take up the ink well. Further the ink produced in the North had a greenish tinge and was shallow, oil nor wax being used when making it. Therefore (rubbings made in the North) have a shallow colour and the mould marks remain visible; these rubbings are therefore called 'cicada–wing rubbings'. The paper produced in the South has vertical mould marks and the ink contains oil and wax so that (rubbings made with these materials) have a deep black tinge and a shimmering lustre; these are called 'black–gold rubbings'" 古 之 北 紙。其 紋 橫。質 鬆 而 厚。不 受 墨。 北 墨 色 青 而 淺。不 和 油 蠟。故 色 淡 而 紋 皺。謂 之 蟬 翅 搨。南 紙 其 紋 豎。 用 油 蠟。故 色 純 黑 而 有 浮 光。謂 之 烏 金 搨。

These two passages show that originally the terms *wu–chin* and *ch'an–i* referred respectively to South Chinese and North Chinese rubbings. Later these two terms were applied to those rubbing–techniques the results of which showed the characteristics of rubbings produced either in the North or in the South, without implying any geographical difference.

Plate **46** gives two photograps of inscribed wooden boards. The upper one reproduces a section of a board inscribed with the two characters *tsun-ming* 尊 明 written in regular style, and carved according to the U-technique. Below is a board showing the two characters *liu-chai* 留 齋 written in archaic script, and engraved according to the W-technique; both boards are 30 cm. high. Calligraphy and engraving of these two boards are very good, in the lower one the perfect balance of *liu* and *chai* is worthy of special notice.

The text of antique stone tablets is as a rule engraved either according to the U or the V technique. The W-technique is used for larger characters, for instance those that compose the title of the tablet on its top, and also for very large characters such as for instance the words *ti-i-shan* 第 一 山 "the best of mountains" which calligraphers used to write in huge characters on a rock on the top of a famous mountain visited by them.

Next to the U, V and W techniques one occasionally meets with a method that might be called " inverted U-technique "; the space surrounding the characters is chiseled away so that the strokes stand out in relief.

It may be added that wooden boards play an important role in the Chinese interior; cf. Plate **6** where such a board is suspended above the *t'ang-hua*. Most of the famous Chinese seal engravers were also well known as carvers of wooden boards; specimens engraved by for instance Wu Chün-ch'ing (cf. page 435 below) are now greatly prized by connoisseurs.

When taking a rubbing of a board carved according to the U or V technique only the outlines of the characters are reproduced, the space in between remaining white. Taking a rubbing of characters engraved in the W-technique, however, calls for much skill; not only the outlines but also the bulging surface in between should appear on the rubbing, so that the movement of the brush is brought to life.

Further, since the wood for making engraved boards is often chosen because of its interesting grain, the rubbing should also reproduce this grain as faithfully as possible.

Before leaving the subject of taking rubbings I may add that anyone who proposes to experiment with making wet rubbings in the open is strongly advised to choose a fine day when there is no wind. The writer of these lines vividly recalls an occasion when he found himself precariously perched on the edge of a monument while a half-completed rubbing well-soaked with ink was lifted off the stone by a playful breeze and nestled itself close to his best white summer suit — to the undisguised delight of the crowd of youthful native spectators below.

The rubbing derives its unique place in Chinese artistic and archeological studies from the art of the engraver which in China has reached phenomenal perfection.

*Artistic and archeological importance of rubbings.*

The engraver works as follows. First he prepares a carefully traced copy of the picture or autograph to be reproduced, using a thin but tough paper. This copy is stuck to the stone and then the engraver, with incredible skill and patience cuts the design into the stone surface; he reproduces every detail of the brush work; literally every trace of every single hair is incised in the stone with unerring precision. Since thus the incised

design is a close rendering of the original, rubbings are valued as highly as superior copies made in the ordinary manner with brush and paper.

In the case of specimens of calligraphy and pictures done in " calligraphic " technique, Chinese connoisseurs consider rubbings even of greater accuracy than ordinary copies. For on the rubbing the movement of the brush is, as it were, underlined by the contrast between the white design and the black ground; weak points in the original will strike the eye sooner and its best parts will stand out clearer than in the original done in black on white. [1]

The study of rubbings of ancient pictures is part of the routine work of Chinese connoisseurs, it was never considered as a special branch of research. But the study of rubbings of autographs has since early times been raised on a pedestal, countless books and essays have been written about its various aspects and these form a special branch of Chinese literature.

The study of calligraphic rubbings can be divided into three separate fields. Epigraphical research into the development of the various styles and forms of the written character is designated as *hsiao–hsüeh* 小學 about which there exists a voluminous literature. Also the study of the history of rubbings made at various times of stones and woodblocks reproducing some famous autograph is a special field, usually referred to as *pei–t'ieh* 碑帖. The artistic evaluation of calligraphic rubbings is yet another branch, called *fa–t'ieh* 法帖 " standard autographs " or *shu–fa* 書法 " methods of calligraphy ". It is significant that while *hua–hsüeh* 畫學 " the study of painting " is a common compound, in later Chinese its counterpart *shu–hsüeh* 書學 " the study of writing " does not exist. This ancient term was preserved in Japan and re–introduced into China only in recent years.

The historical importance of rubbings need hardly be stressed. Often disasters of nature have destroyed important old stone tablets while most of those that survive are too worn or damaged to yield clear rubbings. Ancient stone tablets will grow soft by age and the continouus tapping of the takers of rubbings will wear their inscriptions away. Many tablets in the famous *Shih–lin* 石林, the " Forest of Stone " near Si–an have thus been spoiled by over–eager takers of rubbings. A Ch'ing archeologist says:

" Although the empty space surrounding each column of text remains entirely undamaged, every character has become a hole in the stone so that even their outlines

---

[1] I cannot, therefore, agree with B. LAUFER when in his article *Confucius and his portraits* (Chicago 1912, footnote 1) he says: " The original drawings which were carved into the stone were, of course, black on white. We have made an attempt at restoring these originals by taking a photograph of the first negative obtained from photographing the rubbing, thus securing the original sketch in black outlines. This process should be employed for reproducing all Chinese rubbings of this kind and ensures an infinitely better idea of the style and real appearance of these pictures ". How wrong this view is could hardly be better illustrated than by the illustrations that accompany Laufer's article: these lack completely the expressive force of the white–on–black originals.

I may add that when in 1938 I published my book " Mi Fu on Inkstones " I quoted Mi Fu as saying that rubbings should not be studied since one can capture the spirit of an autograph only by observing the original manuscript (page 6). I should have added there the qualification that Mi Fu's statement applies only to secondary rubbings recarved in wood, or rubbings taken from stones engraved by clumsy carvers.

46. – SECTIONS OF TWO CARVED WOODEN BOARDS. ABOVE: U – TECHNIQUE.
BELOW: W – TECHNIQUE
(Author's Collection). Height: cm. 30.

47. – RUBBING OF A PICTURE OF BAMBOO AND ROCKS,
INCISED IN STONE

The bamboo was painted by the Ming scholar Fêng Ch'i–chên 馮起震,
the rocks by Fêng K'o–pin 馮可賓; dated 1624. Superscriptions
by several well known Ming literati.

(Author's Collection). cm. 170 by 80.

have become confused; on the rubbing the characters look like a flight of white herons or like flocks of white butterflies. Even if one studies such a rubbing with concentrated attention not one single brush stroke, not one single character can be recognized ". [1]

There were also other ways in which man destroyed what had been spared by nature. Despotic rulers ordered the cancellation of entire passages on stone tablets that did not meet their approval and officious censors had numerous tablets demolished. Thus many important old texts survive only in ancient rubbings. Connoisseurs know exactly which of the better known stone tablets have disappeared and rubbings thereof, known as *ku–pên* 孤本 " unica ", are as expensive as rare original works of art.

Next to texts, pictures by celebrated painters were also incised in stone; it is often only through such engraved stones and the rubbings thereof that we can obtain some idea of the brush work of an ancient master; I mention for instance the *Wang–ch'uan–t'u* by Wang Wei (699–759). [2] The subjects most suitable for being incised in stone, however, are pictures done in " calligraphic " technique, and especially those of the quartet dear to the Chinese artist, namely *lan–mei–chu–chü* 蘭 梅 竹 菊 " orchid, plum blossom, bamboo and chrysanthemum ". A rubbing of a picture of stone and bamboo is reproduced on Plate **47**.

Finally, for nearly two thousand years the rubbing has in China taken the place of our modern camera. When a scholar has obtained a rare old bronze, a valuable inkstone, an interesting jade or an important inscription in stone or wood, he will make a number of rubbings of such objects and distribute those among his friends for their study and comments. Archeologists often made several hundred of rubbings of every single item in their collection, had them bound together and published them as books. Such books consisting of original rubbings must be distinguished from publications made by re–cutting a collection of original rubbings in wooden printing blocks. Such can be recognized i. a. by the fact that the explanatory notes are printed together with the rubbing on one and the same page. In the case of books consisting of original rubbings the text is struck off on separate pages bound opposite the rubbings they belong to. The latter are of course more dependable than the former, because the engraver who recuts the rubbings may make mistakes in some details.

In many cases a rubbing is even to be preferred to a photograph, because it will often registrate details that even an expert photographer is unable to record. This was also found out by Western archeologists; I refer to the " dry rubbings " made in England with thin paper and heelball of church bronzes. To–day rubbings are an indispensable aid to Sinologues and students of Chinese pictorial art.

---

1) *Yü–shih* (cf. Appendix I, no. 60): 四 之 字
客。坎 一 陷 字 每 惟。損 不 皆 地。空 圍
如 又。鷺 白 行 一 如 之 望。辨 不 餬 圍 模
無。諦 審 神 疑 雖 則 此。蝶 胡 白 圍 成
釋。能 字 一。見 可 筆 一

2) This rubbing has been described by B. LAUFER in his article *The Wang Ch'uan T'u, a landscape of Wang Wei*, in: " Ostasiatische Zeitschrift " vol. I (1912); here again parts of the rubbing are reproduced as "restored originals" (cf. footnote 1 on p. 92). See also JOHN C. FERGUSON's article *Wang Ch'uan*, ibid., vol. III (1914), and HERBERT FRANKE's *Wang–ch'uan–chi*, ibid., vol. XXIII (1937).

From the above it will be clear that, rubbings being esteemed as highly as original works of art, the greatest care is bestowed upon their mounting.

Generally speaking, rubbings are mounted according to the same principles as paper scrolls. As, however, the paper used is mostly very thin and heavily inked it will expand considerably when moistened and in general is difficult to handle. Thus, for mounting a rubbing exceptional skill is necessary.

For mounting rubbings there exist two methods, known respectively as *chêng–chuang* 整 裝 "uncut mounting", and *chien–chuang* 翦 裝 "cut mounting".

An "uncut mounting" aims at preserving the rubbing intact, showing a pictorial representation in its entirety and, in the case of a literary inscription, the way the text is distributed over the surface, and the shape and decoration of the original stone tablet. The most simple way of mounting such a large sheet is described as follows by a Ch'ing archeologist: "You should back the rubbing with a single layer of bark paper, and then, without having added to it roller or knobs, you neatly fold up this large sheet (like our Western maps. Transl.). Then on the back you paste a title label of *tsang–ching* paper (see the sample in Appendix V, no. 19), on which you write the title of the rubbing, its date, and the names of the men who wrote out or composed the text. Ten or twenty of such folded sheets may be united in a set, and placed between wooden boards (like a book; see Plate **86**), or else in a box of blue cloth (see below, page 221)".[1] This is the simplest and least costly way of "uncut mounting". It goes without saying, however, that in course of time such rubbings are liable to become damaged: they will wear down along the folds, corners will rumple, etc.

A slightly more elaborate way of "uncut mounting" is to mount the rubbing in the form of a hanging scroll. For rubbings, as a rule, all ornamental strips of the front mounting are omitted, there being added only one narrow border of white silk or paper. The border on top may be made a little wider than that at the bottom, thus recalling the traditional proportion of *t'ien* and *ti*, but usually all the four borders are of the same width. Further, stave and roller are added in the customary way. This style of mounting is always used for rubbings of pictorial representations.

The second method, that of "cut mounting", is often applied to rubbings taken from large inscribed stone tablets.

A scholar will wish to study such a large rubbing character by character and stroke by stroke; he will wish to be able to put a thin sheet of paper over a section of the text, and trace it with his brush in order to learn its calligraphic intricacies, and at the same time

---

1) *Yü–shih* (cf. Appendix I, no. 60): 用 皮 紙 一 層 託 之。不 加 桿 軸。搨 疊 平 勻。外 貼 藏 經 紙 籤。寫 碑 目 及 年 月 書 選 人 姓 氏。以 一 二 十 通 爲 一 集。或 加 夾 板。或 靑 布 函。

to improve his own hand writing. As for these purposes a hanging scroll mounting is unsuitable a mounting in album form is preferred.

Transforming a large rubbing into an album is a complicated task: before the real mounting can start the mounter must do much preliminary work.

He first adds a thin backing to the rubbing. When this has dried, the entire text is cut up into long vertical strips, each containing one column of characters. These are again cut horizontally, so that finally the text is divided into a number of strips of equal size (see the schema in Plate **48** A). Before doing this, however, the mounter must have done much calculating. As is well known there exist certain unwritten rules that fix the pattern of a Chinese book page; these rules apply also to the page of an album. Tradition has fixed how many columns there should be to the page, and how many characters to the column. These figures change according to the total number of characters to one page, and according to their size and style. In addition to observing these rules, the mounter must also see to it that all prominent features of the original inscription are preserved on the album page. Where the inscription starts a new column, the album must do the same; features like *t'ai-t'ou-tzŭ* (擡頭字, characters elevated above the top margin of the text as a mark of respect) and *k'ung-ko* (空格, empty space in a column preceding the name of an exalted person etc.) must be faithfully retained, [1] and if at the end of the inscription there appear colophons, dates, signatures, or extra notes, these must also be arranged in the album in such a way as to be clearly distinguishable from the main body of the inscription. Yet the album pages must make a harmonious impression: they must neither be over-crowded with characters, nor be too sparsely spaced.

Finally, in the album the title of the inscription must also appear in its due place. [2] These titles are divided according to their calligraphic style into *chuan-ê* 篆額 "headings in seal script", and *t'i-ê* 題額, indicating headings in chancery script. The text of such headings must be cut up judiciously so as to form the opening pages (*shou-k'ai* 首開) of the album (see Plate **48** A, *a, b, c* and *d*).

When these calculations have been worked out to the mounter's satisfaction and when the rubbing has been accordingly cut up, the mounting can start.

The strips are divided into groups representing the pages of the album (Plate **48** B), and subsequently each of these groups is provided with a backing and borders, in the same way as a scroll. The borders are made of white silk or some ornamental paper, and for upper and lower border the proportion of *t'ien* and *ti* is often retained. When

---

1) *T'ai-t'ou-tzŭ* and *k'ung-ko* together may be referred to by the compound *t'i-k'ung* 提空.

2) As for technical reasons text and *chuan-ê* are usually rubbed on separate sheets of paper, when unmounted they are liable to drift apart, and thus a *chuan-ê* is often lost. Therefore, when buying rubbings of stone tablets which lack a *chuan-ê*, one would do well to ascertain whether at the end of the text, for instance in the lower left corner, there does not appear a notice such as "Text and *chuan-ê* written by X", "Text written by X, *chuan-ê* written by Y-engraved by Z", or some remark to the same effect. Otherwise one risks buying an incomplete rubbing. It is only very seldom that memorial stone tablets do not show a *huan-ê*.

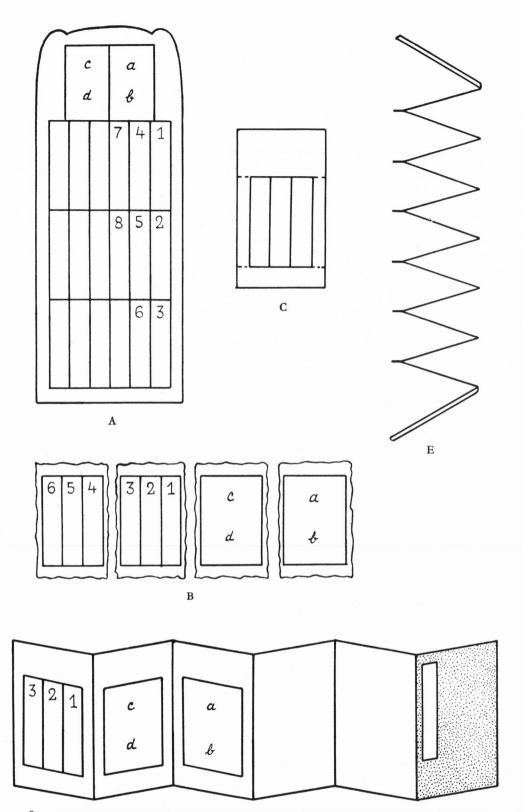

48. — SCHEMATIC DRAWING SHOWING THE METHOD OF TRANSFORMING THE RUBBING OF AN INSCRIBED TABLET INTO AN ACCORDION ALBUM

96

the borders have been attached each page is again separately backed, after which all the pages are joined together in the proper order by pasting on to them a long strip of backing paper. Finally, " folded borders " (*chê-pien*, see above page 68) are added on top and below, and the long strip is folded up accordion-wise (see Plate **48** D and E).

Such cut mountings are often referred to as *so-i-piao* 蓑衣裱 " rain coat mounting ", because the various strips pasted side by side remind one of the strips of cloth or straw whisps the rain coat of a Chinese peasant is made of.

Instead of mounting each page with four borders, one may also add only *t'ien* and *ti*, thus making the text run on continuously. Such albums, known as *chin-chê-piao* 巾摺裱 " folded-cloth mounting ", are especially suited for so-called *ching-chuang* 經幢, rubbings of long inscriptions of comparatively small height, such as those taken from the eight-cornered socles of Buddhist steles (*shih-chu* 石柱, colloquially *pa-lêng-pei* 八楞碑). Such texts may of course also be mounted as hand scrolls.

Further, in the case of texts consisting of excessively large characters, each character for instance measuring one foot square, such are mounted in what might be called a " transverse album ", Chinese *t'ui-p'êng-shih* 推篷式. When viewing such an album it should be placed on the desk horizontally, so that the longest sides form top and bottom; opening it one finds on each page one horizontal row of two, three or four characters, to be read from right to left. The same method is used for sets of larger paintings.

When the album has been thoroughly dried under a heavy weight or in a press, back and front covers are added. These covers are usually made of thick cardboard which is covered with silk or brocade and padded with cotton wool.

The *Yü-shih* gives a detailed description of such album covers. [1] " If ", it says, " for the covers you use fragrant *nanmu* wood, this will frighten off insects, and thus is most suited for South China. But in the North, where the climate is dry, such covers are liable to split, and will often break clean in two. Red sandal wood is too heavy to be used. Apricot wood (*yin-hsing, Salisburia adiantifolia*) may be used, but you should select thin and clean boards; when polished these will take on a beautiful shine. Some people by lack of the necessary means are compelled to use paper covers; these, however, are liable to become torn by much handling, and they easily become stained by grease etc. Old brocade is tasteful and elegant, and must be considered the best material for making covers. Next to this one may also use " cut silk " (see page 206, note 2 below), or new brocade made according to the antique pattern. Nowadays people often also use imported printed cotton; but it is much better to use instead ordinary blue cloth (see the sample in Appendix V, no. 20), then you have a cover that is at the same time simple and strong. Further, there are some who use wooden boards which in the middle are chiselled out so as only to leave a rim round the four sides; the hollowed surface is

---

1) Although this passage of the *Yü-shih* was chiefly written in connection with *rubbings* mounted in album form, the description of covers etc. applies equally to albums containing original calligraphic specimens or pictorial representations.

97

then lined with padded brocade. Such covers betray a vain striving after pompous effect. For the title slips *tsang-ching* paper (see the sample in Appendix V, no. 19) is the best, next comes thin white silk. Ornamental paper with a gold design (see the sample in Appendix V, no. 14) is beautiful, but the gold will in course of time fall off, damaging the characters (written on the paper), and in the end there will be left only one dark mass ". [1] It may be added that when wood is used for making the covers, as a rule no title slips are pasted on, the title of the scroll being engraved on the front cover, and the characters filled in with white, green or red paint. [2] As a final touch the top and edges of the album are covered with red or yellow paint; this not only beautifies the album, but at the same time also acts as a guard against insects, the sworn enemies of all book lovers.

As a rule, the mounter inserts at the beginning and at the end of the album a few blank pages where the owner or his friends may write notes and other comments.

A mounting in album form, even if done with the greatest care will yet often obliterate some distinctive features of the original rubbing. Conscientious connoisseurs therefore will try to obtain two copies of each rubbing, one to be mounted in its entirety, the other in the form of an album. The Ch'ing archeologist Yeh Ch'ang-shih says: " In my opinion one should have two copies of each rubbing. One I call " main copy " (*chêng-pên*); this should be mounted as it is, thus retaining all the features of the original stone. The other, which I call " additional copy " (*fu-pên*), should be cut up and mounted in album form, so as to be easy to handle while sitting before the transparent window or at one's quiet desk ". [3]

Plates **49** and **50** show an actual example of how a rubbing of a stone monument is mounted in album form. Plate **49** A shows a memorial stone tablet, set up at Peking in 1938 in front of the Wên-hua-tien in the Old Palace, and B a rubbing taken from this tablet. The text was drawn up by Wu T'ing-hsieh (吳廷燮, a member of the former Historical Compilation Bureau), and written out by Fu Tsêng-hsiang (傅增湘, former Han-lin scholar). It relates the history of this Palace and records how in 1925 the late John C. Ferguson's extensive collection of antiques was deposited there. Professor Ferguson kindly presented me with these photos when I visited Peking in 1941, adding a rubbing of the tablet. This rubbing I mounted in the form of an album; Plate **50** gives reproductions of pages 2 and 3.

---

1) *Yü-shih* (cf. Appendix I, no. 60):

香方兩者。用之次佳則用木板。楠木。可以辟蠹。即太輕。亦易損。然錦絲亦不如青布。四圍起線。以高日燥。紫檀光瑩。塵擦而雅。古緙絲不惡。近布素中微凹。辟蠹。南方龜圻。或銀杏亦可。古錦顏色。之近人樸凹。用顏料。或選陋用。亦為新用堅實。面宜潔。裂而就簡。池錦印渾。以北為或具其之布。又以錦。用若薄沾仿花洋矣。

此第一。亦金屑脫落。字畫亦無色。徒白金。觀飾泥金。取次之。題籤以綾牋雖華爛。久轉致黯淡耳。以紙為爛。

2) Cf. the engraved wooden book cover reproduced on Plate 86.

3) *Yü-shih* (cf. Appendix I, no. 60): 藏碑原石取便摩拓。版制度以明窗。須有兩本。以副本剪裁。正本整裝。余謂收留淨几。

---

98

49. – CHINESE INSCRIBED STONE TABLET (A), AND RUBBING THEREOF (B)

華殿進講月三次東宮建國
正統初常以月之二日御文
稍北為東宮講學受朝之所
殿始建文華殿於會極門東
明永樂十八年營建北京宮

50. – PAGE 2 AND 3 OF AN ALBUM, CONTAINING THE RUBBING OF PLATE 49

51. – JAPANESE TABLET MOUNTING

The above description of the transforming of a rubbing into an album, if one omits the cutting-up stage, applies also to the mounting in album form of sets of smaller paintings or leaves with calligraphic specimens.

Many albums made from rubbings have become so famous that they were recut page by page in wooden blocks, so that they could be " reprinted ", together with the superscriptions, colophons, comments and seals of the owner of the original album. During the process of recutting it is hardly possible to avoid losing some of the characteristics of the original rubbing. Such " secondary rubbings " are therefore valued much less than original ones, the so-called *yüan-t'a* 原搨. Unscrupulous dealers often try to pass off printed albums for original ones. Such, however, may be detected by holding a page against a strong light. One can then see whether or not the page is made up of a number of separate strips. In an original rubbing the overlapping edges of the various strips will show.

Not only albums but also large-size rubbings of texts and pictorial representations are often re-cut in wooden boards and then multiplied by again taking rubbings of these. During the Ming dynasty epigraphists had a large number of Han inscribed tablets re-cut in wood on a smaller scale, about one-sixth of the size of the original. As many of the original stone tablets and rubbings thereof have since then disappeared, such miniature Ming rubbings are now much sought after.

Although secondary rubbings may thus serve the cause of science, unscrupulous dealers on the other hand often use them for gain. When some decades ago both Western and Chinese scholars became interested in Wei reliefs, some Peking dealers soon started to recut in wood as many original rubbings as they could lay their hands on; by now the greater part of the *soi-disant* rubbings of Wei reliefs offered for sale in Chins and Japan are taken from wooden copies. If when recutting such rubbings dealera would faithfully reproduce the original their work would not be so reprehensible. Unfortunately, however, they often tried to " improve " the original by adding some strange animals or fictitious dates. This evil practise cannot be denounced too sharply.

Sometimes secondary rubbings are clumsily done, many showing even the grain of the wooden boards they were copied on. Often, however, the falsifiers evinced considerable skill, working over the wooden surface so as to make it resemble the coarse grain of the original stone. The collector should train his eye by carefully studying in all their details as many genuine rubbings as he can lay hands on. He will then find that secondary rubbings, even the most cleverly done, all have some undefinable element that soon betrays them to the discerning eye.

The charm of new rubbings lies in the contrast between white design and black ground. With old rubbings the white has toned down to a mellow brown, and the black has become deeper, looking like velvet. These qualities give old rubbings a beauty of their own, which is one of the reasons why connoisseurs prefer them to new ones.

Rubbings re-cut in wood.

Secondary rubbings passed off as originals.

Forged old rubbings and how they are produced.

Unfortunately, since hundreds of years, dealers have been well aware of this preference and "age" new rubbings in a most convincing way. They mount them on backings of paper that has been previously dyed or coloured yellow by holding it in the smoke of some special herbs, and afterwards rub it gently with a ball of crumpled–up tissue paper, to give the black ground a worn look. If finally a few worm holes are added, and the rubbing is mounted with genuine old brocade covers, such fakes can only be detected by an experienced connoisseur, who can tell the difference between an old and a new rubbing of the same stone tablet by the degree to which the outlines of the characters have worn down.

Enterprising dealers will even succeed in transforming rubbings into faked manuscripts.

When they obtain a rubbing showing an autograph written by some famous artist they lay a sheet of good old white paper over it and with incredible patience trace the outlines of each character with a fine brush, using thin ink. This tracing process, called *shuang–kou* 雙鈎, is also widely practised by scholars as a means of faithfully copying scrolls in the collections of their friends, afterwards to study them leisurely at home.

The forger goes one step further. Laying the traced outline–copy on his desk side by side with the original rubbing, he now starts to fill in the characters on his copy with good old ink. If this is done expertly the result will hardly be distinguishable from an original manuscript. The paper is then "aged" by dyeing or smoking it, as described above. Another method to "age" paper is to strew incense–ash over it and then brush it for a long time with a stiff–haired brush. Thus the paper will obtain a greyish tinge and its surface will become slightly burred. Thereupon the "manuscript" is powdered with talc, and polished with a polishing shell. Finally the dealer has the scroll mounted together with some stray colophons by well known scholars, using old and worn brocade as mounting material. Most dealers have large stocks of old silk and stray superscriptions and colophons so that the production of such a forgery involves very little expense.

It needs great experience to detect such fakes. The only final test is perhaps to have the scroll dismounted. When the backing has been taken off and the scroll is scrutinized against a strong light, it may be ascertained whether the characters were traced or really written; this is explained in greater detail on page 110 below.

Further, artificially "aged" paper will then be betrayed: dyed or smoked paper is coloured through and through, the colour also appearing on the reverse, while genuine old scrolls though their face has toned down will show a clean reverse. Or, as the Sung connoisseur Chao Hsi–ku says: "Those who sell scrolls often produce fakes by dying old paper so as to give it a dark colour. But they are entirely unaware of the fact that the water mixed with dust (another means for "ageing" a scroll. Transl.) will penetrate both the face and the reverse of the paper. Genuine darkened paper is only

100

discoloured on the face, while its reverse is as new ". [1]  See further Mi Fu's remarks quoted on page 184.

<div style="float:right; font-style:italic;">A historical example of such a forgery, produced during the Sung dynasty.</div>

Thus the practice of producing forged manuscripts on the basis of rubbings can boast of a long history: it was already used by dishonest dealers one thousand years ago, during the Sung period.

The Sung connoisseur Chao Hsi-ku mentioned above relates how he once proved an alleged autograph by Wang Hsi-chih, the paragon of all Chinese calligraphers, to be such a fake produced on the basis of a rubbing.  He noticed that in the " manuscript " one *k'ung-ko* (empty space in a text column to indicate respect for the name or the person mentioned directly beneath) was missing, the text running on uninterrupted.  Now old rubbings of the stone in which this autograph had been incised did indeed reproduce this *k'ung-ko*.  Later, however, ignorant mounters who mounted rubbings of this stone in album form, while cutting up the text in strips wrongly joined together the text of the column that should be broken off by the *k'ung-ko*, so that this empty space disappeared.  Thus the *soi-disant* autograph was proved to be a fake made on the basis of a badly mounted rubbing. [2]

<p style="text-align:center;">* * *</p>

<div style="float:right;">Tablet mountings.</div>

Finally a few words must be added on the mounting of *pien-ê* 匾額, or tablet-like mountings (see above, page 33).

The first half of the mounting process is identical with that followed when mounting an ordinary hanging scroll.  First the picture is provided with a backing and thereafter the borders attached in the usual way.  These four borders can be compared with the " frame " of a hanging scroll, the only difference being that in the case of a tablet mounting all four have the same width.  It should be noted, however, that Japanese mounters make the left and right strip of a tablet usually broader than the top and bottom one (cf. Plate **28**).  In China the borders are made of monochrome cloth or silk of a dark colour, in Japan of multicoloured brocade, coloured silk, or paper covered with gold or silver leaf.

While the picture provided with backing and borders is drying on the board the mounter prepares a light wooden frame of the required size.  When the scroll has dried and the paste settled, it is moistened again in its entirety, both picture and borders being gone over with a large soft brush dipped in clean water.  Then the moist scroll is stretched over the frame by pasting the extra margin along the outer side of the borders around the four sides of the frame.  In this condition it is left to dry.  On Plate **28** one sees a mounted tablet in this stage, standing on the table against the backwall.  While

---

1) *Tung-t'ien-ch'ing-lu-chi* (cf. Appendix I, no. 27): 鬻 書 者 多 以 古 紙 浸 汁 染 贋 蹟。令 紙 闇。殊 不 知 塵 水 浸 紙。表 裏 俱 透。 若 自 然 舊 者。其 表 色 而 其 裏 必 新。

2) *Tung-t'ien-ch'ing-lu-chi* (cf. preceding note), chapter VIII, second paragraph.

<p style="text-align:right;">101</p>

the scroll is drying it will shrink a little and thus become stretched out over the frame perfectly smooth. Since, however, the area in the centre dries quicker than that near the borders, the middle of the scroll has to be moistened slightly a few times, else wrinkles will develop in the four corners.

In China the mounting of the tablet is complete when the reverse of the frame has been covered with cloth or paper. Japanese mounters, however, place the tablet in an ornamental frame. This frame is usually lacquered black or red, but one will also find frames of wood or bamboo in its natural colour.

In China both horizontal and vertical tablets are in regular use, but in ordinary Japanese houses one finds as a rule only horizontal tablet mountings, the vertical ones being reserved for shrines and temples.

*Screen mountings.*

The technique of screen mounting is essentially the same as that used for transforming pictures into tablets.

A single-panel screen is in reality a tablet mounting placed in a wooden frame and kept upright by a heavy wooden foot; such a screen is seen on Plate **13**, while other varieties will be found on Plates **14** and **15**.

A folding screen can be defined as a number of tablets connected by hinges; all Japanese *byōbu* are of this type. In China each tablet is often placed in a wooden frame provided with legs; then the panels are connected with hinges. The old Chinese type of folding screen is depicted on Plate **14**, the Japanese type on Plate **16**, and the later Chinese type on Plate **15**.

*Scrolls mounted behind glass.*

Since the end of the Ch'ing dynasty one sees in China often scrolls framed behind glass in our Western way. Sometimes a mounted hanging scroll is placed behind glass as it is, only stave and roller having been cut off. Usually, however, the entire front mounting except the " frame " is removed.

The frame is often beautifully carved and the tablet suspended by one or more ornamental copper hooks.

Pictures mounted in this manner look elegant but connoisseurs object to this style on more than one ground. This problem will be discussed in greater detail on page 464 below.

*Special Japanese tablet mountings.*

In Japan there exist many varieties of the tablet mounting that are not found in China.

Dismounted fans, for instance, are in Japan often mounted on wooden boards. First a shallow space corresponding to the size of the fan is scooped out and the fan is pasted in there. Plate **51** shows a fan with a superscription by the famous Japanese Sinologue Rai San-yō (賴山陽, 1780–1832), mounted on a board of carved wood and placed in a blackwood frame of Chinese design. If the fan had been painted in a purely Japanese style, it would have been mounted on a plain wooden board, and instead of the carved blackwood frame the mounter would have added one of lacquered wood.

102

Further Japanese mounters have special methods for mounting *shiki–shi* 色 紙 and *tan–zaku* 短 冊. A *shiki–shi* is a square piece of stiff paper much used by Japanese painters and calligraphers. A *tan–zaku* is an oblong, narrow strip of stiff paper used especially for writing brief poems in Japanese. Both *shiki–shi* and *tan–zaku* are often mounted behind glass in round frames suspended by thick silk cords and decorated with tassels; a *shiki–shi* mounted in this manner is shown on Plate **52**. Such round frames, called *um–pan* 雲 板 may be hung on any spare place on the wall, inside the *toko–no–ma* or above the *chigai–dana* next to it. The term *um–pan* properly denotes a flat bronze gong suspended on a cord and having the shape of a stylized cloud. This is the Japanese version of the Chinese *yün–pan* 雲 版, a musical instrument of the gong class, vulgarly called *tien* 點. In Japan this gong is used exclusively in Buddhist temples but in China it also forms part of the popular orchestra while it was formerly used also in the offices of high officials. The Japanese *um–pan* mounting was thus named because its shape reminds one of a suspended gong.

\* \* \*

The description of the process of mounting given above applies only to the mounting of new pictures and autographs, and generally to all scrolls that are in good condition and that have never been mounted before. Such work may be safely entrusted to any skilled mounter.

The remounting and repairing of antique scrolls, however, is a very different proposition. For this work one should only employ a craftsman who has specialized in this, the most delicate aspect of the art of mounting and who, moreover, can be trusted unconditionally. This complicated subject shall be treated in the next section.

52. – JAPANESE *UM–PAN* MOUNTING

# 2 – THE REMOUNTING AND REPAIRING OF ANTIQUE SCROLLS

Scope of the art of remounting antique scrolls.

THE ORDINARY observer always sees an antique scroll in a condition where its merits are enhanced and its shortcomings concealed. The mounter who remounts such a scroll, however, sees it in its most unfavourable condition: its merits will have temporarily disappeared, while its defects will show to the full. The mounter sees an antique scroll just as a trusted valet sees his master; disheveled and *en négligé* — a sight that leaves only the very idealistic or the very cynical unconcerned.

An antique mounted scroll, although it may be grimy with age, badly worm–eaten, soiled and stained, although its roller may have been torn off, and its mounting falling apart, yet retains much of its charm and its dignity. If, however, the mounter has taken off the front mounting and the backing and puts the scroll on his table in this state, it is a miserable sheet of worn and stained silk or paper, with jagged borders, badly retouched, clumsily patched up here and there, and altogether a sorry sight. The mounter, however, is not easily discouraged. He sets to work on these remains of what once was a work of art and when some months later the scroll leaves his hands it has been completely restored; it is, as it were, reborn in its full former splendour.

The subject-matter divided over three parts.

To accomplish this task is not easy, nor is it easy to give an adequate description of it on paper; all the more so as such a description must include the various manipulations practised by the forger that may come to light when the scroll is remounted.

Therefore, while the process of mounting new scrolls could be dealt with in one continuous description, we shall have to divide the discussion of the process of remounting and restoring antique scrolls into three separate parts.

The first is a general description of the process of remounting and restoring antique mounted hanging scrolls, with special reference to the *Chuang–huang–chih*. In addition to serving as a commentary to the pertinent chapters of that text, this part also includes a discussion of problems of authenticity.

In the second part the various stages of the remounting process are again described, but now with reference to an actual example, viz. a badly damaged Ming painting mounted as a hanging scroll. In connection with this particular scroll we shall consider a number of special questions that could not well be discussed without adducing the features of an actual example by way of illustration.

Finally the third part deals with the problems peculiar to the remounting of hand scrolls, including a special discussion of the seals of artists and collectors.

\* \* \*

(I) The remounting of a hanging scroll. – First stage: taking off the old front mounting and backing.

When the mounter receives an antique mounted hanging scroll to be repaired and remounted, he will start by taking off the old front mounting.

In this very first stage already the ways of the ordinary mounter and the expert in remounting antique scrolls part. The ordinary mounter will separate the front mounting from the picture by cutting off the "frame" along the *inside* while the expert, on the contrary, will cut off the "frame" along its *outside*. In order to appreciate the significance of this difference we must now go farther into a question that was but briefly touched upon in the first section of this chapter, namely the methods for attaching the "frame" to a scroll.

On page 76 above it was described how the four strips of mounting that form the "frame" (Plate **30** A, no. 5) are joined to the painting. It was shown how these strips are pasted on to the protruding margin of the backing of the picture, in such a way that they overlap the picture for the space of a few millimeters. This indeed is the most usual way of adding the "frame", a method at the same time simple and effective which since early times has been widely practised in both China and Japan (see the sample in Appendix V, no. 23).

Various methods for attaching the "frame" to a scroll.

When a painting is mounted for the first time this method will not do any harm; it is of no importance that a strip of a few millimeters along the circumference of the painting thus becomes invisible because the artist as a rule does not use the entire space provided by his canvas.

If, however, the mounter who remounts such a scroll again applies this same method, he will often cover up part of the drawing. And if another mounter when remounting such a scroll for the second time then cuts off the "frame" along its inside, a strip all along the four sides of the picture is irrevocably lost. This evil grows worse everytime the scroll is remounted. Many antique scrolls will indeed prove to have shrunk in the course of the centuries for several centimeters along all four sides; the result is that not only part of the drawing is cut off but also signatures and seals — which as a rule occur near the borders — are halved or even made to disappear entirely.

Dangers inherent in the common method of adding the "frame".

Since early times Chinese art lovers have drawn attention to the dangers inherent in this method of attaching the "frame", and denounced the laxity of mounters who do not take off such a "frame" in the proper way. As early as the Northern Sung period Mi Fu warned people against it and during the Southern Sung period the mounters working for the Palace were especially instructed to avoid this evil (see below, page 212). Further, the *Chuang-huang-chih* in chapter XLII calls this state of having been cut down along the borders one of the characteristics of a badly mounted scroll.

Despite these warning voices, however, up to the present day many Chinese and Japanese mounters still add the "frame" in the way described above, and many are the mounters who when remounting such a scroll, cut off the "frame" along the inside and thus damage the painting.

There exist other methods for attaching the "frame" which leave the original entirely intact and thus preserve it from the danger of being cut down during the process of remounting.

A type often found in China and Japan is shown in the sample in Appendix V, no. 24. In Chinese this is called *ch'ên-pien* 襯邊 "lined borders", or *ts'ao-hsien* 槽線 "groove" (used in South China); the Japanese technical term is *suji-mawashi* 肋廻 "surrounding with a narrow seam". The method is as follows.

Before attaching the "frame", four narrow strips of paper or silk of about half a centimeter broad are pasted on to the back of the painting along its four sides, in such a way that half of them protrudes beyond the borders, thus surrounding the painting with an "inner frame". Subsequently the real "frame" is attached to this "inner frame", just as if this constituted the circumference of the painting itself. Between the "frame" and the painting there remains visible a narrow strip of the "inner frame", surrounding the painting on all four sides. Thus not even the smallest part of the painting itself becomes invisible; and when the scroll is remounted, the "frame" may be cut off along the inside without the painting being damaged.

Such an "inner frame" should therefore be used for mounting all valuable scrolls. As appears from Chapter X of the *Chuang-huang-chih*, its author takes it for granted that mounters use such an "inner frame" for the remounting of all antique specimens.

Moreover, in early times Chinese mounters also used a more elaborate variation of this method consisting of adding several "inner frames" to the scroll. This method now is practically obsolete in China but in Japan it is still commonly used for mounting Buddhist representations; in Japan this method is known therefore as *butsu-jitate* 佛仕立 "Buddhist mounting".

A sample of this method is given in Appendix V, no. 25. To the first "inner frame" there is added a second one, made of strips of a different kind of silk or paper, and to this second "inner frame" the real "frame" is added. Next to the second frame often a third, a fourth and a fifth are attached to the painting, so that the original is surrounded by a quadruple or quintuple border. Such borders not only effectively protect the scroll, but often also produce quite a pleasing effect. [1]

In order to remove the frame of a picture that has been mounted without an "inner frame", the mounter spreads out the painting face upwards on his table and, having moistened it with clean water, carefully peels off the "frame" with a bamboo spatula and iron tweezers, seeing to it that no fragments of the painting itself are torn off at the

---

[1] Japanese mounters informed me that the custom of mounting Buddhist pictures with several "inner frames" has a religious background; it was — and in fact still is — considered sacrilegious to cut down or partly cover up a Buddhist image, such an act being thought to bring misfortune upon the perpetrator. Although it was doubtless this idea that caused the custom to be retained throughout the centuries, its real origin must be sought for in the triple and quadruple borders sewn on to the archaic "banner mountings"; these are described in Chapter III, section 1.

same time.  Since this peeling off is rather a laborious task it is understandable that mediocre mounters prefer to cut off the "frame" along the inside; for then they can immediately proceed with the next stage of remounting, namely taking off the old backing of the scroll.

The process of taking off the old backing is called *chieh* 揭 in Chinese and *hagasu* 剝 in Japanese.  The mounter spreads out the scroll on his table face downwards and then thoroughly soaks it by going over it repeatedly with a large, soft-haired brush dipped in clean water.  After having been left for some time the several backings are peeled off one by one with a bamboo or ivory spatula and tweezers; as a matter of course this should be done while the scroll is still moist.

This is a most delicate task, especially in the case of badly torn pictures: one wrong move will further enlarge old tears or cause fragments of the painting itself to come off together with the backing.  The *Chuang-huang-chih* justly remarks: "There are moments as dangerous as if you were approaching a hidden pit, or were to tread on thin ice" (cf. Chapter VIII).

In the same chapter of the *Chuang-huang-chih* it is pointed out that whether the old backings can be taken off easily or not largely depends on the material they are made of and on the paste used.  Backings made of thick paper are as a rule most difficult to handle.  The thin material of the original in course of time becomes cemented so firmly to a backing of thick paper that, when the latter is taken off, it is almost unavoidable that parts of the original come off together with it.  In Chapter XLII of the *Chuang-huang-chih* it is remarked that *lien-ch'i* paper reacts is such a way and that therefore paintings mounted with this material, for all practical purposes can never more be remounted.  As the *Chuang-huang-chih* is very explicit on this subject of taking off the old backings of a scroll, the reader is referred for further details to Chapters VIII and XLII of the translation.

Here it may be added that, as a rule, old Chinese backings are more easily removed than those stuck on by Japanese mounters.  As was pointed out on page 74 above, Chinese mounters generally employ for backing a scroll some variety of *hsüan-chih*, a paper of close texture which although thin will come off easily in large patches when the scroll has been properly moistened.  The *misu-gami* or *yotsuban-shi* used by Japanese mounters, on the contrary, being tough but of a rather loose structure, becomes as it were one with the original and must be peeled off fragment by fragment.  The reader may see this for himself by making experiments with the samples of Chinese and Japanese backing provided in Appendix V.

Further, if the picture was done on laminated paper, the mounter after having removed the various backings will also take off the superfluous layers of paper from the reverse of the painting itself.  As will be remembered, Chinese mounters when mounting for the first time a painting done on laminated paper only take off two or three layers. It goes without saying that taking off layers of the picture itself is a work more dangerous

even than removing its backings. During the Southern Sung period, therefore, the mounters working for the Palace Collection were instructed when remounting antique scrolls done on thick paper, to take off the backings only and leave the paper of the original intact (see below, page 212).

Generally the backings of pictures on silk are more easily removed than those of pictures done on paper. If a silk scroll is very badly damaged the mounter will take off all the backings save the last, since old silk is more fragile than old paper; if this last support were removed, the picture would fall to pieces.

Fakes produced by utilizing discarded layers. The sheets peeled off from antique scrolls that were done on laminated paper offer the professional forger a good opportunity for producing fakes.

When an artist works on thick paper the ink will penetrate all its layers. At first only the heavy ink and thick pigments will work through, and in the course of the years also the lighter brush strokes and washed colours. Thus especially the second and third layers of an antique scroll, if taken off with due care, will show in slightly faded lines an exact replica of the original brush-work. Falsifiers will touch up such discarded layers expertly, and properly " age " the paper. Thereupon they have the scroll mounted with old silk and paper and pass it off as an original.

Especially in the case of calligraphic specimens such fakes are difficult to detect. The seals impressed on the original will penetrate the paper also and provide the forger with exact copies which, if touched up with vermilion, will be identical with the genuine seal-impressions. Sometimes the condition of the surface of such a forgery will supply a clue; for the surface of a discarded layer inspite of sedulous polishing will usually remain fuzzy, and seldom obtains that smooth, old-ivory like shine of genuine old paper scrolls.

An indiscreet modern Chinese curio-dealer has described this method of producing fakes, as follows:

" Since the Ming dynasty, eminent calligraphers and painters all liked to use *hsüan-chih* (this paper was produced during the Hsüan-tê period of the Ming dynasty, hence its name); [1] this enabled forgers to practise the trick of producing ' peeled-off fakes '. For this paper is very tough by nature, while at the same time it is very thick; it is possible, therefore, to peel off several layers (viz. from the reverse. Transl.). These ' peeled-off paintings ', however, even when taken off by the most skilful of artisans, always will show a fuzzy surface, that does not appear on the original, while they are also much thinner than a genuine scroll. Further, all forgers who ' peel off ' paintings must necessarily first soak the original in water, and this soaking process will cause the colours to become dim and mouldy. It will prove expedient, therefore, to fix the colours

[1] This explanation is wrong. The term *hsüan-chih* refers to the famous paper manufacturing centre Hsüan-ch'êng in Anhui Province (cf. page 74), it is used already in T'ang sources and has nothing to do with the Hsüan-tê period of the Ming dynasty.

108

with an alum solution, before one starts to peel off the layers, paying special attention to the reds ". [1]

Sometimes the ink and colours will work through to the last backing of the scroll and become visible on the back of the mounting. An extreme case in shown in Plate **53**, a mounted silk scroll in my collection, dating from the Ch'ing period. A is a photograph of the picture itself, and B gives the back of the mounted scroll. It will be seen that the reverse shows a clear reflected image of the original. If an antique scroll has this feature it may be safely assumed that it has never been remounted before and that the mounting dates from about the same period as that during which the artist lived.

When the old backing has been taken off and when the picture has had time to dry, the mounter will sit down to study it at leisure.

*Second stage: preliminary examination of the scroll, and the washing process.*

If an outsider sees an antique picture in this stage lying on the mounter's table he will easily mistake it for a piece of waste paper, accidentally left there. For the scroll now is nothing but a crumpled up and soiled sheet of paper or silk, such a poor sight that one has difficulty in believing that it is really an old work of art. It needs the experienced eye of the mounter to recognize the beauty of the scroll even in this sorry state.

At this stage, however, the mounter is more interested in the defects of the scroll than in its charms. For he knows that as soon as he has located the defects and repaired them the beauty of the scroll will reassert itself on its own account.

First the mounter will ascertain the extent of the actual damage to the canvas on which the picture is done. Antique pictures usually have a number of holes and tears which although they do not show when the scroll is still mounted, at this stage are easily located by studying its reverse.

*Examination of holes and tears, and of the colouring.*

Former mounters, before adding the backing, will have patched up such holes by pasting on the reverse thin strips of paper matching in colour the part of the picture directly surrounding the damaged spot. It is by no means rare for an antique scroll to show several hundred of such patches. All of these the mounter will examine one by one.

Then the mounter will give special attention to the condition of the ink and the colouring. Most antique pictures are covered with a coat of grime that has darkened the colouring, often even obliterating parts of the drawing. The mounter must ascertain how this coat of grime is composed. If it consists simply of dust it will soon disappear later when the scroll is being washed. If, however, in this coat there occur patches

---

[1] *Ta-ku-chai-po-wu-hui-chih* (cf. Appendix I, no. 25), page 52:

揭畫法。

自宣故之來。善書畫者。莫不喜用宣紙（按是紙明宣德生造，故名）。於是偽造者其性極韌。書畫質極。以是紙造。書前明流傳。莫不喜用造。時一揭。其時又質極韌。

是其畫至勾水，必浸水。惟其精巧。而揭必水。故何無按水用先。層若層又遇先。數工上矣。凡必至手。雖甚浸之。前意焉。可論有原用未色。終比不故紅色。厚被表質者陰之。於揭面亦莫終。用揭之法。揭之終比不故紅。

of grease or if the pigments have become darkened by chemical reaction, such spots will later have to receive special treatment.

Further the mounter must study the ink. The excellent qualities of Chinese ink are such that as a rule the brush work in ink of an antique scroll suffers least damage by the passage of time. Yet in paintings or calligraphic specimens there frequently occur very delicate spots in the brush-work, faint traces where the brush was lifted off the paper or hesitated for a moment before sweeping out in a bold stroke. Such spots the mounter will fix in his mind for if proper care is not taken they may entirely disappear during the washing process.

Finally the mounter goes over the four borders of the scroll, examining them centimeter by centimeter. As was remarked above, antique scrolls are often badly cut down along the borders; it is the duty of the mounter now to ascertain whether he can not discover parts of old seals or traces of signatures in the narrow margin which when the scroll was still mounted, was concealed by the pasted-on frame. Even if only a small part of such seals and signatures remains, it will often be possible to reconstruct them.

Examining the scroll against the light.

Now comes the most important phase in the preliminary examination of the scroll. The mounter hangs it against a strong light and for a long time scrutinizes its reverse. This phase may well be compared with the X-ray examination applied by Western experts to antique oil paintings: it enables the observer to identify retouchings and later additions.

As was remarked above, old ink and old colours will have penetrated right through the silk or paper they were applied to and, especially in the case of very old scrolls, have become transparent. Ink and pigments added later, on the contrary, will remain as it were lying on the surface. When the painting is observed against the light such later additions and *pentamenti* will show darker than the original drawing. An exception must be made for the whites (both " shell white " *k'o-fên* 珂 粉 and " lead white " *hu-fên* 胡 粉), malachite green (*shih-lü* 石 綠) and azurite (*shih-ch'ing* 石 青), which are naturally so thick as never to grow transparent.

Not only in the case of paintings but also with calligraphic specimens it is advisable not to neglect the reverse. Unmounted scrolls or those backed with thin paper if genuine will usually show on their reverse the movement of the brush, which is less apparent on the obverse. On the reverse one will see exactly where the brush was freshly moistened, where it was firmly implanted on the paper, where it hesitated, doubled on its own track, or swept out in a broad stroke. As shown on Plate **54**, such details often appear on the reverse even without hanging the scroll against the light.

Faked autographs, and how they are detected.

In this way one may not only detect retouchings but also find out whether or not the entire scroll is a fake.

It has already been described how autographs may be forged by tracing rubbings. It goes without saying that an original autograph may be reproduced in the same way.

110

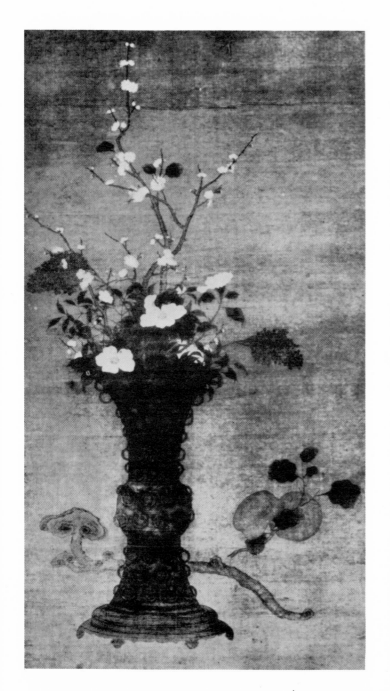 

53. – FLOWER PIECE IN FULL COLOURS ON SILK. A) THE PICTURE ITSELF; B) REVERSE OF THE MOUNTED SCROLL
(Author's Collection)

54. – CHI-I-CHAI 集義齋, WRITTEN BY A JAPANESE SINOLOGUE AND DEDICATED
TO THE AUTHOR (芝臺先生雅屬)

Unmounted paper scroll, front and reverse. 84 by 36 cm.

There are not a few dealers who when they have obtained an autograph of a famous old scholar, prepare three or four copies for their own use before exposing the original in their shop. Selecting a sheet of thin old paper of good quality, they spread it out over the original and trace the outlines of each character with a fine brush. Thin ink is used, so that the tracings are barely visible. Thereafter these outlines are filled up with good old ink, and the copy is ready to be presented as an original.

The seals of the original are also imitated with great skill. One method is to trace them with vermilion that has been mixed with fine oil instead of with water. The oil will run, and create a thin circumference round each line of the legend, making such a traced seal resemble a genuine impression in a remarkable way. If the writer of the original was a very famous personality, unscrupulous dealers will often deem it worth while to have the seals of the autograph re-cut in stone, as they may come in useful on some future occasion. Forged seals.

For copying an old seal the forger does not need the aids of modern science. The original seal impression is traced on a piece of thin but tough paper. This is pasted face downwards on a blank seal stone and a professional seal engraver is ordered to cut the seal exactly according to the design on the paper. If such a seal is then impressed on the fabricated scroll, using old seal vermilion — which can be obtained in the trade if one is prepared to pay a considerable price — it is hardly possible to distinguish it from a genuine one.

Scrolls faked in such a way can be detected by studying the reverse rather than by comparing the seals or the style of the calligraphy. Importance of studying the reverse of a scroll.

When seen on the reverse, characters faked by the tracing-process will show one solid mass of black instead of the typical alternation of black and grey that on genuine specimens marks the movement of the brush.

In applying this test, however, much discretion must be exercised. It must be remembered that, as Chinese literary sources inform us, the early painters and calligraphers used ink that was much thicker than that of subsequent periods. It is because of this fact that many genuine antique calligraphic specimens when observed on the reverse show characters so dark that the movement of the brush is hardly visible, giving them the appearance of traced copies.

On the other hand there are in Peking some experts who, being no mean calligraphers themselves, are able to produce copies of calligraphic specimens that are practically impossible to recognize as such. They use the following method.

Having traced the outlines of the characters in the way described above, they thereafter write out on separate sheets of paper the text of the scroll again and again, making experiments with various kinds of brushes. At last they will have found out exactly what size of brush and what quality of ink the writer of the original had used, and what was the rhythm of his hand. Then, using the traced outlines as guide posts, they will re-write the text on the sheet of thin paper originally prepared. Such fabrications cannot

**III**

be discovered, even when scrutinized on the reverse. They are so perfect that, in my opinion, one who buys such a copy at the price of an original, need not consider himself to have been cheated. It is thanks to the labour of such high–class copyists of former centuries that we can still study rare autographs by ancient masters, the originals of which have been lost since hundreds of years.

Some calligraphic characteristics of tui-fu.

Chinese calligraphers generally do not use ruled paper. This is employed only for copying out longer texts in small characters, for writing letters, and for writing in some archaic style, for instance " seal script " or " chancery script ". When writing large-size calligraphic specimens to be mounted as hanging scrolls expert writers do not need any rulings. A practise of scores of years enables them to cover large sheets with hundreds of characters, in even rows and all perfectly spaced, without the assistance of any lines or rulings to guide the brush.

When, however, a calligrapher writes a so–called *tui–fu*, an antithetical couplet on a pair of long, narrow vertical scrolls, the laws of symmetry require not only that the row of five, six, seven or more characters on either scroll be evenly spaced, but also that the spacing of both scrolls is exactly identical. Since many centuries, therefore, calligraphers before starting to write a *tui–fu*, first will fold both strips of paper in a certain way, so that when writing they have a pattern of fold marks to serve as guide-posts.

Suppose that each half of the couplet counts, for instance, five characters. Then the writer first folds over both ends of the scroll so as to obtain an upper and lower blank margin; the upper margin is slightly broader than the lower, in order to conform to the ancient *t'ien–ti* proportion. Then he folds up the strips accordion–wise, in such a way that the space between upper and lower margin is divided into five equal parts. When both strips have been thus folded up, he again folds them diagonally; see Plate **55** A. When now he unfolds the two strips the marks left by the folds will show exactly what space is allotted to every single character and where the centre of every character lies, viz. where the two diagonals cross (see Plate **55** B). Having smoothed out the paper he now can start writing. When afterwards these scrolls have been mounted, the fold marks will have disappeared completely.

In the case of tough and thick paper it is difficult to smooth out the fold marks perfectly before one starts writing. Thus some strokes will show breaks in those places where the brush met a stubborn fold. This will happen especially when writing in the cursive " draft " style where the movement of the brush is swift and light (see Plate **55** C). When writing characters in the regular, chancery or seal style, such breaks are less liable to occur, for since this style requires a slow movement, the brush is firmly implanted on the paper for every single stroke.

The breaks in the strokes caused by the fold marks are not considered as marring the calligraphic beauty of the script. But forgers copying such a scroll either do not realize the cause of such breaks, or they feel anyhow that they should be corrected. So these breaks supply the connoisseur with a criterium for deciding whether a scroll is

B                                    C

55. – METHOD FOR FOLDING A STRIP OF PAPER PRIOR TO WRITING A *TUI-FU*

113

authentic or not. If one sees two pair of *tui-fu* which are exactly identical, except for the fact that one pair shows some breaks in the strokes while the other does not, one can safely say that the former is genuine and the latter a forgery.

Heavy ornamental papers (see Appendix V, nos. 14, 15 and 16) are never folded, for in the case of these papers the fold marks will show even after the scroll has been mounted. Here the folding system is not practised. Instead one rules the scroll by applying to it a piece of string which has previously been dipped in white powder. After the characters have been written and the ink has dried, the white powder lines are brushed off.

Since the Ming period there have been obtainable in the paper trade pairs of blank scrolls of coloured paper, especially made for writing *tui-fu*. These scrolls are imprinted with an ornamental design, which supplies the writer with guide–posts, the space to be occupied by each character being indicated by, for instance, a large round flower motive, or some other design that is easily distinguishable. Plate **56** gives an example of such a pair.

In these cases one need not look for traces of fold marks, for the paper was never folded at all.

*Washing the scroll.*　　　After this digression we return to the remounting process. When he has carefully examined the reverse of the scroll the mounter may proceed to cleansing the scroll by washing.

From ancient times washing has been considered an indispensable phase in the process of remounting. On page 149 the reader will find how the T'ang writer Chang Yen–yüan describes this process; page 188 quotes the Sung connoisseur Mi Fu on this subject, and both the *Chuang–huang–chih* and the *Shang–yen–su–hsin–lu* devote a special discussion to it, respectively in Chapter VII and Chapter I.

Here I only translate a passage from a late Ch'ing source [1] which gives the following instructions:

" The washing of old autographs and paintings.

" One spreads the scroll out on a flat table, and moistens it evenly by sprinkling it with water. When along all four sides the scroll has become firmly stuck to the table, you take a sieve made from horse–tail hair, and sieve lime [2] with cold water till you can cover the scroll with a layer of this mixture, having the thickness of a copper coin. Then you again sprinkle the scroll with water, and cover it with a layer of a sieved mixture of lime and *tsao–chia* juice. Having waited a little while, you rinse the scroll clean with lukewarm water. If it should then still show dirt and stains, you should dab these with a piece of lamp wick (see below page 328), and then it will be perfectly clean. If there are ink stains on the scroll, you should leave the layers of cleaning mixture (mentioned above) longer on the scroll, and thereafter rinse it with lukewarm water ". [3]

---

1) The *Ku–chin–pi–yüan* 古今秘苑, a small *vademecum* for the householder published in 1890.

2) I take it that this is the meaning of *shih-mo* 石末, lit. "stone powder".

3) 洗舊書畫。將書畫鋪平案間。取水匀噴濕。復令四面平穩。用馬尾羅子。羅濕。又羅卓水衝温温淨。若寒莢灰起。如墨污水石灰末。如有污損。候一伏時。方以温温水衝之。末。如一錢厚。再以前。候片時。取燈草揩。須

56. – TUI–FU WRITTEN ON ORNAMENTAL PAPER BY THE VICE–ROY
LI HUNG–CHANG (1823–1901)
(Author's Collection)
100 by 22 cm.

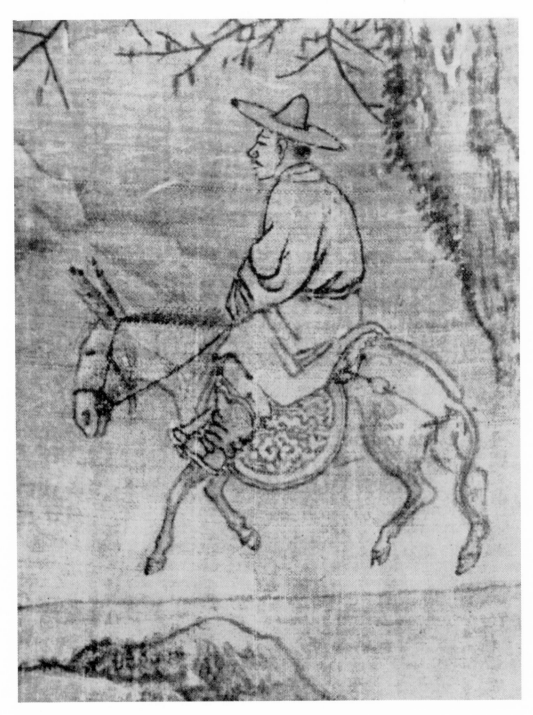

57. – RETOUCHED PAINTING
(slightly enlarged; original 15 by 12 cm.)
(Author's Collection)

As will be seen on the following pages where the methods for washing scrolls practised during former dynasties are discussed, this process has remained largely the same throughout the centuries. All authors writing on this subject mention the juice of *tsao-chia* pods. *Tsao-chia*, also written *tsao-chiao*, is the *Gleditschia horrida*. Its pods must contain some strong detergent, for since ancient times it is mentioned as being used also for washing clothes. The later Chinese term for "soap", *fei-tsao* 肥皂, is derived from the name of this plant.

Dangers of excessive washing.

One should be on his guard against excessive washing. The Sung connoisseur Mi Fu remarks that too much washing may destroy the beauty of a scroll, and a Sung document shows that the mounters in the Palace had strict instructions with regard to this subject (see page 212).

Except for paintings in the so-called *mu-ku* 沒骨 style, the charm of a Chinese painting rests mainly with the brush stroke. Here a deep black, there a grey so shallow as nearly to merge with the colour of the paper, now broad and heavy and round, now thin and sharp and crooked, these brush strokes constitute the life of a painting. If, when the scroll is being remounted these strokes should be blurred through excessive washing and if the ink nuances should disappear, then the scroll is robbed of all its expressive force. Many are the scrolls I have seen which, though doubtless once fine works of art, have become lifeless and flat because they have been inexpertly washed.

Therefore a good mounter, before washing the scroll, will go over in his mind the special features of ink and colouring that were studied during the preliminary examination, and decide accordingly if and to what extent the scroll should be washed and what should be the strength of the solution used for this process.

Third stage: repairing the texture of silk scrolls, and patching up holes.

After the washing has been completed, paper scrolls are left to dry thoroughly. In the case of old silk scrolls, however, the mounter will often find it necessary to repair the texture of the silk while the scroll is still moist. Antique silk scrolls nearly always show spots where through the carelessness of a former mounter the texture of the silk has gone awry. If such spots occur on an empty space in the painting they will not cause much harm and the mounter may leave them as they are. If, however, they occur in the brush work, in seal impressions or in inscriptions, the drawing or design will be distorted and correction is necessary.

Such parts of the silk are straightened out by means of a ladies hair comb, of the straight type called *pi* 篦. Applying the comb vertically to the silk so that the teeth catch the texture, the mounter moves it about gently, till the texture of the silk has been put straight again. As Chinese and Japanese ladies use combs of bamboo, wood or ivory, with much finer and stiffer teeth than those used by their Western sisters, the comb will grip the texture even of very closely woven silk. It goes without saying that this straightening out is a most delicate work that has to be done with infinite patience and care.

Now the scroll is spread out again face downwards, and the mounter proceeds with patching up the holes. In Chinese this process is usually referred to as *pu* 補, while in Japan it is called *tsukuroi* 繕.

With regard to this patching up a difference must be made between holes and bursts.

Holes occur in various shapes and dimensions; they may be caused by insects, tears, and all kinds of accidents. Bursts, on the other hand, occur mainly on account of climatic reasons. If an antique scroll is subjected to an abrupt change from moist to dry weather, fragments of the silk or paper may work loose from the backing and cause horizontal bursts. If these are not repaired immediately (which can be done without remounting the scroll), their edges will curl up further and further. And when the scroll is rolled up, these edges make break off and cause a long, narrow burst in the painting.

As genuine antique scrolls usually show traces of such bursts, falsifiers have deemed it useful to add these defects to the fakes they produce. These artificially-made bursts, however, can easily be distinguished. Natural bursts as a rule show a curved shape, while their edges rise slightly above the surface of the silk. They may be felt by rubbing them softly with the finger tips. Faked bursts, on the other hand, being produced by pulling the silk apart, are straight tears, and their edges can hardly be felt. Or, as the Ming scholar Wên Chên-hêng observes: " Genuine bursts in old silk always have the shape of a carp's mouth, and comprise three or four threads. Faked bursts are perfectly straight tears ". [1]  See for further details page 184 and page 186.

When going to patch up a scroll the mounter must accord special treatment to both holes and bursts. First he sets to work upon the holes.

Regarding the patching up of holes the *Chuang-huang-chih* in Chapter IX recommends the use of thin slips of paper or silk, of exactly the same colour and material as that of the picture itself, adding: " If the texture of the silk, or the thickness of the paper (for the patches) is ever so slightly different from that of the painting itself, then later the observer will notice that two different materials have been used ". If identical material cannot be obtained, Chinese mounters generally use a kind of silk or paper that resembles that on which the picture is done. Japanese mounters for smaller holes always use a tough, white paper, known as *uso-mino-gami* 薄美濃紙 (see the sample in Appendix V, no. 26), even for patching up silk scrolls. The patches are pasted on the reverse of the scroll so that when the new backing has been added the patches are firmly held between scroll and backing, and will not easily work loose. When the scroll has been put on the board to be retouched, the white spots of the patched up holes are tinted till they have the required colour.

---

1) *Chang-wu-chih* (cf. Appendix I, no. 30): 古 絹 自 然 破 者 必 有 鯽 魚 口。須 連 三 四 絲。偽 作 則 直 裂。

Whereas the holes are patched up when the scroll is dry, for repairing the bursts Repairing bursts. many mounters prefer to moisten the scroll; for then the edges of the bursts will become soft and pliable, and easier to paste down flat. Good mounters will add patches also to bursts *in statu nascendi*. Genuine bursts when repaired leave no trace on the scroll and need not be retouched later, except if their edges had been broken.

After the scroll has thus been repaired, the backing is added in the usual way. Fourth stage: adding the new backing, and retouching the scroll. Thereafter an extra backing is added to give the scroll a firm support. Now the scroll is put on the board, face to the front, being kept stretched out smoothly by the protruding edges of the backing.

Up to this phase the mounter could work continuously on the scroll. When the scroll has been put on the board, however, a long pause intervenes. While in some cases new scrolls can be taken off the board after a couple of weeks, a remounted antique scroll must stay on the board for at least one month. Old silk and paper are less elastic than new materials, while it takes a longer time for the paste applied to them to work out completely. Moreover the tinge of the scroll will usually tone down during the drying process so that the mounter can not touch it up before the colours have completely settled.

After the lapse of a month or so when the mounter is sure that the scroll will not work any more and that the tinge has become fixed, he may start retouching it; this work is called in Chinese *ch'üan* 全, in Japanese *iro-sashi* 色差.

The retouching usually takes a long time, especially in the case of badly damaged scrolls. For weeks on end the mounter will work everyday for half an hour or so upon the scroll, having near at hand a complete painter's outfit: brushes of all qualities and sizes, and various pigments. A mounter who is an expert in restoring antique scrolls will have in stock an extensive collection of old pigments, so that he can apply exactly the same colours as were used by the old master.

For the sake of convenience the working up of a scroll is here called " retouching ". Actually, however, two entirely different processes are involved which should be clearly distinguished. One is the colouring of the patched–up holes, and of those spots where heavy blotches of grime were removed, leaving the surface underneath lighter than its surroundings. On the necessity of the application of this colouring there can hardly be two opinions: it forms an indispensable part of the restoration of an antique scroll and in no way interferes with the work of the ancient artist. The other process, however, including the touching up of faded brush strokes and colours, and supplementing parts of the drawing that have disappeared through holes or tears, is a moot question.

The *Chuang-huang-chih* says: " When old paintings show spots where the drawing has decayed or faded, there is no harm in touching up the lines with the brush, using old ink; but for this work you should ask a great artist to apply his talent " (Chapter XII). If made to apply only to those parts of the brush work which although faded to such a

degree as to be hardly visible to the naked eye, are still exact traces of the artist's brush, one will readily agree with this statement. Observation of antique scrolls, however, clearly shows that this statement of the *Chuang-huang-chih* must be given a much wider interpretation; many are the antique scrolls that have passed through my hands where not only a few brush strokes, but entire scenes had been painted in by a later hand. Although it appears, therefore, that old Chinese collectors took a rather liberal view of this question, in my opinion one should strictly refrain from touching up the colours or supplementing brush strokes according to one's own fancy. This should not be done even if one has the good fortune to live in a Chinese artistic milieu where one can obtain the services of an expert; for all such additions are more than simple retouchings, they are falsifications. Nowadays this view is also taken by most modern Chinese collectors and museum officials.

Unfortunately many old paintings have been retouched in a clumsy way that has spoilt them forever. Plate **57**, for instance, shows a section of a Chinese hand scroll in my collection, an ink drawing on silk representing a travelling scholar with his retinue. It was a fine painting, dating from the beginning of the Ming period. The tinge of this scroll had toned down to a deep golden brown, and the drawing had faded considerably. Even so, when seen in a good light it still gave ample evidence of the artist's forceful brush work. Formerly, however, some misguided person tried to improve this painting by touching up the faded brush strokes, with disastrous results. The section reproduced here shows these clumsy retouchings in the upper part of the figure — the hat, face, and parts of the clothes. Although an expert mounter tried his best on this scroll, it proved impossible to remove these retouchings.

More expert retouchings are not so apparent. Sometimes they may be located by studying the scroll against a strong light, in the way described above; in other cases an experienced connoisseur may discover them because of minute differences in the handling of the brush. One must accept the fact, however, that old retouchings added by an expert hand are as a rule impossible to detect.

<span style="float:left; width:20%;">Importance of preserving the frayed edges of antique scrolls.</span>

During the process of retouching special care is given to the edges of the scroll. As was pointed out above, in the course of the centuries scrolls are often cut down badly along the borders. Antique scrolls when their " frames " have been peeled off, often prove to have jagged borders showing fragments of the design of the picture, or parts of seals and signatures. However small, such fragments may supply important clues as to the identity of the artist or to the design of the picture.

Conscientious mounters will always try to preserve such frayed borders. When the scroll has been put on the board to be retouched, they draw new borders round it which include the frayed edges of the painting. Thereafter they confine themselves to giving the required colour to those places where the white of the backing shows along the borders. Ordinary mounters, on the contrary, take the easier way of simply cutting off the jagged borders when they add the new

118

A     C

B     D

58. – HALVED
SIGNATURE

backing to the scroll, or, when adding the new "frame", conceal the borders by pasting the silk of the mounting over it.

How reprehensible this laxity is may be demonstrated by the accompanying figure (Plate **58**), showing a section of the left border of an antique scroll. A–b indicates the new border, drawn by an expert mounter. The fragments of the original thus preserved still suffice to identify the characters *Chêng-ming* 徵 明, the signature of the famous Ming scholar Wên Pi (文 璧, better known by his style Chêng-ming, 1470–1559). The line *c–d* shows where a clumsy mounter will draw the border, causing the signature to be lost for ever.

Now the work of remounting is practically completed. The scroll is taken from the board for adding the front mounting, in the same way as with new scrolls. A discerning mounter will select for the front mounting of an antique scroll some old silk or paper that harmonizes with the atmosphere of the picture.

Fifth and last stage: adding the front mounting, and the final backing.

Thereafter the final backing is added and the backed scroll is put on the board again, first face downwards, then face upwards. This stage need not last longer than a few weeks.

Finally the scroll is taken down and roller, stave and knobs are added. For the knobs old specimens should be chosen, as brand new knobs do not look well on an antique scroll.

\* \* \*

In order to demonstrate the process of remounting and restoring, I shall now briefly describe the work that was done on a Ming painting on paper in my collection.

(II) The process of remounting demonstrated on an actual example: a paper scroll from the Ming period.

When I obtained this painting in Peking it was in a very bad condition. It had apparently been remounted several times, finally as a panel of a folding screen. In this stage it had been bordered with cheap brocade. Finally it had been taken off the screen by cutting it out roughly along the four borders which only showed part of the pasted–on brocade. In this state the painting had passed from hand to hand, being rolled and unrolled carelessly so that when it was ultimately purchased by me it showed some bad creases and numerous holes where fragments of the paper had fallen off.

The painting represents the well known theme of the "Seven Sages in the Bamboo Grove", [1] *Chu-lin-ch'i-hsien* 竹 林 七 賢, treated in the conventional way; cf. the restored painting reproduced on Plate **60**, which measures 95 by 48 cm.

Description of the painting.

Seven scholars, robed in white, are sitting by the water–side in the cool shadow of a bamboo grove the rustling leaves of which fill the upper part of the painting. In the

---

1) For a description and analysis of this popular artistic motif, see my book *Hsi K'ang and his Poetical Essay* *on the Lute*, Monumenta Nipponica Monographs, Tokyo 1941.

119

centre of the picture one sees six of the sages; on the left two are reading poetry, the pair in the middle are engrossed in a musical performance, a third is listening, supporting himself by the slender stems of the bamboos, while another is reclining leisurely on the grass. In the foreground a brook winds its course among moss covered stones. The seventh scholar is standing on a stone slab that serves as a bridge and, thoughtfully stroking his beard, surveys the scene before him. To the right a servant boy is fanning the tea stove, another is bringing an armful of rolled up scrolls to the group in the centre, and on the extreme left a third servant boy is carrying a book.

On the top left there appears a date: *Hsüan–tê–ping–wu–ch'iu–pa–yüeh–hsieh* 宣 德 丙 午 秋 八 月 寫 "Painted in the 8th moon of autumn, 1426". To the left one would expect the artist's signature, but this has disappeared.

This picture has fared badly. The accumulated dust has degraded the clusters of bamboo leaves to solid patches of black, and the entire scroll has become darkened to such an extent that one has difficulty in discerning the design (see Plate **59**). Moreover the surface shows a multitude of holes and tears; some of the older ones have been patched up by a former mounter, others are crudely painted over; others again are of more recent date, and show the yellow backing of the scroll. A clumsy amateur has tried to touch up the faces of some of the figures, but fortunately left the noble folds of the robes intact. The white of these robes, however, has become stained irregularly by patches of grease and dirt, and the water course and its stone banks have disappeared in one greenish brown mess. To make matters worse, when this scroll was mounted on the wooden frame of the screen panel, it was backed with a very thick laminated paper, that had been stuck to the old backing. Thus, when the dismounted scroll was unrolled and rolled, this stiff backing caused some ugly creases to appear on its surface. Despite all these defects, however, one glance suffices to show that this is a good painting that is well worth being entrusted to an expert mounter to be remounted and thoroughly restored.

It must be stated at the outset that to have a scroll expertly restored is, by Oriental standards, not a cheap undertaking. One may have the mounting changed and some of the most essential repairs executed for a few dollars. To have an antique scroll really restored, however, will cost the equivalent of hundred American dollars or more. Therefore it is wasting the mounter's time and the owner's money to have inferior scrolls restored. If, on the other hand, one has the good fortune to obtain a superior scroll, then no matter how badly it is damaged, it is worth several times the cost of remounting to place it in expert hands, and to have it restored to its former glory.

The following is a description, stage by stage, of how the scroll of the " Seven Sages of the Bamboo Grove " was remounted and restored.

First stage: taking off the old front mounting, and the old backing.

Since the only part of the front mounting left to this scroll was a narrow border of pasted–on brocade, it seemed that the first stage of the remounting process, viz. taking off the old front mounting, would not present special difficulties. When, however, as an experiment a small part of the brocade near the lower left corner had been loosened,

120

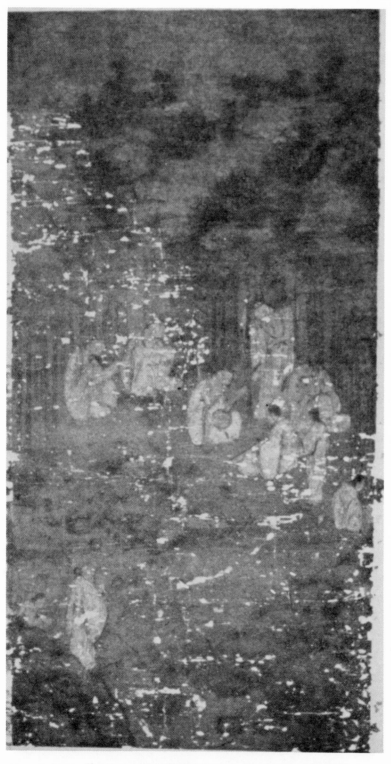

59. – " THE SEVEN SAGES OF THE BAMBOO GROVE "
STUCK TO THE DRYING BOARD AND BEING RETOUCHED

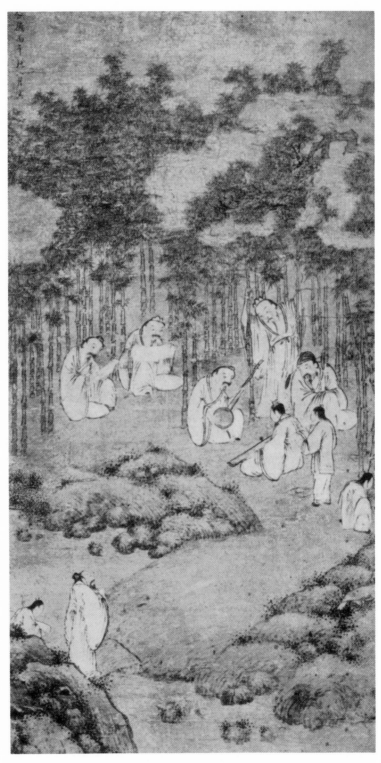

60. – " THE SEVEN SAGES OF THE BAMBOO GROVE ",
AFTER HAVING BEEN REPAIRED AND REMOUNTED

it appeared that the pasted–on brocade concealed a frayed margin of the painting itself measuring about half a centimeter (see Plate **59**). Therefore the brocade had to be taken off with great care, centimeter by centimeter, in order to preserve intact all fragments of this jagged border.

This proved to be a considerable task, the accomplishing of which took the mounter one week working on it, on and off. His labour was well rewarded. In the beginning the fragments that came to light showed only insignificant details of the drawing. But when he had removed the brocade from the upper left corner, there suddenly appeared by the side of the date the artist's signature, reading: *Ch'ien–t'ang Tai Chin* 錢塘戴 進. Now Tai Chin, styled Wên–chin 文進, a native from Ch'ien–t'ang in Kiangsu Province, was a well known artist famous for his copies of Sung paintings, who lived during the earlier half of the Ming period. Even his seals now appeared, although nothing more was left of them than two indistinct patches of red.

The removal of the old backing also proved far from easy. The last backing of stiff paper mentioned above was extremely recalcitrant. It refused to be taken off in larger patches and had to be peeled off fragment by fragment. Underneath it the mounter found two backings of an earlier date. Having taken off one, he deemed it advisable to leave the other; for, since the painting was badly damaged and since the paper had grown brittle with age, he feared that if this last support were taken away the scroll might fall asunder. As it was, the removal of the new and old backings took well over a week.

When the scroll had dried, it proved to be so thin as to be transparant even without being hung against a strong light. Now it appeared that the damage it had suffered was greater than anticipated.

Second stage: preliminary examination and the washing process.

The huge dark blots among the bamboo foliage turned out to be so many holes in the painting, while in other parts there came to light hundreds of larger and smaller holes that had first escaped the eye because they had been covered with grime. On the other hand, the retouchings added to the faces of the figures were now found to be less important than they had seemed. Scrutinizing the scroll against the light, it appeared that some former mounter first had covered the faces with a coat of greyish paint, and drawn over it the faces as he thought they ought to be. Under this coat of grey paint, however, the original drawing, though vague, was still discernible enough to justify, during the process of retouching, a tracing up of the old lines.

The worst hole occurred right in the middle of the painting, across the face of the person supporting himself by the bamboo stems: here part of the original had disappeared. The hole had been patched up from behind by a former mounter, who had not tried to supplement the missing part of the drawing, but simply coloured the hole dark brown. As a portion of the original was thus entirely lost, the mounter feared that this defect, occurring in such a conspicuous place, would have to remain unrestored. As will be shown below, however, through a lucky coincidence his fears proved later to be unfounded.

121

The mounter then considered whether this scroll should be washed. Since it was badly damaged and the paper thin and fragile, he deemed an application of the ordinary washing process too dangerous and resolved to follow a medium course. The scroll was spread out on the table, face upwards, and moistened by going over it repeatedly with a large, softhaired brush dipped in clean, tepid water. When it had been thoroughly soaked the mounter took a clean sheet of thick, unsized[1] white paper and, having smoothed it out over the scroll, left it there for about a quarter of an hour. After brushing the sheet with a dry, hard brush, he replaced it by a new one. When this process had been repeated about a dozen times, most of the grime had disappeared. Then, when the scroll was still moist, some heavy blotches were carefully scraped off with a sharp bamboo spatula. In the same way the mounter removed the coat of grey paint that had been laid over the faces of the figures. Having applied this process to the face of the central figure he had an agreeable surprise. Before the missing fragment had fallen off, the ink had had time to work through to the first backing of the scroll, so that a calque of the missing part of the original drawing was still faintly visible. Through this fortunate coincidence this part of the picture could later be completely restored.

At the same time the mounter made another discovery. On top of the painting, right in the middle, there now came to light the outlines of a large red seal, measuring about eight centimeters square. The legend had disappeared but the size and location of the seal (see page 132 below) left no doubt that this was an Imperial seal, proving, or at least making it probable, that at some time or other the painting formed part of the Palace Collection. On Plate **60** this faint outline is not visible.

After the cleansing process had been completed, the white of the robes of the figures still showed some dark blotches. Now blotches on a white ground should never be scraped off, for then the original pigment will disappear together with the blotch. The mounter therefore painted these parts with a weak soda solution and, having covered them with ordinary blotting paper, he pressed it to the scroll by rolling it with a heavy round stick. When, after the lapse of a few hours, the blotting paper was taken away, the spots of dirt had disappeared. [2]

Third stage: patching up the holes.

Before starting on patching up the holes, the mounter first removed all the old patches. The scroll was spread out on the table face downwards and soaked with clean, tepid water; soon the old patches could be removed one by one with spatula and tweezers. It now appeared that the large holes among the bamboo foliage had, at an early date in

---

1) For this purpose one should never use sized paper which contains alum and glue; it does not absorb moisture well and fragments of the picture might become stuck to it and cause considerable damage.

2) Not a few antique scrolls are damaged by mould. Formerly stains caused by mouldy patches could not be removed but nowadays modern-minded mounters will treat antique silk scrolls with formaldehyde vapour, and mouldy paper scrolls with thymol. Japanese mounters sometimes use oxalic acid or permanganate; the affected spots are painted over with a weak solution which is afterwards removed with blotting paper. Cf. the article by the modern scholar Chiang Hsüan-i described in Appendix I, no. 59.

the history of the scroll, been patched up with very fine silk. This had been a gross mistake for, as this material gathered more grime than the paper of the surrounding surface, the holes soon became much darker than the rest of the scroll. Nor can this silk have looked well at the time when the patches were new.

When the old patches had been removed, the mounter started patching up all the old and new holes and tears, using diminutive slips of a thin, but very tough, white paper. I do not know how many smaller and larger holes this scroll showed, but there must have been at least several hundred. The mounter worked on them for one month, giving every day half an hour or so to this task.

When the patches had dried thoroughly, the mounter added the new backing in the usual way, choosing a superior kind of *hsüan–chih*, known in the paper trade as *mien– lien* 棉 連 (see the sample in Appendix V, no. 5). Thereafter he added two extra-backings, to give the scroll a firm support, and ensure that in course of time the patches would not work loose. Then the scroll was put on the board face upwards, and left there for two weeks, after which it was taken down and put up again with the face to the board, this being repeated from time to time for one month. During this time the mounter did not work on the scroll.

Fourth stage: adding the new backing, and retouching the scroll.

After that the scroll proved to have brightened up to a considerable degree. Its colour had changed from a dark–brown to an old-ivory tinge, dark enough to give the painting an agreeable antique appearance, yet light enough to make the drawing appear to its full advantage. Since the entire surface was defaced by the white spots of the patched up holes it was still impossible to form an opinion as to the artistic merits of this scroll. Yet the experienced eye of the mounter then already told him that when the process of restoring would have been completed, his work would prove to have produced good results.

In the meantime the scroll had completely dried. Now the mounter set to work on retouching the scroll, still leaving it on the board.

As the pigment for colouring the white patches had to match exactly the general tone of the scroll, it took the mounter a long time to prepare it. After some experiments he finally decided on an ochre mixture. When the missing portions of the bamboo foliage had been tinted with this pigment they proved in no way to diminish the charm of the picture: at first sight they appear as clouds or mists drifting among the bamboo. An attempt at painting in the missing parts of the foliage would doubtless have had disastrous results.

Further, the stems of the bamboos, and the folds in the robes of the scholars were touched up lightly, and the faded original drawing of the faces was worked up with a very thin brush, tracing exactly the faint strokes left by the artist's hand.

The mounter had planned the new borders of the scroll in such a way as to include all the protruding fragments of the jagged borders, especially on the left side of the scroll. The right side showed only one larger fragment, near the boy servant with the tea stove;

123

since it did not show a single brush stroke, this fragment was not spared. Its inclusion would have meant that a blank margin would have had to be added along the entire right side of the picture, and this would have marred its artistic effect. I have, however, recorded in my notes on this scroll the width of this fragment, as a clue to the original breadth of the painting. The mounter finally cut it off and used it for patching up a few larger holes in the scroll itself. Expert mounters will often utilize in this way fragments cut off along the margins.

As two–thirds of the artist's signature showed clearly, the mounter proposed to supplement the missing parts. I asked him to refrain from this for, if the opportunity should arise, I wished to compare this signature with other specimens of Tai Chin's handwriting.

Thus the scroll was restored without adding one single stroke that was not authorized by the artist's brush. Yet, as Plate **60** shows, this method had a satisfactory result. Even an outsider will notice at once that this is a badly damaged scroll; but its artistic value has remained unimpaired.

<div style="margin-left:0"><em>Fifth and last stage: adding the front mounting, and the final backing.</em></div>

With regard to the last stage I can be brief. Trying to follow an early Ming style, I had the scroll mounted with a broad " frame " of antique brocade of light brown colour, with a faded design in gold thread. No *yin–shou* or *ko–chieh* were added, *t'ien* and *ti* of plain brown silk being directly attached to the " frame ".

It remains to add that my mounter worked on the restoration of the " Seven Sages " scroll on and off for five months. The cost was at that time (1940) the equivalent of 80 American dollars, an insignificant sum compared with the enormous amount of time and labour involved, and the excellent result that was obtained.

<div style="margin-left:0"><em>Heavy responsibility of the mounter of antique scrolls.</em></div>

Finally it may be remarked that, as was seen above, two important discoveries were made during the remounting of this scroll, namely the signature and seals of the artist, and the impression of the Imperial seal. That such essential features are brought to light by the mounter is by no means rare: the old front mounting and backing of nearly all antique scrolls conceal some features of the original which are revealed only to the eye of the remounter. It is therefore no exaggeration to say that one can know an antique scroll thoroughly only if one has seen it when being remounted.

For this reason one should entrust the remounting of a valuable old scroll only to a mounter whom one knows well and who will faithfully report not only all concealed merits, but also all unsuspected defects that he may discover during the process of remounting.

It also follows that having bought an antique scroll the mounting of which is soiled or torn, it is not advisable to agree to the proposal often made by the curio dealer who sold it that he should have it remounted. For then the dealer will employ for this work his own mounter who will execute hints given by the dealer and do his best to gloss over all defects. It is much better to buy a scroll as it is and afterwards place it in the hands of one's own mounter.

124

* * *

The above description of the work done on the scroll of the " Seven Sages in the Bamboo Grove " illustrates some of the more important problems that arise with regard to the remounting of antique hanging scrolls. There remain a number of minor questions that could not well be touched upon in the frame of the above description. Those points are taken up one by one below.

Some minor questions relating to the remounting of antique hanging scrolls.

Since the scroll of the " Seven Sages " was taken off a screen it did not have any old title label attached to it. Antique hanging scrolls mounted in the usual way nearly always have such a slip pasted on to their backing, alongside the upper stave.

Preservation of old title labels.

The title labels are usually made of some ornamental paper; for a few samples of paper commonly used for this purpose see Appendix V, nos. 17–19. Next to the title of the scroll these labels often also bear short notes by former collectors, as, for instance, the date on which the scroll was entered into their collection, brief appreciative remarks, a few words on the artist, etc., or show impressions of their seals. When the scroll is remounted the mounter should be instructed not to throw away its labels together with the old backing but to peel them off with care. When the scroll has been remounted the old label should be pasted on to the new backing. Hence one need not be astonished to find a label with, for instance, an early Ch'ing date, on a modern mounting.

If a title label is inscribed by a famous connoisseur or by a well known calligrapher, the slip is often not pasted in its usual place on the reverse of the scroll, but included in the front mounting: a patch the size of the label is cut out from the silk, and the label inserted there. In collector's catalogues, labels inserted in the front mounting are referred to as ch'ien-cha 嵌札 " inlaid slips ". Their usual place is on the right side of the painting, in the upper part of the " frame ". Sometimes however, such slips are also found on the left, in the lower corner of the " frame ".

Old collectors sometimes wrote longer comments on the backing of a scroll. In China this custom seems to have fallen in disuse during the beginning of the Ch'ing period, but in Korea it is still much practised. When such a scroll is remounted, the inscribed part of the backing must be carefully loosened, to be added afterwards to the new mounting. If the text is long, it may be pasted on to the new backing; if short and of suitable size and content it may also be mounted on the front side, directly above the painting itself, as a shih-t'ang. Properly, however, the text of a shih-t'ang should be written on a sheet of ornamental paper and agreeably harmonize with the scroll itself in size and calligraphy.

Comments written on the backing of a hanging scroll.

In China a mounted hanging scroll offers few other opportunities for adding comments. Longish colophons are sometimes written directly on the silk of the front mounting, usually on either of the vertical strips of the " frame ", on the lower ko–chieh,

Comments written on the front mounting.

or on the *ti*.  In catalogues such inscriptions are generally referred to as *piao–ling–t'i–pa* 裱綾題跋 " superscriptions and colophons on the silk of the front mounting ".

Although such inscriptions often contain valuable data, I agree with the view expressed by the Ch'ing connoisseur Chou Êrh–hsüeh, who calls the adding of such inscriptions *chieh–tzŭ* 疥字 " smirching with characters "; [1] for such additions will often spoil the effect of the mounting.  When one has such a scroll remounted, it is better to have the inscribed part of the front mounting pasted on to the new backing.  Thus such a comment is preserved together with the scroll without diminishing the effect of the new front mounting.

<span style="float:left">Boxes of antique scrolls.</span> Formerly Chinese connoisseurs placed each of their more valuable scrolls separately in a hard–wood box, to protect them against insects and other dangers.  As early as the T'ang dynasty a literary source mentions scroll bags, [2]  while the Sung connoisseur Mi Fu frequently refers to them. [3] Further we know that, during the Southern Sung period, the scrolls of the Imperial Collection were kept, several specimens together, in large wooden boxes, lacquered red. [4]

During the T'ang period single hand scrolls containing collections of poetry were placed also in wooden or bamboo tubes, provided with an ornamental lid; such containers are known as *shih–t'ung* 詩筒 " poetry tubes ".

Curious containers made especially for Buddhist sûtra rolls are the so–called *ching–t'ung* 經筒.  These are round bronze tubes, standing upright on an ornamental base.  Each tube contains one sûtra roll; when this has been put in it, the tube is closed with a tightly fitting bronze lid.  These *ching–t'ung* were used for burying sûtra's underground as a pious deed, to ensure the Buddha's words being preserved for posterity.  In China this custom seems never to have been very popular, but in Korea and Japan excavations have brought to light hundreds of *ching–t'ung*, dating from the 7th–10th century.

The Ming scholar T'u Lung gives the following description of boxes of antique scrolls, and how they should be taken care of.

" Boxes for keeping scrolls ", he observes, " should be made of cedar wood.  On no account should you apply lacquer to their inside or line it with pasted–on paper, for this will cause mould on the scroll.  When the hot season draws near you should first unroll your scrolls, and while enjoying them, let them be aired and sunned for a short while.  Then you should place the scrolls in their boxes and paste paper over all the openings, so that the boxes become air–tight.  These boxes should be stored away in a lofty, well–aired room, or on a high shelf, more than one fathom from the floor; further it is advisable to choose a room where people live. [5]   The

1) Cf. *Shang–yen–su–hsin–lu*, page 329 below.
2) Cf. Chang Hai-kuan, quoted on page 140.
3) Cf. *Shu–shih*, quoted on page 185.
4) Mentioned in the *Yün–yen–kuo–yen–lu*, as quoted on page 201.
5) The continuous presence of people in a room

is said to prevent mould from forming on scrolls; cf. the *Chuang–huang–chih*, chapter XXXI: " When you have made such a card board album you should not fail to remember to store it away... in a place which is near to human breath... In this way you prevent your album from becoming mouldy ".  Cf. also pp. 184, 187, 307, 464.

126

61. – CHINESE HAND SCROLL IN CHINESE WOODEN BOX
(Freer Gallery of Art, no. 34. 1)

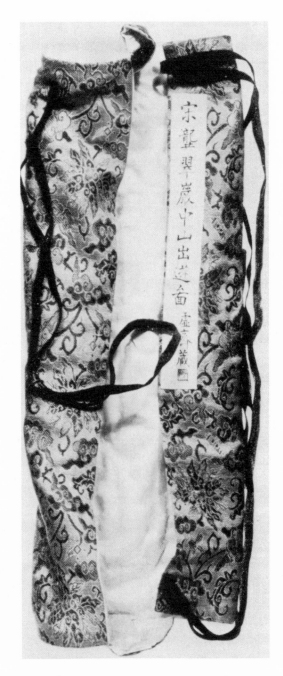

62. – CHINESE BROCADE WRAPPER
OF A HAND SCROLL
(Freer Gallery of Art, no. 38. 4)

boxes may be opened again only when summer is over. In such a way your scrolls never will become mouldy ". [1]

I have seen many examples of Ming scrolls preserved together with contemporary wooden boxes. The boxes were made to measure and had sliding lids for covers, with the titles of the scrolls engraved in them. The wood had acquired a beautiful shine, and the inside was lined with yellow silk. Probably the idea of this yellow lining was to frighten away the insects that might be attracted by the smell of the paper and paste. Occasionally I have also seen Ming scrolls placed in contemporary cardboard boxes, covered with heavy brocade and resembling book covers in construction (see below page 221), only their fastening pins were much larger than those of book covers and made from jade and ivory, elaboratedly carved.

During the Ch'ing period collectors used for their single scrolls, pairs, or sets of four or six scrolls, specially made wooden or cardboard boxes. Wooden boxes are made of a material showing an interesting grain, and the title of the scroll is engraved on the cover. On Plate **61** one sees a hand scroll — the same that is shown partly unrolled on Plate **19** — in its wooden box; note the band wound round it and the fastening-pin of carved jade. On the left the cover of the box with the title of the scroll engraved on it. Since collectors there often add also their seals and signatures, such boxes are of importance to the connoisseur. Cardboard boxes are on the outside covered with blue cloth, the common material for making book covers (see the sample in Appendix V, no. 20), or occasionally also with silk or brocade. On the inside they are lined with padded silk just like the boxes used for all kinds of other antiques, such as bronze vessels, vases, bowls etc. Chinese box makers are very clever in modelling the padded lining so as to fit exactly the shape of the object for which the box is made.

For a number of smaller scrolls connoisseurs often use wooden boxes with trays, each tray offering space for four or five scrolls. Such a box is described in detail by Chou Êrh-hsüeh (see below, page 335). For larger scrolls one prefers solid wooden cupboards or heavy chests.

Each more valuable item is placed in a silk or brocade bag with a silk title label stitched on to it. Such a cover of brocade, lined with white silk, is reproduced on Plate **62**; the title label gives the title of the scroll and the signature and seal of the modern collector P'ang Yüan-chi (龐 元 濟, lit. name Hsü-chai 虛 齋), in Shanghai. During the Ch'ing dynasty, valuable scrolls in the Palace Collection were often wrapped up in square pieces of antique brocade, with their title and other details inscribed on the white silk lining. Such a wrapper is reproduced on Plate **63**. The outside is of brocade with a Buddhist design in brown on a white ground, the inside of white silk. The inscription gives the title of the scroll, its classification as " superior " and its serial num-

---

1) *K'ao-p'an-yü-shih* (cf. Appendix I, no. 29): 以　　紙 封 口。勿 令 通 氣。置 透 風 空 閣。或
杉 桫 木 爲 匣。匣 內 切 勿 油 漆 糊 紙。　去 地 丈 餘。又 當 常 近 人 氣。過 此 二
恐 惹 黴 濕。遇 四 五 六 月 之 先。將 書　候 方 開。可 免 黴 白。
幅 幅 展 玩。微 見 風 日。收 起 入 匣。用

ber; then the note: " Classified on Imperial Command by Chang Chao (1691–1745) and others, in the spring of the year 1744" 乾隆九年春月臣張照等奉勅編次.

Boxes of Japanese scrolls.
In Japan wooden boxes are in universal use; the great majority of the scrolls both antique and modern that one sees in collections, at sales, and in antique shops are each placed in their own wooden box.

That this old Chinese custom was faithfully retained in Japan and became more popular there than it had ever been in the home country must be explained by the peculiarities of the Japanese house. The Japanese house is built so lightly that it affords but little protection against the notoriously moist climate of the country. Since, moreover, the Japanese interior knows no heavy drawers or cupboards, wooden boxes were essential for the protection of the scroll which if left without would soon be covered with mould or eaten by insects. All the more so as those scrolls that do not happen to be exposed in one of the *toko–no–ma* of the house itself are kept stored away in the *kura*, which is never heated and remains closed during the greater part of the year. Therefore not only scrolls, but practically all antiques in Japan are kept in wooden boxes specially made for them.

These boxes, Japanese *hako* 箱, are fine specimens of joinery work; they are made by a special artisan, the *sashimono–ya* 指物屋, or cabinet worker. The most usual material is *kiri* wood (桐, paulownia imperialis), a light, finely grained wood that is used also for making musical instruments. In making such boxes not a single piece of metal is used: the boards are joined together with swallow tails, fitting to a hair, and by spikes cut from bamboo. The wood is usually left its natural colour but from early times till well into the Meiji period, especially the boxes in the collections of the feudal lords were often lacquered red, black or brown, and covered with gold and silver designs showing their family crests.

Comments inscribed on Japanese boxes.
These boxes offer to the connoisseur and the collector a welcome opportunity for writing comments regarding the scrolls they contain. Such comments, known as *hako–gaki* 箱書 " box inscriptions ", are to be found on top of the cover, inside the cover, sometimes also on the inside of the bottom of the box.

On top of the cover one will usually find the title of the scroll and the name of the artist, together with the name and seal of the owner. Such inscriptions take the place of those on the title labels pasted on Chinese scrolls; for in Japan such labels are rarely used. The inside of the cover is used for longer comments: a biography of the artist, an appreciation of the scroll, a note on how and when it reached the hands of the owner, etc. The inscriptions are as a rule signed and dated, the writer also adding the impression of one or two of his seals. The *kiri* wood supplies excellent material for writing, and it is planed so carefully that even seals can be impressed on it with the ordinary vermilion. The old lacquered boxes bear inscriptions in red, gold or silver lacquer.

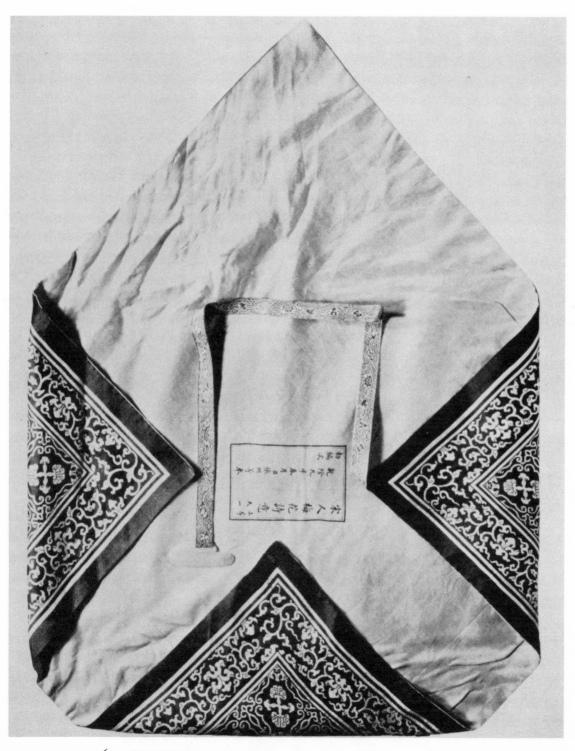

63. – SILK WRAPPER OF A SCROLL FROM THE PALACE COLLECTION
(Freer Gallery of Art, no. 31. 2)

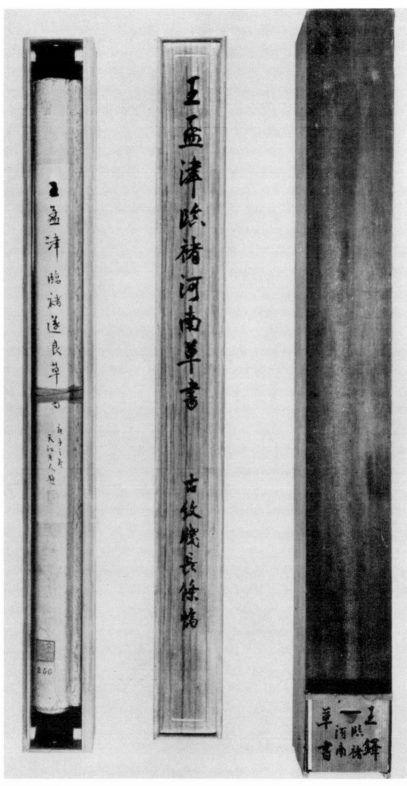

64. – CHINESE HANGING SCROLL IN DOUBLE JAPANESE BOX
(Author's Collection)

Since these boxes are made exactly to measure it is but very rarely that a scroll will fit into a box that originally was made for another one. One may, therefore, safely assume that in nine out of ten cases a scroll and box which fit, originally belonged together. If an antique scroll is remounted a new box is made for it. If the old mounting showed a title label, this may be transferred to the new backing, as is done in China, but it is also often pasted on to the inside of the cover of the new box. And if the old box had on top of the cover an important inscription, this inscribed part of the cover is neatly cut out, and inlaid in the cover of the new box.

It is for these reasons that Japanese connoisseurs attach the greatest importance to scroll boxes: at expositions, in museums and at sales the boxes are always shown together with the scrolls. Antique boxes bearing inscriptions by famous men are highly valued. To preserve the box intact it is again encased in a second one, fitting the first perfectly. The second box is again inscribed, and later often again placed in a third one. Thus in Japan it is quite common that valuable antique scrolls are encased in three or more boxes, the inscriptions on which enable the observer to trace back the history of the scroll for several centuries.

Plate **64** shows a Chinese scroll in a double Japanese box in my collection. On the left one sees the rolled up scroll in the inner box made of *kiri* wood; its title label pasted along the upper stave reads: " Copy by Wang To (王 鐸, 1592–1652; native of Mêng-chin 孟 津 in Honan Province) of an autograph in draft script by Ch'u Sui–liang (褚 遂 良, Duke of Ho–nan, 596–658) "; signed by the Japanese poet and Sinologue Ema Ten–kō (江 馬 天 江, 1826–1901), dated " winter of 1900 ": 庚 子 之 冬 天 江 老 人 題, and sealed by him. Below my own seal (高 羅 佩 藏), and the number the scroll bears in my collection. In the middle is the cover of the box with again the title of the scroll, and a brief description: " A long vertical scroll on antique ornamental paper " 古 紋 牋 長 條 幅. On the inside of this cover there is written a biographical note on Ch'u Sui–liang and Wang To. On the right, one sees the outer box made of *hinoki*, closed on one end by a sliding lid with the title of the scroll inscribed on it.

Although a box may supply valuable clues as to the authenticity of the scroll it contains, among the Japanese public there exists a tendency to overrate their importance. Just as in China it is often jocularly called one of the characteristics of the inexperienced amateur that he will look at the seals and inscriptions on a scroll before giving attention to the painting itself, so in Japan it is said that such a person will start studying the box before he has even unrolled the scroll contained in it.

Further the Japanese have the custom of placing in the box, together with the scroll itself, various written documents bearing upon the scroll and its artist; these documents are called *ten–jō* 添 狀, or *soe–gaki* 添 書.

Although considered as less important than the *hako–gaki*, these documents will often also contain interesting information. In former years they usually took the shape

of so–called *kantei-fuda* 鑑定札 " connoisseur's certificates ". These are narrow strips of stiff, ornamental paper, measuring about 18 by 2 centimeters. They bear the title of the scroll and the name of the artist, and are authenticated by half of the impression of the writer's seal. *Kantei-fuda* were issued by well known tea masters or painters who, as a side–line, appraised antique scrolls for a remuneration. They used to keep a register wherein they copied out what they had written on the *fuda* of each scroll that was given to them to be judged. Then, laying the *fuda* on the page of the register, they impressed their seal over both; thus half appears on the *fuda* issued to the owner, while the other half is preserved in the register. By consulting this register and comparing the seal halves, the authenticity of suspicious *kantei-fuda* could always be verified. [1)]

Old *fuda* issued by famous connoisseurs are highly valued. On the boxes of antique scrolls one often finds notices like: " Accompanied by a *fuda* issued by Mr. So–and–so ". Collectors wrap up such *fuda* in a sheet of ornamental paper and place it in the box together with the scroll.

Next to the *kantei-fuda*, boxes of Japanese scrolls may contain all kinds of heterogeneous documents, one may find there correspondence about the scroll between the owner and a connoisseur, tickets proving that the scroll was exhibited at such and such an exposition, a page torn from a sales catalogue giving the title and price of the scroll, passages copied out from biographical dictionaries, newspaper cuttings on the scroll or its maker, etc. etc. It goes without saying that the value of such documents varies greatly. Each case must be judged on its own merits, it being well to remember always that the most patent fakes often have scores of documents accompanying them, while a genuine master–piece may be found in an uninscribed box and without a single extra document.

Finally boxes contain as a rule also some silk satchels with incense or medicine, to keep away insects and lend an agreeable fragrance to the scroll.

\* \* \*

(III) The remounting of hand scrolls.

It is not necessary to describe here the process of remounting and restoring hand scrolls. It is the same as that applied to hanging scrolls: front mounting and backing are taken off, the necessary repairs are executed and the scroll is remounted with new materials.

There is, however, one problem peculiar to the remounting of hand scrolls, namely the handling of the superscriptions and colophons attached to them. In the first section of this chapter the main features of these additions to a hand scroll were already briefly touched upon. This question must now be taken up in greater detail.

1) For several years I have tried in vain to obtain such an old register of a Tokugawa connoisseur. People in Tōkyō informed me that the late Prof. Ernest Fenollosa had in his collection several such registers that had belonged to the Kanō family. It would be worth while to investi-gate whether these registers can possibly be located in some American library or museum. If published, such books would supply the student with valuable data on the history of Japanese and imported Chinese art.

When unrolling a hand scroll one first sees the inside of the protecting flap, usually consisting of some figured silk or brocade or some heavy ornamental paper. As the scroll is unrolled further, the superscription, *t'i* 題 or *t'i-tzŭ* 題字 will appear.

These inscriptions consist of a few large characters, usually four, and seldom more than eight, boldly written in some decorative calligraphic style, preferably "seal" or "chancery" script. Thus the calligraphy of a *t'i* closely resembles that of the *pien-ê* or horizontal tablet; as a matter of fact detached *t'i* of hand scrolls are not seldom mounted in the form of such tablets.

Choice ornamental papers are used as material for these *t'i*. The superscription is, as it were, a prelude; it must excite the interest of whomever unrolls the scroll and by its elegance prepare him for the impression to be created by the picture itself, bringing him into the right mood to enjoy its beauty. Great connoisseurs always tried to find rare and costly papers to serve as material for the superscription to be attached to their favourite hand scrolls. The famous Ming collector Hsiang Yüan-pien (項元汴, 1525–1590) employed for this purpose the priceless *chin-su-chih* (see below page 301 note 1), and many Ch'ing collectors attached to their more valuable hand scrolls ornamental papers of the Ming period.

Superscriptions on separate pieces of paper added to hand scrolls must be considered as having developed from those written by the artist on the picture itself, irrespective of it being painted in the form of a hand scroll or of a vertical hanging scroll. As is well known, since the T'ang and Sung dynasties painters before signing and sealing their finished pictures, often wrote in some appropriate place on the picture itself short inscriptions, giving the title of the scroll, or the poem that inspired them in creating it.[1] During the Ming period the adding of such inscriptions became a fixed custom, thus nowadays one hardly ever sees a painting without.

Since the superscription of a hanging scroll as a rule is written in an empty space on top of the painting, when the scroll is unrolled it becomes visible before the rest of the painting is exposed. Probably it was felt that a similar "prelude" was desirable also for hand scrolls; for inscriptions on horizontal roll paintings are written at the very end and

[1] The *locus classicus* mentioning superscriptions on paintings is the following passage from the *Shan-shui-lun* 山水論, a short essay on landscape painting, ascribed to the famous T'ang poet and artist Wang Wei. "Sentences like 'Enveloping vapours and dispersing mist', 'Clouds drifting back over the Ch'u mountains', 'Clear autumn morn after overnight rain', 'A broken memorial tablet by an old tomb', 'Spring over Lake Tung-t'ing', 'A man having lost his way among overgrown pathways' all such are called superscriptions of paintings" 或曰 烟籠霧銷。或曰楚岫雲歸。或曰秋 天曉霽。或曰古塚斷碑。或曰洞庭 春色。或曰路荒人迷。如此之類。謂 之畫題。Further, the treatise *Lin-ch'üan-kao-chih* 林泉高致 ascribed to the Sung artist Kuo Hsi gives numerous other instances of superscriptions. Later artists were often not very discreet in their choice of superscriptions for their paintings, which made the Ming scholar Shên Hao 沉灝 remark caustically: "If you cannot think of an appropriate superscription, you had better copy one evolved by some old master. But if you use such a superscription without understanding it, you had better use none at all" (*Hua-chu* 畫麈: 自題非工。不 若用古。用古非解。不若無題。).

131

are seen only when the entire scroll has been unrolled. Thus the custom arose to write a superscription on a separate piece of paper, and to have this mounted at the beginning of the hand scroll. Literary sources are vague as to the question of when this custom started; it would seem that is became really popular only with the advent of the Ming dynasty.

The contents of superscriptions added to hand scrolls are essentially the same as those written on the paintings themselves; they give the title of the scroll or some brief appreciative comment. The difference is that while *t'i* on the scroll itself are as a rule written by the artist, the superscriptions mounted together with hand scrolls are usually written by a friend of the artist or by some later collector.

On *t'i* added to hand scrolls one may find titles such as *Ch'iu-lin-kao-shih-t'u* 秋林高士圖 " Picture of high-minded scholars in the autumnal forest ", *Lao-tzŭ-kuo-kuan-t'u* 老子過關圖 " Picture of the philosopher Lao-tzŭ crossing the mountain pass ", *Li-shu-ch'ih-pi-fu* 隸書赤壁賦 " The Essay on the Red Wall (by Su Tung-p'o), written out in chancery script ". Or one may find brief descriptive comments such as *Sung-fêng-tung-hsiang* 松風洞響 " Rocks echoing the wind through the pines " (attached to a scroll with a picture of pine-clad mountain passes), *Ch'in-shu-tzŭ-yü* 琴書自娛 " Finding one's enjoyment in lute and books " (added to a painting showing a scholar playing the lute in his library), *Hsi-mo-san-mei* 戲墨三昧 " The essence of playing with ink " (attached to an autograph in highly cursive writing, but also applicable to an ink-painting in some bold and original style).

The writer of a superscription may add on top right his library seal, often accompanied by some dedicatory message, and on the left his name seals. Sometimes he will there also record the date and add his full signature. Only the Emperor or an Imperial prince was entitled to print his large seal *above* the characters of the *t'i*, right in the middle.

Colophons.

The colophons, *po* 跋 or *po-wên* 跋文 that are mounted at the end of a hand scroll bear a retrospective character. They are, as it were, an afterthought to the joy of viewing the scroll and if they were too dazzling, they might spoil the impression left by the painting. Colophons therefore are usually written in smaller characters and on ordinary paper.

The contents of colophons vary greatly. A conscientious connoisseur will here give a detailed description of the scroll together with a biographical note on the artist, adding a circumstantial account of how and when he obtained the scroll; some (like the great Ming collector Hsiang Yüan-pien mentioned above) went as far as recording the price they paid for it. Other collectors of a more poetical disposition may write some verses praising the artistic merits of the scroll or extolling the fame of the artist. Others again may prefer to take the subject represented on the scroll as a motif for a lengthy philosophical dissertation. The longer a hand scroll circulates among collectors, the more

132

accumulated superscriptions and colophons it will show. Thus antique hand scrolls with three or four superscriptions, and ten or twenty colophons are by no means rare.

Since a hand scroll is composed of a number of separate parts greatly diverging in material, date and content, it will be clear that it is necessary to mark in some way all of these, to prevent them from drifting apart when the scroll is remounted or heavily damaged, and in order to prove their authenticity.

" Seals astride the seams ", and how they should be treated when the scroll is remounted.

For this purpose Chinese collectors employ the so–called *ch'i–fêng–yin* 騎縫印, *fêng–chang* 縫章 or *ya–fêng–yin* 押縫印 " seals astride the seams "; these were already briefly mentioned on page 68 above. They are impressed over the seams of all the vertical strips of silk that divide the different parts of the mounted hand scroll, the spots marked with dotted lines on Plate **31**.

When one has such a hand scroll remounted he will have to discuss with his mounter how these *ch'i–fêng–yin* should be treated. If this is omitted, in nine cases out of ten the mounter will throw away the vertical strips together with the old front mounting, and thus the remounted scroll will only show parts of the seals. It is true that if many impressions of the same seal were added to the scroll, their legends might yet be identified; still, halved seals make it impossible to ascertain whether or not the edges of the scroll were cut down during the process of remounting, and moreover they present an ugly sight. A conscientious connoisseur will always instruct the mounter to preserve these seals. He has him cut off and keep apart the edges of the vertical strips which show halved seals; when the scroll is remounted these strips are pasted on in such a way as to fit exactly the half seal impressions on the original. Since many people omit to give the necessary instructions to the mounter, one often finds hand scrolls with mutilated seals. But one should not conclude from this fact that the edges of the picture have necessarily been cut down.

The remounting of superscriptions and colophons.

Quite apart from the question of the " seals astride the seams ", collectors usually give definite instructions to the mounter as to how to treat the superscriptions and colophons when the scroll is being remounted. If all of them are of value, the owner of the scroll will tell the mounter to remount the scroll exactly as it was. In such a case many connoisseurs will have an extra sheet of ornamental paper added at the beginning, and two or three blank sheets at the end of the scroll. The owner may either himself utilize this space for adding comments of his own, or leave it blank so as to give a future collector an opportunity for doing so without having the scroll remounted, with all the risks this process involves. This is a charming Chinese custom that shows the loving care the real collector bestows on his treasures, providing for their well–being even in the distant future.

On the other hand, when the owner has doubts regarding the authenticity of a super-scription or a colophon, or dislikes it for some other reason, he may have it removed to be replaced either by comments written by himself or by his friends, or simply by a sheet of blank paper.

**133**

From the above it will be clear that the remounting of a hand scroll furnishes the forger with many opportunities for producing fakes. As a matter of fact, in the antique trade there has been going on for many centuries an enormous amount of juggling and skilful manipulation of superscriptions and colophons.

On this subject a contemporary Chinese art dealer writes the following:

" If once a scroll has been appreciated in a superscription, its fame and value have been increased twenty-fold. Many were the collectors of the Ming and Ch'ing periods who added superscriptions and colophons to scrolls of the Sung and Yüan dynasties. Now, in some cases the original (painting or autograph) has been preserved together with the *t'i* or *po* belonging to it, in other cases the original has become lost, while only the *t'i* and *po* remain. In recent times those who engage in producing spurious scrolls often copy an ancient original and thus produce a fake; then to this they append a genuine old colophon. If many *t'i* or *po* were added to the lost original, then each of these may serve to authenticate a fake ". [1]

On the other hand people may try to boost the value of a genuine scroll that happens to lack appreciative comments by adding a spurious colophon; such a proceeding is alluded to by the Ch'ing scholar Chang Ch'ao, in his preface to the *Chuang-huang-chih*.

Besides, the falsifier has numerous other opportunities for playing tricks with colophons and superscriptions; some of these will be discussed in Chapter I of the Second Part of this essay. Here I only quote a passage written by the Ch'ing connoisseur Lu Shih-hua, whose just ire was excited by these deceits.

" Often some ignoramus having obtained a great scroll does not recognize it as such; thinking that the artist was some unknown person, he fears that he will not be able to sell the scroll at a high price. Then he will cut off the original signature, and instead write on the scroll some famous name. Or, annoyed that a scroll has no colophon, he will write on the paper or silk of the picture itself a few spurious appreciative comments. Such things are indeed a tremendous nuisance and such a person deserves to be condemned to the deepest Hell ". [2]

1) *Ta-ku-chai-po-wu-chih*, cf. Appendix I, no. 25:

一　經　品　題。聲　價　十　倍　⋯　如　宋　元　書
畫。明　清　之　原　人　之　之　者。不　之　乏　其
人　矣。有　人　題　跋　跋　俱　今　有　原　偽
稿　已　殘。稿　與　猶　存　造　偽　即
之　流。往　而　跋　照　者。造　書。一
將　眞　往　往　仿　之　後。詞　多　者。一
書　可　造　續　之　書。焉。跋　者。

2) *Shu-hua-shuo-ling* (cf. Appendix I, no. 47), chapter 10: 或　一　名　蹟。鄙　者　以　爲　此　是
小　名　家。難　獲　重　價。割　去　其　款。另　書
重　名。或　憎　其　無　跋。於　本　身　素。其　人　必
一　二　題　辭。此　則　大　煞　風　景。添
墜　眞　鼻　地　獄。

CHAPTER III

# THE HISTORY OF MOUNTING

## 1 – EARLY HISTORY AND DEVELOPMENT DURING THE T'ANG AND SUNG DYNASTIES

T ILL about the beginning of our era Chinese painters and calligraphers seem to have worked mostly on wooden and lacquered surfaces or on the plaster wall. It is only during 100–200 A. D. when silk and paper had gained popularity as material for writing and painting that the art of mounting scrolls came into existence.

For the next five centuries the purpose of a mounting was only that of strengthening a painted or written scroll; for till the T'ang period pictures and specimens of calligraphy on silk and paper were not used in interior decoration. When the owner wished to view his scrolls he unrolled them on a low table or on the floor. Palaces, temples and dwelling houses were decorated exclusively with mural paintings and carved and painted woodwork.

Some details about early Chinese scroll mounting may be gathered from various literary sources. Since the actual objects referred to in the pertaining passages have not been preserved, their meaning is not always clear and much must be left to conjecture.

A convenient point to start from is supplied by the oldest term for scroll in general, *chüan* 卷, which means literally " a roll ". This appellation derives from the fact that after wooden tablets and bamboo had been replaced by silk and paper, graphic and pictorial documents took the shape of long, narrow sheets, rolled around a stick. This elementary form of a scroll can still be recognized in the present day " hand scroll ".

Until the spread of the art of printing (10–11th century), this term *chüan* is the common denominator for all scrolls, irrespective of whether they contain a written text or a pictorial representation. Thus the term *chüan* covers both manuscript rolls, and rolls containing one or several paintings.

In the category manuscript rolls, two classes must be clearly distinguished. First, rolls with autographs by famous writers, and second, texts of literary works; or, in other words, " book rolls ". The former are unique, the latter multipliable indefinitely by clerks and professional copyists. Manuscripts rolls of the former class properly belong to the domain of fine art, and must, from the Chinese point of view, be classified together with pictorial representations; book rolls, on the other hand, distinctly belong to the field of literature. Here we shall therefore understand by "pictorial rolls" those showing

paintings or autographs by famous masters, and by " book rolls " those containing texts written out by clerks.

After the spread of the art of printing, these two categories drifted more and more apart in construction and outer form. At present, therefore, the common origin of book and scroll is difficult to recognize. In order to obtain an insight into the history of the art of mounting, however, the development of book and scroll cannot be treated separately. On the following pages, therefore, the evolution of " pictorial roll " and " book roll " are discussed together.

Old terms for
" mounting ".

Old technical terms for the process of mounting supply some clues as to the appearance of archaic scrolls. The oldest term in general use was *pei* 背 " back ", " to provide with a backing ". This indicates that the scrolls were lined with a backing in order to strengthen them. In the case of book rolls, we also find the term *chih–shu* 治 書, " to cure book rolls ". This is a rather vague term, which apparently meant both the dyeing of book rolls with a substance in order to toughen the material they consisted of, and at the same time also a more elaborate treatment such as lining them with a material prepared in the same way.

The mounting of
book rolls.

Most common was to drench the paper used in the yellow juice extracted from the bark of the *huang–po* tree (黃 蘗, *Phellodendron amurense*). Considerable care was bestowed on this dyeing process, in Chinese called *jan–huang* 染 潢.[1] The earliest detailed description of this process has been preserved in the *Ch'i–min–yao–shu* 齊 民 要 術 " Important Skills of the Common People ", a treatise on agriculture and related subjects, written by Ku Szû–hsieh (賈 思 勰, fifth century). There it is said:

" For lining scrolls only unsized paper should be used, for such paper is both tough and thick. This lining should be dyed yellow (with a decoction from the bark of the *huang–po* tree). Having been treated with this, the paper loses its white colour; therefore it should not be dyed too deeply, for if the paper is over–treated, in course of time it will turn dark. While dyeing the paper with the decoction, one should not use the clear juice only and throw away the dregs (left after the first boiling of the bark), for this is a useless waste. After having boiled the juice one should pound the dregs and then boil them again. Having pressed out the juice by straining the dregs in a cloth sack, one should again pound and boil them. After the dregs been pounded and boiled three times, the juice obtained from them can be added to the clear juice (obtained from the first boiling). In such a way one saves eight times the quantity of juice, and the paper dyed with this mixture will be glossy and evenly coloured.

1) The character *huang* (read in the 4th tone) speaks for itself, being composed of the elements " water " and " yellow ". In the compound *chuang–huang* 裝 潢 " to mount scrolls ", *huang* is sometimes written 璜; this variant must rest on a mistake of an early copyist.

" Inscribed scrolls (book rolls) should be dyed after the lapse of one year, then the seams (of original and backing) will not become loosened. Newly written book rolls should have their seams pressed with a flat iron, only thereafter may they be dyed. If such rolls are dyed before they have been ironed, the seams will become loose ". [1]

From this passage it appears that not only the backings, but also the rolls themselves were dyed yellow. [2]

1) *Ch'i-min-yao-shu*, ch. 3, section 30: 染潢及治書法。凡打紙欲生生則堅厚。特宜入潢。潢則便宜太即後。凡年用而入熟。熟煮省深則直搗藥無藥復搗入斗棄滓。搗純雜而囊其落漉之。三煮其純和然矣。凡又三添寫後。四彌明寫書須。潢縫淨之其以凡縫綻解。新不熨四縫。熨而潢之零。

F. HIRTH has described this book in his *Bausteine zu einer Geschichte der Chinesischen Literatur* (T'oung Pao, vol. VI, p. 436 sq.). One section dealing with wine and ferments has been translated by Huang Tzu-ch'ing and Chao Yün-ts'ung under the title of *The preparation of Ferments and Wines* (" Harvard Journal of Asiatic Studies ", vol. IX, no. 1); there the suggestion is made that *ch'i* in the title of this book may mean the state Ch'i. This is to be rejected since *ch'i-min* is a common synonym of *p'ing-min* 平民.

2) The *Ch'i-min-yao-shu* also gives a recipe for treating book rolls with *tz'ŭ-huang* 雌黃 "orpiment", in order to keep away insects and make them more durable. Orpiment was used also for correcting manuscripts; since most documents were written on yellow paper one could easily obliterate one or more characters by painting them over with orpiment. The Sung source *Mêng-hsi-pi-t'an* 夢溪筆談 compiled by Shên K'uo (沈括, 1030-1094) says: " If in the clean copies issued by official instances there occurred mistakes these were deleted by painting them over with orpiment " 館閣淨本有誤書處。以雌黃塗之即滅。

In China this custom of correcting manuscripts and books with *tz'ŭ-huang* became obsolete during the Ming period, vermilion (*chu* 朱) taking its place; this *chu* to-day still is the favourite material for correcting and punctuating. In Japan, however, orpiment was used for correcting mistakes till well into the Meiji era although by then, books and manuscripts consisting of white paper, it had lost its real purpose. In China the custom of correcting with orpiment survives only in expressions like *chia* (or *shih*)*-tan-huang* 加 (施) 丹黃 "applying vermilion and orpiment", a literary term meaning "to correct". Further the fact that in ancient times yellow materials were used for book rolls still survives in the compound *huang-chüan* 黃卷 "yellow rolls", a literary term for "books" in general.

It may be added that the paper used during the T'ang dynasty was chiefly made of hemp; it was produced in two qualities, one white (*po-ma-chih* 白麻紙), and the other yellow (*huang-ma-chih* 黃麻紙). The latter was used for all important documents, because, being dyed with *huang-po* juice, it was said to have become tough, and not to be eaten by insects. The same dyeing process was applied to paper made from the bark of the mulberry tree, and from "China grass" (ramie). This yellow paper was further embellished by waxing it, whereby a smooth and hard surface was obtained; such waxed T'ang paper is usually referred to as *ying-huang* 硬黃 "Hardened yellow paper". T'ang and Sung authors often reverse these two characters, and write *huang-ying*. It should be noted that this same term is also used to indicate quite another kind of paper, which has nothing to do with *huang-po* dye, viz. paper made transparent by applying yellow wax to it. Antique autographs which had become darkened by age, were treated in this way to brighten them up, and new paper thus prepared was used for tracing old scrolls. The Ming scholar Li Jih-hua (李日華, 1565-1635), in his book *Tz'ŭ-t'ao-hsien-tsa-cho* 紫桃軒雜綴, describes this paper as follows: " *Ying-huang* paper is made because people dislike the opacity and rough surface of ordinary paper. They heat, therefore, paper over a hot flat iron (Chinese flat irons consist of a round copper pan, with a flat bottom, and provided with a handle; when used the pan is filled with glowing coals. Transl.), and then wax it evenly with yellow wax. Although the paper then has become slightly stiff, it is luscious and transparent, resembling our ordinary flakes of fishbone (formerly used for making window panes. Transl.) or sheets of transparent horn (this refers to a curious process, still practised in China, whereby cow's horn is heated and blown out till several times its size; the thin horn resembles glass, and is used for making ornamental lanterns. Transl.). If one lays a sheet of this paper over something, even the smallest details of such an object will be perfectly discernible. Generally antique autographs from the Wei and Chin periods, left by calligraphers like Chung Yu (鍾繇 151-230, expert in chancery script), So Ch'ing (索靖, 239-303, famous expert in "draft writing"), or Wang Hsi-chih, are treated in this way, because in the course of the centuries they have grown dark " 硬黃者。嫌紙性終帶暗澀。置之熱熨斗上。以黃蠟塗勻。紙雖稍硬。而瑩徹透明。如世所爲魚枕明角之類。以蒙物。無不纖毫畢現者。大都施之魏晉鍾索右軍諸蹟。以其年久本暗也。

A little farther the same source remarks that the upper and lower border of a scroll were sometimes reinforced by adding borders of purple silk, while at the beginning of the roll there was added a *shou-chih* 首紙, an extra length of blank paper that served as a protecting flap. It further mentions a band for winding round the scroll when rolled up, and refers to the roller that served to keep the scroll in shape and to facilitate the rolling and unrolling.

The mounting of pictorial rolls.

Although these passages refer exclusively to the treatment of book rolls, they also apply to the mounting of pictorial rolls. Pictorial rolls were mounted according to the same principle, but the details were more elaborate.

Through a fortunate coincidence there have been preserved some precious data regarding the way in which early pictorial rolls were mounted. Generally details about the mountings of scrolls were deemed of slight importance by the literati, and hence such material was not entered into literary records. It so happened, however, that in the fourth century there lived two calligraphers, Wang Hsi-chih and his son Wang Hsien-chih, who already during their lifetime were acclaimed as the unsurpassed masters in this art, while posterity has in no way altered this contemporary judgement. Since autographs by these two masters were considered more precious than gold, even the earliest sources describe scrolls written by this illustrious pair in minute detail including the way the scrolls were mounted. Thus the history of their works can be traced step by step throughout Chinese history. When after the Sung dynasty their original works had become exceedingly rare, they survived in rubbings, and these were studied with the same loving care as famous connoisseurs bestowed on the original autographs. [1]

This pair of paragons of the calligraphic art is usually referred to as *Êrh-wang* 二 王 the "Two Wang". Most famous is the father, Wang Hsi-chih (王 羲 之, 321-379). His style was I-shao 逸 少, but he is mostly referred to by his official title Yu-chün 右 軍 "Commander of the Right Wing". His best known autograph is the "Essay on the Gathering at the Orchid Pavilion" *Lan-t'ing-hsü* 蘭 亭 序, celebrated both for its contents and its masterly chirography; its name runs like a leading thread through Chinese literature of the succeeding dynasties.

The second is his son Wang Hsien-chih (王 獻 之, 344-388). His style was Tzŭ-ching 子 敬, but like his father he is usually referred to by his official title *Ta-ling* 大 令 "The Major Secretary" (to distinguish him from a contemporary who is called *hsiao-ling* 小 令 the "minor secretary").

Early mountings of famous autographs.

One of the early [2] accounts of the varying fortunes of the autographs left by the "Two Wang" is the *Êrh-wang-têng-shu-lu* 二 王 等 書 錄, written in 760 by the

---

1) For more details the reader is referred to Chu Chieh-chin's excellent study *Wang-hsi-chih-p'ing-chuan* (朱 傑 勤, 王 羲 之 評 傳), published in 1938 by the Commercial Press, at Changsha.

2) The earliest is apparently the *Lun-shu-piao* 論 書 表 "Memorial on Calligraphy" by Yü Ho (see p. 139 note 4), dated 470. The first part of Chang Huai-kuan's discussion is based on this source.

well known T'ang connoisseur Chang Huai-kuan 張 懷 瓘. [1) Those passages that have a bearing on the mounting of these scrolls are translated below.

"During the Chin dynasty (265–420) people mounted these autographs (by the Two Wang) (together on long hand scrolls), but they did not properly arrange them according to the style of the script, [2) and the paper with which these scrolls were backed developed creases. It was Fan Yeh (398–420, author of the *Hou-han-shu* 後 漢 書) who produced somewhat better mountings. The Emperor Hsiao-wu (454–464) of the Sung period charged Hsü Yüan [3) with remounting these autographs in such a way that ten of them formed one hand scroll. ..... The Emperor Ming (465–472) ..... ordered Yü Ho, [4) Chao Shang-chih, [5) Hsü Hsi-hsiu, [6) Sun Fêng-po [7) and others, to rearrange these scrolls, and to remount them, none exceeding two *ch'ang* in length. Autographs by the Two Wang on silk were mounted with coral knobs, on 24 rolls, divided over two covers. [8) Their autographs on paper were provided with gilt knobs, 24 rolls in two covers; other autographs on paper, with knobs encased in tortoise-shell, 50 rolls in 5 covers. All of these scrolls had title labels inscribed in gold, jade rollers, and brocade bands. ..... Autographs written in the *fei-po* [9) and *chang-ts'ao* [10) style, 15 rolls in 2 covers; all of these had knobs of sandal wood. ..... Emperor Wu (502–549) of the Liang period greatly loved pictures and autographs. He had a search made for them throughout the Empire, and thus assembled a very large collection. Because the old mountings had become stiff and hard, not a few characters got damaged. During the T'ien-chien era (502–513) the Emperor, therefore, ordered Chu I, [11) Hsü Sêng-ch'üan, [12) T'ang Huai-ch'ung, [13) Yao Huai-chên, [14) Shên Chih [15) and others, to take off the old mountings and remount them, adding new title labels. Then it was found that (the Imperial Collection) counted all together 78 covers (containing autographs by the Two Wang), 767 rolls, all mounted with coral knobs, brocade bands, title labels inscribed in gold, and jade rollers. ..... In the 13th year of the Chên-kuan era (639) ..... the Tien-i [16) Wang Hsing-chên [17) was ordered

---

1) Chang Huai-kuan's exact dates are not known, but he must have flourished during the reign of the Emperor Hsüan-tsung (713–756). He left a number of writings, some of which Chang Yen-yüan incorporated in his *Fa-shu-yao-lu* 法 書 要 錄 "Important Records on Model Writings" (cf. Appendix I, sub no. 33).

2) Literally: "(Autographs in) regular and draft writing mixed in confusion". As appears from a later remark, in those times it was considered that one hand scroll should contain only autographs in one and the same kind of calligraphy.

3) Hsü Yüan, styled Ch'ang-yü 長 玉, 394–475, favourite of Ming-ti.

4) Yü Ho, learned scholar-official, flourished in the end of the 5th century.

5) Styled Chung-yüan 仲 遠, learned Court official, later Prefect of Hsin-an.

6) Son of Hsü Yüan; see note 3.

7) Calligrapher, Prefect of Huai-nan.

8) The text has the character 秩, a homonym of

the regular character 帙. Also other T'ang sources occasionally write 秩 instead of 帙. Could this be because both characters also mean "decade", which suggested the fact that one cover usually contained about *ten* rolls?

More information on these covers will be found below, on page 220.

9) *fei-po*, lit. "flying white", a peculiar technique used in writing chancery, draft, running and regular script; cf. page 361.

10) A variety of draft writing.

11) Chu I, styled Yen-ho 彥 和, 482–548, great classical scholar.

12) Noted calligrapher.

13) No details known; cf. *P'ei-wên-chai-shu-hua-pu*, ch. 24.

14) Cf. ibid., ch. 24.

15) Ibid., ch. 24, which has Shên Chih-wên 文.

16) *Tien-i*, major-domo in the Palace.

17) Cf. ACKER (Appendix I no. 33), page 221 note 2.

to remount these scrolls. Those old mountings dating from the Liang period as were still attached to them, he had simply cut off. Then it was found that there were all together 2290 autographs by Wang Hsi–chih, mounted so as to form 128 rolls, and divided over 13 covers. Or: 50 autographs in the regular script, mounted in the form of 8 rolls, in one cover, [1] the length of each roll being determined by the length of the various autographs (mounted thereon); 240 autographs in the running script, 4 covers containing 40 rolls, none of which longer than 4 *ch'ih*; 2000 autographs in "draft writing", 8 covers containing 80 rolls, measuring 1 *ch'ang* 2 *ch'ih*. All of these scrolls had knobs inlaid with gold and other precious materials, and they were wrapped up in brocade covers. On every seam (where one autograph was joined to the next), there was impressed a small seal, the legend of which read: Chên–kuan ". [2]

From this text one may derive some important data. In the first place, it appears that round 350 the art of mounting was not yet very highly developed. This is proved by the fact that the paper backing soon developed creases; when such a scroll is frequently rolled and unrolled, these creases will burst, thus causing holes in the picture or autograph itself. Fan Yeh seems to have been the first person who could mount scrolls in a more efficient way. This view is shared by the T'ang connoisseur Chang Yen–yüan (see Appendix I, no. 33), who wrote about one hundred years after Chang Huai–kuan. He starts the section on mounting in his *Li–tai–ming–hua–chi* with the words: " Up to the Chin period, mountings of (pictorial) rolls were not yet beautiful. It was the Sung scholar Fan Yeh who was the first who could really mount scrolls ". [3]

Secondly, we learn that the quality of the scroll was indicated by the material chosen for its knobs. This practice was maintained throughout the ages. In the following we shall often refer to it.

Thirdly, a number of hand scrolls were wrapped up together in a cover. This custom also was preserved throughout the following centuries.

---

1) I read 卷 instead of 紙. If this correction is made, then the numbers given tally:

| | | | |
|---|---|---|---|
| Regular script....... | 50 autographs | 8 rolls | 1 cover |
| Running script....... | 240 " | 40 " | 4 covers |
| Draft script........... | 2000 " | 80 " | 8 " |
| Total... | 2290 | 128 | 13 " |

2) 晉曄愛和編珊二秩。又游檀□□□
起使詔更素金軸帶卷。並
代裝治護倘歲次。珊秩五紙檀
書。微十之以二十書軸。□□□
眞爲紙徐二秩四並飛白梁武
草小爲希又二卷。□□題草帝
渾勝一秀爲十又金章帝
雜宋卷。孫度。四紙玉二尤
背孝明奉二卷書燮。秩好
紙武帝伯王紙玳織十圖書。
皺又□□等。縑書瑁成五書。

搜字唐更七金儀者二十本秩八金皆
訪有懷加百題王但百八長四秩雜小
天損充檢十躞眞剪十眞爲卷。印晉能
下。大天懷二七裝而紙書度。四卷。裝印代裝
獲勑燭大珊十朝軍十紙二度。丈裝
以朱等。紙凡瑚三舊書三一百草二秩。
舊徐析七織比年裝大秩四軸尺其貞不
裝徐而十織令見二百紙千度。每書觀。
堅僧裝八成典存千二隨四紙。並縫。時
強權之。秩帶典存千二隨四紙。並縫。

所中沈書並梁右爲十書爲一織其前。
有監珍二七裝而紙書度。裝印己背。
之己裝五行尺以軸。□□織之。裝

3) 自
晝
始
范
曄

Among the scrolls recovered at Tun–huang [1] there were a number of book rolls dating from the 5th and 6th century.   Here we have thus the rare opportunity of studying the objects themselves.   Unfortunately, Tun–huang at that time was a far outpost of the Chinese Empire, and consequently the book rolls used by the Buddhist clergy and laymen there are mounted in the most elementary way, without the rich adornments that embellished the scrolls mounted in the great cultural centers of that time.   The work of the mounter consisted chiefly of dyeing the paper yellow, and attaching a wooden roller at the end.   Whether the task of the mounter also included manufacturing the covers of cloth or woven split bamboo (see Plate **81**) in which the book rolls often were wrapped up, is doubtful.   Photographs of hand scrolls mounted in such a primitive way may be found in Sir Aurel Stein's magnificent publication on his explorations in Central Asia. [2]

Yet the work of the mounter was not considered lightly, even with regard to such elementary mountings.   In a colophon of a Taoist manuscript roll found at Tun–huang, containing the text *Book of the Transmutations of Lao-tzû* 老 子 變 化 經, described as written on a roll of yellow paper of 6 ¼ foot long, we find a blank space left for the mounter's name, directly after that of the priest who collated the manuscript.   This colophon runs: " Copied by the scribe Wang Ch'ou on the 14th day of the 8th moon of the year 612, on four sheets of paper.   Collated again by a Taoist priest of the Mystic Altar of the Mystic capital, mounted by..., copied in the Department of Sacred Books ". [3]

Early collectors,
and the way they
took care of their
scrolls.

Although during the period treated above the scroll was not used in interior decoration, it was nonetheless greatly valued.   The collecting of scrolls became a fashionable pastime of the nobility and of high officials.   The statesman Huan Hsüan (桓 玄, 369–404), for instance, was an enthusiastic collector of both book rolls and pictorial rolls, and the famous painter Ku K'ai–chih was also well known as a connoisseur.

The *Ch'i–min–yao–shu*, the 5th century source mentioned above shows with what loving care scrolls were handled.   It says:

" Those who unroll a book roll for reading it, should not roll the protecting flap at the beginning of the scroll too tightly, for this may cause creases, and these creases may develop into tears.   If one would wind the band of a book roll directly round the protecting flap, it is certain to become damaged.   One should first wrap the rolled up scroll in a few sheets of paper, and thereafter wind the band round it; then it is kept rolled up tightly, and it will suffer no damage ". [4]

1) Cf. the excellent survey by LIONEL GILES, *Six Centuries at Tunhuang* (A short account of the Stein Collection of Chinese Mss. in the British Museum), The China Society, London 1944.

2) *Serindia, Detailed Report of Explorations in Central Asia and Western-most China*, Oxford 1921. See Plate CLXVI sq., particularly CH 922, a Tunhuang gazetteer dated A. D. 416, and CH 1181, a Buddhist scroll dated A. D. 521.

3) Cf. L. GILES, *Dated Chinese manuscripts in the Stein collection*, in: Bulletin of the School of Oriental and African Studies, vol. VIII, 1935-37, page 6: 大 業 八 年 八 月 十 四 日 經 生 王 儔 寫 囗 用 紙 四 張 囗 玄 都 玄 壇 道 士 覆 校 囗 裝 潢 人 囗 秘 書 省 寫。

4) *Ch'i-min-yao-shu*, loc. cit.: 凡 開 卷 讀 書。 卷 頭 首 紙 不 宜 急 卷。急 則 破 折。折 則 裂。以 書 帶 上 下 絡 首 紙 者。無 不 裂 壞。卷 一 兩 張 後。乃 以 書 帶 上 下 絡 之 者。穩 而 不 壞。

Damaged scrolls were repaired, holes and tears being carefully patched up.

"If you patch up holes and tears in book rolls with Li–fang paper (unidentified. Transl.), these patches will become hard and they will make the surface of the scroll uneven. Thus they will cause creases to appear in the scroll, and there new holes will develop. If, however, one uses for the patches paper thin like scallion leaves, these will merge with the paper of the scroll itself, so that they can hardly be distinguished: if one does not scrutinize the scroll against the light, one cannot see that it has been patched up". [1]

Further, the same source shows how much attention was bestowed upon the preservation of scrolls:

"In the cupboard where you keep your book rolls there should be placed musk and *mu–kua*, [2] to prevent insects from breeding there. Insects are born during the hot and moist days of the fifth moon. If book rolls are not unrolled (to be aired) after the passing of summer, they are sure to be eaten by insects. Between the 15th of the 5th moon and the 20th of the 7th moon, book rolls must be unrolled and rolled three times. This should be done on a clear day, in a spacious room which is airy and cool. They should not be exposed to the sun, for the sun will burn the scrolls, giving them a brown colour. Moreover scrolls heated by the sun will quickly attract insects. Rainy and humid days should be especially avoided. If you take care of your book rolls in such a way, they will last for several centuries". [3]

The early Chinese interior.

It is difficult to form an exact idea of what the Chinese interior of those days looked like. Yet a general knowledge of this subject is indispensable for appreciating the development of the mounted scroll. Here we must, therefore, rapidly review the history of the Chinese house and the decoration of its interior.

When looking over ground plans of ancient and modern Chinese palaces, temples and dwelling houses — the three main aspects of Chinese architecture —, one is at first struck by their bewildering variety. When, however, one studies such plans closer, at the same time consulting pertinent passages in ancient Chinese literature, one will find that the differences are mainly superficial, and that the underlying principle is the same, and has remained so from well before the beginning of our era until recent times. It is possible, therefore, to draw a theoretical floor plan that embodies all the most characteristic features of Chinese house–building. Such a floor plan supplies a standard appliable equally to Chinese palaces, temples and upper–class dwelling houses throughout the ages.

---

1) Ibidem: 補書而於微看之。紙瘡補織而舉之。方瘡硬疽薤非自明補裂。鄭瘡薤如自覺補裂。變攣拳紙會。畔省薄無際。者率損殆不。有入略。

2) Mu–kua 木瓜, Chaenomeles lagenar.

3) Ch'i–min–yao–shu, loc. cit.: 書厨中欲得安麝香木瓜。令蠹蟲不生。五月濕熱。蠹蟲生也。五月以前。必於大令須色氣。書十須屋下書。生。將月日以晴日陰雨潤。經五三度風喝。夏日不以舒涼而避之。舒後而處不熱卷慎書。展卷七見蟲之不生書如此。畦月之。必二須日彌此。熟生十要處速則數百年矣。

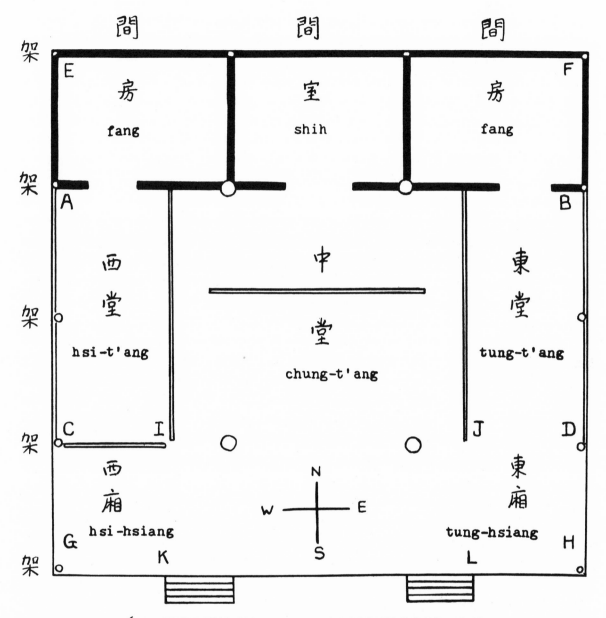

間　　　　間　　　　間

架　E　　　　　　　　　　　　　　　F

房　　　　室　　　　房
fang　　　shih　　　fang

架　A　　　　　　　　　　　　　　　B

西　　　　中　　　　東
堂　　　　堂　　　　堂
hsi-t'ang　　chung-t'ang　　tung-t'ang

架　C　I　　　　　　　　J　D

西　　　　　　　　　東
廂　　　　　　　　　廂
hsi-hsiang　　　　　tung-hsiang

G　　　　　　　　　　　　　　H
架　K　　　　　　　L

架

N
W ─┼─ E
S

65. – THEORETICAL FLOOR PLAN OF AN ANCIENT CHINESE HOUSE

As in other countries, the Chinese house is divided into two parts, namely one destined for receiving guests, conducting business etc., and the other consisting of the living quarters of the family; or, in other words, a public and a private section. Unlike elsewhere, however, in China these two sections are rigidly separated, while moreover their exact location is fixed by an age-old tradition.

Geomantic considerations have prescribed that, if anyway possible, a building should face south. The front rooms (on the south side) are public, and the back rooms (on the north side) private, with the further understanding that the eastern half of the building (or complex of buildings) is considered as less private than the western part. The eastern

Floor plan of the ancient Chinese house.

143

part belongs to the master of the house (cf. expressions like *tung-chu* 東 主, *tung-tao-chu* 東 道 主 "host", "master") and the male servants; the west side belongs to the family and the female servants, headed by the principal wife (cf. terms like *hsi-ch'uang* 西 窓 "western window", the place where the ladies of the household make their toilet).

On the floor plan given on Plate **65** the main part of this private section is formed by the walled-in space EFAB, which consists of an uneven number of rooms. The central room, called *shih* 室 is often larger than the adjoining rooms, called *fang* 房. One *shih* with one *fang* on either side represents the minimum; the number may be brought up to five by adding next to each *fang* another room, in the Classics called *chia-fang* 夾 房, and in later times *chien-t'ao* 間 套.

ABGH is the open section of the building. ABCD is a spacious hall, with in its middle the two heavy main pillars; it is open on three sides. Its main part is the "central hall" *chung-t'ang* 中 堂, which is flanked by the "eastern hall" *tung-t'ang* 東 堂 and the "western hall" *hsi-t'ang* 西 堂. CDGH is a kind of open verandah; the space at the left (CIGK) and right (JDLH) is called respectively "west side-hall" *hsi-hsiang* 西 廂 and "east side-hall" *tung-hsiang* 東 廂.

The size of these various parts of the house in proportion to each other is determined by the location of the pillars that support the roof. Reckoning N. S., one counts the *chia* 架, literally "frame", i. e. the frames running E. W., formed by, for instance, pillars G and H and the girder that connects them on top. Reckoning E. W., one counts the *chien* 間, the "intervening spaces" between the pillars. The standard, as given on the floor plan, is "five frames and three spaces" *wu-chia-san-chien* 五 架 三 間. According to this standard, the private section of the house covers 1 *chia* by 3 *chien*, the hall 2 *chia* by 3 *chien*, and the verandah again 1 *chia* by 3 *chien*.

Large buildings show an increased number of *chia* and *chien*, but the general plan of the house is seldom changed. When one needed more living space, for instance in the case of more than one generation, or several branches of a family living together, next to the original house there were erected one or more identical buildings, and thus a compound was formed.

Such is the tenacity of Chinese tradition that the floor plan given here applies, *mutatis mutandis*, to the house of the Classical period, as well as to Ming and Ch'ing buildings. Since the floor plan given here thus supplies a convenient basis for describing the Chinese interior of succeeding dynasties, it will be often referred to in this and the next chapter. Below it is first utilized for a discussion of the interior of palaces, temples and upper-class dwelling houses of the 3d-6th century.

**Palaces.**  A palace consisted of a complex of buildings each of the same floor plan as described above, but having, of course, a greater number of *chia* and *chien*. Built usually one behind the other and all facing south, these buildings were connected with each other by covered passages and surrounded by parks and gardens, with ponds, arbors and pavilions. The front building was entirely public, its halls serving for audiences and its back rooms

for offices of counsellors and secretaries. The west steps leading to the hall were used by guests, the east steps by the ruler. The second building bore a more private character, being used by the ruler and his personal attendants for daily life, while the buildings at the back of the complex were the living quarters of the ruler, his consorts and the female members of his court.

Contemporary literature gives detailed descriptions of the splendour of such palatial buildings. The pillars were carved with intricate designs and painted in gorgeous colours, and so were the roof beams, and panels in the ceiling (cf. the expression *tsao-ching* 藻井 " painted ceiling "). Movable screens, covered with pictorial representations, served to partition halls and rooms, and elaborately carved balustrades ran all along verandahs and covered passages. Further, hall pillars were often connected by panels or wooden frames filled in with plaster, the surface thus obtained being used by painters for displaying their skill.

Temples.

In the case of temples, the central hall was used for sermons and meetings of the monks. In the middle, about half-way between the central pillars and the back rooms, there stood an altar with by its side a high, throne-like seat, to be used by the abbot. In the side halls the *sûtra*'s were read, while on the open verandah the people came to pray and worship. The central back room contained the inner shrine, the altar of the main deity, while the side-rooms contained the altars of his attendant deities, or holy relics; this back-part is often detached from the central and front section, and constitutes a separate building at the back of the temple compound. As to the decoration, next to painted pillars, beams and ceilings, the most lavish adornment was found in the back rooms: the walls of the inner shrine and its adjoining rooms were covered with religious paintings by the greatest artists of those times. These paintings were done in tempera, directly on the wall, or also on wooden wainscoting previously coated with plaster; the latter technique seems indicated by some passages in contemporary Chinese literature, like for instance the statement by Mi Fu that he had some of such mural paintings removed from a temple to his own library. [1]

While the mounted scroll played no role in the embellishment of palaces, it is quite possible that in temples on the occasion of religious feasts in the main hall there were displayed holy pictures, mounted in the Indian " banner style " (see page 168 below).

Dwelling houses

For the mansion of a personage belonging to what now would be called the " upper middle class " (corresponding to the Chinese term *shih-ta-fu* 士大夫), we again use the floor plan of Plate **65**. Although, then as now, the Chinese were much given to living in the open air, the public section of the house was too much exposed for living there comfortably. This was remedied by a liberal use of movable screens, and by the application of lattice-work between pillars. The main hall was divided in two by placing

1) See page 187, note 1 below.

a screen about half-way between the two central pillars and the back rooms. The space in front of this screen was used for receiving high guests and for other official occasions, while the room behind the screen was used as dining room of the family. The east and west hall could be closed on the inside by movable screens or wooden partitions, and on the outside by lattice work and roll curtains; the same could be done with the side halls. In the western hall, being more private than the eastern part of the house, the master could converse with his wives, and the western side hall was often used as class room for the children. The eastern hall served as library. Here the master could receive his friends, and view together with them his book rolls and pictures.

It is obvious that in the ancient Chinese dwelling house the walls played only a secondary role. The structure of the house depended on basement, pillars and roof; for the partitioning of the space inside, the screen was more important than the plaster wall.

In accordance with their function the screens of these early times were mostly made of solid wood. The *hua-p'ing* 畫 屏 "painted screens" mentioned in the literature of the 2nd to the 5th century A. D. were screens bearing pictures done on the wooden surface that had previously been covered with a thin gesso layer — the same technique used for pictures on pillars and roof beams. Since contemporary literature also mentions wooden screens decorated with carved designs or inlaid with jade and precious stones, it is possible that the term *hua-p'ing* often refers also to such ornamental screens. It was not until the beginning of the T'ang dynasty when the art of mounting had developed further that one finds references to pictures painted on silk or paper mounted as screens. It is perhaps this change in the construction of the screen that the *T'ang-ch'ao-ming-hua-lu* (cf. Appendix I, no. 34) alludes to when it says that the early-T'ang painter Fan Ch'ang-shou 范 長 壽 "devised the present-day screens" (今 屏 風 是 其 製 也). It is also possible, however, that this remark refers to the introduction of the folding-screen; in later literature the term *p'ing-fêng* is used exclusively for that type of screen.

The furniture of the house must have been rather simple, as people were usually sitting on the floor, on mats or also on fur rugs. There were also various kinds of low couches and benches (*ta* 榻), which in the case of high personalities often developed into a kind of throne seats. Tables were so low that they could be used when sitting on the floor, and there were low writing desks (*chi* 几, *chi-an* 几 案) that reached just over one's knees when one was kneeling in front of them. Writing and reading was done on these low desks, and presumably they were also used by painters. Sitting on the floor was made more comfortable by the use of stiff square and oblong cushions (as to-day still used in Korea), and wooden elbow-rests (as to-day still commonly used in Japan).

Scrolls and book rolls were kept on shelves or in heavy wooden chests and cupboards, and they were viewed while being unrolled on low tables or on the floor. The floor was kept clean, for the ancient Chinese, as to-day still the Koreans and the Japanese, upon entering the house left their wooden clogs outside. This custom survives in the

expression *tao-hsi* 倒 屣, literally " sandals put on the wrong way ", at present still used in epistolary style to express the eager welcoming of a guest. It goes back to an anecdote told about a Han scholar, who, when the visit of an honoured guest was announced, left the hall and rushed to the front gate to welcome him in such a hurry that he put on his sandals the wrong way. Inside the house one wore thick socks, strapped to the ankle with bands.

A favourite place for the enjoyment of scrolls was the open verandah, the term *yen-hsia* 簷 下 " beneath the eaves " being frequently used in descriptions of meetings of connoisseurs. Literary meetings were also held outside in the garden, or on some scenic spot in the neighbourhood. Old pictures of Wang Hsi-chih's famous gathering near the Orchid Pavilion (*Lan-t'ing* 蘭 亭) show the guests engaged in a wine game " star scatter'd on the grass ", sitting on rugs of panther skin.

Tendency to luxurious living during the 5th-7th centuries.

The Confucian tenets preached simplicity as a paramount virtue to be made manifest also in one's daily surroundings. Buddhism, however, offered a welcome means for embellishing the interior of one's dwelling. The gorgeous decoration of Buddhist temples gave many clues for beautifying the interior of secular mansions. Painted walls and ceilings found their way from the temples to the houses of the wealthy. One need not wonder that most of the Chinese artists of this period were chiefly known for their mural paintings.

The period of the Six Kingdoms, and the succeeding short-lived Sui Dynasty (590-618) were characterized by a general tendency to elegant living. The numerous Courts set up in succession were centres of literary and artistic activities, Kings and princes vying with each other in painting and poetry. Literary pastimes like *t'ou-hu* 投 壺 " throwing the arrows " (those partaking in this game trying to throw from a distance arrows in a vase placed on the floor), playing the lute and other musical instruments, calligraphy, various kinds of chess, found many eager exponents, and it became the fashion to compose essays in a highly polished literary style, abounding in allusions and flowery expressions. It is during this period that most of the essays contained in the famous anthology *Wên-hsüan* 文 選 were composed.

Development of the art of mounting.

In these times the scroll, as we saw above, was not yet used in interior decoration. Pictorial rolls were viewed in the same way as book rolls. There can be no doubt, however, that the tendency to luxurious living exercised its influence also on the art of mounting, making people try to beautify their book rolls, autographs and pictures. In the Dynastic History of the Sui period it is said: " The best book rolls in the Palace Collection were mounted with knobs of red glass, those next in quality with knobs of dark-violet glass, while those of least quality were mounted with knobs of lacquered wood ". [1] Note the fact that here again the style of mounting indicates different quality. If book rolls were mounted so well, then doubtless pictorial rolls were mounted in a still more luxurious way.

---

[1) *Sui-shih* 隋 史：秘 閣 之 書。上 品 紅 琉 璃 軸。中 品 紺 琉 璃 軸。下 品 漆 軸。

**147**

In the passage of the essay by Chang Huai–kuan quoted above, there were already given a few indications as to the mountings of valuable autographs in the Palace collection during the early years of the T'ang dynasty.

Some more details may be found in an essay by the T'ang author Wu P'ing–i (武平一, end of the 7th century), entitled *Hsü–shih–fa–shu–chi* 徐氏法書記. There he states that when he was still a child he saw " Palace attendants take out over 60 boxes, and sun (the scrolls contained therein) in the I–sui Palace. The greater part of these rolls had knobs of carved ivory, and front mountings of purple silk. They said that these mountings dated from the time of the Emperor T'ai–tsung (627–649) ".[1]

In the same essay Wu P'ing–i describes how he was ordered to criticize the scrolls by the Two Wang in the Palace collection, and " to remove their ivory knobs and purple mountings, and replace them by lacquered knobs and mountings of yellow hemp paper [2] ".[3]

The earliest literary source that gives a complete description of the mounting process is the *Li–tai–ming–hua–chi*, written in 847 by Chang Yen–yüan, a scholar–artist whose family had since generations produced many enthusiast collectors of scrolls (cf. Appendix I, no. 33).

One need not wonder that it was at this time that a detailed account of the art of mounting was written. During the turbulent times preceding the T'ang period, the palace collections of the various minor dynasties and private collections of members of the nobility, were scattered over the country. Priceless scrolls turned up in the most unexpected places, pictures and autographs treasured for centuries could be purchased for one tenth of their real value. Thus art lovers of the T'ang period had excellent opportunities for collecting antique scrolls. These, however, were often badly damaged through passing from hand to hand in a time of warfare and general unrest. One may assume, therefore, that in Chang Yen–yüan's time the remounting and repairing of antique scrolls was an urgent problem; it was probably because of this that he devotes a special chapter of his book to this subject.

In this chapter, entitled " Discussion of the backing, front mounting and rollers (of antique scrolls) ", *Lun–chuang–pei–piao–chou* 論裝背標軸, Chang Yen–yüan treats exclusively the remounting and repairing of antique pictures and autographs. It seems that he, just like later writers on this subject, took it for granted that every reader would know how to mount new scrolls. Since, however, the processes of both mounting and remounting are essentially the same, Chang Yen–yüan's notes may still be considered the earliest account of the art of mounting in general.

1) 時見宮人出六十餘函。於億歲殿曝之。多裝以鏤牙軸。紫羅褾。云是太宗時所裝。 紙。

2) For this paper see page 137, note 2.

3) 去牙軸紫褾。易以漆軸黃麻

Chang Yen-yüan's
description of the art
of mounting.

Elsewhere in his book Chang Yen-yüan stresses the importance of the art of remounting. "Gold", he says, "comes from the mountains, pearls are produced by the deep waters. These constitute an inexhaustible source for the use of the entire Empire. Paintings, however, in course of time are destroyed and scattered, and only a very few are preserved. Since the famous men and talented artists (who created them) will never come to life again, is this not greatly to be deplored? Now those people who do not know how to treasure and enjoy antique scrolls, let them arbitrarily suffer all kinds of indignities. Those who carelessly roll and unroll them, damage the scrolls by their rough handling. Those who do not understand the art of mounting, let scrolls lie about without repairing them in time. That thus the number of genuine scrolls is ever decreasing, is this not a reason for grief?" [1]

In his chapter on the art of mounting Chang Yen-yüan proceeds as follows. [2]

"The time for mounting should be in harmony with the spirit of Yin and Yang. Autumn is the best time, then comes spring, and summer is the worst. One should particularly avoid the very hot and humid season.

"You should not use sized paper for backing scrolls, for such a backing will wrinkle up in creases. You should use thin large sheets of unsized paper which is white and smooth.

"You should take care that no seams (where the sheets of backing are joined together; cf. page 75 above) coincide with the faces of persons (of the painting), or on other important parts of the drawing. For where two seams coincide (i. e. when the scroll is rolled up), on that spot there will be a hard place in the scroll; on account of the frequent rolling and unrolling, the scroll will there become damaged. The seams should be made to occur at irregular intervals; moreover then the force of the paper will be equally divided. If the backing is too thick the scroll will become stiff, if too thin the backing will be too weak.

"Coloured pictures on silk should not be pounded (while being backed). Ink paintings on paper, however, may be pounded with a stone, so that their material becomes firmly and smoothly attached to the backing.

"For mounting you must use a flat table, with a lacquered top ruled with red lines, for ensuring straight and square cutting.

"Old paintings naturally show the dust which has accumulated on them in the course of the years. You should soak paintings for several days in a pure extract of *tsao-chiao* pods. [3] Then spreading the wet scroll out on your flat table, you can rub away the dust. Thus your painting will have become fresh and bright, without its colours fading.

---

1) 夫　金　出　於　山。珠　產　於　泉。取　之　　　痛　哉。
不　己。爲　下　用。圖　書　歲　月　旣　耗　　　2) Cf. also the translation by Acker (Appendix I,
散　將　名　人　圖　不　更　生。可　不　no. 33), pp. 242-253, and by A. Rygaloff, *Dissertation
惜　哉。夫　失　所　士。玩　動　解　勞　辱。*sur le montage et le doublage*, "Journal Asiatique", 1948; the
卷　舒　乘　善　操　便　不　裝　裝　亦 latter's translation differs in part considerably from mine.
者。隨　手　棄　損。遂　使　眞　迹　漸　少。不　亦　　3) *Tsao-chiao* 皂角, *Gleditschia horrida*.

"Having patched up damaged spots, you lift the scroll up on a pair of sticks, and spread it out over a sheet of oiled silk. Then you straighten out the borders, and close the tears, you adjust the warp and woof, [1] thus straightening up the drawing. You correct also minor defects, seeing that the scroll is perfectly smooth, luscious, clean and firm.

"Thereafter you make knobs of carved sandal wood, encased in tortoise shell or plated with gold, as a decoration. Rollers of white sandal wood are the best, they are fragrant and repell insects. For small scrolls knobs of white jade are the best; next comes crystal, and thereafter amber. Large scrolls should have knobs of lacquered pine wood, the best is if they are slightly rounded.

"During the former dynasties various precious materials were used for decorating scrolls, but such caused scrolls to be robbed or destroyed. During the Chên-kuan (627-649) and K'ai-yüan (713-742) eras, therefore, all the scrolls in the Palace collection were mounted with rollers of white sandal wood, knobs of red sandal wood, front mountings of thin purple silk, and woven bands. This was the standard for all Palace paintings. Someone said to me: 'By mounting scrolls (in an elaborate way) you are inviting trouble. You should not lavishly adorn them'. But I said: 'Mounting them with rare and beautiful materials, wrapping them up in costly brocade, refined and elegant in every respect, this is the only right way'." [2]

Earlier in the same chapter Chang Yen-yüan gives a recipe for preparing paste, one of the most important ingredients used by the mounter of scrolls. He says:

"When boiling paste, you must always discard all hard substances, in order to obtain the right degree of viscosity. If (while boiling) you stir it continuously, the paste will on its own account acquire the right composition. I always add a small quantity of powdered *kunduruka* incense (an Indian incense, made from the resin of a tree), ground very fine, as an idea of my own; this will keep insects away for ever, and moreover increase the viscosity of the paste. This is a thing the ancients had not thought of". [3]

1) As was explained on page 115 above, this straightening out is done with a comb. The oil cloth underneath supplies a smooth surface that facilitates this work.

2) 上時滑縫參急。時暑溼之氣以調適。秋爲下時。夏爲中時。陽爲
候陰陽之氣以調適。秋爲下時。夏爲中時。春爲用。時不
可勿漫縫差太可曲

書密其蠶蟲爲

書復補其遺然束其

明。色擡縫陳脫。鮮綵

不策端薄乃後金軸大代觀身畫不繡。

亦油其均鑱白檀上漆寶內首或飾蘊必調出之

不絹經調沈檀白爲木雜中首紫者余藉去

襯潤檀身水頭爲府羅云曰方筋余拙

之就潔爲爲精輕飾圖褾書裝爲稀綬袟意

直其平軸上爲圓易書綬袟之宜

其形穩。首香次。最爲一成以珍稱得入去永

邊制。或潔琥妙剝例帶褾華。所少葺

際。拾裹去珀。壞用以軸裹攪細而

3) 凡擣用白若令強上白制其莢垢。須用卓埃須去其塵。要則朱界。用其

起。敘節損。要有太理紙上制其用

3) 凡糊不薰陸固。古香人未未凡停。

之研牢

書數宿漬之。平案積之年漆埃塵。

不帖之可安石太造一古

背紙生避強人急。及舒均不可平年

熟幅先則失彩石必有

紙背必宿書數

時不漫縫差太可曲清水。

Next to the painting itself, the long hand scrolls of this time contained colophons and other remarks by connoisseurs and collectors. Often also, as we saw above in Chang Huai-kuan's remarks on scrolls by the Two Wang, a number of smaller paintings or autographs were mounted side by side, so as to form together one long roll. Chang Yen-yüan is very particular about the mounting and remounting of such composite scrolls·

"Originally", he says, "all scrolls are a complete unity in themselves, they have their superscriptions and colophons, all duly signed. They should, therefore, not be arbitrarily cut down, and the order of their component parts should not be changed. If, however, it should be necessary to mount together on one scroll say three or four autographs, or three or four small paintings; and if (in the case of some other scroll) the qualitative sequence of its component parts has become mixed up, or if (in an other case) there never was any right sequence, then such scrolls must be remounted in this way: the best picture should come first (i. e. at the extreme right of the scroll), thereafter should come the worst picture, and at the very end those of mediocre quality. Why should this be so? Because everyone's apperception is the keenest when he starts to unroll a scroll. His interest is liable to fag when he reaches the middle part. If (after having seen in the middle an inferior specimen) he thereafter sees a mediocre specimen (this being slightly better), the observer's interest is revived, and he will not leave off, but unroll the scroll till its very end. This is one of the theories regarding the art of mounting evolved by Yü Ho, [1] and a very excellent one". [2]

What strikes one most forcibly when reading Chang Yen-yüan's description is that in his time the process of mounting was mainly the same as it is to-day.

Comments on Chang Yen-yüan's notes.

He mentions the large table with the lacquered top, that nowadays also occupies the most prominent place in a mounter's workshop. The term *chieh* 界 used in the text for "rulings", suggests that the red lines drawn on this table showed the same pattern as the ruled space of a Chinese manuscript (see plate **74**). When cutting down the edges of the long hand scrolls, and when cutting the various strips of silk and paper used for front mounting and backing, these red lines on the table will guide the mounter's knife in cutting straight lines and square corners.

Also present-day mounters prefer unsized paper for the backing of scrolls, and the washing process too has remained unchanged, including the subsequent spreading out of the wet picture on a sheet of oiled silk or paper. The description of how to make paste is brief, but it tallies with more detailed accounts given in later sources (consult the General Index, s. v. *paste*).

The only method that seems to have become obsolete after Chang·Yen-yüan's time is the beating of the newly-backed scroll with a flat stone, in order to attach it firmly to

---

1) For Yü Ho, cf. page 139, note 4 above.

2) 凡圖書本是首尾完全著名之物。不在輒議割截改移之限。若要錯綜次第。或三紙五紙。三扇五扇。揉雜本亡詮次者。必宜與好處爲首。下者次之。中者最後。何以然。凡人觀書。必銳於開卷。懈怠將半。次遇中品。不覺書畫之媺。留連以至卷終。此虞龢論裝書畫之例。於理甚暢。

its backing.    This seems a rather drastic method that, if not used with the utmost care, is certain to damage even the coarsest silk or the toughest paper.    I did not find it mentioned in any later source; those all recommend tapping the scroll with a stiff brush or rubbing it with a rosary, as is still done to–day (see page 79).

Chang Yen–yüan further advises to back scrolls with sheets of varying length, so as to prevent the scroll wearing down on those places where two or more seams would coincide when the scroll is rolled up.    Also this is a wise counsel, that has been practised by mounters till the present.

One may find it difficult to share Chang Yen–yüan's enthusiasm over Yü Ho's theories, which seem a bit far–fetched; but they serve at least to show how much thought connoisseurs of that time gave to the enjoyment of scrolls.

Knobs and rollers. Chang Yen–yüan's remarks on the knobs and rollers of scrolls tally with what we found in the earlier sources which were quoted in the above.    It is not without interest to compare this passage with a list of knobs and rollers of hand scrolls dating from the T'ang period which are still preserved to–day in Japan, in the *Shōsō–in* 正倉院, the famous Repository at Nara.

The Japanese archeologist Harada Jirō 原田次郎 describes these specimens as follows.

" 380. Unused *jiku* (未造着軸).    Two hundred and twenty sticks, ready to be attached to sutras to be rolled around, but unused.    About 30 cm. long, 1 cm. in diameter.    There are the following varieties:

*a*) One hundred and four with blue glass tips.
*b*) Five with brown glass tips.
*c*) Sixty with yellowish glass tips.
*d*) Nineteen with green glass tips.
*e*) Eight with wooden tips decorated with painting.
*f*) Twenty with plain wooden tips.
*g*) Four with lacquered wooden tips decorated with gold painting.

" 381. *Jiku* ends (軸端).    Fifty–seven pairs and fifty–eight pieces, of various materials.    They had not been used, and they are as follows:

*a*) Forty–five pairs and five pieces of agate.
*b*) Thirteen pieces of glass.
*c*) Twelve pairs and three pieces of amethyst and rock crystal.
*d*) Thirty–five pieces of wood.
*e*) One piece of wood, lacquered.
*f*) One piece of wood with paintings in colour. [1]

1) *English Catalogue of Treasures in the Imperial Repository Shosoin*, by Jiro Harada; publ. by the Imperial Household Museum, Tokyo 1932.

152

Thus it appears that these actual specimens generally tally with Chang Yen–yüan's remarks. It should be noted that Harada states that these rollers and knobs were meant for mounting *hand* scrolls with Buddhist texts. This fact is further proved by the size of these objects. As will be discussed in greater detail below, at that time mounted *hanging* scrolls were still rare.

It appears from Chang Yen–yüan's book that prior to the T'ang period no seals were added to the notes and remarks written on scrolls by connoisseurs and mounters. He says: " During former dynasties, from the Chin (265–420) and Sung (420–479) till the Chou (557–581) and Sui (590–618) periods, none of the scrolls in the Palace Collection was sealed. Here I therefore only enumerate the signatures and seals of connoisseurs and artists of those times ".[1] He then gives a list of such names, and thereafter goes on to record some inscriptions found on scrolls of his own time. I quote one regarding mounting: " Mounted on Imperial command on the xth day of the xth moon of the xth year of the Ta–yeh period (605–616) ".[2] Arriving at the Chên–kuan period (627–649), Chang Yen–yüan gives more detailed information, quoting in full lengthy inscriptions that he found on various scrolls. These he prefaces by the following remarks: " During the Chên–kuan period Ch'u Sui–liang [3] and others were charged with the supervision of the mounting (of scrolls in the Palace Collection). Scrolls (of that period) bear the signatures of contemporary connoisseurs, colophons written by them, together with their official rank and full name ".[4] From the large number of inscriptions which he places on record I quote the following, which especially refer to the mounters.

Under the year 639:

" Mounted by the Chiang–shih–lang [5] Wang Hsing–chih,[6] official of the Hung–wên–kuan ".[7]

Under the year 640:

" Mounted by the Chiang–shih–lang Chang Lung–shu,[8] official of the Hung–wên–kuan. "[9]

Under the year 641:

" Mounted by the Wên–lin–lang [10] Chang Lung–shu ".[11]

1) *Li–tai–ming–hua–chi*, chapter three, first paragraph: 前 代 御 府。自 晉 宋 至 周 隋。收 聚 圖 書。皆 未 行 印 記。但 備 列 當 時 鑒 識 藝 人 押 署。

2) Ibidem: 大 業 年 月 日 奉 勅 裝。

3) Ch'u Sui–liang 褚 遂 良, also known as Ho–nan 河 南, 596–658, scholar-official famous especially because of his skill as a calligrapher.

4) *Li–tai–ming–hua–chi*, chapter three, first section: 貞 觀 中。褚 河 南 等 監 掌 裝 背。並 有 當 時 鑒 識 人 押 署 跋 尾。官 爵 姓 名。

5) A minor honorary rank.

6) Wang Hsing–chih 王 行 直, cf. ACKER (Ap-

pendix I, no. 33), page 221, note 2. The Hung–wên–kuan was a kind of Imperial Academy, established in 621 under the name of Hsiu–wên–kuan 修 文 館; in 626 its name was altered to Hung–wên–kuan.

7) 將 仕 郎 直 弘 文 館 臣 王 行 直 裝。

8) Chang Lung–shu 張 龍 樹, no further details known.

9) 將 仕 郎 直 弘 文 館 臣 張 龍 樹 裝。

10) A minor honorary rank.

11) 文 林 郎 張 龍 樹 裝.

153

Under the year 645:

"(Mounted) under the supervision of the acting Huang–mên–shih–lang [1] Ch'u Sui–liang ".[2] [3]

Coming to the K'ai–yüan period (713–741), Chang Yen–yüan remarks: " During the K'ai–yüan period, the Emperor Hsüan–tsung purchased scrolls all over the Empire, and ordered connoisseurs of that time to sign them and add colophons to them. Liu Huai–hsin [4] and others of these connoisseurs often removed the signatures added by former people, and replaced them by their own names ".[5] He then mentions the following notes he found on scrolls, all dated 717:

" Mounted by the Pei–jung–fu–wei [6] Wang Szû–chung ".[7] [8]

" Mounted by Chang Lung–shu ".[9]

" Mounted by Wang Hsing–chên ".[10] [11]

And under the year 727:

" Mounted by the Wang–fu–ta–nung [12] Li Hsien–chou ".[13] [14]

These remarks are of great importance, all the more so as those in charge of the Old Palace Collection at Peking inform me that none of the scrolls there preserved show suchlike notes from the T'ang period: they were cut off when later these scrolls were remounted. If, therefore, Chang Yen–yüan had not recorded these inscriptions, important historical data would have been lost forever. They show that the task of remounting the pictorial rolls of the Palace Collection was entrusted to persons of rank, their work being supervised by high officials. It is here already that the ways of mounting pictorial rolls and book rolls do part. While the pictorial rolls were mounted by scholar–officials, the work of mounting the book rolls of the Imperial Archives was done by ordinary artisans; the Dynastic History of the T'ang period mentions nine " artisans " (*chiang* 匠) charged with this work. [15]

From the point of view of the connoisseur it is interesting to note that those in charge of the Imperial Collection changed or deleted signatures added to scrolls by former experts and collectors. As will be seen below, also during the Sung period connoisseurs attached to the Palace were guilty of such irresponsible acts.

Unfortunately there have been preserved no further details regarding those persons mentioned by Chang Yen–yüan as having been charged with the mounting of scrolls

1) A high civil rank, Vice-president of the Imperial Chancery.

2) See note 3 on p. 153 above.

3) 守 黃 門 侍 郎 褚 遂 良 監.

4) Liu Huai-hsin 劉 懷 信, unidentified.

5) 開 元 中。玄 宗 購 求 天 下 圖 書。亦 命 當 時 鑒 識 人 押 署 跋 尾。劉 懷 信 等 亦 或 割 去 前 代 名 氏。以 己 等 名 氏 代 之.

6) A minor military official.

7) Wang Szû-chung 王 思 忠, no further details known.

8) 陪 戎 副 尉 王 思 忠 裝.

9) 張 龍 樹 裝.

10) Wang Hsing-chên 王 行 眞, cf. ACKER (Appendix I, no. 33), p. 221, note 2.

11) 王 行 眞 裝.

12) Director of Agriculture in a fief.

13) Li Hsien-chou 李 仙 舟, no further details known; other texts read *tan* 丹 instead of *chou* 舟.

14) 王 府 大 農 李 仙 舟 裝 背.

15) Cf. T'ang-shu 唐 書, Po-kuan-chih 百 官 志, under the heading Hung-wên-kuan (see p. 153, note 6): " Nine artisans for sizing paper and mounting scrolls " 熟 紙 裝 潢 匠 九 人.

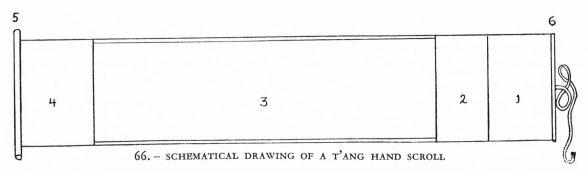

**66. – SCHEMATICAL DRAWING OF A T'ANG HAND SCROLL**

in the Palace Collection; except their name and official rank, nothing is known about them. Later writers use names like Wang Hsing-chih, Chang Lung-shu, Wang Szû-chung etc. as literary allusions designating a highly skilled mounter.

Finally I quote here another passage from the *Li-tai-ming-hua-chi*, that deals with the copying of ancient scrolls, both paintings and autographs. This work was considered as an important part of the artist's training, and moreover as a means for preserving ancient works of art: if the original should perish, an expertly traced copy was considered as nearly as good. Copies of antique scrolls made during the T'ang dynasty.

" Art lovers ", Chang Yen–yüan says, " should keep in stock a hundred sheets of Hsüan paper; [1] these sheets should be waxed (this process makes the paper transparent. Transl.) so as to be ready for being used in making traced copies. The ancients were fond of tracing paintings, they used to trace seven or eight of every ten scrolls they could obtain, and such copies lacked neither the superior colouring nor the brush technique of the originals. There were also traced copies made in the Palace, which go by the name of ' official traced copies '. In the Inner Storerooms, in the Han–lin Academy, and in the Chi–hsien Academy of our present dynasty tracings were continually being made". [2]

As will be seen below, this wide–spread habit persisted throughout the succeeding dynasties, both Palace officials and private painters and calligraphers engaging in the making of traced copies of all famous scrolls they could purchase or borrow. It goes without saying that this habit further complicates the authenticity problems which confront the later connoisseur.

The above quotations enable us to form a fairly clear idea of the appearance of elaborate T'ang mountings. In the schematic drawing given on Plate **66**, 1, is the protecting flap, its outside being made of heavy brocade, its inside of thinner multi–coloured silk. Then follows a strip of blank paper or light–coloured silk, where collectors and connoisseurs wrote their notes and impressed their seals (2). No. 3 indicates the painting or autograph itself, or a series of pictures and autographs. Thereafter again a blank space (4) used for writing colophons. The roller at the end (5) has protruding knobs, Summary of the T'ang hand scroll mounting.

---

1) This paper was produced at Hsüan–ch'êng–hsien 宣城縣, in Anhui Province.

2) *Li–tai–ming–hua–chi* (cf. Appendix I, no. 33), ch. II, section 3: 好事家宜置宣紙百幅。

用法蠟之。以備摹寫。古時好揚書
十得七八。不失神采筆蹤。亦有御
府揚本。謂之官揚。國朝內庫翰林。
集賢祕閣。揚寫不輟。

**155**

carved or otherwise decorated. The thin stave at the beginning (6) has a silk or brocade band attached to it for winding round the scroll when it is rolled up.

Along top and bottom of the scroll there were no strips of mounting but only a narrow " folded seam ". Later a strip of about four or five cm. was added along the top and another one, slightly narrower, along the bottom (cf. Plate **31**). In Japan, however, the old Chinese model has been preserved till today; Japanese *makimono* have only " folded seams ".

Notes and seals in foreign languages found on T'ang scrolls. Chinese connoisseurs of later times are greatly intrigued by an inscription consisting of three characters, which Wu Yen-hsiu (武 延 秀, consort of Princess An-lo 安 樂 公 主, grand-daughter of the notorious T'ang Empress Wu Tsê-t'ien 武 則 天) wrote on a number of antique scrolls in the T'ang Palace collection. These three characters, *t'ê-chien-yao* 特 健 藥, are first mentioned in the *Hsü-shih-fa-shu-chi* (see above, page 148); there it is said that Wu Yen-hsiu wrote this inscription on those scrolls by the " Two Wang " that had been pointed out to him as being of superior quality.

The Yüan source *Cho-kêng-lu* (see Appendix I, no. 24) quotes in ch. 12 this passage from the *Hsü-shih-fa-shu-chi*, as recorded in the *Mo-sou* (墨 藪, a work by the T'ang author Wei Hsü 韋 續), without, however, trying to determine the meaning of *t'ê-chien-yao*.

The Ming scholar Wang Shih-chên (王 士 禎, 1634-1711; v. E. C. page 831) says the following: " The *Cho-kêng-lu* mentions that pictures are sometimes inscribed with the characters *t'ê-chien-yao*, without giving the meaning of this term. Now I think of the fact that the Sung scholar Ch'in Kuan (秦 觀, 1049-1105; here referred to by his lit. name Shao-yu) recovered from an illness by contemplating the picture of the Wang-ch'uan Villa (see above, page 38), and that painters like the Sung artist Huang Kung-wang (黃 公 望, 1269-1354; lit. name Ta-ch'ih) or Ts'ao Chih-po (曹 知 白, 1272-1355; lit. name Yün-hsi), or Ming artists like Shên Chou (沈 周, 1427-1509; lit. name Shih-t'ien) or Wên Pi (文 璧, 1470-1559; lit. name Hêng-shan) all lived to an advanced age, only because of what people are want to call their ' feeding upon mists and clouds '. Is then the expression ' Special medicine for good health ' not a most apposite one (for inscribing on a fine scroll) ? " [1]

This, of course, is quite a fanciful literal rendering of the three characters under discussion. The Ch'ing scholar Liang Chang-chü (梁 章 鉅, 1775-1849; v. E. C. page 499), correctly observes that these three characters must be the transcription of some foreign word that means " excellent ". " I find ", he says, " that formerly collectors sometimes wrote the three characters *t'ê-chien-yao* at the beginning or the end of antique handscrolls, or had this legend engraved in seal script on one of their seals. Now we see that the *Fa-shu-yao-lu* quotes the *Hsü-shih-fa-shu-chi* as saying that the Imperial

1) 香 祖 筆 記：輟 耕 錄 言 或 題 畫 疑 曹 雲 西 沈 石 田 文 衡 山 輩。皆 工 曰 特 健 藥。不 喻 其 義。予 思 昔 人 如 畫。皆 亨 大 年。人 謂 是 烟 雲 供 養。則 秦 少 游 觀 輞 川 圖 而 愈 疾。而 黃 大 特 健 藥 之 名。不 亦 宜 乎。

156

Son-in-law Wu Yen-hsiu, hearing about the autographs by the 'Two Wang' (in the Palace Collection), insisted upon making a careful study of these, and ordered Hsüeh Chi (649-713), Chêng Yin (died 710) and Wu P'ing-i (see page 148) clearly to classify these scrolls according to their merits. On those scrolls which these people reported to be superior specimens, Wu Yen-hsiu wrote the three characters *t'ê-chien-yao*, adding that this is a Turkish word. Its meaning is therefore perfectly clear (viz. 'good', or 'excellent'). But the *Cho-kêng-lu* failed to understand this, and the *Hsiang-tsu-pi-chi* gives a forced meaning, based upon the literal translation of these three characters, which is a worse mistake ".[1]

Liang Chang-chü's explanation is corroberated by the facts. The Dynastic History of the T'ang period (*Chiu-t'ang-shu* 舊唐書) says in Wu Yen-hsiu's biography (ch. 183) that he passed a considerable time with the Turks, and on his return to the T'ang court even could sing Turkish songs (唱突厥歌).[2] Probably *t'ê-chien-yao*, which in T'ang Chinese must have been pronounced approximately *d'ak-g'ian-yak*, is an attempt at transcribing some Turkish expression meaning "excellent".

Further, Chang Yen-yüan lists in ch. 2 of his *Li-tai-ming-hua-chi* one of Wu Yen-hsiu's seals which he impressed on antique scrolls. The legend consisted of four "barbarian" characters, the Sanskrit reading of which was *san-miao-mu-t'o* (胡書四字。梵音云三藐母馱), adding that this seal was made of jade. Since *san-miao* is the regular Chinese transcription of the Sanskrit word *samyak*, and *mu-t'o* that of *buddha*, the legend much have read *samyak-sambuddha* "the completely enlightened one", the *sam* being inadvertently omitted. The Sung connoisseur Mi Fu says that he found on an antique scroll, next to a small seal reading *k'ai-yüan* (viz. the K'ai-yüan 開元 era of the T'ang period), also "a seal in barbarian characters, of the Princess T'ai-p'ing" (太平公主胡書印). It is possible that this is the same seal, which Wu Yen-hsiu later gave to the Princess T'ai-p'ing. But the pertaining passage in the *Li-tai-ming-hua-chi* is corrupt, and the restitution which makes Wu Yen-hsiu the *husband* of the Princess T'ai-p'ing (adopted by *Acker*, op. cit., page 233) is of course mistaken; the Princess T'ai-p'ing married first Hsüeh Shao, and after Hsüeh's execution she married Wu Yu-chi, and not Wu Yen-hsiu. Since both Chang Yen-yüan and Mi Fu state that the legend of the seal was written in "barbarian characters", this must refer to some ancient Indian style or to some early script used for

1) 浪蹟叢談：往見收藏家。於舊有平聞鄭答厥義之。
書跡之尾或考書特健藥字。亦武秀襐事突其解
取篆者記。題法錄武載秀襐隨是謂。
一氏印書書曰武呼延是喻鑒
二之法強云寶乃人薛隨
惝平蹟詳乃善諸云隨喻
稱上一題又特藥不是鑒
語祖者明記較錄穿喻
而矣。不。。以義。鑒
益筆 健耕
誤 字

2) Wu Yen-hsiu had been sent in 698 to the court of the N. Turkish Khan Mo-ch'o (默綴, tentatively transcribed by Franke as Bek-čor), to marry a Turkish princess. The Empress Wu hoped in this way to assure herself of the loyalty of this powerful chieftain. The Turks, however, were well aware of the fact that the T'ang Imperial family bore the surname Li 李, and refused to accept a "prince" of the surname Wu. He was kept for six years as a virtual prisoner, and sent back to the capital in 704. Cf. FRANKE, *Geschichte des Chinesischen Reiches*, vol. II (Berlin 1936), p. 420 sq.

157

writing Turko–tataric languages, perhaps the same that is found in Uigur inscriptions of the T'ang period.

The T'ang interior.    As to the interior of dwelling houses of the T'ang period, little need be added to what was said above regarding the Chinese house of the 2nd–5th century.   The Dynastic History of the T'ang period records under the year 783 the institution of a *chien–chia–shui* 間 架 稅, a house tax, based upon the number of *chien* and *chia*.   This shows that the construction of the dwelling house still conformed to the standard of *wu–chia–san–chien* described above.

The movable screen continued to form a most important element in interior decoration: T'ang poets mention frequently painted screens of various descriptions.   Also the large screen dividing the central hall in two often makes its appearance: it is from behind such a screen that a shy beauty peeps to get a glimpse of a handsome young guest who is being entertained in the hall.   On the outside, parts of the house were closed by lattice work, that was pasted over with paper, or thin silk (*sha–ch'uang* 紗 窓, *i–ch'uang* 綺 窓).   In summer there were used broad bamboo roll–curtains, decorated with silk designs woven into the thin strips (*hsiu–lien* 繡 簾).   Pillars and beams were lavishly decorated, *hua–tung–chu–lien* 畫 棟 朱 簾 "painted pillars and red roll curtains" became a literary expression for a wealthy house.

T'ang literature further mentions that over the door of the main hall there were suspended horizontal tablets, inscribed with the name of the hall, and that the two front pillars showed antithetical inscriptions.   Such inscriptions, however, have nothing to do with the mounter's art: the horizontal tablets were wooden boards with engraved characters, and the pillar inscriptions were carved directly into the wood.   Such engraved inscriptions are also to–day often found in private houses and in temples.

Through foreign (mostly Central–Asiatic) influence, furniture of various kinds became more popular.   High officials used folding chairs (*chiao–i* 交 椅, *hu–i* 胡 椅,[1]) and in Buddhist temple abbots favoured high, broad seats of Indian design.   Generally, however, at home people were still sitting on the floor, which was covered with grass (*hsi* 席) or bamboo (*chien* 薦) mats.

When not sitting on the floor, people used large, low couches, covered with a mat. One of these is shown on the hand scroll depicting the collating of the scriptures during the N. Ch'i dynasty (*Pei–ch'i hsiao–ching–t'u* 北 齊 校 經 圖, now in the Museum of Fine Arts of Boston; reproduced in the *Portfolio of Chinese paintings in the Museum, Han to Sung periods*, with descriptive text by Tomita Kōjirō, Harvard University Press 1938, plate 48).   This painting is further interesting because it shows that people, when sitting on such a couch, often made use of elbow rests, *lai–chi* 瀨 儿.   Such elbow rests are still used in practically every Japanese house, their Japanese name being *kyô–soku* 脇 息 or *hiji–kake* 肘 掛.

1) Cf. the excellent study by G. ECKE, *Wandlungen des Faltstuhls*, in: Monumenta Serica, vol. IX, 1944.

The public section of the house formed, as it were, one with the garden: when the curtains were rolled up, the side halls became a kind of open porches. T'ang literature gives numerous references to the *ch'ü-lan* 曲 闌, covered passages with carved balustrades, that in unexpected turns wound their way from the house to some garden pavilion. It would seem that outside more furniture was used than inside. One reads about rustic stone seats round a garden table that consists of a flat–topped rock; of bamboo couches placed near a cluster of trees for resting in summer, and terraces with carved marble seats and tables for sitting at while enjoying the moon.

The mounted scroll was not yet used in the interior of the first half of the T'ang period. Above mention was made, however, of folding screens and stiff screens, as used in the pre–T'ang interior. Concerning the development of these screens during the T'ang period, we have more material at our disposal.

T'ang literature often mentions *hua-p'ing* 畫 屏, painted folding screens, and *shu-p'ing* 書 屏, screens showing autographs by some celebrated calligrapher.

Such screens were considered as valuable as hand scrolls, and the greatest masters of the brush chose their panels as canvas. Chang Yen–yüan says in his *Li–tai–ming–hua–chi*: " One single panel (of a folding screen) painted by Tung Po–jên (i. e. Tung Chan 董 展, 6th century), Chan Tzû–ch'ien (6th century), Chêng Fa–shih (6th century), Yang Tzû–hua (6th century), Sun Shang–tzû (Sui dynasty), Yen Li–pên (died 673) or Wu Tao–hsüan (flourished round 700), fetches as much as 20 000 ounces, while slightly inferior specimens will sell at fifteen thousand ".[1] From this passage one may conclude that during the Sui and T'ang periods folding screens were constructed in the same way as later during the Sung and Ming periods, viz. each panel consisting of a sheet of silk or paper stretched over a wooden frame.

This is confirmed by some actual examples of T'ang folding screens preserved in Japan. In the Shōsō–in 正 倉 院, the famous Repository at Nara, there is a Chinese folding screen of six panels, each measuring 149 by 56 cm., and consisting of brocade stretched over a frame of lacquered wood. The panels are attached to each other with silk cords. This screen is too gorgeous to have much artistic value. The panels together show a Chinese poem in seal script extolling the rule of a virtuous monarch; every other character is made up of coloured bird–feathers, the rest of the characters are painted in colours.[2]

Pictures originally mounted as hand scrolls were often transferred to screens, and vice–versa. The T'ang source *Chên–kuan–kung–szû–hua–lu* (貞 觀 公 私 畫 錄, written by P'ei Hsiao–yüan 裴 孝 源) states that two paintings on a folding screen by the 6th century artist Chêng Fa–shih were detached from the screen, and mounted in the form of a hand scrolls. This practise still exists to–day. It is quite common that Chinese

---

1) *Li–tai–ming–hua–chi* (cf. Appendix I, no. 33), ch. II, section 4: 董 伯 仁 展 子 虔 鄭 法 士 楊 子 華 孫 尚 子 閻 立 本 吳 道 玄 屏 風 一 片。值 金 二 萬。次 者 售 一 萬 五 千。

2) See description and picture in J. Harada's Catalogue, mentioned on p. 152, footnote 1 above.

curio dealers remove a picture from a damaged or incomplete folding screen, and re-mount it as a hand scroll or a hanging scroll.

Next to such silk or paper folding screens, screens consisting of a number of panels of solid wood (see above, page 34) remained in use. But, although literary references give to understand that such screens were often covered with elaborate carving and inlaid work, from the artistic point of view they could never compete with those showing pictures or autographs on silk or paper.

Stiff screens. The *chang-tzû* 障子, or stiff screens of one panel, pose a more complicated problem. The character *chang* is sometimes written 幛, sometimes 障. The first character, interchanged with 帳, means properly "curtain", varying from a bed-curtain to the long tent-screens that were used for fencing off a street through which some high personage was going to pass. The latter character has the meaning of "protecting", "barring"; when used in its meaning of "screen", it refers especially to a stiff screen that partitions room space, or closes a door passage.

In T'ang literature, however, 障 and 幛 (帳) were used indiscriminately for "screen" in general. I quote the following passage from the *Li-tai-ming-hua-chi*, where Chang Yen-yüan describes in great detail the Ching-ai Temple (敬愛寺). "In the Hall where the Sûtra's are explained", he says, "there is large ornamental screen. In 715 Shih Hsiao-ching drew the design for this screen. Chang O-ch'ien executed the metal inlay work etc., and Li Chêng, Wang Ch'ien-liang and Kuo Chien-tzû made the bronze ornaments and the wax moulds (for casting these)". [1] This was thus a solid wooden screen, made exactly like the later *chang-tzû*, consisting of a slab of carved wood, inlaid with various materials.

Further, both 障 and 幛 are also used to designate stiff screens showing a painting or autograph, and mounted just like the panels of folding screens, viz. on wooden frames, placed on a pedestal to keep them standing upright.

Now it should be noted that the sliding doors inside Japanese houses and also those on the outside are constructed in the same manner; it are light wooden frames covered with paper. These sliding doors are called *fusuma* 襖, and also *shō-ji* 障子 or *kara-kami* 唐紙. The last two terms are significant: *shō-ji* is the Japanese pronunciation of Chinese *chang-tzû*, and *kara-kami* means literally "Chinese paper". If one remembers that later Japanese culture has preserved many T'ang features, one is inclined to assume that the Chinese *chang-tzû* of the T'ang dynasty resembled the later Japanese *shō-ji*; that is to say that they served as doors, walls or screens according to the need of the moment. When serving as a screen to partition off part of a room or to close a door opening, these papered wooden frames were provided with feet to keep them upright. When used to close off room space in a more permanent manner the frames were attach-

---

1) *Li-tai-ming-hua-chi*: 講堂內大寶帳　張阿乾。生銅作幷蠟樣是李正王
開元三年史小淨起樣。隱起等是　兼亮郭兼子。

ed to the pillars.   Chang Yen–yüan mentions painted screens being fixed along the outside of the open gallery surrounding the house and acting as a kind of sun blinds. I refer to his description of the Chao–ch'êng–szû 昭 成 寺 where he says: " On the sun–screens of the Western corridor there are pictures illustrating the (Buddhist work) *Hsi–yü–chi* painted by Yang T'ing–kuang " 西 廊 障 日 西 域 記 圖 楊 廷 光 畫.

It goes without saying that the " wall screens " offered an excellent canvas for painters and calligraphers: the term *hua–chang* 畫 障 " painted screens " frequently occurs in T'ang literature.   It may be added that in Japan the *shō–ji* have since ancient times been used for the same purpose, painters and calligraphers either writing directly on the already mounted screen, or on large sheets of paper or silk that later were made into screens.   The technique of making the screens function as sliding doors seems to have been a purely Japanese invention.

Since private houses of the T'ang dynasty were lacking the ample wall space of temples and palaces, the pictorial *chang–tzû* were used to the same effect as mural paintings. They served the same purpose as hanging scrolls which became popular later when architectural developments had made more wall space available for interior decoration.

How the T'ang con-noisseur viewed his scrolls.

A T'ang connoisseur unrolled his hand scrolls on the floor, or on a low table, squatting in front of it.   Or he may have been seated cross–legged on a broad, low couch, transferring the low table also to this couch, or unroling his scrolls on the top of the couch itself.   Most of the writing and painting in those days seem to have been done also in this way.

Chang Yen–yüan has a brief note on how to view scrolls.   " In your house ", he says, " you should use a flat and steady couch with a coverlet on its top, and, having dusted it, thereon unroll your scrolls to view them.   For large scrolls you must construct a wooden rack, and look at your scroll while it is being hung over it " 人 家 要 置 一 平 安 牀 褥。 拂 拭 舒 展 觀 之。 大 卷 軸 宜 造 一 架。 觀 則 懸 之.

The " coverlet " mentioned here probably resembled the Japanese *mō–sen* 毛 氈. This is a large piece of thick felt, that is spread out on the floor mats.   Painters and calligraphers thereon unroll their blank sheets of paper or silk, press it down in the corners with a few weights, and then start to work.   This *mō–sen* not only protects the floor mats, but also absorbs the moisture that penetrates the paper when ink or colours are being heavily put on, and thus prevents them from running.

The " rack " must have resembled the contrivance described in detail by the Ch'ing author Chou Êrh–hsüeh (see below, page 318), or else the wooden frame used by Indian story tellers for displaying the long picture rolls that illustrate their tales (see page 167). Chang Yen–yüan may have used his rack either for large hand scrolls, or for primitively mounted hanging scrolls.   It is this question of the early hanging scroll that we have to discuss now.

161

<p align="center">* * *</p>

Late appearance of the secular hanging scroll.

In the above there was discussed only the *chüan*, the horizontal hand scroll, no mention being made of the *kua-fu* 掛 幅, the vertical hanging scroll, with which most Western collectors are much more familiar.

The fact is that this hanging scroll mounting is a comparatively late development. Although Buddhist representations mounted in such a way as to be suitable for being suspended on stakes or on the wall, were known in China already during the period of the Six Kingdoms (220–289), the Chinese secular hanging scroll seems not to have come into use until about the middle of the T'ang period.

The evidence for this late appearance of the secular hanging scroll may be summed up under the following five points.

1) In Chinese literature from the 3d–7th century one often reads about pictorial rolls being unrolled on a table or desk. I mention, for instance expressions like *chan-hua* 展 書, *p'i-t'u* 披 圖, *p'i-chüan* 披 卷, etc. On the other hand I have not yet found any indication that in those times secular scrolls were ever suspended on the wall. [1]

2) The *Li-tai-ming-hua-chi*, the T'ang source quoted above does hardly mention any hanging scrolls. All pictures described in some detail are either hand scrolls or wall paintings. Another T'ang source, the *Chên-kuan-kung-szŭ-hua-lu* (see page 159 above) enumerates hundreds of paintings by artists who worked during 220–589; all these are designated as *chüan* 卷 "hand scrolls".

3) The few authentic early paintings still preserved either in original (for instance Ku K'ai-chih's famous *Admonitions of the Instructress to the Court Ladies*) or in reproductions, and also all early calligraphic specimens, were painted, c. q. written as hand scrolls. Thus the few actual materials preserved confirm the impression gained from literary sources.

4) The *Szŭ-ling-shu-hua-chi*, a list of scrolls in the Palace Collection during the Shao-hsing period (1142–1153), with special reference to their mountings (more details on page 203 below), mentions but very few items mounted as hanging scrolls: the majority of the paintings and calligraphic specimens described are mounted as horizontal hand scrolls.

5) Secular hanging scrolls were unknown in Japan till the 12th century. Until that date one finds only Buddhist hanging scrolls. Now during the T'ang dynasty not less than fourteen Japanese official missions visited China, often consisting of several hundred persons, among whom there were many artists and artisans. These missions

---

[1] The character *kua* 挂 in the sentence 畫 挂 也。以 五 色 挂 物 象 也, which is the definition of "painting" in the *Shih-ming* 釋 名, a lexicographical work compiled by the Han scholar Liu Hsi 劉 熙, must not be read in the sense of "to suspend". This sentence is to be translated as "*Painting* is *to put on*, viz. with the five colours *put on* (wood, silk paper etc.) the likeness of things". It is to be noted that in the *Shih-ming* each entry is explained by a character which as much as possible combines semantic and phonetic clues; cg. other definitions such as 德 得 也. Raphael Petrucci's translation of 畫 挂 也 "La peinture, on la suspend" (Encyclopédie de la Peinture Chinoise, vol. I, page 45) is therefore unwarranted. It is curious that Petrucci makes this mistake, for his fine artistic intuition leads him on the next page to the correct conclusion that the Chinese hanging scroll mounting is derived from an Indian religious prototype; hence it could hardly have been popular already in the Han period.

were sent with the special purpose of studying Chinese culture in all its aspects. If at that time hanging scrolls would have been popular in China, doubtless this style of mounting would have been introduced into Japan at a much earlier date.

This tardive appearance of the secular hanging scroll mounting must be explained by its complex origin, being partly Chinese, partly Indian.

Since even religious Chinese hanging scrolls dating from the 9th and 10th century are extremely rare, while Indian ones are non–existent altogether, at the present stage of our knowledge it is difficult to adduce definite historical data proving this theory. It is thought, however, that on the basis of certain data furnished by Indian and Chinese literature, together with a study of such specimens of early Buddhist scrolls as have been preserved, it can, at least, be proved that this theory is not unsupported by facts.

In order to be able to view this problem in its historical setting, we must first rapidly survey the history of the art of mounting in India.

Ancient Sanskrit literature counts a number of painter's handbooks. Sanskrit works such as the *Citralaksaṇa*, [1] the *Viṣṇudharmottara*, [2] the *Mayaçâstra* [3] relate in great detail the theory of art, and further most of the practical subjects that a painter must know: drawing, mixing colours, etc. Unfortunately, however, they say nothing about the art of mounting or its history. For a study of the early development of this art one therefore must depend upon scattered references in Sanskrit literature, and some scanty survivals to be found in modern India.

Up to roughly the beginning of our era, in India — just as in China — mural painting predominated. The two great epics *Mahâbhârata* and *Râmâyaṇa* mention halls decorated with wall paintings, and the *Vinaya Pithak*, a Buddhist work in Pali dating from the 3d or 4th century B. C. speaks of a *chittâgâra* a " painted hall, adorned with painted figures and decorative patterns ". [4]

Yet on occasion one also finds references to paintings executed on board or canvas. The latter were known as *paṭa*, pointing to cloth being used as material. When going to paint his picture, the artist stretched such a piece of cloth over a wooden frame, and having finished his picture left it there to dry. It would seem that often pictures were left permanently attached to this wooden frame, and displayed in this condition: the 7th century author Bâna describes such a picture in his *Harṣa–carita* (a semi–historical work relating the deeds of King Harṣa of Kanauj). He mentions the *Yama–paṭika*, a popular story teller, who on markets and street corners shows a *yama–paṭa*, a piece of cloth on which are depicted Yama, the God of Death, and the tortures of hell. While describing

1) Edited according to the Tibetan version by Ber-thold Laufer, *Das Citra–lakshana, nach dem tibetischen Tanjur herausgegeben und übersetzt*, Leipzig 1913.

2) Stella Kramrisch, *The Vishnudharmottara* (Part III), *a treatise on Indian painting and image making*, Calcutta University Press, 1928.

3) *Principles of Indian Silpasastras, with the text of the Maya–sastra*, by Prof. Phanindra Nath Bose (The Punjab Oriental Sanskrit Series No. XI), Lahore 1926.

4) Percy Brown, *Indian Painting* (The Heritage of India Series), London 1932, page 20.

Complex origin of the secular hanging scroll mounting.

Survey of the history of Indian mounting. – Early period.

these scenes to his audience, he carries in his left hand a wooden frame with the picture stretched over it, and underlines his stories by gesticulating with his right hand, holding a bamboo stick. Often, however, these *pata* paintings were made into long rolls, showing a continuous representation of a narrative character, more or less like the Chinese hand scrolls. The Sanskrit drama *Mudrârâksasa* in the first act describes how such a roll was shown, and commented upon in songs by the man who displayed it. [1] Further one finds in Sanskrit literature among similes based on painting the *citra–pata–nyâya*, "Simile of the painted canvas", which says: "Just like a canvas rolled open reveals its figures, so does the Supreme One make manifest the whole world concealed in him by the Karma of the souls". [2] It is not said, however, how such roll pictures were mounted. Probably they resembled the picture rolls nowadays still shown in Bengal by popular story tellers along the road side: just strips of cloth, backed with a stitched–on backing of rougher cloth, and displayed while being hung over a bamboo rack.

For many centuries, till the advent of the Mughals in 1600, the surface of walls and rough cloth remained the favourite canvas of the Indian painter. In ancient and medieval India paper never became popular as material for drawing or writing; its place was taken by cloth and palm leaf.

Buddhist period.

It was during the so–called Buddhist period (roughly from A. D. to 800) that the *pata* picture greatly developed. Painted scrolls were used not only for the decoration of temples, they also formed an important means for propagating the faith, and explaining the Buddhist creed to the illiterate masses. By this time the work of the Buddhist missionaries of the Emperor Açoka (3d century B. C.) had born fruit, and Buddhism, expecially in its later forms, had spread widely over all parts of India, reaching also adjoining regions. To initiate the people in the intricacies of the extensive Mahâyânic pantheon, the preachers made a large use of religious pictures. Now the *pata* form was easily transformed into a portable picture, eminently suited for being taken along by the missionaries on their long journeys.

A pata depicted on the Borobudur.

As far as I know no actual specimens of such Indian *pata* of the Buddhist period have been preserved. However, their main features can be traced in later Sino–Indian specimens discovered in Central Asia (see below), and the Tibetan *tangka* mounting (see Appendix II) was directly derived from ancient Indian models.

This appears from an instructive picture of a rolled–up *pata* found in a relief of the Borobudur, the famous 9th century Hindu–Javanese sanctuary on the island of Java. This relief represents the story of King Bimbisâra who sent a picture of the Buddha to another king in order to convert him to the creed. Plate **67** is a photograph of part of the relief, showing a man riding on an elephant who respectfully carries a rolled–up

1) Cf. M. Barua, in *Calcutta Review*, June 1927, pp. 370–371.

2) C. Sivaranamurty, *Sanskrit sayings based on*

*painting*, Journal of the Indian Society for Oriental Art, vol. II, no. 2, Dec. 1934.

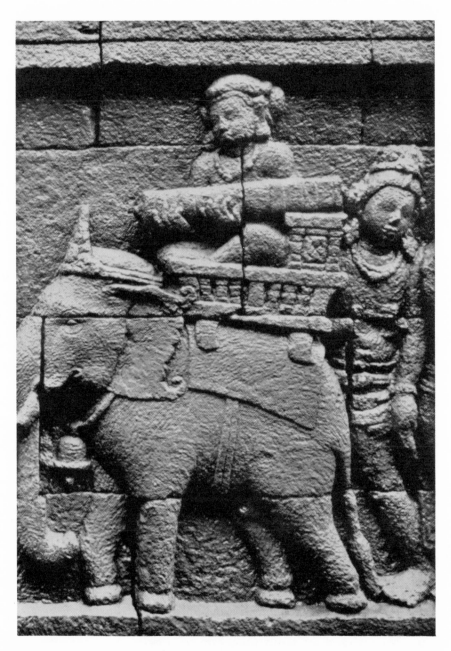

67. – BOROBUDUR RELIEF
(Photograph by Major Th. van Erp)

picture in his arms. A. Foucher identified the object (cf. his *The beginnings of Buddhist art*, London 1917, p. 234) and the Netherlands archeologist Th. P. Galestin has pointed out some important details (cf. his article *Het Geschenk van Koning Bimbisâra*, in the periodical "Phoenix", vol. III, no. 4, Amsterdam 1948); he drew attention to the fact that not only the ends of the roller are visible, but also two broad bands wound round the scroll which can be discerned as four faint lines (cf. Plate **68**).

68. – DETAIL OF THE BOROBUDUR RELIEF
(Sketch by Prof. Th. P. Galestin)

Description of Indian "banner paintings" of the Buddhist period.

These data, together with some remarks found in Sanskrit literature, permit us to reconstruct the main features of the ancient Indian *pata* picture and its mounting. They were painted on cloth, and on top attached to a stave of bamboo or rottan. To this stave there was fastened a loop for suspending the scroll on a stake or pole, so that it could be shown to the multitude in temples, or be carried along in religious processions. Since these pictures thus resembled the ancient Indian banners, the term "banner mounting" is a convenient appellation for this form of mounting.

From a technical point of view these "banner paintings" were but a continuation of the old mural paintings in tempera. The *Pañcadaçî* [1] says that a painting is made in four stages. First the cloth on which the picture is to be drawn should be washed (*dhauta*); then it should be primed with a mixture of chalk and glue (*ghattita*). On this ground the design is drawn (*lâñchita*), and finally the colours are painted in (*rañjita*). The gesso layer was usually made of a mixture of chalk or rice powder, glue and some kinds of powdered incense. Sometimes this ground was gilded, or covered with vermilion. A Chinese author of the 12th century says:

" In the West, in Central India, there is the Nâlandâ monastery, where there are made many paintings of Buddha, Bodhisattva's and Arhats, painted on Indian cloth. These Buddhist representations are greatly different from those of China; their eyes are larger, their mouth and ears are all quaint. They have their robes attached with a rope to the right shoulder, and thus are seated with half of their body naked. First the five mystic syllables [2] are written on the reverse of the painting, and thereafter the picture is drawn in full colours on the obverse. They cover the canvas with a ground of gold or vermilion. They aver that cow's glue [3] is too thick (for mixing the colours), therefore they use peach

---

1) A Vedânta work of the 13th century.

2) 藏 here means magic formula written on the reverse of a Buddhist scroll. Each of the vital parts of the body has its mystic syllable or " seed letter ", Sanskrit *bîja-akṣara*, Chinese *chung-tzŭ* 種 子; for more details about these see my book *Hayagrîva, the Mantrayânic aspect of horse cult in China and Japan* (Leyden 1935), pp. 51 and 82. To-

day still Tibetan monks are wont to consecrate pictures of Buddhist deities by writing these mystic syllables on the reverse of the painting; cf. Appendix II, on Tibetan tangka's.

3) Yet in ancient India cow glue was widely used for making colours fast. The *Viṣṇudharmottara* (see p. 163, note 2) says that buffalo skin is boiled in water till it has become soft like butter. When the water has evaporated,

69. – TIBETAN "BANNER PAINTING"
CARRIED ON A POLE

resin glue diluted with water in which willow branches have been soaked, which makes the pigments durable and bright. This is a devise that is unknown in China. When Mr. Shao was prefect of Li-chou, [1] there used to come to the public offices monks from India. He ordered them to paint images of Buddha. Now in the Office for Tea and Horses there are sixteen Arhats (painted by an Indian monk) ".[2]

The process of drawing also was not essentially different from that used for instance by the artists who painted the Ajanta caves: when the gesso ground had been polished, the outlines of the drawing were painted in red lines, and finally the colours were added. Nowadays this distemper technique is still used for Buddhist representations in Tibet, Mongolia, and to a large extent also in China and Japan. Thus this style of painting can boast of a history of nearly two thousand years.

These scrolls of painted cloth needed some kind of mounting. Several seamed borders of coloured silk were sewn along the four sides of the picture; then a broad border of rough cloth was added, and the whole picture was loosely backed by stitching on a piece of some rough fabric. A rottan stave was attached on top with a valance of thin cloth or silk that served to protect the scroll from profane eyes, at the same time preventing it from being soiled by flies and incense smoke. To the upper stave there were also attached two broad bands of cloth. When the picture was being displayed and the veil lifted these bands kept the veil in its place, loosely rolled up against the upper stave. And when the scroll was taken down again the veil was first smoothed out over the picture and then rolled up together with it; the bands were wound round the rolled-up scroll.

When carried around in religious processions these banner pictures were probably suspended on a pole, surmounted by a canopy decorated with coloured ribbons and strea-

the residue will be found to be a thick paste; this paste is dried in the sun, cut into cakes. When about to use this glue for mixing the pigments, one boils a cake in water, in an earthenware vessel. This same glue is used for making the gesso ground for wall paintings (this gesso paint is called in Sanskrit *vajra-lepa* " cement "; according to the *Citralakṣaṇa* this same term is applied to the cakes of glue. v. G.). For making the gesso ground the glue is mixed with white clay, and then applied to the wall. This coating should consist of three layers, each being allowed to dry before the next one is applied.

1) A town in Yünnan Province.

2) This passage is to be found in the *Hua-chi* 畫繼,

a treatise in 10 ch. on painters and painting of the period 1070-1160, compiled in 1167 by Têng Ch'un 鄧椿. The text reads:

鄧椿。天眼裸塗謂水。史廨漢。
西蘭陀寺。西異肩。乃地枝太公羅。就六
那像。以人右背。作柳邵來十
度漢中帶於朱膠訣天有
印羅與以藏或桃其西司
中薩好怪以五金用得自馬
天菩相俱施以故不僧嘗迦。
西及佛耳先面。口已。書為中釋
書佛之。而於膠清。州。書
多為稍坐彩皮堅黎書
作布目祖五牛甚知令

166

mers. This very elaborate type of banner mountings still survives in Tibet. In wedding processions the Tibetans carry large pictures suspended on poles and surmounted by a canopy. Plate **69** is a sketch of such a picture, a detail of a large Tibetan painting reproduced in full colours in J. Hackin, *Sur des illustrations tibétaines d'une légende du Divyâvadâna* ("Annales du Musée Guimet, Bibliothèque de vulgarisation", vol. 40, Paris 1913); on the same plate is depicted an unmounted "banner picture", stretched over a wooden frame.

During the medieval period Buddhism in India gradually declined and receded before <span style="float:right">Medieval period.</span> the waxing Hindu influence. Great numbers of Buddhist monks emigrated to adjoining regions such as Nepal and Tibet. This emigration increased when the Muhammedan invasion brought destruction to the great Buddhist monasteries and universities of Nâlandâ, Vikramaçila, Odantapurî and Jagaddala. [1] Together with the Buddhist monks the "banner picture" as a medium for religious propaganda gradually disappeared from India. It survives only in the Tibetan *tangka* and the Nepalese *prabhâ* (cf. Appendix II).

Thereafter paper came into its own as material for writing and painting and quite different styles of mounting pictures became fashionable. [2] At present the "banner picture" lives on in India only in the picture rolls shown by public story tellers. [3]

---

[1] Cf. M. Haraprasad Sastri, *Bauddha–dharmer–adhaḥpât* (The downfall of Buddhism), in Bengali.

[2] Viz. Persian styles of mounting miniatures. As these methods show some interesting parallels with Chinese mounting, I here quote the excellent description given by Percy Brown in his standard work *Indian Painting under the Mughals* (A. D. 1550–1750), Oxford 1924, p. 190: "The artist having finished his picture or *taswîr* ... there still remained much to be done before the miniature was considered quite complete. The *taswîr* was only the central panel of the work; added to this there were the mounting and the border-designing, besides several other details, each of which required the services of a separate expert ... The *taswîr*, having been painted on a thin, irregular shaped piece of paper, was first handed over to the *vaslîgar* (mounter) to be trimmed, and mounted on a stouter card. Many Mughal pictures were intended to be bound in a *muraqqa'*, a kind of album or scrapbook, so that they were also mounted on one side by the *vaslîgar* with this object in view. The mounted picture was then taken to the *naqshanavîs*, who painted on it the *hâshiya*, or border. Immediately adjoining the central panel, or *taswîr*, is a narrow band contained beween black and white ruled lines. The lines were called by some *jadval*, and by others *khat*, while the narrow band which was usually decorated with a running pattern of flowers and leaves was known as *bail*. If, however, the band was ornamented with detached flowers repeated at intervals, it went by the name of *phulkârî*, or flower-pattern. The remaining portion of the mount, or *hâshiya*, was embellished by means of a variety of designs, each of which has its special character and name".

[3] An interesting parallel of the Indian story teller with his roll pictures is found on the island of Java, in the former Netherlands E. Indies. One of the oldest forms of popular entertainment preserved there is the so-called *wajang-bèbèr*. The performer owns a number of roll pictures painted in vivid colours on rough paper, about one meter high but measuring several meters in length. Each picture is mounted with a *sêligi*, a wooden roller, on either end; on top these rollers are cut even with the edge of the scroll, but at the bottom they protrude several inches. The ends of the protruding tips of the rollers fit into two holes of about one inch deep, drilled at a distance of about three feet in a heavy wooden log. The performer sits down crosslegged behind this log, and, having set up the roll picture by placing the ends of the rollers in the holes of the log, section by section shows the entire scroll by slowly turning the rollers between his fingers, holding them in the space between log and picture. At the same time he relates the story belonging to the pictures in a sing-song voice. This *wajang-bèbèr* is much older than the famous Javanese *wajang-poerwa*, the shadow play performed with puppets cut from leather, but nowadays it is practically obsolete, and only very rarely seen. The Javanese regard it as holy, and it is only performed on certain solemn occasions. The *wajang-bèbèr* was doubtless introduced into Java by the Hindu conquerors. When in the beginning of the 15th century the Chinese scholar Ma Huan 馬歡 visited Java, he did not fail to notice the resemblance of the *wajang-bèbèr* roll pictures to the Chinese hand scroll. As by then the art of mounting scrolls in China had reached a high perfection, one can hardly expect Ma Huan to have realized that he saw in this

167

After Buddhism had become practically extinct in India, its traditions were continued in foreign countries. The Mantrayânic doctrines flourished in several minor states of Central Asia, in Nepal, Tibet and in the vast plains and mountainous regions of China.

It is well known that since the beginning of the 3d century there existed narrow relations between China and Central Asia. Buddhism flourished greatly during the Northern Wei Dynasty (北魏 386–534 A. D.) when foreign monks visited China in large numbers. Next to the Buddhist sacred books they brought also with them a great variety of religious images including pictures mounted in banner–form. This type of mounting, new to broader Chinese circles, was called by the Chinese *chêng* 幢 or *ch'uang* 幢, terms in later times still used for designating Tibetan *tangka*'s.

Although the fortunes of Buddhism varied, its artistic influence never waned. As a modern Chinese art historian quite correctly observes, Chinese painting during this period was predominantly Buddhist. [1] Thus the 3d–7th century witnessed the great flourishing of the painting of human figures; it was only during the T'ang period that the painting of landscapes came into its own.

It were doubtless the Indian " banner paintings " that supplied to the Chinese the example after which first the Chinese religious, and thereafter also the secular hanging scroll mounting was modelled.

It is a fortunate coincidence that the earliest Chinese " banner paintings " were recovered from Central Asia, the place were Chinese and Indian culture merged, and that they date from the time that the Chinese themselves started to mount hanging scrolls after the Indian example.

It is true that the places where these " banners " were found, Qara Choja in E. Turkestan, [2] and Tun–huang on the Western border of China, [3] were situated at the extreme West of the T'ang Empire. The paintings found there are, with a few exceptions, the work of artisans rather than of artists. Still cultural life there was a copy of that in the

Javanese performance the proof that the ancient Javanese, just like the Chinese, were indebted to India for some methods of mounting and displaying scrolls. His brief description of the *wajang–bèbèr* does credit to his powers of observation. He says: " There is a class of people who paint on paper human figures, birds and all kinds of animals, in the same way as our hand scrolls. These scrolls are provided with a wooden roller on each end, of about three *ch'ih* high, and on one end cut off even with the scroll. The man having seated himself cross–legged on the ground, places the painted scroll upright in front of him, and everytime he unrolls a section, with the painted side facing the audience, he explains it in the native tongue, relating in a loud voice the story belonging to it. The audience sits round him and listens, sometimes laughing, sometimes weeping, just as happens in the case of our Chinese popular story tellers " (*Ying–yai–shêng–lan* 瀛 涯 勝 覽, section on Java, near the end: 有 一 等 人 以 紙 畫 人 物 鳥 獸 鵰 蟲 之 類。如 手 卷 樣。以 三 尺 高 二

坐 膝 蟠 人 其 頭 一 齊 止 榦 畫 爲 木
聲 高 語 番 前 朝。段 一 出 展 每。地 於
之 聽 而 坐 圓 人 衆 歷 來 段 此 說 解
般 一 話 平 說 如 便。哭 或 笑 或

1) Cf. CHÊNG CH'ANG, *Chung–kuo–hua–hsüeh–ch'üan–shih*; described in footnote 1 on page 50 above.

2) Cf. the fine publication by A. VON LE COQ, *Chotscho, Facsimile–wiedergaben der wichtigeren Funde der ersten Königlich Preussischen Expedition nach Turfan in Ost–Turkestan*, Berlin 1913; for a general survey, *Bilderatlas zur Kunst und Kulturgeschichte Mittel–Asiens*, Berlin 1925, by the same author.

3) Next to *Serindia*, mentioned p. 145, note 2, see also *The thousand Buddhas*, ancient Buddhist paintings from the cave–temples of Tun–huang, on the Western frontier of China, recovered and described by Aurel Stein, London 1921. The best technical descriptions of these paintings are given by ARTHUR WALEY, in his *A Catalogue of paintings recovered from Tun–huang*, London 1931.

great T'ang cities of China proper; a copy on a much lower and simpler level, but still a true copy of the cosmopolitan society of, for instance, Ch'ang-an. It may be assumed, therefore, that the Qara Choja and Tun-huang mountings were substantially identical with those produced at that time in the cultural centers of China itself. Details may have differed, but the principle must have been the same.

The oldest actual specimens of Chinese religious " banner paintings " were disco-vered by A. von Le Coq at Qara Choja, and by Sir Aurel Stein at Tun-huang. There is hardly any difference between the " banners " found in these two places; minor varia-tions are caused by the fact that in the former region Indian and Iranian elements were dominant, while in the latter Chinese influence prevailed.

As regards their mountings, these pictures may be divided into two categories. The first, consisting of larger, rectangular pictures, I would designate as " wall hangings ". The second, a group of small pictures painted on narrow strips, seldom exceeding one meter in height, I would call " pillar hangings ", since I presume that they were not used as wall or altar hangings, but rather to be suspended on pillars, or from the eaves of the temple roof.

The mountings of the first category are very simple, most of them only show a num-ber of small suspension loops along the upper edge, and have a backing of rough cloth sewn on to them. I refer to *Serindia*, page 1086, no. CH IXIII.002, a picture of Ksiti-garbha on paper, with paper border and linen suspension loops; page 1080, no. CH IVI.0034, a large silk painting showing the Paradise of Amitâyus, provided with coarse linen backing and border. Further, *Thousand Buddhas*, atlas Plate XXV, left, painting of Ksitigarbha. It is the second category that is mounted in a more elaborate way, and therefore deserves a closer study.

A fairly complete specimen, now in the British Museum, is reproduced on plate **70**. It is a picture of the Bodhisattva Avalokiteçvara, painted in colours on a strip of rough cloth, measuring 116 by 20 cm. The inscription reads " Homage to the Bodhisattva who prolongs life " 南 无 延 受 (vulgar abbreviation of 壽) 命 菩 薩. On top and below there is painted an ornamental band, the one on top evidently representing an attempt at rendering the curtain of coloured silk that covers Indian banner paintings. The upper and lower edge of this picture are sewn around a thin bamboo stave, the lower one of the same width as the picture itself, but the upper one sticking out on either side for about 5 cm. To this upper stave there is sewn on a broad band, that forms a triangle, with the upper edge of the painting as its basis. This triangular space is filled by a small picture of the Dhyani Buddha, painted on a separate piece of cloth. A small suspension loop on top completes the upper part of the mounting. This upper part suggests both the elaborate canopy of Indian banner mountings suspended on poles, and at the same time the crown of Buddhist votive stelae in stone.

The protruding ends of the upper stave carry two olive-green streamers of gauze, of the same length as the picture itself. It is clear that despite the two bamboo staves at

top and bottom, which act as stretchers, such a banner mounting would not hang straight, especially in an airy temple hall. To the lower stave there was added, therefore, an elaborate third stretcher, in the form of a thick wooden board, its front covered with an ornamental design, and fastened to the picture by two long strips of the same material as the streamers, and having about the same length as the picture itself.

Plate **71** shows an apparently later, simplified development. The picture itself representing Avalokiteçvara and measuring 96 by 26 cm. lacks the painted–in ornamental bands along upper and lower border; the triangular shape of the top has been retained, but the extra–space thus obtained forms part of the picture, and is filled out by a flower motif. The wooden board below is missing, but there can be no doubt that originally it was there.

Plate **72**, finally, shows a sketch of a banner painting found by von Le Coq at Qara Choja. He there discovered some Chinese Manichaean pictures of Eclecti and Eclectae, that were mounted as banners according to roughly the same method as was used for the pictures found at Tun–huang. One, showing the picture of an Eclectus, had enough of its mounting left to permit a reconstruction (op. cit., plate 3). The sketch given here was made after this reconstruction. The same publication shows on plate 42 a picture of *Vaiçravaṇa* (P'ei–fang Pi–sha–mên t'ien–wang 北 方 毘 沙 門 天 王), where the upper stave is sticking out on left, showing the empty place occupied by the left streamer.

An early Chinese secular " banner painting ".

That at that early date also secular representations were occasionally mounted in such a manner, is shown by the Tun–huang picture reproduced on Plate **73**. This is a most important specimen, since, as far as I know, it is the earliest Chinese *secular* hanging painting extant, which still has its original mounting attached to it.

The picture itself (measuring 44 by 14 cm.) consists of " dull red damask woven with small conventional floral pattern " (Waley). On this ground there are painted with black ink two flying birds, holding in their bills sprays of a water plant. At the bottom an ornamental band is painted on.

Arthur Waley has described the mounting as follows:

" The banner retains all accessories except side streamers. Head–piece of plain silk, doubled. Face and back of head–piece painted with floral design. Sides bordered with grey silk. Suspension loop of printed silk with floral pattern. Bottom of head–piece held between two cane stiffeners. The cases are wound round with raw white silk thread, over which coloured silk threads cross in a diagonal pattern.

" The four streamers (one incomplete) are of dark olive silk gauze, woven in the same lozenge pattern as the valance–streamer illustrated in *Serindia*, Pl. CXX, and stamped with bird, flower, and insect motifs as in *Serindia*, Pl. LXXX.

" Weighting–board consists of layers of coarse woollen material, glued together and covered with light red gauze similar to that of the streamers, then lacquered dark red on each side, but lacquer now mostly lost. It is attached to stiffeners of streamers by

**170**

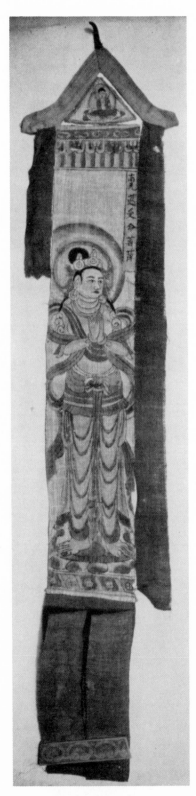 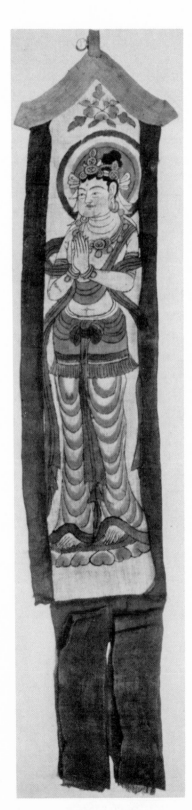

70. – BANNER RECOVERED
FROM TUN–HUANG
(British Museum)

71. – BANNER RECOVERED
FROM TUN–HUANG
(British Museum)

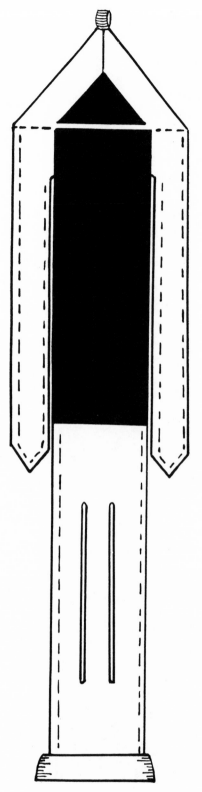

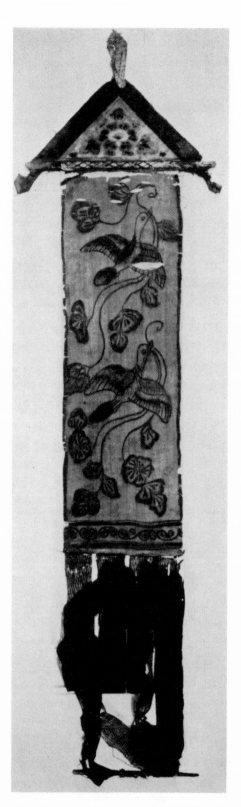

72. – SKETCH OF A BANNER FOUND
IN CENTRAL ASIA

73. – INK–PAINTING MOUNTED AS BANNER,
TUN–HUANG

(British Museum)

three loops of red silk thread, sewn along top; edges of holes strengthened with strips of bronze foil ".[1]

As to the meaning of this picture, Waley tentatively suggests that the birds are mandarin ducks and that, therefore, this picture was perhaps " dedicated on the occasion of a marriage, the mandarin–ducks being a symbol of wedded bliss ".  Be this as it may, it certainly is no purely religious representation.

The above description shows clearly that the mounting of this picture is more elaborate than that of the usual type of Buddhist scrolls found at Qara Choja and Tun–huang; it must have cost the mounter much time and labour to produce it.  Unfortunately we have no material for comparing this Tun–huang banner with mountings produced at that time in China proper.  There have not been preserved any Chinese Buddhist or secular scrolls of that period, painted and mounted by experts living in the cultural centers of the Sui or T'ang dynasty; it would seem that those scrolls painted by the great artists of those periods that escaped the waves of anti–Buddhist agitation and the ravages of time, all were remounted a number of times during subsequent dynasties.

This painting of the two birds, therefore, is all the more precious.  It is the only existing example of how the Chinese sought to adapt the principle  of the Central–Asiatic religious banner mounting to secular Chinese scrolls.  After this picture, which may be ascribed to the 8th century, there remains in the actual material for studying the development of the hanging scroll mounting a gap that stretches to the beginning of the Sung dynasty.  Then antique scrolls preserved in Japan together with their original Sung mountings permit us again to study actual specimens (see page 237).

The Chinese hanging scroll mounting.

Although Buddhist pictures with their original Indian " banner mounting " must have been introduced into China already during the 4th and 5th centuries, and although the Chinese thus must have been fairly familiar with this type of mounting, it was not until the middle of the T'ang dynasty that they started to adapt it to purely Chinese pictorial representations of a secular character.

That it took some time before the Buddhist " banner mounting " was applied to Chinese secular scrolls on a wider scale must be explained mainly by two reasons.  First, as we have seen above, it was not until well into the T'ang dynasty that the Chinese secular interior offered suitable wall space for exposing hanging scrolls, and that the scroll became a regular feature of interior decoration.  And second, the fundamental difference in the material used as canvas by Indian and Chinese artists.  The sewing process used in making " banner mountings " is suitable for the coarse cloth or thick silk covered with a layer of gesso paint used by Buddhist artists, but entirely unsuited to the frail material of Chinese pictures and calligraphic specimens.  Small scrolls, like the picture of the two birds mentioned above, could be  mounted more or less satisfactorily as a " banner ", although, as we have seen, this involved much work on the part of the mounter.

1) WALEY, op. cit., no. CXXVII.

171

This process, however, was wholly unsuited for large–sized Chinese secular pictures on thin silk or paper. With regard to these, Chinese mounters had to replace the sewing process by the pasting technique, borrowed from Chinese hand scroll mounting. And the Chinese hanging scroll mounting, in all its simplicity, is a wonderful specimen of a highly developed pasting technique, a result that could not be achieved in a few score years.

The foreign elements in the Chinese hanging scroll mounting.

In support of the above hypothesis the following four facts are adduced.

1) An old Chinese term for the upper stave of a hanging scroll is *ta–ya–chu* 打壓竹, while old Japanese terms are *hyōshi–take* 標紙竹 or *osae–dake* 押竹; thus all three of these terms indicate that *bamboo* was the material used for the upper stave. Yet T'ang sources already mention only cedar or some other hard wood as the material to be used for making these staves. On the other hand bamboo, rattan and other flexible materials are used for making the upper staves of " banner mountings ", which are so loosely constructed and made of such thick material that they will hang straight also if the upper stave is made of some pliable material. Thus the terms mentioned above can hardly be explained otherwise than as remnants of the time when the archaic Chinese hanging scroll still resembled its model, the Buddhist " banner mounting ".

2) The only logical explanation of the *ching–tai* 經帶, the two strips running across the *t'ien* of later mounted hanging scrolls is that they represent an amalgamation of the fastening bands of hand scrolls, and those attached to the upper staves of " banner mountings " used at the same time for keeping the rolled up veil in place; this problem is discussed in more detail on page 234 below.

3) The multiple borders with which Japanese mounters surround Buddhist pictures have no counterpart in the hand scroll mounting, and must be considered as having been derived from the " banner mounting ".

4) An old Japanese term for " hanging scroll " is *dō–hyō* 幢 (幢) 裱, which literally means " banner mounting ".

Chinese elements in the hanging scroll mounting.

The Chinese hanging scroll mounting shows also a number of features that have no counterpart in the old " banner mounting " and which were derived directly from the mounted hand scroll.

Among these purely Chinese elements we must mention in the first place one of most striking features of a hanging scroll mounting, namely the broad strips at the the top and bottom of the front mounting, and their peculiar proportion.

*T'ien* and *ti*, their origin and evolution.

When observing Chinese or Japanese hanging scrolls one will notice that the *t'ien*, the horizontal strip of paper or silk at the top of the front mounting, is appreciably broader than the *ti*, the corresponding strip at the bottom of the scroll; see Plate **30** A, nos. 1 and 2. On closer inspection one will find that generally the width of *t'ien* is to that of *ti* as 2 is to 1.

The vertical proportion 2 : 1 pervades the entire field of Chinese fine and applied art, it dominates architecture as well as pictorial composition, the products of the handicrafts as well as the art of flower arrangement. A survey of the application of this law in Chinese esthetic theory would provide material for an important special study.[1] Here I shall only try to trace back the 2 : 1 proportion of *t'ien* and *ti* to its counterpart in the horizontal hand scroll.

The terms *t'ien* and *ti* were used originally for indicating the upper and lower margin of a manuscript roll. Plate **74** gives a schematic

74. – SCHEMATIC DRAWING OF PART OF A MANUSCRIPT ROLL

drawing of a section of an unmounted Chinese manuscript roll. The space for writing (technically called *lan-tao* 闌道 or *lan-chieh* 闌界 [2]) is marked off by drawing two horizontal lines. This space is again divided into columns, *hang* 行, by crossing it with vertical lines. [3] Above and below the *lan-tao* there is left a blank margin.

These margins were added primarily for a practical purpose, namely that of protecting the text. When the borders of an unmounted scroll became torn or soiled, the text itself remained intact. That the upper margin was made broader than the lower one must be explained by the fact that it was an old–established custom to write corrections, additions and comments in the upper margin, directly above the column they referred to. [4] Next to such utilitarian considerations, however, the tendency to assimilate all vertical proportions to the standard 2 : 1 must also be taken into consideration. Although it may not have been the origin of this fixed proportion between upper and lower margin, it must at any rate be considered as the reason for its being maintained during succeeding centuries. As will be seen below, it is found also on the later printed Chinese book page.

1) Such a study might lead to an interesting comparison of Western and Chinese esthetic conventions. Western conventional laws for spacing and proportioning are largely based on Greek–Roman esthetic canons. Western architectural profiles, therefore, show a preference for heavy, broad bases, and a lighter superstructure. To the Chinese eye, however, an inverted proportion is more pleasing; hence the heavy roofs and light bases of many specimens of T'ang and Sung architecture.

2) *Lan* is also written 欄 or 闌.

3) General term *wu-szŭ-lan* 烏絲闌. The Ming scholar Yü Fêng-ch'ing 郁逢慶 says in his *Shu-hua-t'i-po-chi* 書畫題跋記 that during the T'ang dynasty these lines were drawn very thin, but with thick ink, while during the Sung period they were drawn with shallow ink, but in broad lines; these *lan-chieh* he calls respectively *t'ang-chieh* 唐界 and *sung-chieh* 宋界. In later times these lines were often drawn in blue (*lan-ko* 藍格), in

vermilion (*chu-ko* 朱格), or also with a piece of lead (*ch'ien-ko* 鉛格). As will be seen below (page 183) during the T'ang and preceding dynasties calligraphers instead of drawing ink lines, ruled their paper either by folding it lengthwise as many times as the number of columns required, or ruled it by drawing deep grooves with a bamboo or ivory spatula. Folding paper strips for writing *tui-fu* has been described already on page 112 above.

4) Comments by the author himself or, in the case of old texts, by ancient scholars of established authority, are usually printed inside the type page itself, as so–called *chia-chu* 夾注, i. e. in two columns of smaller characters, directly under the passage they belong to. When such an old text with its commentary is reprinted, the editors often add their own additional notes in the upper margin. Well known are some superior editions of the *Wên-hsüan* 文選, where the comments in the top margin are distinguished by each author's contribution being printed in a different colour.

The terms *t'ien* and *ti*, originally indicating the upper and lower margin of the manuscript roll, later were transferred to the upper and lower border attached to the hand scroll, and thence to the upper and lower strips of mounting of the hanging scroll. [1]

It was again a combination of practical and esthetic considerations that caused the proportion *t'ien* : *ti* as 2 : 1 to be maintained also for the hanging scroll. During its long history the hanging scroll mounting underwent various changes, but this proportion was never altered. When a hanging scroll is rolled up, its outer cover is formed by the outside of the *t'ien*, partly reinforced by the protecting flap: therefore the longer the *t'ien*, the more layers of silk and paper are interposed between the picture itself and outside dangers. Also from an esthetic point of view a large *t'ien* is most satisfactory. For in the case of large hanging scrolls — and specimens measuring 2 to 3 meters are not rare — suspended on the wall, a long *t'ien* tends to compensate for the perspective error caused by the fact that the upper part of the mounting, being farther from the observer's eye than the lower part, will appear slightly shortened.

Be this as it may, the adoption of *t'ien* and *ti* to the hanging scroll, and the retaining of their peculiar proportion, clearly points to the hand scroll mounting as its source.

Next to *t'ien* and *ti*, also other elements of the hand scroll mounting were used for the hanging scroll. *Yin-shou* and *ko-chieh* were adapted to the requirements of the vertical hanging scroll, and also the roller with its protruding ornamental knobs was borrowed from the hand scroll. None of these elements is to be found in the " banner mounting ".

As far as I could find, the ancient Chinese embroidered banners, like for instance the *hui* 麾, since times immemorial used in the army and, in a more elaborate form, also in Court ceremonies, did not influence the development of the Chinese hanging scroll mounting. I here mention these banners, however, for the benefit of other students who might wish to pursue these researches farther.

Summing up the above, it may be stated that the Chinese secular hanging scroll mounting did not develop as a logical evolution of the ancient Chinese horizontal hand scroll. Its principle was derived from the foreign " banner picture ", while its details were taken over from the purely Chinese hand scroll.

---

1) As long as there have not become available more data on the history of the terms *t'ien* and *ti* in the special meaning of upper and lower margin of a manuscript, and upper and lower part of the front mounting of scrolls, this explanation must remain hypothetical. None of the Chinese and foreign dictionaries which I consulted register this special meaning of *t'ien-ti* although it occurs regularly in Ming literature (cf. i. e. the *Chuang-huang-chih*, ch. XIII), and although to-day still the terms are still used in this sense by Chinese bibliophiles, connoisseurs and mounters. It is only Giles' Dictionary that lists the term *t'ien-ti-t'ou* 天地頭, meaning Chinese printed books which have a generous upper and lower margin.

Admittedly *t'ien* and *ti* in their special meaning do apparently not occur in T'ang and Sung literature; there one finds other terms like *shang-piao* 上標 and *hsia-piao* 下標. This fact, however, does not prove that *t'ien* and *ti* were not yet used at that time; their use may have been confined to colloquial language. The special use in the sense of upper and lower margin seems so obvious and accords so well with the Chinese idiom that it seems not unreasonable to assume its early occurrence.

Raphael Petrucci believes that the terms *t'ien* and *ti* in their meaning of upper and lower strip of a hanging scroll mounting originally referred to *shang-tuan* 上段 and *hsia-tuan* 下段, the upper and lower portion of a picture, and that later these terms were transferred to the mounter's jargon; cf. *Encyclopédie de la Peinture Chinoise*, page 46. This is an interesting theory but until proof to the contrary is forthcoming I prefer my own explanation.

The secular hanging scroll mounting presents, therefore, an amalgamation of two originally entirely different styles of mounting, one purely Chinese, viz. the horizontal hand scroll, and one foreign, viz. the Buddhist " banner mounting ".

Thus during the second half of the T'ang period, secular pictures were occasionally mounted as hanging scrolls. These early Chinese hanging scrolls must have shown a type of mounting that represented a transition from the Tun–huang and Qara Choja banners, to the Chinese hanging scroll of later times.

Two isolated remnants of early hanging scroll mounting may give some idea of what late T'ang and Five Dynasties (*Wu–tai* 五代, 907–960) hanging scrolls looked like. One of these remnants has survived in China, the other in Korea.

The Chinese example is the so-called *chang* 幛 or *chi–chang* 祭幛. This is a long scroll of white cloth or silk, with sewn on borders; its upper edge is sewn to a wooden stick. This kind of " banner " is suspended on a stake standing on a wooden pedestal, and placed in front of the coffin during funeral ceremonies. Its white colour indicates mourning, and it is inscribed with laudatory accounts of the deceased.

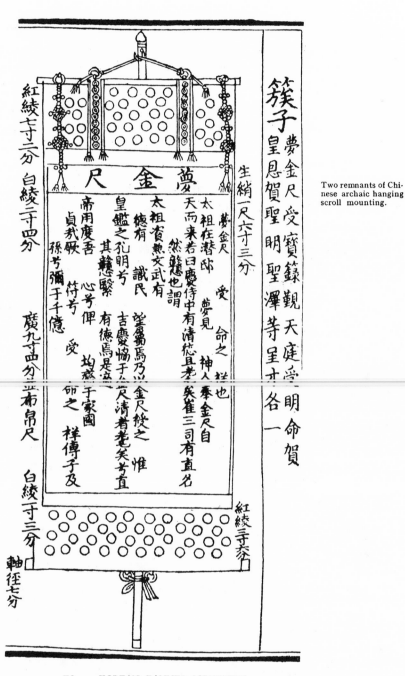

Two remnants of Chinese archaic hanging scroll mounting.

75. – KOREAN BANNER MOUNTING

It would seem that the tenacity of Chinese tradition, especially with regard to funeral ceremonies, was the cause that in this special case the archaic mounting of this banner–scroll was retained throughout the centuries, while the hanging scroll mounting in general developed further.

The second example is a Korean ornamental silk banner (see Plate **75**), called *chok–cha* 簇子. This banner was suspended on a stake, and used during a Korean Court dance, called *mong–gŭm–ch'ok* 夢金尺. This dance belongs to the *tang–ak* 唐樂,

Chinese music that was introduced into Korea during the T'ang period, but thereafter adapted to Korean requirements. [1]

A Korean book on music describes this banner as follows: "The *chok-cha* should be made of raw silk. The strips on top and below should be made of red and white thin silk, with an ornamental pattern (the red silk showing a design in gold thread). The seams are of purple, and the backing of red raw silk. The knobs are made of jade, rose wood or black prune wood. The stake is made of wood, lacquered red, with a hook on top. The upper stave of the *chok-cha* has two rings on left and right, and below these are tassels of white silk, [2] attached to ribbons of green silk. To the left and right of either ring there is a smaller one, on which there hangs a cord of coloured silk". [3]

The measurements are given on the picture. The inscribed scroll measures 1 *ch'ih* 6 *ts'un* 3 *fên*, by 9 *ts'un* 4 *fên*. The *ya-tzû* on top and bottom are of white silk, the upper one 2 *ts'un* 4 *fên* broad, the lower one 1 *ts'un* 3 *fên*. *T'ien* and *ti* are of red silk and measure 7 *ts'un* 2 *fên* and 3 *ts'un* 6 *fên* respectively.

This banner has preserved various characteristics of archaic Chinese hanging scroll mounting: the sewn on silk backing covering the entire reverse of the scroll, and the cords and tassels dangling loose from the upper stave.

As a third example I mention the Japanese hanging scroll mounting of the Kamakura period, decribed on page 237 below.

Even during the later years of the T'ang period, however, the hanging scroll was of neglegible importance when compared to wall paintings, not to speak of the hand scroll. T'ang calligraphers wrote their autographs preferably in the form of hand scrolls, and great painters like for instance Wu Tao-tzû for their larger works still preferred the wall as a canvas. This appears clearly from Chang Yen-yüan's *Li-tai-ming-hua-chi*, which is mainly devoted to hand scrolls and mural paintings, while hanging scrolls are only referred to in one or two isolated places.

Later terms for "mounting".

The art of mounting having reached a more advanced stage, terms like *pei* 背, *chuang-pei* 裝背 or *chuang-huang* 裝潢 were no longer sufficient to describe the mounting process. Thus we find since the T'ang dynasty the compound *piao-pei* 表背 " to

1) The motif of this pantomine is purely Korean, it figured at all banquets which the Korean King gave to honour his relatives (see next footnote). A. Eckardt gives in his book *Koreanische Musik* (Tokyo 1930) a list of the various performances that accompanied a royal banquet; some of them are directly derived from China, others are of local origin. This particular pantomine is performed during the seventh course, when the wine is served for the second time.

2) Cf. the *tsuyu* of Japanese mountings, described on page 74.

3) *Ak-hak-kwe-pôm* 樂 學 軌 範, ch. 6: 簇 子 用 生 綃。上 下 以 紅 白 綾 連 粧 (紅 綾 印 金 花 紋)。邊 兒 用 紫 綃。後 褙 用

紅 綃。軸 用 玉 或 華 梨 烏 梅。竿 以 木 爲 之。朱 漆 竿 上 有 鉤。簇 上 左 右 有 環。環 下 有 白 綾 流 蘇。以 綠 條 纓 掛。於 鉤 環 外 兩 邊。又 各 有 小 環。垂 色 絲 結 子。This book was written in 1493 by the Korean literatus Syông Kyôn 成 俔; in 1933 the Korean original was published in a photographic reprint by the Japanese society *Koten-kankô-kai* 古 典 刊 行 會. Better pictures of the *chok-cha*, however, appear in most of the *Chin-ch'an-uigwe* 進 饌 儀 軌, the magnificent large-sized illustrated accounts of ceremonies that took place at the Royal Court, published by the Yi Dynasty on specific occasions (cf. M. COURANT, *Bibliographie Coréenne*, Paris 1895, nos. 1305-1307).

provide a scroll with a front mounting and a backing ". *Piao* 表 is often interchanged with the homonym *piao* 標, the compound *piao–li* 標 裏 meaning " front mounting and backing ". Chang Yen–yüan also uses the compound *chuang–ch'ih* 裝 襠, which originally meant " remounting ", but was used also as a term for mounting in general.

The compound *piao–pei* 表 背 is often written with the 145th radical added: 褾 褙; this compound is till the present day the most common Chinese term for " to mount scrolls ". [1]

Although during the T'ang dynasty the art of mounting had advanced considerably, there can be no doubt that from a technical point of view even the most gorgeous T'ang mountings were inferior to specimens produced by Ch'ing mounters. The fact that thick paper was used for both the picture itself and the backing of the scroll, and heavy brocade for the borders indicates that those ancient mountings must have been altogether much thicker than those of the Ch'ing dynasty. Moreover, since the " drying board " (see page 59 above) was not yet used and all work done on the table, the pasting technique was still far from perfect.

Nearly all scrolls of the T'ang period or earlier that have been preserved still show traces of vertical creases and worn–down folds, despite their having been remounted several times in the course of the centuries. Such old defects must be ascribed to the fact that when those scrolls were mounted for the first time stiff material was used for backing them, while the component parts of the mounting were stuck together with inferior paste. It was difficult to roll up mounted scrolls tightly so that they would soon develop folds and creases.

It took several centuries of experimenting before the technique of mounting reached its highest perfection, several layers of silk and paper being pasted together so perfectly that they form one smooth, supple sheet not much thicker than one sheet of laminated paper.

\* \* \*

After the collapse of the T'ang dynasty followed a brief interval of political confusion known as *Wu–tai* 五 代, the Period of the Five Dynasties, which lasted from 907 till 960.

The Sung writer Kuo Jo–hsü has recorded in his *T'u–hua–chien–wên–chih* (cf. Appendix I, no. 36) some notes about scroll mountings of this period. These occur in a passage he devotes to the artistic interests of Li Yü (李 煜, usually referred to as Hou–chu 後

---

1) Cf. the *Hsieh–shêng–p'in–tzû–chien* (諸 聲 品 字 箋, by Yü Tê–shêng 虞 德 升, Ch'ing period): " *Piao* means front side, *pei* means back. All pasted scrolls necessarily consist of two layers, the one turned to the front and showing the picture is called *piao*, and the plain paper with which the scroll is backed is called *pei* " 褾 表。褙 背 也。凡 糊 物 者 必 兩 層。以 有 畫 繪 者 向 外 謂 之 褾。以 無 染 素 紙 托 其 背 謂 褙 也。

In later times the term *chuang–huang*, being considered more elegant than the others, came to be used as a literary designation of the process of mounting in its most general sense.

177

主, 937–978), the last ruler of the Southern T'ang dynasty. Since Kuo Jo–hsü wrote less than a hundred years after Li Yü's demise it is probable that he actually saw mounted scrolls emanating from Li Yü's collection. He says:

" Li Hou–chu was a man of great talents and wide knowledge. He greatly loved pictures and autographs, of which he had built up a large collection. He was especially versed in the art of judging these. The scrolls (emanating from his collection) now preserved in the Palace or those obtained by private collectors often bear seals in archaic script reading: ' Pictures and autographs of the Palace ', ' Nei–ho–t'ung–yin ', ' Seal of the Chien–yeh Library ', ' Nei–szû–wên–yin ', ' Seal of the Chi–hsien Academy ', and ' Seal of the Imperial autographs in the Chi–hsien Academy '; (often these seals are impressed with black ink). On some scrolls he wrote with his own hand the name of the artist, others show his ' flourish signature ', [1] others again miscellaneous lines from poems (Li Yü had written in praise of those scrolls. Transl.). Some are embellished with mountings of brocade showing a pattern of large or small turning Phoenix Birds, of cranes and clouds, or sparrows; or also just plain black material. (The present Office of Silk and Brocade imitates these patterns). At the head of these scrolls there are mostly bands of woven brocade and the pasted–on title labels are mostly made of yellow sûtra paper. On the reverse of the scroll one often finds the names of the men who supervised the mounting, and remarks on the assessment of the artistic quality of the scroll ". [2]

It may be assumed that this passage refers chiefly to hand scrolls, in Li Yü's time still the most common type of mounting for secular pictures, and specimens of calligraphy.

The reference to the title labels stuck on the back of mounted scrolls is apparently the oldest place where labels of this particular type are mentioned. As we saw above the T'ang writer Chang Yen–yüan does not describe pasted–on title labels. The yellow sûtra paper has remained throughout the centuries the favourite material for such labels and is still used for this purpose to–day; a detailed description of this paper will be found on page 301 below.

The term *hui–luan* " turning Phoenix birds " is not clear. It probably means that the birds were arranged in horizontal rows, each row consisting of pairs of birds facing each other. Such a pattern is found on actual pieces of *k'o–szû* dating from the Sung period; cf. the sample on Plate **79**.

The expression *t'i–t'ou*, translated " at the head of the scroll ", can be differently interpreted depending on whether one takes it to refer to a hand scroll or a hanging scroll. In the former case it evidently indicates the band used for winding round the rolled up scroll, in the latter it refers to the *ching–tai* (see page 198 below).

---

1) The " flourish signature " and its history are discussed in detail on page 426 below.

2)

題雜鶴織用
詩雲此多姓
歌傚貼人名
或親背名
或為小回
鸞綾院
鵲綢簽
墨]成帶。

印。[此印多用墨]
或有押字。[今
姓成織綾
名。錦標成書
又有墨頭裝監
鵲紙多後第。
提多背及所
練作黃品較
言。提經及所

書。
御書印。
人名。
賢院或有
書人有墨
言。墨提多
又鵲經

尚圖
內府所有
有印篆
多房
建業書院印。
印集

博識雅
鑑今
賞內
所多
得同印
書賢
內殿
文印。

高才圖
精所書
所合有
家集內
圖印府
書印。印

李後主
蓄聚既豐
圖軸。暨
曰人殿
之內圖
寶。內司

Kuo Jo–hsü also describes a kind of mounted picture introduced during the Period of the Five Dynasties that would seem to represent a transition from the mural done directly on the wall, to the mounted hanging scroll.   He says:

" Hsü Hsi [1] of Chiang–nan and others of his school painted on plain sheets of double–thread silk scenes of luxuriant vegetation, herbs sprouting up near piles of stones, and here and there cleverly drawn birds, bees and cicadas.   These pictures were made for Li Yü for the decoration of his palace; they were called *Pu–tien–hua* ' Decoration for covering (the walls of) the palace ', and those of secondary quality *Chuang–t'ang–hua* ' Decoration for decking out the hall '.   The aim was to create a decorous effect by their arrangement, they being hung side by side all orderly and dignified.   But most of the pictures lacked realism and spontaneity and therefore those who saw them generally did not employ them for study ". [2]

Such or similar pictures were still used in Kuo Jo–hsü's own time.   His slightly younger contemporary, the famous artist and connoisseur Mi Fu mentions them in a passage devoted to hanging scrolls in general, saying:

" Those scrolls that because of their equal size are suitable for being displayed side by side can be used as *chuang–t'ang* that cover the wall ". [3]

And elsewhere Mi Fu observes that it does not matter whether *chuang–t'ang* are backed with an inferior material because they are vulgar paintings (cf. below, page 185).

From these remarks one may conclude that these pictures were a kind of wall hangings, large pictures of a decorative rather than artistic value, provided with backings and nailed or stuck to the wall.   In other words, a kind of superior wall paper.

Kuo Jo–hsü gives scant information on the scroll mountings of his own time.   As most connoisseurs he took it for granted that his readers were familiar with those.   He did record, however, a note on the *hua–ch'a* 畫叉 the forked stick used for suspending hanging scrolls (see above, page 44); this is probably the oldest reference to this useful instrument.   Since Kuo Jo–hsü does not add any comment on its employ the *hua–ch'a* must have been quite common already at that time.

The reference occurs in a note on the artistic pursuits of the statesman Chang Shih–hsün (張士遜, style Wên–i 文懿, 964–1049) who apparently was a most fastidious collector of scrolls.   Kuo Jo–hsü says of him:

---

1) Hsü Hsi, see p. 181, note 2.

2) 鋪殿花。江南徐熙輩，有於雙縑素幅上畫叢艷疊石，傍出藥苗，雜以禽鳥蜂蟬之妙。乃是供李主宮中挂設之具。謂之鋪殿花。次曰裝堂花。意在位置端莊，骈羅整肅，多不取生意自然之態。故觀者往往不甚采鑒。

Soper translates the last four sentences: " The idea embodied in the design was severe and correct, and its setting-out was orderly and dignified. For the most part, however, it failed to catch the sense of life and the actual look of Nature; so that those who glanced at it usually gave it no very critical examination ".   I do not think that this is the correct rendering of this passage.

3) The complete passage and text are given on page 181 below.

" He was most diligent in his loving care of them.   Everytime he displayed a scroll he would always first erect a canopy (over the spot where it was to be shown), and for scroll hanger he used (a stick with) a fork of white jade.   These elaborate preparations are sufficient indication of the quality of the paintings (in his collection) ".  [1]

These scroll hangers, next to being used when suspending scrolls high on the wall, were also employed to show a scroll temporarily; a page held the stick upright and the scroll was hung on the fork on top.   Such a proceeding was often depicted on paintings of artistic gatherings; an example is reproduced on Plate **22**.

\* \* \*

**The art of mounting during the Northern Sung period.** The unprecedented flourishing of all the fine arts during the Northern Sung period (960–1127) has been adequately described in various Western books on Chinese art. Then there lived eminent scholar–artists such as Su Tung–p'o, Mi Fu, Wang Hsin, Wên T'ung etc. who, next to being creative artists also were distinguished connoisseurs and collectors.

The Emperors themselves set the example by greatly augmenting the Palace collection, having connoisseurs sift and criticize the paintings and autographs of former dynasties.   During the Hsüan–ho era (1119–1125) the Palace Collection counted more than six thousand scrolls.   It is to this same era that refer the first official catalogues of scrolls the *Hsüan–ho–hua–pu* 宣 和 畫 譜 and the *Hsüan–ho–shu–pu* 宣 和 書 譜, which are valuable books of reference for the history of pictorial art.

During this period the hanging scroll mounting came to the fore and started to compete in popularity with the mural painting and the hand scroll.   The technique of mounting vertical pictures and autographs as hanging scrolls had successfully blended Chinese and foreign elements, thus making the hanging scroll an important addition to interior decoration.

**The Sung interior.** In the dwelling house of the Sung period more wall space had become available for the display of scrolls.   Movable screens were still used on a large scale, but not any longer as a means for partitioning the house; as such their place was largely taken over by the brick or plaster wall.

The Sung artist Li Kung–lin included in the *Lung–mien–shan–chuang–t'u*, the hand scroll depicting his mountain retreat (see page 38 above) a hermitage that gives a general idea of the way people lived in those days.  [2]   This section of the scroll is reproduced on Plate **76**.

---

1) 愛 護 尤 勤。每 張 畫 必 先 施 齋 幕。畫 叉 以 白 玉 爲 之。其 畫 可 知 也。
Soper (op. cit., page 96) translates: " The forks he used to hand his scrolls were made of white jade ".   I take it that *hand* is a misprint for *hang*.

2) A reproduction of this scroll was published in 1937 by the Otsuka–kōgeisha in Tōkyō together with extensive comments by the Japanese connoisseur Harada Bizan 原 田 眉 山.   Although one might doubt whether this is actually the scroll painted by Li Kung–lin it is generally agreed that the picture dates from that period.

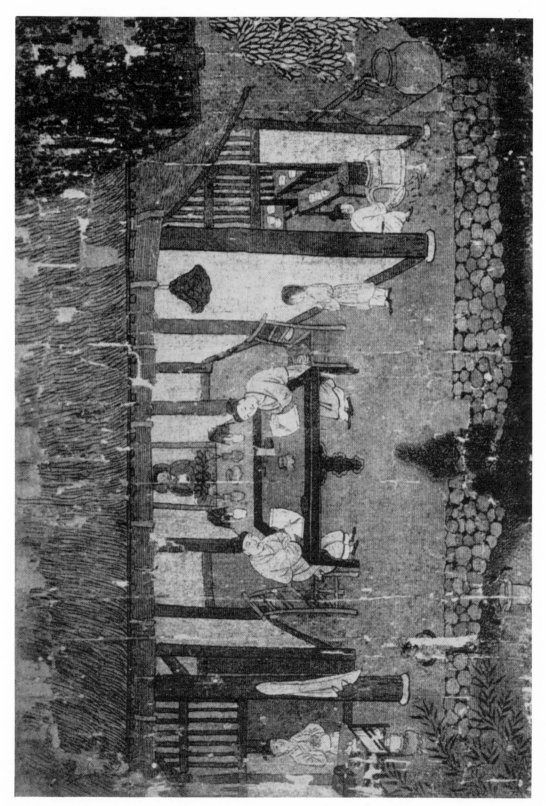

76. — SUNG INTERIOR

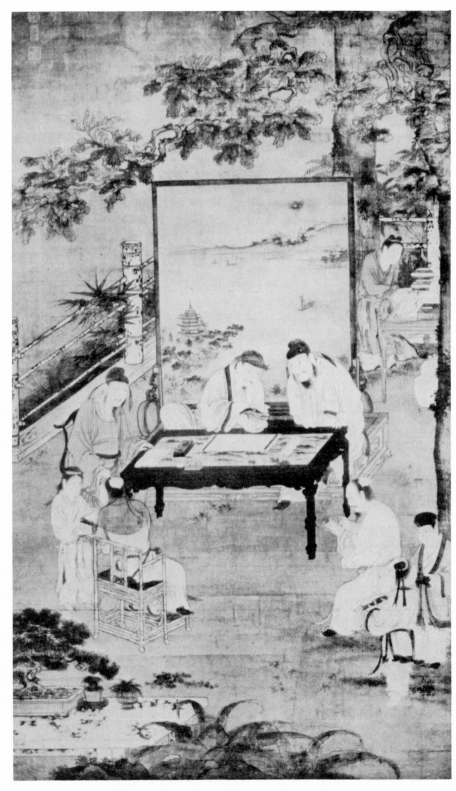

77. — " LITERARY GATHERING "
Ming copy of a picture by the Sung artist Liu Sung–nien
(Old Palace Museum, Peking). cm. 96 by 162.

The building is raised on a stone base and the thatched roof supported by four main pillars, according to the pattern given on Plate **65**; the floor consists apparently of stamped earth. The space between the pillars is filled in by plaster walls. The central room is divided into two parts by a plaster partition wall with a door opening on either side.

Against this partition is hung a *t'ang-hua* with two tables below it; the first is a kind of altar table bearing an incense burner and flower vases, the second is used for reading and writing. Thus the traditional arrangement found in the main hall of a present-day Chinese house described in Chapter I of the present publication, existed already in the Sung period.

On the right one sees a kitchen and scullery, on the left a side room probably part of the living quarters.

The house depicted here is a Buddhist hermitage, as witnessed by the Buddhist *t'ang-hua* and the bronze gong suspended on the eaves. Yet it supplies valuable data on the Sung dwelling house. Other pictures of the time mostly show palatial interiors freely embellished by the fantasy of the painter and far removed from real life. If one imagines the present hermitage enlarged to more generous proportions, with a stone-flagged floor, carved pillars and more ornate chairs and tables, one will have obtained a fairly accurate idea of the main hall in the upper class dwelling house of those days.

By now the sitting mats of reed or bamboo had been definitely abandoned and chairs and tables had come into general use. Sung paintings or copies thereof — notably works by or ascribed to the famous artist Liu Sung-nien (劉松年, 1073–1157) — show heavy wooden tables with marble tops, high chairs of carved blackwood and cupboards and cabinets of all shapes and sizes (cf. Plate **77**).

Literary sources now frequently mention the hanging scroll which had become a regular feature of interior decoration and as such vied in popularity with the murals.

Such literary references further strengthen the impression obtained from the " wall hangings " described above, namely that at that time the hanging scroll was often considered as a convenient means for covering empty wall space rather than as a work of art in itself.

Mi Fu has given a description of how one should display hanging scrolls that reminds one forcibly of the over-crowded picture galleries in old-fashioned Western mansions. Mi Fu says:

" When collecting paintings one must begin with snow pictures of T'ang Hsi-ya, [1] Hsü Hsi [2] or others, and landscapes by the monk Chü-jan [3] or by Fan K'uan. [4] Those scrolls that because of their equal size are suitable for being displayed side by side can

---

[1] T'ang Hsi-ya flourished round 930; he was famous as a painter of birds and flowers, and also enjoyed some fame as a calligrapher.

[2] Hsü Hsi, flourished round 930, specially famous for his paintings of birds and flowers.

[3] Chü-jan was a monk-painter famous for his landscapes; flourished round 960.

[4] Fan K'uan, flourished round 1000, great landscapist.

be used as *chuang-t'ang* that cover the wall.   Above this (more or less permanent decoration) one can suspend in turns other good paintings; those that are of equal size can be hung together as sets.   Further, one can suspend side by side also such scrolls that (because of their being of different size) do not form one set.   Since antique paintings vary in size, when hung side by side they need not necessarily form one straight row.   If pictures from the Chin period (265–420) are hung on the upper half of the wall, then on the lower half you must suspend T'ang dynasty pictures so as to fill in [1] the empty spaces ". [2]

Perhaps it was Mi Fu's preference for smaller hanging scrolls that prompted him to display a number of them together.   He observes elsewhere that some people consider three *ch'ih* as the standard height of *hêng-fu* 橫幅, horizontal hanging scrolls; in his opinion the same standard should be applied to all vertical hanging scrolls.   He says:

" Pairs of scrolls suspended in the Pao-chin-chai [3] never measure more than three *ch'ih* in length.   Thus the lower part of their mounting is not covered by the chairs (standing against the wall), and people passing close by will not soil the scroll by brushing it with their shoulders ". [4]

However, Mi Fu's opinions on the displaying of scrolls should perhaps not be taken as representative of those current among connoisseurs and collectors of his time.   Mi Fu was notorious for his eccentric character which often impelled him to act exactly contrary to what was then considered as correct. [5]

*Mi Fu's writings.*    Mi Fu [6] belongs doubtless to the four or five most famous painters and calligraphers, whose names are household words in China.   His style was Yüan-chang 元章, and he lived from 1051 till 1107.

Of his pictures so few have been preserved that it is difficult to obtain a first-hand impression of his achievements as a painter.   We know only that he created a new style of monochrome landscape painting where heavy ink dots in carefully balanced shades dominated over the other brush strokes and where distant mountains loom in a kind of *pointillé*.   But of his calligraphy many specimens survive either in originals or rubbings and these prove convincingly that in this field he was a master of outstanding talent.

Here, however, we are concerned only with his activities as a connoisseur and his remarks on the art of mounting scrolls.

---

1) *ch'ên* 襯, " to line, to fill out "; it is not clear what space must be filled.

2) *Hua-shih* (cf. Appendix I, no. 37):

凡收書。然堂素無必為。圖畫巨者。裝絹掛不必為。雪圖。等對名筆。又漸鋪掛。熙齊整旋對者。漸齊。唐掛。徐水圖。上成對旋小不第二重掛。雅齊上相掛者。希山乃可旋成大小須。唐寬於其當書筆也。收范乃可古晉掛。必先收寬。乃或遮壁。大小者。蓋若乃可掛。對端襯。正。

3) A name of Mi Fu's studio; cf. my book *Mi Fu on Inkstones*, page 11, footnote 2.

4) *Hua-shih*: 惟寶晉齋中。縣雙幅成對。長不過三尺。標出乃不為椅所蔽。人行過。肩汗不著。

5) See also the general remarks on Mi Fu in *Mi Fu on Inkstones*, mentioned below.

6) As I have explained in detail in my book " Mi Fu on Inkstones ", the reading 芾 *fei* rests on a mistake.   As a matter of fact most modern Chinese literati read the name *fu*, and the traditional Japanese reading is *futsu*.   Yet Western writers, even so careful a scholar as the late Paul Pelliot persist in writing Mi Fei.   It is to be hoped that this wrong reading will finally be abandoned.

182

The most important writings he left on these subjects are the *Shu-shih* 書 史 "Notes on Autographs", the *Hua-shih* 畫 史 "Notes on Paintings", and the *Pao-chang-tai-fang-lu* 寶 章 待 訪 錄 "Records of Searches for Precious Scrolls"; details about these three texts will be found in Appendix I, nos. 37-39.

Although in these books Mi Fu frequently refers to the art of mounting he does nowhere give a consecutive description of the entire mounting process. His notes on the subject are rather haphazard and concern only those points which he thought of special importance and about which he held strong views; these he discusses in great detail. That Mi Fu was not more explicit on the mounting process and the types of mounting popular in his time is all the more to be regretted because next to being a clever observer he was also an expert scroll mounter himself. Just like the T'ang connoisseur Chang Yen-yüan he used to repair and remount the scrolls in his collection with his own hands; we shall see below that on several occasions he refers to the work done by him on antique specimens. It seems to have been quite common at that time that collectors acted as their own mounters. The scholar-artist Su Tung-p'o says for instance in one of his letters: " Recently I purchased a letter written by my late uncle; I myself provided it with a front mounting and backing and added a superscription and a colophon ". [1]

Incomplete as Mi Fu's notes are they constitute valuable material on the art of mounting as it was practised in his time. The most important of the relevant passages are translated herebelow.

" Silk must not be used for backing paintings. And if you use it for patching up damaged spots in the picture these patches will seem good as long as they are new; but when the scroll has been unrolled and rolled for a long time the silk of the patches will prove to have stiffened, and the silk (of the painting) will wear down by rubbing against the patches so that new holes will appear in the undamaged parts of the picture. This is greatly to be regretted.

" The calligraphers of old took great care to preserve the specimens of their handwriting. (Before starting to write) they ruled the paper by drawing deep grooves (with a spatula. Transl.) so that the columns of characters are, as it were, encased in hollow tiles, and thus well protected. The present-day people when they obtain such a scroll will back it with silk. [2] Then the grooves with which such an autograph was ruled, will for some time seem smooth and straight. After the lapse of some years, however, the inscribed parts of the paper will crack; this is greatly to be regretted indeed.

" Even less should autographs or paintings on paper be backed with silk. Even sized, new silk will prove to be hard. Thus continuous rubbing (occurring during the rolling and unrolling of the scroll) will cause the impression of the texture of the silk to appear on the surface of the scroll itself. Moreover this hard backing will in course of

Mi Fu's notes on scroll mounting in his *Hua-shih*.

---

1) *Tung-p'o-ch'ih-tu* 東 坡 尺 牘: 近 購 得 先 伯 父 手 啓 一 通。躬 親 褾 背 題 跋。      2) The two characters 或 絹 do not seem to belong here.

time rub the paper of the autograph or picture till it becomes fuzzy. Paper autographs and pictures backed with this material will suffer damage after the lapse of some months, the ink of the original will be found to have become transferred to the silk backing, by the two surfaces rubbing against each other. Wang Hsin [1] formerly also used to have the autographs in his collection backed with silk. At first he did not believe me. Later, however, he noticed that the characters of his Huan–wên autograph [2] had become blurred (by rubbing against the silk backing), and that the texture of the backing had worked right through the scroll, till its pattern had become visible on the paper of the autograph. Then he was annoyed, and kept a sheet of thin paper from Shê–hsien [3] rolled up together with the scroll (so as to protect its surface against the silk backing). And thereafter he never again used silk.

" If its silk has burst in a hundred places, you can be sure that that is a good (i. e. antique) picture. All such cracks have their distinctive features. Long hanging scrolls and horizontal rolls have transverse cracks. A horizontal scroll will crack straight, therefore the cracks and bursts that develop in its surface are also straight, every one of them running paralel to the roller. These straight cracks do not run along one thread of the texture (of the silk). In the course of the years cracks will develop in a vertical direction, starting from the upper and lower edge of the scroll, they will not correspond to each other (i. e. those running down from the upper edge will not lie in one line with those starting from the bottom edge. Transl.), and they will not show fuzzy edges. If one lifts up these edges with the nail of one's thumb, they will prove to be soft. These cracks cannot be faked. Faked ones run in straight lines, as if they were cut with a sharp knife; they run along one thread of the texture, and their edges are fuzzy. And if lifted up with the thumbnail, these edges will prove to be hard and stiff.

" Silk scrolls artificially ' aged ' by dyeing (can be recognized as faked because they) will show the dye in the interstices of the texture, while those ' aged ' by exposing them to smoke will retain an odour. The dark tinge of all genuine scrolls will be deep on the obverse, but shallow on the reverse. Moreover, genuine old paper or silk has a peculiar fragrance of its own.

" Wên Yen–po [4] used to make boxes of discarded backings of old paintings; his idea was to show his loving care (for these antique materials). But (although thus silk backings have at least some use), if silk is pasted on to a scroll as a backing, its tension [5] will greatly spoil the scroll. The folding screens showing vulgar paintings of the present–day people, all will develop cracks after one or two years, and fall to pieces – which must be considered very fortunate! Boxes are made primarily for storing away wall paintings. But scrolls are preserved from decay by being rolled and unrolled

---

1) High official and great collector; cf. more details on page 192.

2) The text has 柏, which must be a mistake for 桓. Huan Wên was a famous Chin general who lived 312–373.

3) *Shê–hsien* is a paper producing center in Anhui Province.

4) Wên Yen–po, styled Kuan–fu 寬 夫, 1006–1097, a famous statesman and scholar.

5) The text has 紺, which must be a mistake for 弸.

184

continually in people's hands; if you do not unroll them for a number of years, they will burst along the roller and their material will come off in brittle flakes, that can not be pasted down again.

" The fragrance of sandal wood guards against humidity, therefore you will find it useful to make the knobs to be attached to your pictures of this material. Then if you open the box (wherein the scroll is kept), there will be the fragrance of sandal wood, and no smell of paste. Moreover it keeps away insects. If you mount (hanging scrolls) with jade knobs and old sandal wood rollers, this material will prove to be too heavy. Now I make rollers of two hollow pieces of wood that fit exactly to the knobs; such rollers are very light, and therefore will not damage the scroll. For ordinary scrolls *t'ung* [1] or pine wood is the best material. Knobs of scrolls should not be adorned with gold or silver, this is not only vulgar, but also attracts thieves. But this (sound principle) was not followed by Huan Hsüan. [2] If you use knobs of rock crystal for hanging scrolls, you should suspend on either of these knobs a green round coin from Shu, which are heavy.

" Brocade showing a pattern of pairs of orioles is most vulgar. You should not use this material for making the protecting flaps pasted on to the backing of antique scrolls. It can be used, however, for wall hangings [3] painted by modern artists, for these are vulgar anyway.

" If you use knobs of sapan wood, the lime solution (used for attaching the knobs to the roller) will change their colour, and this colour will improve with the years. Moreover this wood is light by nature. Knobs made of horn will attract insects, and moreover when you open the box (in which the scroll is kept) there will be a mouldy odour. But (rollers of) sandal wood and (knobs of) rhinoceros horn will together produce an antique fragrance. If paper or silk are old, they will have this antique fragrance of themselves. [4]

1) *t'ung* tree, *Paulownia tomentosa.*

2) For Huan Hsüan see p. 141; Ling-pao was another name of his.

3) See p. 179 above.

4) Cf. *Hua-shih* (Appendix I, no. 37):

辨。
裂一合偽作　上寶屏落舒隨
有裂當相其生　金若取不宜
各直不不作　臭也在人蘇卷者
裂卷斷斷偽依　有也却輕不
者古匣今恰時開　煙意今恰時開　軸蠹今輕軸
文橫直開可頭　者古匣今不也檀辟重乃也
書也也蘇不兩　薰般作愈裂書久成用又身佳
必文裂兩蘇當緻素古著年畫不粘氣無爲合用
好橫裂頭也間有畫綳即製壞糊身補畫糊桐
畫也也蘇不兩　乾一背損書歲不必氣檀軸杉
片裂軸自則過堅棲紙以背二壁自脆濕而檀空必
百卷隨卷刀搯直又色古博絹一收頻裂辟香古中卷
素橫直歲作快起濕下文然俗匣人乾檀匣軸片畫
絹幅隨歲作久毛刀搯染淺彥貼畫是手斷香有以烈常
長文縷不者毛深惜風也近軸開玉兩損

装　背　書　不　須　用　絹。補　破　處　用　之。
新　時　似　好　展　卷　久　爲　絹　硬　抵
于　不　破　處　大　可　惜　間　作　勒　作
古　書　人　破　字　故　行　人　之。得　之。
字　在　簡　瓦　不　不　令　一　平　時　新
絹　（或　絹　背　所　大　惜　也　熟　雖　紋
久　於　　　字　大　可　絹　背　絹　成　也
終　上　　　書　可　書　面　上　磨　所　絹
取　硬　　　文　書　縷　是　絹　在　色　信
背　爲　　　骨　縷　久　磨　墨　未　初　紙
王　紙　　　書　久　不　背　損　在　磨　薄
之　晉　　　卿　畫　磨　色　絹　歡　以　也
而　栢　　　溫　舊　之　之　墨　也　絹
紙　紋　　　透　書　日　不　色
蓋　而　　　收　紙　亦　　　之
用　絹　　　　　之。書　　　不
上　蓋　　　　　　　紙。
久　　　　　　　　始
一　　　　　　　　其
絹　却　其　以　良　絹　蓋　用　上。

Mi Fu's objections to the use of silk as a material for backing scrolls generally are well founded; mounters have followed his advice ever since, and always back scrolls with paper.

One of the reasons, however, why Mi Fu objects to silk backings, viz. that they will cause wrinkles to appear on paper scrolls to which they are attached, does not hold good for later times. Mounters in Mi Fu's time could not cope with the fact that moist silk, when drying, has a degree of shrinkage that differs from that of paper or other thin material. Mi Fu, therefore, repeatedly refers to the " tension " that develops when silk backings or borders are pasted on to paper scrolls, and which causes wrinkles. For tension he uses the term *pêng* 弸, which literally means " stretched bow ". If one takes it that the bow itself represents the silk backing, and its string the paper, it will be agreed that his use of this character is very expressive. Although Mi Fu's style is unconventional and sometimes cryptic, he generally proves to have a talent for coining new technical terms.

Although silk is not suitable for backing scrolls because of its hard texture, it can, if handled expertly, certainly be used for other parts of the mounting, such as borders etc. It is clear that in Mi Fu's time mounters had not yet fully developed the pasting technique. *Chuang-p'an*, the " drying boards " that play such an important role in the mounting process as practised during later periods (see page 59 above), did not yet exist. All work was done on the table, and scrolls were pasted and left to dry there.

His argument about genuine and faked cracks appearing on scrolls is very much to the point. The silk of antique scrolls is brittle, its texture has become wasted, and small flakes of its fabric will crumble to dust when rubbed in the hand. Genuine cracks therefore develop in more or less irregular patterns, with clean cut edges. New silk, on the contrary, is tough, and its texture still has its full cohesive force. If one pulls it apart to create a crack, the fabric will tear in a straight line along one of the threads in the texture, and the edges will be frayed.

Mi Fu's remark regarding the suspending of heavy bronze coins on the knobs of hanging scrolls, to ensure their hanging straight, is extremely valuable. For this is the only place in Chinese literature I know of that attests the use of " wind guards " in China. As was explained above in greater detail (see page 84), these " wind guards " are till the present-day widely used in Japan, while in China they must have become obsolete during the Yüan dynasty. That nowadays the Japanese still often use antique Chinese coins as " wind guards " for their hanging scrolls, again proves how faithfully a number of Chinese Sung and Yüan customs were preserved in Japan.

Mi Fu asserts that if the lower roller of a hanging scroll is too heavy, this will in course of time damage the scroll. He probably means that such a heavy roller may

久多紙，歲古杏。轉軸又開發，共匣蟲。湯引同，石角檀軸輕，以氣犀有，爲角性自，木又臭古，蘇濕既愈，有佳。素木。

寶性不重背古，靈頭可墜，桓兩俗背，若必俗也，盜。最亦，招幅錦堂，且掛鴛鴦裝，俗軸雙人，既作錢今，銀晶圓背，金水青只，用然蜀書。

186

cause the mounting to tear, especially in the right and left lower corner where it is attached to the roller.    Later this risk has been eliminated by strengthening these corners with the *chüeh-p'an* (see page 67).    Hollow rollers are also mentioned by a Ch'ing source (see page 330), but it seems that they never became popular; if the roller is too light, it will not serve its purpose of acting as a stretcher to the scroll when it is suspended on the wall.

Mi Fu's idea that scrolls are kept in good condition when they continually pass through people's hands, must derive from the very ancient Chinese conception regarding the "vital essence", the *ch'i* 氣, that emanates from the living body.    The *Chuang-huang-chih* says that albums will not become mouldy if they are stored away in a place near to the human breath (note 2 on p. 307); this must be based on the same underlying thought.

Further, Mi Fu's remark that boxes are primarily intended for storing away wall paintings, is a further proof that in his time these pictures often were not done directly on the wall, but on wooden frames covered with plaster.    This question has been discussed in detail by Pelliot, who quotes a remark made by Mi Fu elsewhere to the effect that he had some fresco's removed from a temple to his own study. [1]

Mi Fu is not consequent in his denouncing the use of boxes for storing scrolls; he frequently mentions such boxes in the second part of the notes quoted above.

In his *Shu-shih*, "Notes on Autographs", Mi Fu has the following to say on the mounting of specimens of calligraphy.

Mi Fu's notes on the art of mounting in his Shu-shih.

"When an autograph has not yet been mounted, you should take a sheet of plain paper, and roll it up together with the scroll.    Then, because of this intervening layer of paper, your scroll will be protected as well as if it were mounted on a roller.    You then can observe the scroll till the colophons at the very end, without fear of damaging it.

"Antique autographs are mounted with light wooden knobs. ... [2]

"Paper can greatly benefit a scroll.  'Oil' paper [3] and hemp paper are hard and tough, and thus cause the greatest damage to a scroll.    The paper for backing a scroll [4] should be evenly pressed, to make it soft and prevent the scroll from becoming fuzzy. Ch'êng-hsin paper [5] has these qualities.    The present-day people think that paper produced at Shê-hsien [6] is the same as Ch'êng-hsin paper; a ridiculous mistake. If, however,

---

1) Cf. his article *Les déplacements de fresques en Chine sous les T'ang et les Song*, in: Revue des Arts Asiatiques vol. VIII, no. IV.

2) Here evidently part of the text is missing.

3) *yu-chüan* 油拳; this paper is mentioned in Mi Fu's *Shih-chih-shuo* 十 紙 說 "Discourse on ten different kinds of paper", but from that passage it is not clear what kind of paper this was.

4) *Ch'ih-chih* 池 紙 here evidently means paper backing; cf. my remarks on pp. 69–70.

5) The name of this paper is said to be derived from the *Ch'êng-hsin-t'ang* 澄 心 堂, a palace of one of the Emperors of the short-lived Southern T'ang dynasty (beginning of the 10th century); cf., however, the remarks of P. Pelliot, in his *Les débuts de l'impression en Chine* (Paris 1953), page 102.    Judging by the descriptions given in literary sources, this must have been a very thin, but tough paper.    The *Ch'ing-pi-ts'ang* (cf. Appendix I, no. 31) says the following: "It is thin like the membrane of an egg, tough and clean like jade, and it is covered with a thin, brilliant coat" 膚 如 卵 膜。堅 潔 如 玉。細 箔 光 潤.

6) See note 3 on page 184.

both the autograph and its backing consist on very soft material, then it is not easy to roll and unroll the scroll, and its surface is liable to become fuzzy.   If you let old Ch'êng-hsin paper soak in water one night, and the next day spread it out on your table to let it dry, then the paste and size that was contained in it will have disappeared, while the paper has regained its original nature.   When used for backing a scroll, this paper should be pounded thoroughly till it is extremely pliable and lacks all hard substances.   There exists one thin variety of antique Ch'êng-hsin paper, that is most suitable for backing autographs.   Backings of rattan paper from T'ai-chou [1] are smooth, and never become fuzzy; this paper is the best in the whole Empire, none of the others can be compared with it.

" The people of the T'ang dynasty always used soft sized paper for backing autographs by Wang Hsi-chih; this is soft like cotton wool, and therefore will never damage the old paper (of the autograph to which it is attached as backing).   They also washed it thoroughly in water, and then let it dry again.   By this process old paper will gain in strength, and it will not warp. [2]   For paper after all is made with water, so that (this washing process) is like making the paper all over again.

" Every time I obtain an antique autograph, I immediately take two sheets of good paper.   One I lay over the original, the other I spread out under it.   Then, starting from one side, I moisten the scroll with a thin decoction from *tsao-chiao* pods [3] till it is well soaked, and till the water has penetrated till the bottom sheet.   Then with the flat of my hand, I softly press and rub the paper on top: in this way all the dirt and grease will disappear together with the water.   Turning over the sheets I repeat the process, and then again wash the scroll six or seven times with clean water. Then it will be found that while the paper and the ink of the autograph itself have not been affected, all the dust and dirt have disappeared.   Finally I take off the sheet on top, and let the scroll dry, blotting it with a sheet of good paper.

" Having taken off two or three layers of the backing, you spread out the scroll over a slightly moistened sheet of good paper, and then lift it up again so as to remove the last layer of backing (that stays stuck to the moist paper underneath).   Then you can paste the new backing on to the scroll.   You should not use silk for bordering the autograph but only paper, to prevent the scroll developing wrinkles. [4]

" If the backing is too thick, it will through its tension damage the old paper of the autograph; and (for the same reason) you should not add a lining.   The old paper with which autographs are backed will burst in unexpected places.   You can only take a sheet of thin paper, and attach this to the back of the autograph; it looks especially elegant if thus the old imperfections and holes are still visible; these need not be patched up.

" The ancients used to rule their paper by drawing grooves, so that the columns of characters are, as it were, encased in a hollow tile; in this way they protected the text.

---

1) See p. 189, note 6 below.

2) *Mi* 縻 literally means " halter for an ox, to tie "; here it must have some technical meaning.  My translation is mere guess work.

3) *tsao-chiao*, Gleditschia horrida.

4) Mi Fu's idea apparently is that these silk borders when drying will shrink more than the paper to which they are attached.

At present vulgar people when seeing the thick paper of antique scrolls, always will peel off a few layers, so as to make the scroll thinner, and only thereafter add the backing. But if you take away half of the thickness of old paper, then the spirit of the calligraphy will be lost, and your scroll will look just like a traced copy.

" Moreover, if autographs ruled with grooves are backed with silk, the scroll will for a time be perfectly smooth. But afterwards, when the scroll has been rolled and unrolled for some time, this hard (silk backing) will cause the ruling to disappear, and the text will be damaged. The professional mounters in the capital have in this way spoilt many a scroll. The autographs and the paintings in Wang Hsin's collection often suffered damage by their backings being taken off. I reproved him about this, and now he does not have their backings taken off anymore.

" Further people like to back their scrolls with silk. But even new sized silk is hard, so that (such a stiff backing rubbing against the scroll when it is being rolled and unrolled) will cause the ink of the old autograph on paper to come off, and become transferred to the silk backing. The *Shu–pu* [1] and the *Huan–hsieh* autograph [2] in the collection of Wang Hsin, all became worn down by their silk backing. In recent years I saw many examples of scrolls suffering damage because amateurs had them backed with silk: the impression of the texture of this silk backing had appeared on the surface of the autograph.

" When I had exchanged [3] an autograph–letter written by Wang Hsi–chih to Wang Shu, [4] for an edict written by the T'ang Emperor Wên (827–840) in his own hand, I backed it with thin yellow [5] silk with a date–pattern. Then I found that this pattern gradually became visible on the surface of the autograph itself. I then remounted this scroll with rattan paper from Huang–yen in T'ai–chou, [6] after having pounded and sized this paper, and after having removed half of its thickness. This backing proved smooth, clean and soft, and frequent rolling and unrolling did not make the autograph fuzzy. The greater part of the autographs in my collection are mounted with this paper. Every single one of my scrolls I backed and mounted with my own hands, and only thereafter entered them in my collection. [7]

" (When remounting) autographs that have a good old backing, I first loosen the backing (by soaking the scroll), without trying to remove it. I press a dry sheet of paper on top (of the reverse of the scroll), then cover it with a new sheet of thick paper, having applied paste to its four edges and thus stuck that paper to the table.

1) The *Shu–pu* 書 譜 is the most famous essay on the art of calligraphy, written by the T'ang calligrapher Sun Kuo–t'ing 孫 過 庭. Originally it counted 2 parts, but now only the " General introduction " 總 序 has been preserved, in the form of a rubbing.

2) *Huan–hsieh–t'ieh*, presumably autographs by the two famous statesmen of the Chin period, Huan Wên (see above, p. 184, note 2) and Hsieh An (謝 安, 320–385), mentioned in the *Pao–chang–tai–fang–lu*; Hsieh An excelled in writing the cursive script.

3) It is a century–old custom among Chinese connoisseurs and collectors to exchange their antiques.

4) Wang Shu, 303–368, an eccentric scholar.

5) Mi Fu apparently selected this yellow material because yellow was the Palace colour.

6) Huang–yen is a district of the T'ai–chou prefecture, in Chekiang Province.

7) Lit.: " entered them into my baskets "; *chi* 笈 is a bamboo basket in which the ancients kept their books and manuscripts.

You need not use paste for the autograph itself, you just let the tension of the sheet of paper on top keep it stretched out smoothly. When the paper on top has dried, then the autograph underneath has naturally also become dry. You should be careful, however, not to use for this process a table with a gold–lacquered top, for such a surface will retain a calque of the autograph. When I remounted the autograph letter by Li Jung in which he expressed his thanks to Kuang-pa-lang [this Kuang is Wang Chü], [1] I found, when I took it up from the table, that a calque in a thin layer of ink appeared on the top. I did not wash this table for over a month, in order to spare the calque of this autograph. [2]

Comments on the Shu-shih notes.

The above passages present considerable difficulties. The text must be corrupt in more than one place, and I am not sure, therefore, that my interpunction is right. The translation given above, especially of the first half of the text, must remain provisional until the entire *Shu-shih* has been critically edited.

Mi Fu here repeats his warning against backing scrolls with any other material than soft paper. He also reiterates his criticism of those people who try to smooth out the grooves with which antique autographs are often ruled.

---

1) Li Jung, 678–747, a famous calligrapher, usually referred to as P'ei-hai 北海, because he was prefect of that district. The explanation placed between square brackets is a comment by Mi Fu or some later copyist, that properly should have been printed in two columns of smaller characters. Wang Chü rose high in the favour of the T'ang Emperor, but later was killed through the machinations of Li Lin-fu (B. D. no. 1170).

2) *Shu-shih* (Appendix I, no. 38):

His description of how antique scrolls should be washed and cleaned corresponds to what later sources say on this subject. This process has remained in principle the same till the present day.

As has been described on page 107 above, the taking off of the last layer of backing from an antique scroll is a most delicate task. Mi Fu's method of letting this last layer get stuck to a sheet of moist paper spread out underneath, is very commendable; some modern mounters still practise this method, provided the scroll is not too badly damaged.

The advice not to make antique scrolls done on laminated paper thinner by peeling off a few layers from the back, seems to have inspired a passage in a Southern Sung document on the mounting of scrolls in the Palace collection (see page 212 below).

Changing the backing of an antique scroll always is a perilous undertaking. Mi Fu was well aware of the risks involved in this process, as appears from the following passage, occurring elsewhere in his *Hua-shih*: "If you obtain an antique scroll the backing of which has not become loose, you should not change this backing. If its front mounting is ugly, you may change the front mounting. But everytime you change the backing, the scroll will be damaged, and if this is done often, the damage will be greater still. This is very much to be regretted. For the spirit and colouring of pictures of human figures, and the compact yet slender grace of flower paintings, all this rests entirely with the subtle interchange of heavy and light brush work. If the backing of a painting is changed once, these subtle nuances will mostly be lost". [1]

The activities of Sung collectors and connoisseurs, their theories about pictorial art and calligraphy, the establishing of an "Academy of Art" [2] by the Emperor Hui-tsung (1101–1125), and the contests in painting and the aesthetic discussions that were held at his court, all this has been described at length in Western standard works on Chinese painting. These general aspects of artistic life during the Northern Sung period thus can here be passed over in silence.

Northern Sung connoisseurship.

Attention must be drawn to the fact, however, that this popularity of artistic and antiquarian studies also had its seamy side. Collectors were so keen on outdoing each other in the number of works by famous artists of antiquity in their possession, that they often added arbitrarily great names to anonymous scrolls. " The people of to-day ", says Mi Fu, " who add names to anonymous pictures, are too many to count. Therefore the common saying runs ' If a painting shows a cow, then it is inevitably found to

---

1) *Hua-shih* (Appendix I, no. 37): 古畫若得之不脫。不須背。褾若不佳。換褾。一蓋人在之物精神髮彩花之穠豔。蜂蝶或失之約畧濃淡之間。一經背。多也。深之穠豔一次背。一次壞。屢更矣。

2) In 1104 there was established a "School of Painting", which in 1110 was replaced by a "Bureau of Painting", that formed part of the Han-lin Academy; accordingly the official name of this Bureau then was *Han-lin-t'u-hua-chü* 翰林圖畫局. It was popularly referred to, however, as *Hua-yüan* 畫院, which is the "Academy of Painting" of Western books on Chinese art. As A. G. Wenley has pointed out correctly (in his *A Note on the so-called Sung Academy of Painting*, Harvard Journal of Oriental Studies, vol. VI, 1941, p. 269), this translation is misleading in so far that it suggests that this "Academy" was an institution of the same official standing as, for instance, the Han-lin Academy.

be signed by Tai Sung, [1] if a horse, then by Han Kan, [2] if cranes, then by Tu Hsün, [3] and if an elephant, then by Chang Tê [4] ". [5]   This reprehensible custom of attributing unsigned paintings on the basis of the subjects they represent, entirely ignoring their artistic quality, has persisted throughout the ages, and still exists to-day.

The art of the forger flourished because of the great demand for antique scrolls. And it was not only the professional forger who engaged in this work.   The story about no one less than Mi Fu copying antique scrolls borrowed from his friends, and while returning the copy, retaining the original for himself, is famous in Chinese literature.   Further Mi Fu relates with relish how he discovered that his friend and fellow-collector, the Imperial Son-in-law Wang Hsin, passed copies made by Mi Fu off as originals, and also by other means tried to enhance the value of the scrolls in his collection.

" Every time when I visited the capital, Wang Hsin used to invite me to his mansion, and taking out all the autographs in his collection, ask me to copy them for my edification.   Once rummaging through the autographs and paintings in his cupboards, I found a copy made by me of the O-ch'ün scroll [6] by Wang Hsien-chih.   It had been dyed a nice antique tinge, and the hemp paper was covered with (artificial) wrinkles. It was placed in a brocade cover, and mounted with jade knobs.   At the end of this scroll there were attached (genuine) colophons that had been cut off other scrolls.   Further I found a copy made by me of an autograph by Yü Ho, [7] dyed and mounted like the other one, and provided with colophons which Wang Hsin had asked several high placed persons to write for it.   Seeing these scrolls I burst out in laughter.   Wang Hsin grabbed these scrolls from my hands, and confessed that there were many more of this kind, which he had not yet shown to me.   Further, when I was young, I used to employ the son of a Soochow mounter, called Lü Yen, who now works as a clerk in the San-kuan. [8]   Wang Hsin used to have this young man stay in his mansion, and made him

1) Tai Sung, T'ang painter who specialized in pictures of oxes and rustic scenes.

2) Han Kan, T'ang painter famous for his pictures of horses and human figures.

3) T'u Hsün does not exist.   Mi Fu here ridicules ignorant amateurs, who in their zeal for attributing anonymous pictures, add the signature " T'u Hsün " to pictures of cranes, because there was a famous T'ang poet whose name was Tu Hsün-ho 杜 荀 鶴, the last character of his name meaning " crane ".

4) Same remark as in the preceding note.   Chang Tê does not exist, but Chang Tê-hsiang (章 得 象, 978-1047) was a well-known Sung scholar-official; hsiang, the last character of his name, means " elephant ".   Mi Fu borrows this joke from a passage in the Kuei-t'ien-lu 歸 田 錄 by Ou-yang Hsiu (歐 陽 修, 1007-1072) where a friend of Chang Te-hsiang is quoted as having made the pun.

5) Hua-shih (Appendix I, no. 27): 今 人 以 無 名。命 爲 有 名。不 可 勝 數。故 諺 云 牛.

卽 戴 嵩。馬 卽 韓 幹。鶴 卽 杜 荀。象 卽 章 得 也。

In another passage Mi Fu expresses the same idea: " Ordinary people when seeing a picture of horses, immediately attribute it to Ts'ao Pa (曹 霸, T'ang artist), Han Kan (see note 2) or Wei Yen (韋 偃 T'ang painter), and when seeing a picture of oxes, attribute it to Han Kuang (韓 滉 T'ang painter) or Tai Sung (see note 1); this is most ridiculous " (Ibid.: 世 俗 見 馬 卽 命 爲 曹 韓 韋。見 牛 卽 命 爲 韓 滉 戴 嵩。甚 可 笑).

6) A copy of the O-ch'ün scroll is still preserved; it was published in collotype at Shanghai, by the I-yüan-chên-shang-shê (see note 1 on page 213).   Part of it is reproduced on Plate 152 of the present publication.

7) See p. 139, note 4.

8) Three institutes in the Ch'ung-wên-yüan (cf. below, page 220, note 2), where antique paintings and autographs were stored and studied; cf. Sung-shih, ch. 162, page 25.

trace autographs. I saw one roll containing the *Huang-t'ing-ching* [1] traced by him, and on which Wang Hsin had impressed the faked seal (of the collector) Kou Tê-yüan; [2] but this fake I detected ". [3]

Fakes produced by connoisseurs, however, were made mostly for the purpose of having an opportunity for studying rare scrolls at leisure, or to play jokes on their friends. The worst offenders were the professional mounters and curio dealers. Mi Fu relates in his *Pao-chang-tai-fang-lu* how a scion of the Sung Imperial family once obtained a famous autograph by Wang Hsi-chih, which had a number of old colophons attached to it. " He gave this scroll ", says Mi Fu, " to a mounter of autographs to have its backing changed, but did not receive it back for a long time. The fact was that the mounter had cut off half of the colophons, all written by famous people of the T'ang dynasty. Since these could not be recovered, the mounter offered to pay 40 000 cash as indemnification. Thus it is clear that those cut-off colophons had brought the mounter a tidy bit of money ". [4]

Further, we read in a twelfth century source the following:

" During the Chêng-ho period (1111-1117) there was a distant relation of the Imperial family, whose name has not been recorded. He was a great collector of rare scrolls, and gradually princes and noblemen started to bring their own scrolls to him for being judged. Then this man established relations with ordinary antique dealers. Everytime he heard of someone possessing a rare scroll, he would by all kinds of stratagems get such a scroll in his house. Then he immediately made a copy of it, and substituted this for the original picture. The original he thereafter sold himself for a high price. Thus valuable scrolls often circulated in this way three of four times (i. e. were copied and re-copied numerous times), for which reason at that time this gentleman was nicknamed ' Cheap-three' [5] ". [6]

Needless to say that for a modern connoisseur it is virtually impossible to tell apart copies and fakes produced during the Sung dynasty from, for instance, T'ang originals, not to speak of copies of Sung works. The fact that the Chinese reached such perfection in the copying of master-pieces on the one hand preserved many an antique scroll for posterity; but on the other hand it confronts the later connoisseur who tries to solve authenticity problems with a nearly superhuman task.

---

1) See p. 220, note 5 below.

2) See note 6 on page 332.

3) *Shu-shih*: 過櫃鵝囊又見未之嘗黃書　其中群玉笑示呂門經記乃　第。即翻索古軸。裝虞。又彥。下。余　大書染帖。就余直使　余索麻紙上裝手少今雙　到臨余尚背卿其蘇爲又勾　邀因敬錦後。適多匠摹圖　王籤於跋。其余尚背王見元　下學子文。　都臨王見　王說每余　書染帖他使三書帖所

4) *Pao-chang-tai-fang-lu* (cf. Appendix I, no. 39): 令裝唐四十千。即知其切。真得金己多。書人背。公也。付理不可得。及剪卻半跋。皆匠人願陪

5) *Pien-i-san*, meaning presumably that a " copy from a copy from a copy " could be bought cheaply from him.

6) *Hua-chi* (cf. p. 166, footnote 2): 外王賣其能循宅公交家別環宗貴室人。不令通。即也。記其奇模。本當名。別奇。凡時復四。多識必其厚時號。易用真價易日蓄於是詭計其之便。間往與勾主至宜和圖。途珍政有往常致莫有三。

Finally I here insert a few words on Mi Fu's remarks regarding the impressing of
name–seals and collector's seals on antique scrolls.

As was pointed out above, collector's seals impressed on old autographs and pain-
tings may either embellish or spoil the scroll. The best is to use for this purpose only
seals carved in *chu–wên* (see below, page 420), and in very thin lines; such seals are less
liable to obliterate parts of the text or the drawing of the scroll they are impressed on. Mi
Fu stresses these points in the following passage of the *Shu–shih*. He says:

" In recent years the seals used in the San–kuan [1] and the Secretariat all have
legends carved in very thin lines, but their rims are as broad as half a finger; when im-
pressed on autographs or paintings they will spoil them. When Wang Hsin had seen
that the seals I use (for this purpose) resemble those used during the T'ang dynasty (i. e.
being small and carved in thin lines), he changed all his own seals for new ones with thin
rims ". [2]

The passages from Mi Fu's works quoted above give some idea of how hand scrolls
were mounted in his time, and some general information on hanging scrolls and other
styles of mounting.

It is unfortunate that Mi Fu says little about the material used for the front moun-
ting of hanging scrolls, and the type of these mountings. We shall see below that dur-
ing the Southern Sung dynasty the length of the mounting had been increased by adding
directly above and below the picture itself a horizontal strip of mounting, called *yin–shou*.
These two strips were not as broad as *t'ien* and *ti*, but had the same proportion of 2 : 1.
Since it may be assumed that these *yin–shou* were added in order to make the hanging
scroll more suitable for covering empty wall space, this feature probably occurred al-
ready in Mi Fu's time, although he does not refer to it in his writings.

During the Northern Sung period sections of hand scrolls, and horizontal pictures
from low screens, were often remounted as hanging scrolls. It was probably such
remounted hand scrolls that inspired Mi Fu and his son Mi Yu–jên to paint *hêng–fu* 橫 幅,
large horizontal pictures meant to be mounted as hanging scrolls (see Plate **6**); as mention-
ed already on page 20 above, the invention of this type of picture is ascribed to Mi
Fu and his son.

In the Old Palace Collection are preserved a number of small pictures and autographs
done on round or oval pieces of silk and which date from the T'ang and Sung periods.
These are mounted as hanging scrolls but their size and shape prove that originally it
were stiff fans; most of them still show a slightly discoloured strip running vertically
across which indicates the place of the central rib of the fan; cf. Plate **18** A. The
painting of miniature landscapes in full colours on fans seem to have been particularly
popular during the Sung dynasty.

---

1) See note 8 on page 192.
2) *Shu-shih* (Appendix I, no. 38): 近 三 館 秘
閣 之 印。文 雖 細。圈 乃 粗 如 半 指。亦

印 捐 書 書 也。王 詵 見 余 家 印 記。與
唐 印 相 似。始 盡 換 了 作 細 圈。

194

The movable screen was now widely used. Large paintings on silk or paper were often stretched over wooden frames, and provided with wooden stands so that they could serve as screens. As appears from the literary gathering reproduced on Plate **77** the later Japanese *tsui–tate* (Plate **17**) faithfully preserves the construction of these antique Chinese screens. This painting is further interesting because of the furniture depicted. I may draw attention to the carved blackwood table with marble top and the broad wooden couch behind it. The gentleman on the left is sitting on a wooden chair, the curved back of which betrays Indian influence. Note also the rustic bamboo chair with foot rest of the person in front, and the rolled–up scrolls on the table in the background.

\* \* \*

The artistic splendour of the Sungs continued in full glory till long after their political power had declined. Since the beginning of the 12th century the Chin barbarians had the whole of North China in their possession. They tried to create at Pien–liang (汴梁 present–day K'ai–fêng), the old Sung capital, a kind of new culture, cast in Chinese mould. The Sung rulers, receding before the ever–increasing pressure of the Chin, had fled to the South. Kao–tsung (高宗, 1127–1162), as first ruler of the Southern Sung dynasty (1127–1279), founded a new capital at Hangchow, then known as Lin–an 臨安. On this spot, celebrated for its exquisite scenic beauty, the artistic Sung tradition was continued; halcyon days, the Emperor poring over rare scrolls to forget the troubles past and ahead.

Hangchow then was a real war–capital. It was over–crowded with refugees who lived in hastily constructed huts and houses of bamboo and straw. Two terrible fires (1200 and 1204) laid a considerable part of the town in ashes.

The Southern Sung period.

The troubled political situation and the general uncertainty brought, however, one advantage with them: scholars and artists from all over the Empire flocking together in one place, this brilliant company caused a revival of philosophical, literary and artistic studies that rivalled the heighday of T'ang culture at Lo–yang.

Flourishing of Ch'an Buddhism at Hangchow.

The Chinese annals devote much space to the work of the philosopher Chu Hsi (朱熹, 1130–1200), the famous founder of the so–called Neo–Confucianism, and the political squabbles wherein he and his school became involved. They do not relevate, however, another factor of supreme importance in Southern Sung culture: Buddhism, and more especially its School of Meditation, *Ch'an* (abbreviation of *Ch'an–na* 禪那, the Chinese transcription of the Sanskrit *dhyâna* " meditation ".

Long before becoming the capital of the Southern Sung dynasty, Hangchow had been a center of Buddhist studies. [1] In the beautiful Western Lake region, in the outskirts of the town, there stood many Buddhist temples and monasteries, mostly belonging

---

1) Cf. for more details my Chinese publication *The Ch'an Master Tung–kao*, Chungking 1944.

195

to the Ch'an sect. In 1151 the great Ch'an master Chên-hsieh Ch'ing-liao (真 歇 清 了, 1088–1151) had founded there the Kao–t'ing–szû 皋 亭 寺, a temple that for centuries to come was to play an important role in Chinese Buddhism. Further in famous monasteries such as the Ling–yin–szû 靈 隱 寺 and the Ching–tz'û–szû 淨 慈 寺, other great Ch'an masters as for instance Kan–chieh (感 傑, lit. name Mi–an 密 庵, 1118–1186), Ch'ung–yüeh (崇 岳, lit. name Sung–yüan 松 源, 1132–1202) and Ju-ching (如 淨, lit. name Ch'ang–wêng 長 翁, 1163–1228) exposed the principles of Ch'an, attracting large crowds of eager listeners.

Political persecution and the feeling of suspense caused by the barbarians from the North ever drawing nearer, caused many scholars and artists to seek refuge with the Ch'an doctrine. Some actually joined the Buddhist priesthood, others adopted Ch'an as their spiritual guide and propagated its teachings in broader circles.

Ch'an influence on Southern Sung culture was much greater than the official Chinese historical records would make one believe. This is proved i. a. by contemporary painting. The nearly mystic landscapes by Ma Yüan (馬 遠, flourished circa 1200) and his son Ma Lin 馬 麟, Hsia Kuei (夏 珪, circa 1200) and other artists breathe a pure Ch'an spirit. Even Chu Hsi borrowed for his philosophy largely from Ch'an doctrines. [1]

Ch'an influence in the Chinese interior.

The Ch'an ideology influenced also interior decoration. Its esthetic ideals teaching that simple, natural beauty is superior to luxurious splendour inspired many to model the appointments of their dwelling house after monastic interiors.

A landscape scroll, a picture of flowers or of a few bamboo sprigs serves the Ch'an adept as object for meditation in the same way as an image of a deity. The spread of Ch'an ideals deepened therefore the significance of the secular hanging scroll. From a means for covering wall space the hanging scroll now became a kind of altar piece.

This changed position of the hanging scroll appears clearly from Southern Sung texts on artistic subjects. Now only a few scrolls are exposed so that each can be seen to its full advantage. Further the scrolls displayed on the wall are changed at regular times so as to prevent them from becoming soiled, and in order to harmonize interior decoration with the continually changing aspects of nature outdoors.

The Southern Sung interior embodied elegant artistic notions refined by the spirit of Ch'an. Japanese monks who visited China during this time were greatly impressed by these interiors. As will be seen on page 240 below the later Japanese dwelling house was modeled after these Chinese examples.

Chao Hsi-ku on the display of hanging scrolls.

Chao Hsi–ku, a connoisseur of the Southern Sung period has left a description how a discerning lover of art should display hanging scrolls in his house. This passage shows clearly how greatly the Ch'an teachings had changed the general conception of the role of the hanging scroll in interior decoration. One has but to compare Chao Hsi-ku's

---

1) For a good description of the Ch'an School, see D. T. Suzuki, *Essays in Zen Buddhism*, first series, London 1927.

196

78. — SUNG WOODPRINT

words with the passage from Mi Fu quoted on page 181 about walls covered from top to bottom with scrolls of various dates and sizes.

At the same time Chao Hsi-ku's description proves how carefully collectors looked after their treasured pictures. The room where hanging scrolls were on display was always kept at the right temperature, it was dimly lighted, there were no draughts and there was burnt no incense that by its oily smoke might soil the pictures. He says:

" Having selected some paintings by famous artists one should not suspend more than three or four of these in one room. After having enjoyed these to the full you should change them for other good pictures. In such a way you will (in course of time) see all your scrolls, and they will not suffer damage by draughts or sunrays. Moreover, if they are thus displayed in turns they will not get soiled, and by continually changing the works of one or two masters you will never tire of them.

" For viewing your scrolls you should invite only enthusiastic lovers of art, or have one friend very carefully unroll them. When you take out your pictures to be unrolled you should lightly dust their surface with a whisk made from a horse tail or silk; for this purpose you should never use a coir–hair brush. In the room there should never be burnt sandal wood, laka wood or camphor incense, or other kinds of incense that contain oil and thus produce thick smoke; the only kind of incense you may use there is *chia–chien*. [1]

" The windows of this room should have panes of oil paper and the sunblind of the door should always be kept lowered. Underneath each scroll (suspended on the wall) there should be a low table to protect it. On this table there should be no objects that interfere with the scroll, there should be only such things as an incense burner, a lute, or an ink stone. During the very hot days of summer when it is warm and moist inside the room no pictures should be left on the walls. During the severe cold of winter a slow fire should be kept burning in the room to have there a temperature like that of early spring. Then you can leave the scrolls on the wall (even during winter), provided that they are taken down for the night and put in their boxes to prevent their suffering damage through getting frozen ". [2]

A fortunate chance has preserved a model of a mounted hanging scroll of this period. It is a Southern Sung woodprint that was excavated in Kara Khoto, practically undamaged; see the reproduction on Plate **78**.

A model of a Southern Sung hanging scroll.

This woodprint represents a picture of four famous women of former dynasties, viz. from left to right Pan Chieh-yü (cf. B. D. no. 1599), Chao Fei-yen (ibid., no. 151),

---

1) The text has *chia-chien* 甲 箋, which must be an alternative way of writing 甲 煎; this is a very precious incense, made of the ashes of various herbs and flowers, mixed with wax.

2) *Tung-t'ien-ch'ing-lu-chi* (Appendix I, no. 27): 擇
名筆。別挂名筆。又輪易一家。或使令一童子。畫三五日。決不惹塵然須謹得時易。不蒸瀝埃。止可一室別挂三四軸。觀玩既則換。諸皆次挂之。則看之不細。令一人令不厭。風玩見之。則不令細觀。

拂。切煙油一物。蒸少然妨。絲中多必設之必著。或室油牖必畫中漸不。有窗前障室中之。尾拂。書設則室挂。馬梭子耳。用用腦篦一勿暑於候。日。可眞甲簾上極寒氣凍。之不降萊垂桉極大天恐。納切香口護硯。月匣。出書焚宜唯戶以香爐挂二入。卷舒拂可糊。桉宜不令如必。意輕不之紙小止熱。火遇夜宜。

197

Wang Chao–chün (ibid., no. 2148) and Lü–chu (ibid., no. 1709). The superscription along the top of the picture reads: " The tender beauty of successive dynasties presents its frägrant countenance capable of upturning the land ".

Apart from its significance as a finely executed early Chinese wood engraving, this print is of great importance for the history of mounting; for the man who made it included the mounting of the picture in his drawing.

The front mounting apparently begins with the *lei–wên* band that frames the picture together with its superscription; the latter is perhaps a forerunner of the *shih–t'ang*, the " poetry hall " of later hanging scroll mountings, described on page 66 above. The *t'ien* on top represents brocade with a pattern of Phoenix birds among floral motifs, the *ti* has a pattern of lotus flowers. *T'ien* and *ti* have the traditional proportion of 2 : 1.

We shall see below that the *Szû–ling–shu–hua–chi*, a document dating from the same period, says that hanging scrolls next to *t'ien* and *ti* (there called *shang–piao* and *hsia–piao*) also had *yin–shou*, that is to say horizontal strips of mounting directly above and below the picture. The woodprint lacks these two extra strips. Perhaps the artist left them out in order not to make his print unduly large. For the same reason he must have left out the upper stave and the lower roller.

It should be noted that on the left and right of the picture there is only the narrow *lei–wên* band. That the sides of the picture are thus scantily protected against outside dangers is a characteristic feature of early hanging scroll mountings.

The bow of broad brocade bands at the top of the mounting is of special interest. This bow evidently represents the *ching–tai* 經帶 of the Southern Sung hanging scroll mounting. Below we shall try to show what was the origin of these *ching–tai* and how they developed from broad bands tied in bows at the top of the scroll, to two narrow strips running across the *t'ien*.

<p style="margin-left:2em">*History of the ching-tai.*</p>

On p. 66 of the present publication a description was given of the *ching–tai* of later Chinese and Japanese hanging scrolls. It was pointed out that while the former have *ching–tai* that are pasted down across the *t'ien*, in Japan these two bands are left hanging loose from the upper stave.

The origin of these bands has often puzzled later Chinese writers. The 17th century connoisseur Kao Shih–ch'i (高士奇, 1645–1704) devotes a brief note to this problem in his book *T'ien–lu–shih–yü* 天祿識餘 (cf. Appendix I, no. 44). He thinks that the solution is supplied by *ching–yen* 驚燕 " frightening swallows ", a term that since the Ming period is often used as a synonym for *ching–tai*. He explains this term as follows:

" Swallows are afraid of paper, they will always fly away from places where are strips of paper. The paper strips of a scroll were therefore in olden times not pasted down ". [1]

1) 燕 怕 紙。凡 有 紙 條 處 則 飛 去。畫 上 紙 條。古 不 粘。

198

However, *ching-yen* is a late term that has nothing to do with the original function of the *ching-tai*.

The origin of the *ching-tai* is clearly indicated by their name: " bands (*tai*) of book rolls (*ching*) ". They referred in the beginning evidently to the band attached to the thin stave of a hand scroll; it was wound round the scroll to keep it tightly rolled up. Later when the Buddhist " banner mounting " was applied to secular scrolls, two of such fastening bands were attached to the upper stave. In the case of the hand scroll one band was sufficient for keeping it rolled up tight: but the broader and loosely backed early hanging scrolls needed two of these. When the hanging scroll was displayed on the wall the two fastening bands were tied together in a bow. One loop of the bow was used as suspension loop, being hooked over the nail; the other loops and the loose ends hung down over the *t'ien* as a kind of decoration. Thus the *ching-tai* of hanging scrolls represented, just like the entire hanging scroll mounting itself, a combination of Chinese and foreign elements: their function of fastening bands derives directly from the Chinese hand scroll, their decorative function was suggested by the streamers and valances attached to the upper staves of foreign " banner mountings ".

The word *ching* " book roll " in the compound *ching-tai* had now become meaningless. It was retained, however, throughout the Sung and Yüan dynasties. As was remarked on page 52 above, the Chinese written language has a tendency to retain literary terms for objects of material culture long after the shape and function of those objects has changed so much as not to answer anymore the old name. A more or less colloquial term that accurately described the *ching-tai* of hanging scrolls was *ch'ui-tai* 垂帶 " bands that hang down ". But the term *ching-tai* was older and hence preferred by most writers on artistic subjects.

We shall see below, in the section dealing with the Yüan dynasty, that during that period the *ching-tai* continued having the triple function of (*a*) fastening bands, (*b*) suspension loop and (*c*) decoration of the front mounting.

Thereafter, in the early years of the Ming dynasty, hanging scrolls were provided with a special suspension loop in the form of a cord; to this cord was attached a band for fastening the scroll. Since by that time the hanging scroll mounting had been perfected, one band was sufficient for keeping the scroll rolled up tightly. The old *ching-tai* were reduced to two narrow strips attached to the upper stave and hanging down straight across the *t'ien* and henceforward served mainly a decorative purpose. The terms *fêng-tai* and *ching-yen* date from this time.

*Fêng-tai* 風帶, literally " wind band ", probably refers to the fact that the two loose bands hanging down from the upper stave were occasionally made to serve a practical purpose, viz. preventing the scroll from swaying to and fro when exposed outdoors or in a draughty room. This could be done by filling their lower end with sand or pieces of lead. Some old Japanese mounted hanging scrolls still have such weighted *ching-tai*.

The terms *fêng-tai* and *ching-yen*.

As to the term *ching–yen* 驚 燕 "frightening swallows", this must originally have referred to bundles of long strips of white paper temporarily hung on or near hanging scrolls in order to scare away birds and flying insects that might soil the scroll with their droppings. Since the *ching–tai* dangling loose from the upper stave resembled those paper strips, the term *ching–yen* was transferred to them. It continued to be used as such even after it has become customary to paste the *ching–tai* down on the *t'ien*.

Be this as it may, it is certain that during the Sung period the *ching–tai* were loose fastening bands that were tied in a bow at the top of the scroll when it was going to be displayed. Consequently no painting that depicts hanging scrolls with *ching–tai* pasted down on the *t'ien* can possibly date from that period. Therefore the scroll from the Palace Collection reproduced on Plate **22**, though listed as a picture by the Northern Sung artist Liu Sung–nien, is certainly a Ming copy — if any extra proof were needed, for style and brushwork clearly point to the Ming period.

The Southern Sung Palace collection.

The fact that a scroll was entered into the Palace Collection did by no means imply that it was an authentic work. This applies not only to the Palace Collections of the Ming and Ch'ing dynasties, but also to that of the Southern Sung period. We shall have occasion to revert to this point in the following discussion of the Palace Collection of the Emperor Kao–tsung.

Although, when the Sung court fled to the South, much of its art treasures fell into the hands of the Chin conquerors, still what was left, together with what was subsequently recovered, was enough to enable Kao–tsung to form an impressive Imperial Collection.

It is thanks to the zeal of a late–Sung scholar that there has been preserved a list of the contents of the collection of paintings and autographs, with a detailed description of the way they were mounted. This document, invaluable for the history of the art of mounting, is the *Szû–ling–shu–hua–chi* 思 陵 書 畫 記 "Account of the scrolls in the collection of Kao–tsung". [1]

The Szû–ling–shu–hua–chi, and the scholar Chou Mi.

Although this document is frequently quoted, either partly or in full, by writers of the Yüan and Ming periods, [2] modern Chinese and Western art–historians have not given to it the attention it deserves.

---

1) This document is also referred to as *Shao–hsing–ting–shih* 紹 興 定 式 "Fixed models (of mountings) of the Shao–hsing period", or simply as *Shu–hua–chi* 書 畫 記; it is to be found in chapter 6 of the *Ch'i–tung–yeh–yü*, 齊 東 野 語, a collection of historical notes compiled by Chou Mi, to be found reprinted in various *ts'ung–shu*. Unfortunately this text was never properly collated, so that numerous passages are in need of emendation. The *Szû–ling–shu–hua–chi* has been reprinted as a separate text in some older *ts'ung–shu*, like, for instance, the *Shuo–fu* 說 郛; also these editions contain a number of doubtful readings.

*Szû–ling* in the title is an abbreviation of *Yung–ssû–ling* 永 思 陵, designating the tomb of the Emperor Kao–tsung; as is well known, Emperors may be posthumously referred to by the name of their tomb.

2) Of the Yüan sources that quote this document I mention the *Cho–kêng–lu* (cf. Appendix I, no. 24), chapter 30, and the *T'u–hui–pao–chien* (cf. Appendix I, no. 40), section on mounting; and of the Ming sources I mention, for instance, the *Chang–wu–chih* (Appendix I, no. 30), chapter 5, 15th paragraph.

It is true that this document is so technical that it is difficult to translate, while it contains not a few obscure or ambiguous passages. Also it does not seem to be complete, and some passages have been transmitted in mutilated condition. Yet it is of so great importance to our present subject, that here we shall analyze this document in some detail, and make an attempt at a full translation.

First, however, a few words must be said about the writer who recorded this document, and about the way he obtained the original text.

The literatus responsible for the preservation of the *Szŭ-ling-shu-hua-chi* is the scholar and poet Chou Mi (周 密, styled Kung-chin 公 謹, 1232-1308). Besides being a brilliant writer, Chou Mi also was one of the greatest connoisseurs of the Southern Sung period. Himself an ardent collector of antiques, he was in close touch with artists and art-lovers of his time, and had access to their collections. This appears from his *Yün-yen-kuo-yen-lu* (雲 煙 過 眼 錄, 4 ch.), a collection of antiquarian notes, where he describes the antiques he saw in the collections of other connoisseurs, adding critical remarks. [1]

Chou Mi's visit to the Palace collection.

At the end of Chapter 3 of this book there occurs a passage that is of special interest with regard to the *Szŭ-ling-shu-hua-chi*, although this text itself is not mentioned there. This passage is a brief description of a visit paid by Chou Mi to the Imperial Collection in the year 1299, or only twenty years after the Southern Sung dynasty had perished. Then this collection, though greatly diminished, could still be seen in its old surroundings. Chou Mi's account of this visit reads as follows.

" Then we went on to the Imperial Library, and ascended the Imperial Archives. All along both sides there were arranged a number of chests, which contained the official documents of former dynasties, and Imperial writings and paintings. Apart from these there were over fifty large chests, lacquered red, all of which contained model writings and famous paintings of past and present. On that day we only saw the lots numbered 21, 22, 23 and 24. [2] All of these scrolls were mounted with fine silk showing patterns of phoenix birds and magpies, and their rollers were provided with ivory knobs. Those

---

1) This book has been reprinted in various *ts'ung-shu*, the best text being that given in the *Pao-yen-t'ang-pi-chi* (寶 顏 堂 秘 笈, published by the Ming scholar Ch'ên Chi-ju 陳 繼 儒, 1558-1639; the title " Hall where Yen is treasured " refers to the fact that Ch'ên Chi-ju once obtained an autograph by the celebrated T'ang calligrapher Yen Chên-ch'ing 顏 眞 卿, 709-785). The title *Yün-yen-kuo-yen-lu* is an allusion to a passage in the *Pao-hui-t'ang-chi*, an essay by Su Tung-p'o, where it is said: " I compare them (i. e. antique scrolls) with clouds that pass before my eyes... " (煙 雲 過 眼; cf. below, page 508). The Imperial Catalogue (chapter 123) is indignant that this title reads *yün-yen*, inversing the order of the words as found in Su Tung-p'o's essay, viz. *yen-yün*; this, however, is a pusilanimous remark, as an author when using a quo-

tation is at liberty to modify the text of the original, provided it can still be recognized.

The *Yün-yen-kuo-yen-lu*, although mainly describing paintings and autographs, also treats various kinds of other antiques; it should be read together with the *Tung-t'ien-ch'ing-lu-chi* (cf. Appendix I, no. 27), as these two books supplement each other.

2) The text reads *ch'iu-shou-tung-ts'ang* 秋 收 冬 藏, which is a phrase from the *Ch'ien-tzŭ-wên* 千 字 文. The characters of this book are often used instead of ordinal numbers; the four characters quoted are nos. 21-24. The *Ssŭ-ling-shu-hua-chi* states that the scrolls in the Imperial collection were numbered with the characters of the *Ch'ien-tzŭ-wên*; see below, page 211.

that bore superscriptions by the Imperial brush were mounted with figured gold brocade, while each scroll showed both on front side and reverse the seal of the Imperial Secretariat. Although this collection was strictly guarded, gradually a number of genuine specimens had been replaced by fakes, so that it was impossible to tell them apart. Of those scrolls that were good I mention the following. *Picture of Yü-ch'iu-tzû*, by Tung Yüan,[1] and a T'ang copy of the *Picture of explaining the scriptures* by Ku K'ai-chih;[2] both these paintings are of superior quality and antique elegance. Further the *Chung-man-han-liu-t'u* by Li Ch'êng,[3] the *Image of Fu-shêng* by Chan Tzû-Ch'ien,[4] and *Three Fairies* by an anonymous artist;[5] also these paintings have the wonderful qualities of the art of the ancients. Then an *Image of Chih-kung*, by Sun Chih-wei,[6] and a very fine small hand scroll with a landscape by Yen Wên-kuei,[7] painted on paper. Further a small landscape by Chao Shih-lei,[8] a landscape by Fu Tao-yin,[9] a horse by Hu Huai,[10] a landscape by Kuan T'ung,[11] an old tree with rocks and bamboo by Wên T'ung,[12] and a cedar painted by Ch'ên Yang.[13] The rest were all ordinary specimens, and moreover among them there were several that were obvious fakes. Looking over more than one hundred and sixty scrolls, I found barely ten that were really of superior quality ".[14]

This passage is instructive for several reasons. It tells how the scrolls of the Palace Collection were stored away, and gives some general information on the way they were

1) Tung Yüan (董源; the text gives *yüan* 元), style Shu-ta 叔達, was a famous Sung painter. The picture mentioned probably is the *K'ung-tzû-chien-yü-ch'iu-tzû-t'u* 孔子見虞丘子圖 " Confucius seeing Yü-ch'iu-tzû "; Yü-ch'iu-tzû was a high official in the state of Ch'u. This picture is listed in the *Hsüan-ho-hua-pu*, ch. 11, s. v. Tung Yüan.

2) *Shuo-ching-t'u* " Picture of explaining the Scriptures " (?).

3) Li Ch'êng was a famous Sung painter. I assume that the title of the picture should read *Chung-lien-ch'un-hsiao-t'u* 重槤春曉圖; this picture is listed in the *Hsüan-ho-hua-pu*, chapter 11.

4) Chan Tzû-ch'ien was a painter of the Liang period (502-557). Fu Shêng 伏生 was the Ch'in scholar, famous for having in 213 B.C., when the Ch'in Emperor ordered the " Burning of the books ", concealed a copy of the *Shu-ching*, the " Book of History ", in the wall of his house.

5) The text reads *san-yao-nü*, doubtless a mistake for *san-t'ien-nü* 三天女; cf. *P'ei-wen-chai-hua-pu*, s. v. Ku K'ai-chih.

6) Sun Chih-wei 孫知微, style T'ai-ku 太古, was a great Sung painter, especially known for his pictures of Buddhist and Taoist figures. Chih-kung is the famous Liang monk Pao-chih 寶誌.

7) Yen Wên-kuei 燕文貴, sometimes also referred to as Yen Kuei, was a Sung painter famous for his landscapes and human figures.

8) Chao Shih-lei, style Kung-chên 公震, member of the Sung Imperial family, known for his paintings of landscapes, birds and flowers.

9) Fu Tao-yin 符道隱 (the text reads Fu-tao-shih Yin " Fu Yin, the Taoist ") during the Sung period founded a school of landscape painting.

10) Hu Huai was a Kitan painter of the 10th century especially famous for his pictures of horses.

11) Kuan T'ung was a famous artist of the Later Liang period (907-923).

12) Wên T'ung 文同, style Yü-k'o 與可, 1019-1079, great scholar-artist of the Sung period, noted for his paintings of bamboo.

13) The text has Ch'ên Hui 陳晦, doubtless a mistake for Ch'ên Yang 陳暘. Ch'ên Yang was a Sung painter, especially famous for his pictures of trees.

14) 後步玉渠登秘閣閣內旁別書畫者尚眞
皆藏先匣會要藏今御書法內題有易虞丘畫廋太
列漆巨日五及御古藏內有兩卷
朱也是綾僅收古偽畫書水竹
書鸞鵲花象飾皆書冬笑小山
以以金防綾表裏有此山木謬者
加印關其往往有以展木謬滿
省可閱顧佳董說元妙枯十
不唐模成愷經寒圖水甚
圖古李人之溜女圖隱不
高無名燕蠻亦紙古可
生公像雷天書符山有
誌趙士全貴道文士品
精馬關餘景亦水可
環晝柏六水常絕
陳一百餘餘卷
晦閱十
通
焉。

202

mounted. Further it is interesting to note that Chou Mi did not have a very high opinion on the quality of most of the scrolls. It is true that he saw only part of them, and that, as he says, the collection had been ransacked by thieves. Yet if among over 160 scrolls examined there were only ten that were really superior, it must be feared that also in Kao-tsung's time the Palace Collection counted not a few fakes and inferior specimens. [1]

Finally this passage obtains a special interest if read in connection with the *Szû-ling-shu-hua-chi*; for it would seem that Chou Mi obtained the text of this document on the occasion of his visit to the collection described here. The style of the *Szû-ling-shu-hua-chi* closely resembles that of placards, stuck up in government offices and public buildings, and containing instructions addressed to the people working there. I mention especially the sections C and E, which consist of a number of short sentences of similar construction, each beginning with the character *ying* 應 " ought to ", " must ". I assume, therefore, that the *Szû-ling-shu-hua-chi* represents the text of one or more of such placards, suspended in the Imperial Archives for the guidance of the officials and the mounters who worked in that department. And that it was there that Chou Mi copied out these placards, as he realized that their contents constituted valuable historical material. [2]

The *Szû-ling-shu-hua-chi* opens with a prefatory note by Chou Mi, in which he sums up its contents, adding some critical remarks. He praises the zeal of the Emperor, who gave himself great trouble in order to recover scrolls of the Northern Sung Palace collection, but he questions the judgment of the scholars employed for appraising and sifting the scrolls entered into the collection. Each of these scholars is mentioned by name, but unfortunately about those who seem to have taken the greatest part in this work, like for instance Wei Mao-shih, little is known. Those whose biographies are on record were not especially known as connoisseurs. One need not wonder, therefore, that they arbitrarily cut off old colophons and labels; as was pointed out on page 154 above, some officials connected with the Palace Collection during the T'ang dynasty were guilty of similar irresponsible acts.

Contents of the Szû-ling-shu-hua-chi.

1) For authenticity problems in general, see below, page 396 sq.

2) The modern Chinese art-historian Yü Shao-sung in his *Shu-hua-shu-lu-chieh-t'i* (cf. Appendix I, no. 23), chapter 7, page 7, proposes another theory regarding the *Szû-ling-shu-hua-chi*. He points out that its contents do not correspond to what one would expect after reading Chou Mi's prefatory note, while they neither answer to the term *shu-hua-chi* in the title. He further relevates that the oldest text of this document is found in the *Shuo-fu* 說郛 (a huge collection of minor writings, assembled during the end of the Yüan period; for further details cf. the note by P. PELLIOT in *T'oung Pao*, vol. XXIII, p. 613 sq.), and stresses the fact that this *ts'ung-shu* often only reprinted fragments of larger works, without specifically saying so, and retaining the original title. On these grounds Yü Shao-sung is inclined to assume that the document in its present form is but a small part of a much more extensive work compiled by Chou Mi, being a full description of all the scrolls in Kao-tsung's collection; in this work the passages relating to the mountings of the scrolls occupied but a subordinate place. As long as no further evidence is forthcoming, however, I prefer to keep to my theory, namely that the text as it is now preserved is complete in itself (except for a few mutilated passages), and represents the contents of a number of placards, stuck up in the Imperial Archives. This is the only logical explanation of the peculiar style in which this document is written. As to Chou Mi's preface, we know from his other works that he was greatly interested in the question of the preservation of antique scrolls, so that he may well have thought this text, brief though it is, worthy of a longer preface. Finally the word *shu* in Chou Mi's phrase " I happened to obtain ... etc. " 余偶得其書 does not necessarily mean " book ", but may as well refer to any kind of document.

After Chou Mi's preface follows the text itself. For the reader's convenience it has been divided into five parts: A, B, C, D and E.

A bears no special title. It is a detailed description of the mountings of various scrolls, divided over seventeen groups. In the translation these groups are marked with Roman numerals.

B is entitled "Fixed models and measurements for the mounting of all paintings". Here eight types of mounting hanging scrolls are described, showing how the measurements vary according to the size of the original.

C, without title, contains a number of general rules for the mounting and remounting of the scrolls in the collection; special attention is given to the title labels.

D, entitled "Fixed models for rubbings and hand scrolls", gives detailed measurements of six calligraphic specimens.

E, again without title, in style and contents is a sequel to C.

<span style="font-size:small">Technical terms used in this text.</span>

In describing the scrolls this document uses some technical terms; these deserve a closer examination.

With regard to both hand scrolls and hanging scrolls, the text employs the terms *piao* 標 and *li* 裏. In the case of hand scrolls, *piao* refers to the "protecting flap" on the outside of the scroll (see Plate **31**, no. 7 *b*); in later times this flap usually measures but one or two decimeter, but during the Sung period it often was longer, covering a considerable part of the reverse of the scroll. *Li* refers to the inside of the protecting flap (Plate **31**, no. 7 *a*), and probably at the same time is taken to include the upper and lower border of the scroll; for some hand scrolls that once formed part of Kao-tsung's collection, and now still preserved in the Old Palace collection, show along upper and lower border narrow strips of the material mentioned in the *Szŭ-ling-shu-hua-chi* as used for the *li* of a hand scroll.

When used with regard to hanging scrolls, *piao* refers to the front side mounting, and *li* to the reverse. The broad strip at the top of the front mounting, later designated as *t'ien* 天 (Plate **30** A, no. 1), in this document is called *shang-piao* 上 標 "upper front mounting", while *ti* 地 (ibid., no. 2) is called *hsia-piao* 下 標 "lower front mounting". Further the document mentions the *yin-shou* 引 首 of hanging scrolls. These *yin-shou* were strips of mounting directly above and below the picture, running over the entire breadth of the mounted scroll; in other words, they were horizontal replica of the vertical *yin-shou* of a hand scroll.

While describing hand scrolls, the text employs the term *yin-shou* to indicate the space intervening between the inside of the protecting flap, and the painting itself. As was explained on page 68 above, this space was used later for writing the superscription of a scroll. The equivocal term *tan* 賻 (see above page 69–70) in this text denotes the vertical strips dividing the various sections of a hand scroll.

The two bands attached to the upper stave of a hanging scroll are called *ching-tai* 經 帶, and the upper stave itself *ta-ya-chu* 打 壓 竹.

204

(Chou Mi's preface)

" The late Emperor Kao–tsung had a wonderful understanding for the art of the brush, and was ever observant of antique elegance.    In a time when war was raging, he sought for model writings and famous paintings, grudging no effort.    In his moments of refined leisure he never tired of gazing at scrolls and making copies of them.    In his august zeal, he shunned neither labour nor expense; therefore there was not a single day that people from everywhere did not try to outdo one the other in offering scrolls to him.    Later he moreover bought in the official marts [2] items left over from the Imperial collection of the Northern Sung dynasty.    Thus the Palace Collection formed during the Shao–hsing period (1142-1153), did not yield in extensiveness to that of the Hsüan–ho (1119-1125) period.

" It is to be regretted, however, that the men employed for judging and sifting this collection, people like Ts'ao Hsün, [3] Sung K'uang, [4] Lung Ta–yüan, [5] Chang Chien, [6] Chêng Tsao, [7] P'ing Hsieh [8] Liu Yen, [9] Huang Mien, [10] Wei Mao–shih, [11] Jên Yüan [12] and others, did not rank very high as connoisseurs, they did not have the discerning eye.    They discarded all the appreciative remarks added to the items of the collection by former people, so that now in the Imperial Collection there are many items without any inscribed label at all; thus the history of each item, and the date on which it was entered into the collection, can never more be ascertained.    This is a great pity indeed.

" These scrolls were all mounted according to a fixed measure, and the seals, critical remarks and labels added to them all followed a fixed model.    Now I happened to obtain a document listing these rules.    Having added a few corrections, I reproduce this document here below, being happy to share it with all other lovers of art, in the hope that it may give them an idea of the splendour of works of art during a period of peace ".

思陵妙悟八法。留神古雅搨摹不少怠。蓋當干戈俶擾之際。訪求法書名畫不遺餘
力。清閒之燕。展玩復又於榷場購北方遺失之物。故紹興內府所藏。不減宣政。實
上無虛日。鑒定諸人品不高。如曹勛宋䏓龍大淵張儉鄭藻平協劉琰黃冕魏茂實所
惜乎任源等。人多無題識。其源委授受歲月。凡經品題者。盡皆折去。故今御府藏
藏各有尺度。印識標題。具有儀式。余偶得其書。稍加考正。其裝標裁制。嘉與
好事者共之。庶亦可想像承平文物之盛焉。

---

1) Most editions print several passages in the form of interlinear notes, in two columns of smaller characters. Here these passages are placed between ordinary brackets; in the translation they are marked by square ones.

2) chüeh–ch'ang 榷場; cf. JOHN C. FERGUSON, Ta–kuan–t'ieh, in T'ien Hsia Monthly, vol. X, no. 5 (1940).    On page 433 it is said: " ...trading posts established by the Chin dynasty on the Southern borders of their territory for the sale of objects which they had looted from Pien–liang (K'ai–feng) and other wealthy cities.    There were several of these marts, but the best known was that of Hsü–i, a small city on the Southern shore of the Hung–tse lake at the mouth of the Huai river of Northern Anhui Province. In addition to these marts which were under military control there was a steady trade across the boundary ".

3) Ts'ao Hsün 曹勛, style Kung–hsien 公顯, died 1174, a loyal Sung scholar.

4) Sung K'uang 宋䏓, unidentified.

5) Lung Ta–yüan 龍大淵, high official under Hsiao–tsung (1163-1189).

6) Chang Chien 張儉, unidentified.

7) Chêng Tsao 鄭藻, id.

8) P'ing Hsieh 平協, id.

9) Liu Yen 劉琰, id.

10) Huang Mien 黃冕, id.

11) Wei Mao–shih 魏茂實, id.

12) Jen Yüan 任源, style Tao–yüan 道源, painter who round 1120 worked at K'ai–fêng; he was especially known for his pictures of old trees and strangely shaped rocks.

(Text)

A

" I. Superior autographs and model writings, ink remains dating from the former and later Han periods (B. C. 206 – A. D. 220), the San-kuo period (220–264); specimens written by the " two Wang ", [1] and by rulers and statesmen of the Six Kingdoms (220–589), Sui (590–618) and T'ang (618–907) periods. [All bearing title slips where the Emperor with his own hand had added the remark " wonderful "].

" *Piao* of *k'o-szŭ* [2] showing a pattern of pagodas and towers, *li* of greenish brocade showing a " basket pattern ", [3] *yin-shou* of fine white silk with a pattern [4] of clouds and phoenix birds. *Tan* of Korean paper. [5] Those of the best quality have added to their rollers small protruding knobs, [6] made of white jade, carved with the figures of dragons [or also other designs]. The rollers themselves are made of fragrant sandal wood, and the scrolls are kept in boxes decorated with metal work.

" II. Autographs from the T'ang period, according to their quality divided into three classes [for all those belonging to the first and second class Mi Yu-jên [7] on Imperial Command wrote colophons].

" *Piao* of purple brocade with a pattern of clouds and phoenix birds, *li* of fine green silk with a design of phoenix birds, *yin-shou* of fine white silk of the same pattern. *Tan* of Korean paper. Knobs of white jade. [The first class has small protruding knobs, the others flat ones] Rollers of fragrant sandal wood.

" III. Autographs of the Chin (265–420) and T'ang periods of lesser quality [including famous rubbings after incised autographs of the same two periods].

A

I. 上等眞蹟法書兩漢三國二王六朝隋唐君臣墨蹟(並係御題簽各書妙字)用克絲作樓臺錦褾。青綠簟文錦裏。大姜牙雲鸞白綾引首。高麗紙贉。上等白玉碾龍簪頂軸(或碾花)檀香木桿。鈿匣盛。

II. 上中下等唐眞蹟(內上中等並降付米友仁跋)用紅霞雲鸞錦褾。碧鸞綾裏白鸞綾引首。高麗紙贉。白玉軸(上等用簪頂。餘用平頂)檀香木桿。

III. 次等晉唐眞蹟(並石刻晉唐名帖)用紫鸞雀錦褾。碧鸞綾裏。白鸞

1) Êrh-wang 二 王, i. e. the famous calligrapher Wang Hsi-chih and his son Wang Hsien-chih; see page 142.

2) *k'o-szŭ* 克 絲; *k'o* is also written 刻, 剋 or 緙 all of which mean " to cut "; yet this term might also be the transcription of a foreign word. *K'o-szŭ* is a kind of brocade, made by weaving silk into a gauze ground, so that it appears as if the pattern were cut out one layer deep in the brocade (see the sample on Plate **79**). For a full account of this and other kinds of silk and brocade of the Sung period, cf. the *Szŭ-hsiu-pi-chi* (Appendix I, no. 61), page 30 and 31, and also the Ming source *Tsun-shêng-pa-chien* (Appendix I, no. 28), chapter 15, page 13. *K'o-ssŭ* with a pagoda pattern, *lou-t'ai* 樓 臺, in the *Cho-kêng-lu* (Appendix I, no. 24) called *lou-ko* 樓 閣, was a famous product of the Sung period.

3) *tien-wên-chin* 簟 文 錦; the *Cho-kêng-lu* mentions a five-coloured variety, vulgarly called *shan-ho-shang* 山 和 尙 " mountain priest ", and a green-blue variety called *an-p'o* (闇 婆; other editions read *ko-p'o* 闍 婆.

Of foreign origin ?) or *shê-p'i* 蛇 皮 " serpent hide ". One would conclude that a scaled pattern is meant, which tallies with *tien-wên*, lit. " patterns resembling a reed basket ".

4) *ta-chiang-ya* 大 姜 牙 " Queen's ivory "? See *P'ei-wên-yün-fu* 佩 文 韻 府 sub voce *ta-chiang*. An ivory-coloured variety ?

5) *kao-li-chih* 高 麗 紙; cf. note 21, on page 296,

6) *tsan-ting* 簪 頂, lit. " hair-pin caps ". As sub II these knobs are contrasted with *p'ing-ting* 平 頂 " flat caps ", I take it that *tsan-ting* refers to small, round protruding knobs, resembling the ends of hairpins in a lady's coiffure. The *Tung-t'ien-ch'ing-lu-chi* (cf. Appendix I, no. 27) says: " Antique paintings often have *tsan-ting* knobs, which are small but heavy " 古 畫 軸 多 作 簪 頂 軸 小 而 重.

7) Mi Yu-jên 米 友 仁, son of Mi Fu, 1086–1165; often referred to as Hsiao-mi 小 米 " Little Mi ". Just like his father, he was famous both as an artist and as a connoisseur. For a colophon written by him see Plate **80**.

" *Piao* of purple brocade, showing a pattern of phoenix birds and sparrows, *li* and *yin-shou* as II. *Tan* of purely white paper, [1] knobs of white jade of lesser quality. On the *tan* to the left of the *yin-shou*, and on the seams there is impressed the seal reading *Yü-fu-t'u-shu*, [2] and over the upper and lower seam of the *yin-shou* the seal reading *Shao-hsing*. [3]

" IV. Traced copies of autographs dating from the period of the Six Kingdoms (220–589) [al provided with colophons by Mi Yu-jên].

" *Piao* of blue-green brocade with a pattern of pagodas and towers, *li, yin-shou* and *tan* as II. Knobs of white jade.

" V. Model writings dating from the period of the Six Kingdoms, from the hand of the " two Wang ", and of people of the T'ang period, together with various poems, poetical essays etc., all copied out by the Emperor [The long hand scrolls are mounted without borders, while those on thick paper are not remounted, [4] and left with their original backing].

" *Piao* of *chan-lu* brocade, [5] reddish brown brocade showing a tortoise shell pattern, purple brocade with designs of flowers and dragons, or fine black silk with phoenix birds. *Li* and *yin-shou* as II. Knobs of jade or amber, depending upon the quality of the scroll. For those traced by Chao Shih-yüan [6] there may be used also *piao* of patched brocade, [7] *tan* of purely white paper, and knobs of amber. On Imperial command Chuang Tsung-ku [8] and Chêng Tzû [9] remounted these scrolls on paper of the same colour as the original, also adding the same seals, imitating exactly the original scroll (that served the Emperor as model). Having cut off the old superscriptions and colophons, these scrolls were offered to the Emperor.

" VI. Autographs copied by statesmen of the Five Dynasties (907–960), and of the Sung dynasty.

" *Piao* of fine black silk with phoenix birds, *li* and *yin-shou* as II. *Tan* of purely white laid paper, knobs of jade or amber.

綾裏。白鸞綾引首。�ズ紙贉。次等白玉軸。引首後贉卷縫。用御府圖書印。引首上下縫用紹興印。

IV. 鈎摹六朝眞蹟(並係米友仁跋)用靑樓臺錦褾。碧鸞綾裏。白鸞綾引首。高麗紙贉。白玉軸。

V. 御書臨六朝羲獻唐人法帖。幷雜詩賦等(內長篇不用邊道。依古厚紙不揭不背)用氈路錦衲錦柹紅龜背錦紫百花龍錦皁鸞綾褾。碧鸞綾裏。白鸞綾引首。玉軸或瑪瑙軸。臨時取旨。內趙世元鈎摹者。亦用衲錦褾。䇑紙贉。瑪瑙軸。並降付莊宗古鄭滋。令依眞本紙色及印記對樣裝造。將元本拆下舊題跋。進呈揀用。

VI. 五代本朝臣下臨帖眞跡。用皁鸞綾褾。碧鸞綾裏。白鸞綾引首。夾背䇑紙贉。玉軸或瑪瑙軸。

---

1) *chüan-chih* 䇑紙, a thick white paper produced at Wên-chou 溫州, heavily glazed and showing curved mould marks; popular during the T'ang period.

2) 御府圖書 " Seal of the Palace ".

3) 紹興, seal of the Hsiao-hsing period; cf. Plate **48** A, no. 7.

4) Cf. the remarks below, sub E, first paragraph.

5) *chan-lu* 氈路, unidentified. The *Cho-kêng-lu* writes *ch'iu-lu* 毬路. Perhaps a transcription of a foreign word.

6) 趙世元, unidentified.

7) *na-chin* 衲錦; apparently various pieces of brocade sewn together, like the *chia-sha* 袈裟 of Buddhist monks.

8) Chuang Tsung-ku 莊宗古, unidentified.

9) Chêng Tzû 鄭滋, id.

" VII.   Various writings of the Chin and T'ang periods, copied out by Mi Fu.

" The best have *piao* of purple brocade with phoenix birds and magpies, *li* of purple sarcenet, [1] *tan* of glazed paper. [2]   Those of secondary quality have small round knobs of jade.   To the left and right of the *yin-shou* the seals *Nei-fu-t'u-shu* [3] and *Nei-tien-shu-chi*, [4] or superscriptions and colophons.   Over the seams the seal *Yü-fu-t'u-chi*, and at the very end the seal reading *Shao-hsing*.   After the last *tan* (i. e. on the extreme left) of all these scrolls, Mi Yu-jên on Imperial command added critical remarks in his own hand.

" VIII.   Autograph letters, various poems and poetical essays in original written by Su Tung-p'o, Huang T'ing-chien, [5] Mi Fu, Hsieh Shao-p'êng, [6] Ts'ai Hsiang [7] and others.

" *Piao* of fine black silk with phoenix birds, *li*, *yin-shou* and *tan* as VI.   Knobs of ivory.   Seals: *Jui-ssû-tung-ko* [8] and *Nei-fu-t'u-chi*.

" IX.   Various documents and letters written by Mi Fu.

" *Piao*, *li* and *yin-shou* as VI.   *Tan* of purely white paper.   Knobs of ivory.   Seals: *Nei-fu-t'u-chi* and *Shao-hsing*.   On Imperial command Mi Yu-jên judged the authenticity of these scrolls, and then together with Ts'ao Yen-ming [9] classified them according to their quality.   Ten of these calligraphic specimens were mounted side by side, so as to form one long hand scroll.   Miscellaneous writings were mounted in album form.

" X.   Various model writings of secondary quality, traced by Chao Shih-yüan.

" *Piao* of black-wood brocade, [10] knobs of amber or ivory.   On the *yin-shou* at the beginning the seal *Chi-hsia-ch'ing-shang*, [11] over the seams the seal *Nei-fu-shu-chi*, at the end the seal *Shao-hsing*.   Also of these scrolls the old superscriptions and colophons were cut off before they were entered in the collection.

VII. 米芾臨晉唐雜書。上等用紫鸞鵲錦褾。紫施尼裏。揩光紙膘。次等簪頂玉軸。引首前後用內府圖書。內殿書記印。或有題跋。於縫上用御府圖籍印。最後用紹興印。並降付米友仁親書審定。題於膘卷後。

VIII. 蘇黃米芾薛紹彭蔡襄等雜詩賦書簡眞蹟。用皂鸞綾褾。碧鸞綾裏。白鸞綾引首。夾背䴙紙膘。象牙軸。用睿思東閣印。內府圖記。

IX. 米芾書雜文簡牘。用皂鸞綾褾。碧鸞綾裏。白鸞綾引首。䴙紙膘。象牙軸。用內府書印。紹興印。並降付米友仁驗定。令曹彥明共同編類等第。每十帖作一卷。內雜帖作冊子。

X. 趙世元鉤摹下等諸雜法帖。用皂木錦褾。瑪瑙軸。或象牙軸。前引首用機暇清賞印。縫用內府書記印。後用紹興印。仍將元本拆下題跋揀用。

1) *shih-ni* 絁尼.   *Shih* by itself means sarcenet.   Is *shih-ni* the transcription of a foreign word?

2) *ch'ieh-kuang-chih* 揩光紙.

3) 內府圖書 " Seal of the Imperial Palace ".

4) 內殿書記; cf. preceding note.

5) Huang T'ing-chien (黃庭堅, 1045-1105), famous scholar and calligrapher.

6) Hsieh Shao-p'êng 薛紹彭, friend of Mi Fu, and often mentioned by Mi Fu in his writings.

7) Ts'ai Hsiang (蔡襄, style Chün-mo 君謨, 1012-1067), great scholar and poet of the Sung period.

8) 睿思東閣 " Eastern Pavilion of perspicacious thought ".

9) Ts'ao Yen-ming 曹彥明, unidentified.

10) *tsao-mu-chin* 皂木錦, unidentified.

11) 機暇清賞 " Serenely enjoyed during hours of opportune leisure ".

" XI.   Famous paintings of the Six Kingdoms, mounted as hand scrolls.

" *Piao* and *li* as I.   Those of secondary quality, however, have *li* as II.   *Yin–shou* of fine white silk with a large pattern of phoenix birds, *tan* of Korean paper.   Those of superior quality have knobs of carved white jade.

" XII.   Famous paintings of the Six Kingdoms, mounted as hanging scrolls. [1]

" *Shang–piao* and *hsia–piao* of fine black silk with phoenix birds, *yin–shou* of fine green silk with a design of phoenix birds, and the entire scroll backed with the same material.   Rollers of fragrant sandal wood.   The scrolls of superior quality have knobs of jade.

" XIII.   Paintings of the T'ang period and the Five Dynasties, mounted as hand scrolls.   [The same applies to Sung paintings].

" *Piao* of purple brocade with a " water course motif ", [2] *li* and *yin–shou* as II.   Knobs of jade or amber.   [Those of secondary quality and traced copies have *piao* of black silk, and knobs of various colours].   *Tan* of purely white paper.

" XIV.   Famous paintings of the T'ang, Five Dynasties and Sung periods, mounted as hanging scrolls.
" All mounted as XII, but with varying knobs.

" XV.   Various paintings by Su Tung–p'o and Wên T'ung [3] [mounted by Yao Ming [4]].
" *Piao, li* and *yin–shou* same as VI, knobs of old jade or amber.

" XVI.   Various paintings by Mi Fu, mounted as hand scrolls.
" Same as XV.

" XVII.   Various paintings by the monk Fan–lung, [5] mounted as hand scrolls [Ch'ên Tzû–ch'ang [6] was charged with mounting these].

XI. 六 朝 名 畫 橫 卷。用 克 絲 作 樓 臺 錦 褾。靑 綠 簥 文 錦 裏。次 等 用 碧 鸞
綾 裏。大 白 鸞 綾 引 首。高 麗 紙 膘。上 等 白 玉 碾 花 軸。

XII. 六 朝 名 畫 掛 軸。用 皂 鸞 綾 上 下 褾 碧 鸞 綾 引 首。碧 鸞 綾 託 褾 全
軸。檀 香 軸 桿。上 等 玉 軸。

XIII. 唐 五 代 畫 橫 卷 (皇 朝 名 畫 同) 用 曲 水 紫 錦 褾。碧 鸞 綾 裏。白 鸞 綾
引 首。玉 軸 或 瑪 瑙 軸 (內 下 等 幷 膽 本。用 皂 褾。雜 色 軸) 閷 紙 膘。

XIV. 唐 五 代 皇 朝 等 名 畫 掛 軸。並 同 六 朝 裝 襯。軸 頭 旋 取 旨。

XV. 蘇 軾 文 與 可 雜 畫 (姚 明 裝 造) 用 皂 鸞 綾 褾。碧 鸞 綾 裏。白 鸞 綾 引
首。古 玉 或 瑪 瑙 軸。

XVI. 米 芾 雜 畫 橫 軸。用 皂 鸞 綾 褾。碧 鸞 綾 裏。白 鸞 綾 引 首。古 玉 或 瑪
瑙 軸。

XVII. 僧 梵 隆 雜 畫 橫 軸。(陳 子 常 承 受) 擡 蒲 錦 褾。碧 鸞 綾 裏。白 鸞 綾 引
首。瑪 瑙 軸。

1) This does not imply that these pictures were painted to be mounted as hanging scrolls.   As was remarked on page 196, horizontal scrolls were often remounted as hanging scrolls.

2) *ch'ü–shui–tzû–chin* 曲 水 紫 錦; according to the *Cho–kêng–lu* vulgarly called *lo–hua–liu–shui* 落 花 流 水 " fallen flowers drifting on the stream ".

3) Wên T'ung, cf. p. 202 footnote 12 above.

4) Yao Ming 姚 明, unidentified.

5) Fan–lung 梵 隆, style Mao–tsung 茂 宗, a Buddhist monk famous for his paintings of landscapes and human figures; favourite of Kao–tsung.

6) Ch'ên Tzû–ch'ang 陳 子 常, unidentified.

" *Piao* of brocade with a " dice pattern ", [1] *li* and *yin–shou* as II, knobs of amber.

" All paintings have on top the *ch'ien–kua* seal, [2] below the seal *shih*, [3] and at the end of the scroll the seal Shao–hsing.

B. Fixed models and measurements for the mounting of all paintings.

" Scrolls consisting of one large uncut sheet are mounted with an upper *yin–shou* of 3 *ts'un* broad, and a lower *yin–shou* of 2 *ts'un*.

" Smaller scrolls consisting of one uncut sheet: upper *yin–shou* 2 *ts'un* 7 *fên*, lower *yin–shou* 1 *ts'un* 9 *fên*. *Ching–tai* of 4 *fên* broad. *Shang–piao* except for the part rolled round the upper stave, 1 *ch'ih* 6 *ts'un* 5 *fên*, *hsia–piao* except for the part pasted round the roller, 7 *ts'un*.

" Scrolls consisting of one and a half sheet: upper *yin–shou* 3 *ts'un* 6 *fên*, lower *yin–shou* 2 *ts'un* 6 *fên*, *ching–tai* 8 *fên*.

" Scrolls consisting of two uncut sheets: upper *yin–shou* 4 *ts'un*, lower *yin–shou* 2 *ts'un* 7 *fên*, *shang–piao* except for the part rolled round the upper stave, 1 *ch'ih* 6 *ts'un* 8 *fên*, *hsia–piao* except for the part round the roller 7 *ts'un* 3 *fên*.

" Scrolls consisting of two uncut sheets and a half: upper *yin–shou* 4 *ts'un* 2 *fên*, lower *yin–shou* 2 *ts'un* 9 *fên*, *ching–tai* 1 *ts'un* 2 *fên*.

" Scrolls consisting of three uncut sheets: upper *yin–shou* 4 *ts'un* 4 *fên*, lower *yin–shou* 3 *ts'un* 1 *fên*, *ching–tai* 1 *ts'un* 3 *fên*.

" Scrolls consisting of four uncut sheets: upper *yin–shou* 4 *ts'un* 8 *fên*, lower *yin–shou* 3 *ts'un* 3 *fên*, *ching–tai* 1 *ts'un* 5 *fên*.

" Horizontal scrolls should have a *piao* of 1 *ch'ih* 3 *ts'un* [that of high ones should be made from one uncut sheet], while their *yin–shou* should measure 4 *ts'un* 5 *fên* [that of high ones should measure 5 *ts'un*].

C

" All calligraphic specimens and paintings must be mounted with title labels of genuine old sûtra paper, [4] its quality varying with that of the scroll.

諸 書 並 上 用 乾 卦 印。下 用 世 印。後 用 紹 興 印。

　　B　　諸 書 裝 褙 尺 寸 定 式

大 整 幅。上 引 首 三 寸。下 引 首 二 寸。

小 全 幅。上 引 首 二 寸 七 分。下 引 首 一 寸 九 分。經 帶 四 分。上 褾 除 打 壓竹 外。淨 一 尺 六 寸 五 分。下 褾 除 上 軸 外。淨 七 寸。

一 幅 半。上 引 首 三 寸 六 分。下 引 首 二 寸 六 分。經 帶 八 分。

雙 幅。上 引 首 四 寸。下 引 首 二 寸 七 分。上 褾 除 打 壓 竹 外。淨 一 尺 六 寸八 分。下 褾 除 上 軸 桿 外。淨 七 寸 三 分。

两 幅 半。上 引 首 四 寸 二 分。下 引 首 二 寸 九 分。經 帶 一 寸 二 分。

三 幅。上 引 首 四 寸 四 分。下 引 首 三 寸 一 分。經 帶 一 寸 三 分。

四 幅。上 引 首 四 寸 八 分。下 引 首 三 寸 三 分。經 帶 一 寸 五 分。

横 卷 褾 合 長 一 尺 三 寸 (高 者 用 全 幅) 引 首 闊 四 寸 五 分 高 者 五 寸。

　　C

應 書 畫 面 簽。並 用 眞 古 經 紙。隨 書 畫 等 第 取 旨。

1) *shu-p'u-chin* 摴 蒲 錦.

2) A seal showing the first of the *pa-kua* 八 卦 or Eight Triagrams, namely three horizontal unbroken lines, *ch'ien* 乾. Not to be confused with a similar seal, impressed on scrolls in the Palace Collection by the Emperor Ch'ien-lung (乾 隆, 1711-1799); there the triagram is flanked by two rampant dragons.

3) *shih-yin* 世 印, unidentified.

4) *ching-chih* 經 紙 " sûtra paper "; properly called *Chin-su-chih*, cf. the detailed footnote on this paper on p. 301 below.

" All superior model writings and famous paintings of the Six Kingdoms, Sui and T'ang periods, writings copied by the Imperial brush, and autographs by famous statesmen of the present (i. e. Sung) dynasty, must have title labels written by the Emperor. Those of second and third quality must be handed to the Secretariat, to be inscribed by P'ei Hsi. [1]

" All calligraphic specimens and paintings, irrespective of whether they are mounted as horizontal scrolls or as hanging scrolls, must be placed in covers of variegated brocade, fastened with double bands and provided with loose title labels of ivory.

" All model writings and ink remains acquired must first be handed to the Secretariat. Then Chao Shih–yüan must judge their authenticity, and classify them according to their quality. When they have been laid before the Emperor, Chuang Tsung–ku is to sort them out, and they are again judged by Ts'ao Hsün etc. (the same list of people as enumerated in Chou Mi's preface. Transl.). When this examination has been completed, the scrolls are mounted.

" All famous paintings acquired must first be judged by Wei Mao–shih. They are numbered with the characters of the *Ch'ien–tzŭ–wên* (see above, page 201), and after having been duly sealed they are laid before the Emperor. Then Chuang Tsung–ku is charged with remounting them.

" All old paintings acquired which are so badly damaged as precluding the possibility of their being repaired, must be traced and copied by the Secretariat. Having been laid before the Emperor, Chuang Tsung–ku is charged with mounting them, having given the silk or paper the same antique colour of the original, and sealing ... (text mutilated) ... Liu–niang–tzŭ and paintings copied by Ma Hsing–tsu [2] ... (text mutilated).

" All antique writings and paintings which bear superscriptions by the Emperor Hui–tsung during the Hsüan–ho period, must have these cut off. Ts'ao Hsün etc. must judge these scrolls, and having selected other suitable titles, enter these on a list, to be laid before the Emperor.

D. Fixed models for rubbings and hand scrolls.

" The *Ting–wu Lan–t'ing* text: [3] height of the text 7 *ts'un* 6 *fên*, width of each column 8 *fên*, 28 columns in all.

應 六 朝 隋 唐 上 等 法 書 名 畫。并 御 臨 名 帖 本 朝 名 臣 帖。並 御 書 面 簽。
內 中 下 品。並 降 付 書 房。令 裝 褙 書。
　應 書 畫 橫 卷 掛 軸。並 用 雜 色 錦 袋 複 帕。象 牙 牌 子。
　應 探 訪 到 法 書 墨 蹟。降 付 書 房。先 令 趙 世 元 定 驗 品 第。進 呈 訖。次 令
莊 宗 古 分 揀。付 曹 勛 云 云 覆 定 驗。訖 裝 褙。
　應 探 訪 到 名 畫。先 降 付 魏 茂 實 定 驗。打 千 文 字 號。及 定 驗 印 記。進 呈
訖。降 付 莊 宗 古 分 手 裝 褙。
　應 探 訪 到 古 畫。內 有 破 碎 不 堪 補 褙 者。令 書 房 依 原 樣 對 本 臨 摹。進
呈 訖。降 付 莊 宗 古 依 元 本 染 古 搥 破。用 印 裝 造 □ □ 劉 娘 子 位 並 馬 興
祖 膽 畫 □ □
　應 書 古 畫。如 有 宣 和 御 書 題 名。並 行 拆 下 不 用。別 令 曹 勛 等 定 驗 別
行 撰 名。作 畫 目 進 呈 取 旨。

　　D　碑 刻 橫 卷 定 式
　定 武 蘭 亭。闊 道 高 七 寸 六 分。每 行 闊 八 分。共 二 十 八 行。

1) P'ei Hsi 裴 禧, unidentified.
2) Ma Hsing–tsu 馬 興 祖 was a great Sung painter, a favourite of Kao–tsung, who often asked his advice about scrolls to be entered in the Palace collection.
3) The term *ting–wu* designates one of the many types of old rubbings based on various incised copies of Wang Hsi–chih's celebrated autograph of the *Lan–t'ing–hsü* (see page 138 above). The *Ch'ing–pi–ts'ang* (Appendix I, no. 31) lists not less than 117 different rubbings of this text that were circulating in the reign of the Sung Emperor Li–tsung (1225–1264). Among those there are seven grouped together as the " Ting–wu type ", because all seven are directly or indirectly derived from a stone tablet in Ting–chou 定 州, in the Sung Dynasty called Ting–wu–chün 定 武 軍.

"The *Yo–i–lun*: [1] height 7 *ts'un* 5 *fên*, width of each column 6 *fên*, 43 columns in all.

"The *Ch'ien–tzŭ–wên* in regular and running hand: [2] height 7 *ts'un* 2 *fên*, width of each column 8 *fên*, 200 columns in all.

"The *Kuei–t'ien–fu*, [3] written out by Chih–yung: [4] height 7 *ts'un* 2 ¹/₂ *fên*, width of each column 8 *fên*, 44 columns in all.

"The *Lo–shên–fu*, [5] written out by Wang Hsien–chih: height 8 *ts'un* 3 *fên*, width of each column 6 *fên*, 9 columns in all.

"The *Ku–mu–fu*: [6] height 9 *ts'un* 9 *fên*, width of each column 9 *fên*, 39 columns in all.

### E

"All scrolls done on thick old paper may not be made thinner by taking off layers from the reverse. For if thus half of the paper is discarded, the spirit of the calligraphy will vanish, and the scrolls will appear like traced copies. [7]

"All antique paintings when being remounted may not be excessively washed, lest the essential points of the human figures, and the rich elegance of plants and flowers should disappear. [8] Neither may they be cut down too much along the borders, for then the original charm will be harmed, while moreover it will be impossible later to remount the scroll again.

"Model writings acquired often show rulings in blue, and silk backings. Famous people of the T'ang period often wrote superscriptions and colophons to the right and left of the text. Of such Chuang Tsung–ku must select those of superior quality, and having cut off the upper and lower margin, offer them for the Imperial inspection together with other model writings; those selected are mounted according to the Shao–hsing model.

樂毅論。闌道高七寸半。每行闊六分。共四十三行。
眞草千文。闌道高七寸二分。每行闊八分。共二百行。
智永歸田賦。闌道高七寸二分半。每行闊八分。共四十四行。
獻之洛神賦。闌道高八寸三分。每行闊六分。共九行。
枯木賦。闌道高九寸九分。每行闊九分。共三十九行。

### E

應古書厚紙不許揭薄。若紙去其半。則損字精神。一如摹本矣。
應古畫裝裱不許重洗。恐失人物精神。花木濃艷。亦不許裁翦過多。既失古意。又恐將來不可再褙。
應探訪到法書。多係青闌道絹襯背。唐名士多於闌道前後題跋。令莊宗古裁去上下闌道。揀高格者隨法書進呈取旨。揀用依紹興格式裝裱。

1) The *Yo–i–lun* 樂毅論 was composed by the well known scholar Hsia–hou Hsüan (夏侯玄 209–254). It is chiefly famous because Wang Hsi–chih wrote out this essay in his celebrated chirography.

2) The *Ch'ien–tzŭ–wên* 千字文, the well-known "Thousand Character Book", was written out in regular and running hand by the great Sung calligrapher, the Ch'an monk Chih–yung 智永. It has been often incised in stone, and to-day still is a favourite model for students of calligraphy.

3) The *Kuei–t'ien–fu* 歸田賦 is a poetical essay written by the Han scholar Chang Hêng (張衡, 78–139).

4) See footnote 2.

5) The *Lo–shên–fu* 洛神賦 is a famous composition by the Wei scholar and poet Ts'ao Chih (曹植, 192–232); for Wang Hsien–chih, cf. above page 138.

6) Also called *Ku–shu–fu* 枯樹賦. This is a composition by the 6th century scholar Yü Hsin 庾信, which was written out by the well-known T'ang calligrapher Ch'u Sui–liang (see above, page 153, footnote 3).

7) Apparently inspired by Mi Fu's passage, quoted on page 189 above.

8) See the discussions on page 115 above.

79. – K'O–SZU OF THE SUNG PERIOD
(Municipal Museum, Mukden)
(slightly enlarged)

80. – SECTION OF A HAND SCROLL WITH COLOPHON BY MI YU-JÊN
(Old Palace Museum, Peking)

The contents of this document give valuable data on the art of mounting during the Southern Sung period.

It appears from section A that the scrolls in the Imperial collection were mounted most elaborately.   There have been preserved samples of the silk and brocade mentioned as the material for mounting both hand scrolls and hanging scrolls, which prove that these mountings must have looked magnificent.   Plate **79** reproduces a piece of k'o-szŭ of the Sung period, with a motif of birds and flowers.   One notices that, just as in pre-Sung times, the style of the mounting, and more especially the knobs of the roller, were chosen in accordance with the quality of the scroll (see above, p. 140).

The most important of the scrolls that once formed part of Kao-tsung's collection, and that are preserved now in the Old Palace Museum, in recent years have been published in photographic reproductions. [1)]   When one compares such reproductions with the descriptions given in the present document, it appears that although in the course of the centuries these scrolls were remounted several times, they have retained many original features.   The seals of the Sung period appearing on them tally exactly with those mentioned in the *Szŭ-ling-shu-hua-chi*, and some have Mi Yu-jên's colophons still attached to them.   Plate **80** reproduces a section near the end of a hand scroll in the Old Palace Collection which contains an autograph poem by Mi Fu.   Mi Yu-jên attests in the colophon that this is an authentic specimen of his father's handwriting.   Nearly all the seals visible belong to the Ming collector Hsiang Yüan-pien (see below, page 220).   Further some specimens still show narrow strips left over of the original sumptuous Sung brocade; although much faded, the pattern of phoenix birds, and some other patterns, are still discernible.   It is interesting to note how tenacious Chinese tradition is with regard to decorative motifs.   To-day Chinese mounters for the front mounting of hanging scrolls still prefer silk showing the same designs as nearly one thousand years ago were popular during the Sung period.

It is to be regretted that so little is known about the connoisseurs and mounters mentioned in this document.   Chao Shih-yüan would seem to have been a professional copyist, and Chuang Tsung-ku, Chêng Tzŭ, Yao Ming and Ch'ên Tzŭ-ch'ang specialists in mounting and remounting.   A Ming source states that the mounters working for the Palace collection used to mark their work by impressing a seal in black on the *yin-shou*, giving their " flourish signature " (*hua-ya*, see page 426 below). [2)]   As yet, however, I have been unable to locate such seals on those scrolls of the Old Palace Collection which I could examine; probably they were cut off when the scrolls were remounted.   Just like the names of the T'ang mounters mentioned in literature, also names like Yao Ming and

---

1) Several reproductions appeared in the Peking monthly *Ku-kung-shu-hua-chi* 故宮書畫集, published by the Old Palace Museum.   The *I-yüan-chên-shang-shê* 藝苑眞賞社 at Shanghai used to publish a number of these scrolls in excellent reproductions, done in collotype on a very superior Chinese white paper.

2) *Chang-wu-chih* (cf. Appendix I, no. 30), chapter 5, 8th paragraph: " On the *yin-shou*... there occur single lines printed in black with a wooden seal; all these give the ' flourish signature ' and name of the mounter " 於引首... 有木印黑字一行。俱裝池家花押名欵。

Ch'ên Tzû-ch'ang have become literary allusions used for indicating a highly skilled mounter.

It is worth noticing that of the seventeen categories enumerated in section A, only *two* refer to hanging scrolls (XII and XIV); the rest of the items were all mounted as horizontal hand scrolls. The significance of this fact has been pointed out already on page 162 above. Here it may be added that the fact that section B of the document is most explicit on the measurements of mounted hanging scrolls, might be taken as an indication that at that time hanging scroll mountings were still comparatively new, so that it was deemed necessary to record their measurements in detail, while those of hand scrolls, being fixed by a long tradition, were taken for granted.

The information given sub IX to the effect that some calligraphic specimens were mounted in album form is of great importance. It shows that this form of mounting pictorial scrolls was popular already during the Sung period.

As regards section B, it is unfortunate that its text is so caustic that some of the terms employed leave room for discussion; the translation of this section is given here with due reserve. The measurements of the various parts that compose the front mounting vary with the size of the original. The terms used for indicating this size, however, are rather ambiguous. Since my translation is based on the assumption that the breadth of *shang-piao*, *hsia-piao* and *yin-shou* increases in proportion to the size of the original, I took *shuang-fu* as referring to a scroll twice the size of an ordinary scroll, *szû-fu* as being four times the size of an ordinary scroll, and so on. It is quite possible that this assumption is wrong.

Be this as it may, the measurements of the two pairs of horizontal strips that compose the front mounting leave no doubt on one important point; they establish clearly that the upper strips were broader than the corresponding lower ones — a principle that has prevailed in both Chinese and Japanese hanging scroll mounting throughout the succeeding centuries.

Moreover, the figures given prove that in that time already the proportion of the upper and lower strips was adjusted according to esthetic considerations. While the *t'ien* is about two times as broad as the *ti*, the upper and lower *yin-shou* show a proportion of 3 : 2. We shall see on page 254 below that this principle was carried through consequently; in later, more elaborate hanging scroll mountings the difference in width of the strips above and below the picture decreases according to their proximity to the picture.

Section C gives an idea of the complicated procedure adopted for entering scrolls in the collection. Each item had to pass various instances before it was deemed worthy of this honour. The expression " scrolls acquired " (*t'an-fang* 探 訪, literally " obtained by searching ") evidently refers to those specimens that were recovered by Kao-tsung's emissaries in the official marts mentioned on page 205 above. Since these scrolls had been acquired by the Chin conquerors while looting various localities in N. China, it can be imagined that they were of mixed quality, so that it was imperative that each specimen was carefully examined.

214

Section D is of no special importance for our present subject. It proves, however, that already during this period the study of antique rubbings had advanced far. The information as to the exact measurements of some famous scrolls given here supplies precious material to students of old rubbings.

The last section of the document shows that although admittedly those in charge of the collection sometimes failed as connoisseurs, they were highly competent as regards the technical knowledge of the art of mounting. The principles enounced here, such as the inadvisability of discarding too many layers of thick paper scrolls, the dangers of excessive washing and cutting down borders, testify to their sound judgement in such matters. To-day these rules are still observed by all conscientious mounters.

Finally, some readers will be astonished by the fact that the document lists a considerable number of *copies*; no less than 6 of the 17 categories of section A refer to those. And the information that the mounters were instructed to make those copies resemble the originals as closely as possible, even " ageing " the paper, will alarm Western art historians. Yet this was a generally approved, old–established custom. The T'ang writer Chang Yen–yüan says:

" In the reign of the Empress Wu (684–704) (her favourite) Chang I–chih petitioned the Throne to summon all professional painters in the Empire, for restoring the pictures in the Imperial Collection. Then Chang employed those artisans, each according to his own special skill, letting them diligently copy the old scrolls. Those copies were mounted in the same manner as the originals, so that they looked exactly alike ". [1]

As a matter of fact, in China original and copy are not separated by as wide a gulf as with us in the West. As shall be discussed in greater detail in Chapter I of Part II of the present publication, a good contemporary copy of a painting or autograph is considered by Chinese connoisseurs as nearly as authentic as the original.

\* \* \*

The *Szŭ–ling–shu–hua–chi* mentions in section C covers for protecting the rolled up scroll, and pasted and loose title labels. During the subsequent centuries covers and labels of both pictorial rolls and book rolls went through an intricate process of development. As the history of these two accessories of the mounted scroll throws some interesting sidelights on the evolution of scroll mounting and book binding, a brief summary of this subject is here not out of place.

The history of scroll covers and title labels.

It seems that since early times books were protected by placing them in bags, or wrapping them up in a piece of cloth or other material. Such covers were in use already during the Han period, when books consisted either of a number of wooden or bamboo tablets strung together by leather straps, or strips of cloth or silk, loosely rolled up.

Early bookcovers and title labels.

1) *Li–tai–ming–hua–chi*, ch. 1: 天后朝。張易之奏召天卞畵工。修內庫圖畵。因使工人各推所長。銳意模寫。仍舊裝背。一毫不差。

The bags, called *shu-nang* 書囊, were made of a grey (*p'iao* 縹) material, the wrappers (*chih* 帙) made of yellow (*hsiang* 緗) cloth or silk; hence the literary expression *p'iao-nang-hsiang-chih* 縹囊緗帙, meaning "books". It would seem that the wrappers of book rolls were reenforced by adding a lining, consisting of a matting made of split bamboo, woven together with coloured silk threads.

The most common old term for a book cover is *chih* 帙. In the dictionary *Shuo-wên* (說文, about 100 A. D.) this character, also written 袠, is explained as *shu-i* 書衣, "book robe". Han dynasty literature occasionally mentions less common terms, like *p'a* 帊, *chung* 帴 (also written 幒). Another old Chinese term, *chih-tsê* 帙簀, lit. "cover matting", has become obsolete in Chinese. It has, however, been preserved in Japanese Buddhist Chinese: the *Sairyū-shō* (細流抄, a lexicographical work dating from the 16th century) explains this term s. v. *ji-su*: "a wrapping for enveloping holy books, made from bamboo woven into a matting" (*take no sunoko ni amitaru, fumaki kyō wo tsutsumu mono nari*).

The earliest actual specimens of book covers preserved correspond to this description. The Louvre Museum in Paris has a number of wrappers for book rolls, discovered at Tun-huang, and dating from the late Sui or early T'ang periods. Four of these are reproduced on Plate **81**. The two wrappers on top right clearly show the construction: a woof of fine split bamboo, and a warp of coloured threads woven in ornamental designs. Such wrappers often contained more than one book roll; ten seems to have been the usual number.

In order to show what book rolls were contained in a cover, it was provided with a loose title label. The oldest term for such a label is *ch'ien* 籤, a tag of wood, bamboo or ivory, with the title of the scroll written or engraved on it. During the Han period ivory seems to have been the favourite material for such tags. The *Hsi-ching-tsa-chi* 西京雜記, a work containing notes on various matters connected with the Han Court, calls these tags *ya-ch'ien* 牙籤, "ivory labels".[1] Han literature, however, also mentions jade title tags, inscribed with golden characters, *chin-ni-yü-chien* 金泥玉檢, which were also called "swallow tails", *yen-wei* 燕尾; from the latter term one would conclude that these labels were not unlike those used in later times (see Plate **84**, A and C).

From the Han period till the T'ang dynasty there seems to have occurred little change in either the book covers or the title labels. It is worth mentioning, however, that during the Liang period there came into use the term *han* 函, as a synonym of *chih* 帙.

1) The Japanese Sinologue Kondō Morishige (近藤守重, lit. name Seisai 正齋, 1757-1815) devoted a special study to the history of Chinese ivory title labels. This is the *Gasen-kō* 牙籤考, with two appendices, were all Chinese sources are quoted in extenso. Kondō was a fount of curious knowledge. He was widely read in Chinese literature, especially in lesser known minor works of the Ming and early Ch'ing periods. In Japan he earned fame as a zealous advocate of the exploration of Etoru and other islands in the extreme North, which in 1798 were threatened by a Russian invasion. His complete works, the *Seisai-zenshū* (正齋全集, publ. 1906 by the *Kokusho-kankōkai* 國書刊行會) testify to his broad knowledge and his varied interests.

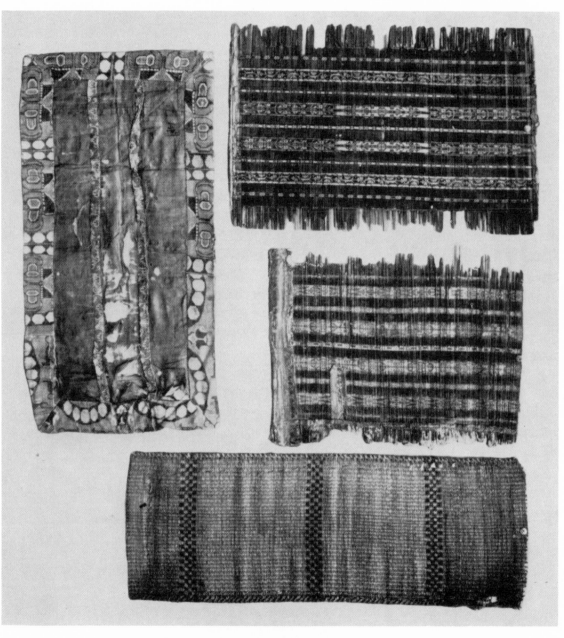

81. – BOOK COVERS FOUND AT TUN–HUANG
(Louvre Museum, Paris)

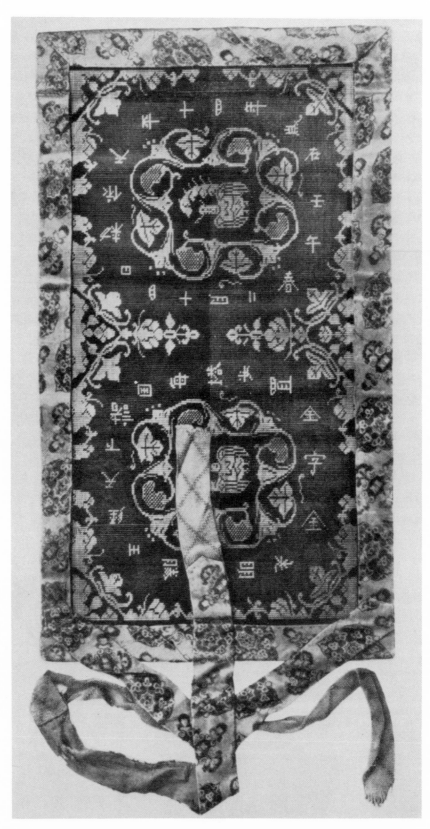

82. – JAPANESE BOOK COVER

Shōsō–in, Nara

The term *t'ao* 套, originally written 幒 or 鋾, [1] since the Ming dynasty the most common term for " book cover ", seems to be of much later origin.

The book roll during the T'ang period.

It was stated above that the book rolls discovered at Tun–huang had very simple mountings. Literary sources from the T'ang period, however, prove that the book rolls used in China proper were mounted in a much more elaborate way. The dynastic history of the T'ang period says: " Those book rolls (in the Palace collection) that contained classical texts were mounted with green ivory knobs, red bands and white ivory title labels; those about history had blue ivory knobs, grey bands and green labels; those about philosophy and science, knobs of carved red sandal wood, purple bands and green–blue labels; and those containing *belles lettres* green ivory knobs, red bands and white ivory title labels. Thus each group had its own distinguishing marks ". [2]

The ivory title tags mentioned in this quotation were probably fastened to the protruding knob of the book roll. It is interesting that here again we find that the knobs were used to indicate the quality of the scroll, or the category to which it belonged.

In another work of the T'ang period, the *Chih–i–chi* 撫異記, a small collection of historical notes completed in 751 by Li Chün 李濬, a scholar who was in close touch with Court circles, it is said that the day–by–day records of the doings and sayings of the Emperor were written on yellow hemp paper (see above, page 137, note 2), and mounted with knobs of carved sandal wood. [3]

T'ang book covers.

In Japan there have been preserved a few actual examples of covers for book rolls, dating from the T'ang period; these were either imported from China, or made in Japan after Chinese models.

Plate **82** shows a magnificent cover, made especially in the year 742 for copies of the *Suvarṇa–prabhâsa–uttamarâja–sûtra* 金光明最勝王經; it is preserved in the Shōsō–in at Nara. J. Harada gives in his English catalogue of the Shōsō–in treasures (cf. p. 156, note 1 above) the following description of this cover:

" The woof is of fine split bamboo, which is not visible, as it is entirely covered with the warp of silk thread with which are woven floral designs and thirty–four ideographs in two rings, saying ' In every tower in the various provinces throughout the realm, a copy of the *Konkōmyō–saishōō–kyō* in gold letters is placed by the Imperial Order issued on the 14th day, 2nd month, 15th year of Tempyō (March 24, 742) '. The *chitsu* (帙) is

---

1) Both these characters, pronounced *t'a*, mean " to envelop, to hold ". When referring to an object made of cloth, *t'a* was written with the 巾 radical, and when used to indicate an object made of metal, with the 金 radical; thus 書幒 means " book cover ", and 筆鋾 " a copper brush holder ". Another example of a change of radical indicating that one term of the spoken language refers to two different objects, is discussed on page 419, in connection with the character *niu* 紐. This custom, which must have played an important role in the development of the Chinese

script, is well worth a special study.

2) *T'ang–shu, Ching–chi–chih.* 唐書經籍志。 經庫書綠牙軸朱帶白牙籤。史庫 書青牙軸縹帶綠牙籤。子庫書雕 紫檀軸紫帶碧牙籤。集庫書綠牙 軸朱帶白牙籤。

3) For more details about this book, cf. EDWARDS, *Chinese prose literature of the T'ang period*, London 1938, vol. II, pp. 227–229.

lined with scarlet *aya* (a kind of damask. v. G.), with a border of brown brocade. It was used for rolling up the sûtra in the two ribbons, or brocade bands lined with patterned scarlet *aya*, attached at the end, being used to tie around it when rolled. Length 515 mm., width 295 mm. " (op. cit., pag. 77).

It may be added that the so–called *fude-maki* 筆卷, square bamboo mats nowadays still widely used in Japan for wrapping up writing brushes (see Plate **83**), are doubtless a remnant of these ancient bamboo covers for enveloping book rolls.

I mention in passing that the Shōsō–in collection also has a few T'ang bamboo containers for Buddhist rolls (see above, page 126), richly decorated.

T'ang title labels. In T'ang literature there are found numerous references to loose title tags, attached to the covers of the book rolls, or to the protruding roller knobs.

The T'ang scholar Han Yü (韓愈, 768–824) says in one of his poems: " In the house of the marquis of Yeh (i. e. Li Pi 李泌, 722–789) there are many books, 30.000 rolls are resting on his shelves, and from each an ivory title label hangs down, new as if no hand had yet touched them ". [1]

All together a Chinese library of the Sui or T'ang period must have curiously resembled a library in ancient Rome. One has but to replace the open shelves, *chia* 架, of the Chinese library by the Roman *plutei* or *pegmata*, the book rolls *chüan* 卷 by the parchment *volumina* (derived from *volvere*, meaning just like *chüan* in its verbal sense, " to roll "), the ivory title labels by the Roman three–cornered slips, and one has a Roman library as it is known, for instance, from the fries excavated at Neumagen, near Trier (see Plate **84** B). As a matter of course this resemblance is entirely fortuitous; it is mentioned here merely as a matter of curiosity.

Sung book covers and title labels. As was pointed out above, while the pictorial roll till the present day essentially has retained its old form, after the spread of the art of printing during the Sung dynasty, the appearance of the book roll underwent drastic changes.

This development of the book roll was caused chiefly by practical considerations. It proved inconvenient that in order to consult a passage near the middle of a text one had to unroll about half of the scroll. To eliminate this inconvenience the entire length of the scroll was divided into leaves of uniform size, and the scroll was folded accordion-wise along these divisions. The division into double pages that was thus obtained made it possible to print longer texts with wooden blocks: these blocks being of limited size, it was easy to strike off each page separately from one printing block at the time. Thus the manuscript hand scroll developed into the printed accordion book, in Chinese *hsüan-fêng-chê-yeh* 旋風摺葉, or simply *ts'ê-yeh* 冊葉. As a further improvement the struck–off leaves were not pasted side by side on one long strip of backing to be folded as

1) 鄴侯家多書。插架三萬軸。一一懸牙籤。新若手未觸。 Li Pi's collection of book rolls was so famous that *yeh-chia* 鄴架 " the bookshelves of Yeh " has become a literary expression for " a well-stocked library ".

218

83. – JAPANESE FUDE–MAKI

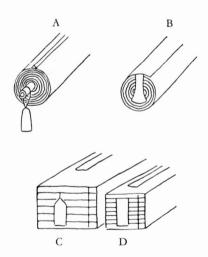

84. – TITLE LABELS
(A) ANCIENT CHINESE BOOK ROLL
(B) ROMAN PARCHMENT ROLL
(C) AND (D) LATER CHINESE BOOK LABEl

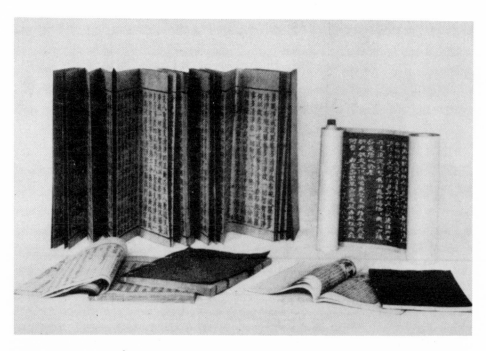

85. – DEVELOPMENT OF THE CHINESE BOOK

On the right a rubbing mounted in the form of a "book roll"; on the left a text mounted as an "accordion album". On the right, lying flat, a "butterfly binding", on the left an ordinary "stitched volume".

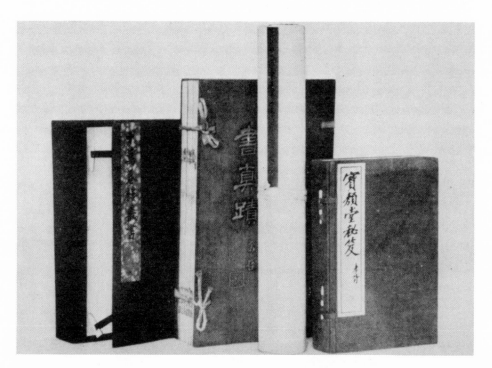

86. – BOOK CASES AND TITLE LABELS

In the centre a "book roll" with title label stuck alongside the stave. On the right several stitched volumes in a cardboard case covered with blue cloth; printed title label of ordinary white paper. On the left an empty cardboard case with handwritten title label of ornamental paper; note the fastening pins attached to the cover. In the centre, behind the "book roll", a number of stitched volumes placed between two wooden boards; the title of the book is engraved in the front board.

an accordion volume, but each double leaf was folded in two, and all the leaves constituting one volume were glued together along their spine. Thus there was obtained a book where every two printed pages alternated with two blank leaves, namely the reverse of the printed surface (see Plate **85**). This form of binding, known as *hu–t'ieh–chuang* 蝴 蝶 裝 "butterfly binding" or *nien–yeh* 黏 葉 "glued leaves", remained in use throughout the Sung and Yüan periods. [1]

These printed volumes were bound between covers of thick paper (*shu–p'i* 書 皮, *shu–hu* 書 護), and the title of the book was written either directly on the front cover, or on a slip of paper that was thereafter pasted on to it. If a literary work consisted of several volumes, these were placed in a bamboo mat cover, or in a wrapper of thick paper. These *chih* resembled very much the modern Chinese book cases, now commonly called *t'ao* 套 (see Plate **86**). Such square book cases were used for keeping a number of printed volumes together, and for encasing albums, both literary and pictorial. On Plate **95** one sees on the two tables several of such book–cases. It must be noted that the title labels of all except one are pasted in the middle of the cover. Since the end of the Ming period it has been customary to paste the title label of albums, books and covers on top left, alongside the edge (see Plate **86**). The old Chinese custom, however, still survives in Japan: there labels pasted on in the middle of the cover are still widely used.

If a number of printed volumes were piled up on the shelves, the titles on the front cover were of course not visible. To enable the owner of a library to find a book on heavily loaded shelves, one used title tags stuck between the leaves (see Plate **84** D). A Sung source calls these tags *chia–chien–tzŭ* 挾 籤 子. [2] They were square pieces of paper folded in two, and inserted between the leaves of the book in such a way that the half inscribed with the title was showing.

Next to these printed or manuscript volumes, the book roll was still widely used throughout the Sung period. Manuscript book rolls produced by copyists were, as a matter of fact, much cheaper than printed editions.

Sung book rolls were wrapped in covers that closely resembled the mat–covers of the T'ang period. The Ming scholar Ch'ên Chi–ju (陳 繼 儒, 1558–1639) observes:

1) Here there is given but a very brief outline of the development of the Chinese book. For further information on this interesting subject the reader is referred to A. W. HUMMEL, *The development of the book in China* (in: Journal of the American Oriental Society, vol. 61, no. 2, June 1941), and MA HÊNG 馬 衡, *Investigation into the development of the Chinese book* (in Chinese) 中 國 書 籍 制 度 變 遷 之 研 究, published in the periodical *T'u–shu–kuan–hsüeh–chi–k'an* 圖 書 館 學 季 刊, vol. I, no. 2, 1926. In 1929 the same periodical printed another article on this subject (ibid., vol. III, no. 4: *Evolution of the binding of Chinese books*, by Li Wên–ch'i 李 文 奇, 中 國 書 籍 裝 訂 之 變 遷), and again in 1930 (vol. IV, no. 2: *Investigation into Chinese bookbinding*, by Li Yüeh–nan 李 耀 南,

中 國 書 裝 考). A very useful survey is further *Chung–kuo–tiao–pan–yüan–liu–k'ao* 中 國 雕 板 源 流 考, a small book published in 1934 by Sun Yü–hsiu 孫 毓 修; although mainly devoted to typographical questions, the last chapter treats at some length the history of book binding. An apt summary of the various old and new Chinese material is the Japanese article *Shina no zōtei to kami* "Chinese bookbinding and paper", by the Japanese bibliographer Nagasawa Kikuya 長 澤 規 矩 也, in *Shoshi–gaku* 書 誌 學, vol. XVI, no. 1, 1941.

2) Cf. the *Mo–chuang–man–lu* 墨 莊 漫 錄, written by Chang Pang–chi 張 邦 基, a scholar who flourished in the 12th century.

87. – EIGHT SCROLLS IN A WRAPPER

"The ancients always used covers to envelop their book rolls when stored away; these covers resembled our present day square pieces of cloth for wrapping up bundles. [1] Po Chü–i (白居易, 772–846, the famous T'ang poet), left some rolls with his writings in his retreat on the Lu mountain, where often parts of them would get lost. The Emperor Chên–tsung (真宗, 998–1022) of the Sung dynasty then ordered these writings to be copied out and collated in the Ch'ung–wên–yüan, [2] and one copy, enveloped in a cover of spotted bamboo, was presented to the temple which Po Chü–i had chosen for his retreat. [3] Once I saw in the house of Hsiang Yüan–pien (項元汴, 1525–1590, the famous Ming collector) a roll with a painting by Wang Wei; this roll was enveloped in a cover made from spotted bamboo, and Hsiang said that this dated from the Sung period. This cover resembled a mat made from thin bamboo staves, and it was lined with thin embroidered silk. From this it can be understood why the character *chih* 袠 is written with the radical *chin* 巾, i. e. 'cloth'". [4]

The Ch'ing painter and connoisseur Kao Shih–ch'i (cf. Appendix I, no. 32) in his book *T'ien–lu–shih–yü* 天祿識餘, after having quoted the above statement by Ch'ên Chi–ju, adds further:

"In the Palace Collection there now is still preserved an old rubbing of the *Tao–tê–ching*, [5] after an original in Wang Hsi–chih's handwriting. This is enveloped in a thin mat made from 'shrimp–feeler grass'. This cover dates from the Hsüan–ho period (1119–1125)". [6]

On paintings of the Sung period one often sees sets of larger literary or pictorial rolls wrapped up together in a cloth or brocade cover, with broad bands wound round it (see Plate **87**). It is probable that also such larger wrappers were strenghtened on the inside by a lining of bamboo matting.

---

1) During the Ch'ing period these pieces of wrapping cloth became less popular in China. In Japan, however, this wrapping cloth, called *furoshiki* 風呂敷, still is extremely popular, and in the markets one hardly ever sees a Japanese without. It is not generally known that originally this was an old Chinese custom.

2) The Ch'ung–wên–yüan was an institute in the Imperial Palace where books, autographs and paintings were stored.

3) This was the I–ai Temple 遺愛寺, on the northern peak of the Lu mountain.

4) 群碎錄。古人書卷之類。必有帙以宋真宗。一帙
藏之。如今集留盧山草堂。屢亡斑竹帙丞是宋物。帙
文令余崇文院寫校。包以斑王云。
余嘗於項外以斑竹帙裹之。

如細簾。其內襲以薄繪。觀帙字巾旁可想也。 The passage about Po Chü–i's manuscript is copied from an older source, viz. the *Ju–shu–chi* 入蜀記, an account of travel in Szuchuan Province, by the prolific Sung writer Lu Yu (陸游, 1125–1210).

5) Lit. *Huang–t'ing–ching* 黃庭經, a text of the *Tao–tê–ching* said to have been written out in the regular script by Wang Hsi–chih, and later incised in stone. Wang was very fond of geese, whose graceful movements are said to have inspired him when wielding his brush. An anecdote asserts that he wrote this text in exchange for a particularly beautiful goose that had caught his fancy. Hence this text is also referred to as *Huan–ngo–ching* 換鵝經 "Text exchanged for a goose".

6) 今大內藏黃庭內經墨蹟。亦有蝦鬚草細簾裹之。是宣和物也。

220

When book rolls were laid on the shelves in one's library, loose ivory title tags were attached to the roller knobs to facilitate quick orientation. In a poem by the Sung philosopher Chu Hsi we read: " The old gentleman has nothing to bequeath to his heirs, but in his library the shelves bristle with the dangling ivory title slips ". [1] And Su Tung-p'o says in a poem: " The rain obscures the inkstone, giving it a colour of clouds in winter; the wind makes the ivory title labels clatter against each other like rustling leaves ". [2]

Later development of book covers and title labels.

During the Yüan period the printed book began to supersede the manuscript book roll. The technique of binding printed books developed further. The intervening blank pages of the " butterfly binding " were eliminated by folding each double page the other way round, so that both sides of a double leaf showed their printed surface. These leaves were glued along their edge in a cover of stiff paper, mostly of blue colour. This style of binding, known as *pao–pei–chuang* 包背裝, prevailed till well into the Ming period. As a final development the glued spine, which proved not sufficiently strong to keep the leaves together for a long time, was discarded. The leaves of one volume were first attached to each other by two paper spills, and then stitched together with a double silk thread, no glue entering the process. This is the *hsien–chuang* 線裝 or *hsien–fêng–chuang* 線縫裝 method, a style of binding that has been the most popular till the present day. [3]

This Chinese method of binding books is a wonder of simplicity and effectiveness: such books withstand all climatic changes, and will last for several centuries. Most readers will be familiar with these limp, stitched volumes. Usually one set of them is protected by a case, made from cardboard covered with cloth. The case is fastened with two bone or ivory pins, and the title is inscribed on a label, pasted on the outside of the cover (see Plate **86**).

Since the Ming period the most common material for book cases is simple blue cloth (see the sample in Appendix V, no. **20**), which is first provided with a thin paper backing, and then pasted on to the cardboard. The title labels stuck on this cover are usually made of some variety of *tsang–ching–chih* (see the sample in Appendix V, no. **19**), or of ordinary white paper. Chinese bibliophiles, however, always eager to embellish their cherished books, often used cases covered with antique brocade, of various patterns and colours (see the books visible on Plate **21**). Such sumptuous covers made by expert

1) 老翁無物與孫兒。樓上牙籤滿架垂。

2) 全集十四卷,和文與可洋川園池三十首:雨昏石硯寒雲色。風動牙籤亂葉聲。

3) A detailed study of the technique of binding Chinese and Japanese books in this style is to be found in a special issue of the Japanese monthly *Shosō* 書窗 " The Library Window ", a bibliophilic periodical. This number, no. 2 of vol. 11, bears the subtitle *Seihon–no–shū* 製本之
輯 " Book binding ", and was published in Tōkyō in 1941. The illustrations were drawn by Takei Takeo 武井武雄, and the accompanying text was written by Ueda Tokusaburō 上田德三郎. The first part deals with the technique of Chinese and Japanese book binding, the second with Western–style binding. The illustrations show each succeeding phase of the process, and all are accompanied by the Japanese, c. q. Chinese technical terms. This book is exquisitely edited, and printed on a very superior Japanese paper.

binders are till the present day still favoured by book–lovers and collectors. Instead of the ordinary bone or ivory fastening pins such covers have pins of jade or agate, often elaborately carved, and with the name of the owner's library engraved on the back. The author of the *Yü–shih* (cf. Appendix I, no. 60) in 1900 saw some books emanating from the famous Ming library Wên–yüan–ko 文 淵 閣, in the Palace at Peking that was later used by the Ch'ing Emperors for storing part of the *Szû–k'u* 四 庫 collection; these were encased in covers of costly old brocade with a swastika pattern, that after five hundred years was still like new. Till recent years government editions issued to official instances were often encased in covers of a special kind of heavy brocade, showing a black "thunder pattern" *lei–wên* 雷 文 on a silver ground; such brocade is visible on Plate **38**, on the end of the roller of the scroll on the extreme left. [1)]

During the Ming and Ch'ing periods manuscript books in roll–form had become rare antiques. [2)] Fastidious bibliophiles, in deference to tradition, often still use the antique loose ivory title labels for marking their printed books. Such labels are attached to a flat ivory pin stuck between the leaves (see Plate **84** C). Most common is the *chia–chien–tzû*, the folded paper label mentioned above, while often also the title of the book is written or printed on the foredge of each volume.

Collectors of pictorial scrolls sometimes use loose title labels of wood or cardboard, which they fasten with a piece of string to the knobs of the rolled up scrolls. When a number of scrolls are put in a cupboard or stacked on shelves, these labels are easier to read than those pasted on the back of the scroll, alongside the upper stave. Curio dealers, and sometimes also collectors, paste small inscribed paper labels on the knobs of their scrolls; this, however, is considered as vulgar.

As cardboard cases are liable to attract insects, in South China they are often replaced by two wooden boards, *chia–pan* 挾 板, kept together by linen bands (see Plate **86**). Paper title labels can be pasted on the front board, but it is considered more elegant to have the title engraved in the board, right in the middle.

Larger works consisting of a great number of volumes, are usually placed in a wooden box. Such "book boxes", *shu–hsiang* 書 箱 are made of hard wood, often

1) In Korea book cases never became popular, and Japan followed the Korean example: until about the beginning of the Meiji period (1868) cases were but rarely used in Japan. In Korea each single stitched volume is protected by covers of stiff paper, mostly brown or yellow, with ornamental mould marks (see the sample in Appendix V, no. 21). A very subtle feature of this paper is that the imprinted design becomes visible on the surface only when the book has been used for some time; then the ornamental designs gradually appear, together with a beautiful patina which the paper will acquire through constant use. Since the paper of the sample is new, the design is visible only on the reverse. Korean binders usually employ thick red cords for binding these books. Other characteristics of the Korean book

are the heavy, purely white paper, clear–cut, large characters, and a flower–like small ornament in the side margin. No title labels are used, the title of the book being written in large characters directly on the cover.

Japanese books are bound with covers of heavy, ornamental paper, waxed and imprinted with various designs (so–called *mombyō–shi* 紋 表 紙, see the sample in Appendix V, no. 42). To prevent the volumes of one set from drifting apart, they are often sewn together, without, however, taking off the stiff covers of each volume.

2) It are only Buddhist *sûtra*'s that to–day still are mostly printed and written an long rolls; also the accordion album is quite common for Buddhist texts.

beautifully grained. Inside they have one or more shelves, and the stitched volumes are piled up on these. On the front side the box is closed by a sliding lid, with the title of the book engraved in it.

Summary of the common features of the ancient book roll and the modern printed book.

Thus the manuscript book roll in its brocade bag was gradually transformed into the set of stitched volumes in a cardboard case. On first sight it is difficult to recognize their common origin. The present–day printed Chinese book, however, on closer inspection will prove to have many features that show its development from the book roll. These may be summed up as follows.

First, a "chapter" of a modern printed book is still called *chüan* 卷, literally "roll". One ancient book roll usually contained one chapter of a literary work, so that, for instance, a work counting six chapters actually consisted of six rolls. This term for "chapter" was retained for the chapters of a printed book, although nowadays one *ts'ê* 册 or limp stitched volume does not necessarily contain but one *chüan*; as a matter of fact usually one *ts'ê* contains two or more *chüan*. [1]

Second, the printed book has above the type page a generous blank margin, and below a narrow one. In the bibliographical jargon this upper and lower margin are still called *t'ien* and *ti*, just as the margins of the hand scroll.

Third, at the beginning of the first *ts'ê* of a printed book, directly after the title page, there often follow two or three pages with superscriptions printed in facsimile, written by friends of the author. These pages are called *t'i–tzŭ* 題字 "superscription". This is a survival of the *t'i–tzŭ* of hand scrolls. Further the colophon at the end of the book is called *po* 跋, exactly the same as the colophon of a hand scroll.

Fourth, the cardboard covers of printed books often are lined with yellow paper, reminding one of the yellow material in ancient times used for backing hand scrolls.

Fifth, the two bone pins for fastening a cardboard book–cover are remnants of the band with fastening pin, attached to the stave of a hand scroll for winding round it when rolled up.

Sixth, the title labels pasted on the cover of modern books are preferably made of *tsang–ching–chih*, since olden times the favourite material for title slips of both literary and pictorial hand scrolls.

The above discussion has led us from the art of mounting scrolls during the Sung period to that of book binding during later dynasties. It is hoped, however, that this digression will not be considered as superfluous. For without a knowledge of the development of scroll and book it is impossible to see the various component parts of the mounted scroll in historical perspective.

---

1) Another term for "chapter" is older still. This is *p'ien* 篇, which refers to the time when wooden tablets, bound together by leather straps, were still the common material for writing. The same applies to the term *ts'ê* 册.

This section may be concluded with quoting a summary of the art of mounting as practised during the T'ang and Sung periods. This summary was written by the Yüan scholar T'ao Tsung-i, and has been preserved in his *Cho-kêng-lu* (cf. Appendix I, no. 24). He wrote it as a sort of preface to extracts which he copied from the *Szǔ-ling-shu-hua-chi*.

" During the T'ang dynasty, in the periods Chên-kuan (627–649) and K'ai-yüan (713–741), the Emperor revered arts and letters. He had all his scrolls mounted on the front side with fine purple silk showing dragons and phoenix birds, while they were backed with fine figured green silk. The knobs of the rollers were made of elaborately carved red sandal wood, or also of persimmon wood, covered by a layer of white sandal wood. Scrolls of secondary quality had knobs of green–blue or red glass, ivory title labels, and brocade bands.

"During the T'ai-ho period (827–835) Wang Ai,[1] having been appointed head of the Monopoly Bureau for Salt and Iron, became ever more luxurious, and he for the first time had his scrolls mounted with knobs of gold and jade. After the 'Ambrosia Incident', people tore off all these (costly ornaments of Wang's scrolls), and nothing was left of them.[2]

" During the Southern T'ang dynasty (937–975) scrolls were mounted with black brocade, showing dancing phoenix birds on the front side, while their title slips were made of paper dyed yellow.

" The scrolls of the Sung Imperial collection had mountings made from large rolls of blue green or purple silk, and bands of figured brocade, while their knobs were made of jade, crystal and fragrant sandal wood.

" After the fall of the Northern Sung dynasty, during the Chin-k'ang period (1126), many of these scrolls came in the possession of the common people. When Emperor Kao-tsung had fled to the South, having in 1141 concluded peace (with the Chin invaders), on the official markets he bought many of such scrolls (that had belonged to the Northern Sung palace collection) ".[3]

---

1) Wang Ai (王 涯, *chin–shih* in 792, executed in 835) was an eminent scholar, who rose high in the favour of the T'ang Emperor. He was a great lover of antique paintings: the ample funds that he obtained as director of the Monopoly Bureau he used for purchasing valuable scrolls and other antiques. After having had his scrolls mounted in a most lavish way, he stored them away in a secret safe, made by building a double wall (*fu-pi* 複 壁; cf. page 509 below) in his library.

2) The "Ambrosia Incident" brought Wang's career to a miserable end. In 835 Wang Ai, confident of his power, together with Li Hsün 李 順 and some other high officials planned to effect a coup d'état. They tried to lure the Emperor to a lonely courtyard in the Palace grounds, by reporting to him that ambrosia had miraculously descended on a tree growing there. Some courtiers, however, noticed that armed men were concealed in the courtyard, and immediately called the Palace guards, who

killed the plotters. Their families were exterminated, and their riches scattered. Wang Ai's house was ransacked, and his scrolls discovered. Greedy people tore off the precious mountings, the paintings themselves they threw away on the street.

3) *Cho-kêng-lu* (cf. Appendix I, no. 24), chapter 23:

唐書紋通二鹽玉南宋爲變議
貞觀皆書綾身等鐵爲唐御帶民既
觀開用裹紫紫心牙相甘府玉間成
元紫檀軸此錦印露以藏青晶得有場
間人龍鳳雲外帶太美人墨大香高爲購
主紬花又於皆錦綾爲宗求
崇綾杵有和於皆錦綾爲宗多
尚爲頭青間財剟鐵爲軸渡
文衰赤玉始剟以縹靖江
雅綠白琉涯用無潢文康後
其文檀璃自金遺紙錦之和

The materials brought together on the preceding pages may suffice to give the reader an impression of the beginnings of the Chinese art of mounting, and its evolution during the T'ang and Sung periods.

The early history of this art poses numerous problems.   The above is a mere outline, aiming at showing the reader where the difficulties lie rather than at making an attempt at solving them.   Yet it is hoped that what is given here will be enough for proving that by the end of the Sung period the art of mounting had made great progress and that its scope had broadened.   It had advanced from the simple process of strengthening a hand scroll by adding a loose backing of some yellow material, to the complicated technique of mounting vertical and horizontal hanging scrolls and albums; moreover the remounting and repairing of antique scrolls had reached a reasonable degree of efficiency.

Although during the following centuries the pasting technique was much improved and the style of the mounting especially of hanging scrolls modified to some extent, by the end of the Sung period there had been formulated a set of principles that still hold good for the art of mounting as it is practised in China to-day.

## 2 – THE YÜAN DYNASTY AND AFTER, INCLUDING THE HISTORY OF MOUNTING IN JAPAN

The Yüan period; revival of Mantrayâ-nic Buddhism.

THE FLOURISHING of all the fine arts at Hangchow was the last brilliant flare of pure Sung culture. In 1280 the Mongols conquered also Central China, and founded the Yüan dynasty.

When Khubilai Khan came to China he brought with him a host of learned Tibetan and Mongolian monks who re–introduced into China Mantrayânic Buddhism that had been rapidly declining after its initial success during the T'ang dynasty. The new La-maist pictures found their way to Chinese Buddhist circles and Chinese artists took them as their model. Thus a new type of Buddhist images became popular in China.

A Mongolian Prince who during the Ch'ien–lung period worked in Peking says:

" Since the Han period all those who wished to make Buddhist images took repre-sentations introduced from Western regions as their example. The Chinese artisans preserved this tradition handed down from their ancestors. This style is known as the Han style, or also as the T'ang style. Now as regards the so–called Indian style, when Shih–tsu of the Yüan dynasty (i. e. Khubilai, 1260–1294) had started to unite the Empire there was a craftsman from Nepal called A–ni–ko who excelled in making Indian pictures from the Western regions. He had come (to China) together with the Imperial Teacher Pa–szû–pa [1] and on Imperial command repaired the bronze image with the acupuncture markings.[2] He was much praised for his skill. His pupil the *chêng–fêng–ta–fu* Liu Yüan was famous all over the Empire for his skill in making statues, and there was established especially (for these craftsmen) an Office for the Inspection of Indian Images. This office was charged with supervising the painting of Buddhist figures and the making of statues in clay and wood. Thus they excelled in quality those of past and present, and later went by the name of 'Indian images'. They represent the type which is called the Indian style ".[3]

---

[1] 'Phags-pa, in Chinese usually written Pa–szû–pa 八思巴, 1239–1280) was a Tibetan monk who in Mon-golia had taught Buddhism to Khubilai. After the latter had become Emperor he conferred upon 'Phags-pa the title of *Kuo–shih* 國師 "National Master" and appointed him as the head of the Buddhist church in China. 'Phags-pa evolved a syllabary for writing Chinese and Mongolian that was adopted as the official script of the Yüan rulers but fell in oblivion soon after their defeat. His name is connec-ted with the translation of three Buddhist texts.

[2] During the T'ang and Sung periods there was in the Palace a bronze statue of a man with marks indicating where acupuncture might be applied. According to A-ni-ko's biography in ch. 203 of the *Yüan-shih* he was charged to repair the image and completed the work in 1265. There also more details about Liu Yüan 元; *chêng-fêng-ta-fu* was the 12th honorary rank, cf. *Yüan-shih* ch. 91.

[3] Quoted from the *Tsao–hsiang–liang–tu–ching* 造像量度經, a small work on the painting of Buddhist images translated in 1742 by Kung–pu–ch'a–pu 工布查布, an outer Mongolian Prince who in Peking was in charge of the translation of Mongolian sûtras; he added to the book a sequel 續補 written by himself.

The text of the passage quoted reads:

自來謂梵波像。針正像削梵
西所謂你梵堂劉梵刻爲
取此所初。梵堂設木遂
傳。其之西修門特士稱
相海善奉稱天佛於古及今。
者。嘗述唐式。
佛祖謂混尼八巧名畫藝絕者
造家以行或祖阿思巴以藝董其梵式
欲模工也。元匠世人巴以塑司。故所謂梵式
凡以爲式者。國帝銅像以舉羅從炙奉提之像。
漢以來。像漢式式羅

This passage was written several centuries after the Yüan dynasty had come to an end, and the writer was prejudiced in favour of Mongolian Buddhist art. Yet it gives a good idea of the influence exercised on contemporary Chinese art by the Indian, Mongolian and Tibetan craftsmen in Khubilai's entourage. This influence affected not only the style of painting but also the manner in which Buddhist images were mounted.

The advent of the Mongols heralded a new and steady influx of " banner pictures ". These religious mountings contributed to the growing interest of the Chinese in their own secular hanging scrolls — if it were only because they sought to stress their own Chinese culture vis–à–vis that of the foreign conquerors.

Increasing popularity of the hanging scroll.

It is during the Yüan dynasty that the hanging scroll became more popular than the hand scroll for mounting pictures, although the latter continued to hold the field for specimens of calligraphy till well into the subsequent Ming dynasty.

Contemporary literature devotes as much attention to the hanging scroll as to the hand scroll. Of the many direct references to the hanging scroll in Yüan literature I quote only the elegant lines by the " sinified " Mongolian poet Sa-tu-la (薩 都 剌, born in 1308), where he says: " Looking at mountains and loving bamboos one feels freed entirely from official affairs; burning incense and suspending paintings one becomes like an Immortal " 看 山 愛 竹 了 公 事. 焚 香 挂 畫 似 神 仙。

The Palace Collection of Timur who succeeded Khubilai with the reign title of Ch'êng-tsung (成 宗, 1295–1307) counted more hanging scrolls than hand scrolls. This becomes apparent from a document on Timur's measures concerning the Chinese scrolls in the Palace.

This document is entitled *Yüan-tai-hua-su-chi* 元 代 畫 塑 記 " Notes on the Pictures and Statues of the Yüan Period " and included in ch. 18217 of the great Ming encyclopedia *Yung-lo-ta-tien* 永 樂 大 典. [1]

Scroll mountings of Timur's reign.

It says that in the autumn of the year 1300 Timur gave orders that the autographs and paintings in the Palace Collection be checked and sifted and those items that stood in need of repair be remounted by experts from Hangchow. At the end of the year no less than 646 hanging scrolls and hand scrolls had been remounted.

After these introductory remarks the document then gives a detailed list of the material used for this work. This list, drawn up with meticulous care, supplies precious data on the art of mounting of that time. The items are enumerated in one continuous list and the meaning of some terms is not clear. Yet a closer examination of those items that can be identified proves that the list is divided into six separate categories. In the translation of the list that follows below these six categories are marked with the letters A–F.

[1] The last manuscript of this huge encyclopedia was burnt in 1900 during the Boxer troubles and only a few volumes still exist. The *Yüan-tai-hua-su-chi* belongs to a group of works that survive in manuscript copies extracted from the encyclopedia, and the text was published by the Ch'ing scholar Wang Kuo-wei (王 國 維, 1877–1927) in ch. 15 of the *Hsüeh-shu-ts'ung-pien* 學 術 叢 編 of the *Ts'ang-shêng-ming-chih* University 倉 聖 明 智 大 學.

A – " Bands used for scrolls consisting of four uncut sheets: 20 *chang*. – Idem for scrolls of three sheets: 20 *chang*. – Idem for scrolls of two sheets: 80 *chang*. – Idem for scrolls of a single sheet: 400 *chang*. – Bands for hand scrolls: 80 *chang* ". [1]

This category is devoted entirely to the *ching–tai* of hanging scrolls and the fastening bands of hand scrolls. The hanging scrolls are divided according to their size, in the same manner as in Section B of the *Szû–ling–shu–hua–chi*.

Although there are many uncertain factors, it is difficult to withstand the temptation to base some rough calculations on the figures given. If one takes the length of an average pair of *ching–tai* of smaller and larger hanging scrolls to be 5 *ch'ih*, then for one pair there is needed 10 *ch'ih* of band, viz. 5 *ch'ih* for the frontside and 5 *ch'ih* for the reverse; since the *ching–tai* were tied in bows both sides had to be of the same material. Thus the total of 520 *chang* = 5200 *ch'ih* would suffice for providing approximately 520 hanging scrolls with *ching–tai*. Further, if one puts the average length of a hand scroll band at 3 *ch'ih*, then 6 *ch'ih* would be needed for each hand scroll, and out of 80 *chang* = 800 *ch'ih* one could make the bands of approximately 130 hand scrolls. This brings the total of scrolls remounted to 520 + 130 = 650 scrolls, which comes very close to the total of 646 mentioned in the introduction of the document.

B – " Smooth white and bleached fine raw silk for patching holes: 15 rolls. – Smooth, very thick laminated paper: 2000 sheets. – Thread paper (?): 1500 sheets. – Medium thick laminated paper: 6500 sheets. – Lien–szû office paper from Ch'ing–chiang: 1500 sheets. – Lien–szû office paper : 3000 sheets. – Coarse office paper : 5000 sheets. – Yü–ku paper from Hui–chou: 4000 uncut sheets. – Great table–top green (?) from Fu–chou: 3018 catty (?) – paper : 1000 sheets. – White T'ang lien–szû paper: 2000 sheets. – Black T'ang lien–szû paper: 1000 sheets ". [2]

The materials listed here all belong to the repairing and backing of scrolls.

Holes were repaired by sticking on patches of raw silk. We have seen, however, that Mi Fu advises not to use silk for this purpose (see page 183 above), and later mounters also preferred slips of tough paper.

It appears that scrolls were backed mainly with double paper of medium thickness; of this paper 6500 sheets were used. The " coarse office paper " that comes next in quantity with 5000 sheets was probably used for the last backing of the scroll. The meaning of the term *lien–szû*, and the various kinds of paper it refers to, are discussed on p. 296, note 4. *Hsüan* 線 " thread " may be a copyist's mistake for *hsüan* 宣; we

1) 畫帶 等 四 幅帶 二 十 丈。 三 幅帶
帶 二 十丈。 雙幅帶 八 十 丈。 單幅帶
四 百 丈。 手卷 帶 八 十 丈。

2) 補 畫 勻 淨 細 白標 清 水 生 絹
十 五 匹。 勻 淨大 厚 夾紙 二 千 張。 線 五
紙 一 千 五 百 張。 中 樣 夾紙 六 千

百。 清 江 連 四 劄 紙 一 千 五 百。 連 四
處 劄 三 千。 毛 連 四 處 劄 五 千。 玉 股 千
徽 紙 三 四 千。 福 大 卓 面 青 三 二 千。
一 十 八 斤。 紙 一 千 張。 白 唐 連 二 千。
卓 唐 連 一 千

we have seen on page 155 above that *hsüan-chih* 宣紙, paper from Hsüan-ch'êng, is mentioned already by the T'ang writer Chang Yen-yüan. *Yü-ku* 玉股 may be a variant of *yü-pan* 玉版, or *ku* may be just a copyist's mistake for *pan*; in cursive writing these two characters are easily confused. The " great table-top green " from Fu-chou poses a problem: perhaps *ch'ing* stands here for a grey colour and the term refers to powdered pigment used for dyeing the first backing of antique scrolls, although the quantity mentioned seems disproportionally large. In the next item the qualification of the paper must have been omitted by the copyist.

The last item, " Black T'ang paper " is very curious. Black paper could be used only for the front mounting of hanging scrolls and therefore would imply that already during the Yüan period front mountings were occasionally made from paper instead of silk or brocade. It is also possible, however, that *tsao* refers to *tsao-chiao* 皂角, the detergent referred to in the next item.

C – " Tsao-chiao husks: 1 catty. – White Ta-hsin lien-szû paper: 2200 sheets. – Large oil-paper: 2000 sheets. – Yellow wax: 1 catty. – White wax: 1 catty. – Alum: 5 catty. – Po-chi: 1 catty. – Frankincense: 2 catty. – Rue incense: 8 ounces. – Camphor: 4 ounces. – Tsao-chiao pods: 3 catty. – Honey: 5 catty. – Lead and tin: 1 catty. – White flour: 50 catty ". [1]

This category gives the ingredients needed for washing antique scrolls and for preparing the mounter's paste.

A decoction of the pods of the *tsao-chiao* plant is a detergent used by mounters throughout the centuries for washing scrolls darkened by age; cf. above, page 149 for its use in the T'ang period, and consult the General Index s. v. *tsao-chiao*. Oil paper was placed under the scroll during the washing process; we saw above that Mi Fu already mentions it in this connection. The Ta-hsin paper was probably used for removing spots of dirt from the wet scroll by blotting it. As regards wax and alum, the Yüan source *Cho-kêng-lu* (see below) states that these ingredients were used for straining the mounter's paste. However, yellow and white wax were also employed to make paper of old scrolls transparent, as described on page 137 above; and in Chapter II of this book it was described how alum is used to make heavy ink strokes and colours fast, prior to washing the scroll. Po-chi 白及, also written 白芨, is the *Bletilla hyacinthina*; a decoction of its pods is used in pharmacy and also mixed with paste to increase its viscosity. That it was used in preparing the mounter's paste of this period is attested by the Yüan recipe quoted below. Incense was mixed with the mounter's paste to protect the scroll against insects, and honey to add lustre to the paste. The lead and tin mentioned were probably used for inserting into the lower roller of hanging scrolls in

---

1) 皂皮方一斤。白大信連二千　二斤。芸香八兩。樟腦四兩。皂角三
二百。大樣油紙二千。黃蠟十斤。白　斤。蜜五斤。鉛錫一斤。白麵五十斤。
蠟一斤。明礬五斤。白芨一斤。乳香

order to increase its weight (see p. 80). Most connoisseurs, however, disapprove of this custom; cf. Mi Fu's remarks on page 185. White flour, the last item, is the main ingredient for making mounter's paste; hence the large quantity used.

D – " Acorn cupules: 30 catty. – Wên–t'u yellow (ochre?): 2 catty. – Pei–lo green: 1 catty. – Gamboge: 1 catty. – Superior lamp–black: 1 catty. – Charcoal: 100 sticks ". [1]

The items listed here all pertain to dye stuffs. Acorn cupules produce a dye widely used for silk and paper, lamp–black is the main material for making ink. Charcoal sticks were employed either for marking paper and silk, or for ink–manufacture.

E – " Coal: 1500 catty. – Fuel: 1000 catty. – Pinesoot: 20 catty. – Candles: 50 pieces ". [2]

This category evidently pertains to miscellaneous expenses incurred by the mounters when manufacturing ink–cakes.

F – " Brocade with a pattern of Phoenix birds and sparrows: 130 rolls. – Jade roller knobs: 50 pairs. – Ivory roller knobs: 300 pairs. – Large and small rings of t'ou–shih: 1500 pieces. – Large and small blue strips: 200 chang. – Large and small rollers and upper staves of Lo–wood: 300 pieces. – Light blue fine silk: 2007 chang and 4 ch'ih. – Yellow fine silk: 6 chang 8 ch'ih 5 ts'un ". [3]

Here the material for making the front mounting of scrolls is listed, including their rollers, roller knobs and upper staves. Apparently most scrolls had a front mounting of the same kind of brocade (viz. that showing the traditional pattern of Phoenix birds and sparrows) and silk; of the former material 130 rolls (520 chang) were used, and of the latter about 2000 chang. The " blue strips " were probably used for the seams of the mountings. In the compound chou–lu 軸 賂 I take lu to be a copyist's mistake for t'ieh 貼; Lo–wood, of the sha–lo 桫 欏 tree, *Stewartia pseudocamellia*, is much used by Chinese cabinet workers.

It is interesting that ivory knobs were most common; 300 scrolls were mounted with these and only 50 with knobs of jade. Later Chinese mounters only rarely use ivory knobs, but in Japan they always remained very popular. The rings of the upper stave served to attach the ching–tai; t'ou–shih is an ore that yields a yellow metal.

Thus the Yüan–tai–hua–su–chi gives a fairly accurate idea of the technique of mounting during the Yüan period. Additional data are supplied by the Cho–kêng–lu (cf. Ap-

1) 橡斗三十斤。溫土黃二斤。北烟一斤。
羅青一斤。藤黃一百筒。
木炭一

2) 煤炭一千五百斤。木柴一千
斤。松油二十斤。蠟燭五十條。

3) 鸞鵲木錦一百三十匹。玉軸

頭五十對。象牙軸五百。藍軸賂百條大黃對小三百。鍮石二天八
環百大小欏木軸桿丈四尺。青大小綾百丈
碧尺小千七尺。黃六丈
綾二千
五寸。

pendix I, no. 24), a collection of miscellaneous notes compiled in 1360 by the scholar T'ao Tsung-i, only fifty years after Timur's demise.

In ch. 27 of his work T'ao Tsung-i enumerates thirteen things the mounter can not do without. This list is an imitation of similar ones which already existed for painting and medical science. His use of *k'o* 科 rather strains the meaning of this word. However, the list is in itself sufficiently interesting for being translated here in full.

" People generally only know that medicine and painting have 'thirteen subjects' but they are ignorant of the fact that the art of mounting has them too. These ' thirteen subjects ' are the following: (1) Coarse and fine woven silk; (2) the same material dyed; (3) strips of paper; (4) dyestuffs for the preceding item; (5) wheat flour for making the paste; (6) alum and wax for straining the paste; (7) rulers, cutting boards, upper staves and lower rollers; (8) roller knobs [of metal, jade, stone, agate, crystal, coral, sandal wood, rosewood or ebony; for each scroll one kind is used, hence all different kinds are included in one category]; (9) paste brushes: (10) scissors; (11) bands; (12) *ching-tai*; (13) knives for cutting (silk and paper).

" If a mounter's outfit lacks but one of these, then a complete mounting can not be made.

" There exist technical terms for paste brushes and rulers. Soft coir brushes are called *p'ing-fên*, hard ones *hu-shuo*, medium ones *nien-ho*; small and thin brushes are called *ts'un-chin*. Broad rulers for (guiding the knife while) cutting are called ' a span ', more narrow ones ' three fingers ' and the next size ' two fingers '; very thin ones are called ' one finger ' ". [1]

This list is useful in that it confirms the data contained in the *Yüan-tai-hua-su-chi*. The great variety of roller knobs mentioned is interesting.

The greatest value of this list, however, lies in what it does *not* mention. I refer to the *chuang-pan*, the drying boards that are of such vital importance for producing superior mountings. These boards must have been invented towards the middle of the Ming dynasty when hanging scrolls increased in size.

In ch. 29 of the *Cho-kêng-lu* there occurs a note on the paste used for sticking together the various sheets that form a long Buddhist sûtra roll. T'ao Tsung-i cites a note by a scholar called Wang Ku-hsin 王古心 who while describing a certain Buddhist temple says:

1) *Cho-kêng-lu*, ch. 27:

世人但知醫藥畫有十三科，不知裱背亦有科。裱背十三科：一織造綾帛一色。二染練顏色。三抄料桿瑪。三十一版軸上。科。一晶水用軸。科。歸帶。一裁欄榍。一數鍘鍘之手。一刷。鍘內刷之中，謂得金，謂之刷稠者。鍘軟大之等。謂之小滿。一能名，謂之小狹者曰兩指。裁之中裁三指，次狹者曰單指。一闕裁平者，尺又謂極次等等。鉸其尺分。錬一亦樓之等等。所以一則省硬黏闊曰色。

"The librarian was a monk called Yung-kuang, his style was Ch'üeh-chao. He once came to visit me in my Kuan-wu studio; then he was already 84 years old. During our conversation I asked him how it was possible that the sûtra rolls of former dynasties (in the temple library), although their seams were thin like a thread, had after all this time not become loose. He answered: 'The method is to use sap of the mulberry tree, fine flour, and powder of *po-chi* pods. When you mix these three together for your paste and therewith stick together the sheets of your scrolls, they will never become loose for this paste will become hard like glue or varnish ". [1]

The *Chuang-huang-chih* also mentions *po-chi* in connection with mounter's paste. In Ch. VIII it says that paste prepared with *po-chi* should not be used for attaching the backing to a picture since it will prove practically impossible to take the backing off when the picture is being remounted.

Pictures of hanging scrolls of the Yüan period.

So far we have confined our discussion of scroll mounting during the Yüan dynasty to the data found in literary sources. Since numerous Yüan paintings have been preserved, the question arises whether on those that depict literary gatherings or meetings of art lovers one cannot find a good picture of a mounted hanging scroll.

As a matter of fact the Old Palace Museum in Peking has several paintings listed as Yüan which depict scenes where mounted hanging scrolls are being viewed; one of those is reproduced on Plate **22**. However, none of the paintings of this kind which I had occasion to examine was a Yüan original; all were early or late Ming copies.

Now most copyists, and more especially those of the Ming period, would modify or make mistakes in details which they did not understand because they occurred in objects that had become obsolete in their own time. To verify this point one has but to compare for instance the various kinds of caps men wear on Tun-huang frescos, with those worn by persons on Ming paintings aiming at representing T'ang dynasty scenes. On the latter one will find many mistakes in bands and tassels. The Ming artists who painted them had a general idea of what T'ang caps looked like, but they did not know how they were actually worn. Similarly, when Ming or later artists copied Yüan paintings depicting hanging scrolls, they drew those with *ching-tai* hanging down across the *t'ien*. As will be demonstrated below, however, in the Yüan period the *ching-tai* were still tied in bows. For details relating to material culture later copies of Yüan paintings are of slight use.

The most dependable source for studying aspects of material culture is the book illustration, provided of course that the book deals with a contemporary subject. The illustrations of a Ming print containing for instance the biography of a Han general are worthless for the study of Han customs and costumes; but Ming woodcuts illustrating for

1) *Cho-kêng-lu*, ch. 29: 藏僧永光。字 楮樹汁飛麵白笈末。三物調和如
絶照。訪予觀物齋。時年已八十有 糊。以之黏接紙縫。永不脫解。過如
四。話次因問光。前代藏經。接縫如 膠漆之堅。
一線。日久不脫。何也。光云古法用

instance erotic poetry of that
period give a true picture of
the way of life of that time.[1]

Thus the Yüan book
illustration showing mount-
ed hanging scrolls described
here under deserves special
attention.

In 1330 the Mongolian
Court physician Hu–szû–
hui 忽 思 慧 published a
hand–book on healthy liv-
ing, entitled *Yin–shan–chêng–
yao* 飲 膳 正 要, in three
volumes.   The original
Yüan edition seems to have
become lost.   But in 1456
the book was republished
facsimile; a photographic
reprint of this Ming edition
is included in the great mo-
dern collection of reprints,
the *Szû–pu–ts'ung–k'an* 四 部
叢 刊. It may be added
that the observation of
Yüan dynasty taboos, the

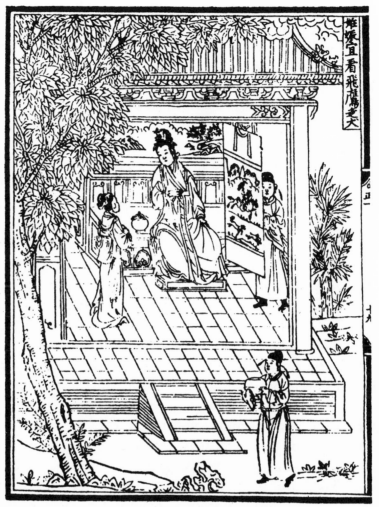

Hanging scroll moun-
tings depicted in the
*Yin–shan–chêng–yao*.

88. – YÜAN BOOK ILLUSTRATION

style of printing and that of the illustrations prove that the Ming edition is indeed a
true copy of the Yüan impression, produced by pasting the leaves of the latter on
printing blocks and engraving these accordingly.

This book has a section dealing with pre–natal care, a subject to which Chinese phy-
sicians have given much thought as early as the Han period. [2]   The text is illustrated
with four plates that depict the correct physical conduct of an expectant mother.   The first
of these has no bearing on our subject.   Each of the three others, however, features one
or more hanging scrolls.   The second, inscribed " A pregnant woman should look at
carps and peacocks " represents a lady of rank seated on a couch and looking at two
hanging scrolls depicting carps and peacocks, held up on a *hua–ch'a* by a page.   The third,
inscribed " A pregnant woman should look at pearls and jade " shows the same lady

---

1) Cf. my book *Erotic Colour Prints of the Ming
Period*, Tokyo 1951.

2) Cf. *Erotic Colour Prints of the Ming Period*, vol. I
passim.

looking at a hanging scroll depicting a plate full of jewels.  The fourth picture is reproduced here on Plate **88**, since it is better printed than the others; its inscription runs: " A pregnant woman should look at flying hawks and running dogs ".

The hanging scroll depicted agrees with the descriptions in the Southern Sung and Yüan texts quoted above, and with the S. Sung woodcut reproduced on Plate **78**. Directly above and below of the picture there is a *yin–shou* and adjoining these a — fairly narrow — *t'ien* and *ti*.  All four strips have the traditional proportion 2 : 1.

The *ching–tai* of Yüan hanging scrolls. The *ching–tai* are tied in a bow at the top of the mounting.  Since this particular part of the drawing is not very clear, Plates **89-90** give detail–photographs of the upper parts of the hanging scrolls on the second and third illustration.

These plates show that there is no special cord for suspending the scroll, one loop of the bow serves this purpose.  Another loop hangs down in a curve over the *t'ien*, and the two ends of the *ching–tai* are hanging free on either side of this curve.

On p. 199 above it was pointed out already that the *ching–tai* served as fastening bands when the scroll was rolled up.  When one wanted to suspend the scroll the bands could very easily be transformed into a bow that functioned both as suspension loop and as decoration of the front mounting.  For instance, one could pass the *ching–tai* on the left through the ring of the one on right and fix it there by tying a slipknot; this *ching–tai* then acts as suspension loop, its loose end hanging down from the right ring.  The *ching–tai* on the right is passed through the ring of the left band so that part of it hangs down in a curve over the *t'ien* and its end dangles under the left ring so as to match the other band. An actual experiment will show that it takes very little time to effect this result, and it is equally easy to untie the bands again.

This Yüan book illustration proves that the *ching–tai* with a triple function — fastening bands, suspension loop, and decoration of the front mounting — were still in use during the Yüan dynasty.·

As far as I know in China no actual example of a Southern Sung, Yüan or early Ming mounted hanging scroll has been preserved.  In Japan, however, one often sees 15th and 16th century mountings which have ordinary suspension loops, but instead of the *ching–tai* a complicated knot of silk cord more than a finger thick; attached to the upper stave its tasseled ends hang down over the *t'ien* (see p. 264).  These ornamental cords are evidently a remnant of triple–function *ching–tai* of earlier Japanese mountings which followed closely the Southern Sung example.

During the Southern Sung dynasty many Japanese visited China and a number of Chinese came to Japan.  Thereafter Khubilai's attempts at invading Japan caused a temporary breach of diplomatic and cultural relations of the two countries.

This seems, therefore, an appropriate place to turn to Japanese sources and to relate briefly the history of the art of mounting in that country, from its early beginnings till the advent of the Ming dynasty in China when the old Sino–Japanese contacts were re–established.

89. – DETAIL OF A YÜAN BOOK ILLUSTRATION

90. – DETAIL OF A YÜAN BOOK ILLUSTRATION

Already during the early stage of Japan's relations with the continent, Chinese culture introduced into Japan via Korea bore a pronounced religious character: Japan was taught Chinese civilization clad in Buddhist garb. Thus the earliest examples of Chinese mounted scrolls that came to Japan were the so–called *kyō–kan* 經 卷, book rolls containing Buddhist texts. These mounted text rolls were imitated by Japanese priests, and this may be called the beginning of the art of mounting in Japan.

The art of mounting in Japan. Early Buddhist book rolls.

In the 7th century direct contact with China was established. In 607 the first Japanese Embassy was sent to China, to make a thorough study of all aspects of Chinese culture, a custom which during the next centuries was repeated at regular intervals. In 645, with the Taika Reform (*Taika–kaishin* 大 化 改 新), the national administration of Japan was reorganized after the Chinese T'ang model; this sinification of Japan was completed in 701 by the promulgation of a series of laws, known as the Taihō Code, *Taihō–ryōritsu* 大 寶 令 律. In this code — a frantic attempt at forcing the existing Japanese customs and common law into a Chinese mould — mention is made of four mounters attached to the Court. Under the heading " Rules for the Library of the Central Ministry " (*Naka–tsukasa–shō zusho–ryō* 中 務 省 圖 書 寮) there is found the item: " Four mounters, charged with the mounting of book rolls " [1] This institution evidently was a direct copy of a similar one in China. The term *chuang–huang* (*shō–kō* 裝 潢) is explained exactly as in the Chinese T'ang source: " *Shō* means cutting to measure, *kō* means to dye ". [2] It may be assumed, therefore, that in Japan during the 7th and 8th centuries book rolls were mounted according to the Chinese model, viz. as hand scrolls backed in a simple way with some dyed material.

Introduction of Chinese secular book rolls.

During the Heian period (平 安, 794–858) the more ornamental styles of mounting hand scrolls that were in vogue in T'ang China gradually were taken over by the Japanese. The front mountings were made of thin purple silk (*murasaki–usumono* 紫 羅) or a yellow hemp material (*hanada* 縹), the bands of red, purple or green brocade (*kambata* 綺), and the knobs of white sandal wood or of wood covered with gold and silver lacquer.

Mountings of the Heian period.

Buddhism being extremely popular, the custom of copying out Buddhist texts as a meritorious work, the so–called *sha–kyō* 寫 經, spread widely. Such copies of sûtra's, often written in gold ink on glazed blue paper, were mounted with special care: their front mountings were made of red brocade with gold designs, and their knobs of red–lacquered wood or carved coral.

As most mounted hand scrolls bore a religious character, one need not wonder that the work of mounting was entirely in the hands of the Buddhist clergy. Thus the oldest

---

1) 裝 潢 手 四 人。掌 裝 潢 經 籍。　　　2) 截 治 曰 裝。染 色 曰 潢。

Japanese term for "mounter" is *kyō-ji* 經 師, literally "Sûtra master". These priest-mounters were charged not only with the mounting of Buddhist texts, but also with that of book rolls of a secular character, such as Chinese literary works and collections of Japanese poetry.

During this period the mounted hanging scroll was still unknown in Japan. Temples and palaces were decorated with wall paintings, painted either on stucco or directly on the wood of panels and ceilings.

Mountings of the Fujiwara period.

It was during the Fujiwara period (藤 原, 897–1183) that the art of mounting gained in importance.

Under the protection of the art-loving Fujiwara nobles at Kyōto, the Imperial capital, painting and calligraphy flourished. Next to the Chinese styles now also purely Japanese schools of painting, like Kasuga and Yamato, developed further and won official approval.

Flourishing of the hand scroll.

It were especially hand scrolls with pictorial representations, the so-called *e-maki-mono* 繪 卷 物 that became greatly popular. Originally also these pictorial hand scrolls bore a Buddhist character; in their earliest form they would seem to have been devoted chiefly to religious subjects, such as the lives of Buddhist saints (*gyō-sō* 行 壯), or the history of famous temples and sanctuaries (*en-gi* 緣 起).

Soon, however, illustrations were added also to scrolls containing Court novels and collections of Japanese poetry. As such scrolls asked for gorgeous mountings, one finds that there are utilized for the mountings of these hand scrolls all the various kinds of costly brocade and silk that are known from the pictures of Fujiwara Court dresses.

The Itsukushima kyōkan.

A good example of the splendour of Fujiwara mounting is supplied by the so-called *Itsukushima-kyōkan* 嚴 島 經 卷, a set of mounted hand scrolls containing Buddhist texts, that in 1164 were offered by the Taira clan to the temple of Itsukushima, an island off the W. coast of Japan. These rolls are still preserved, together with their original mountings. The text is written on thick paper decorated with all kinds of designs painted in full colours, and the inside of the protecting flap of each scroll shows a coloured Buddhist representation. The knobs are made of crystal or ivory, encased in silver filigree, studded with precious stones. [1]

Valuable scrolls were kept in boxes covered with gold and silver lacquer, and when taken out for being viewed they were deposited on special stands, also richly decorated with gold and silver. The display of scrolls was made a kind of ceremony, the Court nobles at the capital vying with each other in organizing magnificent gatherings for the

---

[1] The designs of these rolls are reproduced in the local history of the island, the *Itsukushima-zue* (嚴 島 圖 繪, illustrated block print published in 1842); one of these illustrations is inserted in L. GONSE, *L'art japonais* (Paris 1883), page 156.

viewing and criticizing of scrolls, and holding contests in calligraphy and painting. [1] These meetings may be called the beginnings of Japanese connoisseurship.

It would seem that in the earlier part of the Fujiwara period Buddhist representations occasionally were mounted as hanging scrolls. The Buddhist sect that at that time overshadowed all others was Shingon (Chinese *Chên-yen* 真言), the Sino-Japanese version of the Indian Mantrayâna.

Early religious hanging scrolls.

Now in the Shingon ritual an important place is taken by the *mandara* (曼茶羅, Sanskrit *maṇḍala*), mystic maps [2] which were only displayed on special occasions. Some passages in contemporary Japanese literature would seem to imply that these *mandara* often were mounted as hanging scrolls.

Further each of the countless deities of the Mantrayânic pantheon had to be worshipped according to its own special ritual;[3] therefore, although the altar remained largely the same, the image of the deity displayed there and some accompanying representations had to be continually changed. There are indications that such images were mounted in banner style, a way of mounting that facilitated frequent changing.

In 1941 I examined in a private collection at Kyōto a Buddhist scroll that during the Kamakura period was remounted according to early Fujiwara style. The mounting of this scroll was entirely composed of silk strips, sewn together, no paste or paper entering the process. The original, painted on rather course silk, was surrounded by five narrow silk borders representing the five colours, each a little broader than the one nearest to the painting, and overlapping each other along the seams. To this quintuple border there was sewn on a " frame " of heavy gold brocade, and on top and below a *t'ien* and *ti* of thick embroidered silk were added. The entire scroll was loosely backed with several sheets of pink silk, stitched on along the borders. The lower roller was very thick, and the protruding knobs were covered with thin copper plate, heavily studded with coloured stones. The upper stave, made of cedar wood, was thinner than usual, and loosely inserted in a broad seam along the top of the mounting. As this stave could easily be pulled out, I doubt whether this was the original one. The original stave could well have been made of some more pliable material like for instance bamboo, as is indicated by old terms for upper stave such as Chinese *ta-ya-chu* 打壓竹 or Japanese *osae-dake*

---

1) The *Genji-monogatari* 源氏物語, the famous Japanese novel of Court life during the 10th century, gives a detailed description of the ceremonies attending such an occasion; this is to be found in Chapter VIII, *E-awase* 繪合 *The Picture Competition* (cf. the excellent translation by Arthur Waley, in *The Sacred Tree*, the second part of the *Tale of Genji*, London 1926).

2) The essence of the Chên-yen doctrine is graphically expressed by a pair of *maṇḍala*. The one, called *Chin-kang-chieh* (金剛界, Japanese *Kongō-kai*, Sanskrit *Vajra-dhâtu*) represents the esoteric aspect of the cosmos, the other, called *Tai-tsang-chieh* (胎藏界, Japanese *Daizō-*

*kai*, Sanskrit *Garbha-dhâtu*) the exoteric aspect. These *maṇḍala* play an important role in Tibetan, Chinese and Japanese Buddhist art. Cf. Toganoo Shō-un, "Study of the Maṇḍala" (梅尾祥雲, 曼茶羅の研究, one illustrated volume, publ. Kyōto 1927); G. TUCCI, *Teoria e pratica del Mandala* (Rome 1949), and my book *Siddham, an Essay on the history of Sanskrit studies in China and Japan* (Nagpur 1956), p. 79 sq.

3) Cf. the discussions in my book *Hayagrîva, the Mantrayanic Aspect of Horse-cult in China and Japan*, Leyden 1935, page 81 sq.

押竹 (see above page 65).   Such a pliable stave would not have hampered this scroll, for its mounting was so stiff that when suspended it would have hung straight also without a strong stretcher at the top.   It is doubtless to such mountings that refers the old Japanese term *dō-hyō* 幢褙 "banner mounting", and we may assume that the mounting of this particular scroll represents the transition from the Central Asiatic "banner mounting" to the later Chinese *kua-fu*.

That during the later part of the Fujiwara period Buddhist scrolls actually were mounted as hanging scrolls is attested by Japanese literary sources.   In the *Jinsha-ki* [1] it is said under the year 1166: "Right in the middle of the main building ... there was erected a Buddhist altar of black lacquer with inlaid silver designs, and there were hung the Mandara's of the Two Worlds, each one scroll".   From this quotation it appears that the Buddhist hanging scroll was used not only in temples but also during domestic religious ceremonies.

The Fujiwara, though fervent Buddhists, at the same time did not neglect Shintō rites.   Some of these rites included the exposition of mandara-like representations, like for instance the *Kumano-mandara* 熊野曼荼羅 , showing the Nachi waterfull 那智瀧, as a symbol of purification. [2]   It is, therefore, quite possible that at that time also during Shintō ceremonies hanging scrolls made their appearance.

Be this as it may, such materials only apply to religious representations mounted as hanging scrolls.   During the Fujiwara period the hand scroll still was the only of mounting used for all secular scrolls.

<p style="margin-left:2em"><b>The art of mounting during the Kamakura period.</b></p>

After the fall of the Fujiwara, the Hōjō founded the first Shōgunate, or military administration, at Kamakura 鎌倉 in East Japan.   This is the beginning of the Kamakura period, which lasted from 1183 till 1331.

The first hundred years of the Kamakura period about coincide with the Southern Sung dynasty in China.   During this time a number of Japanese priests visited China, and were much impressed by the splendours of Hangchow.   Returned to Japan, these Japanese priests propagated the tenets of the Ch'an school, together with the new artistic conceptions that were taught by this doctrine.

<p style="margin-left:2em"><b>Ch'an influence.</b></p>

These teachings were readily accepted by those in power at Kamakura.   The Kamakura warriors, although they were in full possession of political power — the Emperor at Kyōto leading a shadow existence — were well aware that measured by cultural stan-

---

1) For Mandara of the Two Worlds, cf. note 2 above. The text reads: 母屋中央立黒漆平文佛臺。奉懸両界曼荼羅各一鋪。The *Jinsha-ki* 人車記 is a collection of historical notes covering the period 1149-1169, by Taira Nobunori 平信範, who entered the priesthood in 1177.   The title is formed by taking elements from the author's personal name: 人 from 信, and 車 from 範.

2) Nishibori Ichizō (cf. Appendix I, no. 72) suggests that the famous painting of the Nachi Waterfall by Kose Kanaoka (巨勢金岡, 9th century) actually is an example of such a Shintō *mandara;* this is an interesting theory, although it will be difficult to prove it.

dards they were inferior to the powerless but refined Court nobles in W. Japan; the latter indeed considered Kamakura as a center of upstarts and ignorant swashbucklers. The Kamakura nobles saw that by adopting the new Chinese ideals imported from Hang-chow, they could enhance the prestige of Kamakura by making it the center of a new culture.

The shōgun, therefore, encouraged Chinese priests to come to Japan and at Kama-kura built for them several Ch'an monasteries. In 1253 the Kenchō-ji 建長寺 was erected, and in 1282 the Enkaku-ji 圓覺寺, in as pure a Sung style as the Japanese materials permitted. [1] The shōgun appointed als first head of the Enkaku-ji the Chinese Ch'an master Tsu-yüan (祖元, 1226-1286; arrived in Japan 1279), a great scholar round whom there soon gathered a wide circle of eager disciples.

It was these Chinese Sung priests who introduced the secular hanging scroll into Japan.

<div style="float:right">Secular representations mounted as hanging scrolls.</div>

The Chinese Ch'an interiors were the ideal after which the Kamakura warriors sought to shape the interior decoration of their mansions. They themselves lacked artistic background and their domain lacked settled guilds of skilled artisans that worked accor-ding to a century-old tradition; they knew quite well, therefore, that they could never hope to emulate the glamour of the Western capital. The Ch'an teachings, however, enabled them to create a new art of considered simplicity, that in the end was to prove superior to the dazzling display of Kyōto Courts and palaces.

The Buddhist clergy having started to mount secular pictures as hanging scrolls, the Kamakura nobles followed this example. As yet, the Japanese house provided no suitable place for exposing secular hanging scrolls. It was only during the next period that with the development of the *toko-no-ma* the hanging scroll could fully unfold its decorative possibilities.

Next to the mounted secular hanging scroll at this time another Chinese culture-good was imported into Japan: tea, and the art of drinking it. [2] During the following centuries this art, narrowly connected with Zen, would exercise a decisive influence on cultural life in Japan.

---

1) Although part of the Enkaku-ji was destroyed in 1923 by the Great Earthquake, several of its buildings could be restored in their old form. Especially the Shari-den 舍利殿, a building containing a tooth of Buddha brought over from China, is said to represent pure Sung architecture. In this temple there are preserved a number of valuable antique Chinese paintings.

2) In Chinese poems and essays written by Japan-ese of the Heian and Fujiwara periods one occasionally finds expressions like *yin-ch'a* 飲茶 "drinking tea", *chien-ch'a* 煎茶 "brewing tea", etc. This fact does not imply, how-ever, that at that time tea was actually drunk in Japan; such expressions are merely figures of speech borrowed from Chinese literature (cf. my discussion in *The Lore of the Chinese Lute*, pp. 201-202). At that time tea was not yet planted in Japan; if during Buddhist ceremonies occasion-ally tea was brewed then the dried leaves had been imported from China. When in 1191 the Japanese Ch'an priest Eizai (榮西, also called Senkō-soshi 千光祖師, 1141-1215) returned to Japan from his second visit to China, he brought seeds of the tea plant with him and these were plan-ted in Kyūshū, later also near Kyōto. In 1214 Eizai wrote the *Kissa-yō-jō-ki* 喫茶養生記 in which he explain-ed the beneficial influence of tea drinking; this is the real beginning of tea and tea drinking in Japan.

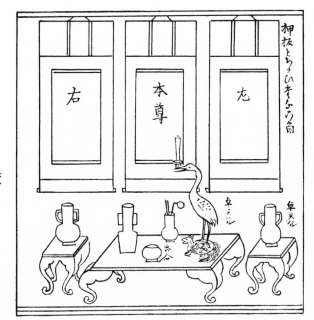

The Ashikaga period: development of interior decoration.

91. – TOKO–NO–MA DEPICTED IN THE *GO–SHOKU–KI*

After the Mongol invasion had brought the intercourse with the continent to a stand still, the Sung influences had time to mature and to penetrate Japanese life, also outside Kamakura and the other centres of the shōgun's power.

Thus, when the Ashikaga shōgunate (足利, 1331–1573) was founded, the Ch'an conception of art had come to be an important factor in Japanese artistic life. The amalgamation of these new ideas from China with the Japanese traditional conception of art was further promoted by the removal of the shōgunal capital from Kamakura to Kyōto. There the Kamakura culture merged with the old Court traditions, and gave rise to a style that has remained famous throughout Japanese history. The esthetic ideals of the immigrant Chinese priests supplied the foundation upon which to the present day the rules for Japanese interior decoration still rest.

The toko-no-ma. Origin.

The Japanese interior, justly famous for its austere beauty, developed from the so-called *shoin-zukuri* 書院造. This style of building, dating from the Ashikaga period, aimed at adapting Ch'an esoteric principles to domestic requirements. It was as a result of these attempts that originated the *toko-no-ma*, the niche that to-day still is the most characteristic feature of a Japanese room [1] (see Plate **107**, and the discussions on page 28–30 above).

In Kamakura and early Ashikaga interiors there were found the so-called *oshi-ita* 押板, narrow tables resting on feet of a few centimeter high; on these tables were placed weapons, writing implements and other utensils, or some simple ornaments. Next to the *oshi-ita*, there came into use also more elaborate stands, the so-called *tana* 棚: a kind of cupboards consisting of open shelves, alternating with closed lockers. These pieces of furniture were combined with the decoration of the Ch'an room: domestic interiors showed the mounted hanging scroll, and thereunder the *tana* or *oshi-ita*, with a few decorative objects placed on it. This semi-religious, semi-secular arrangement is the origin of the later *toko-no-ma*.

[1] It may be remarked in passing that the term *toko-no-ma* itself is much older than the architectural feature later called by this name. It means literally "bed-space" and in hoary antiquity must have referred to a kind of recess in the backwall of the house, actually used for sleeping. Cf. the discussion in MORSE, *Japanese homes and their surroundings*, pp. 329–330.

The Ashikaga shōguns were notorious lovers of pomp and magnificence. While the economic structure of the country was growing weaker by the day and the peasantry was sinking in unbelievable misery, the shōgun spent millions on erecting extravagant buildings and on the accumulation of rare works of art. As the military and the Court nobility strove to follow the example set by the shōgun, the Ch'an element in interior decoration soon was drowned in a multitude of ostentatious adornments. Thus the primordial *toko-no-ma* described in Ashikaga literature do not seem to have been very satisfactory from an artistic point of view: neither the arrangement on the picture preserved in the *Go-shoku-ki*, [1] nor those appearing in the *Kundaikan-sayū-chōki* [2] can be called tasteful creations. Plate **91** is a sketch of a *toko-no-ma* occurring in the *Goshoku-ki*. Below the three scrolls hung against the back wall stands a low table bearing a candlestick in the shape of a stork, an incense box, a vase, and a container with sticks of incense and a spoon for smoothing the ash. On either side of the table one sees a flower vase on a separate stand. Plate **92**

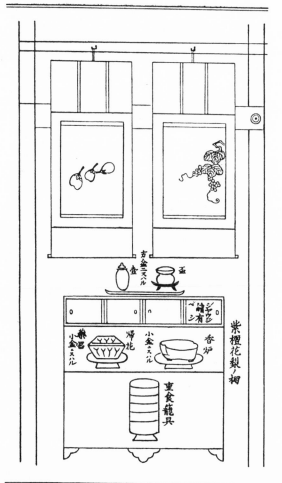

92. – TOKO–NO–MA DEPICTED IN THE
*KUNDAIKAN-SAYU-CHŌKI*

shows an alcove described in the *Kundaikan-sayū-chōki*. Below a pair of scrolls stands a low cupboard with two open shelves, and compartments with miniature sliding doors.

After the development of the *toko-no-ma* had supplied also the secular Japaneseinterior with a place suitable for displaying hanging scrolls, this form of mounting gradually became more and more popular. While the Fujiwara period may be called the heyday of the hand scroll, the Ashikaga period witnessed the first great flourishing of the hanging scroll.

The pictures of the *toko-no-ma* preserved in the two books mentioned above, though probably more or less modified by later hands, still are most instructive as regards the art of mounting during this period. They show that it had become customary to expose three hanging scrolls together. The middle one was called *hon-zon* (本尊, literally

1) Cf. Appendix I, no. 65.　　　　　　　　　2) Cf. Appendix I, no. 64.

" main deity ", and often indeed a religious representation), and those on left and right *waki-e* 脇繪 " side pictures ". These hanging scrolls were mounted with *ichi-monji* of brocade, while also the " frame " was made of some figured material. It should be noted that these mountings lack both upper and lower *ko-chieh*.

**Influence of the tea masters.**
Now the tea ceremony had become an important factor in Japanese life; it was considered as the epitome of culture and refinement. The experts in this art, the tea masters, were mostly Ch'an monks; they formed the bridge connecting monastic and secular life, they were the moral and esthetic mentors who showed how Ch'an principles could be applied to the conduct of the layman, to his way of living and to the decoration of his house. The tea masters formulated rules that regulated both social manners and interior decoration, and few dared to challenge their authority.

As to the arrangement of the *toko-no-ma*, the tea masters insisted that the scrolls there exposed should be changed according to the season. Each nobleman, therefore, who wished to give the main rooms in his mansion an elegant appearance, had to possess a fairly large collection of hanging scrolls. This increasing demand for hanging scrolls contributed to the development of this style of mounting in Japan.

**Ashikaga Yoshimitsu. Popularity of Chinese hanging scrolls.**
The shōgun Yoshimitsu (足利義滿, 1358-1406) had gone to great trouble in order to obtain a re-establishment of the diplomatic relations with China. He was badly in need of funds for the gratification of his extravagant tastes and the China trade had always been a gold mine for those in power in Japan. In China in the mean time Chu Yüan-chang (朱元章, 1328-1399, reign name Hung-wu 洪武) had ousted the Mongols and in 1368 had proclaimed himself the first Emperor of the Ming dynasty. China whose coasts were continuously harassed by Japanese pirates, at first was reluctant to accept the Japanese proposals. Finally, however, the Ming Emperor consented to send an embassy to Japan. Yoshimitsu received this Chinese mission with great pomp in the *Kinkaku-ji* 金閣寺, the " Golden Pavilion ", [1] a magnificent abode that he had built to the North of Kyōto. The Chinese mission was mollified by Yoshimitsu's hospitality, while moreover the fact that the shōgun showed that he considered himself a vassal of the Chinese Emperor did much to ease the negotiations. Thus the relations with China were resumed. There was appointed a *Kara-fune-bugyō* 唐船奉行 " Chinese vessel official " charged especially with supervising the trade with China, and the port cities of Kyūshū (that all along had maintained a thriving smuggling trade with the continent) now became the centres of a brisk China trade. [2] From Kyūshū the Chinese antiques were transported to Kyōto were they fetched fabulous prices among the new nobility.

Chinese hanging scrolls were greatly sought after. The shōgun himself set the example by accumulating in the Kinkaku-ji an extensive collection of Chinese paintings;

1) The Kinkaku-ji was destroyed by fire in 1951, but the Ginkaku-ji (see next page) is still preserved together with its beautiful garden.

2) Cf. the discussion of the Japanese trade relations with China, in Chapter I of the Second Part of the present publication.

a list of these has been preserved in the *Kundaikan-sayu-chōki* (cf. Appendix I, no. 64). These scrolls were discussed and criticised at elaborate meetings there organized, where famous artists and tea masters engaged in contests in judging incense and appreciating tea.

This example was followed by Yoshimitsu's grandson, shōgun Yoshimasa (足利義 政, 1435–1490). To the East of Kyōto Yoshimasa built the *Ginkaku-ji* 銀閣寺 "Silver Pavilion" and there tried to outdo his grandfather in lavish entertainment of painters, poets and tea masters. The artistic aspirations of the Ashikaga shōguns were guided by the so-called *San-ami* 三阿彌 the "Three Ami's", viz. Nō-ami 能阿彌, his son Gei-ami 藝 阿彌, and his grandson Sō-ami 相阿彌; all three were famous as painters and calligraphers and, above all, as eminent masters of the tea ceremony. As tea masters they were considered as the highest authority in all artistic matters. Each of them became an *arbiter elegantium* whose judgement was deemed beyond questioning. They used to keep notes of the artistic gatherings organized by the shōgun, recording which scrolls were displayed on each occasion, in what order they were hung, how they were mounted, what objects were shown together with the scrolls, etc.; these notes were copied out again diligently by their disciples who considered these texts as indisputable canons of artistic refinement. Some of these collections of notes have been preserved in manuscript form, others were published as block prints. Best known among the books of this kind that emanated from the Ami-trio are the *Kundaikan-sayū-chōki* and the *Goshoku-ki* mentioned above.

A later work, the *Kissa-nambō-roku* (cf. Appendix I, no. 66) says that Sō-ami divided the correct styles of mounting hanging scrolls into three types. These he designated by the three Japanese esthetic criteria *shin* 真 "formal", *gyō* 行 "ordinary", and *sō* 草 "informal"; these terms, originally borrowed from Chinese calligraphy, in Japan are employed for classifying various artistic creations, such as paintings, garden landscapes, flower arrangements etc.

The *shin* type of mounting resembled the type that later was designated as *shinsei-hyōgu* 神聖表具 (see Plate **99** A), and that is generally called *butsu-jitate* "Buddhist mounting". In this type the picture itself is surrounded by an "inner frame" of two or more narrow seams; Sō-ami called it *hyō-hoè* 裱褙, the Chinese term for mounting in general. The *gyō-type* resembled the later *honzon-hyōgu* 本尊表具 (see Plate **99** B), and was called *dō-hoè* 幢褙 "banner mounting". The *sō-type* was a simple style of mounting, the picture being surrounded by a one-coloured frame and lacking *ichi-monji*; Sō-ami called this type *rin-hoè* 輪褙 "all-round mounting", but later it was called *chūzon-hyōgu* 中尊表具 (see Plate **99** C).

These three styles of mounting hanging scrolls must be considered as a combination of newly-imported late-Yüan styles, and the Sung style that had been previously introduced into Japan by Chinese Ch'an priests of the Kamakura period. Both the *shin* and *gyō* type would seem to derive from the archaic "banner type", while the *sō* type might represent the influence of Yüan mountings.

Ashikaga Yoshima- sa. The Ami trio.

Sō-ami's classifica- tion of hanging scroll mountings.

243

During the Ashikaga period the mounting of hanging scrolls developed into a highly specialized art. For this work there were now needed skilled artisans. While the mounting of Buddhist sûtra–rolls still remained in the hands of the clergy, the mounting of secular scrolls was entrusted to lay artisans.

When Fujiwara Takakane (藤原隆兼, early 14th century) painted his famous twenty pictures of contemporary artisans, he represented the mounter as an elderly priest assisted by a novice (see Plate **93**). And the *Shichijūichiban–shokunin–uta–awase* 七十一 番職人歌合, compiled round 1500, under the heading *kyō–ji* 經師 "mounter" still shows a black–robed Buddhist priest working on the mounting of a hand scroll (see Plate **94**). Other Ashikaga sources, however, describe the lay mounter, called *hyō– hō–shi* or *hyō–hoè–shi* (written 裱褙師, 表補衣師, or 表補繪師). This *hyō– hoè–shi* is the fore–runner of the *hyō–gu–shi* 表具師, the Japanese professional mounter.

Next to these *kyō–ji* and *hyō–hoè–shi* there were also the tea masters, many of whom preferred to make themselves the mountings for their favourite scrolls.

The Ch'an monk Ikkyū (一休, 1394–1481) who was famous as a tea master, painter and poet, devised simple hanging scroll mountings, using monochrome materials. Scrolls emanating from Ikkyū's brush and having his original mountings are valued very highly in Japan: in 1919 on an auction at Kyōto one scroll was sold for 45.000 Yen (at that time more than U. S. $ 21.000).

Also the celebrated tea master Shu–kō (珠光, real name Murata Shigeyoshi 村 田茂吉, 1421–1502) was famous for his scroll mountings. In the Konoye family 近 衛家 there is preserved a painting on silk, representing two herons among lotus leaves, and ascribed to the 10th century Chinese painter Hsü Hsi 徐熙. This painting still has the original Japanese mounting added by Shu–kō: for the front mounting there were used simple kinds of silk of various shades of brown; no *ichi–monji* are added, but to the upper stave there are attached two *fū–tai* of the same colour as the "frame".

Having thus followed the development of the Japanese art of mounting till the end of the Ashikaga period, we now again return to China, leaving a description of Japanese mountings of later times till after a survey of the Chinese art of mounting during the Ming period.

\* \* \*

The earlier part of the Ming dynasty was marked by a tendency to revive a purely Chinese culture.

The system of literary examinations was re–established in the same form as it had existed during the Hsi–ning period (熙寧, 1068–1077) of the Sung dynasty; the Ming rulers hoped in this way to rally the flower of Chinese scholarship under the new administration. Further the philosophy of Chu Hsi was made a kind of State Confucianism, the official doctrine of the Empire — probably also as a reaction to the Buddhist proclivities of the defeated Yüan rulers. In literary style a return to the "classical" Han standards was advocated.

244

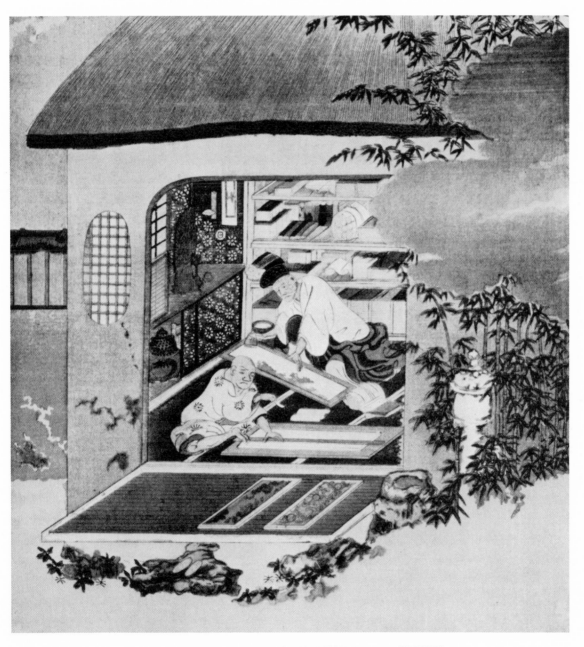

93. – JAPANESE MOUNTER OF THE EARLY 14TH CENTURY

94. – LEFT: JAPANESE MOUNTER, CA. 1500

It must be noted that most Ming scholars and artists saw antiquity, viz. the Han period and preceding centuries, as a kind of idealized version of their own time. Gradually an entirely artificial image of antiquity came into being that differs widely from what now is considered as the historical truth. It was generally assumed that antique Chinese culture was characterized by a simple grandeur, and that in order to revive this " classical " world one had but to remove some ornamental features of T'ang and Sung culture. Thus Ming pictures frequently depict Confucius sitting in a sparsely furnished Ming library and reading a printed stitched volume. There were a number of Ming scholars who realized the fundamental mistake of this official conception of antiquity, but to express such doubts was considered black heresy.

Ming interior decoration.

The tendency to return to imaginary classical standards affected Ming architecture and Ming furniture. House were built with lofty halls and high arched door openings, beams and pillars were made of solid logs of wood, without the lavish carvings that, partly under Indian and Central-Asiatic influence, had been popular since the T'ang dynasty. The aim was an austere beauty based on noble form rather than on intricate detail work. In this respect the purely Chinese " classicism " lead to the same results as the Ch'an teachings of the S. Sung period.

The striving after unadorned beauty is also apparent in the furniture of the Ming period. In the carved details of the substancial blackwood chairs, tables and couches especially of the early years of this dynasty one recognizes decorative motifs directly copied from the faultless Chou and Han bronzes.

Although now the wall had become the predominant element in domestic architecture the screen remained popular, more as an embellishment of the interior than as a means for partitioning room space. Since the pasting technique was making great progress we now find large pictures on silk and paper mounted in the form of screens.

Plate **95** provides a good example of such a large Ming screen, a landscape painting mounted on three panels. It will be noticed that the mounting of this screen differs widely from that of later pictorial screens of the Ch'ing dynasty (see Plate **15**), but resembles closely the Japanese *byō–bu* depicted on Plate **16**. As a matter of fact the Japanese folding screen has till the present day preserved the old Chinese style of screen mounting while in China itself this type of mounting developed into a new type.

Next to these silk and paper screens also the antique solid wooden screen decorated with carving or inlaid with plaques of jade, marble or porcelain was widely used. These stiff screens too were made ever larger in size so as to adapt them to the high and spacious rooms and halls of the Ming dwelling house.

Early Ming mountings.

During the Ming dynasty the hanging scroll was promoted to the predominant position in interior decoration which it has held ever since. This promotion brought about a modification of the style of the hanging scroll.

It seems that in the early years of the Ming dynasty mounters evolved more elaborate front mounting for hanging scrolls in order to make them a more effective wall decoration.

As was explained above, during the Yüan dynasty the front mounting of the hanging scroll consisted of four horizontal strips, viz. *t'ien* and upper *yin-shou* above the picture, and lower *yin-shou* and *ti* below. The left and right side of the picture were protected only by a narrow seam. Pictures mounted in this manner would, when hanging on the wall, easily become soiled or torn along the sides, and these parts were unprotected against insects, mould and dampness when the scroll was left stored away.

It was probably chiefly in order to eliminate these risks that now a new type of front mounting came into use where the pictures was surrounded on all four sides by a " frame ". The strips of mounting forming the top and bottom of this " frame " had the traditional proportion of 2 : 1, those on the left and right were as a rule of the same breadth as the lower strip. Along the inside of the upper and lower strips of this " frame " and directly adjoining the picture, a kind of miniature *yin-shou* were added. As we saw in Chapter II, these are called *ya-tzŭ* in the mounter's jargon of the Ch'ing period, while in Japan they are known as *ichi-monji* (cf. Plate **30**, nos. 6 and 7).

The *ching-tai*.      It would seem that about the same time the *ching-tai* 經帶 in their double roll of fastening bands and suspension loop were replaced by a cord connecting the two rings of the upper stave, to which was sewn a single narrow band of about two feet long. The cord served to suspend the scroll, the band was wound round it when rolled up; the technique of mounting had made such progress that it was not any longer necessary to have two fastening bands for keeping the scroll rolled up tight.

Although the *ching-tai* thus were not used any more for suspending and fastening the scroll, in deference to tradition they were retained as ornaments in the simplified form of two narrow bands hanging down perpendicularly across the *t'ien*. However, the place where they were attached to the upper stave, viz. directly beneath the rings, indicates their original function when they were still longer and broader, and sewn on to these rings.

This new type of mounting described above was introduced into Japan in the early part of the Ming period when Sino-Japanese cultural relations had been resumed after the temporary break of the Yüan dynasty; in Japan this type has remained till modern times the most common one of hanging scroll mounting (see Plate **7**). When the scroll was displayed on the wall the *ching-tai* were dangling over the *t'ien*, and when it was rolled up they were folded along the upper stave. In China, however, the loose *ching-tai* were later pasted down on the *t'ien*.

It is difficult to determine the exact time when Chinese mounters started to stick down the loose *ching-tai*. Chinese writers, when describing objects they saw and used daily, usually took it for granted that future readers would be as familiar with the shape and appearance of these objects as they themselves, and that the objects concerned would

246

95. — CHINESE LIBRARY

Ming painting in colours on silk. (Freer Gallery of Art, no. 11. 486)

always retain the same shape and appearance. An early Ming author accepted the fact that the *ching–tai* on the scrolls he saw were hanging loose as quite natural and would not mention this feature when describing them. Neither would it occur to those writing at the time when the *ching–tai* were always pasted down to make special mention of this fact.

The late–Ming writers Wên Chên–hêng (see App. I no. 30) and Chou Chia–chou seem to have known only pasted down *ching–tai*; in their time, therefore, this custom must have been firmly established already. Probably the change was gradually effected between 1400–1450, soon after the *ching–tai* had been reduced to mere ornaments; this would agree also with Japanese data.

The Korean *chok–cha* described on page 178 above represents perhaps an intermediary stage. It has a pair of *ching–tai* that hang down loose across the *t'ien*, but next to them there are suspended from the upper stave two ornamental tassels.

In Chapter I mention was made of the *tui–lien*, the antithetical couplets written on a pair of long, narrow scrolls, that are such a characteristic feature of interior decoration of the Ch'ing period and modern times.

Development of the *tui–lien*.

Although *tui–lien* displayed on the wall are mentioned already in Sung and Yüan literature, it was during the Ming period that they became an indispensable element in interior decoration. Here a few words may be inserted regarding the origin of this custom.

The *Yü–chu–pao–tien* 玉燭寶典 written by the Sui scholar Tu T'ai–ch'ing 杜臺卿 [1] quotes various older books on the custom of putting up on New Year's day tablets of peach wood, the so–called *t'ao–fu* 桃符, near the front door of the house. These tablets were supposed to frighten off evil spirits that might try to enter. This is explained by a reference to a giant peach tree — originally said to grow on a certain mountain but later localized in the Western Paradise of Hsi–wang–mu — under which two deities held watch and killed all evil spirits that dared to approach; these two deties were later promoted to *mên–shên* 門神, the well known door–gods the images of which are pasted on the front doors of houses all over China.

On these door gods, their names and their origin, there has grown up a considerable literature. There can be no doubt, however, that all myths and legends directly or indirectly connected with the peach tree rest on secondary interpretations. The origin of the evil–repelling properties of the peach tree lies in the sexual connotations of its fruit which go back to hoary antiquity. As a symbol of feminine fertility the peach stood for the forces of light and life that could dispel those of darkness and death.

It were doubtless the *t'ao–fu* that suggested the custom of hanging on New Years eve *ch'un–lien* 春聯 "spring scrolls" on either side of the front door; *ch'un–lien*

---

1) This work has not been preserved in China, but eleven of the original twelve chapters survive in an old Japanese manuscript copy. In 1943 the eleven manuscript rolls were published in a magnificent photographic reproduction by the Ikutoku Foundation 育德財團 of Viscount Maeda, as a part of the series *Sonkeikaku–sōkan* 尊經閣叢刊. The passage referred to here is found near the end of the first roll.

are auspicious words or phrases written in large characters on scrolls of red paper. Later when the inscriptions on the *ch'un-lien* became more and more elegant these antithetical couplets were transferred from the front door to the hall; they were mounted as hanging scrolls and suspended on either side of the *t'ang-hua*. In Chapter I it was pointed out that the place occupied by the *t'ang-hua* has a religious background, and thus scrolls of the auspicious red colour — which is also a symbol of light and life — and inscribed with felicitous phrases inviting luck and happiness for the house and its inmates were there exposed in the right place.

I agree with the Ch'ing connoisseur Liang Chang-chü (梁章鉅, 1775–1849) that the *ch'un-lien* are the precursors of the later *tui-lien*. [1] The *ch'un-lien* suggested a suitable means for introducing antithetical couplets — which constitute the basis of all Chinese poetry in the regular metre, and to a certain extent also of literary prose — in interior decoration. Written on long strips of silk or paper by skilled calligraphers and mounted as hanging scrolls, these *tui-lien* became a regular feature not only of the main hall but also of most other rooms in the Chinese house.

References to *tui-lien* in Sung and later literature indicate pairs of inscribed silk or paper hanging scrolls hung on the wall. The *tui-lien* mentioned in older literature were couplets carved in pillars or engraved on wooden boards. Both are used till the present day, although the latter, however skilfully they are often carved, are as a rule of less artistic quality than the former.

*Tui-lien* written on various kinds of silk and paper and in all sizes and colours figured largely in the Ming interior. During this period there also arose the custom of fashioning each character of the text of the couplet out of coloured porcelain, its strokes standing out in relief from a white plaque. These plaques are placed in their proper order in a wooden frame which is subsequently filled up with cement or lacquer so that only the raised characters show above the surface. They are usually made of white or blue porcelain, pink and red ones being rare and highly valued.

The "bag-type" hanging scrolls.

It was probably the slightly amateurish love of an imaginary antiquity mentioned above, together with lingering echos of Ch'an teachings, that brought into being an entirely different type of hanging scroll mounting, peculiar to the Ming period.

Some Ming connoisseurs seem to have taken it for granted that if some ornamental features of the common hanging scroll mounting were removed one would *ipso facto* have obtained the "antique model". Thus *t'ien*, *ti* "frame" and *ching-tai* were left out and the picture mounted with an enlarged "frame" of plain material (see Plate **110**). The only ornamentation of this austere type of mounting was occasionally a narrow seam of coloured silk added along the left and right sides of the mounting.

This type of mounting, known as *chêng-wa* 正挖, enjoyed great popularity towards the middle of the Ming dynasty. Many Ming scrolls, at that time imported into Japan

1) Cf. Liang Chang-chü's book *Ying-lien-ts'ung-hua* 楹 聯 叢 話, 12 ch. in 6 vls., published in 1840.

and preserved there together with their original Chinese mounting, are of this type. In Japanese it is called *mincho̅-shitate* 明朝仕立 "Ming dynasty mounting", or also *fukuro-hyo̅gu* 袋表具 "bag-type mounting" (cf. Plate **104**). Since most of these scrolls reached Japan from Ningpo, it may be assumed that at that time the Chekiang and Kiangsu mounters often mounted scrolls in this manner.

During the first half of the Ming dynasty the centre of Chinese culture was not located in the North — where too many Yüan influence was still lingering on — but rather in the East part of Central China, mainly in the provinces Chekiang and Kiangsu. Here the Southern Sung had held their Court in Hangchow and in this region, in Chin-ling (Nanking), the Ming dynasty now established its capital.

Chekiang and Kiangsu bristled with artistic and literary activities. It was here that the great early Ming artists lived and worked, and it was here that were found the most famous mounters.

Literary sources mention a Ming mounter T'ang Ch'ên 湯臣, a member of the T'ang family at Soochow that produced a number of prominent mounters. The *Fei-fu-yü-lüeh* 飛鳧語畧, written by the Ming scholar-artist Li Tung-yang (李東陽, 1447-1516) mentions that T'ang Ch'ên played a role in the scandal centring round the famous picture *Ch'ing-ming-shang-ho-t'u* 清明上河圖 painted by the Sung artist Chang Tsê-tuan 張擇端. Yen Shih-fan 嚴世蕃, the son of the notorious profligate minister Yen Sung (嚴嵩, 1481-1568) thought that he had acquired the original painting, but the father of the scholar Wang Shih-chên (see below, page 311) proved that it was a forgery; Yen Shih-fan was greatly mortified by this and later caused Wang Shih-chên's father to be executed. Some literary critics aver that thereupon Wang Shih-chên wrote the erotic novel *Chin-p'ing-mei* 金瓶梅 to take revenge on Yen Shih-fan whom he made the dissolute main character of this story. T'ang Ch'ên is mentioned as the mounter who was instrumental in producing the faked copy of the picture that caused the feud between the Yen and Wang families.

One mounter left a brief descriptive catalogue of the scrolls that passed through his hands. This was the Changchow mounter Sun Fêng 孫鳳 whose style was Ming-chi 鳴岐. The book he compiled is entitled *Sun-shih-shu-hua-ch'ao* 孫氏書畫鈔, 2 ch.; it was published in recent years by the modern bibliophile Sun Yü-hsiu 孫毓修. Unfortunately Sun Fêng tried to give his book a literary air; it does not say in what manner the scrolls described were mounted, although Sun Fêng was more than any one else qualified to give details about this subject. Neither does the book supply any data on Sun Fêng's career or the connoisseurs and collectors who patronized him.

According to the *Chuang-huang-chih* the most famous mounter in Soochow was Chuang Hsi-shu 莊希叔. Chou Chia-chou mentions him in chapters XXXIX, XL and XLI of his book, but beyond what is given there nothing is known about him. If, however, one takes into account the tenacity of family-tradition among the better classes of Chinese skilled artisans, it does not seem impossible that Chuang Hsi-shu was a

descendant of Chuang Tsung-ku 莊宗古, one of the mounters attached to the Palace in Hangchow during the Southern Sung Dynasty and mentioned on page 207 above.

Chou Chia-chou evidently was a great admirer of Chuang Hsi-shu: he not only warmly praises his noble character but also depicts him as an authority on the judging of antique scrolls. Kiangsu mounters of the Ming period often had a good knowledge of connoisseurship in general and played a not unimportant role in the artistic life of that time.

Unfortunately little is known about their life and work. Literary sources mention names like T'ang Han 湯翰, T'ang Chieh 湯傑, Ling Yen 凌偃 and Shu Sou 殳叟; to these applies the same remark as was made above with regard to mounters of the T'ang and Sung periods (see pp. 155 and 213): their names have become merely literary expressions for indicating a highly skilled mounter.

Later Ming mountings. Many hanging scrolls together with their original mountings of the 16th and 17th century have been preserved, and the 17th century scholar Chou Chia-chou has left in his *Chuang-huang-chih* a detailed description of the technique of mounting of that time. From now on, therefore, we leave the field of conjecture and we can in most cases limit our discussions to statements of fact.

The ample wall space offered by the Ming mansions asked for hanging scroll mountings that set off pictures against their surroundings. Their mountings, heretofore aimed mainly at strengthening and protecting the scroll and at its embellishment as a separate unit, now gained the additional function of link between scroll and interior; even smaller pictures had to be mounted in such a way as to form a wall decoration, adequate from both the practical and artistic point of view. I think that it was because of such considerations that mounters further expanded the surface of the front mounting.

We saw above that after the introduction of the "frame" surrounding the picture on all four sides, the old *yin-shou* were represented by two narrow strips directly above and below the picture and as broad as the picture itself. Now the old *yin-shou* were reintroduced as horizontal strips of mounting adjoining the "frame" running across the entire breadth of the mounting. During the Ch'ing period and also at present the miniature *yin-shou* inside the frame are called *ya-tzŭ*, and the other ones *ko-chieh* (see Plate **30** A).

While this addition — which was never adopted in Japan — already enlarged the surface of the mounting, it was expanded still further by increasing the size of *t'ien* and *ti*. Hence from now on the front mounting of small and medium size pictures takes up more space than the picture itself. This elaborate style of front mounting has remained popular in China till to-day and still is the most common one for medium pictures and autographs. Very small pictures have often the "bag-type" mounting, and large pictures a simpler type as reproduced on Plate **4**.

Mounters by now had learned to differentiate between various kinds of silk and paper suitable for being used as mounting material. But even this advanced knowledge

acquired by centuries of experimenting would not have been sufficient for enabling the mounter to paste so faultlessly together the component parts of the large hanging scrolls of this time if he would have had to depend on his table only. It was the introduction of the *chuang-pan* that made possible the ultimate perfection of the pasting technique.

The drying boards *chuang-pan.*

In Chapter II of the present publication the function of the *chuang-pan*, the boards hung on the wall where the mounted scrolls are left to dry, was described at length. It were these boards that enabled the mounter to make large mountings that although not thicker than one sheet of laminated paper yet will never warp or sag and always present a perfectly smooth surface.

When T'ao Tsung-i in 1360 drew up his list of " Thirteen Subjects of the Art of Mounting " the *chuang-pan* did not yet exist. Neither does the well known picture of a Japanese mounter's workshop by Fujiwara Takakane reproduced on Plate **93** show the *chuang-pan*. But when Chou Chia-chou in about 1600 wrote his *Chuang-huang-chih* he took it for granted that these drying boards were a regular feature of the mounter's atelier, and that every reader would be familiar with their appearance and their function. The *chuang-pan* must have come into use sometime in between those two dates.

It may be assumed that these drying boards developed gradually together with the expanding surface of the hanging scroll mounting. The comparatively small mountings of the Sung and Yüan periods, the total area of which took up much less space than the picture they were attached to (cf. the Yüan hanging scroll reproduced on Plate **88**) could be stuck together on the mounter's table. But when the front mountings grew larger and larger through the addition of the " frame " and of the *ko-chieh*, and through the broadening of *t'ien* and *ti*, while at the same time the materials used became ever more thin and fragile, large surfaces where the moist scroll could be left for weeks on end became a definite necessity.

We shall, therefore, not be wrong too far if we place the time that the *chuang-pan* had come into regular use in the middle of the Ming period, for instance between 1400–1500.

Excessively large scrolls of the Ming period.

It was not only the surface of the mounting that increased during the later half of the Ming dynasty; also the pictures themselves were made larger and often reached the size of the ancient murals.

Particularly painters who specialized in birds and flowers, artists such as Lin Liang (林良, circa 1500) and his contemporary Lü Chi 呂 紀 liked to do pictures of birds and flowers in full colours that measured more than two to three meter in height. Such paintings did well in the large halls of Ming houses, although one often obtains the impression that their decorative value exceeds their intrinsic artistic quality. Perhaps the *chuang-t'ang* by Hsü Hsi that were mentioned on page 179 above were not unlike the large scrolls painted by Lin Liang, Lü Chi and others of their school.

251

While the hanging scroll was developing into the most common canvas chosen by painters, calligraphers still preferred the hand scroll as their medium of expression; when they desired to write texts in large characters they utilized the *tui–lien* or the horizontal tablet.

Towards the middle of the Ming period, however, calligraphers started to write longer texts in large characters meant to be mounted as hanging scrolls. It is from this time that date the huge autographs written by talented calligraphers such as Chang Jui–t'u (張 瑞 圖, flourished circa 1600), measuring more than three meters in height and where each character is often two foot square.

These autographs in large characters are among the finest examples of Chinese pictorial art. They present a combination of abandon and controlled strength that was the secret of Ming calligraphers; there were only very few Ch'ing artists who in this field could compete with the masters of the Ming period.

Measurements of Ming paper. Artists who wished to paint excessively large pictures or write very large characters found a suitable canvas in the large sheets of paper that were manufactured during the later half of the Ming dynasty.

Although literary sources give detailed descriptions of paper manufacture and long lists of the names of various kinds of paper, they supply scant information on the size of the sheets produced. Yet this point is not without importance for the connoisseur. Artists would visualize their projected works in terms of the canvas at their disposal so that it is useful to know what sizes were easily available to them. All the more so since the size of paper sheets was more or less standardized; that of silk was much more diversified and differed greatly according to the size of the looms used in various localities.

As regards the measurements of early Ming paper I have not yet found dependable data. I had occasion, however, to examine blank sheets of later Ming paper in the shops of curio dealers and paper merchants in China and Japan. The following notes are based on these observations.

The most current sizes were " large " (*ta* 大), " medium " (*chung* 中) and " small " (*hsiao* 小). The first class is composed of heavy laminated papers, the second of thinner laminated papers, and the third of single papers. The three sizes are reproduced on Plate **96**.

A " large " sheet (Plate **96** A) measured 12 by 4 *ch'ih* and was used for excessively large pictures and autographs. When cut lengthwise each half could be used separately for a large hand scroll or horizontal inscription, or the two together could be employed for a pair of large *tui–lien*.

Medium sheets (B) measured 8 by 4 *ch'ih* and provided a canvas for pictures and autographs that though smaller than the " large " sheets was still larger than average. From one medium sheet one could make four sheets each measuring 4 by 2 *ch'ih* which offered a canvas suitable for both pictures and autographs.

Small sheets (C) measured 6 by 3 *ch'ih*. They were used for pictures and autographs that demanded paper of a finer texture than that of medium sheets. One sheet could be cut up into three narrow ones measuring 6 by 1 *ch'ih*, suitable for *tui–lien*. Each of these could again be halved so as to produce two sheets of 3 by 1 *ch'ih*, a size much favoured by Ming painters and calligraphers.

During the Ch'ing dynasty the three sizes described above were used only for the heavy *pi–chih* (cf. the sample in Appendix V, no. 12). The most common size of medium thick and thin paper produced during that period was 4 *ch'ih* 2 *ts'un* by 2 *ch'ih* (cf. Plate **96 D**).

96. – UNCUT SHEETS OF MING PAPER

Uncut sheets of Chinese paper are usually stocked in quires of about fifty sheets; when the sheets have been stacked the quire is folded three times along its breadth to make the quire easier to handle. During the Ming dynasty each sheet was first marked by impressing the seal of the mill in the lower left corner. After the sheets had been stacked and folded, a large seal of the mill, enclosed in an ornamental cartouche, was impressed on the side of the quire, on the surface presented by the overlapping top edges of the sheets. Such mill seals will occasionally come to light near the edges of Ming scrolls when they are remounted, and fragments of mill seals are frequently met with on the pages of books printed in the Ming dynasty. In the Ch'ing period small red seals with the name of the type of paper and the mill were impressed in the lower left corner of the reverse of each sheet; the custom of imprinting a large seal on the edge of the quire seems to have fallen into disuse.

It was customary to fold larger sheets lengthwise in two halves prior to stacking them so as to decrease the bulk of the quire. Those folds were apparently ironed: they are still clearly visible on some mounted scrolls. Most of the larger bird and flower pieces by Lin Liang and Lü Chi which I saw show this feature which among Chinese connoisseurs is usually referred to as " Ming fold mark ". It is visible i. a. on the photograph of a picture by Lin Liang measuring 6 ft. **2** in. × 3 ft. **3** in. reproduced on Plate XLIX of Waley's "Introduction to the Study of Chinese Painting" (cf. Appendix I, no. **2**).

A feature that distinguishes most later Ming hanging scroll mountings is the gradation in colour of the strips composing the front mounting. Although individual taste

Gradation in colour of the various parts of the front mounting.

253

and the fashion of the moment determine the choice of colours, there is one general rule that governs the gradation of the chosen colours in accordance with their distance from the picture or autograph itself.

Irrespective of what materials are selected for the front mounting, the strips adjoining the picture should have the deepest colour; those next should be paler, and *t'ien* and *ti* again be darker. Thus the *ya-tzŭ* are usually of multicoloured brocade, the frame of dark silk, the *ko–chieh* of white, or ivory coloured silk, and *t'ien* and *ti* of some dark material, sometimes even black.

This gradation of the colours in a hanging scroll mounting has been maintained till the present day.

Adjustment of the proportion of the strips of the front mounting. When in the preceding chapter we discussed the models of hanging scroll mountings described in the *Szŭ–ling–shu–hua–chi* it was pointed out that although the proportion of *t'ien* and *ti* is as 2 : 1, that of upper and lower *yin–shou* (i. e. the later *ko–chieh*) is nearer to 3 : 2.

This esthetic principle of adjusting the proportion of the horizontal strips in such a manner that the difference in width decreases as the strips approach the location of the picture itself was worked out further in the second half of the Ming period. Since that time the width of the horizontal strips of the front mounting shows roughly the following proportion:

$$t'ien : ti = 2 : 1$$
$$\text{upper } ko\text{–}chieh : \text{lower } ko\text{–}chieh = 3 : 2$$
$$\text{upper strip of frame : lower strip} = 4 : 3$$
$$\text{upper } ya\text{–}tzŭ : \text{lower } ya\text{–}tzŭ = 5 : 4$$

The relative width of the strips is adjusted according to the measurements of the picture. In some cases a very broad *t'ien* will produce a pleasing effect, in others a comparatively narrow *t'ien* will prove better; some pictures look well if surrounded by a narrow "frame", others appear to greater advantage in a " frame " composed of broader strips. Here the mounter lets himself be guided by his personal taste and preference. But whatever their breadth, the proportion between the upper and lower strips always conforms to the table given above.

It should be noted that this adjustment of proportion was never adopted in Japan. Hanging scrolls mounted in Japan follow the rule 2 : 1 for all the strips of the front mounting regardless of their proximity to the picture. The reason is that in Japan hanging scrolls are nearly always displayed in the *toko–no–ma* and consequently are hanging rather low, their roller being only two feet or so above the floor level. Thus the proportion 2 : 1 of the strips of the front mounting places the picture itself at a suitable height for being seen by an observer who is sitting on the floor mats in front. If, however, one suspends a Japanese hanging scroll higher up on the wall — as is the custom in China — it will be noticed that the picture itself seems too low in proportion to the surface of the mounting surrounding it, so that the entire scroll seems rather top heavy.

254

This fundamental difference between Chinese and Japanese hanging scroll mountings is demonstrated on Plate **7** where the two are shown side by side.

Knobs of Ming mountings.

In the preceding pages mention was made of the knobs of hand scrolls and hanging scrolls. We discussed the various materials used for making these knobs in the T'ang, Yüan and Sung periods and attention was drawn to the fact that the material of the knobs indicated the quality of the scroll they were attached to.

Ming connoisseurs devoted much attention to scroll knobs. The Ming scholar-artist Wên Chên–hêng, having described the elaborately decorated knobs of older mountings, then observes:

" Now these ancient types can not be used. You should make the rollers of your scrolls of pine wood, and the knobs either of rhinoceros horn, ivory, or cow horn; such may be decorated with carved motifs in ancient style. You should not employ red sandal wood, cabinet wood or cloisonné, for such knobs are vulgar. Hand scrolls should have protruding knobs; if small these may be made of jade. But you should on no account use flat knobs (that are level with the scroll). The fastening pins (attached to the bands of hand scrolls) should be made of rhinoceros horn or jade. I have seen pins made of Sung jade that were inserted for half of their length in the brocade band (for winding round the scroll); these were most remarkable ". [1]

It should be noted that the Ch'ing collector Chou Erh–hsüeh in his *Shang–yen–su–hsin–lu* often attacks Wên Chên–hêng's ideas although he does not mention him by name. In ch. IV he says for instance that protruding knobs should never be used for hand scrolls.

Among the Ming hanging scrolls preserved with their contemporary mounting one finds many with very elaborate knobs which connoisseurs had made to order; for instance knobs of blackwood with the name of the owner's library inlaid in silver thread, or cloisonné knobs inscribed with the title of the scroll. Other scrolls have knobs of white porcelain decorated with a blue motif suggested by the subject of the picture; flowers if the painting they belong to is a flower piece, a miniature landscape if the scroll is a landscape painting, etc. Fastidious collectors had sometimes even the year of accession indicated on the knob, represented by its two cyclical signs.

It should be remembered, however, that knobs are easily taken off so that detached pairs of Ming knobs are often found in curio shops. Hence the fact that a hanging scroll has knobs of the Ming period is no guarantee that it was mounted in that dynasty.

Artistic trends in the second half of the Ming period.

The earlier half of the Ming dynasty was marked by a revival of Chinese culture, inspired by the reassertion of national consciousness after the period of alien rule. This revival led to an extensive stock-taking of Chinese culture, including a re-examination

---

1) *Chang–wu–chih* (cf. Appendix I, no. 30): 今
軸。形 製 既 小。不 妨 以 寶 玉 爲 之。斷
既 不 能 如 舊 製。只 以 杉 木 爲 身。軸
不 可 用 平 軸。籤 以 犀 玉 爲 之。曾 見
用 犀 象 角 三 種。彫 如 舊 式。不 可 用
宋 玉 籤。半 嵌 錦 帶 內 者 最 奇。
紫 檀 花 梨 法 藍 諸 俗 製。畫 卷 須 出

255

of the artistic records of the past.   In the last hundred years of the Ming period the various trends and traditions that composed the artistic heritage of the nation were welded into an impressive unity that must probably be considered the apex of Chinese cultural achievement.

Gifted artists found in the process of cultural integration inspiration for evolving new artistic trends, the influence of which was felt throughout the succeeding Ch'ing dynasty and which is still evident in the China of to-day.

The centre of artistic activity was the region usually designated as *chiang-nan* 江 南 " South of the Yangtse River ", comprising the southern half of Kiangsu and the northern part of Chekiang Province.   In Chinese literature this region is also referred to as Wu-yüeh 吳 越, a combination of the old names of those two provinces.

The artistic fame of Chiang-nan dates from long before the Ming dynasty.   The T'ang writer Chang Yen-yüan says: " In Chiang-nan the land is rich and without dust, and most of its people are proficient in the fine arts " (*Li-tai-ming-hua-chi*, ch. 3, third section: 江 南 地 潤 無 塵。人 多 精 藝).   It received an enormous influx of famous scholar-artists and skilled artisans from all over the Empire when in 1127 the Sung court moved to Hangchow.   When the newly-founded Ming dynasty established its capital in Nanking there was a new influx of talent and the region retained its attraction even after 1421 when the Ming capital was removed to Peking.   Then Chiang-nan became a haven of refuge for all high-minded and scholarly persons who wished to devote themselves to literary and artistic pursuits in an agreeable climate and far from the political strife and Palace intrigues that centred in the northern Metropolis.

These scholars and artists formed among themselves a number of small, exclusive " cercles " where the study of beauty and elegant living was elevated to a veritable cult.   It is from these circles that emanated most of the manuals for the furnishing of the elegant scholar's library; I mention the *Chang-wu-chih*, *K'ao-p'an-yü-shih* and other books of that kind.

It is here not the place to go further into the manifold artistic activities that marked that region in that particular period, [1] or mention the galaxy of great writers and artists who lived and worked then and there, or the wealth of the collections built up by contemporary connoisseurs.   I only refer in passing to the interesting record of an exhibition of antiques organized in 1570 by the four great clans of Kiangsu Province.   A list of the objects exhibited there is preserved in Chang Ying-wên's *Ch'ing-pi-tsang* (cf. Appendix I, no. 31); among the scrolls we find Ku K'ai-chih's well known picture of the Admonitions to the Court Ladies.

Although the elegant amateurs of Chiang-nan lacked a critical approach in their art-historical discussions, they made a careful study of practical aspects such as the art of mounting, and the place of the mounted scroll in interior decoration.   We shall see below that it was in these surroundings that the *Chuang-huang-chih* was written.

1) Cf. *Erotic Colour Prints of the Ming Period*, vol. I, Introduction, pp. XIII-XVI.

It was also in Chiang-nan that lived the great mounters who were mentioned above, and it was there that developed some new trends in interior decoration that engendered new styles of mounting.

In 1635 Chi Ch'êng 計 成, a native of Wu-chiang near Soochow wrote his *Yüan-yeh* (園 冶, cf. Appendix I, no. 32), a manual for garden architecture including the building of pavilions and country houses. He placed on record countless designs for lattice work, rustic doors and windows, ponds, rockeries etc., codifying an artistic tradition that had gradually developed in the preceding centuries. New trends in interior decorations.

His work was amplified by a man who remoulded the records of the past according to his own original and often brilliant ideas. This was the scholar, poet and playwright Li Yü.

Li Yü 李 漁, better known by his style Li-wêng 笠 翁, lived from 1611 to 1680. [1] He worked in and around Hangchow, later also in Nanking.

His very names indicate the personality of this remarkable man. His personal name Yü means "fisherman", and his style Li-wêng means "Old man with a straw hat". Both appellations immediately suggest that favourite subject of Chinese painters and poets: a high-minded recluse living in the mountains who passes his days with fuel gathering and fishing, aloof from all worldly care and ambition. Li Yü viewed the vicissitudes of life — and his was particularly rich in these! — in the same detached way as a mountain recluse. That at the same time he was a famous gastronome and a notorious bon-vivant is no contradiction; for has it not been said that it are only those who are aware of spiritual values that can fully enjoy material pleasures?

In Li Yü all traits that characterized the typical Ming scholar found full expression. In his literary works he has summed up the Ming theories regarding a harmonious life, a way of living that aims at effecting a combination of beauty and comfort.

Li Yü lived in about the same time as Chou Chia-chou, the author of the *Chuang-huang-chih*. Since he was Chou Chia-chou's contemporary, Li Yü's theories about the art of mounting, and about the roll of mounted pictures in interior decoration are not yet noticeable in the *Chuang-huang-chih*. But Li Yü's theories have exercised a decisive influence on Chinese artistic life of subsequent centuries, while his teachings became also popular in Japan.

Li Yü devotes in his collected works [2] a special chapter to the home of a man of taste. This chapter, entitled *Chü-shih* 居 室 "The Dwelling", in reality is a collection of essays on interior decoration. Reading through those pages one sees Li Yü as a man Li Yü's influence.

---

1) For an excellent biography of Li Yü the reader is referred to E. C., page 495. Li Yü's personality has been aptly described by Lin Yü-t'ang in his book *The Importance of Living*, New York 1937.

2) Best known is the *Li-shih-i-chia-yen* 李 氏 一 家 言, preface dated 1672, publ. by the Chieh-tzŭ-yüan 芥 子 園, the famous "Mustard Seed Garden". Collections of Li Yü's plays and minor writings are fairly rare; cf. the bibliography in E. C., loc. cit.

who had a veritable passion for beauty.   In his zeal to beautify especially daily life and man's ordinary surroundings, he forcibly reminds one of William Morris: both aimed at the achievement of a simple, natural beauty, both had, although along different ways, come to the conclusion that those forms of applied art come nearest perfection that are in close harmony with nature.   It was Li Yü's aim to devise interiors that while giving man a comfortable shelter at the same time did not separate him and his works from nature outdoors.

Some critics remark unfavourably upon a few rather eccentric innovations in interior decoration proposed by Li Yü, such as, for instance, transforming a room into a huge bird cage; sometimes he seems to let himself be carried away by his imagination, and evolves ideas that he himself would probably not care to put into practice.   Further, the tendency to discard superfluous ornamentation in the interior is found already in the Ch'an teachings of the Southern Sung period, and Li Yü's general principles, therefore, were nothing new.   His theories, however, for beautifying one's daily surroundings by simple and natural means, and about living in closer contact with nature, struck a note that was new for this time and the echo's of which lingered on for centuries after he had died.

Li Yü gave much thought to the art of mounting and the place of the mounted scroll in interior decoration.

He was in close contact with mounters in the many cultural centers visited by him during his variegated career.   In the *Li–shih–i–chia–yen* there has been preserved a couplet which he wrote " improvised on the spot, for a mounter who asked me for a pair of antithetical phrases to be displayed in his workshop " 裱工乞聯信筆題此.  This couplet might be translated as: " If you despise the cheap fame of being an artisan who dazzles people by feats of specious skill, then you will soon obtain the lasting renown of being likened to a meritorious statesman ". [1]

Li Yü himself experimented with various methods for incorporating the scroll into interior decoration.   The third section of the chapter on " The Dwelling " mentioned above, is called *ch'iang–pi* 牆壁 " Walls "; here Li Yü discusses in detail the wall decoration of various parts of the house.   " The walls of your hall ", he says, " should neither be too bare nor too crowded.   Naturally there should be displayed a number of scrolls by great artists; such, however, should be harmoniously distributed over the wall space available, and such an array should show a thoughtfully arranged alternation (presumably of size or style of the scrolls.   Transl.) ". [2]

Li Yü is, as far as I know, the first Chinese author who advocates the use of " wall paper " in our Western sense of the word and who described this form of wall decoration in some detail.   Speaking about the decoration of the walls of a library, he recommends

1) 不肯讓人稱絕技。行將呼爾作功臣. Cf. the statement by the Ch'ing connoisseur Lu Shih–hua, quoted on p. 9 above.

2) *Li–shih–i–chia–yen*: 廳壁不宜太素。亦忌太華。名人尺幅。自不可少。但須濃淡得宜。錯綜有致。

258

to cover them with pasted on, tinted paper.  On such a papered wall he then pastes scrolls showing pictures or calligraphic specimens; this method he calls *hu–pi* 糊壁. In this passage he says that he prefers this method to hanging on the wall scrolls mounted in the ordinary way, complete with stave and roller.  "In my opinion", he says, " to paste scrolls directly on the wall (*shih–t'ieh* 實貼) is better than to mount them as hanging scrolls.  For if you use hanging scrolls mounted with stave and roller, each gust of wind that makes them sway to and fro will cause you anxiety lest great works of art might thus be damaged; scrolls pasted directly on the wall preclude this evil ".  [1]

Li Yü, however, seems to have been well aware of the fact that also the *shih–t'ieh* method, even when applied to a wall that has been previously papered, is not conducive to the preservation of scrolls.  A little later he observes: " You should on no account paste scrolls on a wall consisting of wooden boards.  For when these boards become dry, they will develop cracks, and these will tear the picture to pieces.  You should make square wooden frames, similar to the wooden frames of folding screens (see page 107 above).  The people of old, when designing things for practical use, decided upon their final shape only after frequent experiments.  Screens, therefore, they did not make of solid wooden boards; they gave them wooden frames (and stretched the scrolls over these) ".  [2]

Here Li Yü thus described a " tablet mounting ", mentioned on page 107 above. It is clear that this " tablet " method is much to be preferred to *shih–t'ieh*: both silk and paper scrolls will soon decay when being too close to the wall.  As was pointed out on page 73 above, one of the functions of the lower roller of a mounted hanging scroll is to permit the air to circulate freely between the scroll and the wall.

It would seem that neither Li Yü's idea of covering the walls with tinted paper, nor the *shih–t'ieh* method of pasting scrolls directly on the wall, ever became popular in broader circles.   In China one will occasionally see paper used for pasting over wooden walls or ceilings, but no one would think of pasting good paintings or calligraphic specimens directly on the wall; if one wants a decoration executed on the wall, one writes with a brush directly on the plaster, or paints in *fresco*.  In N. China plain white paper or thin silk is used for pasting over windows, and in South China such paper or silk window panes are not unfrequently decorated with small sized pictorial representations.  The first "China wall paper", imported into Europe during the 17th century, most probably in reality was no " wall paper " at all, but painted paper used for covering window–openings. Since these papers soon became extremely popular in Europe, Cantonese merchants started to manufacture " wall paper " especially for export.  The " Old Canton wallpaper " (forty rolls, each measuring 12 × 4 feet) brought over to America round 1770 by Robert Morris, for instance, was evidently made to suit Western interiors and Western taste.

*Wall paper in China*

1) Ibidem: 予 謂 裱 軸 不 如 實 貼。軸 搖。損 傷 名 蹟。實 貼 則 無 慮 風 起 動 搖。損 傷 名 蹟。實 貼 則 無 是 患。

2) Ibidem: 糊 紙 之 壁。切 忌 用 板。板 乾 則 裂。板 裂 而 紙 碎 矣。用 木 條 縱 橫 作 槅。皆 經 屢 試。而 後 得 之。屏 不 用 備 用。板 而 用 木 槅。即 是 故 也。

259

In the chapter following that devoted to the dwelling, Li Yü discusses various pieces of furniture, implements used for the tea ceremony, etc. Under the heading *p'ing-chou* 屏 軸 he makes a remark that is important for the history of mounting. After having pointed out that formerly each scroll, however small, was mounted separately, he adds that at the time of writing his book it had become a popular fashion to have a number of smaller scrolls mounted together; this method he calls *ho-chin* 合 錦. Thus we know that such mountings date from the end of the Ming period. Li Yü seems to have carried through this principle to its extreme; he describes, for instance, a screen plastered with a number of smaller scrolls. This mounting together of numerous pictures on one screen like a kind of jig-saw puzzle did not appeal to the general public in China, but in Japan it found more appreciation: Japanese folding screens with thirty or forty small pictures mounted on them are by no means rare. Mounting three or more small pictures together on one hanging scroll, on the contrary, is still very common to-day in China, while it does not seem ever to have appealed to Japanese connoisseurs.

In the chapter on " The Dwelling ", in the second section, entitled *ch'uang-lan* 牎 欄 " Windows and Balustrades " Li Yü proposes some highly original designs for windows. His discourses on this subject are written in a narrative vein, setting forth at length how he hit on these ideas. Since only one window-design has a direct bearing on the art of mounting, below I do not translate the entire passage but confine myself to a brief summary of Li Yü's principles.

Li Yü holds the view that windows should be more than just apertures in the walls for admitting light and air: they must be considered as forming part of interior decoration. He recommends, therefore, that when laying out a garden, one should take into account the various views obtained on it by looking through the windows of the house. When a window is opened one should behold a small group of rocks flanked by some slender bamboos, pine trees overshadowing a quaintly shaped stone, in short, such a part of the garden that in itself is a perfect piece of scenery. Such windows he calls *t'ien-jan-t'u-hua* 天 然 圖 畫 " Natural paintings ".

Developing this idea further, he advises to give the window such a shape that it forms a fitting frame for the view obtained through it. For instance, give the window the shape of an unfolded fan: when you look at this window, it will be as if there were displayed on the wall a picture painted on a fan. Should the view obtained through such a *pien-mien-ch'uang* 便 面 牎 " fan-shaped window " happen to be unsatisfactory, human skill may supply this deficiency by fastening for instance a blossoming twig of the cherry tree across the window opening.

Moreover, when choosing the place for a window you should take care that also when looking in through it from outside, the eye will meet with a pleasing corner of the interior; thus also when looking from outside the eye will meet a " natural painting ".

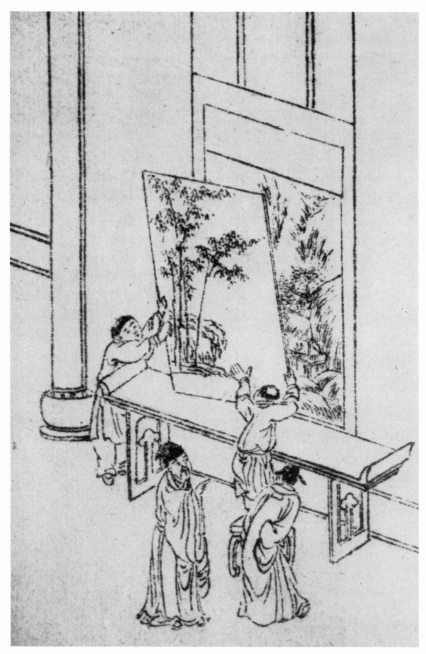

97. – "LANDSCAPE WINDOW" DEVISED BY LI YÜ

As a further perfection Li Yü suggested that a window giving on a charming corner of the garden should, on the inside, be made to resemble the front mounting of a hanging scroll. On the wall space round the window there should be pasted strips of paper or silk, representing the "frame" of a mounted scroll, and on top and below there should be added strips representing *t'ien* and *ti* (see Plate **97**). For closing such a window you should have a painting on silk of the right size mounted on a wooden frame (in the same way as a tablet mounting; see page 101 above), and fit this into the window opening. Then, also when the window is closed, the mounting on the wall will be complete. This invention of his Li Yü called *ch'ih-fu-ch'uang* 尺 幅 牕 "landscape window". [1]

From the fourth section of the chapter on the dwelling house, entitled *lien-pien* 聯 匾, "On antithetical scrolls and tablets", one learns how broad the interest was that Li Yü took in all questions regarding the embellishment of one's daily surroundings. Here he explains how, next to paper and silk, also wood, bamboo and other materials can be utilized for decorative inscriptions, with very little expense and striking results. He designed, for instance, antithetical couplets engraved in wooden boards shaped like banana leaves, or on the two halves of a bamboo split lengthwise; further inscribed wooden tablets, shaped like an unrolled hand scroll, like a stone tablet (white letters on a black ground), and other variations. [2] Models of such inventions are depicted on the illustrations included in the *Li-shih-i-chia-yen*. Since most of these devices have nothing to do with the art of mounting they are not further described here. I mention them in passing because there can be no doubt that the immense popularity of such inscribed vertical and horizontal wooden tablets during the Ch'ing period in China, and during the Tokugawa period in Japan, must be in part ascribed to Li Yü's influence.

Generally speaking Li Yü's teachings promoted the already existing tendency to mount hanging scrolls with simple materials. Further, the harsh pronouncements of Sung connoisseurs and Ming esthetes, condemning sumptuous mountings as typical of the vulgar taste of the profane crowd, by now had been so often quoted that people

---

1) *ch'ih-fu* in this term refers especially to a landscape painting. Cf. the expression *ch'ih-fu-ch'ien-li* 尺 幅 千 里 "a thousand miles contained in a canvas of one foot square".

2) Li Yü does not make special mention of inscribed wooden tablets having the shape of a *ch'in* 琴, the antique seven-stringed Chinese lute. During the Ch'ing dynasty inscribed wooden boards showing this shape were often used over doors, and they were hung also on pillars and doorposts, bearing antithetical couplets. To-day they are still frequently seen in Chinese houses, and they are considered as in quite good taste. The curious fact is, however, that in Japan such inscribed boards having the shape of the Chinese *ch'in*, are exclusively found at the entrance of low-class houses of prostitution, the *jorô-ya* 女 郎 屋; they are never seen in the more refined "tea houses" *cha-ya* 茶 屋 or *machi-ai* 待 合. Why this instrument, that in China has always been considered as a symbol of all that is unworldly and refined, in Japan should have become a sign board for the lowest class of prostitution, is a problem that deserves further investigation. It could hardly be because it is considered as a symbol of music and gaiety generally, for then the *samisen* 三 絃 or some other favourite instrument of Japanese female entertainers would have been the obvious choice. Moreover, the Chinese *ch'in* never was a popular musical instrument in Japan; cf. my *Lore of the Chinese Lute*, Appendix IV: "The Chinese lute in Japan". Could the custom go back to a prank of some ancient Japanese Sinologue, who was thinking of *ch'in-sê* 琴 瑟 "lute and cither" as a symbol of conjugal love? A search through *zui-hitsu* 隨 筆 of the Tokugawa period might elucidate this matter.

in general grew ever more diffident in having their scrolls mounted in a luxurious way. For no one liked to take the risk of being ridiculed by his friends when one of his elaborately mounted scrolls some day would turn out to be a wholly inferior specimen. Some collectors still showed a proclivity to ornate mountings (cf. Chapter XXVII of the *Chuang-huang-chih*), but discerning connoisseurs more and more aimed at achieving for their mounted scrolls a combination of solidity and simplicity.

It may be assumed that Buddhism also contributed its share to the ever increasing preference for sober mountings.

The rigid Chu Hsi Confucianism, although more or less adopted by the state, held few attractions for Ming poets and painters; these sought refuge by that old fount of artistic inspiration, the Ch'an school of Buddhism. As the Western Lake region was the center of this meditative school, one will not be far wrong in assuming that persons like Li Yü and other scholar-artists in Kiangsu Province directly or indirectly underwent its influence.

Literary sources of the late-Ming period show that a smattering of Ch'an was considered as indispensable to the scholar of refined taste. In his library there should be a *ch'an-i* 禪椅 "Ch'an chair", a bamboo seat for sitting on while meditating, and neither should there be lacking a rosary and an alms bowl. In opulent mansions there was often even built a *fo-t'ang* 佛堂, or hall for Buddhist worship. [1] Since Ch'an Buddhism preached above all an abolition of all luxury and a return to simple, natural beauty, its influence on the art of mounting is a factor that should be reckoned with.

Next to the hanging scroll, also the album flourished greatly during the Ming period.

Calligraphic specimens and rubbings mounted as accordion albums were common already during the Sung and Yüan periods. It was during the Ming dynasty, however, that artists began to show special interest in the painting of sets of small-sized pictures, suitable for being mounted in this form. As subjects they chose either a well known series of scenic views (eight famous mountains, ten celebrated palaces, etc.), or simply thus united a number of pictures of various subjects but uniform in size. Such albums with pictures by Ming artists like T'ang Yin, Tung Ch'i-ch'ang, Wên Chêng-ming, Ch'iu Ying etc. are often described in collectors' catalogues.

Literary sources of the Ming period frequently mention the horizontal tablet mounting. Scrolls mounted in this way usually showed a few large characters, giving a studio name or some admonition from the classics. Such tablets as a rule were put up in the library of the scholar, but on occasion they were used also in other rooms of the house, usually over a door.

1) Cf. *K'ao-p'an-yü-shih* (see Appendix I, no. 29), chapter 4, and *Chang-wu-chih* (ibid., no. 30), chapter 1 and chapter 6.

During the periods treated on the foregoing pages, the hanging scroll mounting Hand scrolls went through various phases of evolution. The pictorial hand scroll, on the other hand, remained essentially the same. Although the hand scroll, just as the hanging scroll, benefited by the development of the pasting–technique and by the more discriminate use of various kinds of silk and paper, its style and form did not change.

This difference in the evolution of hanging scroll and pictorial hand scroll is easily understood if it is remembered that whereas the former, being part of interior decoration, developed together with it, the latter, being a unit in itself, in style and form could retain its archaic features.

<center>* * *</center>

Having thus followed the development of the art of mounting in China till the The art of mounting in Japan after the Ashikaga period. beginning of the Ch'ing period, now we must turn once more to Japanese materials.

Above it was observed that during the Ashikaga period the tea masters reigned supreme over Japanese artistic life. It was they who decided which scrolls should be displayed on what occasions, how they should be mounted, and what flower arrangements should be exposed together with them. This state of affairs continued during 1573–1603, the turbulent years that intervene between the Ashikaga and Tokugawa shōgunates.

The most famous tea master of that tumultuous time was Sen Rikyū (千利休, The period of the wars for supremacy. 1520–1591), favourite of the great war lord Toyotomi Hideyoshi (豐臣秀吉, 1536–1598), the formidable figure that dominates this period of sanguinary strife. For a long time Rikyū was Hideyoshi's trusted adviser, playing a prominent part in his political counsels, and whose voice was law in Japanese artistic life. Finally, however, his career was brought to an abrupt end: having offended Hideyoshi by refusing him his daughter who was a famous beauty, shortly afterwards Rikyū was ordered to commit suicide.

Rikyū has had a far–reaching influence on the art of mounting. As the hangings Rikyū's influence. scroll was one of the chief adornments of the room for the tea ceremony, Rikyū in his quality of tea master gave much thought to the art of mounting these scrolls. His rules and instructions regarding the *toko-no-ma* and its decoration were transmitted in his family and also placed on record by his devoted disciples. Thus the works left by his grand–son Sen Sōtan (千宗旦, 1578–1658), and tea masters like Takeno Shō-ō (武野紹鷗, died round 1556) and Nambō Sōkei (南坊宗啓, 16th century) enable us to form an idea of Rikyū's teachings regarding the art of mounting, and interior decoration in general.

At that time Japanese interior decoration was in the main a continuation of the styles that had become fashionable during the later half of the Ashikaga period. The woodwork inside the house was lavishly adorned with lacquer work in garish colours,

and the *toko–no–ma* was made a receptacle for a mass of heterogeneous works of art. The hanging scrolls there exposed were mounted with brocade that in sumptuous magnificence outdid Sung and Yüan examples. The feudal lords liked front mountings glittering with gold and silver; they often had brocades especially woven for this purpose, with large patterns representing their family crest. The knobs were made of old ivory, horn, crystal, or some rare fragrant wood. The suspension loop had attached to it a thick cord of coloured silk, several feet long and ending in large tassels; when the scroll was exposed, this cord was tied in several complicated bows, the tassels hanging down over the upper part of the scroll as an additional decoration.

When not displayed, these scrolls were kept in boxes lacquered with gold and silver designs, and decorated with thick silk cords or coloured ribbons.

These gorgeous mountings accorded well with the ornate interiors of the fortified castles. Famous strongholds built in this time, like those of Himeji, Hikone, Akashi, Ôsaka and Nagoya, showed a combination of strategic efficiency and the pomp accompanying luxurious living.

As a protest against these lavishly appointed interiors, Rikyū preached a return to the austere simplicity of the tea room. He advocated that for the front mountings of hanging scrolls the use of gold brocade (*kin–ran* 金襴) and multi–coloured silk (*don–su* 緞子) be abolished, and he advised to employ instead so–called *hok–ken*, [1] a brownish silk imported from China.

**Paper mountings introduced by Rikyû.**

Next to such simple mountings of one–coloured silk, Rikyū is also credited with having used for the first time front mountings made entirely of paper. This shows that by this time also in Japan the technique of pasting had developed; for while making the front mounting of a hanging scroll, paper is much more difficult to handle than silk or brocade.

Further Rikyū devised some new styles for knobs of hanging scrolls, made of wood, and stressing elegant form rather than costly material; some of these models to–day still go by his name (see Plate **40**). He objected to large scrolls and fixed a height limit which mounted hanging scrolls should not exceed.

**Rules evolved by the tea masters.**

This simplification of the appearance of mounted hanging scrolls, however, did not imply that the work of the mounter became more easy. On the contrary, Rikyū was most particular about countless minor details, such as the correct proportion of the front mounting and the painting itself, the proportion of the various parts composing the front mounting, the thickness of roller and upper stave, etc.

This same proclivity to — often futile — details is apparent in his directions regarding the choice of the appropriate style of mounting for a hanging scroll. Each of the

1) *Hok–ken* is usually written 黄絹. Japanese sources explain this irregular reading by the fact that this silk was imported from Fukien Province 福建, in Japanese pronounced Hok-ken. On the other hand *bok–ken* is also written 北絹 " Northern silk ", which would seem to imply that it was imported from N. China, instead of from the South.

three styles of mounting classified by Sō-ami as *shin*, *gyō* and *sō* (see page 243 above), Rikyū again subdivided into three categories, one mounted hanging scroll for instance being described as *shin-no-sō*, another as *sō-no-gyō*, etc. etc.

Further, when a large scroll showed a calligraphic specimen in bold characters, it was decreed that the text should consist of only one vertical line; for, admiringly reading a text of two lines, the guest kneeling in front of the *toko-no-ma* first bows his head (when reading the first line), and then lifts it up again (to start reading the second line), which was considered as impolite to the host.

Finally the sequence in which a set of scrolls should be hung, the distance separating the roller from the floor, the way the bows of rolled up scrolls should be tied, all such minor points were fixed by rules.

Thus, although Rikyū's teachings had a beneficial influence on artistic life in general since they curbed to a certain extent the prevailing preference for garish effects, on the other hand they encouraged a tendency to overstress details, and often degraded art into artificiality.

Various styles of mounting hanging scrolls during the period of the wars for supremacy.

At this time the so-called *Yamato-hyōgu* 大和表具, or "Japanese mounting" (see Plate **100**, b.) was the most common style for mounting hanging scrolls. The tea masters devised numerous variations of this type many of which are still in use to-day, being called after the tea master credited with its invention. Thus one finds appellations like *Rikyū-konomi* 利休好 "favoured by Rikyū", or *Shō-ō-yō* 紹鷗樣 "the style of Takeno Shō-ō". Further the *dai-bari* style of mounting (see Plate **102**, a, b. and c.), which had come into use during the later years of the Ashikaga shōgunate, during this period became greatly popular. Also the "bag style" (Plate **104**), being deemed especially suited for calligraphic specimens in Chinese, was much favoured by the tea masters; to them a hanging scroll showing some Ch'an maxim still was the most appropriate decoration of the *toko-no-ma*.

Importance of Ch'an teachings.

In conclusion here there is quoted a passage from the *Kissa-nambō-roku* (cf. Appendix I, no. 66) a work by one of Rikyū's most famous disciples. This quotation shows the supreme importance attached by the tea masters to the hanging scroll as part of interior decoration, and at the same time demonstrates the influence of Ch'an teachings. It says:

"The hanging scroll epitomizes the entire room, it should serve to purify our thoughts and spirit. Formerly, therefore, the scrolls displayed as a rule showed a Buddhist representation or an image of a Buddhist saint. And after the tea master Ikkyū had presented a specimen of Engo-zenji's hand writing [1] to Shukō (see page 244 above), it became a widely spread custom to expose scrolls chiefly showing some Ch'an quotation. Why is it, therefore, that a guest before entering the room will first wash his hands and rinse

---

[1] Engo-zenji (Huan-wu-ch'an-shih 圜悟禪師, also called Fo-kuo 佛果, 1063-1135) was a famous Chinese Ch'an master, author of the celebrated *Pi-yen-lu* 碧巖錄, one of the basic Ch'an texts. It is said that in China none of his autographs has been preserved. In Japan there are known three specimens of his calligraphy. The one mentioned in the passage quoted is now in the collection of the Tokugawa family. The second one,

his mouth? Because formerly one used to pay homage to the Ch'an teaching imparted by the hanging scroll (in the *toko-no-ma*), and would ponder over its meaning. Thus a hanging scroll is treated as the first among one's treasures, it is viewed in the same light as a deity or a holy sage ". [1]

The art of mounting during the Tokugawa period.

After Hideyoshi had passed away, Tokugawa Ieyasu (德川家康, 1542–1616) took the reins of power. Having defeated all war lords who opposed him, in 1603 he founded the Tokugawa shōgunate, that was to last till the Meiji Restoration in 1868.

During the Tokugawa period the Japanese interior underwent a great change, which in its turn influenced the development of the art of mounting, and especially the hanging scroll.

Development of the Japanese interior.

Heretofore Japanese society could be roughly divided into two classes, an upper one, extremely opulent, and a lower one living in utter indigence. Above there were the luxurious palaces, the sumptuous temples and lordly mansions, below the miserable hovels of the commoner and the peasant. Between these two extremes there was no transition phase: something like a middle–class dwelling house did not exist.

With the advent of the Tokugawa this situation was drastically changed. In order to strengthen their central position the Tokugawa rulers made deliberate efforts at creating a middle class to counter–balance the power of the feudal lords. Their policy, devised to make the money flow from the treasuries of the feudal lords into the pockets of either the shōgun or the merchants, in course of time brought into being a prosperous middle class. The merchants soon could afford to spend a considerable amount of money on the embellishment of their daily surroundings. Tradition forbidding them to imitate the style of the lordly mansions, they created interiors that, although simple, yet left ample space for a display of works of art. It was in this way that the ordinary Japanese interior as it is known to–day came into being. In the following centuries the pomp of the lordly mansions gradually disappeared, while finally, during the Meiji era, also palaces and temples lost much of their former splendour. It was the middle–class interior that, having absorbed the main features of the old Japanese styles, became the standard, and has remained so till the present day. [2]

The toko-no-ma.

In this middle–class interior the *toko-no-ma* was of paramount importance. Here the owner of the house, not being allowed to display emblazed swords, helmets and

preserved at Mito, some years ago was sold at Ôsaka to the Fujita family, for the sum of 14.200 Yen (about $ 8000, –). The present whereabouts of the third scroll are unknown.

1) *Kissa-nambō-roku* (cf. Appendix I, no. 66): *Kakemono wa sunawachi shitsu zentai wo sōtō shi, mata shimpō-kannen waga seishin wo seijō ni subeki mono nareba shu toshite butsu-zō soshi-zō wo kake-tarashi ga, Engo-zenji no bokuseki wo Ikkyū, Shukō ni ataerarete nochi, moppara zengo wo kakuru koto ryūkō*

*itaseri. Sareba kyaku sho-iri no toki, nani-ka tame ni chōzu wo tsukai, kuchi wo susugi hairu ya? Kore kakemono ni taishite mukashi wa mazu zengo wo hai shi, sono imi wo kōron shikeru nari. Kakemono wo miru ni mattaku shinsei shi shi, kahō no dai-ichi ni atsukau yue nari.*

2) For a complete survey of Tokugawa social history the reader is referred to G. B. Sansom's excellent study *Japan, a cultural history*, London 1931; revised ed. 1946.

other pieces of armoury that were the privilege of the warrior class, yet could show his wealth by exposing some rare scrolls or other costly works of art. The prosperous merchants were not greatly attracted by the teachings of the tea masters. While the tea masters favoured monochrome ink paintings, Chinese pictures in faded colours or calligraphic specimens, the merchants wanted to hang in their *toko-no-ma* gay, purely Japanese pictures, like the vividly coloured paintings of the Tosa and Yamato schools. Such scrolls asked for ornate mountings of coloured brocade, with a liberal display of gold and silver patterns.

Diminishing influence of the tea masters.

During the first decennia of the Tokugawa period the strict rules evolved by the tea masters still exercised a more or less restraining influence. Famous tea masters like Furuta Oribe (古田織部, 1543-1615), Kobori Enshū (小堀遠州, 1579-1647) and Katagiri Sekishū (片桐石州, 1608-1673) continued the teachings of Rikyū, preaching the superiority of simple mountings, and the rustic soberness of the tea room. At first the merchants tried to follow this example; for the tea masters, protected by powerful lords, and often having a voice in political matters, could profer their artistic views *ex cathedra*, respectfully listened to by the crowd. With the increasing prosperity of the middle class, however, the might of the feudal lords and their protégés, the tea masters, dwindled away. Patronized by the central authorities and the wealthy merchants, there now arose another class of artistic experts who claimed a voice in matters of taste. This class was composed of the Japanese-style painters, and the semi-official Sinologues.

Influence of the Japanese-style painters.

Towards the middle of the Tokugawa period popular art developed, and soon came to occupy an independent place. The painters in Tosa and Yamato styles now no longer needed to turn to some influential lord for protection: they could easily find a generous patron outside aristocratic circles among the members of the merchant class. For them they painted lively pictures of the elegant adventures of ancient heroes, colourful scenes from old legends, or episodes from the gay nightlife that now was going on in the capital.

In mounting these scrolls, patron and artist could follow the dictates of their own taste. As at this time the arts of weaving and dyeing had reached a high perfection, the mounters had at their disposal a wellnigh unlimited variety of coloured and embroidered silk, precious brocades of multifarious patterns and designs, damask, satin, and all kinds of woven fabrics. The hanging scroll mountings favoured by the new middle class thus offered a dazzling display.

Influence of the Sinologues.

In the mean time Chinese learning, heretofore monopolized by the Buddhist clergy, had passed into the hands of lay scholars. [1] Charged with various administrative duties, these Japanese Sinologues were employed by the Tokugawa government in a semiofficial

---

1) Cf. my article *Kakkaron, a Japanese echo of the Opium War*, in " Monumenta Serica ", vol. IV (Peking 1939); in the introduction the reader will find a full account of the history of the Japanese official Sinologues.

capacity, being called *ju–kan* 儒官 " Literati–officials ". Having acquired a distinguished social position, these Sinologues were eager to create for themselves dignified surroundings, similar to those of the literati in China. They carefully studied late–Ming treatises on the daily life of the elegant scholar–official, and tried to adapt the principles they found there to the Japanese interior. Books like for instance the *K'ao–p'an–yü–shih* (cf. Appendix I, no. 29) were copied out time and again, and often also published in Japanese editions. Among these Japanese Sinologues especially Li Yü's teachings found many followers, [1] and through them affected Japanese life in general.

The Sinologues, steeped in Chinese literary tradition, looked down upon the Japanese–style scrolls with their vividly coloured mountings. In their opinion nothing could be compared with Chinese paintings. These they mounted in simple styles, as was the Chinese fashion during the later years of the Ming period. Although with regard to artistic matters the Sinologues on many points agreed with the tea masters, they despised the latter because of their ignorance of purely Chinese esthetic ideals as advocated by late–Ming scholars. The Sinologues, often having close contacts with Chinese emigree–artists who after the fall of the Ming dynasty had settled down in Japan, maintained that they, having an up–to–date knowledge of Chinese fashions, were the only ones qualified to pass judgment in artistic matters. Yet in the end the influence of the Sinologues led to the same result as had the teachings of the tea masters: calligraphic scrolls in Chinese were re–instated in their former privileged position, inscribed horizontal tablets were widely used, and hanging scrolls were mounted with one–coloured materials, the " bag style " mounting regaining its popularity.

The Tokugawa mounter.

The mounter, *hyōgu–shi* 表具師, now had to be an artisan at home in many trades. Next to the work of mounting itself, he also had to make himself the materials he needed for this process. He was at the same time an expert in dyeing silk and cloth, a cabinet worker, a manufacturer of ornamental paper, and of gold paper with coloured and embossed designs. [2]

1) There have been preserved numerous excellent Japanese manuscript copies of Li Yü's works, all made during the later part of the Tokugawa period; it is easier in Japan to purchase such an old manuscript copy than a later Chinese printed edition.

2) Since olden times paper covered with gold leaf played an important role in Japanese pictorial art. During the Tokugawa period Kyōto was the centre of gold leaf production, the workmen there holding a virtual monopoly of this craft. In 1775 this monopoly was officially endorsed by the Tokugawa government; round 1800, however, the shōgunate suspended the production, as being too luxurious. Thereafter the gold leaf was produced clandestinely in Kanazawa (Kaga Province) which to–day still is famous for this article. It is made in thin leaves of about two inches square; these are pasted one by one on the surface one wishes to gild. This is a difficult work, the successful

performance of which asks for long experience (see the detailed description in the *Hyōgu–no–shiori*; Appendix I, no. 70). Genuine antique gilded screens will show the traces where the leaves of gold are joined together, whereas those gilded later with gold paint (a much cheaper process) will show an even surface.

Japanese tradition has it that the art of making gold leaf with embossed designs was taught in the beginning of the 17th century by a Chinese immigrant to a Japanese artisan at Kyōto. Gold leaf with such a pattern is especially favoured for making the inside of the protecting flaps of Japanese hand scrolls. Next to embossed gilded paper, Japanese mounters also use for this purpose heavy glazed paper sprinkled with gold dust (see the sample in Appendix V, no. 41). Formerly these latter papers also were manufactured by the mounters themselves.

268

98. – JAPANESE EARLY TOKUGAWA MOUNTINGS. A) A *SHIKI-SHI* MOUNTED IN *DAIBARI* STYLE;
B) A CHINESE LETTER MOUNTED IN " BAG STYLE "

Contrary to China, in Japan historical records mention but few mounters by name. Practically the only ancient Japanese mounter whose name has been preserved is Naraya Seijun 奈良屋西順, a mounter who lived in Kyōto in Rikyū's time, and who was one of the favourites of this famous tea master. According to contemporary literary records he was a past master in the art of mounting, whose tradition was continued by his descendants.

Further, later the great painter Kanō Akinobu (狩野章信, 1763-1826) was charged with mounting the scrolls in the collection of the shōgun. From this fact it may be concluded that during the Tokugawa period painters often at the same time were mounters of scrolls.

Albums.

Although the mounting of hanging scrolls was the mounter's chief task, he also had to mount hand scrolls and albums. Tradition says that the first mounting in album form (ga-chō 畫帖) made in Japan was the *Kohitsu-tekagami* 古筆手鑑, a collection of calligraphic specimens mounted together under the reign of Hideyoshi. Thereafter this style of mounting became ever more popular, being applied to *shiki-shi* and *tan-zaku* (see above page 103). Just like in China, such albums were protected by brocade covers, and often placed in costly lacquer boxes.

Thus the work of the mounter asked for great skill and a many-sided technical knowledge. It would seem, however, that his interest never went beyond that of the skilled artisan. Unlike in China, in Japanese literature one does not find indications that professional mounters ever were considered as experts in artistic matters in general, or that value was attached to their opinion on questions of authenticity.

Tokugawa hanging scroll mountings.

To give a description of all the various styles that during the Tokugawa period were used for mounting hanging scrolls would far exceed the limits imposed by the present publication. Here it may suffice to list 21 of the more common types of older and later Japanese types of hanging scroll mounting together with their technical names and a brief indication of the kind of pictures they are used for. It is hoped that these types, presented in schematic drawings on Plates **99-105** will supply the reader with some landmarks that will help him to find his way through the bewildering variety of Japanese hanging scroll mountings.

The nine types reproduced on Plates **99-102** are the older ones, divided into three groups of three according to the esthetic classification of *shin* 真 "formal", *gyō* 行 "ordinary" and *sō* 草 "informal"; each of these three groups is again subdivided according to the same esthetic standard.

Plate **99** gives the three types of the *shin* class.

a) *Shin: Shinsei-hyōgu* 神聖表具; used for representations of the Buddha, magic circles of the Shingon Sect, and other very sacred religious representations. The "seamed border" mountings belong to this class.

269

99. – JAPANESE TYPES OF HANGING SCROLL
MOUNTINGS. A) SHINSEI; B) HONZON; C) CHŪZON

b) *Gyō: Honzon–hyōgu* 本尊表具; portraits of the Emperor, Buddhist patriarchs and saints and other religious subjects.

c) *Sō: Chūzon–hyōgu* 中尊表具; Buddhist and Taoist figures, coloured pictures of superior quality, autographs by Buddhist saints.

Plate **100** presents the three types of the *gyō* class.

a) *Shin: Yamato–ichimonji–mawashi* 大和一文字廻; Shintō pictures, Imperial autographs, coloured pictures of birds and flowers, images of the Goddess Kwannon (Kuan–yin), famous warriors, Buddhist and Taoist figures, Buddhist texts.

b) *Gyō: Yamato–hyōgu* 大和表具; pictures of the Tosa, Shijō and Kano schools, warriors, minor Buddhist representations, pictures of Mount Fuji.

c) *Sō: Dōho–chūfūtai* 幢褙中風帶; poems in Japanese, autographs by Zen monks and tea masters.

These three types were particularly favoured by the tea master Rikyū.

Plate **101** gives the three types of the *Sō* class.

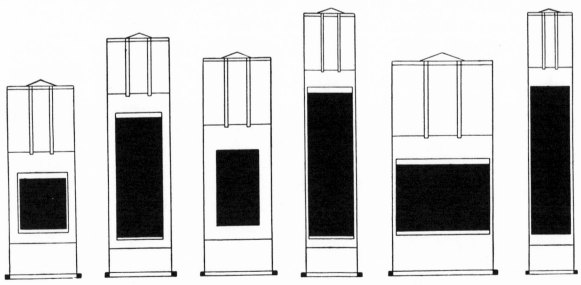

100. – JAPANESE TYPES OF HANGING SCROLL
MOUNTINGS. A) YAMATO–ICHIMONJI–MAWASHI;
B) YAMATO; C) DŌHO–CHŪFŪTAI

101. – JAPANESE TYPES OF HANGING SCROLL
MOUNTINGS. A) YAMATO–RINBO; B) ID.
(HORIZONTAL); C) RINBO–CHŪFŪTAI

270

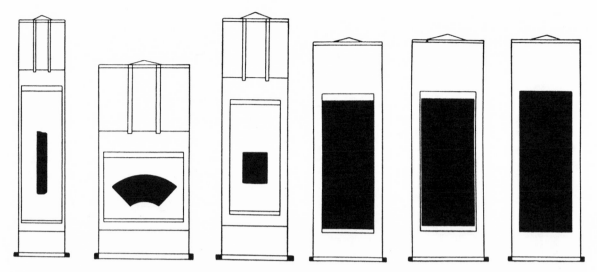

102. – JAPANESE TYPES OF HANGING SCROLL MOUNTINGS. A) TANZAKU–DAIBARI; B) SENMEN–DAIBARI; C) SHIKISHI–DAIBARI

103. – JAPANESE TYPES OF HANGING SCROLL MOUNTINGS. A) BUNJIN; B) BUNJIN–ICHIMONJI–MAWASHI; C) FUKURO

a) *Shin: Yamato–rinbo* 大和輪補; scrolls for the tea room (*chagake*), poems in Japanese, short sentences in large characters written by Zen masters, superior pictures of beautiful women.

b) *Gyō: Yamato–rinbo* (horizontal); scrolls of the same character as above, the breadth of which exceeds the height (*yoko–mono*).

c) *Sō: Rinbo–chūfutai* 輪補中風帶; same as (a), depending on the size of the picture.

Plate **102** shows three types of the so–called *dai–bari* class; this term indicates that the picture or autograph to be mounted is so small, or has such an unusual shape, that it is unsuitable to being mounted as it is, and has first to be mounted on a sheet of silk or paper of a more regular shape and size; the latter is thereafter mounted in the ordinary way.

a) *Tanzaku–daibari–hyōgu* 短冊臺張表具; used for mounting *tanzaku*, long and narrow strips of paper inscribed with Japanese poetry.

b) *Senmen–daibari–hyōgu* 扇面臺張表具; used for dismounted fans.

c) *Shikishi–daibari–hyōgu* 色紙臺張表具; used for mounting the *shiki-shi*, square sheets employed by painters and calligraphers for smaller pictures or small specimens of calligraphy.

Other ways of mounting *tanzaku* and *shikishi* behind glass were described on page 103 above.

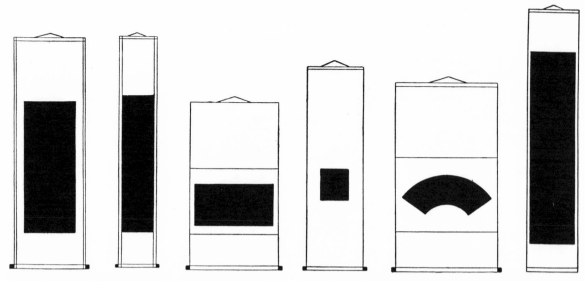

104. – JAPANESE TYPES OF HANGING SCROLL MOUNTINGS. A) FUKURO–MINCHŌ–SHITATE; B) FUTO–MINCHŌ–SHITATE; C) NIDAN

105. – JAPANESE TYPES OF HANGING SCROLL MOUNTINGS. A) KURINUKI; B) CHŪGIRE–RENDAI; C) TSUIREN

Plate **103** gives three types of simpler hanging scroll mountings which were introduced into Japan in the Ming dynasty and used preferably for Chinese scrolls, or scrolls done in Chinese style.

a) *Bunjin–hyōgu* 文 人 表 具 " mounting of the literati "; all monochrome ink paintings, Chinese texts or autographs in Chinese style, Chinese pictures.

b) *Bunjin–ichimonji–mawashi* 文 人 一 文 字 迴; all monochrome ink paintings, Chinese–style pictures of cranes, pinetrees, deer and other auspicious subjects; famous men of Chinese history.

c) *Fukuro–hyōgu* 袋 表 具 " bag mounting "; same subjects as (a) and (b).

Three variations of these mountings in " literary style " are represented on Plate **104**.

a) *Fukuro–minchō–shitate* 袋 明 朝 仕 立 " Bag mounting of the Ming Dynasty "; used for Chinese poems, landscapes in Chinese style, pictures of birds and flowers in Chinese style, autograph letters.

b) *Futo–minchō–shitate* 太 明 朝 仕 立; same as (a) if the picture or autograph is done on a longer, narrow canvas.

c) *Nidan–hyōgu* 二 段 表 具; same as (a) and (b) if done as *yoko–mono*.

Plate **105** shows three less common types of mounting, viz.:

a) *Kurinuki–hyōgu* 刳 找 表 具; used for *shiki–shi*.

b) *Chūgire–rendai–hyōgu* 中 切 連 臺 表 具; used for dismounted fans.

c) *Tsuiren–shitate* 對 聯 仕 立; used for long, narrow scrolls with Chinese texts.

272

Japanese mounters have adopted two rules of Chinese hanging scroll mounting, but not without adding a few changes so as to adapt these rules to Japanese requirements. Two rules governing Chinese hanging scroll mountings observed in Japan.

First, the rule that the upper strips of mounting should be broader than the lower ones is observed also in Japan; but whereas in China the difference in breadth grows less as the strips are located nearer to the picture, in Japan all upper and lower strips show the proportion 2 : 1. As was pointed out above, this difference is based on the fact that in Japanese houses hanging scrolls are nearer to the floor than in China.

Second, the gradation in colour of the various strips of the front mounting is observed in Japan in so far that the " frame " is lighter in colour than the *ichi–monji*, while the *jō–ge* are again of a darker material. If for the *ichi–monji* there is used glittering gold brocade, then one will choose for the " frame " brocade where gold–thread is less prominent, and for the *jō–ge* a darker brocade with an unobtrusive pattern.

The choice of the material to be used for the front mounting is ruled by two criteria, *iro–awase* 色合 " harmonization of colour (of original and mounting) ", and *gara–awase* 柄合, " harmonization of design (of original and mounting) ".

As regards *iro–awase*, there may be mentioned the following general rules. It is customary to mount highly coloured pictures with plain materials, while for less gaudy representations ornate brocades are preferred. For instance, a Tosa painting of an ancient Court scene is mounted with light green brocade showing a pattern in brown while on the other hand an ink painting of bamboo is mounted with a dark brown brocade with a design in gold thread. Harmonization of colour.

Generally speaking a contrast between original and front mounting is aimed at: a picture of a winter landscape should have a front mounting of dark blue or violet material, to stress the whiteness of the snow, while a painting of a battle scene done in full colours should be mounted with some quiet, light–coloured material, so as to make the colours of the original show to their full advantage.

In the case of autographs, a distinction is made between those in Chinese and in Japanese. Calligraphic specimens written in Chinese are mounted with sober materials: dark blue, brown or green, either without any design or with a pattern of a literary character, such as books, brushes, clouds, dragons etc. For Japanese autographs, such as Japanese poems and essays, one prefers gaudy mountings: brightly coloured brocades with a liberal use of gold and silver thread, or silk embroidered with ornate, large designs. [1] This especially applies to poems mounted in the *dai–bari* style (see Plate **102**).

Further the design of the mounting material should harmonize with the subject represented on the scroll. Paintings of an auspicious character, such as representations Harmonization of design.

---

[1] A few actual samples of Japanese brocade used for the front mounting of hanging scrolls are to be found in Appendix V, nos. 38–40. As materials with a large pattern are not suited for being shown in these samples, there only brocades with a small pattern are given.

of the Isles of the Blest, of immortals and genii, or of the trio pine tree–bamboo–peach blossom (*shō-chiku–bai* 松竹梅, symbols of a happy New Year), should be mounted with brocade showing stylized forms of the character *kotobuki* 壽 "longevity", or gourds (containing the Elixir of Immortality), bats, or other designs of good omen. The front mounting of landscape paintings should show a pattern of drifting clouds, a flower piece should be mounted with brocade showing blossoming flowers, while a gay Ukiyo–e scroll should be mounted with the lively brocades that are used for the robes and sashes of dancing girls.

Buddhist representations must be mounted with materials that show appropriate religious motives, such as lotus flowers, stylized Wheels of the Law and Holy Knots, etc. For portraits of an Emperor or Imperial autographs white materials are preferred, often showing a design in gold or silver; the same applies to images of Shintō deities. Pictures of famous ancient heroes and great statesmen are also mounted with white materials, but these have a design in brown, green or blue, never in gold or silver.

This harmonization of subject and mounting is carried through consequently, and often produces pleasing effects. I have in my collection an old Nagasaki painting, showing a Hollander and his wife. This picture has been mounted with imported Dutch printed cloth, as about a century ago was used in the Netherlands for upholstering chairs and sofas.

The influence of metaphysical speculations of the Sinologues.

Further Japanese esthetes divide scrolls according to their subject into *yō* 陽 "positive" and *in* 陰 "negative" pictures. If one of a pair of scrolls represents for instance a tiger, and the other a dragon, then the former is considered as *yō* and the latter as *in*; if one shows a mountain landscape, and the other a river or a lake, the former is *yō* and the latter is *in*. Now it is a fixed rule that *yō*–pictures should be mounted with *in*–materials, and *in*–pictures with *yō*–material. Whether a front mounting is *yō* or *in*, is decided by counting the number of times the design shown on the upper *ichi–monji* repeats itself. If, for instance, such a strip shows an uneven number of peonies, then the mounting is *yō*, if an even number, then the mounting is considered as *in*.

This system is evidently based upon the metaphysical speculations of the *I–ching* 易經, the ancient Chinese Classic of Divination, which in Japan since early times has enjoyed great popularity. Especially the Tokugawa Sinologues were diligent students of this book, and it was doubtless they who drew up these *yō–in* rules for mounted scrolls. I could find no indication that this *yō–in* distinction of scrolls was ever made in China.

The same influence of *I–ching* metaphysics is noticeable in some of the rules for determining the exact place where a scroll must be hung in the *toko–no–ma*. The surface

274

of the back wall of the *toko-no-ma* is divided into six equal parts by drawing five imaginary perpendicular lines. Then each of these six parts is again divided in two by parallel lines. Now the former five lines are considered as *yō*, the six latter lines as *in* (see Plate **106**). The nails for suspending a scroll, no matter whether only one scroll is displayed or sets of two, three or more scrolls, may never coincide with an *in* line.

Abnormal forms of mounting hanging scrolls.

Finally, during the Tokugawa period there were occasionally used some forms of mounting which in China have been obsolete for many centuries.

One of these is the so-called *kaki-hyōgu* 畫表具 "painted mounting". When he has finished a picture, the artist paints round the four borders of the same piece of silk an imitation mounting. I myself have never seen a specimen of such a mounting, but it is sometimes mentioned in Japanese literature. Anderson gives the following description of such a scroll:

"Kakemono on silk, painted in colours. Size 63 $^3/_4$ × 18 $^1/_2$. A ghost. A weird female figure, with ghastly corpse-like features and disheveled hair, floating upwards out of the confines of the picture. The illusion is effected by replacing the usual brocade bordering by an imitation mounting painted on the margin of the silk upon which the subject is designed ". [1]

This style of mounting reminds one of the T'ang "banners", where the picture has along top and bottom a painted ornamental band (see Plate **70**). Many Tun-huang murals have also a kind of ornamental frame painted along their four borders. Thus it is probable that the Japanese *kaki-hyōgu* is a remnant of these ancient Buddhist banners and mural paintings.

Further there exists the so-called *oride-hyōgu* 織出表具 "woven mounting". The picture is painted on a piece of silk, round the borders of which there has been previously woven a "frame" of coloured silk. Also this style is rarely met with.

Hand scrolls

Just as in China, also in Japan the mounting of hand scrolls remained unchanged during the succeeding centuries.

On page 71 above a few distinctive features of Japanese hand scrolls were relevated: contrary to Chinese hand scrolls, they usually have no superscription, no long strip of blank paper at the end, and few colophons. Further, pictorial hand scrolls as a rule lack an upper and lower border, the edges being enforced by adding an extra narrow strip of backing on the observe of the scroll.

The Chinese custom of impressing collectors' seals over the seams separating the various sections of a hand scroll, in Japan never became popular. Purely Japanese hand scrolls as a rule show but one seal of each individual collector, impressed either in a corner of the original (sometimes also in a corner inside the protecting flap), or at the

---

[1] Cf. *Descriptive and historical catalogue of Jap. & Chin. paintings in the British Museum*, London 1886, page 386; the scroll is reproduced in Anderson's *The Pictorial Arts of Japan* (Appendix 1, no. 5).

275

very end of the scroll, on the strip of mounting near the roller. Most often, however, seals and comments are not found on the scroll itself but on the box it is kept in or on the documents that accompany it.

The art of mounting during the Meiji period, and in recent times.

The above description of the art of mounting during the Tokugawa period applies also to the Meiji era (1868–1912), and to modern times.

In recent years there is noticeable a tendency to return to the teachings of the ancient tea masters. Especially for purely Japanese hanging scrolls — like Tosa paintings and Ukiyo–e, Japanese poems and modern Japanese–style paintings — front mountings of paper have again become popular; for such mountings one prefers good Japanese papers of pale colours (see Appendix V, nos. 29, 30, 35–37). As long as they are new, these mountings have a pleasing effect, and accord very well with the Japanese interior; but if they become soiled or faded all their charm is gone.

For the knobs of hanging scrolls one notices nowadays a pronounced preference for ivory. Since in recent years this material has become rather expensive, now imitation ivory knobs of celluloid are widely used.

Present–day Japanese mounters do not any longer themselves manufacture the materials needed for their art. Ornamental papers are obtainable in stationary shops, while rollers, staves, boxes etc. are supplied by the *hyōgu–zairyō–ten* 表具材料店, special shops that stock mounting materials.

Chinese influences in the Japanese interior.

Since on the foregoing pages the development of the Japanese interior was frequently mentioned, in conclusion here there is added a brief summary of the Chinese elements in Japanese interior architecture.

The Sung influence dating from the Kamakura and Ashikaga periods is recognizable in the esthetic principles upon which the Japanese interior is founded. The scrupulously clean mats that cover the floor, the woodwork left in its natural colour, the function of the *toko–no–ma* as a kind of secularized domestic shrine, all these features may be traced back to the daily surroundings of the ancient Ch'an priests.

The Ming influence that was paramount in Japan during the later half of the Tokugawa period is apparent in the wide use of horizontal tablets with calligraphic specimens as wall decoration. Li Yü's influence in particular is noticeable in the ornamental lattice work over the sliding doors, in the use of round, octogonal and fan–shaped windows with bamboo bars, and in some styles of balustrades and open corridors or verandahs.

While in China interior decoration was always left largely to individual taste and preference, the Japanese interior is governed by numerous strict rules. Although it is possible to achieve something like a personal touch without offending against these rules (see the remarks on page 31 above), yet as a rule Japanese interiors of the upper middle class show a striking uniformity. The Japanese interior, therefore, although justly famous for its austere beauty, after one has lived in it for a while, becomes too frigid to be comfortable. Thus even Japanese artists and scholars find it difficult to live all the

time in such chilly surroundings and prefer to disregard conventional rules and prescriptions. In the studio of the Japanese connoisseur one will find the same homely confusion that characterizes the library of the Chinese scholar–artists.

This will appear from a comparison of Plates **107** and **108**. The former shows the uncompromising beauty of the traditional Japanese living room, the latter the comfortable sanctum of a Japanese connoisseur and Sinologue of the Meiji period; there the mats are covered with well–worn felt rugs, books and boxes are piled up in the *toko–no–ma* and against the walls, and scrolls are hung in every available corner in defiance of all carefully formulated rules.

\* \* \*

Finally we return to China for a discussion of the art of mounting of the Ch'ing period (1644–1910).

The art of mounting during the Ch'ing dynasty.

The various types of mounting current in the Ch'ing period and the place occupied by the mounted scroll in the Chinese interior of that time have been described at length in the First Chapter. A comparison of what was said there with our remarks about the art of mounting during the second half of the Ming dynasty will show that Ch'ing hanging scroll mounting is largely a continuation of late–Ming styles, while the mounting of hand scrolls, albums and tablets remained practically the same as during the preceding centuries. Here are added only a few words about some distinctive features of Ch'ing mountings.

In the Ch'ing dynasty the tendency to choose simple materials for the mounting of hanging scrolls became ever more prevalent. While in the last years of the Ming period one still finds occasionally front mountings composed of heavy figured silk or brocade with multicoloured patterns, Ch'ing mounters used nearly exclusively thin, monochrome silk with inwoven patterns that hardly strike the eye; only the *ya–tzŭ* were made of more gaudy material.

If one would have to characterize the spirit of Ming and Ch'ing culture by one single epithet for each, one might call the former esthetic and the latter scientific.

Prevalence of literary and archeological interest.

The preponderance of scholarly interest over esthetic enjoyment typical for Ch'ing culture has impressed its stamp also on the art of mounting. Not a few scholars viewed pictures and autographs as objects for antiquarian research rather than as works of art.

The custom of including in the front mounting of hanging scrolls old title labels and strips of paper inscribed with critical comments became ever more popular. Ch'ing connoisseurs also wrote comments and even lengthy essays on the silk of the front mounting; the pale silk popular during the Ch'ing dynasty presented a suitable groun for such inscriptions.

Some Ming connoisseurs condemned the custom of adding a *shih–t'ang* to a hanging scroll because they thought that it might interfere with the enjoyment of the artistic qualities of the picture or autograph itself. Ch'ing collectors, however, were greatly

partial to the inclusion of a *shih-t'ang* and most antique hanging scrolls mounted in that period have this feature. While formerly a *shih-t'ang* was usually inscribed with poems or essays praising the artistic merits of the scroll, now they mostly contain biographical details about the artist or learned discussions of problems of authenticity.

Plate **109** is a photograph of a hanging scroll mounted in an elaborate style in the Ch'ing period. The picture itself is an ink painting on silk representing an ox, and much darkened by age. Directly above the picture one sees a *shih-t'ang* made of genuine sûtra-paper cut from a Buddhist text mounted as an accordion album; this *shih-t'ang* has not yet been inscribed. On top right is an old title-label. The *ya-tzŭ* are of heavy brocade, brown dominating. The "frame" is of plain silk, celadon green, and the *ko-chieh* of figured silk of a light ivory colour. *T'ien* and *ti* are of light green brocade. Knobs of hardwood.

Plate **110** shows a simpler Ch'ing mounting of the "bag type" consisting of pale, blue-green plain silk. All along the right and left side there is a narrow "folded seam" of brown paper. The *ya-tzŭ* are of multicoloured brocade. Directly above the painting one sees a *shih-t'ang* of pale green waxed paper, inscribed with the title of the picture in chancery script. On top right an old title label, and on either side of the picture an old colophon, all three inlaid in the front mounting. The knobs are of hardwood, lacquered black.

In the works left by Ch'ing connoisseurs there are found occasionally the names of mounters of that period who became famous because of their exceptional skill.

The 18th century connoisseur Lu Shih-hua mentions two Soochow mounters, Chang Yü-jui and Shên Ying-wên, both experts in the restoring of antique scrolls (see page 25 above). The Ch'ing collector Chou Erh-hsüeh mentions a mounter called Chêng Mo-hsiang (see below, page 332) who probably was charged with repairing the scrolls in his collection.

Further, the *Hsi-ch'ing-pi-chi* 西 清 筆 記 compiled by Shên Ch'u 沈 初 says that during the Ch'ien-lung (1736-1795) and Chia-ch'ing (1796-1820) periods collectors all over the Empire were eager to have their antique scrolls mounted and repaired by mounters of Soochow, especially Ch'in Ch'ang-nien 秦 長 年, Hsü Ming-yang 徐 名 揚, Chang Tzû-yüan 張 子 元 and Tai Hui-ch'ang 戴 彙 昌; he adds that the names of these mounters were on the lips of all connoisseurs of pictorial art.

The *Mo-lin-chin-hua* 墨 林 今 話 published in 1852 by the scholar-artist Chiang Pao-ling 蔣 寶 齡 has a note on a mounter of Ch'ang-chou 長 洲 called Fang T'ang 方 塘 whose literary name was Pan-mou 半 畞. Next to being an expert mounter Fang T'ang was at the same time a man of refined taste who enjoyed some reputation as a painter of orchids.

It will be noticed that all these mounters lived in Chiang-nan, the region "South of the Yangtse". Above it was pointed out already that in the Ming period Chiang-nan was the centre of cultural activities; so it has remained throughout the Ch'ing dynasty.

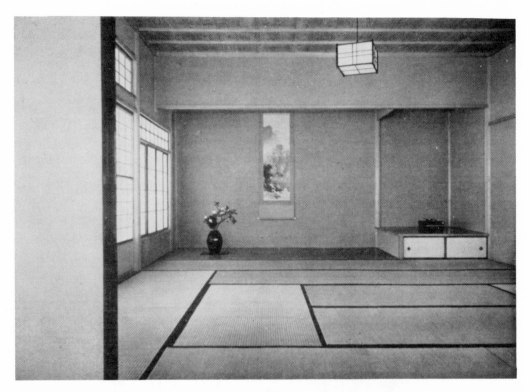

107. – JAPANESE INTERIOR
(Photograph supplied by K. B. S.)

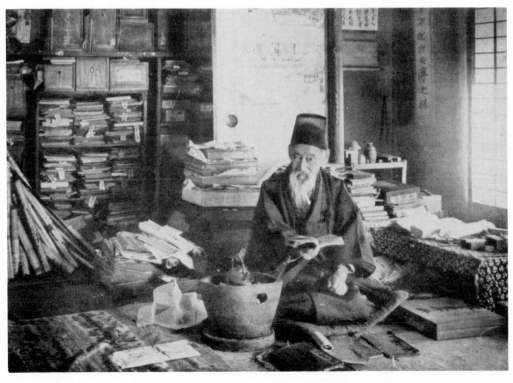

108. – JAPANESE INTERIOR. LIBRARY OF THE JAPANESE PAINTER, CONNOISSEUR
AND SINOLOGUE TOMIOKA TESSAI (富岡鐵齋, 1836–1924)

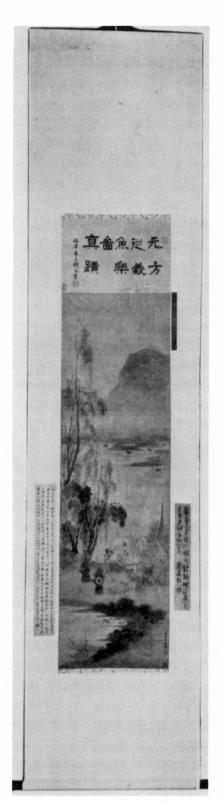

109. – CH'ING DYNASTY HANGING
SCROLL MOUNTING
Size of the entire scroll including
the mounting, cm. 269 by 53.
(Freer Gallery of Art, no. 17. 333)

110. – CH'ING DYNASTY HANGING
SCROLL MOUNTING (BAG TYPE)
Size of the entire scroll including the
mounting, cm. 290 by 67.
(Freer Gallery of Art, no. 18. 8)

As the Ch'ing collector Lu Shih–hua observes in his *Shu–hua–shuo–ling* (cf. Appendix I, no. 47, ch. 20), for centuries most of the traffic of the Empire went through Chiang–nan. Places like Hangchow, Soochow, Yangchow etc. saw a continuous coming and going of traveling high functionaries and their staffs.  Scholar–officials returning from the South had here repaired and remounted the scrolls they had collected during their term of office, and those on their way from the capital to the provinces here could purchase scrolls and other antiques for adorning their official mansion on their new post.  Thus both artists and mounters were kept busy and found ample opportunity for showing their skill.

In this region there also lived a large class of well–to–do landed gentry whose fortunes were derived from the salt monopoly and the traffic along the Grand Canal, while the port cities thriving on the profits obtained from the Japan trade counted numerous wealthy merchants.  Professional artists found no difficulty in obtaining liberal patrons and as a consequence here many new schools of painting came into being.

These conditions had, however, also another aspect.  Especially in Kiangsu there flourished a brisk antique trade side by side with a luxurious night life; old Yangchow paintings and young Soochow girls enjoyed fame all over the Empire.  This pair is not as incongruous as it would seem at first sight.  Many a scholar having bought a valuable painting to–day, after a night carousing had to sell it again the following morning to pay his debt to the tea house.  Often antique dealers and tea house proprietors were in collusion, they passed on to each other information about the finances and valuable antiques of the travelers and then joined hands in trying to relieve them of either or both.  Chinese light literature contains many stories about the dire straits of promising young officials who had fallen victim to the wiles of this formidable combination.

Also these aspects of life in Chiang–nan, however, contributed to Chinese culture. Among the patrons of the tea houses there were many distinguished scholars through whose influence the art of the singing girls was brought up to very high standards.  New words in polished verse were composed for old tunes and thus were laid the foundations of a refined dramatic genre that later became famous as the *Wu–p'ai* 吳派, the " Kiangsu School ".  Finally, many a traveling scholar–official who had lost at Soochow his treasured antiques and a good deal of money could take with him to his new post a fair companion instead, to alleviate the gloom of life in some boundary district.

Lu Shih–hua, the Ch'ing collector mentioned above was very familiar with this region.  He describes it as follows:

" While roaming through the district of rivers and lakes I always diligently sought for the traces left by the people of former times.  I ascended steep cliffs and searched the waterside, risking my life just for studying from nearby some half–effaced antique inscription.  Everytime when I found a heap of waste paper I would turn them over one by one always hoping to discover some valuable item.  Thus I gradually also learned about local customs and became familiar with local conditions.  Elegant and refined indeed is the subject of autographs and paintings! But alas, unfortunately it has not a few regrettable aspects – not to speak of other things! The Wu–yüeh region is the hub

279

of all highways, everyday there are numerous encounters of old friends.   The curio shops in the cities try by all sorts of means to attract these travelers to do business with.   The people (who sollicit customers) are called 'brokers', there are more of them than one could count, and nearly all of them are wholly unreliable.   As soon as one of them disappears another will immediately take his place.   Wu–yüeh is a good place for merchants to do business, and it is also a profitable place for 'selling flowers'; the waterways are crowded with the pleasure boats of the courtezans, and every other house is a wineshop.   These people employ all kinds of clever strategems and tricks to ensnare customers; as soon as one has one foot in it, one will surely submerge entirely in this dissipated life ". [1]

Soochow fakes.

There lived in Chiang–nan a number of professional forgers who were engaged day and night in the production of faked scrolls and the copying of antique paintings, in order that the antique dealers might be able to answer the continuous demand.   The reader will see from the stories quoted in the Third Chapter of the Second Part of the present publication that not a few unreliable mounters also took part in this nefarious trade.   Here I translate a note on the flourishing of the forger's craft in Soochow, written by the Ch'ing scholar Ch'ien Yung (錢泳, 1759–1844).

"In the beginning of the present dynasty there lived in the Chuan–chu Alley in Soochow a Ch'in family.   All its members without exception were experts in forging paintings and autographs.   Most of the paintings circulating in recent years and attributed to artists of the Sung and Yüan periods, such as the Sung Emperor Hui–tsung (1082–1135), Chou Wên–chü (ca. 950), Li Kung–lin (ca. 1150), Kuo Chung–shu (ca. 1000), Tung Yüan (ca. 960), Li Ch'êng (916–975), Kuo Hsi (ca. 1000), Hsü Ch'ung–szû (Sung), Chao Po–chü (ca. 1130), Chao Mêng–chien (1200–1265), Ma Ho–chih (ca. 1150), Su Han–ch'ên (ca. 1120), Liu Sung–nien (1073–1157), Ma Yüan (ca. 1200), Hsia Kuei (ca. 1200), Chao Mêng–fu (1254–1322), Ch'ien Hsüan (1296–1370), Su Ta–nien (1296–1364), Wang Mien (1287–1359), Kao K'o–kung (ca. 1280), Huang Kung–wang (1269–1354), Wang Mêng (ca. 1360), Ni Tsan (1301–1374), Wu Chên (1280–1354), either small or short hanging scrolls, large–size albums or long hand scrolls, in fact are forgeries made by this family.   These, therefore, are commonly called 'Ch'in family products'." [2]

1) Shu–hua–shuo–ling (cf. Appendix I, no. 47): 余水偶冀俗可越凡銷殆人花妓船鱗比。一

飄泊江湖刊留心古人遺跡亦山巒細覽釋智悲吳日而數一越。於吳越。而得之者。
湄模一所糊處敗刊即隨亦必覺尋其悲吳逢可有吳聯千計。得之亦以居於吳越。
至有即書得此書而己亦冒必必反風雅其蓋可有吳蟬然矣。般巧計。而得之者。
泊模一所糊處得書事省城呼講繼心不由古日實計生險以至舉路鋪木絕易以稍一以居於
飄泊江湖刊留心古即一隨道勝之玩捐斷之人冒堆以至舉路鋪木絕易銷酒投足蟬聯而薄

2) Cf. Li–yüan–ts'ung–hua 履園叢話 (preface dated 1825), ch. 11, introductory section, 3d paragraph: 子之麟趙堅珪蓁。父傳公嗣趙孟夏克所矩徐崇駒遠。高李來者。李崇趙伯年。馬周欽近文熙年。王冕姓書宗成。貴。劉有巷。諸作專州善蘇俱元董忠寬之。燕漢類。范錢和孟趙令馬趙國兄初弟宋郭忠穰范和孟趙令馬趙

The only consolation one has while reading this sad note is that one can at least be sure that the scrolls signed by the masters mentioned which were imported into Japan prior to 1650 cannot have been made by this family of expert forgers!

In recent years the best mounters are still found in Peking and Soochow. In the former city the Shang–ku–chai 尙古齋 was still flourishing in 1950, and in Soochow the mounter Yüan Tzû–ying 阮子英 continued the old Kiangsu tradition.

As to the styles of mounted hanging scrolls used at present by Chinese mounters, one notices a revival of some popular Ming models. I mention the "bag style", nowadays much favoured for ink paintings and specimens of calligraphy, and the use of gaudy silk and brocade for more elaborate types of mounting. Further some mounters make experiments with new materials such as brown hemp cloth or various kinds of ornamental paper.

However, not all innovations are improvements. In recent times a deplorable fashion has caught the fancy especially of some mounters in Shanghai. They give the *ching–tai* of hanging scrolls the shape of the iron work on Gothic doors, complete with the holes for the nails. It is to be hoped that this strange phenomenon will soon migrate to the special inferno that — as the present writer is fond of thinking — the Powers on High keep reserved for all products of abominable taste.

On the basis of the data collected in this chapter the history of the mounted scroll in China and Japan can be summarized as follows.

From the beginning of our era till well into the T'ang dynasty pictures and autographs were mounted as hand scrolls: long horizontal rolls of silk or paper wound around a stick. The wall was the favourite canvas of painters, all larger pictures were executed as murals.

During the T'ang dynasty the vertical hanging scroll mounting was evolved as a combination of the technique of the foreign "banner mounting" and of the Chinese hand scroll. The picture was surrounded by a narrow frame of brocade, on top and below a broader strip of the same material was added, and on top of the scroll a stretcher and at the bottom a wooden roller. To the stretcher were attached a number of bands which had a triple function: when the scroll was hanging on the wall they acted as suspension loops while their loose ends served as decoration, and when the scrolls were rolled up they were used as fastening bands. Pictures intended to be mounted as hanging scrolls were mostly done on cloth or silk. Larger pictures were still preferably executed as murals.

In the Sung and Yüan periods the mounting technique improved, also pictures on paper could now be mounted as hanging scrolls. Multi–coloured brocade was used for the front mounting, the bands were tied in a bow when the scroll was exposed. Among

黃公望。王蒙。倪瓚。吳鎭諸家。小條
短幅。巨册長卷。大半皆出其手。世
謂之欽家欵。

This passage has been already translated in part by Arthur Waley, in his *An introduction to the study of Chinese painting* (cf. Appendix I, no. 2).

painters the hanging scroll became ever more popular, at the expense of the mural; but calligraphers still stuck to the hand scroll.

During the Ming period larger hanging scrolls on silk and paper came into general use, also for autographs. *T'ien* and *ti* were made broader and an extra–strip (*ko–chieh*) added above and below the picture. A special suspension cord with fastening band was attached to the upper stave, the function of the old bands being reduced to decoration of the front mounting; first they appear as two loose strips hanging down from the upper stave, later they are pasted down on the *t'ien*. Thin, monochrome silk replaces as mounting material the heavy, multi–coloured brocade. The hand scroll remained in use for both paintings and autographs, but it could no longer compete in popularity with the hanging scroll. Mural paintings of artistic value are found henceforward only in temples and palaces.

Since the mounting table proved unsuited for handling large scrolls of thin material, between 1400–1500 the drying boards (*chuang–pan*) were introduced. This development is the last major change in the mounting technique; it has remained largely the same till the present day.

While the hanging scroll went through a complicated evolution, the hand scroll, forming a unity in itself unrelated to interior decoration, remained essentially the same.

As regards Japanese scroll mounting, the Japanese became acquainted with this art in the 6th century A. D. through Chinese hand scrolls containing Buddhist texts. In the Heian and Fujiwara periods secular texts and pictures also were mounted in this form; religious hanging scrolls began to be introduced from China. Scroll mounting was entirely in the hands of Buddhist priests.

In the Kamakura period Chinese emigrant priests brought more hanging scrolls to Japan, and when during the Ashikaga period the *toko–no–ma* had fully developed, the hanging scroll became increasingly popular. The tea masters acquired great influence in this field and replaced as mounters the priests who thereafter confined their work to the mounting of sûtra rolls.

During the 17th century the influence of the tea masters went on increasing, they followed the simple Ming styles of mounting that accorded better with the atmosphere of the tea room. These types were adapted to Japanese taste and thus Japanese hanging scroll mounting began to develop its own style.

In the Tokugawa period a well–to–do middle class emerged, they favoured gaudy mountings reminiscent of Chinese Sung and Yüan types which were better suited for Japanese–style paintings. At the same time the Japanese Sinologues propagated the simpler types of Ch'ing mountings. The tea masters continued to evolve new, purely Japanese types, including mountings consisting entirely of paper. Thus modern Japanese hanging scrolls cover a wider range of types and materials than modern Chinese mountings.

As in China, so in Japan the hand scroll mounting remained essentially the same throughout the centuries, and for the same reason.

282

# THE BOOKS OF MOUNTING

## 1 – CHOU CHIA–CHOU'S CHUANG–HUANG–CHIH

### NOTE ON THE CHUANG–HUANG–CHIH AND ITS AUTHOR

THE *Chuang–huang–chih* "The Book of Mounting" was written by Chou Chia–chou 周 嘉 胄 styled Chiang–tso 江 左, a native of Yangchow in Kiangsu Province, who flourished during the last years of the Ming dynasty. Since he is not included in the biographical works relating to this period we must depend upon the literary works left by him for a general idea of his life and personality. *Chou Chia–chou.*

His *magnum opus* was a comprehensive work on incense entitled *Hsiang–shêng* 香 乘; *The Hsiang–shêng.* this book is praised by the Imperial Catalogue for its extensiveness and its accuracy (cf. op. cit. ch. 115, page 7).

In its initial form it counted 13 chapters; the well known Ming scholar Li Wei–chên (李 維 楨 1547–1626) added a preface, dated 1618. Later Chou Chia–chou became dissatisfied with the incompleteness of this book; having added 15 more chapters he published this enlarged edition in 1641 adding a preface of his own. It was reprinted ca. 1662 by a publisher who says that after Chou Chia–chou's death his son turned over the blocks to him in order to enlarge the circulation of the work (cf. The Library of Congress, "Orientalia Added", Washington 1927, page 266). Thus Chou Chia–chou must have died ca. 1660.

The contents of this book testify to the wide reading and the critical methods of the author. An amazing number of various kinds of incense are discussed in detail, their origin and composition investigated, and authoritative sources quoted. That Chou Chia–chou devoted more than twenty years to the study of this one subject proves his enthusiasm for research work and his passion for detail.

Chou Chia–chou seems to have written also a small work on tea pots from Yang–hsien, the well known porcelain producing centre in Kiangsu Province, near I–hsing 宜 興. The Ch'ing scholar Wu Ch'ien (吳 騫, 1733–1813) quotes in his *Yang–hsien–ming–t'ao–lu* 陽 羨 名 陶 錄 a book entitled *Yang–hsien–ming–hu–pu* 陽 羨 茗 壺 譜 "Account of tea pots from Yang–hsien", written by Chou Chia–chou. As far as I know, however, this work has not been preserved. *The Yang–hsien–ming–hu–pu.*

While the *Hsiang-shêng* shows us Chou Chia–chou as a research worker, the *Chuang-huang-chih* proves that he was deeply interested also in the study of paintings and autographs.

As is stated clearly in his preface, he wrote this brief treatise in order to acquaint collectors with the secrets of the art of remounting and repairing antique scrolls, so that such works of art might be saved for posterity. Drawing from a rich experience gathered during many years of close association with artists and mounters in Kiangsu Province he placed the various aspects of the art of mounting on record with painstaking care. If at times his style is so terse as to be ambiguous or if in other passages he seems to pass over important details, then this is no fault of the author. For he was quite justified in assuming with the contemporary reader a knowledge regarding certain varieties of silk and paper, and regarding the facts of the actual mounting process, which the present-day reader must acquire by a patient investigation of old records. As it is, the *Chuang-huang-chih* is an accurate and well-composed account of the art of remounting antique scrolls, written in good literary style.

Apart from the Preface (Chapter I) and the Epilogue (Chapter XLII), the forty chapters of this treatise may be conveniently divided into five parts.

The first part consists of chps. I–V, which clearly bear an introductory character. From these the reader obtains a good idea of Chou Chia–chou's attitude to antique scrolls, and of his sympathetic personality. One sees him as an ardent lover of art, to whom a valuable scroll is like a father: he will reverently sit before it, and let it teach him by its beauty. And just as a good son will care tenderly for the well-being of his father, so a real lover of art must know how to care for the well-being of his scrolls. He must have a good knowledge of the art of mounting, so as to be able to have his scrolls expertly restored and remounted (ch. II). In this connection Chou Chia–chou stresses the importance of a good mounter: such a man is a real artist, and he should be treated as such. A scholar should not consider it beneath his dignity to consult with him about the best way of remounting a scroll, the style of the mounting, treatment of damaged spots, etc.; for only by an ungrudging collaboration of patron and mounter a work of complete beauty can be created (ch. V).

Then, in the second part (chps. VI–XXII), the actual process of remounting is described stage by stage, starting with the washing of the scroll, and ending with pasting on the title label and adding a cover to the scroll when the process of mounting has been completed. This second part forms the main body of the treatise.

In the third part, chps. XXIII–XXIX, there are taken up a number of special questions. We learn what silk and paper should be used for backing scrolls (ch. XXIII), how to restore white pigments that have turned dark (ch. XXIV), how to remount hand scrolls (ch. XXVI) and how to mount albums (ch. XXVII), together with some notes on the mounting of rubbings (chps. XXVIII–XXIX).

The fourth part, consisting of chps. XXX–XXXVIII, is concerned with the materials used in mounting. The author explains how one should make the card board for the covers of albums (chps. XXX–XXXI), how to make paste and how to use it (chps. XXXII–XXXIII), what paper one should employ (ch. XXXIV), and what kinds of silk are suitable (ch. XXXV). Finally he adds a note on the material for the knobs of hanging scrolls (ch. XXXVI), on the right season for mounting (ch. XXXVII), and on what requirements the workshop of the mounter should answer to (ch. XXXVIII). With these four parts the technical aspect of the subject is finished.

The fifth and last part, chps. XXXIX–XLI, bears a more general character. In a narrative style the author illustrates the remarks made in the preceding chapters by quoting some actual examples of the remounting of famous scrolls by expert mounters, and also relating some of his own experiences. From these passages we learn something more about the author himself. Although he was a native of Yangchow, he seems to have passed a considerable part of his life at Nanking. He was on friendly terms with some well known scholar–artists of that time, like Wang Chih–têng, Chêng Chung, and Li Yung–ch'ang. One is probably justified in assuming that he himself was some minor official, not prominent enough to become involved in dangerous political intrigues, but sufficiently well–off to pursue his learned and artistic interests. The portentous years that presaged the impending change of dynasty left him unperturbed in the absorbed contemplation of his beloved art treasures, or discussing with some intimate friends abstruse problems of artistic judgement and the appreciation of perfect beauty. In ch. XLI he says, when speaking of his friend Ku Yüan–fang: " United in close friendship, we used to retire to some secluded abode, there to engage in critical discussions of delicate artistic problems, and rapt enjoyment would carry us away as if in a trance ". This sentence in itself adequately depicts Chou Chia–chou's charming personality.

* * *

Various editions.

It would seem that for a long time the *Chuang–huang–chih* circulated only in manuscript form; I have found no indications that it ever appeared in print as a separate volume. During the last years of the Ch'ing dynasty, however, the text was published in four *ts'ung–shu*, and in recent years it was reprinted in two modern collections. These six editions are the following.

1) *Hsüeh–hai–lei–pien* 學 海 類 編, a huge collection of minor writings, assembled by Ts'ao Jung (曹 溶, 1613–1685; cf. E. C., page 740), and published in 1831.

2) *Chao–tai–ts'ung–shu* 昭 代 叢 書, collected and critically edited by the well known Ch'ing scholar Chang Ch'ao (張 潮, 17th century), and published in 1833.

3) *Shu–ku–ts'ung–ch'ao* 述 古 叢 鈔, a small collection of reprints of works of artistic interest, published in 1871 by Liu Wan–yung 劉 晚 榮.

4) *Ts'ang–hsiu–t'ang–ts'ung–shu* 藏 修 堂 叢 書, published in 1890 by Liu Wan–yung (see preceding item).

5) *Ts'ui–lang–kan–kuan–ts'ung–shu* 翠 琅 玕 館 叢 書, a large collection of reprints, published in 1916 by Huang Jên–hêng 黃 任 恆, republished in 1921. Originally this *ts'ung–shu* was published by Fêng Chao–nien 馮 兆 年, who incorporated also the contents of the *Ts'ang–hsiu–t'ang–ts'ung–shu* (see preceding item), the old printing blocks of which he had purchased. During the turbulent time of the Revolution in 1911, Fêng Chao–nien had to sell the blocks to pay his debts. The entire collection of blocks was then purchased by Huang Jên–hêng, who used them for publishing this *ts'ung–shu*.

6) *Mei–shu–ts'ung–shu* 美 術 叢 書, a modern reprint of old Chinese books and manuscripts relating to all branches of Chinese fine and applied art, assembled by Têng Shih 鄧 實 and the well–known connoisseur Huang Pin–hung 黃 賓 虹; first series published 1911. [1]

From a textual point of view these six versions of the *Chuang–huang–chih* are not very instructive. The *variae lectiones* are few and unimportant, occurring only in passages that present no special difficulties. Only a few of the differences among the six editions enumerated above seemed important enough to be mentioned in my notes to the translation. None of the editions gives a commentary, although sometimes such would have been most welcome.

The present translation is based upon the text as published by Chang Ch'ao (see above sub 2); for several reasons this edition is to be preferred to the other five.

In the first place, it would seem that the manuscript upon which this edition is based emanated from the direct surroundings of Chou Chia–chou himself. In the colophon which Chang Ch'ao added to this text, he states that he received the manuscript from his friend Hu Ch'i–i (胡 其 毅, style Ching–fu 靜 夫); and Hu Ch'i–i is also mentioned at the beginning of the reprint, as having collated the manuscript. Now this Hu Ch'i–i is the son of the famous scholar–artist Hu Chêng–yen (胡 正 言, style Yüeh–

---

1) The *Mei–shu–ts'ung–shu* is a convenient collection, much used by Chinese art students. Here there may therefore be added a few more details about this publication.

The original edition consists of three parts, namely one main section, one sequel (*hsü–pien* 續 編), and one second sequel (*hou–pien* 後 編); each part contains ten collections, or *chi* 集.

The greater part by far of the texts published concerns the arts of painting and calligraphy; ceramics, bronzes, jades, embroidery etc. occupy a rather modest place. Some of the texts reprinted are rather rare, others are quite common and easily obtainable in their original editions. Yet the present collection, uniting a great number of works on artistic subjects in one uniform edition, is most convenient for purposes of reference. The editorial policy, however, leaves much to be desired. The modern Chinese art historian Yü Shao–sung (cf. Appendix I, no. 23) raises several points of criticism, of which I mention the following. The collection reprints several texts that are known actually to have been written much later than they pretend to have been, without adding a warning remark; the editor in his

choice of texts shows a marked preference for minor treatises of less importance, while standard works are either omitted or only reprinted in an abbreviated form; the editor does not mention what printed version he used, and in the case of manuscripts he does not say where the original may be found, omitting also remarks about the history and the quality of such a source. To these objections I add further that the editors did not properly collate the texts; numerous misprints are reproduced uncorrected, and not a few new ones are added while moreover the sequence of chapters or paragraphs is often mixed up, or entire passages left out, without the reader being warned of such arbitrary lacunae. When therefore one wishes to quote from a work as given in this *ts'ung–shu*, such a passage should first be compared with other editions.

The editors later added to the three parts mentioned above a fourth one, consisting of ten collections, *chi* 輯, and bearing as title *Mei–shu–ts'ung–shu–szŭ–chi* 美 術 叢 書 四 集. This collection, although also containing numerous misprints, on the whole is edited with greater care.

ts'ung 日從, ± 1582 – ± 1670). This contemporary of Chou Chia-chou first held an official position, but later lived in retirement, devoting himself entirely to painting, calligraphy and seal carving, and dabbling in medicine. His studio at Nanking, the *Shih-chu-chai*, became a center of art-loving scholars, among whom there were distinguished literati and artists like Mi Wan-chung (米萬鍾, died round 1620) and Wên Chên-hêng (文震亨, 1585-1645). That also Chou Chia-chou belonged to this select circle of connoisseurs and artists appears from the fact that he wrote one of the poems contained in the *Shih-chu-chai-shu-hua-pu*,[1] the finely edited collection of paintings by Hu Chêng-yen. We may assume, therefore, that the manuscript of the *Chuang-huang-chih* sent by Hu Ch'i-i to Chang Ch'ao was an old copy preserved in the *Shih-chu-chai*, and perhaps written or corrected by Chou Chia-chou himself. It probably was also this copy belonging to the *Shih-chu-chai* that was consulted by Wên Chêng-hêng when he wrote his *Chang-wu-chih* (see Appendix I, no. 25); several passages relating to the art of mounting in the *Chang-wu-chih* evidently were written as a reaction on sections of the *Chuang-huang-chih*.

Secondly, Chang Ch'ao's edition is the only one that has been punctuated with some care, and which replaces some vulgar or unauthorised characters by their correct forms.

Finally, Chang Ch'ao is the only editor who added to the text a preface and a colophon. The former, written in Chang Ch'ao's original and witty style, also contains some interesting observations on the art of mounting, and therefore seemed worthy of being included in the translation. I have added also the translation of his colophon.

While preparing Chang Ch'ao's edition for being reprinted in the present publication, with a few exceptions I followed his interpunction. For the convenience of the reader, proper names and titles of scrolls are underlined, according to the system nowadays much used in Chinese publications. Further I divided the text of each chapter into paragraphs, corresponding with the paragraphs in my translation. This division, however, is only meant to facilitate a comparison of text and translation, it does not imply that the Chinese style there actually has a pause. My aim was to produce a readable translation, as free as the technical subject-matter allowed.

---

[1] The *Shih-chu-chai-shu-hua-pu* is an important source for the study of Chinese colour printing and of pictorial art in general. It is a collection of paintings by Hu Chêng-yen himself or members of the " cercle " of artists and literati that used to gather in the Shih-chu-chai; this name, " Hall of the Ten Bamboos " is derived from the fact that Hu Chêng-yen had planted ten bamboos in front of it. This studio was located in Nanking, below the present-day Observatory of the Metereological Institute, built in 1928 on the Chi-lung Hill 鷄籠山, on the site of the old Pei-chi-ko 北極閣. Each painting is accompanied by a poem in facsimile, Chou Chia-chou's poem being found in vol. 2. Although the range of subjects represented is limited (bamboo, plum blossoms, orchids, birds, fruits, flowers and stones), the paintings are exquisite examples of this genre of Ming painting. To obtain more space for each picture the ancient " butterfly style " of binding (cf. above, page 222) has been retained, so that each painting occupies two joint pages. Since moreover the blocks have been cut and struck off with meticulous care, subtle nuances of the brush stroke and the colouring being admirably reproduced, this book is a work of art that will satisfy the most exacting bibliophile.

For more information about Hu Chêng-yen and his artistic activities the reader is referred to Hsiang Ta's article in the *Quarterly Bulletin of Chinese Bibliography* (*T'u-shu-chi-k'an* 圖書季刊, 向達: 記十竹齋, vol. II, 1935); Hsiang Ta wrote this article under his penname I-wêng-shêng 蟬嗏生. Cf. also The Library of Congress, " Report of the Division of Orientalia ", Washington 1936, and the article *The Ten Bamboo Studio* by Robert Treat Paine, published in the " Archives of the Chinese Art Society of America ", vol. V, 1951.

Although on the whole the text of the *Chuang-huang-chih* has been well preserved, there is one chapter that, although all editions print it, certainly did not belong to the original manuscript. This is the last chapter, entitled *Piao-pei-shih-san-ko* 表背十三科 (see above, page 231). As a matter of fact this chapter is a slightly abbreviated version of a passage in Chapter 27 of the *Cho-kêng-lu* (cf. Appendix I, no. 24). One wonders why the various editors of the *Chuang-huang-chih* did not draw attention to this obvious addition, that must have been added by some later copyist. The preceding section, entitled *t'i-hou* 題後 "Epilogue", clearly bears the character of a concluding chapter, the contents showing beyond doubt that the author meant this to be the end of the book. In my text I have omitted this spurious chapter.

<p style="text-align:center">* * *</p>

The Chuang-huang-chih in Japan.
The *Chuang-huang-chih* was also studied in Japan. It is sometimes quoted in works left by Tokugawa tea masters, and there exist a few Japanese manuscript copies. These copies, however, were apparently made by Japanese with a scanty knowledge of Chinese for none of them is punctuated or provided with Japanese reading marks.

In the collected works of the Japanese Sinologue Matsusaki Kōdō (松崎慊堂, 1771–1844), the *Kōdō-ibun* (慊堂遺文, published 1901, in 2 Japanese volumes) in chapter I, page 77, there is to be found a "Preface to the reprint of the Chuang-huang-chih" 刻裝潢志序, dated 1815. I have been unable to trace a copy of this reprint; probably this plan of publishing a Japanese reprint of our text was never executed.

Japanese literary sources of the Tokugawa period occasionally quote from a book called *Wakan-shōkō-shi* 和漢裝潢志 "The book of mounting in Japan and China". I have neither been able to find a copy of this text, although I have been searching for it during several years. This text, however, cannot be the reprint of the *Chuang-huang-chih* for which Matsusaki Kōdō wrote a preface. The *Wakan-shōkō-shi* is cited by sources dating from long before 1815, and moreover the passages quoted are entirely in Japanese, and bear no semblance to Chou Chia-chou's *Chuang-huang-chih*.

*The Book of Mounting*

by
Chou Chia–chou, styled Chiang–tso, from Huai–hai, [1]
published by Chang Ch'ao, styled Shan–lai, from Hsin–an. [2]
Collated by Hu Ch'i–i, styled Ching–fu, from Chiang–ning. [3]

*Chang Ch'ao's Argument.*

The mounting is to a scroll what make–up is to a handsome woman. Even when a beautiful woman is gifted with natural charm, if all day she walks about in coarse attire and with tousled hair, although this will not detract from her charm, yet it will make her look insignificant. But if she powders herself and paints her eyebrows, and daintily adds some spots of rouge, if she cuts her garments from gauze fine like a mist, and fashions her sleeves out of crystaline silk, shall not then her beauty be increased and her charm enhanced?

The art of mounting flourished during the Hsüan–ho period (1119–1125). Thereafter the existing technique was brilliantly developed, and a summum of beauty and efficiency was reached. So perfect had become this art that sometimes for the remounting and repairing of an antique hand scroll there were charged scores of ounces gold. How then could those connected with this art be considered as insignificant?

I have heard that formerly someone cut off the colophon from an antique scroll, and then gave the scroll to a mounter for being remounted. After having reached an agreement about the price of the remounting, the mounter, being an expert in judging antiques, said: " It is a pity that to this scroll there is not attached a superscription or a colophon by a famous scholar; for if there were one attached to it, its value would rise considerably ". Thereupon the patron asked the mounter to look around for him, and try to obtain somewhere a suitable colophon. If he would find one fit to be used, there was no objection to 'eking out a sable robe with a dog's tail'. [4] When some weeks had passed

裝潢志

淮海周嘉冑江左著
新安張潮山來輯　江寧胡其毅靜夫校
小引
　書畫之有裝潢。猶美人之有妝飾也。美人雖姿態天然。苟終日相服
亂頭。卽風韻不減。亦甚無謂。若使略施粉黛。輕點臙脂。裁霧縠以爲裳。
蹙冰綃而作袖。有不增妍益媚者乎。
　裝潢之法。盛于宣和。後此踵事增華。逾臻美善。甚有重修舊卷。爲值
至數十金者。其所係豈淺尠哉。
　聞昔人有以舊蹟。去其跋而付裝潢家。議價已諧。其人頗精鑒賞。云
惜無名人題跋。若有之。斯其值益昂。是人因屬以代訪。設有可假借用

<hr>

1) Huai–hai, Yangchow, Kiangsu Province.

2) Hsin–an, Shê–hsien 歙縣, in Anhwei Province, famous producing center of ink stones. In my book *Mi Fu on Ink stones* wrongly transcribed *Hsi*–hsien.

3) Chiang–ning, Kiangsu Province, S. of Nanking.

4) The full quotation is *kou–wei–hsü–tiao* 狗尾續貂, i. e. supplement a defect of a good thing by adding something of inferior quality.

by, however, the patron brought the original colophon to the mounter, saying: " Recently I purchased this one, which seems suitable ". In due time the mounter realized the truth, and said: " This is the original colophon! You only took it away to deceive me. If the other day you would have brought both painting and colophon together, do you think I would have remounted this scroll for you unless you had paid me several ounces more ? " From this it may be seen that the power of judgement of a mounter must indeed not be thought lightly of.

I have heard that the best paste (used for mounting) is old paste. There is paste that has been stored for a number of years, which still may be found in Soochow. If you use for your scrolls new paste, then hung in your hall they will warp, and stored away in your chests they will be eaten by insects. [1] Therefore the mounting may both benefit and harm a scroll.

In my opinion for laying out on your desk an album is better than a hand scroll. An album you may open at any place you like to look at, while a hand scroll you must every time unroll from beginning to end. But will not outsiders consider my words as so much idle talk?

<div align="right">Written by Chang Ch'ao, of the Hsin-chai.</div>

*I. Author's Preface.*

The people of later times have copied out on scrolls and engraved in printing blocks the wise words and edifying teachings of the Holy Sages, and thus spread them widely over the realm. Being recited and studied in the homes of the people, these teachings will not perish during ten thousand generations. Now great scholars and talented men have exerted themselves to express the essence of their wisdom in writings and paintings. The transmission of these, however, entirely depends upon silk and paper. Now paper and silk are frail materials. They are menaced by all kinds of calamities: as when falling into the hands of the wrong people, being destroyed by disasters of war and fire, becoming grimy, torn and worm-eaten, or being seized by force and sold for gain. Because of these evils, but one-hundredth part of them is preserved. If the scrolls constituting this one-hundredth part that survives are mounted by the wrong people, they will be spoilt beyond repair. This truly is a cause for great indignation.

者。不妨即以續貂。越數旬。是人携原跋語之曰。吾近購此。似可用。其人
久之。乃悟。此即原跋。君蓋去之以紿我耳。若當日並此借來。非若干金。
吾肯爲君治之乎。由此觀之。其權亦不輕矣。

余聞其漿以陳爲貴。有至數年者。吳中尚時有之。漿苟不陳。縣之堂
中。必且如瓦。藏諸櫃。必且捐于蠧。是裝潢能爲功。亦能爲罪矣。

然余以爲置之案頭。爲卷不若爲册。册可隨便繙閱。卷非自首至尾
不可。不識世之人。河漢余言否也。

<div align="right">心齋張潮 譔</div>

I. 序

聖人立言教化。後人抄卷彫板。廣布海宇。家戶頌習。以至萬世不泯。
上士才人。竭精靈於書畫。僅賴楮素以傳。而楮質素絲之力有限。其經
傳接非人。以至兵火喪亂。黴爛蠧蝕。豪奪計賺。種種惡劫。百不傳一。於
百一之中。裝潢非人。隨手損棄。良可痛惋。

[1] The smell of new paste will attract insects.

290

Since the fate of famous scrolls depends entirely upon the quality of their mountings, I venture to say that the mounter is the arbiter of the destiny of scrolls. During a long time I therefore diligently studied the art of mounting, and so discovered many a precious devise. [1] The results of my investigations I now record here in great detail, hoping that they may become known all over the realm.

I beg of all you gentlemen, lovers of art, who in your strong–boxes or on your shelves have collected rare treasures, should you wish to have them remounted, first to make a careful study of this book of mine, to spare yourself the fear lest in course of time these treasures might perish. Then old scrolls may be renewed, an achievement as great as re–making them.

Because of these considerations I dare say that this book will be of some use to kindred spirits. I hope that they will recognize its merits, however small, in the cause of the supreme art, thus increasing my personal dedication to the Subtle Pact (of those bound together by artistic interest).

## II. Remounting old scrolls is like calling a doctor when ill.

Nearly all the scrolls of olden times that have been transmitted to the present are badly damaged. When you wish to have them remounted, you should consider this in the same light as calling in a doctor when you are gravely ill. If the doctor is good, you will soon recover, but if he is incompetent, you will die as soon as you have partaken of his potions. Since taking no medicine at all is no worse than trusting yourself to a quack, if you cannot find a good mounter, it is better to leave a scroll as it is.

Ah! Famous scrolls of superior quality should indeed not be considered lightly. To the people they are the glory of their state, and talented men venerate them like they would their master. Now a master is like a father. Just as a good son must know a good doctor for his father, so they who treasure scrolls must study the art of mounting.

故 裝 潢 優 劣。實 名 迹 存 亡 係 焉。竊 謂 裝 潢 者。書 畫 之 司 命 也。是 以 切
切 於 兹。探 討 有 日。頗 得 金 針 之 祕。乃 一 一 拈 志。願 公 海 內。好 事 諸 公。有
獲 金 匱 之 奇。梁 間 之 祕 者。欲 加 背 飾。乞 先 於 此 究 心。庶 不 虞 損 棄。俾 古
迹 一 新。功 同 再 造。
則 余 此 志 也。敢 謂 有 補 於 同 心。冀 欲 策 微 勳 於 至 藝。以 附 冥 契 之 私
云。

II. 古 迹 重 裝 如 病 延 醫

前 代 書 畫。傳 歷 至 今。未 有 不 殘 脫 者。苟 欲 改 裝。如 病 篤 延 醫。醫 善。則
隨 手 而 起。醫 不 善。隨 劑 而 斃。所 謂 不 藥 當 中 醫。不 遇 良 工。寧 存 故 物。
嗟 夫。上 品 名 迹。視 之 匪 輕。邦 家 用 以 華 國。藝 士 尊 之 爲 師。師 猶 父 也。
爲 人 子 者。不 可 不 知 醫。寶 書 畫。不 可 不 究 裝 潢。

1) *Chin-chên* 金 針, lit. " golden needle ". Allusion to a story told in the *Kuei-yüan-ts'ung-t'an* 桂 苑 叢 談; this is a collection of anecdotes, compiled by a certain Fêng-i-tzû 馮 翊 子 (perhaps the great T'ang poet Po Chü-i, who is sometimes referred to as Fêng-i-hou 馮 翊 侯). Near the end, under the heading *Ts'ai-niang* 采 娘 there is told that a girl received from the Goddess of Weaving Chih-nü 織 女 a magic golden needle, with which thenceforth she was able, without the slightest effort, to make the most beautiful embroideries.

*III. Superior skill.* [1]

Those who are skilled in mounting scrolls are spread over the realm, but they all must yield to the mounters of Kiangsu. The Kiangsu mounters number several thousand, but they who are past masters in the art do not exceed a few score people. Men like Mr. T'ang and Mr. Ch'iang of former days [2] deserve to be called the very best in the Empire. Although in later times there still were some who might be compared to them, it is also necessary that their patron be a man with a thorough knowledge of the subject, who takes part in the study of the planned mounting, and lets the best material be used. When all the details of the mounting have been settled satisfactorily, then they may create between them a harmonious and beautiful piece of work, so that wonderful scrolls obtain, as it were, a womb from which they can be reborn, [3] and enter upon a glorious second existence. How could the merit of having achieved this ever be called shallow?

*IV. Liberally rewarding skilful artisans.*

Skilful artisans must have hands that can repair the firmament, [4] eyes that can distinguish the heart of a louse hung up in a window, [5] a free and detached spirit, and an undivided concentration. To those who answer these requirements you may entrust your orders. Besides, they should be in the full force of their years, for if they are too old their spiritual powers are no longer sufficient.

Lovers of art must liberally reward such artisans. If the precious scrolls in their collections are remounted well, their value becomes doubled, but if the mounting is clumsily done, they become nothing but rubbish. Should you not then guard against this beforehand?

You should be excessively obliging to good mounters, in order to protect the life of your scrolls, for those people consider the life of scrolls as their very own. If you serve those people, you serve your scrolls.

III. 妙 技

裝潢能事。普天之下。獨遜吳中。吳中千百之家。俅其盡善者。亦不數人。徃如湯強二氏。無忝國手之稱。後雖時不乏人。亦必主人精審。於中參究。料用盡善。一一從心。乃得相成合美。俾妙迹投胎得所。名芳再世。功豈淺鮮哉。

IV. 優 禮 良 工

良工須具補天之手。貫蝨之睛。靈惠虛和。心細如髮。充此任者。乃不負託。又須年力甫壯。過此則神用不給矣

好事者。必優禮厚聘。其書畫高值者。裝善則可倍值。裝不善則爲棄物。詎可不慎於先。

越格趨承此輩。以保書畫性命。書畫之命。我之命也。趨承此輩。趨承書畫也。

1) The text reads *ch'ao-chi* 抄技; I prefer the reading *miao-chi* 妙技 given in the other editions.

2) Cf. above page 249.

3) *T'ou-t'ai* 投胎, Buddhist term.

4) Allusion to the mythical being Nü Kua (女媧, B. D. no. 1578), who melted together stones of five colours and therewith repaired the firmament, when the universe threatened to collapse through the outrages of the rebel Kung Kung (共工, B. D. no. 1024).

5) *Lieh-tzŭ* 列子, chapter *T'ang-wên* 湯問, describes the sharp eye of the archer Chi Ch'ang 紀昌, who hung a louse on a hair against the light in a window, and then pierced its heart with his arrow without the hair breaking.

## V. Collaboration between patron and mounter.

A wise patron who is a lover of art will try to find a skilful mounter, to whom he can entrust the mounting of his scrolls till the end of his days; but to find such a good mounter is of course not easy. It is still more difficult, however, for a skilful artisan to obtain such a wise patron for whom to work. If the right people meet, then rare scrolls are mysteriously brought to life again, they are, as it were, reborn in this world. Everytime a scroll is remounted with complete success, this can be compared to a calamity overcome, or the Elixir of Life extracted from the cinnabar. [1]  When such a fortunate union (of a discerning patron and a skilful mounter) has been effected, shall it then not be as if miracles were being performed?

Patron and artisan should start with preliminary deliberations, fixing beforehand the style and model of the mounting.  The work should not be started before both parties completely agree on all points: then by such a collaboration a work of lasting beauty may be created.

## VI. Examination of tone and colours.

Before starting to remount a scroll, first its tone and colours must be carefully examined.  If the colours have darkened and the general hue toned down, or if the scroll should be covered with mould and accumulated dust, it should first be cleansed by washing.  But washing includes that the scroll suffers from the water, it may interfere with its charm.  Therefore, if its only result would be that the scroll is brightened up a little, you had better leave it as it is.

## VII. Washing.

Before starting to wash a scroll, you should first examine whether the texture of the paper is loose or close, and in case of silk whether it is old or new, and moreover the general tone of the painting. Spots that have become grimy or which show other defects must be studied one by one so that they can be mended.  Damaged scrolls should be washed together with their backing, but from those that are

V. 賓 主 相 參

好 事 賢 主。欲 得 良 工。爲 終 世 書 畫 之 託。固 自 不 易。而 良 工 之 得 賢 主。以 聘 技。更 難 其 人。苟 相 遇 合。則 異 跡 當 冥 冥 降 靈。歸 託 重 生 也。凡 重 裝 盡 善。如 超 劫 還 丹。機 緣 湊 合。豈 不 有 神 助 耶。

而 賓 主 定 當 預 爲 酌 定 裝 式。彼 此 意 愜。然 後 從 事。則 兩 獲 令 終 之 美。

VI. 審 視 氣 色

書 畫 付 裝。先 須 審 視 氣 色。如 色 黯 氣 沈。或 烟 蒸 塵 積。須 浣 淋 令 淨。然 浣 淋 傷 水。亦 妨 神 彩。如 稍 明 淨。仍 之 爲 妙。

VII. 洗

洗 時 先 視 紙 質 鬆 緊。絹 素 歷 年 遠 近。及 畫 之 顏 色。黴 損 受 病 處。一 一 加 意 調 護。損 則 連 托 紙 洗。不 損 須 揭 淨。只 將 畫 之 本 身。副 油 紙 置 案 上。

1) *huan-tan*, the supreme achievement strived after by Taoist alchemists.

still intact the backing should first be removed.   You should spread out under the painting a sheet of oil paper, and the table should be tilted by putting something under two of its legs, so that all the water runs in one direction.   Then you brush away the dirty spots with a large brush, not stopping until the water (which comes off the scroll) is clean.   If the grime is thick and the dust inveterate, then you should take some loquats, and mash them in boiling water.   When this mixture has cooled down, you should wash the scroll with it; then you will find that the dirty spots disappear entirely.   You may use also pods of *tsao-chiao* [1] (in the same way as the loquats), but in either case immediately after the washing process the painting should be washed again with clean water, in order to remove the remnants of the loquat or *tsao-chiao* juice.   If this precaution is omitted, the painting will be injured; beware of this! After washing you should spread a sheet of new paper over the painting, and by pressing make it absorb the moisture.   The sooner your scroll is dry, the better.

### VIII. *Taking off the old backing.*

The fate of a scroll depends entirely upon the way in which the old backing is taken off.   In the case of silk scrolls, this process as a rule will not be difficult.   In the case of paper scrolls it will sometimes be easy to remove their backing, but on the other hand when the paper is thin and when thick paste had been used (by the former mounter) it may prove difficult to take off the backing; this will be especially difficult if *po-chi* [2] was used in preparing the paste.   The successful completion of this task rests entirely with the diligence of the mounter: he should know how to start his job in the right way, [3] and then patiently go on slowly, concentrating his utmost efforts on every tiny detail.   Often there are moments as dangerous as if you came near a hidden pit, or were to tread on thin ice. [4]   If, however, the work has been successfully completed, then this is a triumph which surpasses the victory by the river Fei. [5]

將 案 兩 足。墊 高 一 邊 瀉 水。用 糊 刷 灑 水。淋 去 塵 污。至 水 淨 而 止。如 黴 氣
重。積 污 深。則 用 枇 杷 核。錘 浸 滾 水。冷 定 洗 之。卽 垢 污 盡 去。或 皂 角 亦 可
用。則 急 將 清 水。淋 解 枇 杷 皂 角 之 餘 氣。否 則 反 爲 書 害。愼 之。洗 後 將 新
紙。印 去 水 氣。令 速 乾 爲 善。

### VIII. 揭

書 畫 性 命。全 關 於 揭。絹 尚 可 爲。紙 有 易 揭 者。有 紙 薄 糊 厚 難 揭 者。糊
有 白 芨 者。猶 難。特 在 良 工 苦 心。施 迎 刃 之 能。逐 漸 耐 煩。致 力 於 毫 芒 微
渺。間 有 臨 淵 履 氷 之 危。一 得 奏 功。便 勝 淝 水 之 捷。

1) *Tsao-chiao* 皂 角, *Gleditschia borrida*.
2) *Po-chi* 白 芨, *Bletilla hyacinthina*, an orchidaceous plant; the sap of its roots is used in preparing various kinds of paste.
3) *Ying-jên* 迎 刃 "meeting the blade", refers to a difficult matter becoming easy through skilful handling. If, when splitting bamboo, the correct incision is made, the bamboo will easily split lengthwise.   The same applies to the peeling off of the old backing: having worked loose the tip of one patch in an expert way, the rest will also come off easily.
4) Quoted from *Lun-yü* 論 語, ch. VIII, 3.
5) Allusion to the victory won by Hsieh Hsüan (謝 玄, 343-388), a famous general of the Chin period, who by this river inflicted a crushing defeat upon the enemy; it is said that the current was stopped by the mass of corpses.

*IX. Patching up holes.*

For patching up the holes you should use paper or silk of exactly the same kind as that of the scroll itself. If the colour of the material at your disposal should differ from that of the painting, you can still dye it so as to make it fit for use. If the texture of the silk, or the thickness of the paper used for the patches is ever so slightly different from that of the painting itself, then (after the remounting has been completed) the difference of material (of scroll and patches) will show.

Therefore, although an artisan may have skill sufficient for repairing the firmament, [1] he must also first have studied the nuances of colouring. If silk patches are used their texture must be the same as that of the scroll itself, and in the case of paper patches they must not show on the surface of the scroll.

*X. Lining the borders.*

When the scroll has been patched up, you should take paper of the same colour as the painting itself, and with this material border the scroll on all the four sides with a narrow seam of about 2 to 3 *fên* broad, to be utilized later for pasting on the "frame", so that this will not cover up one hair's breadth of the painting itself. [2]

*XI. Adding the first backing.*

When the scroll has been provided with its first backing, the main task has been performed. The worst defects will have disappeared, and the original charm of the scroll has been restored. Such result could be compared to that of a cure effected by Hua T'o [3] or Pien Ch'iao: [4] not only has the painting regained its original aspect, but its charm and beauty have even been increased in a surprising way.

IX. 補

補綴須得書畫本身紙絹質料一同者。色不相當。尙可染配。絹之粗
細。紙之厚薄。稍不相侔。視則兩異。

故雖有補天之神。必先煉五色之石。絹須絲縷相對。紙必補處莫分。

X. 襯邊

補綴旣完。用畫心一色紙。四圍飛襯出邊二三分許。爲裁鑲用糊之
地。庶分毫無侵於畫心。

XI. 小托

畫經小托。業已功成。沈痾旣脫。元氣復完。得資華扁之靈。不但復還
舊觀。而風華氣韻。益當翩翩遒上矣。

---

1) See note 4 on p. 292 above.
2) Cf. the discussions on page 105–106.
3) Hua T'o 華佗, a famous physician of the 3d

century, cf. B. D. no. 830.
4) Pien Ch'iao 扁鵲, well known doctor of the period of the Warring States; cf. B. D. no. 396.

## XII. Retouching.

When antique paintings show damaged or missing spots, there is no harm in having them touched up, with old ink; but for this work you must ask a great artist to apply his talent. My friend Chêng Chung [1] is marvellous in retouching. Once he retouched for me a painting by Chao Po-chü, [2] entitled "Spring Morn in the Fragrant Forest": (so cleverly was this done that) if Chao Po-chü [3] were reborn, even he would not be able to detect it. If, however, for this work you do not employ the right man, the harm done will not be small.

## XIII. Models of mounting hanging scrolls.

If the scroll to be mounted consists of one ordinary sheet of uncut *lien-szû* paper, [4] then for large-

XII. 全

古畫有殘缺處。用舊墨。不妨以筆全之。須乞高手施靈。友人鄭千里
全畫入神。向爲余全趙千里芳林春曉圖。即天水復生。亦弗能自辨。全
非其人。爲患不淺。

XIII. 式

中幅如整張連四。大者天一尺九寸。地九寸五分。上玉池六寸五分。
下四寸二分。邊之濶狹酌用。

---

1) Chêng Chung 鄭重, lit. name Ch'ien-li 千里, well known Ming painter, famous for his human figures, landscapes and Buddhist subjects.

2) Chao Po-chü 趙伯駒, lit. name also Ch'ien-li 千里, famous Sung painter.

3) T'ien-shui 天水, in Kansu Province, was the home of the Chao family; here it evidently refers to Chao Po-chü. Often used also to designate the Sung Emperor Hui-tsung, and the Yüan artist Chao Mêng-fu.

4) *Lien-szû* 連四, lit. "connect four"; also written *lien-szû* 連泗 or *lien-shih* 連史. The Yüan scholar Fei Cho 費著 says in his *Chien-chih-pu* (牋紙譜, a description of various ordinary and ornamental papers produced in Szuchuan Province; appended to his *Sui-hua-chi-li* 歲華紀麗, a brief survey of calendar feasts celebrated in the provincial capital): "All the various kinds of paper may be produced by two, three or four dippings" 紙皆有連二連三連四. From this passage it would seem that terms like 連泗 and 連史 are less correct, as "four" in 連四 has a special meaning: it refers to the fact that this paper is produced by dipping the mould four times in the vat of pulp (other sources aver that "four" means that each sheet consists of four very thin sheets pounded together, thus referring to a laminated paper). Since the term *lien-szû* 連四 thus only indicates the construction of the paper and not

material, quality or colour, evidently it was originally used for designating all kinds of paper. Chapters XV, XXIV, XXXIV and XLII of the *Chuang-huang-chih* mention also a paper called *lien-ch'i* 連七 "connected seven", which is described as thick and stiff. This tallies with the following statement given by another Ming source: "During the Yung-lo period (1403-1424) at Hsi-shan (i. e. Hsin-ch'ien 新建, right opposite Nan-ch'ang, present capital of Kiangsi Province) in Kiangsi there was established an official paper mill; the largest size paper of good quality produced there is called *lien-ch'i*" (cf. *K'ao-p'an-yü-shih*, Appendix I, no. 29: 永樂中江西西山置官局造紙. 最大而好者曰連七). It appears, therefore, that *lien-ch'i* was produced in very large sheets, and consequently must have been rather thick; probably it was not unlike the modern *pi-chih* (see the sample in Appendix V, no. 12). Nowadays the term *lien-szû* refers to a superior white paper, made from bamboo pulp, and produced in Ho-k'ou 河口, in NE Kiangsi Province. Directly to the south of Ho-k'ou lies Ch'ien-shan 鉛山, also famous for its bamboo paper, and still farther south, over the provincial border, in Fukien Province, lie Kuang-tsê 光澤 and Shao-wu 邵武, well known for the *chu-lien* 竹連 produced there. This paper is made from the young shoots of *mao-chu* 貓竹 "cat's bamboo". These shoots are cut when the leaves have not yet come out, and

sized specimens [1] the *t'ien* (see Plate **30** A, no. 1) should be made to measure 1 *ch'ih* 9 *ts'un*, and the *ti* (ibidem, no. 2) 9 *ts'un* 5 *fên*. The upper *yü-ch'ih* [2] should measure 6 *ts'un* 5 *fên*, and the lower *yü-ch'ih* 4 *ts'un* 2 *fên*. The breadth of the borders (constituting the " frame ") should be fixed accordingly.

Specimens of smaller size should be mounted in such a way as to become short scrolls. Short hanging scrolls are the antique style, and they are easy to suspend on the wall. Paintings of about 3 *ch'ih* high should be mounted with a " frame " consisting of four strips (see Plate **30** A, nos. 5 *a, b, c* and *d*); if the painting is very short, it can be mounted with a " frame " cut from one piece of fine silk of a very pale blue colour. [3] If the painting should be highly coloured, you may also use borders of a pale ivory tinge. Such nuances should be decided according to the colouring of the painting.

In the case of small paintings, the *t'ien* should measure 1 *ch'ih* 8 *ts'un*, the *ti* 9 *ts'un*, the upper *yü-ch'ih* 6 *ts'un*, and the lower one 4 *ts'un*.

小 幅 宜 短。短 則 式 古。便 於 懸 掛。畫 心 三 尺 上 下 者。俱 嵌 邊。太 短 則 挖 嵌。用 極 淡 月 白 細 絹。畫 如 設 色 深 者。宜 用 淡 牙 色。取 其 別 於 畫 色 也。小 畫。天 一 尺 八 寸。地 九 寸。上 玉 池 六 寸。下 四 寸。

then are left to soak in a lime solution. After about one month they have become soft, and the hide can be peeled off. Then the remaining pulp is beaten till it becomes a soft substance, technically called *chu-szŭ* 竹 絲 " bamboo silk "; the moulds are dipped in this.

The paper producing center in Anhwei Province is Wu-hu-tao, where lie such famous places as Hsüan-ch'êng 宣 城 and Ching-hsien 涇 縣 (see Chapter XXXIV). Paper made at Hsüan-ch'êng is generally designated as *hsüan-chih* 宣 紙 " hsüan-paper ", a term occurring already in T'ang dynasty literature; single papers are called *tan-hsüan* 單 宣, laminated papers *chia-kung* 夾 貢. The best paper is made from the bark of the mulberry tree, and hence called *mien-lien* (棉 連, cf. Chapters XV and XLII); to-day this paper is still used by mounters for backing scrolls (see page 74 above). In the first month of summer the bark is peeled off, and left to soak in a lime solution. Then it is thoroughly pounded, and the pulp thus obtained is poured in large vats. In these vats the workmen dip moulds made of thin bamboo slips, and the film collected on these moulds constitutes the paper. Only the very best *mien-lien* is made exclusively of bark (Chapter XXX); most paper makers, however, add one-third of bamboo pulp.

Chapters XV and XLII mention a paper called *kang-lien* 扛 連, and Chapter XXXIV a paper called *kung-tan* 供 單. About these two papers I could find no further details, but the context gives to understand that *kang-lien* paper is rather thick and stiff, not unlike *lien-ch'i*, while *kung-tan* is thin, and resembles *lien-szŭ*.

D. Hunter and R. H. Clapperton, both experts with an intimate knowledge of the technical details of paper making, have written excellent accounts of how various kinds of Chinese and Japanese paper are made (cf. their publications mentioned in Appendix I, A). It is hoped that now that these technical data have been made available a Sinologue will undertake to correlate these with the hundreds of papers mentioned in older Chinese artistic literature and try to identify them.

1) Qualifications like *ta* 大 " large ", *hsiao* 小 " small ", *tuan* 短 " short " and *ch'ang* 長 " long ", must always remain rather ambiguous, since they are based upon the personal opinion of each individual author. From this chapter it would appear that Chou Chia-chou considers a painting to be mounted as a hanging scroll of average size if it is three *ch'ih* high. On the other hand the *Mo-yüan-hui-kuan* (see Appendix I, no. 46) applies the epithet " large " to a hanging scroll measuring 3 *ch'ih* by 1 *ch'ih*. Most hanging scrolls mentioned in the *Tung-t'u-hsüan-lan* (東 圖 玄 覽, compiled by the Ming scholar and connoisseur Chan Ching-fêng 詹 景 鳳, Wan-li period), however, measure from 2 *ch'ih* 5 *ts'un* by 1 *ch'ih* 5 *ts'un*, to 3 *ch'ih* by 2 *ch'ih*. Thus it may be assumed that during the Ming period about three *ch'ih* was considered the height of an average hanging scroll.

As to hand scrolls, the *Tung-t'u-hsüan-lan* calls " small " a hand scroll of 3 *ch'ih* by 6 *ts'un*; those measuring 8 *ch'ih* by 8 *ts'un* are considered of usual size, while those of 1 *chang* by 2 *ch'ih* are called " large ".

Nowadays in China and Japan an uncut sheet of paper of normal size usually measures about 4 *ch'ih* by 2 *ch'ih* 2 *ts'un*; half of such a sheet cut lengthwise is a common size for a painting or autograph to be mounted as a hanging scroll. When this size became more or less the standard, I have been unable to ascertain. Cf., however, the discussion of Ming paper on page 252 above.

2) Cf. the discussion of this term on page 69–70 above.

3) *Yüeh-po* 月 白, a colour obtained by mixing indigo and lead white.

For larger paintings these dimensions should be enlarged in proportion but you should refrain from adding a *shih-t'ang* (see Plate **30** A, no. 14). Formerly I thoroughly discussed this question with Wang Chih-têng.[1] He himself has mounted several hundred scrolls, but among these not a single one shows a *shih-t'ang*. Neither should a *shih-t'ang* be added to small scrolls. It is not easy, however, to discuss such questions with anyone who has not advanced very far in the knowledge of the connoisseur.

### XIV. *Adding the borders.*

For adding the borders you should wait for damp weather. It is in the cutting and joining together of these borders that a good artisan can display his skill.

### XV. *Backings.*

For the backings only paper made of the bark of the mulberry tree should be used; its thickness must be decided according to each particular case. The scroll must be spread out on the board together with its backing, then both must be thoroughly soaked with water. Whether then the backing will become glued securely to the scroll, entirely depends on vigorous and continuous brushing: when thus the scroll and its backing will come to form as it were one single sheet, then this can be called superior skill.

Bamboo *lien-szŭ* paper of the best quality may also be used for the first backing of a scroll; if then for the second backing you use good mulberry paper you will obtain wonderful results.[2] Moreover bamboo paper can easily be polished by rubbing (see above, page 79); when the scroll is being unrolled, this shine (of the backing) will enhance the beauty of the painting. In no case you should make backings of *lien-ch'i* or *kang-lien*[3] paper.

### XVI. *Putting the scroll on the board.*

Scrolls of superior quality when not excessively large, and all middle-sized or small scrolls, should be put on the board vertically. If they would be put on transversally, then the moisture will not be

大書隨宜推廣式之。惟忌用詩堂。徃與王伯穀切論之。伯穀經裝數
百軸。無一有詩堂者。小幅短。亦不用詩堂。非造極者。不易語也。

### XIV. 鑲攢

嵌攢必俟天潤。裁嵌合縫。善手施能。

### XV. 覆

覆背紙必純用綿料。厚薄隨宜。亦須上壁與畫心同幪過。灑水潤透。
用糊相合。全在用力多刷。令紙表裏如抄成一片者。乃見超乘之技。

或用上號竹料連四。以好綿料紙。托爲覆背用。亦妙。竹料砑易光。舒
卷之間。與畫有益。切忌用連七及扛連。

### XVI. 上壁

上品之迹。無甚大者。中小之幅。必須堅貼。若橫貼則水氣有輕重。燥
潤有先後。糊性不純和。則不能望其全勝矣。

1) Wang Chih-têng 王穉登, 1535-1612, volu-
minous Ming writer; the text gives his style Po-ku 伯穀.

2) *Lien-szŭ* paper, see note 4 on p. 296 above.
3) Cf. same footnote.

equally divided, the scroll will dry unevenly, the power of the paste will not be effective, and you cannot expect a complete success.

For putting the scroll on the board you should choose damp weather, that is the right time. While it is drying, you should take a sheet of thin paper, and spread it over the scroll on the board, to avoid its being soiled by mosquitos and flies, or rendered unclean by flying dust. The longer you leave the scroll on the board, the better; for thus its capacity for warping will become entirely exhausted. In such a way you will achieve the wonderful effect that can only be obtained by a complete harmony of heart and hand. [1]

*XVII. Taking the scroll off the board.*

When the scroll is being put on the board it should be moist, the degree of its humidity being of great importance. When being taken off the board, however, the scroll should be dry, then afterwards it will not warp. The successful mounting of a scroll depends entirely on whether one strikes the exact degree of both dryness and humidity.

*XVIII. Attaching the knobs to the roller.*

For attaching the knobs to the roller of the scroll you should use dough of non-glutinous rice, adding thereto a little lime, and pounding these elements together until the mixture resembles glue. If the knobs are attached with this mixture, they will remain permanently fixed. But if alum solution is added, the knobs soon burst, and they will easily come off.

*XIX. Adding the roller to the scroll.*

For the roller fragrant sandal wood is the best material, while old cedar wood from Wu-yüan[2] comes next. You should be careful to choose only seasoned timber (that will not warp any more). Ce-

上壁值天潤。乃爲得時。乾卽用薄紙粘蓋。以妨蚊蠅點污。飛塵浮染。停壁逾久逾佳。俾盡歷陰晴燥潤。以副得手應心之妙。

XVII. 下壁

上壁宜潤。貴其滋調。下壁宜燥。庶屛瓦患。燥潤失宜。優劣係焉。

XVIII. 安軸

安軸用秔米糭子。加少石灰。錘粘如膠。以之安軸。永不脫落。灌礬汁者。軸易裂。又易脫。

XIX. 上桿

軸桿檀香爲上。次用婺源老杉木舊料。採取木性定者。堪用。杉性燥。檀辟蠹。他木無取。

---

[1] *Shou-ying-hsin* 手應心, quoted from *Lieh-tzŭ* 列子, chapter *T'ang-wên* 湯問.

[2] Wu-yüan 婺源, Wu-hu tao 蕪胡道, in Anhwei Province.

dar wood is dry by nature, while sandal wood will keep insects away.   Other kinds of wood should not be used.

You must instruct the carpenter to make the roller  perfectly round, and make both ends exactly the same, not differing one hair's breadth from the set measure.   Then, when the scroll is being rolled up, it will not get askew.

*XX. Adding the upper stave.*

Generally the upper stave of a scroll is rounded along one side, like the back of a carp.   I myself occasionally use square and flat upper staves, slightly hollowed out on the inside, so that (when the scroll is rolled up) the curve of the scroll wound round its roller fits in the concave side of the stave.   This is a special method of my own discovery

If you cannot afford to have the eyes for the suspension loop (screwed in the upper stave) made of gold or silver, copper will also do, provided it has been polished smooth.   These eyes should not be too large; they should be of exactly the same size, and bored into the stave by turning them round (like a screw).

Adding the upper stave to a scroll is not easy, it is as difficult as fitting a bonnet to your head. Therefore you must add the stave with great care.

Handling richly decorated scrolls naturally gives great pleasure: every time you unroll such a splendid thing, your spirit will soar. [1]   If, however, you cannot afford to have such costly mountings, then simple but tasteful materials will do just as well. [2]

須 令 木 工 製 極 圓。鏧 兩 頭 一 齊。分 毫 不 逾 矩 度。捲 則 無 出 入 之 失。

XX. 上 貼

畫 貼 槩 用 鯽 魚 背 式。余 間 用 方 而 委 角 者。靠 裏 一 面。令 稍 凹 以 適 圓 桿 之 宜。此 余 究 心 之 微 而 然。

繩 圈 如 不 能 金 銀 者。銅 條 亦 可。須 稍 粗 加 磨 拭。堪 用。圈 眼 勿 大。大 小 一 同。轉 脚 入 木。

上 貼 亦 不 易 事。如 人 着 冠。切 須 留 意。

瓊 瑤 在 握。自 亦 可 喜。再 展 菁 華。則 色 飛 神 爽 矣。若 不 三 雅 酬 興。亦 須 七 碗 熏 心。

1) Lit.: "To have precious things within one's grasp, this naturally is gratifying.   Again unfolding their splendour, the colour soars and the spirit is bright". Perhaps a quotation.

2) 若 不 三 雅 酬 興。亦 須 七 碗 熏 心, literally: "If there are not the Three Elegant Goblets to answer your elated mood, then the Seven Cups should delight your heart with their fragrance".  *San-ya* "Three Goblets" refers to a story told about the 3d century scholar Liu Piao 劉 表, who was a great wine bibber; he had three goblets made, the largest, which he called *Po-ya* 伯 雅, could contain seven pints of wine, the middle one, called

*Chung-ya* 仲 雅, five, and the smallest one, called *Chi-ya* 季 雅, three (cf. *Tsun-shêng-pa-chien*, Appendix I, no. 28: chapter 14, page 12).   This quotation thus refers to luxurious enjoyment.  *Ch'i-wan* "Seven Cups" refers to a famous poem on tea drinking by the T'ang poet Lü T'ung 盧 仝, where the refined enjoyment of drinking seven small cups of tea in succession is described in detail: the first cup moistens the mouth, the second elates the feelings, etc.  Thus this second quotation means that even simple things can be a source of joy.   I have tried in my translation to reproduce the contrast implied in these two quotations.

## XXI. Pasting on the title label.

The Sung Emperor Hui–tsung (1101–1125) and the Chin Emperor Chang–tsung (1190–1208) for the title labels of their scrolls often used porcelain–blue paper, inscribed with golden characters, which truly looks magnificent. Next best are strips of *chin–su* paper. [1] As regards their length, the title labels should just come up to were the band is wound round the scroll, not falling short of nor going beyond this limit. This is the fixed model.

## XXII. Covers of scrolls.

The protecting flap [2] of a scroll is easily damaged, which is a great calamity for a painting. Therefore, as soon as the mounting of a scroll has been completed, the mounted scroll should immediately be wrapped up in a cover.

## XXIII. Dyeing the paper for backing old silk scrolls.

For backing antique silk paintings you should use paper that has been dyed yellow with ochre. Then the colours and the general hue of the painting will become limpid, a very beautiful effect that will become ever more excellent with the passing of the years.

XXI. 貼 籤

宋 徽 宗。金 章 宗。多 用 磁 藍 紙。泥 金 字。殊 臻 莊 偉 之 觀。金 粟 牋 次 之。長 短 貼 近 圈 繩 處。毋 得 過 與 不 及。此 定 式 也。

XXII. 囊

包 首 易 殘。最 爲 畫 患。裝 褫 始 就。急 用 囊 函。

XXIII. 染 古 絹 托 紙

古 絹 畫 必 用 土 黃 染 紙 托 襯。則 氣 色 湛 然 可 觀。經 久 逾 妙。

1) *Chin–su–chih* 金 粟 紙, lit. "Paper from the Chin–su Temple". This temple was situated on the foot of the Chin–su mountain, about 35 miles S. W. of Hai–yen 海 鹽, on the coast of Chekiang Province. It is said to have been founded between 238–250 by the Sogdian monk K'ang Sêng–kuei 康 僧 會, who in 247 had arrived in Nanking; in 1353 his image was still preserved in the temple (cf. the *Lo–chiao–sza–yü* 樂 郊 私 語, by the Yüan scholar Yao Tung–shou 姚 桐 壽). The name of the temple is said to refer to Vimalakīrti, who is also called *Chin–su–ju–lai* 金 粟 如 來. In this temple there was preserved a set of the Buddhist Scriptures, said to have consisted of several thousand of rolls, and dating from the T'ang period. They were written on a peculiar kind of very superior paper, coloured yellow, and heavily glazed. Since an early date mounters used to cut strips from this paper for the title labels of valuable scrolls. The Ch'ing archeologist and seal engraver Chang Yen–ch'ang (張 燕 昌, 1738–1814; especially noted for his ceramical studies and his epigraphical work *Chin–shih–ch'i* 金 石 契, quoted by L. C. HOPKINS, *The Chinese numerals and their notational systems*, Journal of the Royal Asiatic Society, China Branch, April 1916) wrote a special treatise discussing this paper, entitled *Chin–su–chien–shuo* 金 粟 牋 說, to be found in various *ts'ung–shu*. The writer himself was a native of nearby Hai–yen, and thus was in a position to collect genuine specimens of this paper; these he describes in great detail, reproducing the seals they bear, and quoting extensively from literary sources. Later this paper was imitated; these imitations are known in the trade as *tsang–ching–chih* (cf. the sample in Appendix V, no. 19). To-day this paper is still the most common material for the title labels of scrolls and books, and also much used by calligraphers.

2) *Pao–shou* 包 首, cf. Plate **30** C, no. 1.

The clay used for this dyeing process comes from the foot of the Chung mountain; [1] because this locality is near the grave of our Emperor T'ai-tsu (1368–1398), it is not permitted to take clay away from there; therefore now this material is difficult to obtain. Dyeing shops usually have a supply in store.

For dyeing you should on no account use acorn juice, for after the lapse of some time this dye will work through, and it will show on the surface of the silk, thus causing the picture to become covered with spots, which is most annoying. Neither should you use old paper, or paper dyed with water colour.

### XXIV. *How to restore white pigments that have turned black.*

When white pigments have been used in a painting, in course of time they will often turn black, either because the pigment itself was not prepared in the right way, [2] or because it has been obscured by the dust accumulated on it. White pigments especially show a tendency to turn black when they have been used on unsized paper. If treated in the right way, however, the white will regain its former brightness.

The method is as follows. Melt a lump of pure white soda in water, just as if you were going to wash clothes. Then dip a new brush in this solution and therewith dab the spots that have turned black, taking good care that the soda solution does not spread over the edges of the spots treated. Then take a sheet of *lien–ch'i* paper, [3] and having spread that over the scroll, roll them up together. If after the lapse of two weeks you take away the covering paper, you will find that all the black spots have been transferred to the sheet of *lien–ch'i* paper. If the dirt should not have disappeared entirely, you should treat the painting in the same way for a second time. If the dirt consisted of only a thin layer, it will disappear when the painting is treated once or twice. Paintings covered with a layer of many years will become white again after having been treated three of four times. When the white pigments are again as bright as if they were newly laid on, you should finally dab the spots treated with thin tea water newly brewed, in order to remove what is left of the soda.

土出鍾山之麓。因近孝陵。禁取難得。染房多有藏者。

最忌橡子水染紙。久則透出絹上。作斑漬可恨。舊紙浸水染。俱不堪用。

XXIV. 治畫粉變黑

畫用粉。或製不得法。或經穢氣熏染。隨變黑色矣。生紙用粉。猶易變黑。用法治之。其白如故。

法用白淨醋塊調水。卽浣衣者。以新筆塗黑處。不可使暈開。將連七紙覆蓋捲收。過半月取看。其黑氣盡透連七紙上。如未退淨。再如法治。輕則一二次退。年久者。三四次。無不潔淨如新。再用新烹淡茶。塗一次。以去醋氣。

---

1) *Chung–shan* 鍾山, mountain near Nanking.

2) Chinese and Japanese painters used two kinds of whites, viz. shell white *k'o–fên* 珂粉, and lead white *hu–fên* 胡粉. In course of time lead white will turn black by its chemical reaction, and therefore was disliked by painters. The making of shell white, on the other hand, was a most laborious process, it taking days of grinding to prepare it. For this reason many painters often used lead white. For more details about these pigments see the *Hua–fa–yao–lu* (Appendix I, no. 43), and the *Tōhō-zenshoku–bunka–no–kenkyū* (ibidem, no. 75).

3) See note 4 on p. 296 above.

*XXV. A thing to be avoided.*

When backing a scroll with a paper backing, you should be careful that in no case you get a seam (where two sheets of backing are joined together) in the middle of the painting. For if the scroll is rolled and unrolled many times, this seam will wear away a hole in the painting itself.

*XXVI. Hand scrolls.*

Everytime I see famous hand scrolls that still have their original Sung dynasty mountings, I notice that all have paper borders which even to–day are still intact. On the other hand the silk borders [1] of modern scrolls will come off after but a few years. This is a fact which must be deeply deplored.

The ancients meant all things they made to last forever; but the present people only aim at temporary splendour, and do their work slovenly. If patron and mounter do not work together with mutual sympathy, the result will not come up to the standard set by the ancients.

When I mount a hand scroll, I add borders of *chin–su* paper, [2] using paste prepared with *po–chi*, [3] then these borders will never fall off, while moreover they give the scroll a most elegant appearance. This *po–chi* paste, however, should be used only for adding the borders.

For backing hand scrolls you should select *lien–szŭ* paper [4] of superior quality, which is pure and thick; if it is first pressed it will be tougher still, and form a substantial material (for backing the scroll). From the protecting flap at the beginning till the end, the scroll should be attached in its entirety to one long sheet of backing. You should use a long table, so that (during the pasting process) the scroll may be unrolled in its full length. If the scroll should prove too long for the table, you should first paste on the first half, and then press it down with a weight until it has dried; thereafter you can paste on the other half. But the backed scroll should be all like one piece, the best being when no seam shows at all. Afterwards you should polish the reverse till it has obtained a brilliant shine.

XXV. 忌

覆背紙。切不可以接縫當中。舒捲久。有縫處。則磨損畫心。

XXVI. 手卷

每見宋裝名卷。皆紙邊。至今不脫。今用絹折邊。不數年便脫。切深恨之。

古人凡事。期必永傳。今人取一時之華。苟且從事。而畫主及裝者。俱不體認。遂迷古法。

余裝卷。以金粟牋。用白芨糊折邊。永不脫。極雅致。白芨止可用之於邊。

覆紙選上等連四。料潔而厚者。錘過則更堅緊質重。包首通後必長托。用長案接連窴之。如卷太長。則先表前半。壓定俟乾。再表後半。必以通長無接縫爲妙。研令極光。

---

1) *chi–pien* 折邊, see page 68 above.
2) See note 1 on p. 301 above.

3) See note 2 on page 294.
4) See note 4 on page 296.

For making the stave and the roller of hand scrolls there are but few suitable materials. You should use fragrant sandal wood, and see to it that the roller at the end of the scroll is slightly hollowed out on both ends, so that the flat tops can be inserted there. [1] If you look at the rolled up scroll from the side, it is nice when the edges of the borders offer a completely smooth surface. [2]

The band should be made of antique gold and silver brocade, and the fastening pin attached to it should be made of antique jade. When you but take the scroll, thus equipped with various elegant decorations in your hand, heart and eye shall be delighted by its pure beauty, even before you have unrolled it.

The scroll should be wrapped up in a wrapper of embroidered silk, and then it should be placed in a box, made either of sandal or prune wood, or else of the wood of the lacquer tree. The material of the box should vary according to the quality of the scroll it contains.

## XXVII. Albums.

When the people of old had superior scrolls mounted in album form, they bordered them with paper, even if the scrolls themselves were done on silk. At present, however, even mediocre scrolls are mostly mounted with silk, both the outside seams, and inside the " one–piece frames " (are made of the same costly material). Even erotic pictures [3] are mounted in an especially luxurious way with fine white silk, having outside seams of silk perfumed with aloes, and inside borders of blue satin. The cleverer the decoration, the more vulgar it becomes; and the disease of vulgarity is difficult to cure. I fondly hope that those who share my views will faithfully keep to the antique models, rejecting the vulgar fashion of the day.

卷 貼 與 卷 心 桿。用 料 不 多。必 用 檀 香。卷 桿 兩 頭。刻 凹 些 須。以 容 包 首。
折 邊 之 痕。視 之 一 平 可 愛。
帶 攀 用 金 銀 撤 花 舊 錦 帶。舊 玉 籤。種 種 精 飾。總 一 入 手。不 待 展 賞。其
潔 緻 璀 煌。先 己 爽 心 目 矣。
綾 錦 包 袱。袱 用 匣。或 檀。或 柟。或 漆。隨 書 畫 之 品 而 軒 輊 之。

XXVII. 冊 葉

前 人 上 品 書 畫 冊 葉。卽 絹 本。一 皆 紙 挖 紙 鑲。今 庸 劣 之 跡。多 以 重 絹°
外 折 邊。內 挖 嵌。至 松 江 穢 跡。又 奢 以 白 綾。外 加 沈 香 絹 邊。內 裏 藍 線。逾
巧 逾 俗。俗 病 難 醫。願 我 同 志。恪 遵 古 式。而 黜 今 陋。

---

1) I. e. small disks of jade or some other material; see page 85 above.

2) See the side-view of a rolled up hand scroll on Plate 43.

3) *Sung-chiang-hui-chi* 松江穢蹟. *Hui-chi* refers to *ch'un-kung-hua* 春宮畫, Japanese *shun-ga* 春畫, scrolls with realistic sexual representations; their purpose is partly pornographic (cf., for instance, chapter VI of the *Jou-pu-t'uan* 肉蒲團, a realistic novel written by Li Yü, the scholar-artist mentioned on p. 257 above), partly educational (in Japan such scrolls used to form part of the bride's trousseau). Their popularity in both China and Japan must be ascribed partly to hoary magical associations, dimly realized, regarding the emanation of vital essences from sexual representations. In both China and Japan such pictures are often laid in clothes boxes, being supposed to guard against insects and to prevent the contents of the box in a general way against deterioration. Chinese bookshops often keep one pornographic scroll or illustrated book on their premises to protect the shop against fire and other calamities. The Ming painter T'ang Yin (唐 寅, 1470–1523) was especially famous for his pictures of this kind. Since he was a man from Sung-chiang, I presume that *sung-chiang* in this passage refers to him, to define more clearly the term *hui-chi*, which in itself could also mean " bad, low-class pictures ".

304

To use for the backing of an album several layers of *lien-szŭ* paper is twenty times better than using various kinds of silk for the rest of the mounting. Simple in appearance, and strong in substance — this was what the ancients strove after.

An album should be thick and substantial: the larger ones should count twenty pages, the smaller ones at least twelve or fourteen. For the various ways of cutting up (larger scrolls so as to make them suitable for being mounted as albums), consult the article on rubbings below.

## XXVIII. Rubbings from stone tablets. [1]

I spend great care on inscriptions on bronze and stone. Every time I have rubbings from such inscriptions mounted, I spare no effort to obtain good results. First I copy out the text, counting how many characters each column contains, and into how many columns the text should be divided. And having noted the " elevated characters ", [2] the date, the superscriptions and colophons and extra-sheets at beginning and end, choosing a sheet of beautiful paper I draw a detailed sketch showing how all these parts of the rubbing should be mounted together. Then with respectful mien and winning words I hand the rubbing to the mounter.

Now the skill of the mounter appears from the vertical and horizontal cutting. The vertical cutting should be done in such a way that all pages are nicely fitted to each other in one unbroken row, the horizontal cutting should result in a perfectly straight top and bottom. If this cutting is expertly done, the work is as good as finished.

The above regards the mounting of rubbings from stone tablets; the same, however, applies to other rubbings.

## XXIX. The paper of rubbings. [3]

The paper of rubbings from stone tablets is sometimes made of mulberry bark and sometimes of bamboo, and its appearance varies according to the method used in taking the rubbing, whether

但 裹 紙 層 層 用 連 四。勝 外 用 綾 絹 十 倍。朴 於 外 而 堅 於 內。此 古 人 用 意 處。

册 以 原 實 爲 勝。大 者 紙 十 層。小 者 亦 必 六 七 層。裁 折 之 條。後 同 碑 帖。

XXVIII. 碑 帖

余 於 金 石 遺 文。尤 更 苦 心。每 拓 一 碑 授 裝。心 力 爲 竭。先 錄 其 文。籌 定 每 行 若 干 字。每 字 若 干 行。及 擡 頭 年 月 首 尾 附 題 小 跋。前 後 副 葉。皆 擇 名 箋。一 一 晝 定 程 式。然 後 恭 貌 婉 言 致 之。

裝 者 之 能。惟 在 裁 折。折 須 前 後 均 齊。裁 必 上 下 無 跡。裁 折 善 而 能 事 畢 矣。

碑 已 條 悉。帖 亦 如 斯。

XXIX. 墨 紙

碑 帖 本 身 紙。或 綿 或 竹。及 搨 法。或 烏 金 蟬 翅 雪 花 等 色。俱 一 一 染 搨。配 同 一 色 裝 成。則 渾 成 無 跡。

---

1) See the discussions on page 94 sq. above.

2) See page 95 above.

3) *Mo-chih* 墨 紙; this term applies both to blank sheets of paper suitable for being used to make rubbings, and to a completed rubbing.

*wu-chin, ch'an-i, hsüeh-hua* etc. [1]   All such rubbings should be mounted with paper that matches their colour, then a harmonious result will be achieved.

## XXX. *How to make cardboard.*

It is the cardboard cover that lends rubbings mounted in album form and albums in general a splendid look, and ensures their being preserved without damage for a long time to come.   For making this cardboard, however, you need double work and much material, so that you cannot expect a mounter to make it for you.   I myself have mounted more than a hundred rubbings and some score of albums, making the cardboard covers always with my own hands.

Your paste should be made of *po-chi* [2] and white alum, to which there should be added a little frankincense and yellow wax, and also *hua-chiao* [3] and *po-pu*. [4]   These ingredients should be boiled together.   For paper you should use discarded scrolls that have been used for the literary examinations: this paper is made of pure mulberry bark (i. e. without an admixture of bamboo pulp; see note 4, p. 296), although its price is as low as that of new paper of poor quality.   To use such paper for this purpose is the best of all.   Occasionally, however, you may also use *chin-kao* paper. [5]

Choosing a windy and dry day, you start with pasting together three sheets, covering them with thick paste; these are then pressed with a stone roller.   After several layers have been added in the same way, the sheet thus formed should be dried in the glaring sun, and then pressed under a large stone.   Then you will have obtained a sheet of cardboard that is hard like wood, its only disadvantage being that the mounter will find it difficult to cut.   On the other hand, however, it is never eaten by insects, nor will it work loose or be subject to other suchlike evils.

If the outside of your album is protected by covers made from this cardboard, its inside will be safe — a conspicuous achievement indeed! Afterwards you may adorn these covers by coating them with various kinds of silk, according to your taste.

## XXX. 硬　殼

碑帖冊葉之偉觀。而能歷久無患者。功係硬殼。工倍料增。不敢屬望
於裝者。余裝有碑帖百餘種。冊葉十數部。皆手製硬殼。
　糊用白芨明礬。少加乳香黃蠟。又用花椒百部。煎水投之。紙用秋闈
敗卷。純是綿料。價等劣紙。以之充用。可謂絕勝。間用金膏紙。擇風燥之
候。用厚糊刷紙三層。以石砑之。疊疊如是。曝之烈日。乾以大石壓之。聽
用。其堅如木。但裝者難裁。而可永無蠹蝕脫落等患。帖冊賴此外護。內
獲無咎。功莫大焉。各種綾絹。隨宜加飾。

1) These three processes of making rubbings are described on pp. 94-96.

2) See note 2 on p. 294.

3) *Hua-chiao* 花椒, also called *ch'in-chiao* 秦椒, *Xanthoxylum piperitum*, used as an aromatic substance.

4) *Po-pu* 百部, *Stemona Japonica, Miq.*, suppos-ed to keep away insects.

5) *Chin-kao* 金膏, unidentified. Since some sources give *yü-kao* 玉膏 as an equivalent, one would think that a heavily glazed paper is meant; such paper, however, seems unsuitable for making cardboard.

*XXXI. Another method.*

Soak glutinous rice till it is soft, and then mash it through a fine sieve till it is pure. Having let the water trickle away until the right degree of viscosity is reached, you should add bean meal, and a little lime that has been previously sieved, of both only a small quantity. Then this mixture should be strained till you obtain the thick paste. If you use this paste for making the cardboard covers of albums etc., they will be harder still. This paste, however, should be used exclusively for making the covers; for the inside mounting of the album you must use the ordinary flour paste. [1]

When the covers have been added to the album, you should not fail to remember to store it away during the first year in a place that is near to the human breath, for instance the shelve over the bed where the bedding is stored away is an excellent place.[2] In such a way you prevent your album from becoming mouldy. After the lapse of one year, the chemical elements in the cardboard have worked out, and it has become hard like stone. Then it will never become mouldy or be eaten by insects.

*XXXII. How to make paste.* [3]

First boil *hua-chiao* [4] with water, and having filtered it, pour the fluid in a clean earthenware bowl, and let it cool off. Then you add white flour, and let it slowly dissolve in the water by moving about the bowl very gently; you must not stir it. Then, when the mixture has been left standing one night, on the next morning you may stir it (to make the flour dissolve better). Thus you should continue for several days, each morning stirring the mixture once, until the flour has dissolved completely. Then you let drip off the *hua-chiao* fluid, and pour this into a separate bowl (to be used again in a later stage of the

XXXI.　又 方

糯 米 浸 軟 擂 細 濾 淨。淋 去 水。稠 稀 得 所。入 豆 粉。及 篩 過 石 灰。各 少 許。打 成 糊。以 之 打 硬 殼 裝 帖 册 等 用。更 堅。此 只 用 外 面。裝 裏 仍 用 麪 糊。

切 記 成 器 後。初 年 須 置 近 人 氣 處。或 牀 榻 被 閣 上。尤 妙。不 可 令 其 發 蒸。待 一 年 後。於 中 藥 性 定。其 堅 如 石。永 不 蒸 蛀 也。

XXXII.　治 糊

先 以 花 椒 熬 湯。濾 去 椒。盛 淨 瓦 盆 內。放 冷。將 白 麪 逐 旋 輕 輕 糝 上。令 其 慢 沈。不 可 攪 動。過 一 夜。明 早 攪 勻。如 浸 數 日。每 早 必 攪 一 次。俟 令 過

1) Chang Ch'ao's text has: 外 面 裝 裏。仍 用 麪 糊; the reading given in the Chinese text as reprinted here I took from the *Mei-shu-ts'ung-shu* version.

2) Cf. Mi Fu's remark quoted on p. 187.

3) Paste is one of the most important ingredients used by the mounter of scrolls. Recipes for preparing it are quoted *passim* in the present volume (consult the General Index, s. v. *paste*).

Also Japanese mounters value their paste very highly. An old poem says: "The mounter considers his paste as more valuable than his paper, it is as dear to him as his own life" (*hyōgu-shi ga shōbu no nori wa, kami yori mo onore ga inochi wo tsugu mono zo kashi*). Mounter's paste, called *shōbu* 生 麩, is prepared in the following way. During the coldest part of winter, flour of wheat is boiled; thereafter molten snow is added, and the mixture then poured into a large earthenware jar. This jar is closed air-tight by pasting paper over its mouth, and then it is placed under the house, or buried underground. There it is left to mature, being taken out only once a year, in winter, for changing the water. After four or five years this paste, known as *kusari-nori* 腐 糊 "foul paste", is fit for use. If too thick, it is diluted by adding some thin new paste.

4) See note 3 on p. 306.

process).  Add white alum powder to the remaining paste, together with a small quantity of frankincense.  Now you add new water to the paste, till it has acquired the right degree of liquidity.  You put it in an iron pan, and pound it with a large wooden pestle, not stopping for one moment, to prevent the paste from solidifying into lumps.  You heat it on a slow fire, and wait till it is boiling, all the time seeing to it that no lumps form.  Then you add the *hua-chiao* fluid (that was mentioned above as having been set apart in a separate bowl), and let the paste boil with it.  Having boiled it stir it well, thereafter boiling it again, stirring the mixture all the time; this continuous stirring will increase the viscosity of the paste.  When it has boiled well, you may take the pan from the fire, and pour cold water on the paste.  If you regularly change this water, you can keep your paste ready for use for several months.  If you use paste made in this way, your scrolls (mounted with it) will show a perfectly smooth surface, and they shall not warp.  During the hot and rainy season, however, you may not let the paste stand about for a long time on end, and when once it has been frozen, it will have become entirely unfit for use.

### XXXIII. How to use paste.

Paste is of the same importance to a mounting as glue is to a cake of ink.  A cake of ink is solidified by the glue,[1] a mounting gets its shape by the paste.  If the glue is expertly added, the ink (rubbed from such a cake) shall be pure and limpid.  If the paste is nicely applied, a mounted scroll can be rolled and unrolled smoothly.  The success of a mounting entirely depends on whether the paste has been used judicially or not.

A skilful artisan uses his paste as if it were water: this can only be achieved by brushing it often, for by frequent brushing the moisture will penetrate into the paper.  That the paste when solidified is, as it were, gripping the paper does not depend exclusively upon its quality (but also on the skill with which it has been applied).  In the same way an ink cake, although containing but little glue, may still be good if the soot and glue have been pounded together in the right way.

性。淋去原浸椒湯。另放一處。却入白礬末乳香少許。用新水調和。稀稠
得中。入冷鍋內。用長大擂槌。不住手擂轉。不令結成塊子。方用慢火燒。
候熱。就鍋切作塊子。用元浸椒湯煮之。攪勻再煮。攪不停手。多攪則糊
性有力。候熱取起。面上用冷水浸之。常挽水。可留數月。用之平貼不瓦。
徽候不宜久停。經凍全無用處。

XXXIII.  用糊

表之於糊。猶墨之於膠。墨以膠成。表以糊就。膠用善則靈液清虗。糊
用佳則捲舒溫適。調用之宜。妍媸攸賴。

良工用糊如水。止在多刷。刷多則水沁透紙。凝結如抄成者。不全恃
糊力矣。如墨用膠輕。只資錘擣之力耳。

---

[1] Chinese ink cakes are made by mixing soot (usually of pine wood) with glue; this mixture is then pounded into moulds of various shapes, and left to dry.  The quantity of glue added should be just enough to give the ink cake a compact structure.  If too much glue is added bubbles will appear when the ink is rubbed (cf. my book *Mi Fu on Ink stones*, page 28), and if the quantity added is insufficient the ink rubbed from such a cake will not hold on to the paper or silk it is applied to.

*XXXIV. Paper.* [1]

For making the backings of scrolls you should use mulberry-bark *lien-szŭ* paper from Ching-hsien, [2] *kung-tan* paper or *lien-szŭ* made from bamboo, according to the requirements of each case.

When mounting hanging scrolls, hand scrolls, albums and rubbings, I use exclusively *lien-szŭ*, and not one single sheet of *lien-ch'i*. *Lien-ch'i* paper is tough by nature, and therefore not easy to handle. *Lien-szŭ* is to a scroll what fine gauze is for a beautiful woman, while *lien-ch'i* is like common rough cloth for a country wench. When Nan-wei or Chiang-shu [3] were going to ascend the stage to sing and dance, they relied on brocade and variegated silk to enhance their charm. How could they let themselves be impeded by rough cloth, and risk to be ridiculed as country wenches?

*XXXV. Silk.*

Good fine silk of the Hsüan-tê period (1426-1435) is better than the same material of the Hsüan-ho era (1119-1125). Next comes the fine silk that is used for covering windows. [4] In Chia-hsing there was recently produced a variety of fine silk, two *ch'ih* broad; both its pattern and material are excellent. If you have this silk rewoven on a loom for brocade, if used for the front mounting it will certainly make a fine garb for your scrolls.

The looms of Soochow are narrow, so that if you should try to make a *t'ien* (see Plate **30** A, no. 1) or *ti* (ibidem, no. 2) from silk produced there, the seam where the two pieces are joined together will show (one piece being too narrow for making a broad strip as used for *t'ien* or *ti*), which looks ugly. You must tell the weavers to reweave it; if a second woof is added, it can be used.

Also the fine silk nowadays woven at Nanking can be used, although its patterns are not very elegant; this material would be very beautiful if a second woof were added. But although I repeatedly spoke about it to the weavers, they insist that it cannot be done.

XXXIV. 紙 料

紙 選 涇 縣 連 四。或 供 單。或 竹 料 連 四。復 背 隨 宜 充 用。
余 裝 軸 及 卷 冊 碑 帖。皆 純 用 連 四。絕 不 夾 一 連 七。連 七 性 強。不 和 適。
用 連 四 如 美 人 衣 羅 綺。用 連 七 如 村 姑 着 布。夫 甫 威 絳 樹 登 歌 舞 之 筵。
方 藉 錦 綺 以 助 妍。豈 容 曳 布 趨 趄。以 取 村 姑 之 誚。

XXXV. 綾 絹 料

宣 德 綾。佳 者 勝 於 宣 和。糊 窗 綾 其 次 也。嘉 興 近 出 一 種 綾。闊 二 尺。花
樣 絲 料 皆 精 絕。乃 從 錦 機 改 織 者。固 書 畫 之 華 袞 也。
蘇 州 機 窄。以 之 作 天 地。有 接 縫 可 厭。須 令 改 機。加 重 定 織 者 堪 用。
白 門 近 亦 織 綾 可 用。但 花 不 高 拱。須 經 上 加 一 絲 織 爲 妙。屢 語 之 終
不 能 也。

---

1) For the various kinds of paper mentioned in this chapter, see note 4 on p. 296 above.

2) Ch'ing-hsien 涇 縣, Wu-hu-tao 蕪 胡 道, in Anhwei Province.

3) Nan-wei 南 威 and Chiang-shu 降 樹 were famous beauties of antiquity.

4) See page 158 above.

For ordinary silk you should use that which is woven at Soochow by the Wang family in the Chung–chia street, or also that produced in Sung–chiang. These varieties can be used for making " one–piece frames ", [1] protecting flaps etc.

Although black silk when used for making *t'ien* and *ti* gives an impression of antique elegance, it does not last long, being easily torn. I often use pale blue [2] or dark blue silk.

### XXXVI. *Various kinds of knobs.*

Knobs made of jade, although they look magnificent, are not good for use. Rhinoceros horn is the best material. I had Pu Chung–ch'ien [3] carve for me knobs of ivory and red sandal wood, with motifs borrowed from Han dynasty jades. Occasionally I also use knobs of carved white bamboo, or make them from *mei–lü* bamboo, [4] or spotted bamboo. [5]

I also ordered lacquer artisans to imitate Japanese lacquer with gold and silver flakes, [6] and had them make also other lacquer knobs in various patterns and designs, exceedingly splendid and beautiful. All these are knobs which I had made.

### XXXVII. *The right season for mounting.*

The best time is autumn, when it is already cool and yet not cold. The period which directly precedes the rainy season is also good. Winter is too dry, while summer is muggy. Autumn is on the whole better than spring, and spring again is better than winter or summer. In summer you should guard against humidity, and in winter against freezing. [7]

絹 用 蘇 州 鍾 家 巷 王 姓 織 者。或 松 江 絹 皆 可 爲 挖 嵌 包 首 等 用。
天 地 卓 綾。雖 古 雅。卓 不 耐 久。易 爛。余 多 用 月 白。或 深 藍。

XXXVI. 軸 品

軸 以 玉。雖 偉 觀。不 適 用。犀 爲 妙。余 以 牙 及 紫 檀。倩 濮 仲 謙 倣 漢 玉 雕
花。間 用 白 竹 彫 者。及 梅 綠 竹。斑 竹 爲 之。

又 命 漆 工。倣 金 銀 片 倭 漆。及 諸 品 塡 漆 等。製 各 種 款 樣。殊 絢 爛 可 觀。
皆 余 創 製。

XXXVII. 佳 侯

己 涼 天 氣 未 寒 時。是 最 善 侯 也。未 黴 之 先。侯 亦 佳。冬 燥 而 夏 溽。秋 勝
春。春 勝 冬 夏。夏 防 黴。冬 防 凍。

1) See page 65 above.

2) See note 3 on page 297.

3) Pu Chung–ch'ien 濮 仲 謙, famous carver who lived during the end of the Ming, and the beginning of the Ch'ing dynasty. Cf. the *Ch'a–hsiang–shih–ts'ung–ch'ao* 茶 香 室 叢 鈔, ch. 11. page 11 *a*.

4) *Mei–lü* 梅 綠, unidentified.

5) *Pan–chu* 斑 竹, also called *hsiang–fei–chu* 湘 妃 竹; cf. *Tsun–shêng–pa–chien*, Appendix I, no. 28: chapter 16, page 70. Some varieties, with large, evenly spread spots,

are greatly prized, and much used for making the handles of high–quality writing brushes.

6) I. e. gold and silver *maki–e* 蒔 繪.

7) These remarks on the right season for mounting tally with the observations made by the T'ang author Chang Yen–yüan, who says: "The time for mounting should be in harmony with the interaction of Yin and Yang. Autumn is the best time, then comes spring, and thereafter summer. You should not mount scrolls when the weather is very hot or moist"; cf. above, p. 149.

*XXXVIII. The room for mounting.*

Your room hates a damp place, and shirks draughts and heat. It takes delight in a warm and mild atmosphere, and loves airiness and brightness. Your pasting boards should be hung on a high place, this will prove advantageous to the paintings (put up on them). Only when vertical scrolls are put on, the boards must be stood up on the floor (see Plate **19**), but then you should guard against the moisture that comes up from below (as it might cause mould to form on the wet scroll).

*XXXIX. Those who knew the importance of the art of mounting.*

Wang Shih–chên [1] came from a family that during generations had produced discerning connoisseurs, so that his house was full of rare art treasures. He had made a deep study of the art of mounting, and when he invited the mounter Ch'iang to his house, he gave him the place of honour, and rewarded him with great munificence. All lovers of art of his time without exception followed Wang Shih–chên's example. From this it may be seen that the art of mounting deserves to be highly regarded.

The houses of well known mounters like Mr. T'ang and Mr. Ch'iang resembled a market (so many customers went in and out there). Mr. Ch'iang spent half of his life in the residence of Wang Shih–chên.

Once Wang Ching–shun [2] in Nanking obtained an autograph by Wang Hsi–chih. [3] Having first sent rich presents, he went to Mr. T'ang and invited him to come to his house. Having entertained him at a dinner, he humbly asked him to mount this autograph. The work lasted about two months, and during all that time Wang Ching–shun did not leave the mounter's side, carefully seeing to all his needs, and finally rewarding him most generously.

When Li Yung–ch'ang [4] had obtained the painting " Inviting the Recluse of the Hui mountain ", a splendid specimen of the brushwork of Ni Tsan, [5] he asked Chuang Hsi–shu [6] to remount it for him.

XXXVIII. 表 房

　表 房 惡 地 濕 而 憚 風 燥。喜 溫 潤 而 愛 虛 明。裝 板 須 高。利 書。覽 幀 必 安
地 屏。杜 濕 上 蒸。

XXXIX. 知 重 裝 潢

　王 弇 州 公。世 具 法 眼。家 多 珍 祕。深 究 裝 潢。延 強 氏 爲 座 上 賓。贈 貽 甚
厚。一 時 好 事。靡 然 嚮 風。知 裝 潢 之 道 足 重 矣。

　湯 氏 強 氏。其 門 如 市。強 氏 踪 跡 半 在 弇 州 園。

　時 有 汪 景 淳。於 白 門 得 王 右 軍 眞 跡。厚 遣 儀 幣。徃 聘 湯 氏。景 淳 張 筵
下 拜 授 裝。功 約 五 旬。景 淳 時 不 去 左 右。供 事 甚 謹。酬 贐 甚 膩。

　又 李 周 生 得 惠 山 招 隱 圖。爲 倪 迂 傑 出 之 筆。延 莊 希 叔 重 裝。先 具 十
緡 爲 聘。新 設 牀 帳。百 凡 豐 給。以 上 賓 待 之。凡 此 甚 多。聊 舉 一 二。奉 好 事
者。知 寶 書 畫。其 重 裝 潢 如 此。

1) Wang Shih–chên 王 世 貞, style Yüan–mei 元 美, 1526–1590, famous literatus and art lover. The text refers to him as Yen–chou 弇 州, one of his literary designations.

2) Wang Ching–shun 汪 景 淳, unidentified.

3) Wang Hsi–chih, the paragon of all Chinese calligraphers; cf. p. 138.

4) Li Yung–ch'ang 李 永 昌, a well known Ming painter; the text gives his style Chou–shêng 周 生.

5) Ni Tsan 倪 瓚, famous Yüan painter, 1301–1374; the text gives one of his many literary designations, Yü 迂. For a list of his paintings see FERGUSON, *Li-tai-cho-lu-hua-mu*, p. 200 sq.

6) Chuang Hsi–shu, cf. the remarks on page 250 above.

First he sent him ten ounces gold to obtain his service, then in his house he arranged a special room for him to work in, luxuriously appointed, and he treated him like an honoured guest. There were many other art lovers who took the same attitude to mounters, but here I adduce only these few examples, in order to show to collectors how highly those who know how to treasure scrolls value the art of mounting.

## XL. *Old stories.*

When Chuang Hsi-shu from Soochow stayed at Nanking, he was famous for his skill as a mounter. His skill about equalled that of Mr. T'ang and Mr. Ch'iang, and he was regarded as the very best of that time. He was a man of a robust character, loving righteousness, and a true and staunch friend. High officials and members of the nobility gladly cultivated his company, and were unanimous in their praise. He himself however was very modest about his ability, but he did not idly place his service at the disposal of the vulgar. Occasionally, responding to the request of friends, he kindly favoured me with his opinion (presumably on authenticity problems. Transl.), and then he would ungrudgingly impart his knowledge.

When formerly I went to Soochow, I took with me some specimens of Chuang Hsi-shu's work, and showed them to all the mounters there, asking them to follow these models. But they were all profuse in their protestations of admiration and of their own inability, declaring that no one but Chuang Hsi-shu could produce such work. Since there exist already such excellent lines about the "clear streams" and the "fragrant grasses", who would ever dare to attempt writing a description of the Huang-ho Pavilion?[1]

## XLI. *Old stories (continued).*

There live many connoisseurs and collectors in Kiangsu, but among them only Ku Yüan-fang[2] had a sound knowledge of mounting. United in close friendship, we used to retire to some secluded abode, there to engage in critical discussions of delicate artistic problems, and rapt enjoyment would carry us away as if in a trance.

XL.　紀舊

　　吳人莊希叔。僑寓白門。以裝潢擅名。頡頏湯強。一時稱絕。其人慷慨慕義。篤誠尚友。士紳樂與之遊。咸爲照拂之。然以技自諱。不妄徇俗。間應知己之請。謬賞余爲知鑒。所祈弗悋。

　　徃余之吳門。攜希叔之製。示諸裝潢家。希其彷彿效爲之。皆嘖嘖斂服。謂非希叔不能也。信芳草晴川之句在。孰能續爲黃鶴之題乎。

XLI.　又

　　吳中多藏賞之家。惟顧元方篤於裝潢。向荷把臂入林。相與剖析精微。彼此酣暢。

---

[1] Huang-ho-lou 黃鶴樓 "Yellow Crane Pavilion" was a famous site, about which the T'ang poet Ts'ui Hao (崔顥, died 754) wrote a poem that is much praised by literary critics; it is to be found in the well known anthology of T'ang verse *T'ang-shih-san-po-shou* 唐詩三百首. Especially the two lines "The limpid stream flows placidly under the trees of Han-yang, the fragrant grasses rustle softly by the Parrot Isle" 晴川歷歷漢陽樹。芳草萋萋鸚鵡洲 are celebrated by literary gourmands, who maintain that it is impossible to surpass these as a word picture of the site in question. In the same way it is impossible ever to produce a mounting that can stand comparison with those made by Chuang Hsi-shu.

[2] Ku Yüan-fang 顧元方, unidentified.

After Ku Yüan-fang had passed away, I found a kindred spirit in Hsü Kung-hsüan, [1] who at that time was sub-prefect at Nanking. He was a man of extraordinary intelligence, and an unfailing judge of works of art: in his collection there was not one single spurious item. When he had obtained a painting by Ni Tsan, [2] entitled " Lonely Pines by the Profound Mountain Stream ", he had Chuang Hsi-shu remount it for him. Hsü Kung-hsüan was exceedingly pleased with the result, and exclaimed: " How is it that in his art he reaches such a perfection? " Then I said: " You need not look for anything else: it is because of his *taste* that he differs from other people ". Hsü Kung-hsüan much appreciated this word " taste ", and said: " If there is not the discrimination of a Sun Yang, [3] how could the rare qualities of a steed like ' Chasing-the-wind ' [4] be discerned? "

## XLII. *Epilogue*.

In the foregoing I have tried to be both most detailed and accurate. For, when the life of wonderful antique scrolls is threatening to break off, if you find the right man for remounting them, they are brought to life again, and will last for years and years to come; to bring about such a revival, is not this a great achievement?

Therefore I have worked assiduously (on the study of the art of mounting), with a loving disposition, and shunning no labour. But when nowadays I see mediocre scrolls, made up with ordinary mountings, why should I trouble to study them?

There are two most important points, and to these the owner of a scroll should pay full attention. First, for the backings only paper made from mulberry bark should be used. [5] Clumsy mounters, however, will always use for making backings *kang-lien* or *lien-ch'i* paper. [6] Using *kang-lien* (for remounting a scrolls) is like using arsenic as a medicine: it is impossible ever to take such backings off again, the life of the painting is finished. Using *lien-ch'i* is like taking calomel: although this is also a poison, the pa-

元 方 去 世 後。值 徐 公 宣 爲 南 都 別 駕。時 與 余 有 同 心 之 契。公 宣 聰 頴
過 人。賞 鑒 精 確。所 藏 無 一 僞 跡。時 獲 倪 高 士 幽 澗 寒 松 圖。莊 希 叔 爲 之
重 裝。公 宣 喜 不 自 勝。謂 何 以 技 至 於 此。余 曰。不 待 他 求。只 氣 味 於 人 有
別。公 宣 深 賞 氣 味 二 字。曰 非 孫 陽 之 鑒。安 別 追 風 之 奇。

## XLII. 題 後

前 所 條 列。頗 極 詳 嚴。蓋 爲 古 跡 神 妙 者。氣 脉 將 絕。倘 付 托 得 人。便 可
超 劫 回 生。再 歷 年 月。垂 賞 於 世。豈 不 偉 歟。

故 余 切 切 婆 心。不 辭 煩 瀆。若 近 代 庸 跡。尋 常 付 裝。何 煩 深 究。

但 有 切 要 二 條。書 主 必 自 經 心。托 書 須 用 綿 紙。庸 工 必 以 扛 連 紙 托。
或 連 七 紙。用 扛 連 如 藥 用 砒 霜。永 世 不 能 再 揭。書 命 絕 矣。連 七 如 用 輕
粉。雖 均 是 毒。尙 可 解 救。扛 連 雖 與 綿 紙 等 價。庸 工 必 不 肯 易。此 可 痛 恨
者 一 也

1) Hsü Kung-hsüan 徐 公 宣, unidentified.

2) Ni Tsan, see note 5 on p. 311 above.

3) Sun Yang 孫 陽 was a famous connoisseur of horses of the Chou period.

4) Chui-fêng 追 風 "Chasing-the-wind ", name of a celebrated steed that belonged to Ch'in-shih-huang-ti,
the " First Emperor ".

5) The text inserts here the three characters 自 備 去, which I have left out in my reprint, as they do not seem to make sense.

6) For these papers see note 4 on p. 296 above.

tient may still be saved. But although mulberry paper is as cheap as *kang-lien* and *lien-ch'i* paper, clumsy mounters simply refuse to use it. This is the first sad mistake.

Secondly, the painting itself should never be cut down. Clumsy mounters if the material to be used for the borders is not sufficient, sometimes will cut down the painting along its circumference; or also, when remounting a scroll, they do not trouble to peel off the old borders, but simply cut them off along the painting; or, when attaching the new border, they make it overlap the painting for the space of one *fên*. [1] In such a way (in the course of the years) the painting itself will grow smaller and smaller, it may shrink to such a degree that signatures and seals [2] are damaged. This is the second sad mistake.

Even a mediocre mounting of bad style, if it does not show the above-mentioned two shortcomings, will fulfill its purpose of protecting the painting. Let all those who are concerned with the art of mounting scrolls bear these two points in mind!

*Chang Ch'ao's Colophon.*

When I met Hu Ch'i-i in the " Ten Bamboos Studio ", I came to know him as a man of taste and as a zealous scholar. In the spring of the year 1695 he sent me a copy of his collected poems, entitled *Cho-ching-chai-shih*, [3] together with the present text (i. e. the *Chuang-huang-chih*), asking in exchange for a copy of my compilation *Yü-ch'u-hsin-chih*; [4] I was greatly elated by this acquisition. Now Hu Ch'i-i is a past master in the art of engraving seals in bronze and stone, his works are treasured by the present generation. I regret that being separated from him by the Great River, I cannot more often enjoy his company.

Written by the Recluse of the Hsin-chai.

又書心勿令裁傷。庸工或因邊料不敷。裁書就邊。或重表時。不揭邊
縫。從裏裁截。又將新邊鑲進一分。書本身逾蹙。致傷欵印。所可痛恨者
二也。

苟無此二患。雖劣表惡式。尙可保書之本身。拈裝者愼之。

跋

胡子靜夫。風雅嗜學。余曾識于十竹齋中。乙亥春。以所著拙靜齋詩。
曁此帙寄余。索余所輯虞初新志。余得之不勝狂喜。胡子金石篆刻精
妙絕倫。爲當世所寶。惜以一江之隔。不能與之樂數晨夕也。心齋居士
題。

1) See the discussion on page 105 above.

2) *K'uan* 欵 signature, including date etc., *yin* 印 seals. Both *k'uan* and *yin* as a rule occur in one of the corners of a scroll, near the border, and therefore are especially liable to become damaged when the scroll is cut down.

3) *Cho-ching-chai-shih* 拙靜齋詩. As I have never seen this text, I cannot say whether it is really a collection of poetry, or just one poem bearing that title; the text admits of both interpretations.

4) *Yü-ch'u-hsin-chih* 虞初新志, a collection of minor writings collected and edited by Chang Ch'ao in 20 chapters; his preface is dated 1683, and his colophon 1700. Not to be confused with the *Yü-ch'u-hsü-chih* 虞初續志, a continuation published in 1802 by Chêng Shu-jo 鄭澍若, or the *Yü-ch'u-chin-chih* 虞初近志, a second sequel published in 1913 by Hu Chi-ch'ên 胡寄塵.

## 2 – CHOU ERH–HSÜEH'S SHANG–YEN–SU–HSIN–LU

### NOTE ON THE SHANG–YEN–SU–HSIN–LU AND ITS AUTHOR

Chou Êrh–hsüeh

THE AUTHOR of this brief treatise, Chou Êrh–hsüeh 周二學, was a comparatively obscure collector of scrolls at Hangchow, who flourished during the Yung–chêng (雍正, 1723–1735) period. He was a native of this beautiful city, and seems never to have left it. His style was Yao–p'o 藥坡, and his literary name Wan–sung chü–shih 晚菘居士. His name does not occur in the various biographical works of the Ch'ing period, and I have searched for it in vain in local histories of Hangchow and its surroundings. Such information as is given below is derived from Chou Êrh–hsüeh's own works, and the prefaces which others wrote for them.

He has left only two works, one a *catalogue raisonné* of the scrolls in his collection, and the other a treatise on the art of mounting and related subjects. For details about the first work, the *I–chüeh–pien* 一角編, the reader is referred to Appendix I, no. 49. The second is the *Shang–yen–su–hsin–lu* 賞延素心錄, translated here.

Although there can be no doubt that Chou Êrh–hsüeh was an enthusiast collector, he can not have been a brilliant scholar, nor did he have sufficient means for building up a valuable collection. Neither of his two books is written in a very good literary style, and among his scrolls there were only two Yüan specimens, the rest consisting of works by later artists. When Wang Chu, in his preface to the *Shang–yen–su–hsin–lu*, speaks of " a simple and poor scholar ", he evidently refers to Chou Êrh–hsüeh.

The prefaces to his books.

It is rather astonishing, therefore, to find that the prefaces to both his books are written by eminent literati. It is true that most of them were natives of Hangchow, or passed the greater part of their lives there, so that Chou Êrh–hsüeh could easily approach them. Yet it seems strange that a number of such distinguished men of letters wrote prefaces for two books of such minor importance. The first preface to the *I–chüeh–pien* was written by Li Ê (厲鶚, style T'ai–hung 太鴻, lit. name Fan–hsieh 樊榭, 1692–1752; cf. E. C., page 454), a famous literatus of that time. The second preface was written by Hang Shih–chün (杭世駿, 1696–1773; cf. E. C., page 276), a well known scholar–official, and the third by the great artist Ting Ching (see page 434 below). As to the *Shang–yen–su–hsin–lu*, next to prefaces by Li Ê and Ting Ching mentioned above, it has one by the connoisseur, poet and painter Ch'ên Chuan (陳撰, style Lêng–shan 楞山, lit. name Yü–chi 玉儿, ± 1670– ± 1740; cf. E. C., page 85), and one by the high official and prolific writer Wang Chu (王澍, style Jo–lin 若林, lit. name Hsü–chou 虛舟, 1668–1739). Although, however, these prefaces are written with care, the slightly patronizing tone gives the impression that the writers did not consider Chou Êrh–hsüeh as their social or scholarly equal.

These considerations would lead one to think that Chou Êrh–hsüeh was either a curio dealer with scholarly interests, or a physician who dealt in antiques as a side–line; the latter alternative is suggested by his style Yao–p'o " Medicine Hill ".

Analysis of the contents of the Shang-yen-su-hsin-lu.

Be this as it may, the *Shang–yen–su–hsin–lu* is in both form and contents inferior to the *Chuang–huang–chih*. The description of the process of remounting scrolls is incomplete, and the material has not been systematically arranged. Ting Ching in his preface to this book evidently sacrifices truth to a literary quip when he says, in the last line, that the *Chuang–huang–chih* is completely outdated and superseded by this book. Hang Shih–chün, in his preface to the *I–chüeh–pien*, is much nearer the mark when he says: " (Chou Êrh–hsüeh) modeled his mountings on the precepts given by Chou Chia–chou " 裝潢 法周江左.

As is often the case with Chinese book titles, the phrase *Shang–yen–su–hsin–lu* is difficult to translate. The two characters *shang–yen* refer to a passage in the *Book of History* 書經, chapter " The Counsels of Yü " 大禹謨, where it says: 罰弗及 嗣, 賞延于世 " Punishments do not extend to the criminal's heirs, while rewards reach to after generations " (Legge). *Shang–yen* thus would imply that if a collector has his scrolls repaired and remounted in the correct way, this guarantees that not only he himself, but also his children and grandchildren can enjoy them. *Su–hsin* means the simple, detached mind of the genuine lover of antiques. These ideas I tried to express in my English rendering of this title as " Records of prolonged gratification of the simple heart ".

The ten sections that constitute this text are not numbered in the original, neither are they provided with headings. For the reader's convenience I have marked the sections with Roman numerals, and added a brief indication of the contents of each section in the margin, between brackets. Further I have, wherever the contents suggested this, divided some sections into paragraphs.

Section I repeats the counsel given by various previous writers, that one should not have an antique scroll remounted if it is not absolutely necessary. Then follows a brief description of washing and cleaning an old scroll.

Section II describes how damaged scrolls should be patched up.

Section III is more explicit, it goes into some detail regarding the backing of scrolls, and their front mounting. The author is against the adding of a *shih–t'ang* (see *Chuang–huang–chih*, ch. XIII), and he protests against the habit of many collectors of writing comments on parts of the front mounting. Further he describes protecting flaps, suspension loops etc. Finally he mentions the best materials for making rollers and knobs.

Section IV treats of the mounting of hand scrolls and albums. Special attention is given to the correct way of adding the narrow seams along the upper and lower border of a hand scroll; this is indeed an important problem, for it are these seams that often become loose and frayed. Further he describes the various kinds of paper and silk used for the front mounting of a hand scroll, its protecting flap, fastening pin and knobs.

The album he treats very cursorily, dismissing the subject in a few lines about the materials used, and the making of the covers.

Section V gives a recipe for the preparing of the paste used for mounting scrolls; by and large this corresponds with the recipes given in older sources.

Section VI discusses the right season for mounting, and some general characteristics of correctly mounted scrolls.

Section VII is a brief note on the importance of a knowledge of seals, and on the objectionable practice of adding famous names to anonymous scrolls. The chief purpose of this passage seems to be to give the author an opportunity to show off his knowledge of old artistic literature.

Section VIII describes two implements for displaying hanging scrolls, viz. a rack, and a scroll hanger. This chapter is, in a way, the most interesting part of the entire treatise; for Chou Êrh–hsüeh is, as far as I know, the only author who ever described these two implements in detail. The rack for displaying scrolls will be further commented upon below.

Section IX is also of antiquarian interest: a description of the tables used for viewing scrolls on.

Section X, finally, is concerned with wooden boxes for smaller scrolls, cupboards for larger scrolls, and covers for hand scrolls and albums.

The last three sections prove that the author had a wide knowledge of all kinds of minor antiques, such as ancient padlocks, pieces of furniture, various kinds of jade and porcelain, etc., which makes one all the more inclined to think that he was in some way or other connected with the antique trade.

The *Shang–yen–su–hsin–lu* has been printed in three *ts'ung–shu*. None of the editors added interpunction to the text, or made any attempt at editing it. With one minor exception (see p. 334 note 4), they printed the text in exactly the same form, and with the same prefaces. Only one editor added a colophon, without supplying, however, any further information on the history of the text, or on the life and works of the author. These three *ts'ung–shu* are:

A) *Chao–tai–ts'ung–shu* 昭代叢書 (see page 285 above). The *Chuang–huang–chih* was printed in the first (甲) collection of this *ts'ung–shu*. The present text is to be found in the fifth (戊) collection, which was edited by the Ch'ing bibliophile Yang Fu–chi (楊復吉, style Lieh–hou 列侯, lit. name Hui–chi 慧楼, 1747–1820). He added a colophon to the text, which says: " The first collection of this *ts'ung–shu* contains Chou Chia–chou's *Chuang–huang–chih*, which shows painstaking and penetrating research. The present essay supplements those points which were not discussed in the *Chuang–huang–chih*. Thus each of these two books serves a good purpose, they mutually benefit and clarify each other. Both these Messrs. Chou are to be called meritorious servants of the artistic world. Written by Yang Fu–chi, from Soochow, in the intercalary autumn moon of the year 1786" 甲集載周江左裝潢志。搜剔入微。茲錄

317

更足補所未逮。各成其是。相得益彰。二周君並可稱藝苑功臣。
丙午閏秋震澤楊復吉識。

B) *Yü-yüan-ts'ung-k'o* 娛園叢刻, a collection of reprints published by Hsü Tsêng (許增, style Mai-sun 邁孫, lit. name I-chai 益齋, 1824-1903), a bibliophile of Hangchow.

C) *Sung-lin-ts'ung-shu* 松鄰叢書, a collection of various minor writings, published in 1917 by the modern scholar Wu Ch'ang-shou 吳昌綬, also of Hangchow.

The rack for displaying hanging scrolls.

A curious problem is posed by Chou Êrh-hsüeh's description, in section VIII, of a rack for showing hanging scrolls. On page 161 we have seen that the T'ang author Chang Yen-yüan makes passing reference to such a rack, which he calls *chia* 架. Chou Êrh-hsüeh calls it *shan* 橾. I have been unable to find another description of this contrivance in Chinese literature, and none of the Chinese connoisseurs and collectors whom I consulted had ever seen an actual example. Chou Êrh-hsüeh's description, however, enables us to form a fairly adequate idea how such racks were constructed.

The term *shan* which he uses for designating this rack must be an invention of his own, or else represent an attempt to transcribe some colloquial word of his own local dialect. New and old Chinese dictionaries give this character *shan* only as an alternative for *shan* 閂, meaning "a cross bar to close a door", 關門機. If this was the sense in which Chou Êrh-hsüeh uses this character, then he must have thought especially of the upper part of the rack, viz. the transverse roller on top, and used this word as *pars pro toto*. Another possibility is that some copyist by mistake wrote *shan* for *hu* 櫃. Since *hu* may be explained as meaning "a rack for putting books on",[1] this character would supply an appropriate literary rendering of the plain term *chia* 架.

Chou Êrh-hsüeh in his description of this rack confines himself to its upper part, viz. a cross-bar that revolves in sockets on either side. But surely this upper part must be supported by two or four legs, the whole contrivance probably resembling our modern wooden clothes-horse. Chou Êrh-hsüeh's idea is that for displaying a larger hanging scroll on such a rack, one should fasten its upper stave to the revolving cross-bar on top, and wind the upper part of the scroll round it, as far as the upper *ko-shui-ling*. Thus the entire *t'ien* is wound round the bar on top, and the picture itself, surrounded by "frame" and both *ko-shui-ling*, is hanging downwards, exposed for inspection.

[1] 書櫃藉書具也; this definition, given i. a. in the Ming dictionary *Chêng-tzŭ-t'ung* (正字通 by Chang Tz'û-lieh 張自烈) is generally understood as meaning "*shu-hu* is a contrivance (chü) that acts as a support (chieh) to books". Other writers, however, take *chieh* in its meaning of "envelop" and consider *hu* as a synonym of *chia-pan*, the wooden boards used for keeping a number of printed volumes together (see Plate 85); cf. for instance the *Piao-i-lu* (表異錄 an encyclopedical work in 20 ch. by the well known poet Wang Chih-chien 王志堅, 1576-1633) which says "The boards books are placed between are called *shu-hu*" 承書夾曰書櫃. But since the term *shu-hu* occurs already in documents of the Han period there can be no doubt that the former explanation as "book shelves" is correct; I refer to the *Shu-hu-fu* 書櫃賦, a poetical essay by the Han writer Tu Tu (杜篤, died 78 A. D.), a fragment of which is reprinted in the *Ch'üan-shang-ku-san-tai-ch'in-han-san-kuo-liu-ch'ao-wên* 全上古三代秦漢三國六朝文, collected by Yen K'o-chün (嚴可均, 1762-1843).

318

In order to prevent the scroll slipping from the revolving cross bar, Chou Êrh–hsüeh says that this roller must not be round, but square; but its four edges should be slightly rounded, else they will cause folds and creases in the scroll. The idea of the cross–bar between two sockets he illustrates by referring to the shape of a padlock. Since some readers might not be able immediately to visualize the construction of a Chinese pad-lock, [1] a sketch is shown in Plate **111**. A shows the padlock when closed, the cross bar connecting the two sides of the case. If, as Chou Êrh–hsüeh suggests, one imagines that the two sides of the

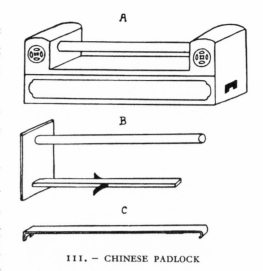

III. – CHINESE PADLOCK

case have the shape of a socket, and that the transverse bar revolves in these; and if, in addition, one visualizes this contrivance as supported by two or four wooden legs, then the reader will have a fair idea of how Chou Êrh–hsüeh's rack was con-structed. Such an implement would be quite useful for viewing larger hanging scrolls, although one cannot help thinking that suspending such a scroll on a hook high on the wall would be far simpler.

Apparently the adding of a revolving bar on top of the rack was a later invention. Antique racks seem to have had only an immovable cross bar on top, slightly curved like a saddle (Chou Êrh–hsüeh compares this shape with the concave top of a " shoe " of silver bullion). This tallies with the fact that primitive mountings of the " banner " type, with thin and flexible bamboo upper staves, when draped over such a rack, would still hang fairly straight. When later the art of mounting had been perfected, a straight bar was necessary, and the revolving bar was the latest innovation.

I suspect that there exists some connection between this rack for displaying hanging scrolls, and another more or less mysterious contrivance for viewing hand scrolls, refer-red to in Chinese literature as *i–chia* 欹 架 " reclining rack ", or *lai–chia* 孏 架 " lazy rack ". Plate **112** gives an illustration of such a rack, as depicted in the Ming edition of the well known encyclopedia *San–ts'ai–t'u–hui* (三 才 圖 會, section *ch'i–yung* 器 用, ch. 12). The text accompanying this picture quotes the *Ch'ieh–yün* 切 韻, a rhyme dictionary published in 601 by the Sui scholar Lu Fa–yen 陸 法 言 as saying:

The " lazy rack ".

1) For the sake of completeness I have added on the plate a picture of the inner part of the padlock, and of its key. When the lock is closed, the transverse bar on top passes through the two eyes of the cupboard or box the lock is attached to. The padlock has an inner part that can be pulled out; attached to it is a second transverse bar which is not visible when the case is locked. This lower bar has two or more steel springs; when the inner part is pushed into the case these springs are compressed by a groove that runs along the bottom of the case. These springs distend again as soon as they have left the groove, and thus the case is locked. When the key (c) is pushed through the key hole it compresses the two springs so that the lower bar can be drawn back through the groove, thus unlocking the case.

"Ts'ao Ts'ao (155–220) made a *reclining rack*, for reading books when he was lying down on his bed. The present day *lazy rack* is constructed in the same way. Thus this implement dates already from Emperor Wu of Wei (the posthumous title of Ts'ao Ts'ao. Transl.)" 曹公作欹架。臥視書。今嬾架卽其制也。則是罨起自魏武帝也。

Other sources, however, give quite another explanation of the use of the implement depicted here.

Virtually the same picture is found in a small work on the paraphernalia of the scholar's library, viz. the *Wên-fang-t'u-tsan-hsü* 文房圖贊續, compiled in 1334 by the Yüan scholar Lo Hsien-têng 羅先登, as a sequel to the *Wên-fang-t'u-tsan* 文房圖贊, written in 1237 by Lin Hung 林洪, a descendant of the celebrated Sung poet Lin Pu (林逋, 967–1028). This source calls the implement *kao-ko-hsüeh* 高閣學, and describes it as a rack for stacking letters.

112.–RACK DEPICTED IN THE *SAN-TS'AI-T'U-HUI*

"Outgoing and incoming correspondence", Lo Hsien-têng observes, "letters and documents, all these are needed at regular times; if there were no suitable implement for keeping them, they would certainly become scattered and lost. Now, however, they can be stacked on this rack high on the wall, arranged in an orderly way". 蓋箋翰往來。簡牘書卷。亦各有時。苟無職當。寧免散漫。今得置在高位者。羅而收之。

Also Ming and Ch'ing sources, while giving pictures identical with, or very similar to that given in the *San-ts'ai-t'u-hui*, describe this implement as a rack for stacking smaller scrolls and letters. The *T'u-hui-tsung-i* 圖繪宗彝, a small illustrated encyclopedia in 8 ch., written in 1607 by Yang Êrh-tsêng 楊爾曾, a popular writer of the Ming period, gives a picture that is practically identical with that of the *San-ts'ai-t'u-hui*, without explaining its purpose. Since its name is given as *chu-ch'ih-ko* 竹紙閣 "paper rack, made of bamboo", this author evidently understood it to be used as a rack for stacking letters rather than as a contrivance for displaying scrolls on.

That this was the use it was put to during the Ch'ing dynasty is proved by the *Shinzoku-kibun* 清俗紀聞, an illustrated account of Chinese manners and customs during the 18th century, compiled by the Japanese scholar Nakagawa Chū-ei, and published in Nagasaki, in 1799 (for more details, see the note on page 11 above). Plate **113** gives a reproduction of the implement as depicted there. This source calls it *sho-ka* 書架 "letter (or book) rack".

Moreover, the two specimens of this rack seen by me were actually used for stacking letters. One I saw in the house of a Chinese scholar in Peking, the other in a curio shop in Seoul, Korea; both were made of bamboo, and corresponded closely to the picture given in the *San-ts'ai-t'u-hui*. Chinese connoisseurs whom I consulted in this matter said that since many centuries this implement was hung on the wall, and used by people

320

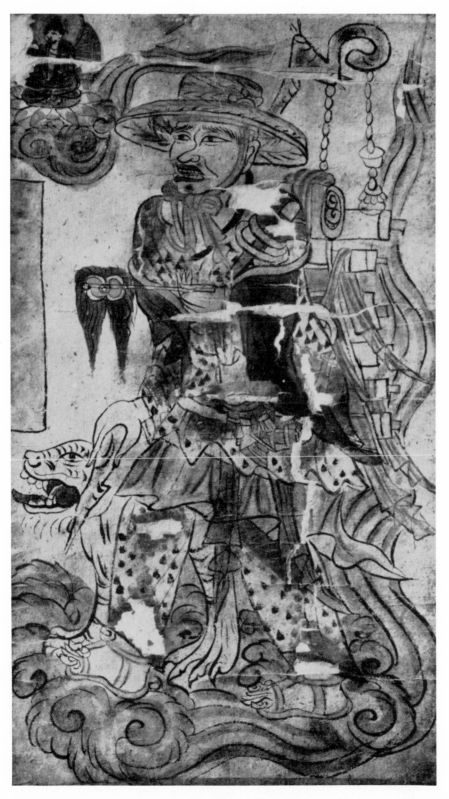

114. – PAINTING ON PAPER
(Tun–huang Collection of the Musée Guimet, Paris, no. 17683)

of elegant taste for stacking their letters, and smaller scrolls; but they agreed that it was quite possible that this was not its original use.

Finally, I may draw attention to a rack that is very similar to that depicted in the sources quoted above; this is a contrivance used by Buddhist monks of the T'ang period for carrying their holy books along when traveling. Some pictures discovered in Tun–huang give a clear picture of such a rack.   Plate **114** reproduces a painting, which is tentatively identified as representing Hsüan–tsang on his travels, and which is now preserved in the Musée Guimet, in Paris.   The British Museum has in its Tun–huang collection a painting very similar to this one; it is reproduced on Plate XXV of the atlas belonging to *The Thousand Buddhas*.   Aurel Stein, however, failed to recognize the rack, and the text volume belonging to the atlas describes it wrongly as " a bundle of manuscript rolls tied in a cover and slung by a chain to a thorny branch " (op. cit., page 48); this " thorny branch " is in fact part of the rack.   In present–day China I have never seen such racks actually used in this way, but Koreans still use a similar contrivance for carrying loads on their back.

書架

113. — RACK DEPICTED IN THE *SHINZOKU–KIBUN*

From the above evidence it may be concluded that there are two possibilities.   First, that the editors of the *San–ts'ai–t'u–hui*, although aware of the fact that since the Yüan dynasty this implement was used for stacking letters, yet had data at their disposal which proved that its *original* use was as a real *lai–chia*, a rack for reading books while lying on one's back.   Since in Ts'ao Ts'ao's and Lu Fa–yen's time books still had the form of hand scrolls, one could imagine that the implement was used for reading in bed; it could be laid across one's lap, with the two upturned handles on left, to prevent a partially unrolled scroll from slipping off.   Second, the editors used the wrong picture, this implement being no *lai–chia* at all, but a rack for stacking letters, made after the model of the scroll rack formerly used by Buddhist priests for transporting on their back their treasured holy books.

It may be left to the reader's ingeniousness to solve this problem.

## ANNOTATED TRANSLATION

*Records of Prolonged Gratification of the Simple Heart*

by
Chou Erh–hsüeh, styled Yao–p'o, from Jên–ho. [1]

A.

Wang Chu's preface.

The appreciation and the preserving of scrolls has been esteemed highly since olden days. Yü Ho [2] of the Liang dynasty, Hsü Hao [3] and Wu P'ing–i [4] of the T'ang period, all such persons were experts at classifying scrolls, and their discrimination was hair–fine. Thereafter it were the rulers and statesmen of elegant tastes who exhausted the riches of the Empire, adorning their scrolls with " golden labels and jade rollers ", [5] thereby dazzling their age. That a simple and poor scholar is able to investigate thoroughly these refined enjoyments is rarely seen indeed. Now Mr. Chou, whose literary name is Yao–p'o, in his reading exhausts antiquity. He has used his spare energy for drawing up ten rules for mounting scrolls, intended for connoisseurs and collectors; every article is clear and to the point, to such a degree that not one word could be changed. Hereby he has shown that he has certainly a subtle understanding of fine art. If, some day, I should be visiting Hangchow, and he would bring out all his scrolls to be studied by me as I like, then this would be a reason for great, ecstatic joy.

Written by Wang Chu, from Lang–hsieh. [6]

B.

Ting Ching's preface.

The painting " Excursion to the Western Garden on a clear night " by Ku K'ai–chih [7] was preserved until the T'ang period; then Ch'u Sui–liang [8] with his own hands remounted it. Kuo Jo–hsü [9] of the Sung dynasty saw Ch'u Sui–liang's record of this occurrence in his superscription added to this painting, and while writing his *T'u–hua–chien–wên–chih* described it in detail. Mi Fu, in the poems he added as a colophon to a T'ang copy of an autograph by Wang Hsien–chih, [10] said: " Although my hands became

書畫鑒藏。矜重自古。梁之虞和。唐之徐浩武平一。皆品目精盡。鑒入
毛髮。自茲以降。惟君相有雅好者。屈天下之物力。金題玉躞。照映一世。
寒門素士。能講求雅玩者。蓋難之矣。周君藥坡讀書稽古。以其餘力。爲
鑒藏者定爲裝潢十則。一一精到。不可移易。知其賞會者微矣。他日過
武林。將盡發其藏而縱賞之。引滿狂叫一大快事也。瑯邪王澍書。

顧長康所畫清夜游西園圖。流傳至唐。河南褚公親爲裝背。宋郭若
虛猶及見公題記。郭有圖畫見聞志。特詳錄焉。米海嶽以詩題大令帖

1) Jên–ho, old name of Hangchow.
2) See page 139, note 4.
3) See next page, note 4.
4) See page 148.
5) Quoted from Chang Huai–kuan, see p. 139, line 15 from top.
6) Lang–hsieh, old name of Chin–tan 金壇, in Kiangsu Province.

7) The famous 4th century painter; here referred to by his style Ch'ang–k'ang.
8) See page 153, note 3.
9) Cf. Soper's translation of the *T'u–hua–chien–wen–chih* (listed in Appendix I, no. 36), page 83.
10) See page 138.

chapped (*kuei* is read *chün*. Transl.) I myself washed this scroll several times; that still the paper did not become fuzzy, who could equal me in this achievement?"[1]  Here Mi Fu thus extolls his own skill in mounting.  Therefore, every time Mi Fu obtained a superior scroll, he himself washed it clean of all dust and stains and entered it in his collection[2] only after its mounting had been adjusted and its material cleaned.  And also, when other persons had acquired a scroll that struck his fancy, he would himself remount it for them.  For instance, the Lan-t'ing scroll preserved by Su Chi,[3] and the scroll with the appointment of Chang Chiu-ling, [written by Hsü Hao,[4]] and preserved by Chang Chung-jung;[5] he himself recorded these facts in the *Pao-chang-tai-fang-lu*, where they can be verified.  And the picture of Vimalakîrti by Ku K'ai-chih in Mi Fu's own collection, had a jade title label attached to it, inscribed with extremely small characters, filled with gold, engraved by Li Lung-mien[6] himself, and thus confirming this common bond among art lovers.[7]  Others like Yü Ho[8] of the Liang period, Lu Yüan-ch'ing,[9]

後云。龜澥雖多手屢洗。卷不生毛誰似米。蓋自矜其裝背之妙也。故每
得劇跡。必手自湔浣塵垢。界運楮滶始入於笈。卽他氏收蓋有入意者。
亦躬與背飾之。如蘇激家蘭亭。張仲容家張曲江誥。身載之寶章待訪
錄可按也。而自藏顧畫維摩像。標識虎頭金粟字玉牌。亦李伯時手琢
以結緣者。他如梁之虞和。唐之盧元卿武平一張彥遠宋之趙叔盎元
之周公謹陶南邨。遇法裝名飾。皆謹其條件款樣。以薦嗜古之士。嗚呼

1) These two lines occur in a long poem that Mi Fu added as a colophon to a T'ang copy of an autograph by Wang Hsien-chih; cf. *Shu-shih* (Appendix I, no. 38), under the heading: 子敬范新婦唐摹帖.

2) See page 189, note 7.

3) Su Chi was a son of the famous scholar-artist Su Shun-ch'in (蘇舜欽, 1008-1048); he must have been a great collector of scrolls, for Mi Fu repeatedly mentions him in both his *Hua-shih* and his *Shu-shih*. The occurrence referred to is to be found in the *Pao-chang-tai-fang-lu* (cf. Appendix I, no. 39), under the heading: 王右軍蘭亭燕集序. There Mi Fu says: "I was a good friend of Su Chi, and every time I visited him, he would always take out this scroll; at last I myself remounted it for him" 某與激友善。每過。公必一出。遂親爲背飾.

4) Hsü Hao often wrote out important official documents in his own famous chirography.  Mi Fu has recorded the full text of this particular document in his *Shu-shih*, under the heading: 唐彭王傅徐浩書贈張九齡司徒告.

5) About Chang Chung-jung nothing is known except the fact recorded by Mi Fu in his *Pao-chang-tai-fang-lu* that he was a descendant of the famous T'ang poet Chang Chiu-ling (張九齡, 673-740; B. D. No. 38).  "This scroll", Mi Fu says, "now is in the house of (Chang Chiu-ling's) grandson, Chang Chung-yung from Ch'ü-chiang, prefect of Ling-nan (Canton). When I was occupying an official position at Kuei-lin, I borrowed this scroll for two weeks.  It was mounted with the same old paper (that had been added to it in the T'ang period. Transl.). I

intended to remount it.  But Chang Chung-jung did not allow me to do so, because he wished to spare the seals on the seams and the antique paper" 今在其孫曲江人嶺南縣令張仲容處。某官於桂林。借留半月。仍以紙覆裹。欲爲重背。仲容惜其印縫古紙。不許.

6) The famous painter Li Kung-lin (flourished 1150), here referred to by his style Po-shih.

7) This refers to the following passage in Mi Fu's *Hua-shih*: "The picture of Vimalakîrti as a heavenly nymph, painted by Ku K'ai-chih, that is now in my collection, measures two *ch'ih* five *ts'un*, which agrees with the measurement given in the *Li-tai-ming-hua-chi* (ch. IV). It still has its knobs of carved ivory dating from the T'ang period, and its front mounting consists of purple brocade.  When Li Kung-lin saw this painting, his loving admiration knew no bounds; he himself made a jade title label for it, inscribing it with old seal characters taken from antique bronze vessels, engraving the text in very small characters filled with gold, and carving its surface with a pattern of clouds and cranes, (by this labour) showing the common bond existing between art lovers" 余家顧淨名天女。長二尺五。應名畫記所述之數。唐鏤牙軸。紫錦裝禠。李公麟見之。賞愛不已。親琢白玉牌。鼎銘古篆虎頭金粟字。皆碾雲鶴。以結緣也.

8) See page 139, note 4.

9) Lu Yüan-ch'ing was a connoisseur of the T'ang dynasty, author of a small work on calligraphy, entitled *Fa-shu-lu* (法書錄, dated 808).

Wu P'ing-i, [1] and Chang Yen-yüan of the T'ang period, Chao Shu-ang [2] of the Sung period, and Chou Mi [3] and T'ao Tsung-i [4] of the Yüan period, all these when happening to obtain scrolls that were correctly mounted and beautifully adorned, diligently applied themselves to note all their details, so that their records might serve as reference for scholars with an antiquarian interest. Alas, how should these gentlemen not make us shrink from a tiresome comparison of the work described by them with that of common artisans? How true it is that although chalk and ink are minor items in themselves, they still are the medium through which the men of antiquity explained their spirit. In its broad aspect, scrolls serve to support the true doctrine and benefit our knowledge, in its narrow aspect they grant repose from this noisy world, and cleanse us of vulgarity. And this applies all the more to pictures left by the refined, the loyal, the unconventional, and those of filial piety, and to the paintings by high-minded recluses and famous sages. But with the passing of the years, paper and silk ever more decay, and it becomes increasingly difficult to find expert mounters such as T'ang Han, [5] Ling Yen [6] and Shu Sou, [7] not to mention men like Li Hsien-tan,[8] Chang Lung-shu,[9] Yao Ming [10] and Ch'ên Tzŭ-ch'ang.[11] Thus things have come to such a pass that mists and clouds are obscured and drift away (referring to landscape paintings), and that flowers and birds come to grief (referring to pictures of these subjects); this certainly is a reason for sorrow and affliction. Now my friend Mr. Chou, being much distressed by this state of affairs, has evolved methods for mounting, ten articles in all, covering the entire subject from taking off the old backing and washing, to the correct way of displaying the remounted scroll. Although this essay does not closely correspond to all the ancient precepts, if one tries out these rules oneself, one shall find that every single one of them leads to good results. From now on every collector should keep a copy on his shelves, and treat his scrolls according to the rules set forth there, thus saving them from the ruthless methods and rough work of vulgar artisans and clumsy workmen. Is this not a joy that brightens the eyes and gratifies the heart? Formerly I found among the papers in Chu I-tsun's library [12] the " Book of Mounting ", by the Ming scholar Chou Chia-chou, in one volume. I was most anxious to copy it out, but the pressure of other affairs prevented me from realizing this project. Now, having obtained this essay

古人精忠奇孝之點畫。高隱名賢之皴染。又不待論矣。慨夫日月愈遠。楮素之朽靡。己渺不可得。況李仙丹張龍樹姚明陳子常其人者耶。致使煙雲黯汩。花鳥深愁。良堪痛悼。吾友周君深憂之。於是酌斟修飾之法。自揭洗至懸置。凡得一十件。雖未盡與古合要。若已試之。方一一悉有成效。今而後收蓄家人儲一帙。按法而治。庶不恣俗工莽匠之撑搶塗割。豈非霽目賞心之快舉乎。先是予從曝書亭簿錄中見有明人周嘉冑裝潢志一卷。亟欲傳寫。忽忽未果得。今是諸公者。豈好爲不憚煩與工藝之流較優劣哉。良以粉墨雖微。小可以破囂紒浣俗氛。至

1) See page 148.

2) Chao Shu-ang was a member of the Sung Imperial family. He was a great collector of scrolls, and as such a friend of Su Tung-p'o and Mi Fu; he is mentioned *passim* in the latter's *Hua-shih* and *Shu-shih*. He himself was known as a painter of horses.

3) See page 200.

4) See Appendix I, no. 24.

5) See page 250.

6) See page 250.

7) See page 250.

8) See page 154, note 13.

9) See page 154.

10) See page 209, note 4.

11) See page 209, note 6.

12) The text mentions the *Pao-shu-t'ing*, which was the name of the library of the great classical scholar Chu I-tsun (朱彝尊, 1629-1709; cf. E. C., page 182).

by Mr. Chou (Erh-hsüeh), that is detailed without being verbose, and concise without missing the main points, I know that fellow Chou (Chia-chou) had better make a strategic withdrawal to some distant spot.[1]

Written respectfully by the ignorant younger brother Ting Ching, the friend from South of the city, on the 16th day of the 11th moon of the year 1734.

## C.

Li Ê's preface.

Among the professional mounters of scrolls who during the T'ang period were attached to the Palace, there were people like Chang Lung-shu,[2] Wang Hsing-chih,[3] Wang Szû-chung,[4] Li Hsien-tan,[5] all of whom must have been excellent workers and skilful artisans. And as to the connoisseurship of Lung Ta-yüan[6] and Tsêng Ti,[7] working in the library of the Sung Emperor Kao Tsung, although their discriminative powers were insufficient, they were most diligent as to the various kinds of brocade and silk to be used for the mountings, and the distinctive features of rollers and knobs; these matters may be found in the records left by Chou Mi.[8] Thus the people of old paid great attention to the fine arts and did not wish to pronounce careless judgements. In the field of collecting scrolls, their methods as set forth, for instance, by Chao Hsi-ku in his *Tung-t'ien-ch'ing-lu*,[9] must be called detailed and yet concise. The retired scholar Yao-p'o possesses the discriminative powers of a K'o Chiu-szû,[10] while his collection of scrolls vies with that assembled by Ni Tsan.[11] The ten sections forming the present essay all show thorough investigation, while moreover propounding some new ideas evolved by the author himself. This essay truly is a loyal defender of precious ink-remains, and a buckler and rampart of pictorial art. Chang Yen-yüan said: " If one does not do useless things, how then could one enjoy this limited life ? "[12] Now our country is not lacking in scholars of elegant taste; having obtained this let it be to them an aid to the enjoyment of life.

Written on the 21st day of the 12th moon of the year 1734, by Li Ê, called Fan-hsieh.

得受周君是編。精而不苟。簡而有要。知彼周郎自當退避三舍也己。雍
正甲寅仲冬十六日城南友愚弟丁敬頓首拜撰。

　唐內府書畫裝潢匠。則有張龍樹王行直王思忠李仙丹輩。要皆良
工好手。宋思陵祕閣龍大淵曾純甫。審定目力雖短。而標贉諸錦綾。桿
軸名色不一。各務精麗。見於周公謹氏所記。蓋古人留心游藝。不欲苟
簡。如是若收藏之法。如趙希鵠洞天清祿所載。亦可謂之詳且密矣。藥
坡居士有丹邱之鑒識。兼清閟之儲藏。此錄十則。悉經講求。自出新意。
誠寶墨之金湯。繪林之干城也。張彥遠云非爲無益之事。又安能悅有
涯之生。海內不乏雅流。得此亦悅生之一助云。雍正甲寅嘉平月廿有
一日樊謝屬鶚。

---

1) *San-shê* 三舍 " ninety miles "; *shê* is an old military term meaning 30 miles, used in the *Tso-chuan.*

2) See page 153, note 11.

3) See page 153, note 6.

4) See page 154.

5) See page 154, note 13.

6) See page 205, note 5.

7) Tsêng Ti 覿, here referred to by his style Shun-fu; cf. *Sung-shih*, ch. 470.

8) See page 200.

9) See Appendix I, no. 27.

10) K'o Chiu-szû (柯九思, style Ching-chung 敬仲, lit. name Tan-chiu 丹邱, 1290-1343), great scholar-artist of the Yüan dynasty, at one time charged with sifting the scrolls in the Palace Collection. The text only gives his literary name *Tan-chiu.*

11) Ni Tsan (倪瓚, 1301-1374), famous painter and connoisseur. His studio was called *Ch'ing-pi-ko* 清閟閣, and he is referred to here by that name.

12) See page 47 for the full text where this quotation occurs.

## D.

Ch'ên Chuan's preface.

The sages of old have passed away, the only things that remain of what they had to offer us are these few antique scrolls. These should, therefore, be protected like one's own life. Reflecting that the task of mounting them is entrusted to clumsy artisans, so that one sees less and less of these scrolls, often this strikes me dumb with horror. My friend Mr. Yao-p'o has a pure and real love of antiquity, he has a wide reading and a broad artistic experience. Those items which he especially values are dear to him like his very life. Moreover he has written this essay, to warn all lovers of art. Reflecting on his eminent discussions, I find that they uncover the essence of connoisseurship. The ancients in their works used to start with the small things, and thence proceed to their greater achievements. Thus the profound should not be mistaken for shallow. As regards the indiscriminate use of superscriptions and colophons, and the omission in these of corroborating data, people freely indulge in this habit. To cover a scroll with such irrelevant scribblings, is very objectionable indeed. When reading the passage " When the Imperial son-in-law Wang Hsin, etc. ", I feel like having recovered something that I long thought I had lost; what a joy, what a joy!

Written in the 4th moon of the year 1737, by the younger brother Ch'ên Chuan, called Yü-chi.

## E.

Author's preface.

If scrolls are not provided with a mounting, they become dry and their silk will be spoilt. If the mounting is not done exceedingly well, then this (mediocre mounting) will rob the antique flavour of the scroll. And what to say about those who extravagantly display all the scrolls in their collection together, without any proper arrangement? The vulgarity of such things soils one's spirit. When wonderful scrolls become covered with dust, then this is as bad as when they get soiled by greasy fingers. [1] The methods described in this essay do not disagree with ancient precepts, and the types of mounting described include also some new principles. Occasionally this essay also touches upon the correct use of things, thus contributing to the enjoyment of pictorial art. Is this not really treasuring and preserving that what in most essential? All true connoisseurs must understand the works of art they are confronted with, so that they can do away with what is vulgar, and follow what is elegant. Having collected these words formulated in my humble study, I entitle this essay: " Records of prolonged gratification of the simple heart ".

前哲已往。其所留貽。僅此殘墨數點。護之當如頭目腦髓。顧裝潢委
諸凡手收置。則又鮮會見之。徃徃令人氣塞。吾友藥坡先生。清眞好古。
誦鑒淹遠。其於銘心之品。旣性命以之。復著爲此說。以戒好事。觀其立
論。開發淵深。如昔人創物。必造微而後已。蓋深者不能使之淺也。至於
題識蓊苅。引據罕據。初不省度。疥癩滿紙。尤可惋痛。讀王都尉云一
則。向所失物取次得之。快絕快絕。乾隆丁已清和玉几弟陳撰書。

書畫不裝潢。旣乾損絹素。裝潢不精好。又剝蝕古香。況復侈陳藏弄。
件乖位置。俗涴心神。妙蹟蒙塵。庸愈桓元寒具之厄。此編法不違古。制
匪翻新。旁及器用。藉以供養煙雲。豈殊寶護頭目。世有眞賞之士。定知
寓目會心。祛凡設雅。取吾家草窗之言。名曰賞延素心錄。

---

[1] Reference to the famous story told about Huan Hsüan; cf. page 46, note 3.

Experts in the art of remounting scrolls are difficult to find.    If, therefore, you are fortunate enough to purchase an excellent scroll, that had also been mounted correctly, then you should only devise means for repairing (such minor defects as) frayed edges, but not change the backing.    Hardly one tenth of all the paintings by artists of former dynasties has been transmitted to the present in perfect condition. Only, therefore, in order to remove white mould marks accumulated for years, should you remove their backing.    The picture should be spread out on a white-washed flat table, and it should be cleaned with old rain water fallen in autumn.    Yellow stains caused by water leaking through the roof should be cured by dismounting the picture as before; then it should be soaked in the water mentioned above, and thereafter its surface blotted with a roll of lamp wick, [1] absorbing the stains by gently pressing. When these stains have thus been loosened, you should then tilt the table, and soak the scroll again with the water mentioned above; you should let it drip dry and then again moisten it, until all the dust and stains have disappeared.    This correct method for taking off the old backing and washing the scroll will ensure that colours and ink are not damaged, and it will not harm its antique flavour.    As regards red and black mould stains, and greasy spots, these must be compared to the various poisons having entered the heart: they can never be cured.

## II.

As regards the methods for patching up damaged scrolls, nothing need be added to or left out from what former writers said on this subject.    Here it be merely stated that if, when the scroll has been re-mounted many times, and bad mounters have cut down arbitrarily its four sides, you should try to find paper or silk of exactly the same colour as that of the picture itself.    The picture should be backed with this material in such a way that this backing protrudes all along the four sides of the picture, surrounding it with a narrow edge of one *fên* broad, which will not interfere with the picture itself.    The most important is that the paper of an autograph or a picture is smooth and white, so that it looks as if it were new.    If, however, the paper should have decayed, or the ink become blurred, then no matter whether it concerns a work of recent date, or a magnificent specimen from the Ch'in, T'ang, Sung or Yüan periods, its beauty will inevitably stay impaired.

I. 裝潢書畫好手難得。倘幸購劇蹟。兼獲法裝。卽繾楮蘇脫。宜斟酌修整。不可重背。至古人寸巒尺壑。流傳後世完好者。什不得一。惟治積年黴白。揭去背紙。正托白粉平案。用秋下陳天水瀟洗。治屋漏黃蹟。亦如前揭托。先用前水灑滲。次清鐙帅盤結。依跡輕吸。跡旣浮動。卽斜豎案。再用前水淋漓遞灌。幷塵垢盡出。按揭洗良法。能不損粉墨。不傷古澤。若紅黑黴點及油污。譬之雜毒入心。不能去也。

II. 補綴破書法。備前人無可增損。惟有經褾多次。上下邊際。爲惡手濫割。必須覓一色紙絹。接闊一分。才不逼畫位。要之書畫以紙白版新爲貴。若紙弊墨渝。無論近代。卽晉唐宋元烜赫有名之蹟。亦當減色。

1) The wicks of Chinese lamps are made of the dry stalk of a plant; see also page 114.

# III.

For backing paintings one should use uncut sheets of pure thin *lien-szŭ* paper from Ching-hsien, [1] pounding two of such together till they form one single sheet; the paste must be dried in the wind. Then this sheet should be cut according to the size of the picture, you should not piece several smaller sheets together to obtain a sheet of backing of the required size. This backing should protrude slightly along the four sides of the picture, forming a narrow seam. For backing the entire scroll the same kind of paper should be used, provided that you select a closely knit and thick variety. Then such a backing will not only through its toughness protect the picture, but it will also prove easy to take off if later on the scroll should be remounted, and the paper can be used by calligraphers and painters.

For the front mounting you should use thin silk from the Hsüan-tê period with a small design of clouds and phoenix birds. *T'ien* and *ti* should be dyed black entirely with good ink, or given a light blue colour. As to the two *ching-tai*, [2] you should not slavishly imitate the antique examples, and indicate them by two pairs of lines drawn in ink; moreover not all antique mountings show this feature. The upper and lower part and the right and left border of the "frame" [3] should be made of white silk. Large pictures should have a narrow frame, smaller pictures a broad frame. If along the upper side of the picture you add a narrow seam of gold brocade (*ya-tzŭ?*), then along the left and right sides you should add seams made of mulberry bark paper, dyed with garoo incense. The ancient people were wont to utilize the "frame" and other parts of the front mounting, for writing there superscriptions and critical remarks. In my opinion, having judged a painting, it is not necessary to scribble (critical remarks) all over its mounting. This habit should not be followed.

For short scrolls and small pictures you should employ fine white silk, made in imitation of the "Academy silk" of the Sung period. Single scrolls are provided with a "frame" cut from one piece of silk. The width of their *t'ien*, *ti* and *ko-shui-ling* should be fixed in accordance with the size of the picture, the size of these parts of the front mounting should not be determined by the height of your library. And in no case should you arbitrarily add a *shih-t'ang*. [4]

The best material for making the "protecting flap" is soft, thin antique brocade, with a pattern of falling blossoms and flowing water. The next best material is slightly sized, grey silk, fine but closely woven. These materials can be pasted down perfectly smooth, so that the upper stave will be thin. The

III. 畫背紙用元幅精匀漫薄涇縣連四。砑熟兩紙合一。糊就風乾。視
書之長短闊狹裁割。勿以零剩補湊。交接細止一線。稍闊便橫梗畫面。
托畫亦用前紙。更揀密賦者。不但質韌護畫。他日復褾。且易揭起。可供
書畫家揮染。

褾用宣德小雲鸞綾。天地以好墨染絕黑。或澹月白。二垂帶不必泥
古。墨界雙線。舊褾亦竟有不用者。上下及兩邊。宜用白。大畫狹邊。小畫
闊邊。如上嵌金黃綾條。旁用沈香皮條。邊等古人取以題識。鄙意劇蹟
審定。未宜羼字。此式不必效之。

短幀尺幅。必用仿宋院白細絹。獨幅空嵌。其上下隔水。須就畫定分
寸。不得因齋閣之高卑。意爲增減。更不得妄加贉池。

軸首用綠薄落花流水舊錦爲佳。次則半熟細密褾絹。最熨貼。壓竹

[1] See the description of this paper on page 296, note 4.

[2] See page 246.

[3] See Plate **30** A, 5.

[4] This seems to be a confirmation of the statement in Ch. XIII of the *Chuang-huang-chih*.

scroll should be provided with four eyes of red copper, and through these should run a suspension loop of gold thread. For the band (to be attached to this loop, for winding round the scroll when rolled up), you should employ antique brocade.

The body of the lower roller should be made of pine wood, perfectly round, and hollow inside. [1] For the knobs you should try to find early crackled Sung porcelain (*kuan-ko*), or porcelain from Ting-chou (*ting-yao*), or ware from the Hsüan-tê period, with blue designs on a white ground. Or old knobs of red and white sandalwood, of ivory, rhinoceros horn, or box wood, selecting such knobs as are of an elegant yet simple type. All knobs should have a cavity that fits exactly the protruding tenon of the roller, then they will not become loose and fall off when the scroll is unrolled. Knobs should not be too thick, but on the other hand they should on no account be long and thin.

## IV.

The *yin-shou* and *ko-shui-ling* of a hand scroll should be made of fine silk from the Hsüan-tê period, showing a design of small clouds and phoenix birds. For the space reserved for the superscription, you should use white paper of the Sung period, *sûtra* paper, or also glossy paper from the Hsüan-tê period. As regards ornamental paper with a gold design of the Sung and Yüan periods, although this is elaborate and attractive, it is certainly not suited for this purpose. [2] For the seams along top and bottom one uses good thin *sûtra* paper, these seams should not be broader than three *fên*. The method for adding these to the scroll is as follows. One cuts the paper in narrow strips of 7 *fên* broad, and cuts off both ends (of each strip) obliquely, so that (when several of these strips are joined so as to form one longer strip) the oblique ends fit together, one overlapping the other for 1 *fên*. Then one pastes this strip (i. e. a margin of 7 — 3 = 4 *fên*; it was stated above that a margin of 3 *fên* shows on the frontside of the mounting. Transl.) along the edge of the picture, on the reverse, and one folds the rest of the strip (i. e. a margin of 3 *fên*) over, sticking it firmly round the edge of the scroll. Then these seams will be narrow but strong, they shall not only protect the painting, but also not suffer from the evil of getting loose or frayed. Very narrow hand scrolls should be mounted with broad borders of the white silk mentioned above, so as to increase their height; then add a border of *sûtra* paper, finally adding a seam of flossy and thin, but closely woven "Academy silk", or of mulberry bark paper dyed yellow or grey. This seam should be attached to the scroll in the same way as mentioned above.

即 狹。書 必 釘 紫 銅 四 紐。貫 金 黃 絲 繩。縛 用 舊 織 錦 帶。軸 身 用 杉 木。規 員
剡 空。

軸 頭 覓 官 哥 定 窰。及 青 花 白 地 宣 甆。與 舊 做 紫 白 檀。象 牙。烏 犀。黃 楊。
製 極 精 樸 者 用 之。凡 軸 頭 必 方 鑿 入 柄。卷 舒 才 不 鬆 脫。不 可 過 壯。尤 忌
纖 長。

IV. 橫 卷 引 首 及 隔 水。用 宣 德 小 雲 鸞 綾。賝 池 用 白 宋 牋 藏 經 牋。或 宣
德 鏡 面 牋。如 宋 元 金 花 粉 牋。雖 工 麗。卻 不 入 品。邊 用 精 薄 藏 經 牋。闊 止
三 分。其 法 以 牋 裁 七 分 條。兩 頭 斜 剪。再 斜 接 一 分。黏 書 背 餘 對 折 緊 貼
卷 邊 際。則 邊 狹 而 有 力。不 但 能 護 書。且 無 套 邊 蘇 脫 之 患。矮 卷 用 如 前
白 綾 鑲 高。然 後 接 藏 經 牋。次 用 細 密 綂 薄 院 絹 作 邊。或 染 皮 條 黃 或 標
色。亦 如 前 邊 法。

---

1) This idea was first propounded by Mi Fu; see page 185.

2) In course of time this gold design may turn black, or drop off, and then the writing becomes damaged; cf. the remarks in the *Yü-shih*, quoted on page 98.

The backing of hand scrolls should not be stiff and thick, you should use exclusively one layer of pure and soft *lien-szŭ* paper from Ching-hsien. For the protecting flap there should be used genuine brocade or embroidered silk from the Sung dynasty, but these materials are difficult to get. Brocades made by expert workmen of the Ming dynasty in imitation of brown brocade with a pattern of geese and turtles and suchlike patterns, these also are very fine and attractive. For the knobs white jade, or a variety of greenish jade stone is the best. Occasionally you may also use rhinoceros horn, provided it is well carved, in order to have this type of knob also represented in your collection. The knobs, however, should be inlaid into the ends of the roller, then it will be easy to roll and unroll the scroll. You should not imitate the ancient fashion of having thick, protruding knobs. Antique jade is the best material for the fastening pin; in course of time, however, such a pin will cause a depression that will penetrate right into the picture itself, causing no small harm. It is far better, therefore, just to use a band of antique brocade, that should be broad and never wound too tightly.

Every album leaf should be mounted in a " frame " cut from one piece[1] of Hsüan-tê paper, or from a piece of fine but closely woven grey or white silk. You should avoid using grey ordinary silk. If every single leaf is much broader than it is high, you should use the ancient type of "transverse album"[2] you may not fold the leaf in two. The best material for the outside cover of your album is genuine Sung brocade, the next best in speckled *nanmu*. The wooden frame round the cover should be made of fragrant *nanmu*, covered with dull lacquer. It should be exactly square, and not have crooked corners. For the title label (to be pasted on the front cover) you should use *sûtra* paper, or white paper from the Sung period, and inscribe this label with characters in the seal, chancery, square or running script. The characters should never be carved into the wood.

V.

For making paste you should pour old rain water in a jar with a wide mouth, and thereon strew clean white flour. When this mixture has become sour, you should change the water, continuing till the acidity has disappeared entirely. Then you let the mixture dry in the sun, and having added a little alumn powder, pound it with old rain water fallen in autumn, till it has become one solid mass. Then put this in a pan, and boil it well. Now the paste is poured in a jar, and left to cool off. You pour old rain water over it, changing it once every day. Before using this paste, it should be pounded tho-

*On preparing the paste.*

復背忌健厚。止用精漫涇縣連四一層。卷首用眞宋錦及宋繡。然不
易得。卽勝國高手翻鴻龜紋粟地等錦。亦精麗。軸用白玉西碧爲上。犀
角製精者間用之。以備一種。須縮入平卷。才便展舒。勿仿古粗出卷外。
古玉籤雖佳。但歷久則籤痕透入畫裏。爲害不小。不如用舊織錦帶作
縛。寧寬無緊。
　　册葉用宣德紙空嵌。或細密縹白二色絹。忌綾縹幀若扁闊。必仿古
推篷式。不可對折。面用眞宋錦爲上。次則豆瓣柟。或香柟作胎。黑漆退
光。貴方平。勿委稜角。面籤用藏經牋。或白宋牋。隨作篆隸眞行書標題。
不得鏽刻。

V. 糊法用陳天水一缸。以潔白飛麪入水。水氣作酸。再易前水。酸盡爲
度。旣曝乾。入白礬少許。和秋下陳天水。打成團。入鍋煮熟。傾置一缸。候

1) For the term *wa-ch'ien*, see page 65.      2) For the term *t'ui-p'êng*, see page 97.

roughly in a porcelain bowl, diluting it with the rain water used before until it has acquired the right degree of liquidity. [1] You must avoid by all means that the paste becomes too thick. If the mounting is done during the summer, your paste should be prepared ten days in advance, in spring and autumn one month previously. If, however (after having prepared it for use) you leave the paste standing about too long, it will lose its force.

The mounter Chêng Mo-hsiang says: " The (hairs of) new paste brushes are hard and uneven, those of old ones are brittle and often fall out. The best are those that are neither too new nor too old ". This statement certainly is very much to the point; I append it here to be used by those interested in this art.

## VI.

General observations on mounting.

For mounting scrolls the cool spring and the dry autumn are the right seasons. You should avoid the hot and rainy season, and times when a strong wind is blowing, or during severe cold. You should aim at producing mountings that are rich and smooth and which are not stiff and cracky; the ink and colours should not become dull, and the paste should have penetrated all the layers of paper. Further the " frame " and the strips above and below the picture should be cut straight and even. Then the scroll may be unrolled smoothly, both when being unrolled on the table and when being suspended on the scroll hanger. (If your mounting possesses these qualities) then, although you can never possess the wonderful secrets of Chang (Lung-shu) [2] or Li (Hsien-tan), [3] you may still claim to be called a highly skilled worker of this time, equal to T'ang Han [4] and Ling Yen. [5] Further, you must suspend (your scrolls on the wall) with loving care, changing them every four or five days. Then the picture will not develop defects, and the mounting will not be spoilt.

## VII.

The importance of seals and colophons; the practice of adding famous names to anonymous scrolls.

When the Imperial Son-in-law Wang Hsin had engraved an imitation of the seal of Kou Tê-yüan, and therewith sealed the scrolls in his collection, Mi Fu discovered that this was a faked seal by observing the two feet of the character yüan. [6] Chao Mêng-fu wrote colophons to the Ting-wu copy of the Lan-

冷。浸 以 前 水。日 須 一 易。臨 用 入 甆 甌。干 杵 爛 熟。以 前 水 匀 薄。大 忌 濃 厚。
夏 禔 治 糊 十 日 之 前。春 秋 治 糊 一 月 之 前。過 宿 便 失 糊 性。
　　裝 潢 鄭 墨 香 云。糊 帚 新 則 硬 澁。舊 則 脆 脫。利 用 在 不 新 不 舊 之 間。說
頗 切 理。附 入 以 備 藝 林 采 取。

VI.　　裝 潢 春 和 秋 爽 爲 佳 候。忌 黃 梅 積 雨。凝 風 嚴 寒。裝 潢 之 法。但 得 脉
潤 不 枯。墨 入 不 伏。層 糊 疊 紙。中 邊 上 下 之 均 平。展 案 擎 叉。轉 折 舒 卷 之
熨 貼。卽 未 能 如 張 李 祕 妙。亦 今 世 之 湯 凌 高 手 也。更 須 懸 挂 寶 愛。約 四
五 日 一 易。旣 不 病 畫。亦 不 損 禔。

VII.　　王 都 尉 刻 句 德 元 圖 書 記 印 書 畫。米 海 嶽 辨 出 元 字 腳。趙 集 賢 跋
定 武 蘭 亭。董 宗 伯 猶 議 其 不 識 唐 彥 猷。由 知 跋 尾 印 記。精 確 最 難。今 人

1) This pounding of the paste is shown on Plate 27.
2) See page 153, note 11.
3) See page 154, note 13.
4) See page 250.
5) See page 250.

6) As is stated in Mi Fu's *Shu-shih*, many valuable antique scrolls that in his time circulated among collectors had a seal reading *Kou-tê-yüan-t'u-shu-chi* 句 德 元 圖 書 記 impressed on them. Mi Fu says that this must be the seal of Kou Chung-chêng 句 中 正, a Sung

t'ing scroll, but Tung Ch'i-ch'ang said that Chao did not know T'ang Hsün's observations. [1]  From these examples it will be clear that colophons and seals are most difficult to judge with certainty.  Present-day people have but a feeble understanding of the art of seal engraving, and their attributions (in colophons) are more often false than true.  They always like to add glamourous names to the scrolls in their possession.  This is exactly like heaping dirt on the head of the Buddha, and merely causes real connoisseurs to fume with indignation. [2]

## VIII.

Although a rack for displaying hanging scrolls on, with the upper transverse stave curved like a silver ingot, is the antique type, this should certainly not be used.  (This upper stave) should on either end fit like a tenon in a mortise, and it should be perfectly straight.  This (upper part of the rack) may

The rack for displaying hanging scrolls; the scroll-hanger.

鐫 法 庸 劣。考 據 蹟 譌。每 好 附 名 烜 赫。正 如 佛 頭 著 穢。徒 貽 識 者 噴 筍 滿 案 也。

VIII. 銀 錠 畫 幆 制 雖 古。卻 不 入 品。須 合 兩 頭 枘 鑿。平 如 一 字。或 作 鎖 殼 形。更 須 外 凸 中 凹。四 棱 略 規 員。用 堅 老 香 楠 木 爲 之。挂 畫 之 法。將 擘 竹

scholar who enjoyed some fame as a historian (*Shu-shih*: 德 元 當 是 中 正。本 朝 人。通 史 學).  Near the end of his *Shu-shih*, Mi Fu relates the following story regarding Wang Hsin using an imitation of this seal: " Paintings can be traced, autographs can be copied but they can not be traced.  Only seals can never be faked; (even the best) imitations will always be different (from the original).  Wang Hsin engraved a copy of the seal of Kou Tê-yüan, and stamped impressions thereof all over the scrolls in his collection.  But I detected a small difference in the feet of the character *yüan*, then he confessed it was a fake " 畫 可 摹。書 可 臨 而 不 可 摹。惟 印 不 可 僞 作。作 者 必 異。王 詵 刻 勾 德 元 圖 書 記。亂 印 書 畫。余 辨 出 元 字 脚。遂 伏 其 僞. Mi Fu was very proud of this discovery of his; he mentions it again in a later passage (quoted on page 193).

1) The famous scholar-artist Chao Mêng-fu of the Yüan dynasty (here referred to by his official title of member of the Chi-hsien-yüan 集 賢 院, an Imperial Academy), was a great admirer of Wang Hsi-chih's calligraphy.  As was related on page 138 above, Wang Hsi-chih's most famous autograph is the *Lan-t'ing-hsü*.  The original autograph was preserved till the beginning of the T'ang dynasty, when the Emperor T'ai-tsung (627–649) obtained it from the Buddhist monk Pien-tsai (辯 才, ca. 600.  The Emperor greatly treasured this autograph; he had some eminent calligraphers make a traced copy of it, and this was incised in stone.  Then the Emperor distributed a limited number of rubbings, taken from this stone, to some high officials.  During the ensuing turbulent years both the original autograph and the stone the Emperor had engraved were destroyed.  Other stones, however, had in the mean time been cut after rubbings of the original stone, and the

best among these stones was one preserved at Ting-wu (the present Ting-hsien 定 縣, in the Pao-ting district, Hopeh Province).  This Ting-wu stone, however, got lost also, Chinese sources giving varying accounts of the vicissitudes it underwent.  Thereafter other stones were cut after rubbings of the Ting-wu stone, and rubbings thereof were often passed off as rubbings from the real Ting-wu tablet.  Chinese connoisseurs have made careful studies of all the rubbings that bear the name of Ting-wu, and the result of these form a special branch of the voluminous literature that in the course of the centuries has gathered round the *Lan-t'ing-hsü*.  For detailed discussions of the Ting-wu copy of this most celebrated of all Chinese autographs, the reader is referred to ch. 19 of the *Shan-hu-wang* (珊 瑚 網, 書 錄, compiled by Wang K'o-yü 汪 珂 玉, 1587-ca. 1650).  Now Chao Mêng-fu obtained a rubbing which he thought was taken from the original Ting-wu stone.  He was delighted with this acquisition, and took it with him on a boat voyage, during which he admired it every evening, and wrote not less than sixteen colophons to it, extolling its rare qualities.  The Ming scholar Tung Ch'i-ch'ang, however, seems to have pointed out that the Sung scholar T'ang Hsün (唐 詢, style Yen-yu 彥 猷 flourished 1025) expressed doubts about the authenticity of this rubbing.  Chou Êrh-hsüeh's argument seems to center round this authenticity problem, but I have not succeeded in locating in the vast Lan-t'ing literature the exact passage to which he refers.  See also p. 211, note 3.

2) The text has literally: " fill the table with spit-out bamboo shoots ".  I have been unable to trace this expression, which is not given in the *P'ei-wên-yün-fu*.  But it is clear from the context that it must mean some strong expression of disgust.

333

also have the shape of the outer case of a lock, provided that (on either end) it bulges on the outside, while it is concave within. The upper stave of the rack (revolving in these two sockets) should be square, but its four edges should be slightly rounded. It should be made of old and tough sandal wood. While displaying a painting on this rack, the upper stave of the scroll should be fastened to the roller on top of the rack; in the case of small scrolls it will suffice if you wind (its *t'ien*) a few times around the roller of the rack, in the case of large scrolls (the *t'ien*) should be wound round it several times. While doing so, however, you should never roll the upper part of the scroll further than the upper *ko–shui–ling*. Most objectionable is simply to drape the scroll over the rack, so that it hangs over the roller of the rack in a sharp crease, with the upper part of the scroll dangling at the back of the rack. [1]

To use a bronze fork of the Han dynasty as (top of) your scroll hanger is the most beautiful. For the stick (itself) you should select a piece of " square bamboo " [2] with straight corners and evenly distributed nodes. Having scraped off the green outside skin, this stick should be rubbed till it is smooth and lustrous, thus nursing it till its colour is like honey. For the hook on top you may also carve a piece of white jade succulent like a slice of fat into the shape of a shining new moon sickle. This type is also elegant and distinctive.

IX.

<div style="margin-left:2em">The table for viewing scrolls on.</div>

As to tables for unrolling your scrolls on, there are some of Sung or Yüan lacquer with crack-marks, [3] and inlaid along the edges with silver thread. They are shaped like a trapezoid and do not need legs since the table-top slopes down to the floor. On one side the table has a curled-up edge, so that when you are looking at a picture its roller may repose [4] in this curl. As regards other tables, those of red sandal wood or teak are the best; the next best is cabinet wood from the South. The length of such a table should be about six *ch'ih*, its breadth two *ch'ih*. You should preferably use tables with square tops, and avoid those which have irregular corners. There are also tables consisting of a top supported by two trestles; also this type is elegant. Such tables, however, should be covered with a piece of blue felt, or a coral-red or white woollen rug, so that the elegant old brocade of the mounting (of the scrolls unrolled on the table) will not become glossy.

For wall-tables one should look for specimens of pure red teak, these are the most elegant. The ancients used to polish them continually, so that in the end their top would obtain a smooth lustre, brilliant like a mirror. As regards the common type with heavy legs that is arbitrarily called " Table of Tung

貼攊。短 幅 一 二 轉。長 幅 多 轉。但 不 得 過 隔 水。最 忌 升 起。攊 上 作 一 曲 與
硬 折 拖 落 攊 後。

　漢 銅 縱 鉤 代 畫 叉 最 佳。柄 覓 方 竹。棱 直 而 節 勻 者。去 青 摩 弄 滑 膩。養
其 色 如 蜜。叉 取 白 玉 若 截 肪 者 琢 如 新 月 一 痕。制 亦 雅 別。

IX. 畫 案 有 宋 元 退 漆 斷 紋。週 邊 嵌 銀 絲。方 勝 不 用 四 足。卽 案 面 拖 尾
著 地。一 邊 飛 捲。便 看 畫 承 軸。制 最 奇 別。他 則 紫 檀 鐵 木 爲 上。香 楠 花 欄
次 之。長 可 六 尺。闊 可 二 尺。貴 方 棱。忌 委 角。有 作 兩 架 承 案 面 者。亦 雅 重。
然 必 復 以 靑 氈 祇。或 珊 瑚 色 及 瑩 白 毧 罽。與 精 麗 舊 錦 卷 軸。才 不 惹 潤。

---

1) This passage was discussed in detail in section A above.

2) *Fang–chu, Arundinaria quadrangularis.*

3) Good lacquer in course of time will develop cracks, *tuan–wên* 斷 文. Chinese connoisseurs distinguish various kinds of cracks, and they determine the age of the lacquer by these. See the discussion in my *The Lore of the Chinese Lute*, page 177.

4) I read 承 instead of 成, following the text as published in the Yü–yüan edition.

Boxes and cupboards
for scrolls, covers and
boxes for albums.

Ch'i–ch'ang ", [1] Tung himself always denounced this as a false accusation; this type should never be used.

## X.

For small paintings you should make a box of fragrant *nanmu*, [2] the measurements of which correspond to the size of the scrolls. One box should have four drawers, and each drawer should offer place for five scrolls. On top of the box there should be a transverse handle bar. It should have a transverse sliding door, with a square knob of red copper. This knob should have an opening to fit a pin, for easily locking the box. The lock should be a nice antique specimen, the most beautiful is an iron padlock of the Sung dynasty, inlaid with gold and silver. The next best is a lock of red copper. In the back of the box you should make four slits, through which you can put your fingers when you want to make the drawers come out; this will save you the labour of attaching a knob to each drawer. The stand [3] for such boxes is a square table, not higher than two *ch'ih*, large enough to hold two boxes together. Then you can easily take out the scrolls when you wish to look at them, and moreover you can easily carry the boxes along.

For larger scrolls you should make a cupboard; the best material is speckled *nanmu*, the next best fragrant *nanmu*. Its height should be determined in accordance with the size of the scrolls, its breadth should not exceed two *ch'ih*, and it should be about one *ch'ih* deep. One of the door panels should open, one should stay closed; [4] the pins of the hinges should be made of red copper, and have the ancient spool–shape. The stand of such a cupboard should not be higher than six *ts'un*. The inside should on no account be covered with paint or lacquer, or be lined with paper.

Hand scrolls and albums should be put in bags made of antique brocade, or be placed in boxes made of red or white sandal wood. The inside of such a box should be lined with fine white silk of the Hsüan–tê period, showing a small design of clouds and phoenix birds. If such a lining is padded with new cotton wool sprinkled with sandalwood powder, then this will not only make the scroll exhale fragrance when it is unrolled, but it will also keep away insects.

壁 桌 覓 純 紫 鐵 木 制 極 精。古 者 不 時 拭 抹。久 則 滑 澤。發 光 如 鑑。若 俗 制。
相 稱。脚。竊 名 董 桌。常 爲 文 敏 稱 寃。可 竟 廢 不 用。

X. 小 畫 作 匣。用 香 楠 木。長 短 闊 狹。隨 畫 定 制。一 匣 容 四 替。一 替 容 五 畫。
頂 置 提 梁。橫 開 一 門。嵌 入 門 上 釘 紫 銅 方 紐。紐 中 起 柄 入 鑿 便 鎖。鎖 貴
精 古。覓 宋 鐵 嵌 金 銀 者 最 佳。紫 銅 者 次 之。匣 後 鏤 四 穴。入 指 出 替。省 卻
替 橫。釘 紐 殿 制 如 方 几。高 不 過 二 尺。兩 匣 並 置。既 取 看 不 勞。即 攜 帶 亦
便。

大 畫 作 廚。用 豆 瓣 楠。次 則 香 楠 木。高 亦 隨 畫 定 制。闊 止 二 尺。深 可 尺
餘。一 門 開 展。一 門 藏 榫。上 落 鉸 釘 用 紫 銅。仿 古 梭 子 式。承 殿 止 高 六 寸。
惟 廚 內 忌 粉 漆 及 糊 紙。

卷 册 用 舊 錦 作 囊。或 紫 白 檀 作 匣。匣 內 襯 宣 德 小 雲 鸞 白 綾。以 檀 末
糝 新 棉 花 爲 胎。不 但 展 舒 發 香。且 能 辟 蠹。

1) The famous Ming scholar–artist Tung Ch'i–ch'ang (董 其 昌, 1555–1636), here referred to by his posthumous name Wên–min.

2) *Nanmu*, a kind of cedar wood from Kiangsi Province, much used by cabinet makers.

3) Chinese connoisseurs informed me that *tien* 殿 in the jargon of cabinet makers has the special meaning of a low case or table, acting as a stand for a box or cupboard. This meaning is not recorded in Chinese and foreign dictionaries.

4) The text has *tsang–shun* "hidden tenons"; perhaps this term too belongs to the jargon of carpenters, but I could obtain no information on its meaning.

# SECOND PART

CHAPTER I

# THE JUDGING OF ANTIQUE SCROLLS

THE PRECEDING CHAPTERS were meant to acquaint the reader with the means the Chinese connoisseur has at his disposal for judging antique pictures and autographs; the methods used by him were only mentioned in passing. Before now proceeding to a more systematic survey of the methods for judging scrolls we must first discuss how such works of art are created. For it is obvious that one cannot judge an antique scroll if one does not have at least a general idea of how the artist made it and what media he used.

First of all we shall here discuss the brush stroke, the basic element of Chinese pictorial art.

The art of the brush existed in China as early as the Chou dynasty (1049–256 B. C.). Archeological evidence such as characters written with a brush on bone and pottery [1] proves that calligraphy was practised already ca. 1000 B. C. and Chou literature occasionally refers to the painting of pictures. [2] As yet no actual pictures dating from before the 3d century B. C. have been discovered. But the highly conventionalized drawings of men, animals and trees on some Chou bronzes [3] are evidently derived from pictures done on a more tractable material such as silk or wood, and with a more convenient tool than the chisel or the engraving stylus. And the oldest picture that has been discovered to–date, viz. the painting of a woman and a mythical animal on silk, dating from the Period of the Warring States, recently found near Changsha, [4] presupposes a painting–tradition with a long history behind it.

It may be assumed that the brush used in this early period was not greatly different from our Western brush used in water–colour painting, viz. a tuft of hairs bound together at the base and attached to a shaft. Presumably rather thick and stiff animal hair was used; literary sources mention varnish and ground charcoal as the common writing material, and a soft brush could hardly be used for applying such a sticky fluid. The primitive brush was most suitable for drawing lines of uniform thickness, and for applying colours; it could not be used for setting down strokes showing much variation

*Historical development of the brush stroke.*

1) Cf. H. G. CREEL, *Studies in Early Chinese Culture*, First Series (Baltimore 1936), pp. 44–45.

2) Cf. the stories quoted in GILES, *An introduction to the history of Chinese Pictorial Art*; also the *T'ien-wên* 天問 of Ch'ü P'ing (屈 平, 343–290 B. C.).

3) Cf. i. a. the article *A "Hu" with pictorial decoration*, by Dr. Eleanor von Erdberg Consten, in "Archives of the Chinese Art Society of America", vol. VI (1952).

4) Cf. the article "Relics of the State Ch'u", by Wang Yu-chuan, in the periodical "People's China", 1954, no. 2. This is a brief description of the excavations carried out in 1951 by the Archeological Institute of the Academy of Sciences of the Chinese People's Republic, near Changsha in Hunan Province. Several objects are reproduced, including the picture on silk; it measures 31.5 by 23 cm.

in thickness.  As will be discussed in greater detail below, it was probably not until the 3d century B. C. that the pointed brush consisting of a " kernel " surrounded by a " mantle " of longer hairs came into general use.

The technique of Chou, Ch'in and to a certain extent also Han painting was probably confined to contour drawing, the line serving only its original function of delineating; its capability of plastic expression by nuances in the thickness of one and the same stroke remained unexplored.  This means that there can have been little " free painting ", as it appears in the rapid ink sketches that are so characteristic for later Chinese pictorial art.  Every picture was carefully planned beforehand and the main parts of the drawing sketched in with charcoal or some other medium that could easily be obliterated; it was only after the completion of this preliminary work that the artist would apply the ink and colours.

"Linear" and "calligraphic" technique.

During the Han period the development of calligraphy acquainted also the painter with the plastic possibilities of the brush stroke.  If one observes actual pictures dating from the 2nd and 3d century A. D. one can distinguish already two fundamentally different brush techniques.

The human figures depicted on the basket found in Lo–lang [1] represent the archaic contour drawing where the brush strokes are of uniform thickness.  On the other hand the pictures on hollow tiles now in the Boston Museum of Fine Arts [2] show clearly that the artists who painted these were fully conscious of the expressive force of the calligraphic nuances of the brush stroke.  There are strokes that suggest the plastic form of robe-folds by varying thickness and some are broad sweeps of the brush that end in fine points, as found in calligraphy.  The former brush technique might be designated as " linear ", the latter as " calligraphic ".

This basic distinction in the technique of Chinese painting obtains throughout the succeeding centuries and can serve even to–day for dividing all styles of Chinese painting into two broad categories.  The " linear " technique survives in its purest form in the style of painting known as *po–miao* 白 描 (Plate **115**), and the " calligraphic " technique finds its highest expression in the *hsieh–i* 寫 意 style of monochrome ink sketches (Plate **116**).  All other techniques lie in between these two extremes.

It took several centuries until the " calligraphic " technique of painting found wider application.  The invention of the " stiff brush " (see below) had given painters and calligraphers alike the means for exploiting to the full all nuances of the brush stroke. But calligraphy developed much quicker than painting.  In the 4th century Wang Hsi-chih and other great masters of calligraphy had already reached a sublime standard that was never surpassed, while painting was still in its formative stage.  It was only during the T'ang dynasty that the " calligraphic " painting technique made great progress.

1) Cf. " Select specimens of the remains found in the Tomb of the Painted Basket of Lo–Lang ", one vol. published 1936 in Kyōto for the Prefectural Museum of Heijō, Korea.

2) Some good detail-photographs will be found in Tomita's article listed in Appendix I, no. 7.

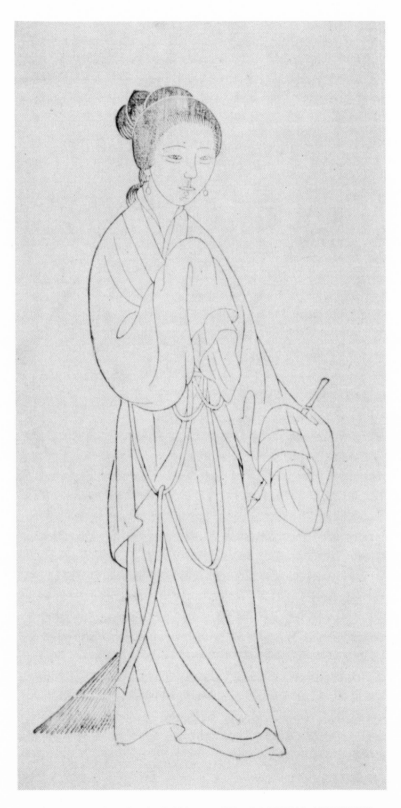

115. – PICTURE OF A WOMAN, DRAWN IN LINEAR TECHNIQUE

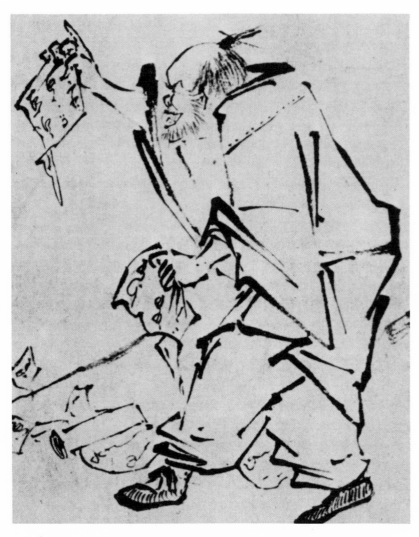

116. – THE PRIEST HUI–NENG, DRAWN IN CALLIGRAPHIC TECHNIQUE
(Private Collection, Japan)

The development of
the linear and calli-
graphic techniques.

The slow development of " free painting " must be ascribed in part to the dominant position held by Buddhist art from the 3d to the 7th century. Buddhist art is ruled by canons that prescribe how Buddhist subjects must be depicted, covering not only minor details such as the correct form of crowns, ear rings, bracelets etc. but also the exact proportions of the different parts of the body, the postures of the hands, and facial expressions.

These strict rules that form the foundation of the ancient Indian *çilpa-çāstra* were drawn up primarily because of religious considerations. It was believed that an image would lose its magic power if not reproduced exactly according to the prescribed model, and ritually incorrect representations were supposed to become inhabited by evil spirits. Thus deviations from the canon were not only impious but also actually dangerous. Even as late as the T'ang dynasty Buddhist murals by famous masters were executed on the basis of sketches carefully drawn with the aid of compass and ruler. There can hardly have been much " free painting " that would have allowed the artist to develop the nuance of the brush stroke. The *T'ang-ch'ao-ming-hua-lu* (cf. Appendix I, no. 34) mentions that a large crowd of onlookers gathered round Wu Tao-tzû when he drew the nimbus round the head of a deity on one of his murals without using a compass, which proves that at the time such free drawing was a rare exception. " Calligraphic " technique entered probably only into the drawing of Chinese figures that had become completely conventionalized, or Buddhist ones that had become completely sinified; I mention the well known Kuan-yin by Wu Tao-tzû that has been preserved in rubbings.

It would seem that with regard to secular subjects painters enjoyed more freedom. Unfortunately, superior non-religious T'ang pictures on silk or paper are so rare that all theory about the secular painting technique of that period must be largely confined to conjecture. It may be assumed, however, that also when drawing subjects less bound by convention, the artist would first sketch the main features of his picture with a piece of charcoal or lead.[1]

It may be assumed that the free, calligraphic style of ink-painting came into being towards the end of the T'ang period, after the landscape had risen from its secondary function of background and come into its own as an independent subject of pictorial representation. Flowers, birds, trees and rocks followed in its wake.

This establishment of free, calligraphic ink-painting sealed for ever the bond between painting and writing. Henceforward the calligraphic line constitutes the basis of the picture's brushwork, and the rules for balancing the component parts of one character, and for spacing a number of characters written together, determine the picture's composition.

At the same time the coming into being of this branch assured painting a place of its own in officially recognized Chinese culture, it was raised from a professional skill to an art practised by accomplished scholar-artists.

---

1) Lead was used in China at an early date as a means for drawing and writing; cf. the reference to *ch'ien-pi* 鉛 筆 " lead pencil " in the *Tung-kuan-han-chi* 東 觀 漢 記, compiled by Liu Chên (劉 珍 ca. 150 A. D.) and others.

The "calligraphic" technique of painting reached marvellous hights during the Sung and Yüan periods when it received inspiration from the ideals of the Ch'an sect, while the predilection for this technique evinced by scholar–artists of high repute further promoted its popularity in literary circles. Now monochrome paintings of bamboo, orchids, plum blossoms and stones became a class by themselves and the doing of such pictures became one of the favourite pastimes of cultured amateurs and persons of elegant taste.

Such monochrome pictures of bamboo and other traditional subjects were as a rule done directly on the paper or silk without previous sketches. This special branch of painting merged completely with calligraphy, its technique was mastered in exactly the same way as one learned to write characters. One need not wonder, therefore, that later painters' manuals teach the painting for instance of bamboo by means of characters: the nodes in the stems should be indicated by two strokes resembling the character *pa* 八, etc. A painter of bamboo or orchids would not dream of first sketching his picture on the canvas, just as no calligrapher would ever think of drawing an outline of the characters before actually writing them.

On the other hand historical scenes and larger landscape paintings were doubtless first set up in rough outlines, in chalk or charcoal. This was absolutely necessary in the case of *chieh–hua* 界畫 " ruled painting ", detailed architectural drawings featuring bridges, palaces and terraces which could not be done without the aid of ruler and compass. While doing such pictures there was as a matter of course little scope for " calligraphic " painting; except for trees, plants, rocks and such details the drawing was done in the contour technique. Straight lines were drawn with a ruler, *chieh–ch'ih* 界尺. This was done — as to–day — by means of a thin brush with the shaft of another one tied alongside in such a way that the end of this shaft reached till about halfway the tip of the brush. The end of the shaft was drawn along the ruler so that the tip of the brush tied to it produced the line. In the case of less complicated pictures the artist would first make a number of tentative sketches on separate sheets of silk or paper, the so–called *hua–kao* 畫稿. These were done in a free style, and hence succeeded sometimes even better than the detailed picture that was subsequently drawn after such models. A Yüan writer observes:

" The preliminary sketches of the people of old were called *fên–pên*; former people often treasured these. For their nonchalant and spontaneous character gave them a natural beauty ". [1]

Towards the end of the Ming dynasty the " type forms " and " conventional motifs " (see below) had become so firmly established that not only monochrome paintings of bamboo, orchids and similar subjects, but also various types of landscapes, human figures, birds, fishes and flowers could be done directly on the silk or paper without any preliminary sketches. Thus came into being the " literary school " of painting that during the Ch'ing period became so popular that it relegated all others to a secondary place.

---

1) *T'u–hui–pao–chien* (Appendix I, no. 40): 古人畫稿。謂之粉本。前輩多寶畜之。蓋其草草不經意處。有自然之妙。

A calligrapher, or a painter in the literary style needs but few accessories. The paper or silk is spread out on the desk and kept flat by one or more paper weights. Then the artist moistens his brush and in an incredibly brief time has written his text or painted his picture. Also for painting in more elaborate styles few preparations are necessary. Some extra brushes are added, and next to the ink stone the painter has by his side a number of small dishes containing the colours and a larger bowl with water for mixing the colours and washing the brushes.

It was this very simplicity of the creative process that permitted masters of the brush to bring on the canvas great compositions in a few moments. It should be remembered that whereas in Western painting the work as a rule " grows under the brush ", in China the artist does not start until he has a complete vision of the planned picture before his mind's eye. Thus he is able to record in a few seemingly casual strokes the inspiration that in a sudden flash gives final shape to conceptions that had been maturing in his mind for months or even years. It was in this way that works were created that now are counted among the world's master pieces.

Therefore both painters and calligraphers deem the moment that the brush touches the paper for the first time — called *lo-pi* 落 筆 — of supreme importance. It is the first link between the mental picture and its transfer to the visible world; upon the success of this first stroke depends that of the entire work. Only a person who has practised Chinese calligraphy or painting himself can fully realize the importance of *lo-pi*. When the brush is poised for the first stroke one feels that there is nothing in the whole world as hostile and forbidding as the sheet of white paper spread out on the desk. As soon, however, as the first stroke has been set down, everything changes as by magic: one feels that contact has been established, the movement of the brush comes as easily as " splitting a piece of bamboo ", and painting and writing immediately become an intense joy. It is therefore that persons who are mediocre performers or who are out of practice will start with setting down the less important strokes of a painting, or write the last characters of a text first; but this expedient is frowned upon by real artists of the brush. If the first few brush strokes of a picture or a specimen of calligraphy do not turn out to the artist's complete satisfaction he will lay down his brush and either start anew on another piece of paper, or wait till a more propitious time.

Plate **117** shows Kuan Tao-shêng 管 道 昇, the wife of the Yüan artist Chao Mêng-fu, painting a monochrome sketch of bamboo while her husband is looking on. Dress and interior are translated into the style of the Ming dynasty, but the manner of painting and the artist's accessories are the same as those of the Yüan period.

On the right of the paper one sees an ink stone of irregular shape, a flat porcelain dish with five compartments that represents a plum blossom, and a small round water container with a diminutive silver spoon. Each of these implements has its specific use. In an ink sketch of bamboo some leaves are as a rule set down in black ink, others in a greyish tinge. For painting the former the brush is moistened with the black ink on the ink stone, for the latter the fluid in the tip of the brush is adjusted by dipping it in

343

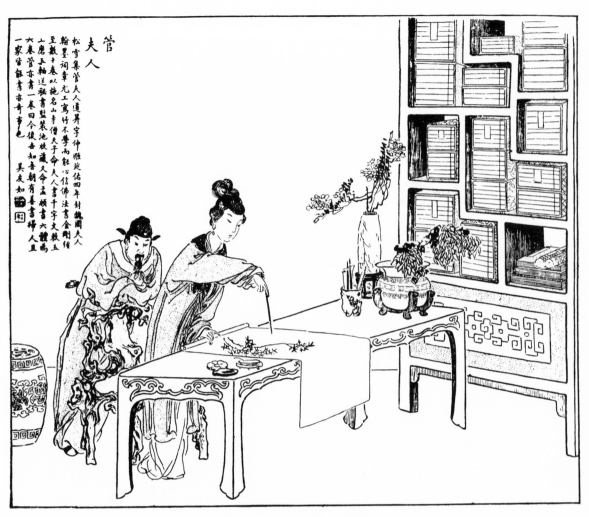

117. – LADY PAINTING BAMBOO
(From the *Wu-ju-yu-hua-pao*, cf. Appendix I, no. 42)

the water of the flat porcelain dish.   This dish is filled with water from the round container, being ladled out with the small spoon, and the ink stone is moistened in the same way prior to rubbing the ink.

On the left one sees a brush container with rolled up scrolls and a few brushes.   In the background is a high book case; the books, lying flat on the shelves, are marked with title labels stuck among the leaves.   On the right, below, one sees three albums and two rolled up hand scrolls.

On Plate **118** one sees a lady of the Ch'ing period writing characters.   The paper is kept flat by a heavy ruler placed along the bottom, the top of the paper is lifted up by a servant girl so that the artist can survey the entire text while writing it.   She holds the long sleeve of her right hand up with her left.

Another servant girl is rubbing more ink on a small side table.   A lady–visitor is looking at a rubbing of an autograph, mounted as an album.   Note further on the left

344

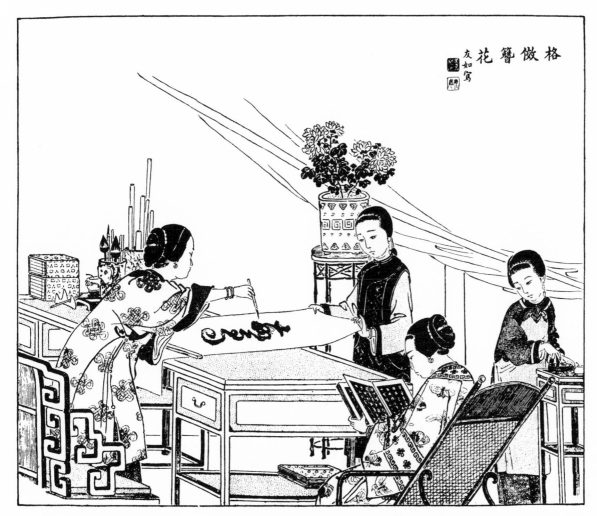

118. – LADY WRITING CHARACTERS
(Same source as Plate 117)

of the writer a tile–shaped ink stone, a brush stand shaped like a three–peaked mountain, and a porcelain water reservoir with spoon on a carved wooden stand. Further two books in brocade covers, a brush holder with two large and a few smaller brushes, and a tubular container with rolls of blank paper.

Plate **117** gives an idea how a painter will handle the brush when doing pictures in a free style. As is well known, both in painting and writing the brush is always held perpendicular or nearly perpendicular; if held in a slanting position it will be impossible the produce the correct strokes. Plate **119** shows the normal way of holding the brush, as depicted in a Chinese manual of calligraphy.

Both in painting and writing the movement of the brush originates in the unsup-ported arm rather than in the fingers or the wrist. Only when painting in the *kung–pi* technique or when writing very small characters the wrist rests on the paper or is sup-ported by the lefth and. Plate **120** shows a posture used when writing very small

345

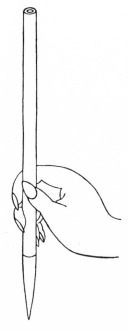

characters; the right hand is supported by the left, and the brush held a little farther from the tip. In these cases one may also employ a special arm rest; these usually consist of a tile-shaped piece of bamboo, ivory or jade, often decorated with delicately carved inscriptions and ornamental motifs.

When painting in free style or writing large characters the manner of holding the brush changes. From its normal position of about one inch from the tip the hand moves upwards along the shaft. Plate **121** shows the posture used when writing or painting on a folding fan; here the brush is held near the middle of the shaft. Plate **117** shows an extreme position, near the top of the shaft. The other extreme occurs when writing characters of about one foot square with a very large brush. Then the shaft is grasped directly above the tip (see Plate **122**), the fingertips digging into its very hairs. This direct contact of fingers and ink is said to allow the *ch'i* 氣 of the writer to flow into the characters.

After these introductory remarks we shall now briefly describe the three factors that enter into the brush stroke, namely brush, ink and ink stone. For the intricacies of the stroke can be analyzed only on the basis of these concrete data.

Chinese literary sources mention an amazing variety of brushes used for the purpose of writing and painting. Some have tips made of rabbit hair, others of the hair of a wolf, goat, fox, marter or other animal, also of human hair or the whiskers of a rat. Some have shafts of lacquered wood, rare kinds of spotted bamboo, carved jade or ivory and even silver or gold, others are made of plain reed or bamboo; some are as thick as a man's wrist, others as thin as a knitting needle.

However, regardless of the material and size of tip and shaft, all brushes of old and modern times can be divided into two classes according to the structure of their tip. In later colloquial these two classes are designated as *shui-pi* 水筆 " water brush " and *kan-pi* 乾筆 " dry brush ".

119. – THE NORMAL WAY OF HOLDING THE BRUSH

The brush.

平覆枕腕法

霹雲閣珍藏

120. – WRITING SMALL CHARACTERS

346

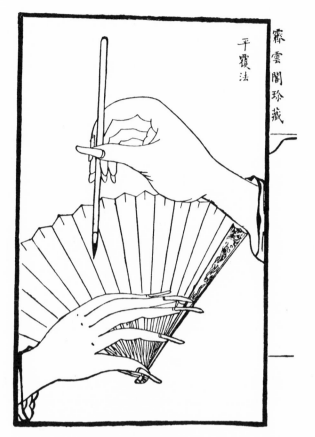

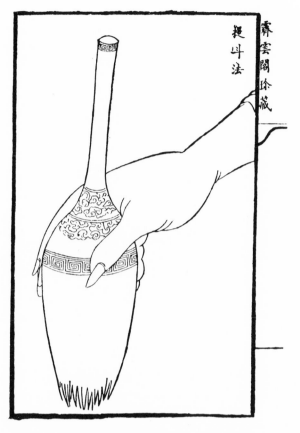

121. – WRITING ON A FOLDING FAN        122. – THE WAY OF HOLDING A LARGE BRUSH

Both types are constructed according to the same principle. They have a " kernel " in the centre, with one or more " mantles " of hair arranged around it. The kernel is called in Chinese *chu* 柱 " pillar " or *hsin* 心 " heart ", the mantles are called *pei* 被 " covering " or *fu* 副 " accessory ". This construction lends the tip its fine point and its capacity of retaining a large quantity of ink. The fine point makes possible the infinite variety of the brush stroke, the ink–reservoir inside the tip permits the artist to draw a number of strokes without remoistening the brush; as will be discussed below the principle of our fountain–pen was known in China already many centuries ago.

The difference between *shui–pi* and *kan–pi* is that the kernel of the latter is stiffened with wax or glue. When the *shui–pi* is dipped in the ink it is moistened through and through while in the case of the *kan–pi* the moisture penetrates only the mantles and the top of the kernel. Before tracing the effect of this structural difference on the brush stroke we must first consider more closely the way a brush is manufactured.

The technical terms denoting the component parts of the brush tip occur already in the *Pi–ching* 筆 經 of the 4th century A. D., and they are constantly used in the voluminous literature that subsequently grew up around the brush. As far as I know, however, none of these sources are illustrated so that their remarks on the manufacture of

The structure of the brush tip; *shui–pi* and *kan–pi*.

How the *shui–pi* is made.

347

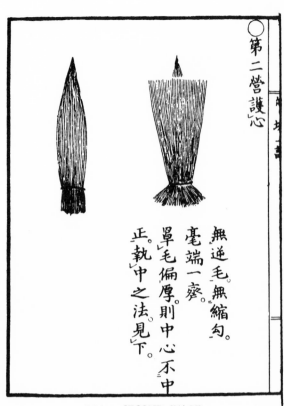

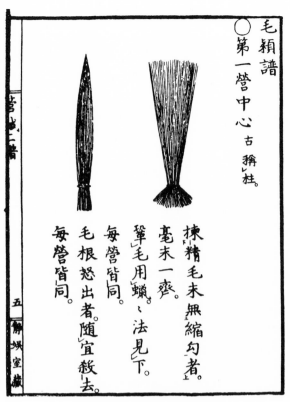

毛頴譜

○第一營中心 古稱柱。

揀精毛末無縮勾者。
毫末一齊。
筆毛用蠟、法見下。
每營皆同。
毛根怒出者隨宜敕去。
每營皆同。

○第二營護心

無逆毛無縮勾。
毫端一齊。
罩毛偏厚則中心不中
正執中之法見下。

123. – MAKING A BRUSH TIP: FIRST STAGE
(From the *Kanjō-nifu*, cf. Appendix I, no. 76)

124. – SECOND STAGE

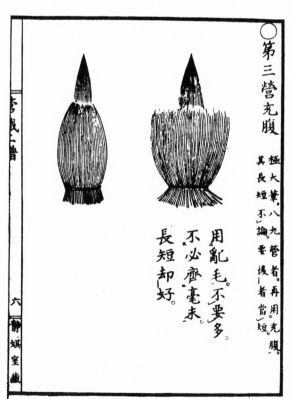

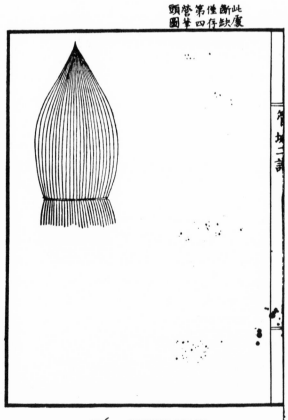

○第三營充腹

極大筆八九營者。再用充腹。
其長短不論要後者當短。
用亂毛不要多。
不必齊毫末。
長短却好。

此處缺廬
斷筆僅存
第四營
頭營圖

125. – THIRD STAGE

126. – FOURTH STAGE

348

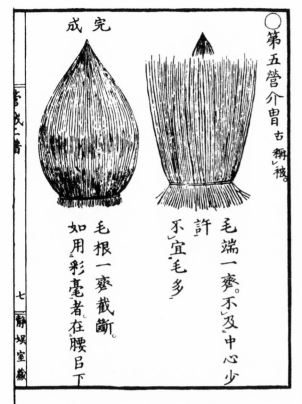

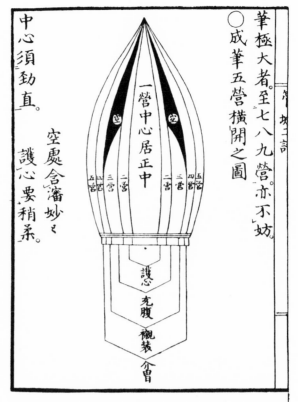

127. – FIFTH STAGE  |  128. – CROSS–SECTION OF A COMPLETED BRUSH TIP

brushes are often cryptic. [1] Fortunately a Japanese Sinologue and calligrapher of the 18th century has left an illustrated account of the Chinese brush describing its manufacture in detail (cf. Appendix I, no. 76). I have checked his statements in the workshops of brush–makers in Peking and Shanghai and found them substantially correct; minor differences may be explained by local usage. Below the process is described on the basis of these Japanese illustrations.

The successive stages of making a brush tip are designated by the term *ying* 營. Plate **123** shows the first *ying*. The kernel is made by tying a thin tuft of hairs together at the base in such a way that the natural tips of the hairs are all even; then the irregular ends of the hairs at the butt end are cut off directly below the thread.

The second stage depicted on Plate **124** consists of surrounding the kernel with a mantle of slightly shorter hairs which are flattened out towards the point of the kernel; this is called *hu–hsin* 護心 " protecting the kernel ".

In the third stage (Plate **125**) another mantle of much shorter hairs is added; this is called *ch'ung–fu* 充腹 " filling the belly ".

The fourth stage consists of adding a mantle of hairs that are longer than those of the kernel (Plate **126**; as noted in the upper margin, the explanatory text belonging to

[1] I have been unable to consult the *Pi-chih* 筆志 by the modern scholar Hu P'u-an 胡樸安, included in the *P'u-hsüeh-chai-ts'ung-k'an* 樸學齋叢刊.

349

this *ying* has become lost). The top of this mantle is flattened towards the tip of the kernel so that inside the brush tip there is created a hollow space.

Finally there are added one or more mantles of hairs that are shorter than those of the preceding mantle; this last mantle is called *chieh-chou* 介胄 "the armour" (Plate **127**).

Plate **128** shows a cross-section through the completed tip. Here the ink reservoir inside the tip is black and marked with the character *kung* 空 "hollow". Everytime the brush is moistened by being applied to the ink stone the point will spread out and, while absorbing the ink, at the same time allows the fluid to enter the hollow space. When the brush is lifted up the hairs at the tip close again but a quantity of ink is retained in the "reservoir" inside. When the brush is implanted on the paper the point spreads again and the ink from the "reservoir" keeps it moist. Thus the Chinese brush functions more or less on the same principle as our Western fountain pen. The modern Chinese brushes which I examined have a smaller "reservoir" than the older ones, the capacity for retaining the ink of small brushes is approximately the same as that of the curved space of Western steel nibs.

In the case of a *kan-pi* only the first stage is different. When the tuft of hair that composes the kernel has been fastened at the base by winding round it a thin silk thread, fine wax powder or powdered resin is strewn among the hairs. Then the tuft is stiffened by pressing it between the finger tips. Formerly it was further stiffened by wrapping a strip of hemp paper round its base but this practice was abandoned since the paper would rot after the brush had been used for some months on end.

Besides this structural difference the tip of a *kan-pi* is usually considerably longer than that of a *shui-pi*. Since the main difference of *shui-pi* and *kan-pi* lies in that of the resilience of their tips we shall henceforward call them respectively "soft brush" and "stiff brush".

In the beginning of our era rabbit hair seems to have been the most common material for making brush tips. This is indicated i. a. by Kao Yu's gloss on the well-known line in Huai-nan-tzû 淮南子 "When Ts'ang Chieh had invented writing the devils wept in the night".

Kao Yu states that *kuei* 鬼 "devil" might be a scribe's error for *tu* 兔 "rabbit". [1] Although this is a doubtful emendation, the fact that it was proposed at all clearly proves that in Kao Yu's time (Eastern Han) rabbit hair was widely used for making the tips of writing brushes.

[1] 淮南本經訓。蒼頡作筆鬼夜哭。高誘註以爲鬼或作兔。兔恐見取毫作筆。害及其軀。故夜哭。 Thus Kao Yu explains his gloss "The rabbits fear that their hairs would be used for making writing brushes and that thus harm would come to them; therefore they wept in the night". This is a far-fetched explanation. The reading "devil" is doubtless correct; the devils wept because the invention of writing would acquaint people with spells and magic formulas which destroy devils and ward off their evil influence.

The following passage from the *Pi-ching* shows that in the 4th century a mixture of rabbit and goat hair was used for this purpose. It says:

" Of the rabbit hair of all parts of the country only that of Chao (in Hopei Province) is fit for use. Chao consists of a broad and fertile plain, there is no wild vegetation but only thin grass. Therefore the rabbits are fat and their hairs long and pointed. The hair should be gathered in autumn. When making the tip of a brush one should always first take a few score human hairs and mix these with the hairs of a grey goat. Fine rabbit hair should be cut to equal length and a strip of hemp paper should be wrapped around the lower part of this kernel. Thereafter a thin mantle of longer hairs should be arranged round the kernel so as to cover it completely. Finally one should add the thin hairs the tips of which constitute the fine point of the brush; the tip should measure nine–tenth of an inch ". [1]

This passage proves that the " stiff brush " was commonly used in the 4th century A· D., and that its structure did not differ materially from that of later brushes of this type·

In the Shōsō–in in Kyōto there are preserved " stiff brushes " of a different type that date from the 8th century. They measure about 20 cm. in length and have fairly thick shafts but the tip consists of only a thin tuft of hair. Several layers of paper are wound round the tip and run up in a spiral till about three quarters of its length, leaving only a small tuft of hair sticking out at the top; thus these large brushes could be used only for writing small characters (cf. Harada, op. cit., Plate XXXVIII). I do not know whether such brushes consisting of a kernel only were an original Japanese idea, or whether they were also used in China.

Below we shall explain how and when " soft " and " stiff " brush originated. These problems can be best discussed on the basis of an analysis of the differences between the strokes produced by these two types of brush.

When a " soft " brush is moistened the ink will soak the entire tip, penetrating mantles and kernel and making it soft and pliable. Implanted on the silk or paper the tip will bend and stay that way also after the brush has been lifted up again. After use, when the brush has been washed clean in water and dried the tip will have lost its pointed shape; its hairs stand out sparsely just as those of a dry Western painter's brush. Before using it again the tip should be restored to its pointed shape by pressing it between the moistened finger tips.

*The strokes produced by " soft " and " stiff " brushes.*

---

1) 諸國是採羊柱不分。原冤竟。丼以毫毛根見。郡廣肥。先次冤取然後見。冤澤。毫無長用芚上安。毫。無雜用裁薄毛杪之。惟雜而髮令薄裁毫。超草銳齊薄杪合毛。國木。須數布合長。毫。唯仲以柱令鋒。中有秋蓰上。令長。用。細收雜紙長。超草之。青裏柱九。

This is the text as it is usually quoted. The Pi-ching has been transmitted in bad condition; judging by quo-tations in later sources parts of commentaries were inserted into the text. The present passage as quoted e. g. in the *Wên-fang-szŭ-pu* 文房四譜 of Su I-chien (蘇易簡, 958–996) contains several evident interpolations, while the text as given in the fragments included in the *Shuo-fu* 說郛 has a slightly different wording. Since, however, the essential points are the same in all versions, this textual problem need not concern us here.

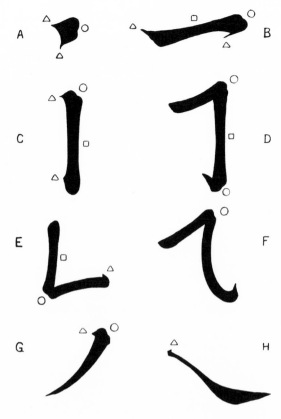

129. – EIGHT STROKES PRODUCED BY A STIFF BRUSH

When a " stiff " brush is moistened, on the other hand, the ink will penetrate the mantles but not the lower part of the kernel. Therefore the tip will retain its resilience even when thoroughly soaked. When applied to the silk or paper the tip will bend but resume its original shape immediately one relaxes the pressure. When such a brush has been washed and dried it will automatically resume its original pointed shape.

Soft and stiff brushes produce strokes of a fundamentally different character. This may be demonstrated by an analysis of eight essential types of strokes. [1]

Plate **129** gives eight types of strokes produced with a stiff brush. The chief characteristic of these strokes is the slight dent that appears for instance in the right edge of the dot (A). This dented part, which we shall call " knuckle ", is marked on the Plate with a circle. The " knuckle " is produced by the resilience of the fine point of the stiff brush: when implanted on the paper the tip forks out, the hairs of the mantle split away for a moment from the tip of the kernel; as soon as the pressure is relaxed the fork closes again leaving the traces of its two ends.

Since at the beginning and end of a stroke, and also when making a hook one has the tendency to increase the pressure exercised on the brush it is in these places that " knuckles " will make their appearance. On Plate **129** all these spots are marked by small circles.

The second characteristic is that all straight strokes show a tendency to narrow down slightly towards the middle. This feature too is caused by the fact that one naturally diminishes the pressure there. Then the resilient tip closes slightly and the line becomes thinner. These spots, which we shall call " waists ", are marked by squares.

The third characteristic is an extra point or flourish at the beginning and end of strokes, often so small as to be hardly noticeable. This feature, which we shall call " beard ", is the trace left by the fine point of the tip when it is applied to the paper or leaves it. These " beards " are involuntary, they have nothing to do with the hooks that appear for instance at the lower ends of strokes D and F; these hooks are

---

1) Since many centuries Chinese children start their writing lessons with the character *yung* 永 that can be broken up into the eight fundamental strokes of calligraphy. Since here we discuss painting and writing together I evolved another set of eight strokes, which have nothing to do with the character *yung*.

compulsory, they form an integral part of the character the stroke occurs in. On the Plate the " beards " are marked with a small triangle.

If one compares these basic strokes of the " stiff " brush with the corresponding ones as produced with a " soft " brush reproduceed on Plate **130** the difference will be evident at a glance.

All strokes reproduced on Plate **130** have instead of " knuckles " rounded tips and corners. Instead of narrowing down towards the middle they show, on the contrary, a tendency to thicken there. " Beards " are completely absent. These differences are caused by the fact that the " soft " brush lacks the resilience of the " stiff " one. While using the latter only one third of the tip comes into contact with the paper, but the " soft " brush is used for nearly three-quarters of its length. If one applies a " soft "

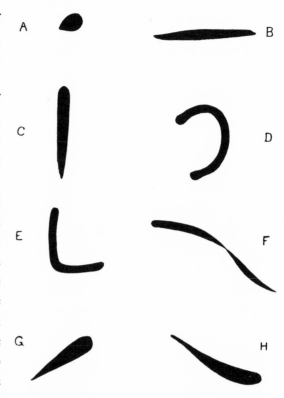

130. – EIGHT STROKES PRODUCED BY A SOFT BRUSH

brush lightly to the paper one can produce a clean–cut dot (A) and if one increases the pressure holding the brush at a slant one will obtain the typical stroke used for painting leaves of bamboo (G).

Further, it is fairly easy to draw a stroke of uniform thickness. It is difficult to do this with a " stiff " brush the springy point of which will registrate on the paper the slightest variation in the pressure exercised. Strokes done with a " soft " brush rarely show waists; they have, as said above, a tendency to thicken towards the middle, as shown in B, while the limp point encourages jagged ends.

Finally, a twisted stroke will produce a clear–cut turning point without " beards " or other accessory traces of the hairs (**F**); this type of stroke is used especially in the painting of orchid leaves.

It remains to add that for the sake of clarity the characteristic features of the strokes reproduced on Plates **129** and **130** are greatly exaggerated, more so than consistent with the dictates of good calligraphy. It should also be noted that it is not impossible to produce with a soft brush the strokes depicted on Plate **129**, and vice–versa. The point is that the strokes of Plate **129** come naturally to the " stiff " brush, while those of Plate **130** can be reproduced with a " soft " brush without any special effort.

Painters and calligraphers make use of both stiff and soft brushes. Painters employ for pictures in classical style and *kung–pi* technique a thin soft brush for delineating, and

" Stiff " and " soft " brushes used in painting.

a thicker one for heavy dots and for applying the colours.   Stiff brushes are used for the leaves of trees and plants, the folds in the robes of human figures, and other parts of the picture where a " calligraphic " delineation is indicated.

The use of the brush is here illustrated by four examples, purposely chosen from different periods so as to demonstrate that the brush technique has practically remained the same during the last thousand years.

Plate **131** reproduces a section of a Sung painting on silk, of the Old Palace Collection.   It will be noticed that the folds of the robes are done with a stiff brush according to the calligraphic technique, the faces of the persons represented with a thin soft brush producing lines of uniform thickness.   The lines of the table and the balustrade are drawn with a soft brush with the help of a ruler.

Plate **132** is a picture of chickens under a banana tree painted in my presence by Yang Ta–chün 楊大鈞, one of the most outstanding pupils of Ch'i Po-shih 齊白石 in Peking.   It was done on paper in ink and light green, and measures 132 by 33 cm. without the *shih–t'ang* which was added later when the picture had been mounted.   First the banana leaves were put on the paper in a series of rapid strokes with a large, soft brush dipped in pale green colour.   Then Mr. Yang did the bodies of the chicken, using a medium–size soft brush; this same brush was used for adding the ribs of the leaves. Last of all he added the beaks and legs of the chicken.

Plate **133** gives a detail of this picture.   It will be noticed that the head and body of the chicken consist of a number of dots produced by pressing the brush at a slant on the paper.   The thickness of the ink was purposely so adjusted that it would run along the contour of the dots in order to suggest the fluffy appearance of the chicken's down. The eye and the spots in the tail were added with the tip of the same soft brush, dipped in darker ink.   Here one sees clearly that the beak and legs were painted with a stiff brush.

Mr. Yang painted this picture in 1945 after a dinner party in the Netherlands Embassy in Chungking, having spread out the paper casually on a corner of the cleared table and in the space of 12 minutes — not counting the time used for rubbing the ink and preparing the green colour.   The motif is conventional and the technique borrowed from Ch'i Po–shih, but Mr. Yang's individual talent appears in the faultless spacing of the banana leaves and the broad, seemingly careless brushwork.   The artist was satisfied with the result but stated that the spacing would have been still better if he had placed the lone chicken on left slightly lower and a little more to the right.   As it is I consider this a fine specimen of " free painting " that demonstrates the artist's complete mastery over the brush stroke.   I had the picture mounted with a " frame " of pale yellow silk, a *shih–t'ang* of heavy white paper, *t'ien* and *ti* of plain white paper, and knobs of cowhorn.   Later the well known calligrapher Shên Yin–mo 沈尹默 wrote for me a poem in the *shih–t'ang*.

In monochrome painting in free style soft brushes are used for those parts of the drawing that are done in light ink, while the black lines are usually done with a stiff brush. For larger dots and " splashes " in dark ink a soft brush is preferred.   Plate **116** reproduces a section of the well known picture of the Buddhist Patriarch Hui–nêng 慧能

354

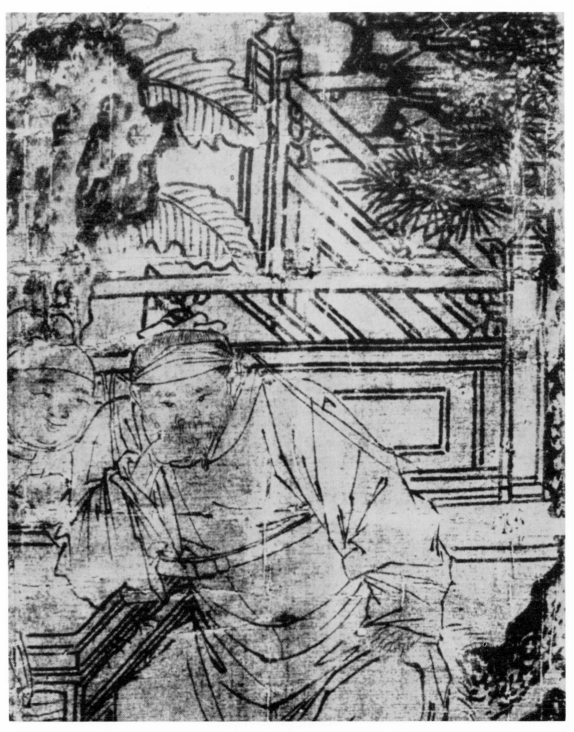

131. – SECTION OF A SUNG PAINTING ON SILK
(Old Palace Collection)
(Original size)

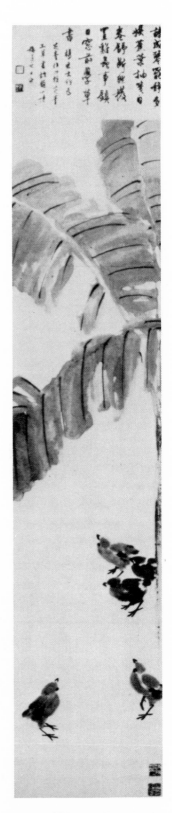

132. – PAINTING ON PAPER,
BY THE MODERN ARTIST YANG
TA–CHÜN
(Author's Collection)

by the Sung artist Liang K'ai 梁 楷, in a private collection in Japan.   Except for the hairs of the priest's head this part of the painting is done entirely with a stiff brush according to the calligraphic technique.   Plate **134** is a section of the equally famous picture of the recluses Han-shan 寒 山 and Shih-tê 拾 得 by the same Sung painter.   Here we find the calligraphic technique executed entirely with a soft brush and shallow ink.

Monochrome paintings of bamboo are as a rule done exclusively with a soft brush. After a few heavy strokes one will have to refashion the tip of the brush with one's tongue and lips.   Hence expressions such as *tsun-pi* 吮 筆 "to lick the brush", *ch'ih-mo* 喫 墨 "to feed on ink" etc. have come to stand for the arts of painting and writing in general.

When painting a blossoming branch of a plum tree the branch itself is done with a larger soft brush slightly moistened with shallow ink; the thin twigs and the blossoms are painted in with a stiff brush dipped in darker ink.

When selecting his brushes the artist takes into account also the length and shape of the tip, and the hair it is composed of.   Wolf-hair is more resilient than goat-hair and hence used for very thin, "soft" brushes intended for drawing the lines in *kung-pi* painting, while larger brushes of wolf-hair are widely used in painting monochrome pictures in calligraphic technique, and for writing larger characters in "regular" script. The calligraphy of the Sung Emperor Hui-tsung was probably done with a "stiff" brush of wolf-hair that had a particularly long, fine point.

Medium brushes of goat-hair are used for applying colours; larger ones with long tips for painting the leaves of bamboo and orchids.   Both medium and small ones with short tips are employed by calligraphers for writing smaller "draft" script.

Small "regular" script is usually written with a stiff brush of rabbit-hair.   Tips of rabbit-hair are mostly stained red in order to distinguish them from those of goat-hair; hence they are referred to in the trade as *tz'ŭ-hao* 紫 毫 "purple tips".[1]   Some brushes have tips which are composed of different kinds of hair; such are called *chien-hao* 兼 毫.   A common combination is a kernel of rabbit hair surrounded by a mantle of goat hair; these tips have a peculiar resilience and hence are preferred by many calligraphers.   The proportion of the mixture is usually indicated on the shaft, for example *ch'i-tz'ŭ-san-yang-hao* 七 紫 三 羊 毫 "tip composed of seven parts of rabbit, and three parts of goat hair".

Further, some artists prefer stiff brushes for working on silk and coarse-grained paper, and soft ones for smooth surfaces; others again are wont to do it the other way round.   Some prefer new brushes, others prefer ones that have worn down by long use.

There is one point that deserves special discussion.   This is the technique of piling ink upon ink in different shades, much used in monochrome "free" painting, and sometimes referred to as *t'an-chung-chia-nêng* 淡 中 加 濃 " adding thick on shallow

The t'an-chung-chia-nêng technique.

1) For the origin of this term cf. *Acker* (Appendix I, no. 33), page 157.

ink". Superior monochrome pictures often derive their beauty from this feature, while it is on this point that the insufficiency of the work by mediocre amateurs is most convincingly demonstrated.

Its remarkable effect appears most clearly in rain clouds, groups of trees, and clusters of large leaves of trees and plants painted in confusion. First the parts in shallow ink are set down and, when they have not yet dried completely, the heavy ink strokes are added. The successful execution of this technique asks for a complete mastery of all the subtle nuances that both brush and ink can produce.

Parts of a picture done in this manner are uncommonly difficult to copy; even the most skilful forger who can imitate every modulation of the calligraphic line will betray himself when trying to reproduce the *t'an–chung–chia–nêng*. Hence if one has doubts regarding a picture where this technique has been used one will do well to concentrate his attention first of all on those parts.

One could fill page after page with discussions of the various brush strokes employed by Chinese painters. However, the above examples, chosen at random, may suffice to give an impression of how the painter handles his brush and how his work may be analyzed.

<div style="float:left; width:120px; font-size:small;">Soft and stiff brushes used in calligraphy.</div>

In China are used four main styles of calligraphy. These are called *chuan–shu* 篆書 "seal script", *li–shu* 隸書 "chancery script", *ts'ao–shu* 草書 "draft script" and *kai–shu* 楷書 "regular script". Of each of these four there exist numerous varieties, mostly called by the title of a famous autograph written in that style, or by the name of the calligrapher who developed that particular variety. For our present purpose, however, the general division into four main styles suffices.

Pictures of the Chou, Ch'in and Han periods are of extreme rarity, but specimens of the writing of those early periods — mostly engraved in stone — have been preserved in abundance. With regard to calligraphy we are therefore in a better position to analyze the development of the brush stroke and, at the same time, to survey briefly the history of the brush itself.

Of the four styles of writing mentioned above the seal script is the oldest. It was used in daily life throughout the Chou dynasty and remained the common style of writing till well into the Han period. Then it was gradually replaced by the chancery script, a style that originated in government offices towards the end of the Chou period and was perfected by Li Szû (李斯, died 208 B. C.), the notorious minister of the Ch'in dynasty (255–206 B. C.). [1] But the seal script has remained in restricted use throughout the succeeding centuries for ornamental and calligraphic purposes, and especially for the legends of seals; it is still used at present for the last–mentioned purpose, hence its Western name.

---

1) This subject is discussed in detail in D. BODDE, *China's First Unifier* (Sinica Leidensia, voll. III, Leiden 1938), ch. VIII: "The unification of writing".

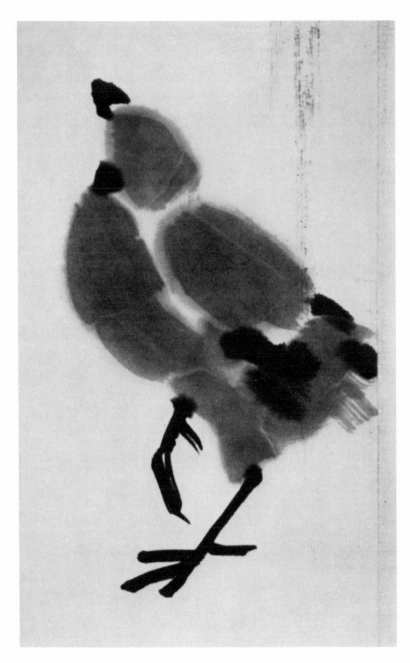

133. – SECTION OF THE PAINTING REPRODUCED ON PLATE 132

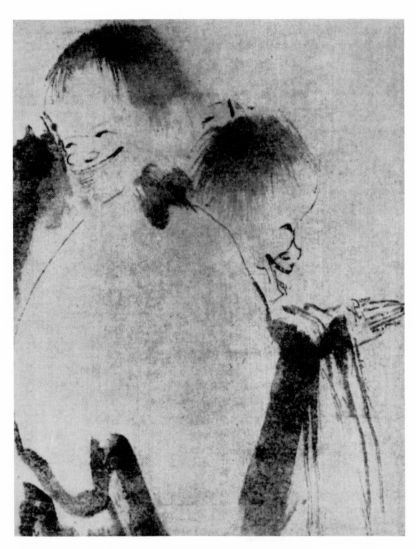

134. — SECTION OF A SUNG PAINTING
(Private Collection, Japan)

Plate **135** A shows the character *tao* 道 written in seal script. The reader will notice at a glance its three characteristic features, namely that all strokes are of equal and uniform thickness and end in blunt tips; that the corners are rounded; and that the height of the character exceeds its width. After the discussion of the strokes produced by the " soft " brush given above one will readily understand why calligraphers prefer this kind of brush for writing seal script: its tip is best suited for reproducing strokes of uniform thickness, and round corners. But the brush must be handled in a manner quite different from that used in writing the later styles. For instance, the element □ is written in chancery and regular script in three strokes: │ , ┐ and lastly the bottom stroke ＿. In seal script, however, this element is written with two strokes, first └ and then ┘; one will notice in the character *tao* reproduced here the spot where the two halves are linked together, in the lower part of the element ⺼. Further, it requires special training to achieve the blunt tips of the strokes. Thus the " soft " brush is by no means the ideal instrument for writing seal script, although it is better suited for this purpose than the " stiff " brush.

135. – A) THE CHARACTER *TAO* IN SEAL SCRIPT; B) THE SAME, IN CHANCERY SCRIPT

As a matter of fact during the Chou and Ch'in dynasties when the seal script was used in daily life it was either engraved with a stylus or written with a brush that consisted of a tuft of hairs of equal length without kernel and mantle; or, in other words, a kind of brush that closely resembled our Western one used for aquarelle painting. And indeed if the reader makes the experiment he will find that it is much easier to write seal script with a Western brush than with a Chinese one.

As to the chancery script, later Chinese calligraphers write it with a " soft " brush if they aim at an effect of *ku–cho* 古拙 " antique rusticity ", and with a " stiff " one if they wish to achieve an elegant effect by adding to the strokes " knuckles ", " waists " and " beards ". Chancery script is still used to–day for calligraphic purposes.

As shown by Plate **135** B, the character *tao* written in chancery script with a " soft " brush, this writing is characterized by modulated strokes of varying thickness, ending

357

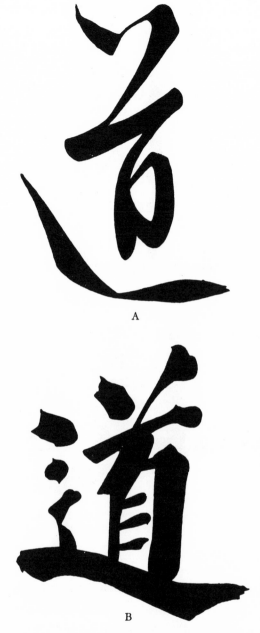

A

B

136. – A) THE CHARACTER *TAO* IN DRAFT
SCRIPT; B) THE SAME, IN REGULAR SCRIPT

sometimes in pointed or jagged ends; by square
corners and by the tendency to stress the width
of the character at the expense of its height.

The strokes of the chancery script come na-
turally to the "soft" brush. This is only to be
expected since when this script was still used in
daily life it was written with a brush that did not
differ greatly from the later "soft" one. Although
it is not impossible to write *li–shu* with a Western
brush, it is much easier to do so with a slightly
worn, Chinese "soft" brush.

*Ts'ao–shu*, the draft script, developed in go-
vernment offices probably at the same time as the
chancery script, that is to say near the end of the
Chou dynasty. [1]    It is a highly cursive style of
writing where even the most complicated charac-
ters are reduced to a few dots and scrawls. From
an artistic point of view the draft script can be
compared to the "free" style of painting; it is
considered as the highest expression of calligraphy
and of pictorial art in general. Masters in this
style of writing are called *ts'ao–shêng* 草聖 "holy
men of the draft script", an appellation that was
never applied to experts in the other styles of
writing although they also are greatly admired.

The draft form of the character *tao* repro-
duced in Plate **136** A, was written with a "soft"
brush. Note the complete absence of "knuckles";
the round curves, and the twisted stroke at the
bottom representing the radical 辵. The latter
reminds one of the twisted stroke used in the
painting of orchid leaves; it would be difficult
to produce this stroke with a stiff brush. Chinese
calligraphers when writing medium and larger
draft characters prefer the "soft" brush; the "stiff" brush is used for writing small
draft script.    Provided one uses smooth foreign paper as a ground, *ts'ao–shu* can be
written also with a Western brush; those interested may experiment with for instance

<hr>

[1] It is often wrongly stated that the draft style
originated later, as a cursive form of the chancery, or even
of the regular script.    That its earliest form was derived
directly from the seal script is proved by the draft forms of
for instance the characters *yu* 友 and *lu* 鹿.

358

Wang Hsi-chih's famous writing-model *Shih-ch'i-t'ieh* 十 七 帖;[1] they will find that this text can be traced with a thin Western brush of badger-hair.

The draft script has remained in regular use from the beginning of our era till the end of the Ming period. Thereafter this style of writing — which requires long and assiduous practice — became more and more reserved for calligraphic purposes. In daily life people in general used another, less abbreviated cursive style called *hsing-shu* 行 書 " running hand ", a way of writing that will develop more or less spontaneously if one writes *kai-shu* quickly. [2]

*Kai-shu*, the regular script, began to compete with the chancery script as the common form of writing during the later years of the Han period. It reached perfection during the T'ang dynasty and has till to-day remained the standard style of writing and printing most widely used in China. Although *kai-shu* can be written and printed in various forms, the basic characteristics of the strokes are substantially the same. As will be seen from the character *tao* written in *kai-shu* reproduced on Plate **136** B, the thickness of the strokes varies greatly, they have a tendency to develop " knuckles ", " waists " and " beards ", and width and height of a character are approximately the same.

It is the " stiff " brush that reproduces best all special features of the regular script. One will find it wellnigh impossible to write standard *kai-shu* with a Western brush.

Thus the calligraphic data reviewed above supply an outline of the development of the Chinese writing brush — the same implement as used also by painters.

The strokes of the seal script prove that the archaic brush resembled that used by Western aquarelle painters. The fact that this archaic brush lacked kernel and mantle did not interfere with the artist's work since the seal script was written in strokes of uniform thickness, while painting was done in unmodulated linear technique. Painters who wanted to draw very thin lines had to give the tip of their brush the required shape by licking it. Chuang-tzû's line " to lick the brush and mix the ink " *shih-pi-ho-mo* 舐 筆 和 墨 (op. cit., chapter T'ien-tzû-fang 田 子 方) aptly sums up the preparations a painter had to make before he could start working: he had to give the tip of his brush a pointed shape by licking it, and he had to mix water and powdered charcoal in order to prepare his ink.

Chinese sources state that in the third century B. C. the Ch'in general Mêng T'ien 蒙 恬 improved the brush. If one remembers that it was in about that same time that

<div style="text-align: right">The history of the brush.</div>

---

1) This is a collection of 25 letters and fragments of letters in Wang Hsi-chih's handwriting, preserved in rubbings based on a traced copy of the T'ang period. The first letter begins with 十 七 日 " The 17th day ", and the collection is named after this phrase.

2) While *hsing-shu* has been used since olden times by all classes in China, since the beginning of the Ch'ing dynasty draft script is used and understood only by accomplished scholars and professional calligraphers. In Japan, on the other hand, draft script has always been widely used in the daily life of all classes; even to-day one will often find on the sign boards of vegetable dealers and fishmongers draft characters that in China are known only to experts in calligraphy. The Japanese have a special talent for this style of writing, possibly also because of their familiarity with the *hiragana*, the Japanese syllabary which is entirely composed of draft-forms of Chinese characters.

the chancery script came into common use, it may be assumed that this improvement consisted of dividing the tip of the brush into two distinct parts, viz. the kernel and the mantle, thus creating an instrument suitable for producing the modulated strokes of the chancery script.

The "stiff" brush must have been invented towards the end of the Han dynasty when the regular script came into use. When in the 4th century A. D. the *Pi-ching* was written the existence of brushes with a stiffened kernel was taken for granted.

During the next thousand years the brush remained practically the same. Till the end of the Ming dynasty brushes had elaborate shafts of spotted bamboo or carved lacquer decorated with intricate ornamental designs, and with the name of the maker or the owner engraved on them. These brushes were used for years on end, only the tip being discarded when it had become worn down. At one extremity the shaft had a shallow cavity where the tip was attached by means of glue or rosin; thus it was easy to replace a worn-down tip by a new one, in the same way as we will put a new nib in a penholder. This custom is indicated i. a. by the often-quoted anecdote related in the *Shu-tuan* 書斷, a work on calligraphy by the T'ang writer Chang Huai-kuan 張懷瓘. There he says the following about the celebrated 6th century calligrapher, the Buddhist priest Chih-yung:

"After the priest Chih-yung had practised calligraphy for a number of years he had ten jars filled with worn-out brush tips; each jar had a capacity of several piculs. Later he buried these brush tips and called (that spot) 'The tomb of worn-down brush tips'. He himself composed a memorial inscription for it". [1]

The last modification of the brush occurred in the beginning of the Ch'ing period. Then brushes with elaborate shafts and detachable tips became rare, they were used only for special occasions being very popular as complimentary gifts. In daily life people used more simple brushes with cheap bamboo shafts; when the tip had become worn down the entire brush was thrown away. The name of the manufacturer was not any longer carved into the shaft but replaced by a printed paper label stuck to it, only the name of the type of brush being engraved on the bamboo. The ancient brushes had elaborate caps for protecting their tips, made of carved wood or ivory, but during the Ch'ing dynasty simple ones made of bamboo or copper were used.

*Worn brushes.*

"Soft" brushes can be used longer than "stiff" ones, they are considered worn down only when the tips of the hairs have become quite uneven. A stiff brush will wear down much quicker; as soon as the kernel loses its cohesion the tip will develop a jagged point and it will lack most of the original resilience.

Many painters and calligraphers are known to have had a predilection for worn-down brushes, which in Chinese are called *pai-pi* 敗筆, *t'ui-pi* 退筆 or *t'u-pi* 禿筆.

---

[1] 僧智永積年學書。有禿筆頭十甕。每甕皆數石。後取筆頭瘞之。號為退筆塚。自製銘誌。

360

A worn–down brush is especially suitable for producing bold, irregular strokes with shallow ink; such strokes occur for instance in the trunks of old trees, the robes of monks, various types of stones, etc. Calligraphers like to use these brushes for writing seal script which is usually done in shallow ink and with a brush that is only slightly moistened. Thus one can produce strokes showing streaks of white which give one's writing an appearance of " antique rusticity ". This style is technically called *fei–po* 飛白 " flying white ". It may be added that some writers aver that the ancients when writing in the *fei–po* style did not use an ordinary writing brush but a kind of wooden stylus. The Sung author Huang Po–szû 黃伯思, however, has refuted this theory in his book *Fa–t'ieh–k'an–wu* 法帖刊誤, section *Lun–fei–po–fa* 論飛白法.

The preference for worn brushes in writing seal script probably harks back to five or six centuries before our era. A worn–down modern brush comes nearer to the archaic one, without kernel and ink–reservoir, while moreover the ancient ink composed of powdered charcoal and varnish or water could not produce the solid black strokes of later calligraphy.

Also draft and chancery script are often written in the *fei–po* technique with a worn–down brush, and the same brush is used for a special style of *kai–shu* where the jagged ends of the strokes and a profusion of " beards " lend the calligraphy an air of insouciance and freedom of worldly cares. The great Sung artist Su Tung–p'o often wrote *kai–shu* in this manner.

Famous brush makers.

The *Pi–shih* 筆史, a collection of notes on the writing brush by the Ch'ing scholar and calligrapher Liang T'ung–shu (梁同書, 1723–1815) quotes numerous names of well known brush makers. It appears that in former times the Chu–ko 諸葛 family of Hsüan–chou 宣州 in Anhui Province was famous for the brushes they made; members of this family are first mentioned in T'ang sources but their tradition continued till well into the Sung dynasty. Liang T'ung–shu also lists brush makers of the Ming and Ch'ing periods but beyond a few anecdotes little seems to be known about their careers.

It is thanks to a Japanese scholar that detailed pictures of Ch'ing brushes have been preserved. This was the Japanese Sinologue and calligrapher Ichikawa Bei–an (市河米菴, 1777–1854). In 1834 he published a treatise on the Chinese brush entitled *Zōhitsu–fu* (藏筆譜; cf. Appendix I, no. 77) where about 200 Chinese brushes are reproduced in colour prints; all of these date from the early half and the middle of the Ch'ing period. This book is a valuable contribution to the study of the Chinese brush. Whereas specimens of the more elaborate Ming brushes will occasionally be found in museums and curio shops, simple brushes of the Ch'ing dynasty are difficult to obtain because the owners used to throw them away when they had become worn down.

An examination of the labels stuck to the shafts of the brushes reproduced in the *Zōhitsu–fu* shows that ca. 1700 there were two famous brush makers in Peking who also worked for the Palace, viz. Wang Wên–i 王文燡 whose trade–name was T'an–ning–t'ang 澹寧堂, and Chiang Jui–yüan 蔣瑞元 who used the trade name

361

Fêng-i-chi 鳳儀記. Other great brush manufacturers in Peking were Ch'ên Ta-hsing 陳大興, Lu Shên-ch'üan 陸申權, Sun Chih-fa 孫枝發 and Liu Pi-t'ung 劉必通; the latter two are also mentioned in Liang T'ung-shu's *Pi-shih*. It were the products of these houses that were used by the famous Ch'ing painters in Peking. Further we find in the *Zōhitsu-fu* the names of two well known brush manufacturers in Soochow, viz. Ch'ên T'ien-hsün 陳天順 and Chou Hu-ch'ên 周虎臣, and one in Fukien called Kuo Jui-yüan 郭瑞元.

Plate **137** reproduces four brushes depicted in the *Zōhitsu-fu*. On the right is a brush made by Ch'ên Ta-hsing marked *Tung-fa-ts'ao-shu* " For draft script in the style of Tung Ch'i-ch'ang "; Bei-an adds a note to the effect that this brush is very resilient which proves that Tung Ch'i-ch'ang's style was far from weak. The next brush was by Chiang K'ai-wên ca. 1750 and also intended for writing draft script. The third is a large brush which according to Bei-an's note used to belong to the well known Japanese calligrapher and seal carver Hosoi Kōtaku (see Appendix I, no. 76); it was used for writing characters of one foot square. The fourth is a very large brush — technically called *t'ou-pi* 斗筆 — which measures 1 *ts'un* 8 *fen* in diameter; Bei-an notes that it is especially suited for writing large *kai-shu*.

The *Zōhitsu-fu* gives accurate pictures of the brushes used by painters and calligraphers of the Ch'ing dynasty who worked in the two artistic centres Peking and Soochow; it would be worth while to make a closer study of the quality, shape and measurements of the tips of those brushes.

Ink and ink stone.

Next to the brush, also ink and inkstone play a role in the creation of the brush stroke. Therefore these two accessories of the artist's studio are briefly reviewed here.

The black ink used by both painters and calligraphers is made in solid sticks or cakes. Everytime it is needed the fluid ink is prepared by rubbing the ink cake on a slab which is first moistened with clean water.

The prepared ink will spoil overnight [1] but the solid cakes will keep for centuries. The slab, formerly made of bronze and later of stone, will last practically forever. There have been preserved ink cakes dating from the T'ang dynasty, and ink slabs from the Han period are by no means rare. Thus we have next to the references in literature, also concrete data for studying the subjet.

The history of ink and ink slab.

Han inkslabs were mostly made of bronze, they had the shape of a shallow pan supported by three or more legs. Mi Fu states in his *Yen-shih* 硯史 [2] that sometimes

---

[1] Freshly rubbed ink has an agreeable fragrance that will linger on even after the scroll has been mounted. Spoiled ink, on the contrary, has a most offensive smell that will stay with the scroll even longer. Contact with copper prevents the prepared ink from spoiling; hence the boxes with pads for fluid ink are always lined with copper, and also brush stands meant for sticking wet brushes in are made of the same material. The Chinese will drop a few copper coins in a jar or bottle of fluid ink to prevent it from spoiling.

[2] I have published an annotated translation of this text, under the title " Mi Fu on Inkstones ", one illustrated vol., publ. Peking 1938. The references given here are marked by the page number of my English translation. The passage about the slab of baked clay is found on page 54.

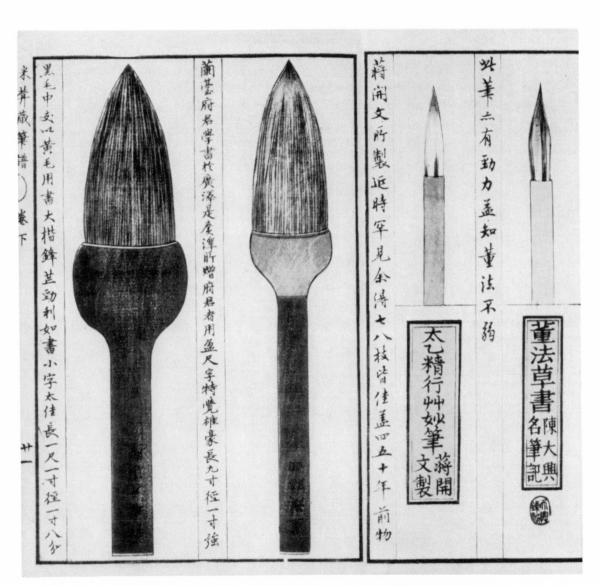

黑毛中支以黃毛用書大楷鋒芒勁利如書小字太佳長一尺一寸径一寸八分

米芾藏筆譜（）卷下

廿一

蘭臺府君學書於廣澤是庚渾盱贈府君者用盈尺字特覺雄豪長九寸径一寸強

蔣閎文所製延特軍見余得七八枝皆佳盖四五十年前物

太乙精行艸妙筆蔣文製開

此筆六有勁力盖知董法不弱

董法草書名筆記陳大興

137. – FOUR BRUSHES REPRODUCED IN THE *ZŌHITSU-FU*

a flat piece of baked clay was placed inside to accelarate the rubbing process. One may conclude from this remark that in the Han dynasty the ink was usually mixed instead of rubbed; the bronze pans were suitable for the ancient process of mixing ground charcoal with water or thin varnish, as was done during the Chou period. Apparently these bronze slabs were retained for some time even after the solid balls had come into use. But it was soon found that the rubbing of these balls was facilitated by placing an extra bottom of baked clay inside the bronze container, and this discovery doubtless caused the gradual replacement of the bronze inkslabs by ones made of earthenware or stone.

At first these earthenware inkslabs were copies of the earlier bronze models. In a French collection there is a remarkably graceful concave slab of baked clay dating from the Han period that has the form of a tortoise; this slab is reproduced on Plate **77** of D'Ardenne de Tizac, *L'art chinois classique*, Paris 1926. Later it was found that a flat slab on which small quantities of ink could be rubbed allowed better adjustment of the ink than a concave one, and thus the panshaped inkslab fell into disuse.

The flat inkslab does not seem to have come into general use till approximately the 6th century A. D.; this was at least the tradition current during the Sung dynasty. Mi Fu observes in his *Yen–shih* (page 50) that concave inkslabs were still employed in the Chin period (317–420). This tallies with the following statement by the Sung connoisseur Chao Hsi–ku who says:

" When rising in the morning the ancients used to start with rubbing ink till the cavity in the ink slab was completely filled and there was ink sufficient for the whole day. If in the evening all the ink had not been used, the remainder was thrown away and the next morning they rubbed ink anew. Therefore it is clear that the cavity of their inkslabs was large and deep. No matter whether they wrote regular, draft, seal or chancery style, all their writing was done with this thick ink. Thus even in autographs in running and draft style every stroke, albeit as thin as a silk thread or a hair, is put on the paper in heavy ink ". [1]

Apparently Chao Hsi–ku did not realize that the ancient inkslabs were concave, he knew only the flat slab with the depression as used in his own day; hence he thought that ancient slabs differed from the later ones only in that their water container was unusually deep. But Mi Fu had studied the inkslabs depicted on Chin paintings and interpreted the tradition correctly by pointing out that the ancient slabs were shaped like a flat pan or a mortar.

The Yüan writer T'ao Tsung–i states that balls of solid ink, *mo–wan* 墨丸 were not used until the fourth century A. D. However, Mi Fu's remarks quoted above point to a much earlier date. [2]

---

1) *Tung-t'ien-ch'ing-lu-chi* (Appendix I, no. 27): 古
人晨起。必濃磨墨汁滿硯池。以供
一日之用。用不盡則棄去。來早再
作。故研池必大而深。其眞草篆隸。

皆用濃墨。至行草過筆處雖如絲
髮。其墨亦濃

2) T'ao Tsung-i's remarks on the history of ink are found in ch. 19 of his *Cho-kêng-lu* (cf. Appendix I, no. 24).

T'ao Tsung–i further observes that the early ink was made from soot produced by burning pinewood and that this ink was coarse. In the T'ang period ink of a better quality was produced, the cakes having the shape of cylindrical sticks. A few T'ang specimens of this type of ink cake are preserved in the Shōsō–in in Nara; cf. Harada, op. cit., Plate XXXIX. It would seem that at that time flat inkslabs with a depression for accumulating the rubbed ink had definitely replaced the old concave type.

It was found that the properties of a flat inkslab made of a suitable kind of stone would not only facilitate the rubbing of ink but also contribute to its quality. According to Chinese connoisseurs every time the ink is rubbed a small quantity of the stone powder ground off by the inkcake will mix with the fluid and enhance the colour and durability of the ink. However this may be, ever since the flat stone–slab came into use, the inkstone has been counted among the most important paraphernalia of the artist's studio. Together with brush, ink and paper it forms the quartet known as *Wên–fang–szŭ–pao* 文房四寶 " The Four Treasures of the Library ", round which there has grown up an extensive special literature. [1]

During the T'ang dynasty we hear for the first time the names of famous manufacturers of ink cakes. The founders of this handicraft seem to have been Hsi Ch'ao 奚超 and his son Hsi T'ing–kuei 奚廷珪. They came originally from I–shui 易水 in Hopei Province but later settled down in Shê–hsien 歙縣 in the southern tip of Anhui. This locality has till the present day remained the centre of ink cake manufacture in China. [2]

It so happened that Shê–hsien also a finding–place of a kind of stone the grain of which made it particularly suited for making ink slabs. The site is said to have been discovered during the K'ai–yüan period [3] (713–731); slabs made of this kind of stone have remained popular throughout the succeeding centuries. The second locality famous as finding–place for ink stone material are the quarries at Tuan–chou 端州, Kao–yao–hsien 高要縣 in Kwangtung Province. These quarries were explored in the 10th century; in 991 A. D. inkslabs made there were sent as tribute to the Imperial Court. [4]

In the Sung dynasty the inkslab became a beautiful work of art. Its sides were carved with elaborate designs, the celebrated " Gathering of the Orchid Pavilion " [5] being a motif commonly found on larger Sung ink slabs still preserved in museums and private collections. The owner of a good inkslab would give it an individual name and engrave poems and essays on its sides and bottom, and later connoisseurs would add thereto remarks of their own, in exactly the same way as they did in the case of antique scrolls. If no blank space was left on the surface of the slab itself, the wooden box it

1) Some of the more important sources are quoted in my book " Mi Fu on Inkstones ".

2) More data on the manufacture of ink cakes will be found in the Japanese book by Togari described in Appendix I, no. 78. Cf. also Appendix I, nos. 18 and 19.

3) Cf. " Mi Fu on inkstones ", my note on page 39.

4) Ibid., page 35; cf., however, *Tung–t'ien–ch'ing–lu chi* (Appendix I, no. 27) which states that in the Southern T'ang period the oldest quarry there had become exhausted.

5) Cf. page 138.

138. — TWO INK CAKES OF THE MING PERIOD
(Togari Collection)

was kept in was engraved with inscriptions, all duly signed and dated. Good inkslabs that bear the names of great scholars and artists are valuable antiques which fetch high prices in China and Japan.

Also the ink cake grew to be a finished work of art. First a paste was made by mixing together soot obtained by burning pine wood or *tung* oil together with glue and special kinds of incense. This paste was pressed into wooden moulds previously carved with inscriptions and ornamental designs. When the cake had dried it was as hard as a shell; hence these later ink cakes are called *lo-mo* 螺墨 " shell ink "[1] to distinguish them from the ancient *mo-wan* 墨丸 which were of softer substance. The hardened ink cakes were hand-painted. Well known artists designed the ornamental motifs and wrote the models of the inscriptions to be reproduced in miniature on the cakes. Most manufacturers signed and dated their cakes.

The art of ink cake manufacture reached its zenith during the Ming dynasty. Some famous manufacturers published illustrated catalogues of the cakes made by them; these books are fine specimens of Ming wood prints and give a good idea of the meticulous care bestowed on the ornamentation of the cakes. I mention the *Ch'êng-shih-mo-yüan* 程氏墨苑 which describes the work of Ch'êng Chün-fang 程君房, and the *Fang-shih-mo-pu* 方氏墨譜 by the equally famous ink cake maker Fang Yü-lu 方于魯; both these books were printed during the Wan-li era. Products of these two and of other well known manufacturers of the Ming period are available in the antique trade and much in demand by both painters and calligraphers, some being worth their weight in gold. Plate **138** shows on top a photograph of a round ink cake made by Ch'êng Chün-fang and decorated with the popular motif *Po-tzǔ-t'u* 百子圖 " The Hundred Children "; below a ground-down ink cake made by Fang Yü-lu where the upper half of his seal is still visible. Both cakes are now in a Japanese collection.

The manufacture of ink cakes continued to flourish during the Ch'ing dynasty. Famous was Wang Chin-shêng 汪近聖 who lived in the K'ang-hsi era. His descendants compiled ca. 1750 an illustrated catalogue of the ink cakes made by him and his two sons Wang Wei-kao 汪惟高 and Wang Erh-ts'ang 汪爾臧; in 1928 this catalogue was published in a beautiful facsimile reprint under the title of *Chien-ku-chai-mo-sou* 鑑古齋墨藪, where many of the ink cakes are reproduced in full colours.

Equally famous were the Ch'ing manufacturers Ts'ao Su-kung 曹素功 and Hu K'ai-wên 胡開文. Most ink cakes made in China to-day are copies of the work of these two masters. [2]

Since during the first six centuries of our era the ink was rather coarse and the ink slab concave, it was difficult to produce brush strokes that had clear-cut, sharp angles that characterize the regular script in its later, perfected form. After the brush had been

The influence of ink and ink stone on the brush stroke.

1) Cf. *Cho-kêng-lu*, ch. 19.
2) Some specimens of Ts'ao Su-kung's work are reproduced in Togari's book (cf. Appendix I, no. 78), pp. 103-104.

dipped in the ink accumulated in the bottom of the pan–shaped slab, its tip could not so easily be given a firm, pointed shape as can be done by passing it over the surface of the later smooth, flat slab, moistened with a small quantity of finely ground ink. This explains the comparatively few modulations of the brush strokes in the chancery and regular script of that period. Coarse ink and concave slab did not, however, affect the smooth curves of the draft script; according to Mi Fu the great 4th century calligrapher Wang Hsi–chih used an ink slab that had the form of a mortar. [1]

It is only to be expected, therefore, that during the first six centuries A. D. " calligraphic painting " developed very slowly; the peculiar properties of the media used, together with the limitations imposed by the Buddhist artistic canon mentioned above, retarded full application of the calligraphic stroke to pictorial representation.

With the subsequent development of free painting in calligraphic style more attention was paid to the artistic possibilities of combining in the brush work strokes in light and heavy ink. The ability of correctly adjusting the tinge of the ink has remained an essential element of the painter's technique ever since.

The inkslab is used exclusively for producing jet–black ink, its tinge is adjusted by dipping the inked brush into water poured out in a separate container. These water basins are usually flat dishes of white porcelain, divided into two or more compartments. Since the Chinese painter does not use a palette, he judges the tinge of the ink by that of the water after the inked brush has been dipped into it.

Pictures in *kung–pi* style are as a rule drawn in shallow ink, or with ink that naturally has a greyish tinge; ink cakes that produce this variety are called *ch'ing–mo* 青墨. When painting monochrome ink sketches in a free style the artist generally uses black ink for the thin calligraphic lines, and shallow ink for the broader calligraphic, and the thin unmodulated lines. The beauty of pictures done in this style often lies as much in the different shades of ink used as in the expressive force of the calligraphic stroke.

Calligraphers use ink in various shades of black. Depending upon the ingredients used for making the ink cake the tinge of the ink produced by it ranges from a dull, jet black to a shining black with a faint golden or purple lustre.

We know of many Ming and Ch'ing painters and calligraphers what kind of ink they preferred. Not a few of them even used to make their ink cakes themselves, and specimens of these can be studied in museums and curio shops. An examination of the properties of these ink cakes will not only serve to deepen our understanding of the artist's brush work but also supply clues to its authenticity.

For instance, the versatile Ch'ing artist Chin Nêng (金農, better known by his literary name Tung–hsin 冬心, 1687–1764) used oil as a base of the lampblack for making ink cakes, which explains the lacquerlike quality of his autographs. Ink cakes made by him bear the inscription *Wu–po–chin–yu* 五百斤油 " Five hundred catties

1) Cf. " Mi Fu on Inkstones ", page 51.

of oil ", and may still be obtained in antique shops.   Thus one can experiment with this ink and compare the results with actual specimens of Chin Nêng's work. [1]

Calligraphers attach great importance to the degree their brush is wetted with ink. As a rule seal and chancery script are written with a rather dry brush, but while writing draft and regular script the brush is mostly well soaked with ink.   Characters written in *fei-po* style are as a matter of course always done with a dry brush.

Pigments.

The colours of a polychrome picture provide, with a few exceptions, few new data for the study of the brush stroke.   Colours are either set down with the same kind of brush and according to the same technique as ink, or they are just used for filling out space delineated in ink.

Among the exceptions I mention, for instance, the brushwork of some *mu-ku* paintings where the fact that colour is used makes possible special plastic effects that could not be realized in black and white.

However, although the colours of antique paintings are unimportant for an analysis of the brush stroke, they may provide useful clues to the date and authenticity of scrolls. Hence a few observations on this subject may be inserted here.

Thanks to the researches of Petrucci, March and Uemura [2] we know more about the pigments used by Chinese painters than about most other media.   These scholars have described and analyzed the various pigments and established the terminology of the different shades of the colours.   It appears that during the last ten centuries or so Chinese and Japanese painters have been using fundamentally the same pigments.   However, some special shades of one particular colour were more popular at one time than at another, and thus the palette of an antique picture may provide data that can be utilized for deciding problems of authenticity.

However, the historical aspects of the subject have not yet been fully worked out. It should not be impossible at this stage to make a special study of the historical development of the pigments used by painters in various localities and periods, comparing the pertinent statements in literary sources with the results of an examination of the colours found on actual pictures.   Such a study would also have to include the relation between the pigments used by painters, and those employed in producing coloured porcelain; in the latter field our colleagues in ceramic studies are far ahead of us.

\* \* \*

The above observations will perhaps have convinced the reader that the brush stroke is not such an abstract and inscrutable entity as some Western writers are wont to assume.   It is true that a general knowledge of Chinese artistic theory is necessary for a full appreciation of the background of the brush stroke; but that should not make us

---

[1] A photograph of an ink cake made by Chin Nêng will be found in Togari, op. cit., page 104.

[2] See Appendix I, nos. 8, 41 and 75.

overlook the fact that there also exist very tangible data, namely the media by which the brush stroke is achieved. Thus far the tendency has been to stress the former at the latter's expense.

It is the study of the artist's technical means that provides a direct and certain approach, whereas abstruse speculations if divorced of practical knowledge take one along a circuitous road — and one that moreover as often as not will lead the traveller completely astray.

After this review of the elements that enter into the production of the brush stroke, we now proceed to the general principles for judging antique specimens of pictorial art.

<p style="text-align:center">* * *</p>

General principles for judging antique scrolls.

" When about to observe an antique scroll ", notes the Ming scholar Wên Chên–hêng, " one should commence with purifying one's heart and concentrating one's thoughts. Then one should first see whether the brush work is strong and real and whether it is in harmony with the spirit of the subject. In the second place one should assess the natural talent of the artist and see whether his work shows the strength that is testified by a free handling of the brush ".

" Thereafter one should investigate the old and new colophons attached to the scroll and thus verify its past history. Last of all one should study critically the collectors' seals impressed on the scroll, the colour of the paper and the quality of the silk ". [1]

The above passage was written in connection with the judging of antique autographs. But so intimate is the bond existing between Chinese calligraphy and painting that Wên Chên–hêng's words apply equally to antique pictures. The following discussion has grown out of an analysis of the words of this distinguished artist and connoisseur.

I intentionally divided the passage quoted here into two paragraphs in order to show more clearly that Wên Chên–hêng distinguishes between the two agents that enter into the process of appraising a scroll: the eye and knowledge. Or, expressed otherwise, sentiment and reason. Both of these two agents are essential to the appraising of scrolls, but Wên Chên–hêng quite properly places the eye first.

When confronted with an antique scroll, irrespective of whether it be a painting or an autograph, the Chinese connoisseur first of all lets his eye savour its artistic qualities. He knows that if he has not thus taken in the spirit of the scroll there is no point in scrutinizing inscriptions, seals, signatures, etc., for such will only interfere with the spontaneous, unbiased appreciation of the artistic qualities.

Learning to see Chinese pictures through Chinese eyes.

In the judging of an antique scroll the eye thus comes foremost. We of the West, however, should be careful not to overrate our receptive powers. A spontaneous appreciation of the artistic qualities of a Chinese scroll presupposes years of study; for the

---

1) *Chang-wu-chih* (see Appendix I, no. 30): 觀古 作。次考古今跋尾相傳來歷。次辨 法書當澄心定慮。先觀用筆結體。 收藏印識。紙色絹素。 精神照應。次觀人為天巧。自然強

368

eye, no matter how sensitive it be to artistic values in general, needs considerable schooling before it may become adapted to Chinese pictorial art.

There are certain Chinese pictures, such as for instance dreamy landscapes in ink, groups of delicately drawn human figures, portrait studies full of personality, ink sketches drawn in a few bold brush strokes, all of which will appeal immediately to everyone who has an eye for beauty, whether he be a Chinese or a Westerner. On the other hand there are also other subjects, such as an oddly-shaped stone, a couple of crab apples, a turnip and some fungi that, although greatly admired by successive generations of Chinese connoisseurs, will at first make not the slightest appeal to the Western observer. Yet a serious student of Chinese art should not dismiss such pictures as uninteresting. By patiently educating his eye he should teach himself to appreciate their less obvious appeal.

It should be remembered that we need a certain amount of schooling before we can fully appreciate some of the creations of our own great masters. Thus it is only natural that such a study is all the more needed for the appreciation of works of art belonging to a culture which is so different from ours as is the Chinese. Works of art of a culture different from our own should serve a greater purpose than the mere production of an agreeable sensation in the observer: they should serve to broaden and deepen our whole capacity for enjoying beauty.

It is true that during the last fifty years the attitude of Western art lovers in general has undergone important changes and shows an ever-growing understanding of Chinese esthetic ideals. Earlier students of Chinese pictorial art, as for instance Anderson and Fenollosa, were chiefly attracted by realistic Chinese paintings. With regard to works in the *hsieh-i* style they were extremely reserved in their judgement, evidently they had difficulty in determining their attitude to them. This preference was understandable in so far that realistic pictures come nearest to our own traditional art. Appreciation of the *hsieh-i* style was only gradually achieved when, partly through the intermediary of Japanese art, the esthetic and philosophical ideals underlying Chinese painting had become more widely known in the West and when Western artists had started to experiment with these styles themselves.

Even at this stage, however, the full capacity of seeing Chinese scrolls through Chinese eyes presupposes long and patient study. On the other hand it is an acknowledged truth that impressions of beauty easily obtained soon pall upon one. True beauty will often be found to be shy and inaccessible — it will not reveal itself to the first comer. But those who have taken the trouble to follow its elusive tracks, having reached it at last will find in it a true companion, one that will never more desert them.

The schooling of the eye calls for the acquisition of an understanding of Chinese artistic ideals in general and of how the artists gave expression to these ideals. The Chinese connoisseur is familiar with these as a matter of course. We may reach the same aim by studying as many original scrolls and good reproductions as possible, trying to

retain their distinctive features by visual memory. [1]  Here those students who are familiar with the Chinese written language will derive much benefit from the experience gained while memorizing Chinese characters — at the same time an excellent means for learning the Chinese rules for balancing and spacing.

If, at the same time, the student should have the time and inclination to acquire some skill in handling the Chinese brush himself, so much the better.  Every Oriental and Western artist will, prior to setting to work, subconsciously visualize his planned picture in terms of the technical means available to him.  Practising with the Chinese brush will teach the Western student what means of artistic realization the Chinese artist has at his disposal.  It should be remembered that nearly all great Chinese connoisseurs of old and modern times were at the same time calligraphers of note and often also good painters.  Although it is difficult to achieve the same proficiency in these arts as they, an attempt in this direction will at least open one's eyes to hitherto unsuspected intricacies of the brush work of Chinese scrolls.

Besides these general principles which *mutatis mutandis* also apply to the appreciation of our own works of art in the West, there are some points peculiar to the judging of Chinese scrolls.  With regard to these there must be first mentioned two questions of a more or less technical character, viz. the " type forms " and the " conventional motifs ".

" Type forms ".

The term " type form " was coined by the late Benjamin March. [2]  It designates the stereotyped forms of stones, trees, clouds etc. which since centuries every Chinese

1) Next to the publications mentioned in note 1 on page 213 above, the following collections of reproductions are recommended for study.

a) " A special collection of the second National Exhibition of Chinese Art ", Part One, comprising the Chin, T'ang, Five Dynasties, Sung, Yüan, Ming and Ch'ing periods, Nanking 1937.  Owner and measurements of each item are indicated.

b) *Shina-nanga-taisei* 支 那 南 畫 大 成, publ. Tōkyō 1935 in 23 large volumes.  The reproductions are excellent but sources and measurements are not given.

c) *Shōraikan-kanshō* 爽 籟 館 觀 賞, 3 vls. published Ōsaka 1930.  Reproductions of the best Chinese scrolls in the collection of Abe Fusajiro (阿 部 房 次 郎, 1868–1937).  The Abe Collection is especially rich in Sung and Yüan paintings and is generally considered the best private collection of Chinese pictures in Japan.  Most of the scrolls reproduced are described in Harada's catalogue (cf. Appendix I, no. 63).

d) *Shina-meiga-hōkan* 支 那 名 畫 寶 鑑, one foreign vol., publ. Tōkyō 1936 by Harada Bizan.  The reproductions are so small that they hardly give any idea of style and brushwork of the originals; but this book is useful for quick orientation.

e) *Tōsō-genmin-meiga-taikan* 唐 宋 元 明 名 畫 大 觀, 2 vls. published Tōkyō 1929 by the Ōtsuka-kōgeisha 大 塚 工 藝 社.  Fairly good reproductions of several hundred Chinese pictures which were shown in an exhibition in the Ueno Museum in Tōkyō 1926 on the occasion of the enthronement of the Shōwa Emperor.  The special value of this publication lies in the fact that next to antique scrolls preserved in Japan it also reproduces many items lent by private collectors in China for this occasion.  The names of the owners are indicated, but measurements and other details are missing.

f) *Wei-ta-ti i-shu-ch'uan-tung t'u-lu* 偉 大 的 藝 術 傳 統 圖 錄 " Pictorial Records of a great artistic heritage ", two foreign volumes, publ. Shanghai 1952.  A collection of reproductions of representative specimens of Chinese art, selected by Prof. Chêng Chên-to 鄭 振 鐸.  The plates include a large number of antique scrolls, many of which are reproduced in full colours.  The book is beautifully printed, but measurements and owners are not indicated.  It seems that several of the paintings reproduced are in foreign collections.

2) See the Preface to his *Some Technical Terms of Chinese Painting* (Appendix I, no. 8).

painter learns to draw in the conventional way, in exactly the same manner as he learns to memorize and write the Chinese ideographs.

March gives the following characterization of the type forms: " They are the evidences of essential reality distilled through centuries of observation of transient effects. Chinese painters were at the same time, often primarily, literati, men of culture and learning, poets. They were men whose habits of observation and of visual memory and analysis were quickened by their discipline in the writing and reading of the Chinese characters. They were studio painters, without suffering the divorce from nature that such a description often implies in the West ... Natural forms were studied with reference to their typical and permanent, rather than their accidental and transient phenomena; with reference to their functions as well as to their appearances; and certain general principles were deduced. The type forms are the epitome of these principles. The habits of growth, the effects of seasonal change, the genetic and functional relations of parts were observed; and the infinite variety of nature was deliberately emphasized ". [1]

A study of these type forms — the building stones with which the Chinese painter constructs his works — is not only necessary for the Chinese artist, but also for the Westerner who wishes to be able to view Chinese paintings in a critical manner. For this study one need not be an expert in the Chinese written language: the Chinese painter's handbooks give accurate illustrations of the various type forms, which speak for themselves. [2] If one takes the trouble to go over these carefully again and again till one has memorized the more important ones, it will be found that one's outlook on Chinese painting has broadened considerably while at the same time one has acquired an interesting new approach to nature outdoors. It is highly instructive to see how the type forms for the different kinds of clouds, mountains, rivers and trees sum up the essential features in the minimum of brush strokes.

It may be added that it is these type forms that explain why among the enormous amount of indifferent literary paintings one sees in China and Japan, so few are downright bad. The type forms are so perfect that even persons devoid of talent and taste, provided they have taken the trouble to memorize a number of type forms, are thereby able to produce pictures that although without any artistic value yet do at least not jar on the eye. The same perfect tools that allowed real artists to paint great masterpieces enabled untalented amateurs to engage in a polite pastime, without creating horrors.

Secondly, there is the question of conventional artistic motifs. Although to a certain extent these motifs play a role also in Western pictorial art, in China they are of paramount importance.

Certain historical or semi-historical scenes have since early times caught the fancy of Chinese artists. Once depicted by an old master they were drawn again and again by

Conventional artistic motifs.

---

1) Ibid., pp. XI–XII.
2) A few type forms are reproduced in the work by
March mentioned above; a complete collection is found in the *Chieh-tzŭ-yüan-hua-chuan* (Appendix I, no. 41).

later painters and thus in the course of the centuries developed into an artistic convention. Among old and modern Chinese scrolls one will find numerous pictures which all show one and the same motif: Tung–fang So stealing the Peach of Immortality (cf. B. D. no. 2093), Chang Liang being instructed on the bridge (ibid., no. 88), The Seven Sages of the Bamboo Grove (see above p. 119), etc.

These may be compared with the conventional motifs we are familiar with in our own pictorial art; hundreds of artists have depicted the same Classical or Biblical scenes without anyone thinking of accusing them of lack of originality. When painting such motifs Chinese artists are confronted with the same problems as their Western colleagues, viz., chiefly that of how to attain individual expression while depicting a more or less stereotyped motif.

The Chinese connoisseur can easily judge in how far the artist succeeded. Being familiar with the historical motifs through the observation of countless examples of old and modern times, he can verify at a glance whether a picture is an original artistic creation or just a nearly automatic reproduction of older models. Most Western students of Chinese pictorial art have recognized the necessity of acquiring a thorough knowledge of Chinese historical motifs. There are still too many, however, who with regard to Chinese art deem such a study superfluous, although none of them would attempt to judge Classical art without having first refreshed his knowledge of Greek history and mythology.

Although as regards historical motifs the position is the same in China and the West, in the former the conventional motif has a much wider scope. It is no exaggeration to say that conventional motifs cover practically the entire field of Chinese pictorial art.

All kinds of scenes or situations that appealed to the Chinese eye and imagination sooner or later developed into conventional motifs. These range from such poetic themes as a man playing the lute near the waterside or under an old pine tree; a fishing boat returning to a reedy shore; two or three gaunt, lonely trees in a mountain vale, etc., to certain groupings and combinations such as a cock under a banana tree, stones and bamboo, a tea pot and a blossoming sprig, some crabs and a fish basket, etc.

The existence of these conventional motifs in a way facilitated the task of the Chinese painter: almost every possible combination, every possible grouping that lends itself well to pictorial representation, and the most advantageous angle from which such a subject can be depicted, has been determined by countless precedents. The homogeneity that marked Chinese culture from the Sung period upwards prevented such established motifs from becoming dated. Thus an artist could easily choose from among these artistic precedents the particular subject that answered his inspiration of the moment, without the trouble of experimenting with various angles and combinations. On the other hand, however, the fact that these motifs were all stored away in his visual memory tended to discourage a mediocre artist to create independent interpretations. In the same way also the type forms often stultified artistic effort.

Be this as it may, every one engaged in the appraising of Chinese scrolls must know these conventional motifs. Often, however, one finds that Western writers in their

descriptions of Chinese pictures praise features for which no credit should go to the artist who painted them. With regard to a picture of a cock and a banana tree, for instance, there is no point in stating that the man who painted it had a fine feeling for colours because he found out that the soft, velvety green of the banana leaves contrasts so well with the luscious colours of the bird; for it was precisely because of this contrast that, centuries ago, this combination was established as a conventional motif. In this case one should observe the expression and stance of the bird, the brush work of the banana leaves — in fact everything except the choice of subject. Neither will it do to expatiate on the discerning eye of a painter who draws for instance a young lady in white robes leaning on the gnarled trunk of a prune tree. For also this combination is an old–established convention, based on both magical and esthetic considerations. [1]

Only he who is thoroughly conversant with the general artistic conventional motifs can really judge the merits of a picture; for it is this knowledge that enables one to differentiate between the data supplied by convention and the traits that embody the artistic individuality of the artist. In other words, one will be able to decide if and in how far the painter has succeeded in rising above the conventionalized forms of expression provided by the fixed conventional motifs.

It is to the mastery of a stereotyped technique, circumscribed by the type forms and the conventional motifs that might be applied Wên Chên–hêng's formula: "the strength that is testified by a free handling of the brush". Since his words apply primarily to calligraphy, in the context the formula quoted means that a true calligrapher even when writing in the regular script will be able to unfold his individual style without transgressing the prescribed standard forms of the characters. Thus the genius of the great calligrapher and the gifted painter can be defined in identical terms: having completely mastered all conventions they make them subservient to their artistic power, thus creating a strength of form that is all the more impressive because it keeps within the boundaries fixed by an age–old tradition.

This applies not only to the Ming and Ch'ing periods, when type forms and conventional motifs had all been duly sifted, classified and published in painter's handbooks. Also in the pictorial art of the T'ang, Sung and Yüan dynasties this adherence to precedent and convention is clearly noticeable. Then the traditional means of expression of " literary painting " had not yet been codified, but certain general artistic conventions ruled pictorial art as strictly as in later times. If more pictures of those periods had been preserved we would have been able better to decide the intrinsic quality of those paintings of cats and peonies, dragons and waves, groups of Arhats etc. that have survived.

As a matter of course there were several painters who studiously ignored type forms as well as conventional motifs and founded an independent style all their own. To this

[1] An old plum tree sending forth blossoms — here symbolically represented by the young woman — stands for the revival of vital force in spring. Similar, more realistic representations are found on erotic pictures of the Ming period.

group of innovators belong the Sung master Mi Fu, the Ming painters Hsü Wei [1] and Chu Ta, [2] and Shih–t'ao, [3] Shih–ch'i [4] and Chin Nêng [5] of the Ch'ing dynasty — to mention only a few of the more famous names. The new techniques introduced by them, however, in due time also developed into conventions. Mi Fu's technique was adopted by scores of painters of the Ming and Ch'ing periods, and Hsü Wei and Chu Ta inspired the well known modern painter Ch'i Huang, [6] The work of the " innovators " is further proof — if any were needed — of the remarkable vitality and capacity for self–renewal of Chinese pictorial art.

The view that during the Ming and Ch'ing periods Chinese painting was reduced to a sterile imitation of older models, is based on insufficient knowledge of the pictorial art of those two dynasties and should be abandoned. The only excuse that the exponents of this dated theory have is that the Chinese conception of originality is different from ours; inexperienced observers may well have taken for life–less imitations paintings that are recognized by the Chinese connoisseur as spirited creations.

The difference between the Western and the Chinese point of view is not apparent in the appraisal of pictures of historical conventions. No one would find a lack of originality in a Chinese painter who depicted for instance " The Seven Sages of the Bamboo Grove ", in the same way as no one would find fault with a Western artist just because he selected the " Judgement of Paris " or " Leda and the Swan " as subject. As regards the artistic conventions of a more general character, however, the ways of West and East part.

Western art critics would doubtless frown on a modern picture in classical style representing a group of 17th century doctors with their large black hats assembled round a dead body on the surgical table, while they are listening eagerly to the anatomical explanations of the professor. While in the West such a painting would be considered as an imitation of Rembrandt's " The Anatomical Lesson ", in China it would be looked upon as an original work of art, provided that the artist would have added here and there a new detail, or developed further some feature not fully expressed in Rembrandt's original.

---

1) Hsü Wei (徐渭, 1521–1593) was a gifted poet, painter and calligrapher who introduced a new style of monochrome ink painting in a highly impressionistic manner; best known are his pictures of plants, trees and stones.

2) Chu Ta (朱耷, better known by his literary name Pa–ta–shan–jên 八大山人, 1626–ca. 1705) further developed Hsü Wei's style; he is especially famous for his pictures of animals but left also some good landscapes.

3) Shih–t'ao, cf. Appendix I, no. 13.

4) Shih–hsi, ibid.

5) Chin Nêng, cf. above page 366. A very original artist who is counted among the *Yang–chou–pa–kuai* 揚州八怪 " The Eight Eccentrics of Yang–chou ". Originally he was chiefly known as a poet and calligrapher but later in life started painting and became famous for his human figures set down in a few expressive brush strokes.

6) Ch'i Huang 齊璜, better known by his literary name Po–shih 白石, was born in 1861. Of humble descent he first attracted attention as a very original and gifted seal engraver. Later he started painting in the style of Hsü Wei and Chu Ta, concentrating on flowers, plants and animals. He did much work for publishers of illustrated letter–paper; these colour prints have in recent years become well known also in the West. Chinese connoisseurs, however, still value his seals more than his paintings. At the time of writing (1954) he is despite his advanced age still active in Peking.

374

In fact Chinese collectors consider " imitations " by good Ming and Ch'ing artists of works by famous Sung and Yüan masters as of the same value as the original works of those Ming and Ch'ing painters. The painters themselves marked such pictures clearly as copies; they usually wrote on them inscriptions reading " In imitation of (*fang* 倣) the X–painting by Y " etc., and no one would think of accusing them of a lack of originality.

Further, when a Chinese painter has completed a picture that he likes particularly, he will often do exactly the same picture three or four times, adding to each one the same seals and inscriptions, and changing only the date. Yet by doing so he does not lay himself open to the censure of repeating himself or of being unoriginal.

This is a peculiarly Chinese viewpoint that necessitates considerable adjustment on the part of the Western art–historian.

It is almost unnecessary to say that the student of Chinese pictorial art must be well versed in both the historical motifs and the more general artistic conventions. The visual experience needed must be acquired by poring over hundreds of original Chinese pictures and good reproductions thereof, and by leafing through again and again Chinese printed collections of painter's models.

Determining the common denominator that marks all works of a given artist.

Books with painter's models are different from the " painter's handbooks " mentioned above. They take knowledge of the brush technique and of the type forms for granted, and give only complete pictures, mostly simplified versions of well known works by famous old masters. Especially during the later years of the Ch'ing dynasty a great number of such illustrated block prints circulated among amateurs and professional painters, and their number waxed after the spread of lithography in China when it had become possible to publish cheap editions of such picture–books.

Among the better known manuals I mention the *Tien–shih–chai–ts'ung–hua* 點石齋叢畫 published in 1885 in 8 vls. on the basis of old and modern paintings selected by Wang T'ao (cf. Appendix I, no. 42). Benjamin March utilized this manual when he wrote his book on the technique of Chinese painting (cf. Appendix I, no. 8, p. 1 of Preface).

Learning to recognize the general conventional motifs is a task of years rather than of weeks or months. Yet this is the only way to acquire the ability of distinguishing in a picture the individual traits of the artist from the elements determined by convention. And it is this differentiation that gradually leads to the identification of the common denominator that stamps every work of a given artist — including his copies of older pictures — with the mark of his personality.

Among Chinese connoisseurs the common denominator weighs heavily when they investigate the authenticity of an antique scroll. But this subtle element is not easily recognized. Beyond the advice to study carefully as many specimens of one and the same artist as possible, little could be said that would be of real help; it is largely a question of a wide visual experience and a sensitive eye, combined with intimate knowledge of

the brush–technique. Some Chinese connoisseurs have tried to formulate definitions of the essential features that mark the works of prominent artists. But these definitions are couched in nearly esoteric language, its terminology being mostly derived from that of calligraphic theory. I refer, for instance, to the *Tung–yin–lun–hua* by the Ch'ing connoisseur Ch'in Tsu–yung (cf. Appendix I, no. 56); his definitions are carefully formulated after a conscientious study of the works of each of the artists listed, but they are as difficult to understand as the pronouncements of a Ch'an master.

The task of fixing the common denominator is easiest in the case of those artists who created an entirely new style. One does not need much experience in order to recognize the individual traits of painters such as Hsü Wei or Chu Ta mentioned above. On the other hand, with regard to their works the common denominator has slight value for deciding the authenticity. The individual traits of the brush work of these painters are so obvious that the forger has little difficulty in reproducing them in his fakes. Beginners will often be deceived by such fakes, because in their joy to be able to recognize at a glance the peculiar technique of Hsü Wei or Chu Ta they declare the work to be an original without looking further into it. Experienced connoisseurs, however, will detect these fakes without much difficulty; they discount at once the obvious characteristics and concentrate on more subtle points such as the nuances of dark and light ink in Hsü Wei's pictures, and the peculiar humorous and nearly human expression that Chu Ta used to give to all animals depicted by him.

It is also a wise policy to verify whether the individual traits are not overdone. A forger is often so eager to impress on a fake the hallmark of the personality of a given artist that he exaggerates those special traits. The celebrated Ch'ing calligrapher Chêng Hsieh (鄭 燮 better known by his literary name Pan–ch'iao 板 橋, 1693–1765) created a new style of calligraphy peculiarly his own where he freely mixes the " seal ", " chancery " and " draft " script; genuine specimens of his writing show a number of queer and antiquated characters. But I have seen many specimens that proclaimed themselves to be fakes by the fact that every other character was written in an unusual way.

Generally speaking it is far more difficult to decide the authenticity of pictures done in traditional style than of those painted in a very individual manner; for in pictures of the former class only a very sensitive eye can discern the personal traits of the painter.

Associations. A problem narrowly related to that of the historical conventions is that of literary associations.

Literature and the literary allusion govern all plastic aspects of Chinese culture, and pictorial art is no exception to this rule. It is no exaggeration to say that Chinese pictorial art is largely an illustration of Chinese literature.

A Chinese connoisseur may discover in a picture of a historical or semi–historical scene some traits that escape the observer who is not thoroughly familiar with the literary background of that scene. The connoisseur will recognize in a peculiar gesture or a facial expression of one of the figures represented on the picture an aspect of the situation

that was stressed in some poem or essay describing the occurrence. Such details excite the enthusiasm of Chinese connoisseurs but they can be discovered only by some one who when seeing the picture immediately remembers the text in question.

In this respect the collector schooled in Chinese literature is in a better position than one who is unconversant with the language. The latter, however, may to a certain extent supplement the lacuna by reading good translations of the Chinese Classics and the better known poets and essayists, and by making himself familiar with Chinese history. [1] It ought to be superfluous to raise this point. But with regard to Chinese art it is too often assumed that any one who has an eye for artistic values is thereby, and thereby alone fully qualified to pass judgement on Chinese scrolls.

This brings us to the second agent that enters into the process of appraising antique scrolls, namely knowledge.

Wên Chên–hêng, in the passage quoted at the beginning of this section, quite properly devotes the first half of his pronouncement to the eye. The second half treats of the process of reasoning; this can begin after the eye has had full opportunity for taking in the artistic qualities of a scroll, unhampered by purely intellectual reactions. Although it is placed second, knowledge is as indispensable to the connoisseur as a sensitive eye.

The intellectual appreciation of Chinese pictures.

The intellectual appreciation of a scroll is based upon a study of dates, signatures, seals, superscriptions and colophons, and of the quality and condition of the silk or paper on which the scroll was done.

Since Wên Chên–hêng wrote with special regard to autographs — which mostly are mounted in the form of hand scrolls — the above quoted passage mentions in the first place old and new colophons, which are a characteristic feature of that form of mounting. Here, too, we shall first discuss the problem of evaluating colophons.

The discussions on pp. 132–134 above will have made it clear that colophons in themselves have slight value; their significance lies in the fact that they may serve to authenticate the picture or autograph to which they are attached. Therefore the question whether a colophon does really belong to the scroll it is mounted together with is of the utmost importance. There exist a number of criteria that may help one to form an opinion on such problems. Although none of these is decisive in itself, if considered together these criteria will often supply conclusive evidence. Some of these criteria are briefly discussed below. For the sake of convenience the various kinds of colophons are broadly divided into two groups, which may be called " friends' colophons " and " collectors' colophons ".

Colophons.

---

[1] Many well known stories and anecdotes often represented on pictures will be found in H. A. GILES, *A Chinese Biographical Dictionary*; cf. further JOHN C. FERGUSON, *Stories in Chinese Paintings*, article in " Journal of the North China Branch of the Royal Asiatic Society ", vol. LVI (1925), vol. LXI (1930) and vol. LXIII (1932).

"Friends' colophons" are usually written at about the same time as the picture is painted or the autograph written: they are composed by friends or acquaintances of the artist.

An artist will often expressly leave a few feet of blank space at the end of a hand scroll, in order that one or another of his friends may there write a few words. Later, when the scroll is remounted, these colophons are sometimes cut off and mounted directly after the picture, being separated from it by a vertical strip of silk. Discerning connoisseurs, however, will insist that the mounter does not cut up the scroll in this way, for then the value of the colophon as proof of authenticity of the work it is attached to is considerably diminished.

The authenticity of "friends' colophons" may be tested by ascertaining from the biographies of the artist and the writer of the colophon whether these two persons were really contemporaries; and if so, what was the nature of their relationship. Usually one will find that both belonged to the same literary or artistic circle or were colleagues in office, or again connected by family ties. In that case one must pay special attention to the dedication — if there is any — and verify whether the writer addresses the artist in the proper way. As is well known, there exists a code that regulates the terminology of dedications in minute detail, covering the entire range of human relations. Terms such as for instance *jên–hsiung* 仁兄 and *wu–hsiung* 吾兄 have entirely different connotations. If, therefore, the writer of a colophon done directly on the picture addresses the artist as an intimate friend, while one finds that they hardly knew each other, then there is good reason to assume that that colophon was written on the scroll by a later forger. And the same applies to colophons written on a separate piece of paper or silk and mounted together with the scroll.

As regards their content, "friends' colophons" are usually rather disappointing. They will often praise highly what is in reality quite a mediocre scroll, or call an insignificant amateur painter "No. 1 under Heaven", as required by courtesy to one's friends and relations. It should also be remembered that as often as not the picture was painted and the colophon written on the occasion of some elegant meeting of kindred spirits when the mellow mood that follows a good repast made the writer express himself in somewhat more extatic terms than he would use in ordinary circumstances.

"Friends' colophons" that can be proved not to belong to the scroll they are attached to are nearly always "partial fakes", that is to say they have been cut off from another scroll, or copied after a genuine one. For few forgers are sufficiently familiar with literature and with the circumstances of the artist's life to be able to compose a false "friend's colophon" themselves.

"Collectors' colophons" are those added to antique scrolls by connoisseurs and collectors who had no personal relations with the artist or lived in a later age.

These colophons are as a rule written in a more detached and scholarly manner. Chinese literati, always bearing in mind the dictum "If you fall in the water you may

378

still be saved, but haven fallen down in literary matters there is no life left for you ", [1] are diffident in committing themselves to paper, also with regard to artistic matters. When a connoisseur has obtained an antique scroll he will study it carefully, discuss it with his friends, and compare its style, signature and seals with specimens by the same artist in other collections. Then, after mature thought, having decided that the scroll deserves a permanent place in his collection, he sets himself to writing a colophon for it. If he has doubts about the identity of the artist or if on other points his opinion differs from that expressed by the writers of older comments attached to the scroll, he will include such reflections in his own colophon. When the colophon, duly dated and sealed, has been mounted together with the scroll, conscientious connoisseurs will always add their seals over the seams of the strips of mounting that separate picture and colophon, and also in a corner of the picture itself. Great collectors thereafter copy out the text in a scrap book, to be printed when later they publish a descriptive catalogue of their collection.

Nearly all fakes mounted in the form of hand scrolls are either what might be called " complete fakes ", viz. more or less successful copies of pictures or autographs together with their colophons, superscriptions etc., or " combination fakes " produced by mounting together pictures and colophons etc. that originally do not belong to each other; in the latter case both or one of them may be a fake or genuine — the reader can figure out for himself all possibilities.

In the case of " friends's colophons " combination fakes are difficult to produce. It is true that stray colophons — i. e. sheets of paper with artistic or antiquarian comments written by well known scholars, that for some reason or other became detached from the scroll they were originally written for — are easily obtainable in the antique trade. But it would of course be practically impossible to find one suitable for serving as a " friend's colophon ".

In the case of " collector's colophons ", however, the problem is more complicated; here one will find the " combination fake " in all its variations.

The value of a genuine picture that lacks a colophon will be enhanced if a forger adds to it a colophon that in itself is also genuine but was written for quite another scroll. Since collector's colophons are often couched in such general terms as to fit various pictorial representations, and as a matter of course have no dedications, it is generally not too difficult to find one that is suited for the purpose; a colophon consisting of an essay composed by a Ch'ing scholar on the delights of living in retirement can be mounted together with a Ming picture showing a man playing the lute under a pine tree, or a picture of two friends sitting near a mountain stream, or of a man tending flowers, etc.

Further, if a dealer has obtained a Ch'ing copy of a good antique scroll by a Ming master, he will if possible attach to it a genuine colophon by a scholar from the Ming period, in order thus to conceal the fact that the picture itself is a Ch'ing copy.

---

1) 陷 水 可 脫。陷 文 不 活。

379

I do not propose to enumerate here all the further possibilities of " Combination fakes ". I only add that with regard to " collector's colophons " one must be prepared also for " complete fakes ", viz. those cases where a forger has copied both the picture and the genuine colophons attached to it.

In order to find out whether a " collector's colophon " really belongs to a scroll one should in the first place ascertain whether its contents have a direct bearing upon the subject represented. It is not enough if, for instance, a picture of a flight of geese signed by the 18th century painter Pien Shou–min 邊 壽 民 has attached to it a poem by the Ch'ing connoisseur Wêng Fang–kang (翁 方 剛, 1733–1818), praising the graceful movements of flying geese. For most genuine " collector's colophons " clearly show by their contents that they were written especially for one particular picture. Wêng Fang–kang may write a poem on geese for a friend, or just for his own amusement; but if he wrote a colophon for a picture of geese painted by Pien Shou–min he would first give some comments on the artist's brushwork, then perhaps state where and how he saw or purchased the scroll, etc.

Further, one should compare carefully the seals impressed on colophon and picture. As will be explained in greater detail below, impressions made with one and the same seal but at different times and different vermilion may diverge considerably; but impressions made at the same time and by the same hand are practically identical. The latter case applies to the seal a collector will impress on the colophon written by him, and on the picture to which the colophon is attached. If the impressions differ, one may assume that either the picture or the colophon is a fake.

Finally, if the colophon is signed by a connoisseur who has published a catalogue of his collection one should verify whether the colophon is entered there. Sometimes one will locate the colophon but find that it was written for quite another scroll. If one is lucky, this means that although the picture itself is a fake, the colophon is at least authentic. Mostly, however, it will turn out that both picture and colophon are copies. For unfortunately not a few forgers are diligent readers of old collectors' catalogues. If, on the other hand, both painting and colophon are duly registered in the catalogue, the problem becomes considerably simplified: one has to decide only whether or not the entire scroll, including picture and colophon, is genuine or a " complete fake ".

If a colophon signed by A. is not found in A.'s catalogue this does not preclude that picture and colophon are authentic. As a first step the dates of catalogue and colophon should be compared. If the colophon is later than the book, the scroll may have been acquired by A. after he had published his catalogue. In such a case, however, one had better make sure that A. was still alive on the date given in his colophon. The Chinese associate historical figures with eras rather than with years and so, until recently, did Chinese biographical dictionaries and other works of reference. [1] For instance, A.

---

[1] Among Chinese biographical dictionaries that do give exact dates I recommend the excellent *Chung–kuo–wên–hsüeh–chia–ta–tz'ŭ–tien* 中 國 文 學 家 大 辭 典 one foreign volume, published in 1934 by Tan Chêng–pi 譚 正 璧; although, as the title indicates, this book is primarily devoted to the biographies of literati, one will

will be referred to as " a connoisseur of the Wan–li era " because he flourished during the Wan–li period which lasted 1573–1619. A forger who wishes to pass off a faked colophon or inscription as A.'s work, may inadvertently date it *wan–li–jên–tzû* 萬 歷 壬 子, i. e. 1612, while in reality A. died in 1609. As a matter of course this possibility need not be taken into account in the case of " complete fakes ".

If the colophon is dated earlier than the catalogue but not entered there, it may still be genuine. Collectors often include in their printed catalogues only those items which they consider of special interest or importance, and leave out those which are not of superior quality. But as a rule it are especially such mediocre specimens that in course of time will make their appearance in antique shops; thus present–day collectors will find it useful to keep this point in mind.

Generally speaking one will do well to begin by assuming that the colophons attached to an antique picture or specimen of calligraphy are in themselves genuine. If there should be suspicious features one should question the authenticity of the picture rather than that of the colophon. This applies especially to colophons signed by Ch'ing connoisseurs. Stray leaves with poems, essays or other brief comments that may eventually be made to serve as *soi–disant* colophons of antique hand scrolls are so easily obtainable in the antique trade that it is not worth the forger's while to copy them out or to manufacture them himself.

It is a wise policy, however, to view with suspicion those colophons and other inscriptions added to antique scrolls, the date or signature of which suggest that they were written when the author had reached an advanced age. For many a mediocre forger will try to gloss over his inability to imitate convincingly a famous man's handwriting by speculating on the observer's making allowance for failing eyesight, shaky hand and other infirmities of old age. If one tells a shady dealer that such an inscription does not resemble the alleged writer's calligraphy, he will reproachfully point to the date, or the signature preceded by " written in my 86th year " , or some similar remark.

"Old man's colophons".

Before going further into various methods for producing fakes it may be added here that although the above discussion was concerned with colophons attached to hand scrolls, the same principles apply, *mutatis mutandis*, to the inscriptions written on hanging scrolls, either on the picture itself or on parts of the mounting.

Of fakes produced by utilizing heavily damaged scrolls mention should first be made of what might be called " split–up scrolls ".

Fakes produced by the "splitting up process".

Suppose that a dealer obtains a large landscape painting on silk painted in classical style by a Ming artist. To the right one sees a group of rocks, with a lonely temple

here find also a great number of scholar-artists. An important work of reference is further the *Li–tai–ming–jên–nien–li–pei–chuan–tsung–piao* 歷 代 名 人 年 里 碑 傳 總 表, one foreign volume, published in 1937 by Chiang Liang-fu 姜 亮 夫. This comprehensive work gives next to the dates of a very large number of persons of note of olden times, also their place of birth, and references to the sources where one may find their biographies. Both these books are indispensable for the study of colophons, artists' signatures, etc.

hidden among pine trees. In the centre of the picture a lake spreads its placid waves and to the left a fisherman is mooring his boat on the reedy shore of a small island. Now this painting, although delicately drawn and otherwise well preserved, is defaced by an enormous hole that runs through its middle, cutting across the water of the lake but leaving the island intact. As this scroll, although unsigned, is of superior quality while material and colouring point definitely to the Ming period, the dealer can dispose of it, damaged as it is, for say fifty Chin. dollars.

Instead of placing this picture on sale, however, the dealer " splits it up ". He cuts out the undamaged portion that shows the mountains and the temple and part of the lake, and has this fragment remounted separately. He has now obtained a nice small landscape painting representing *Tung–t'ing–wan–chung* 洞 庭 晚 鐘 " Evening Bells over Lake Tung–t'ing ", or a similar conventional pictorial motif. Then he cuts out the portion showing the island and the fisherman. If it cannot be cut in rectangular shape, he gives the picture a round outline and folds it double so that when mounted it will show a fold–mark running perpendicularly through the middle, suggesting the mark left by the central bone of a round fan. Then the forger adds to it the superscription *Han–chiang–san–wang* 寒 江 散 網 " Throwing out the nets in the cool river ", affixes the seals of a Ming painter, and thus obtains an attractive scroll, looking like a dismounted round fan of the Ming period. If he sells the former picture for 100 dollars and the latter for 150, he will have increased his profit several times.

Plate **139** shows an unsigned landscape scroll that eventually might be split up in three parts, as indicated by the black lines. This scroll, a Ming landscape in *kung–pi* style painted in full colours on silk measures 85 by 158 cm. When split up, the lower part could be mounted as a horizontal hanging scroll; on the spot indicated by the square in the lower left corner a false signature and seal might be added. The top left part is very suitable for being passed of for a vertical hanging scroll; a false seal or signature could be added in the lower left corner. The part on the right is least satisfactory from the point of view of the forger; the palace in the foreground is too large to harmonize well with the rest of the picture. However, the balance could be restored more or less by adding a longer spurious inscription, duly signed and sealed, in the box indicated on top left.

Large paintings of the *lou–ko* 樓 閣 type, i. e. landscapes with palaces and towers populated by minute human figures, are especially suited for being split up. In 1939 after the Japanese had occupied Peking, an astonishing number of small, delicate paintings of palaces appeared on the market. Peking dealers, well aware of the Japanese preference for small landscape scrolls suitable for being exposed in the *toko–no–ma*, obligingly cut up some large Ming landscapes, which brought in good money. Let us hope for the sake of art that at least only damaged and unsigned large scrolls fell victim to this vandalism!

As a rule " split up " pictures are difficult to detect. Most shady dealers have good eyes and are skilful in selecting from a damaged scroll those portions that will form

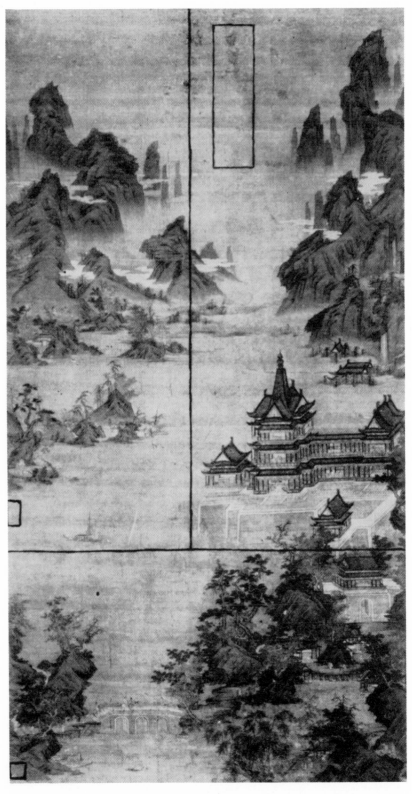

139. – LARGE LANDSCAPE SCROLL OF THE MING PERIOD,
SUITABLE FOR BEING "SPLIT UP"
(Author's Collection)

a satisfactory entity by themselves. A test that will sometimes work is a detailed examination of the paper or silk: if a small painting is done on rather coarse material one may suspect that it is part of a " split up " scroll, since small pictures are as a rule painted on fine silk or paper.

Chinese connoisseurs often refer to this type of fakes. Below I translate some remarks on the subject by the Ch'ing collector Lu Shih-hua.

" If they (i. e. curio dealers) find an old painting they have no particular use for, they cut it down so as to remove the signature, and then write on it the name of some famous Sung or Yüan artist instead. They go even so far as to cut up a very large scroll into three or four smaller ones, writing on each of these auspicious titles. Having in this way assembled a hundred or so of such cut-up paintings, they go and sell them in some other locality. At first I thought that these people engaged in a very risky undertaking indeed. But after a few months I saw them come back with money, or with merchandise they had bought elsewhere (with the money obtained by selling their fakes) and which they sold in their home village; or they purchased with this money some small official rank for themselves. When asked about this they said: ' The value of the name of a Sung or Yüan artist ranges within several ounces of gold; thus one scroll will make us gain several times our original outlay '. This is something I would never have suspected ". [1]

Some dealers next to "splitting up" pictures also follow a reversed process, viz. that of producing " combination pictures ".

Fakes produced by the " combination process ".

When they obtain a larger fragment of what once was a valuable painting, unsuitable for being repaired or " split up ", they will search among their stock for one or two other old fragments, the material and design of which match that of the larger fragment. Then they manipulate these fragments as though they were parts of a jigsaw puzzle; when they have obtained a satisfactory result they have them mounted together as one painting.

Many forgers have a good eye for such possibilities, and they are further assisted by the fact — already discussed above — that tradition has more or less fixed the conventional themes that may be chosen by an artist. A group of pine trees may be combined with a couple of cranes, a few butterflies may be added to a flower piece, a small house among a cluster of bamboo may be added at the foot of a mountain — all without arousing the suspicion of the casual observer. Moreover the forger takes good care to cover such " combination pictures " with a thick layer of artificial grime which glosses over the spots where the component parts are joined together. If on examining the scroll against

---

1) *Shu-hua-shuo-ling* (cf. Appendix I, no. 47): 於問一幅。或宋名或宋元名。余嘗見其著三四處。另書數款。改作幾輩。往往越數月見之。以此鎮小幅。去小巨幅。至積此輩。爲瑞祥。必甚用舊人。無元名始。收名宋。或著四幅。命三。歸以鄉。或宋元本。計然如此。持家之軸料。以銀計然。別捐銀名只可得。帶又宋元人己。帶別銀名可。處小數倍在三。之小金。貨之小。售名不可。功以倍矣。事。

383

a strong light one points out to the dealer these marks, he will answer that the scroll was badly torn and that he had it repaired by a good mounter.

Next to discrepancies in the brush work the only dependable test is to compare the texture and thickness of the silk or paper of the various parts composing the scroll. Since " combination pictures " are fairly difficult to produce, this form of falsification is rarer than that of " splitting up ". Actually it is met with most often in the case of anonymous paintings or autographs, which an enterprising dealer has " combined " with a fragment bearing the signature or seal of some well known artist.

The seal as an aid in determining the authenticity of antique scrolls.

In Wên Chên-hêng's passage quoted at the beginning of this section seals occupy the last place but one. One may conclude that Wên Chên-hêng did not attach much importance to seals as aids in appraising antique scrolls.

Other writers, however, consider the seal as a decisive factor in authenticity problems. They maintain that if the artist's seal impressed on a doubtful scroll is genuine, that picture must be declared to be authentic.

Personally I agree with Wên Chên-hêng, and his attitude is adopted also by most modern Chinese connoisseurs whom I consulted about this question. They are agreed that seals alone, although doubtless supplying valuable additional criteria for the authenticity of antique scrolls, can not be considered as conclusive evidence.

As was pointed out already on page 111 above, for counterfeiting a seal impression one does not need photogravure or other aids of modern science. A seal impression may be painted on a scroll with a special vermilion preparation, or impressed on it with a seal stone re-carved after an original. The re-carving of an old seal presents no difficulty to a seal engraver; it is done after a traced copy of an impression on a genuine scroll, or after an impression preserved in a *yin-pu*. [1] When one examines such a false seal impression side by side with a genuine one through a magnifying glass, one may well discover a number of small differences. Yet this fact is in itself insufficient for proving that one of the impressions is a falsification. There exist four main factors that may cause that two or more impressions made with the same seal stone show marked divergences. These factors may be described as follows.

1) The vermilion used. Vermilion seal pads exist in various kinds and qualities. Some have a rather coarse granulation, others contain an excessively large quantity of oil; some are hard and dry, others soft and moist. Needless to say that such differences in the seal pad are reflected in the seal impression. Seals inked on pads containing much oil will produce *chu-wên* legends in thick lines, and *po-wên* legends in thin lines; for the oil will run, carrying with it some of the red pigment. On the other hand dry seal pads will cause the lines of *chu-wên* legends to appear thinner whereas *po-wên* legends will show broader lines. Further, if a seal is inked with an inferior seal

---

1) For information about *yin-pu* see page 428.

384

pad, hairs and fragments of fibre will come off together with the vermilion and thus prevent a clear impression of the seal being formed.

2) The manner of impressing the seal. The methods of impressing a seal vary according to individual taste and habit and the mood of the moment. Some people will impress a seal at once firmly on the paper and then lift it up immediately. Others will begin by placing the seal stone lightly on the paper, then pressing it down firmly. Others again, having placed the seal on the paper will first firmly impress the left side by slightly tilting the seal and thereafter the right side by tilting it the other way round. It goes without saying that impressions of seals made by, for instance, the first and last method will show considerable differences, especially along the four edges. A seal placed firmly on the paper and then immediately lifted up will produce an impression that shows normal edges; the other will show an accentuated profile reproducing every minute flaw in the circumference of the seal.

Similar divergences are caused by the substance of the pad that is placed under the paper or silk prior to impressing the seal, in order to ensure a clear impression. Some people like to use a pad of felt, others prefer a harder substance such as a flat stone or a glass pane.

3) The material on which the seal is impressed. Thin, unsized white paper will give the most accurate reproduction of a seal legend. The leaves of *yin-pu* are therefore as a rule good-quality *hsüan-chih*; see the sample in Appendix V, no. 5. Thereafter come glazed and waxed papers, while thick paper and coarse silk give the worst reproductions.

It will prove especially difficult to obtain a clear seal impression on old silk or paper much darkened by age. Collectors will often dust the impression of their seal affixed to a newly-acquired antique scroll with red coral powder and thus obtain a clear impression. Dealers sometimes trace seals on antique scrolls that have become nearly illegible with thin oil, and then dust them with coral powder. Such restored seals can often be recognized by their light colour, mostly the lines are nearly white; this is due to the calcium contained in the coral. Further, some artists will always dust their own freshly impressed seals with vermilion powder in order to enhance the colour.

It goes without saying that this powder treatment will obliterate details that would help to determine whether the seal is genuine or not.

4) The condition of the seal. Even seals cut in stone of a very hard variety, when regularly used will in course of time wear down. This applies especially to seals in *chu-wên*, the lines of which will gradually grow thicker. When a seal is used many times every day — as for instance the ex-libris seals of bibliophiles — it will after some years have worn down to such a degree that its original charm has become lost, so that it must be re-carved.

It is true that in order to diminish this deterioration most painters and calligraphers handle their seals with the utmost care, keeping them in padded boxes. Yet if one compares the seals on the early works of a given artist with impressions of the same seal

stone on his later paintings one will often have no difficulty in discovering various differences.

Since it is thus by no means certain that two impressions of the same seal must be exactly identical, one should not overrate the value of the seal as an aid in proving or disproving the authenticity of an antique scroll. All the more so since it happens not infrequently that perfectly genuine seals are impressed on scrolls that are not genuine; this point is worth a further discussion.

It is by no means rare that one finds in the antique trade in China or Japan a genuine old seal that was used by a well known artist or collector of the Ch'ing or Ming period. Shady dealers will buy such seals at a high price, for they can be used to authenticate as many faked scrolls or copies as one likes. If for this purpose one employs an old vermilion pad — which is obtainable in the trade — it is evident that such a fraud will be impossible to detect if one goes only by the seals.

Moreover, it should be remembered that it was — and still is — not unusual that a famous scholar–artist who occupies a high official position has on his staff a secretary who has learned to imitate his employer's style of painting or writing in a creditable way. The names of a few " ghost artists ", in Chinese called *tai–pi* 代筆, are found in literary records. The *Liang–pan–ch'iu–yü–an–sui–pi* (cf. page 426, note 2) states that the Sung master Su Shih employed as *tai–pi* a man called Kao Shu 高述; the famous Yüan artist Chao Mêng–fu a scholar called Kuo T'ien–hsi 郭天錫; and the Ming painter and calligrapher Tung Ch'i–ch'ang an official on his staff called Wu Ch'u–hou 吳楚侯. The latter is apparently identical with Wu I 吳易, mentioned E. C. page 789 as employed by Tung Ch'i–ch'ang for imitating his calligraphy; E. C. also mentions Chao Tso 趙左, who imitated his painting. If the employer approves of the work done by the " ghost artist ", he will have his seals impressed on it.

This is not done to deceive people. The fact is that such famous persons receive almost daily requests for writing or painting scrolls, the applicants supplying the silk or paper together with a suitable present. Ordinarily the artist does only those scrolls himself that are asked for by friends, relatives, connoisseurs, collectors and very important people; the others, mostly asked for some special occasion, he leaves to his *tai–pi* to deal with, authorizing him to employ his seals. In the latter case the applicant knows quite well that the scroll was not written or painted by the artist himself, but the offering of a scroll written or painted by someone else is not impolite as long as its brush work sufficiently resembles the artist's own and as long as it bears the true impressions of his seals. The applicant will be glad to suspend it in his hall since even such an imitation suffices to show his relatives and friends that the famous artist whose name it bears takes an interest in his affairs; and this was the main reason why he asked for the scroll.

However, when later such scrolls fall into the hands of unscrupulous dealers they will try to pass them off as originals. It is clear that in such cases the seals, being perfectly genuine, will lead the student astray instead of helping him. This also applies to

scrolls done by disciples of famous artists. If the master wishes to express his approval of his student's work he will often add thereto his own signature and seals. This point is discussed in greater detail on page 398.

Criteria supplied by special features of some seals.

Attention may be drawn to a few special features of seals that may provide clues to the authenticity of antique scrolls.

Many artists followed some fixed habits while impressing their seals. For instance, the scholar–artist Huang Tao–chou (黃道周, 1585–1646) did not use the ordinary seal pad but preferred the ancient way of moistening his seals with a mixture of vermilion and water; seals impressed in this manner are called *shui–yin* 水印 "water seals" (cf. page 420 below). Further, the Ming painter Shên Chou (沈周, 1427–1509) used a seal pad which contained a large quantum of mercury. Therefore the seal impressions on his hanging scrolls have nearly all turned black, whereas those on pictures mounted as hand scrolls or in the form of albums, being less exposed, have better retained their original colour.

It is important that a collector makes notes of such special features whenever he finds them, to be used for future reference.

Collectors's seals are often more instructive than those impressed on the scroll by the artist himself. Most collectors will change their seals on important occasions such as promotion in rank, changing their abode, changing the name of their studio, reaching the age of sixty, etc. Thus a comparison of the date of a colophon with the legend of the seal added to it may provide a clue to its authenticity; if X. reached the age of 80 in the year 1630, a colophon of his dated 1610 which has a seal attached to it reading "The old man of 80" is obviously a fake.

Further, according to an old–established Chinese custom one does not use vermilion for impressing one's seals when one is in mourning; then blue ink is used instead. This custom is still observed to–day. When in 1943 Lin Sen 林森, the President of China had died, all official documents were sealed in blue all through the prescribed period of national mourning.

Since the periods of mourning that occurred in the lives of prominent scholar–artists can be easily found out from their biographical accounts, the blue seals found on the works left by them may also provide clues to the authenticity.

The deciphering of seals.

A discussion of the methods for deciphering seal legends — a branch of epigraphy — would lead us too far from our subject. Here it may suffice to remark that as a matter of course a working knowledge of the " seal script ", *chuan–shu* 篆書, is absolutely necessary. Next to the well known Chinese and foreign handbooks one also needs for this study special seal script dictionaries, preferably those dating from the late Ming or early Ch'ing periods; [1] for those will record many quaint and fanciful variants that

---

1) For literature on seal script see below, page 421.

are dear to the seal engraver although they are not found in the more scholarly dictionaries of the later half of the Ch'ing dynasty.

Artists of the "iron brush" employ some abbreviations or unusual forms of common seal characters. Some of these are justifiable on epigraphical grounds, others would seem to be mere fancies, sanctioned by tradition. For instance, the character *chu* 主 is often represented in seal legends by a simple dot, the character *hsien* 軒 is written double, etc.

In order to acquire the necessary experience in deciphering seals one should work through one or more of the standard *yin-pu*, selecting those that give transcriptions of the legends in regular script. Further, a study of the publications by V. Contag and P. Daudin will prove very useful; these books are discussed on page 417 sq. below.

When a seal has been deciphered, its legend must be interpreted. It is hoped that in this work the reader will derive some help from the tables given on pp. 450 sq. below. Then the owner of the seal may be identified by referring to special dictionaires of styles, literary designations and studio names. [1]

<p style="margin-left:2em">Signatures.</p>

Also with regard to the reading of artists' signatures experience is the best master.

Signatures are usually written in a more or less cursive script. Next to the name or names of the artist they often also record the date, and an indication whether the scroll is a copy or an original creation.

In the case of original works the name of the artist is followed by *hua* 畫 or *hsieh* 寫 "pinxit", *tso* 作 "fecit" or similar terms. In the case of copies the signature is preceded by for instance *mu–mou–shih–mou–hua* 摹 某 氏 某 畫 "Copied after such-and-such a painting by X.". If the picture is a free interpretation or "paraphrase" rather than an exact copy one may find for instance *fang– (ni–, i, yung) mou–shih–fa* 仿 (擬 . 依 . 用) 某 氏 法 " in the style (or manner) of X. ".

Before or after the signature one will sometimes find a dedicatory message indicating that the picture was painted especially for a friend or relative of the artist. One may find there also other remarks stating that the scroll was done on some special occasion, for instance when the painter was traveling by boat, or having a meeting with his friends, etc. Since such additional remarks may supply clues to the authenticity of the scroll, Chinese connoisseurs check their contents whenever possible with the biographies of the artists concerned. They are also diligent readers of the literary works left by their favourite artists and will try to locate there the poems or prose texts the artists wrote on

<hr/>

1) I especially recommend the very complete *Ku–chin–jên–wu–pieh–ming–so–yin* 古 今 人 物 別 名 索 引, one foreign volume, published in 1937 by Ch'ên Tê-yün 陳 得 芸, of the Ling-nan University; this work, giving not only styles and library names, but also posthumous and other designations, has entirely superseded earlier lists like, for instance, the *Shih–ming–so–yin* 室 名 索 引, published in 1933 by Ch'ên Nai-ch'ien 陳 乃 乾. The Harvard-Yenching Institute has published in 1934 a special index for Ch'ing artists, entitled *Index to the fancy names of the calligraphers and painters of the Ch'ing dynasty* 清 代 書 畫 家 字 號 引 得 by Ts'ai Chin-chung 蔡 金 重, Sinological Index Series No. 21.

pictures acquired for their collection. They will often embody the results of such research in the descriptive catalogues of the scrolls collected by them.

In Japan there have been published some books with facsimile reproductions of the signatures of Chinese painters.[1] These books are useful for the purpose of identification but they have slight value as a help in deciding the authenticity of the signatures. As was pointed out above, nine out of ten Chinese falsifications are " complete fakes ", that is to say that the original has been copied out in its entirety together with its signature, seals, colophons and superscriptions.

In Wên Chên–hêng's description of how one should proceed when judging antique scrolls, a study of the silk and paper that served as canvas is mentioned last of all.

Chinese literary sources in general are rather vague as regards the kinds of silk and paper used by old artists. Wên Chên–hêng himself has the following to say on this subject:

" Painters' silk of the T'ang period has a rough texture and is thick, but at that time beaten and sized silk was also used occasionally; also single–shuttle silk of over 4 *ch'ih* broad. During the Period of the Five Dynasties (907–960) silk was very coarse, almost like ordinary cloth. , Under the Sung dynasty there was produced the so–called Academy silk [2] that had a very smooth surface and a close texture; also single–shuttle silk of more than 5 *ch'ih* broad and so fine that it resembled paper. Yüan silk and the silk used in the Palace of our present dynasty (i. e. Ming) is the same as that produced during the Sung period. During the Yüan period there was used so–called *Mi–chi–chuan* ' Silk from the looms of the Mi family '; artists like Chao Mêng–fu and Shêng Mou (盛懋, style Tzû–chao 子昭, Yüan period) often used this silk for their paintings. It is produced at Chia–hsing (Kiangsu Province), the place where the Mi family became famous as silk–producers. Nowadays Chia–hsing is still famous for the silk made there ". [3]

Another Ming source makes the following observations regarding silk scrolls of the Sung dynasty.

" The texture of the silk (of Sung paintings) has wasted and moreover it is affected by the paste applied to it (when being mounted) so that it has lost all its cohesive power. If you scratch off a little with your nail the silk will decorticate like flakes of plaster, the face and reverse of which show the same grey colour. But new silk that has been ' aged ' by dyeing will always show white threads if it is scraped off a little, and if

---

1) For instance the *Shina–gaka–rakkan–inpu* 支那書家落欵印譜, published Tōkyō 1902 by Saitō Ken 齋藤謙.

2) I. e. silk made for the painters working in the *Han–lin–t'u–hua–chü* 翰林圖畫局; cf. note 2 on page 191.

3) *Chang–wu–chih* (cf. Appendix I, no. 30): 唐絹絲粗而厚。或有搗熟者。有獨梭絹。布絹。極稀。亦有獨梭絹。元絹及松雪子昭家以絹得名。今此地尚佳者。絹密絹。如紙者。與宋子昭書。絹多用此。蓋出嘉尚有者。宋潤國時有宓嘉有宋。闊四有院五尺內機興府佳者。尺餘絹。勻細絹。俱松雪府。宓。

389

you try to peel it off with a knife it will not break up in flakes of plaster. This is the way to distinguish new silk from old ". [1)]

One will often find antique silk scrolls that show this wasted condition; they are the dispair of the mounter charged with repairing them. However, such scrolls need not necessarily date from the Sung period. Even late Ming or early Ch'ing scrolls will occasionally have this feature which must be ascribed to climatic conditions and the quality of the silk rather than to the great age of the scroll.

Further, one often hears that the silk of every dynasty had its own characteristic features. Since, however, literary sources often mention the fact that weavers of the same period living in different localities used different looms and weaving methods, such generalizations are evidently of limited application and can not be accepted as real proof. I here quote a pertinent passage from a book on antiques published by a modern curio dealer in Peking. I cite his theories for what they are worth.

" When one observes silk from the Sung dynasty through a magnifying glass it will be seen that there is not left the slightest trace of glossiness; it looks exactly like old hemp cloth that has been left lying about for many years. On its surface there does not appear any floss. New silk, on the contrary, will always have on its surface a layer of shiny floss which will not disappear no matter how often one boils or dyes it. Moreover every single thread has fine hairs resembling those on the body of a fly; genuine Sung or Yüan silk never has such hairy threads. Of silk from the early Sung period both the horizontal (woof) and vertical threads (warp) are single, although the woof is sometimes (so coarse as to) seem double. During the middle of the Sung period both warp and woof still consisted of single threads but slightly thicker than those used before.

" Coming to the Yüan dynasty, both warp and woof consisted of single threads, but the texture is closer and the threads finer.

" In the case of silk of the early Ming period, the warp consists of thin single threads, but for the woof double threads are used. In the middle of this period the threads of both warp and woof become more coarse, but the warp still consists of single and the woof of double threads. Its surface still does not show any gloss. Towards the end of the Ming dynasty and the beginning of the Ch'ing period both warp and woof consisted of double threads and a faint glossiness appears on the surface.

" As regards new silk, both warp and woof consist of double threads and these are flat. Its surface is glossy and covered with floss that can never be discarded. At present forgers have woven for them especially a kind of ' Yüan silk '; but one can see at first glance that it is different from that of the Sung or Yüan dynasty. No matter how many times one boils or dyes this silk its gloss will stay and its surface will remain covered

---

1) *Tsun-shêng-pa-chien* (cf. Appendix I, no. 28): 多 宋 畫 迄 今 其 絲 性 消 滅。更 受 糊 多。無 復 堅 韌。以 指 微 跑。則 絹 絲 如 灰。堆 起。表 裏 一 色。若 今 時 絹 素。以 藥 水 染 舊。無 論 指 跑。絲 絲 露 白。即 刀 刮 亦 不 成 灰。此 古 今 絹 素 之 辯。

with floss resembling that on fly legs, and there exist no means by which one could obliterate these features ". [1]

The tradition still living among Chinese connoisseurs supplies little help on this point. Aged scholars have in the course of their long lives often developed a kind of sixth sense for old silk and paper. Some go by touch, others go by their olfactory sense. The former will determine the age of old silk by softly rubbing it with their finger tips, the latter smell it. Although their determinations often prove to be very much to the point, such criteria must always remain rather individual.

Also as regards old paper we have few concrete data. Notes on the sizes and properties of various kinds of paper used by artists and mounters of former times are scattered over the preceding pages. About Ming paper I could supply some material for reference, and varieties dating from the Ch'ing dynasty will be found among the samples included in Appendix V. But for the earlier periods our knowledge remains largely confined to conjecture.

The conclusion is that the problem of judging old silk and paper is one of those few questions related to Chinese connoisseurship that might possibly be solved by utilizing the aids of modern science. If chemical experiments were made with selected T'ang, Sung and Yüan specimens emanating from the various famous producing centres of paper and silk we might at last arrive at the formulation of reliable standards for testing doubtful specimens.

Yet it must be remembered that even if it is proved by the incontestable results of a chemical analysis that the silk or paper of a given picture or autograph dates from the Sung or Yüan dynasty, this does not mean that the painting or calligraphy done on this material actually dates from the same period. In a country like China where for centuries antiquity and antiques have been regarded with nearly religious veneration, it is not too difficult to acquire blank sheets of antique paper, and unused rolls of old silk. Ming scholars often wrote or painted on Sung material, Ch'ing artists were proud to use Ming silk, and even at present Chinese painters and calligraphers often use paper dating from say the Ch'ien–lung period. It will be readily understood that this habit of bona–fide artists and scholars was all the more eagerly cultivated by professional forgers.

---

1) *Ta–ku–chai–ku–chêng–lu* (cf. Appendix I, no. 26, Chinese edition), pp. 79–80:

皆竪絹。橫雙。橫夫竪能元似。能更竪元業。仍初。若橫不種相不狀。時。明中絲清光。且終一絹終之橫元細。代橫末亮猶絨織之染腿始至且明單明有雙浮特元煮蠅絲造而雙。仍至稍皆光雖宋何猶絹稀迫亦絲亮流。與如毛。業粗己絲竪之者下。論絨中稍絲絲竪光上竪之者下。代絲其橫惟亮其橫上偽之無之宋竪惟細。仍稍仍雙不扁。今遼亮絲可單。橫仍絲上皆現。其絹法而惟仍絲竪絹。其絹新絲退雙單絲竪竪其竪新絲退無微皮上香元炭鏡未若一毛絨。似以層內而顯年絨現是絲之去紙苫辨與以與無仍一絕惟紙如剝夾有不且之光上煮上之單代上儗墨內白烏宋無異如絹宋竪宋如色亦色。毫無論且異。橫竪之其上墨假色。墨異絹舊絲蘇無猶照之。霜白作其無絹舊光。毛之鏡照之。食現其塗字黑之。之新絨蠅初猶蟲白。之照用夫層與宋

The above is offered as a commentary on the passage by Wên Chên-hêng quoted at the beginning of this section. Illustrations of the problems mentioned above will be found in Chinese collector's catalogues.

* * *

Collector's catalogues. Chinese bibliographers usually divide collector's catalogues in four main groups. They differentiate between catalogues of official and private collections, and the latter are divided again into those listing scrolls actually possessed by the compiler and those describing scrolls the publisher had seen or studied. For our purpose, however, it suffices to distinguish between two groups, viz. those catalogues that have merely theoretical value and those that are of practical use to the collector.

Catalogues for theoretical studies. Catalogues belonging to the first group describe items of so great rarity that one cannot reasonably hope ever to obtain a single scroll mentioned in them; such are in museums in China or abroad, or fixed family property. From a theoretical point of view these catalogues are most instructive. With a few exceptions the scrolls described are famous specimens the history of which can be traced back several centuries. During the Ch'ing dynasty many of such famous scrolls showing specimens of calligraphy were incised in wood or stone and published as rubbings. The best known collection is the *Yü-k'o-san-hsi-t'ang-shih-chü-pao-chi-fa-t'ieh* 御刻三希堂石渠寶笈法帖, published by order of the Emperor Ch'ien-lung. When he had obtained the *K'uai-hsüeh-t'ieh* 快雪帖 by Wang Hsi-chih, the *Chung-ch'iu-t'ieh* 中秋帖 by Wang Hsien-chih, and the *Po-yüan-t'ieh* 伯遠帖 by Wang Hsün (王洵, 350-401), he called one of the Imperial studios *San-hsi-t'ang* 三希堂 "Hall of Three Rare Specimens". The Emperor had these three autographs together with 29 others in the Palace Collection re-cut in wood and published them together under the title mentioned above (often abbreviated to *San-hsi-t'ang-fa-t'ieh*). At the same time there was published the *San-hsi-t'ang-fa-t'ieh-shih-wên* 三希堂法帖釋文, 16 ch. in six volumes, a block print which gives the transcriptions of all the autographs, with explanations. If one studies these two publications together one will be well prepared for further researches in calligraphy and antique rubbings.

As regards famous old paintings, in recent years many of these have become available in excellent photographic reproductions; I refer to the publications mentioned in note 1 on page 370 above. These reproductions of scrolls mentioned in the old standard catalogues can thus be studied side by side with the descriptions and critical remarks recorded in the catalogues themselves.

The most famous of Chinese collector's catalogues is the *Chiang-ts'un-hsiao-hsia-lu* 江村銷夏錄 by the Ch'ing painter and collector Kao Shih-ch'i (高士奇, 1645-1703), described in Appendix I, no. 44. Although this book is not without errors it is generally considered as the standard catalogue after which most later connoisseurs modelled their own publications. A study of this catalogue will facilitate the use of later works of the same nature.

After having studied the *Chiang-ts'un-hsiao-hsia-lu* one would do well to work through the *Shu-hua-chien-ying* 書畫鑑影 by Li Tso-hsien 李佐賢 which is described in greater detail in Appendix I, no. 51. This catalogue hovers on the boundary of the two categories mentioned above. Part of the scrolls listed did not belong to the compiler; some he saw in the collections of his friends or in curio shops, others he had not seen at all.

Since this catalogue lists a number of famous scrolls it should in a way be classified with books like the *Chiang-ts'un-hsiao-hsia-lu*. On the other hand Li Tso-hsien also included many scrolls from his own collection among which there are not a few which one may reasonably expect to find some day at a sale or in a curio shop. Therefore this catalogue next to its theoretical interest has much practical value as well. Since moreover the range of scrolls treated is wide — due attention being given to specimens from the Ming and Ch'ing periods — I recommend it to fellow students in this field, notwithstanding its many errors and misprints.

As a specimen of the contents of the *Shu-hua-chien-ying* I here translate the description of one item in ch. 19, selected at random from the scrolls in the compiler's own collection.

"Landscape by Jên Hsün. Hanging scroll. Painting on silk measuring 4 *ch'ih* 1 *ts'un* 7 *fên* by 2 *ch'ih* 5 *fên*. Done in a free manner, with heavy brush strokes; here and there touches of colour. In the lower half a forest of luxuriant trees in the shadow of which one sees a gate giving on a narrow mountain path that crosses a bridge. In the upper half of the picture high cliffs with a cascade coming down. On the brink of the mountain opposite there is sitting a man in a small pavilion who is looking at the waterfall. The brush work has an antique broadness and a simple strength which mark this painting as an excellent specimen.

Translation of one passage from a collector's catalogue.

"On top left the inscription: ' Painted by Chün-mou, called Lung-yen, on the third day of the seventh month of the year 1161 ' (two columns in running hand). At the end of the inscription an oblong seal in *po-wên*, reading ' Chün-mou '; further a square seal, also in *po-wên*, and reading ' Personal seal of Mr. Jên '.

"In the *shih-t'ang* the following superscription: ' Jên Chün-mou's personal name was Hsün, his literary designation was Nan-lu; son of Jên Kuei. [1] He was a man from I-chou (in Chih-li Province) who was born in Ch'ien-chou (in Kiangsi Province). Having in 1157 obtained the rank of *chin-shih* he served thereafter as a magistrate in Ch'êng-tu (Szuchuan), and as Salt Commissioner in Peking. He was a man of a noble and steadfast character whose paintings may be classified under the ' divine ' category. In landscape painting he followed Wang T'ing-yün, [2] and acquired the essence of his

---

[1] Jên Kuei 任貴, no details known except that he too enjoyed fame as a painter.

[2] Wang T'ing-yün, 1151-1202, famous scholar-artist who served under the Chin Emperor Chang-tsung; excelled in painting landscapes and bamboo.

master's style.   In his calligraphy he did not yield to the two Wang. [1]   Critics say that his painting is better than his calligraphy, his calligraphy better than his poetry, and his poetry better than his prose.   The above details are found in his biography in the *Dynastic History of the Chin Period*, in the section ' Scholars and artists '.

" Further, I find that there has been preserved a rubbing after a painting by Jên Hsün, representing old cedar trees; there he signs himself Lung–yen.   Now on the present scroll which was obtained by me in Hai–wang–ts'un [2] in Peking, he also signs himself Lung–yen.   Moreover the brush work of this scroll is strong and clear and is exactly the same as that found in the picture of the cedar trees.   I have no doubt, therefore, that this scroll is a genuine specimen of Jên Hsün's work.   Jên Hsün was in his own time already widely known for his talents with the brush; must not then a scroll like the present one which although painted in 1161, i. e. 725 years ago (correctly: 707 years.   Transl.) has been preserved undamaged, be called a great rarity?   I had it remounted and now treasure it like a precious gem.

" Inscribed in the autumn of the year 1868, by Li Tso–hsien named Chu–p'êng, from Li–chin (in Shantung Province).

" (Sixteen columns in running hand; two seals at the end I do not record) ". [3]

The above is an example of a rather brief description.   Often one item covers scores of pages; old works an art are quoted in extenso, the colophons and superscriptions are discussed, etc.

Reading through such a catalogue it not as dreary a task as one would imagine.   The artistic merits of the works listed are described in good literary style while the poems, essays and other inscriptions on the scroll — as a rule reproduced in full — contain many true gems of Chinese literature which are all the more interesting since they are often not found in other literary sources.   Moreover, the reader will come to know various odd bits of historical and biographical information useful for other researches.

Catalogues of the Palace Collection.

The catalogues of the Palace Collection published in former times are valuable mainly for theoretical studies since the greater part of the items described are lost.

---

1) I. e. the famous Chin calligrapher Wang Hsi–chih and his son Wang Hsien–chih; cf. above, page 138.

2) The well known curio–dealers quarter in Peking; cf. Appendix I, no. 52.

3)

人都大其高史有師與疑世年而裝利押

生勾節三於文古海古也況所絹潢津印

於判書畫昧書書傳行村行謀幅迄完球佐不

虞官入書書藝柏王柏君此作素當李二

北神法高又欵亦無書題今好琳賢竹

正京不於按署署異在已七損之朋

隆鹽山讓詩今龍欵其在己七歲百豈同題（行

丁使水二詩世嚴爲當秋百豈同題（行

丑爲師王高傳此嚴君時初二易治（行

進人王許於君畫筆謀己乃十親戊書十六

士歷人文謀得力眞名正乃戊書十六

慨慷篤謂見石於清跡震隆五重新（行）

益多得畫金刻京剛無一六年付秋（行）

州。　　　　　　　　　　　　　　　軸有木略一屬名

尺寫蔭高瀑。左　書

四筆下峯觀在　謀（長方印）。

本。分林。上坐蹟。嚴君（方

高粗林段而題君（長方印）。

絹五成幻。客名日龍（白文）。

水尺喬通中泂　　三（白文印）。

山二段徑亭勁　有尾任氏詩堂

君分色。小岸古　初押私印。號

謀寬下山方簡　　秋（行）　任君詩名詢。號南簏。貴子。易州

任七著對對蒼己二　上題任君謀在

一寸微門落法辛書　　任君謀上

意屋泉筆上（行書（白文）

Moreover, also these catalogues must be used with great discretion. The fact that a picture was entered into the Palace collection does by no means imply that it was a genuine specimen, nor that it was of superior quality; many items were accepted and listed merely because of the official status of the donor, or because of the Emperor's whim. Further, the compilers did not dare to express their opinion freely lest they offended the Emperor himself or some powerful person who had approved the scroll in question.

Yet catalogues such as the *Shih-ch'ü-pao-chi* 石渠寶笈, the *Pi-tien-chu-lin* 祕殿珠林 e. a. should not be lacking on one's shelves, if only for the purpose of reference.

Catalogues of practical use.

The catalogues belonging to this category are mostly of comparatively late date. Older collectors did not gladly publish a catalogue of their collection if they could not include a fair number of Sung and Yüan scrolls. But since the later half of the Ch'ing period collectors generally adopted a more catholic attitude and devoted much attention to Ming and Ch'ing artists, specimens of whose work are still available on the antique market in China and Japan.

As pointed out elsewhere in the present book, Western students until recently laid too much stress on the importance of T'ang, Sung and Yüan scrolls, at the expense of those dating from the Ming and Ch'ing periods. Catalogues that describe items by artists of the last four hundred years gain additional value because those descriptions can be compared with actual specimens which have a reasonable chance of being perfectly genuine.

This applies only to unpretentious catalogues published by serious Chinese collectors and connoisseurs. One should beware of a certain class of catalogues published during the twenties in Shanghai, sumptuously illustrated and provided with English explanations. Most of these were published by enterprising dealers who wanted to advertise their wares and attract foreign buyers.

Ferguson's index on collector's catalogues.

Since collector's catalogues exist in vast numbers, students used to have considerable difficulty in finding their way through this mass of sources. In 1933, however, John C. Ferguson published his excellent *Li-tai-cho-lu-hua-mu* 歷代著錄畫目, where thousands of items described in most old and new catalogues are indexed on the name of the artist to whom they are ascribed, each item being accompanied by a reference to its source.

Next to being useful for the purpose of reference, this work also provides instructive reading matter by itself. While leafing it through one will obtain an idea of conventional artistic motifs, of their technical appellations, which of those were preferred by what artists, and during what period. Further, if one takes together all items recorded under the name of a given artist, one will receive a fairly accurate impression of the scope of his artistic oeuvre.

In order to be able to use this index to its full advantage one should properly have near at hand all the catalogues and other works on which the index is based. This,

however, is not an easy proposition. Many of the books quoted are buried in lesser-known *ts'ung-shu*, others are of extreme rarity or exist in manuscript copies only. Students will have to content themselves with purchasing only the most important sources, leaving it to museums and research institutes to assemble a complete collection.

It should be remembered that the value of the works indexed varies greatly. The compilers of some catalogues were of a rather optimistic turn of mind and marked scrolls as genuine which in reality are subject to serious doubt; others on the contrary were more realistic and their judgement is worth a careful study. The *Li-tai-cho-lu-hua-mu* should therefore be used together with the *Shu-hua-shu-lu-chieh-t'i* 書畫書錄解題 (cf. Appendix I, no. 23) which supplies the critical material that could not be included in Ferguson's book.

Catalogue of the Old Palace Collection.

There exists an extremely useful descriptive catalogue of the Old Palace Collection, comprising the objects stored at Peking, Nanking and Shanghai in the late thirties. Unfortunately this book is difficult to obtain since it forms part of the documents printed for official use by the Chinese Ministry of Justice, in connection with the case of I P'ei-chi.

It will be remembered that in 1935 the then Director of the Old Palace Museum I P'ei-chi and two other museum officials were indicted for having stolen and smuggled abroad a large number of antiques belonging to the former Imperial Collection. The case was never decided and some of its ramifications were never entirely cleared up. This unfortunate case was an occasion for the Chinese government to have an inventory made of the entire collection.

The results of this investigation were embodied in a detailed critical catalogue, which was printed under the title of *I-p'ei-chi-têng ch'in-chan-ku-kung-ku-wu-an chien-ting-shu* 易培基等侵占故宮古物案鑑定書, in two bulky volumes. The first section of vol. I (pp. 1–310) covers 2145 scrolls checked during the first investigation made in Shanghai, the second section (pp. 1–62) 478 scrolls in Peking, and the third section (pp. 1–112) 516 scrolls checked during the second investigation in Shanghai. The first section of the second volume (pp. 1–136) describes 1029 scrolls stored at Nanking, the second section (pp. 1–64) 327 items, also in Nanking, while the third section describes 109 items in the secretariat of the Museum in Nanking. The rest of the volume is devoted to bronzes, jades, etc. Thus this catalogue covers a total of nearly five thousand scrolls. Since all the items were studied one by one, their authenticity tested and size, seals, colophons etc. carefully placed on record, this catalogue is a veritable mine of information on what, despite various vicissitudes, still is the most important collection of antiques in China.

\* \* \*

On copies and the Chinese view of authenticity.

A few words must now be said on the subject of originals and copies, and on the Chinese view of authenticity.

In China copies were — and are — made for either one of two purposes: for study or for gain. It may be assumed that copies made for the purpose of study and practice are much more numerous than those made with the express intent of producing a forgery. In the antique trade, however, these two kinds of copies merge: copies originally made for scholarly purposes may be passed off for originals by unscrupulous dealers, and students may knowingly purchase falsifications to be used as reference material.

Since early times a distinction is made between two methods of copying, viz. *mu* 摹 and *lin* 臨.

Various methods for making copies and their application.

*Mu* means copying a painting or autograph by laying a sheet of thin paper or silk over the original and then tracing it exactly with the brush. In the case of *lin* a sheet of silk or paper is laid side by side with the original and then the picture or text is copied out thereon. Thus *mu* might be described as producing a close, and *lin* as producing a free copy.

Next to these two methods there exist several others. Mention has been made already of the process called *shuang-kou* 雙鈎, that is to copy an autograph by tracing the outlines of the characters and filling the tracing subsequently with ink. Originally the term *shuang-kou* designated a special technique for incising an autograph into stone, the outlines of the characters being indicated by means of a thin double groove. It is used also for the painting technique where first outlines are drawn in ink which are afterwards supplemented by the addition of light colours.

Further, in the case of autographs much darkened by age the *hsiang-t'a* method may be applied. The original is stretched over a light wooden frame with a sheet of thin paper on top of it. The frame is then placed against the light and the text traced in the usual way.

Finally, there exists the *fên-lin* 粉臨 method which might be described as calquing. Benjamin March explains this method as follows: " The painting is traced in outline, then the tracing paper is reversed and the outline retraced in white. The paper is placed white side down on a new piece of silk or paper and rubbed with a damp cloth, transferring the white outline to the new ground. The term also indicates an exact copy, whether made by this process or not ". [1] I myself saw a slightly different method being practised in Peking and Shanghai that also went by the name of *fên-lin*. The main parts of the brushwork were traced on the reverse of the scroll with tailor's wax; then the scroll was spread out waxed side down over a piece of silk, and ironed with a flat iron. The same method is used by embroidery shops in Peking for transferring decorative designs traced on thin paper to the silk for guiding the needle work of the embroiderers.

Since olden times the copying of standard calligraphic specimens according to the *mu* and *lin* method has been considered an indispensable part of the training of the

---

1) Appendix I, no. 8, page 20.

calligrapher. It not only improves the student's handwriting but also is the method for making him familiar with the work of a given master. Already during the Sui and T'ang periods this was one of the approved pastimes of the refined scholar. As models for copying, rubbings of standard autographs, *fa-t'ieh* 法帖, incised in stone were preferred to originals. The fact that the white characters contrast sharply with the black ground facilitated the tracing process and one needed not be anxious lest the ink penetrate the thin tracing paper and thus soil valuable original autographs.

The above applies to painting as well. The copying of good pictures is the main discipline that will lead to a mastery over the brush. Disciples of some famous artist will for years on end do nothing but faithfully copy in all details the works of their master; they will not try to develop a technique of their own before having successfully completed this preliminary training.

This discipline was not confined to the period of novitiate. Accomplished masters of the brush would next to painting original pictures in their own style, continue to make close copies of works by famous old artists till the end of their days. We saw on page 188 above that everytime the Sung artist Mi Fu had borrowed a superior antique scroll from one of his friends he would immediately make a copy of it for his own reference — and often even try to return to the owner his copy instead of the original (p. 192).

<p style="margin-left:2em;"><strong>Attitude to copies of former artists and collectors.</strong></p>

Many painters will mark a copy made by them by adding a note to that effect to the picture. Others, however, would write on it only the inscriptions of the original including the signature of the artist.

This is not done with the intention to deceive others. The thought underlying this proceeding is that expertly made copies of antique scrolls are just as good as the originals or, in case the original is damaged, even better. One must take into account the desire inborn in every Chinese scholar to try to preserve the works of the ancients unimpaired for posterity. When reading old books a Chinese scholar will always have near at hand a vermilion brush for correcting misprints and supplying missing characters. [1] It is in this same spirit that a painter copies a famous old master piece together with its inscriptions and seals. For him it is important that such a work is preserved intact so that others again may enjoy it and profit by studying it; if he added his own signature of wrote his own remarks on it many critics would set this down as reprehensible presumption.

We have seen above that the Throne set the example. It is recorded in the *Szŭ-ling-shu-hua-chi* that in the Southern Sung period the mounters attached to the Palace had instructions to "age" copies made of antique scrolls, impress on them imitations of the original seals and mount them with the same material as the original scroll.

Since early times good copies have been valued as highly as original works of art. The same Sung source quoted hereabove states that the copies entered into the Palace

---

[1] Chinese blockprints which emanate from the collection of a well known scholar are much sought after because such books have the emendations and marginal notes added by the former owner.

collection were mounted and catalogued with the same care as bestowed upon original specimens. As a matter of fact Chinese connoisseurs never object to copies as such; they most emphatically object, however, to bad copies, pretentious copies and copies on which a forger has practised his tricks.

This being so it will be readily understood that a considerable number of the famous ancient paintings and autographs are now known to exist in duplicates or triplicates. The history of most of these scrolls can be traced back several centuries and their present owners can adduce various reasons why they opine that their particular scroll is the original one. To examine these duplicates together and compare their respective claims to authenticity is one of the many tasks that lie ahead.

How copies can be detected.

With regard to Chinese scrolls one will have to rid oneself of the idea that producing a copy of the work by an old master that is so good that it might deceive a connoisseur, presupposes on the part of the forger the possession of a complicated technical outfit and months of laborious toil. This view is justified with regard to antique Western paintings; most of our own old masters made their own colours and employed them in a peculiar manner the secret of which died out with them. In China, however, there is little basic difference between the media used by a painter say of the Sung dynasty and those employed by present-day artists; we saw above that brush, ink and paper underwent few changes during the last thousand years. And if one insists upon using the very materials of the artists of old, one may purchase from the antique dealer round the corner genuine Ming ink cakes and unused paper or silk of that period, while old-fashioned drug stores have in stock pigments used by generations of artists.

Fortunately there are but few forgers who have real artistic gifts; their greatest assets are a sensitive eye and manual skill, they lack the creative power of the real artist. Their work will therefore often lack the spontaneous strength of an original production.

Professional forgers will further often fail to recognize the " common denominator " that was discussed above, the subtle element that marks all the works by one and the same master as his own. For they have neither time nor inclination to study again and again the works of one old master. Chinese artists and connoisseurs will spend days over an antique painting, absorbing its every detail; this is called *tu–hua* 讀 畫 " to read a painting ". Their visual memory is so remarkably developed that after having studied a given picture for an hour or so they can often afterwards paint a good copy of it from memory. This is of course beyond the power of the average forger.

A modern connoisseur of Western painting makes the following observations concerning the difference between an original picture and a copy.

" The copyist, by contrast to the creative master, takes as his starting point a picture, not life; and is concerned with a vision already realized " (op. cit., page 234). " The truly creative master struggles with the task of projecting on the picture surface the vision which exists in his imagination... The copyist faces a task which is laborious and soporific, but, in his view, perfectly feasible. Before his eyes he has the artist's

projection, which constitutes the real task, and he requires only keenness of perception and skill in order to perform his work" (ibid., page 235). "The creative master stakes the whole of his intellectual and spiritual forces, the copyist only memory, eye and hand. Whoever feels the difference between growing and making is not going to be easily deceived. An original resembles an organism; a copy, a machine" (ibid., page 236). [1)]

It is not without interest to see in how far these remarks apply to Chinese painting.

The peculiar technique of Chinese painting implies that the artist's struggle for realization takes place in his imagination rather than on the canvas. The work of a Western painter, on the contrary, grows under his brush. As was pointed out above, a Chinese painter will, before taking up his brush, visualize the entire painting in his mind, he translates his impressions into type forms, arranges them in certain conventional patterns till the entire picture stands clearly before his mental eye complete with every detail; this process may take days, weeks or months. Then, when the inspiration comes he will transfer this vision to the silk or paper in a few hours or less, without much effort. As soon as he has moistened his brush this means that the struggle for expression is over, the rest is merely a question of technique. It is therefore that Chinese paintings show no pentamenti, no corrections, no obliterated or emendated brush strokes; if the artist finds that he has made a mistake he throws his work away and starts all over again.

It follows that in the case of Chinese copies and originals the difference between "growing and making" and between "organism and machine" so aptly formulated in the above quotation will be much less apparent than in Western paintings. Chinese copies usually show the same unwavering, decided strokes as originals. Where the copyist will often make mistakes, however, is in the interpretation of the master's brush work. For instance, some strokes may merge lightly into each other, some are piled up in one solid mass. The bona-fide copyist who is thoroughly familiar with the technique of the master he takes as model will have no difficulty in correctly analyzing such parts of the brushwork; but the professional forger will often be puzzled as to how the movement of the brush went. Consequently he will make mistakes or improvize in his own manner, and such spots in the brush work will not escape the eye of an experienced connoisseur.

Further, one of the most striking characteristics of a genuine picture by an old master is that the force of the brush work is sustained throughout; his individual style marks every detail of the painting. If he depicts for instance a meeting of lute players he will pay as much attention to the rapt expression on the faces of the player and the listeners

---

[1)] Max J. Friedländer, *On Art and Connoisseurship*, London 1942. The author — well known as an authority on Western painting — gives several other felicitous formulations of problems concerning the appreciation of pictorial art in general while he goes also into considerable detail with regard to forgeries and copies. Hence this book is recommended also to students of Chinese pictorial art, for a general orientation. It should be born in mind, however, that the author knew very little about the pictorial art of the East. This appears with distressing clarity from for instance the following passage: "Painting in Asia, even in its finest performances, does not know that thirst for space, which in Europe led to the realization of the laws of perspective. Painting in Asia cultivates the flat surface and decoration" (op. cit., page 67).

as to the cluster of bamboo that forms the background, and the small servant boy with the tea stove in the corner. But a copyist although tracing the central group assembled round the lute player with painstaking care, will often relax his effort while doing those parts that are not directly connected with the subject of the picture; there his own brush technique will intrude upon that of the old master and thus betray him.

However, the above observations apply only to productions of mediocre copyists. Copies produced by a forger who at the same time is a gifted artist will be nearly impossible to detect. This is a fact every collector will have to keep in mind.

Since both bona- and mala-fide copying have been practised in China for many centuries, we will have to resign ourselves to the fact that at least one third of the scrolls ascribed to famous masters of the Ming and Ch'ing dynasties now preserved in public and private collections are copies, while as regards older scrolls the proportion is anybody's guess.

This fact does not unduly distress the Chinese connoisseur; he prefers a good copy of a superior antique painting to a genuine old scroll of mediocre quality. The modern art-historian, however, will of course find it difficult to share this detached view. Although we can agree that an exact copy of an old master can be considered as reliable material for the study of his brush-technique, we want to be sure that it *is* indeed an exact copy. And that is precisely the point which in the present stage of our studies can not be decided.

The difficulty of deciding the authenticity of an antique scroll on its own merits makes it all the more necessary to study its past history. Specimens that have passed through the hands of several generations of connoisseurs who all approved of it have a reasonable chance of being genuine; and even if one should have doubts about their authenticity, one can at least be certain that it are superior and old copies made by experts.

The provenance of antique scrolls.

When, on the other hand, one is confronted with an antique scroll about the provenance of which nothing is known, one has to start from the very beginning and without any material for comparison with one's own opinion.

If an antique scroll has attached to it a genuine colophon signed by a well known collector or connoisseur and if it is certain that this colophon belongs to that scroll; and if it has been ascertained that picture and colophon are not a "complete fake", then one has at least a good starting point for a critical study of that scroll.

The first step is then to verify the scholarly standing and reputation of the connoisseur from whose collection the scroll emanates. It would lead us too far afield to describe here the many avenues of research that might be explored. Here it may suffice to repeat that not all famous collectors were discreet in their attributions.

For instance, the Ming collector Hsiang Yüan-pien (項 元 汴, style Tzŭ-ching 子 京, lit. name Mo-lin 墨 林, 1525-1590) owed his fame mainly to the enormous amount of scrolls assembled by him. He cannot have cared much for the authenticity

**401**

of his acquisitions and seems to have aimed at quantity rather than quality. There exist numerous scrolls really emanating from his collection that are patent fakes. Not to speak of the countless scrolls on which shady dealers impressed his seals just because he was so well known that even inexperienced buyers would recognize them.

The Ch'ing scholar Wêng Fang-kang (翁 方 剛, lit. names Tan-hsi 覃 溪 and Su-chai 蘇 齋, 1733-1818; cf. E. C., page 856) was a great expert in epigraphy but he did not know much about antique pictures. Therefore although autographs approved by him are as a rule superior specimens, the pictures emanating from his collection should be judged on their own merits. Apart from the fact that also his seals and colophons are frequently forged by unscrupulous dealers.

The Vice-roy Tuan Fang (端 方, lit. name T'ao-chai 陶 齋 1861-1911; cf. E. C., page 780) had ample means and stood high in the favour of the Manchu Court. Although he himself was not a great connoisseur he associated with eminent scholars and artists of that time and often profited by their advice when buying antiques; therefore his collection contained not a few excellent specimens. However, since he was a high official with great influence he was flooded with scrolls and other antiques presented to him by persons who sollicited his favour. Many of those objects, though of doubtful authenticity, were entered automatically in his collection by his secretaries who duly impressed on them their master's seals. Thus the fact that an item comes from Tuan Fang's collection does not guarantee its high quality or authenticity.

On the other hand there were many other collectors who were more particular in their choice and whose judgements deserve careful consideration. To this class belong those collectors whose catalogues are listed in Appendix I of the present publication. Below I mention four other connoisseurs who justly enjoy a high reputation.

In the first place the collector Liang Ch'ing-piao (梁 清 標, lit. names Chiao-lin 蕉 林, T'ang-ts'un 棠 村 etc., 1620-1691), a Ming scholar who later served under the Ch'ing dynasty. He was an authority on the appraising of antique pictures, and scrolls bearing his genuine seals are nearly always genuine specimens of superior quality.

The same may be said of Sun Ch'êng-tsê (孫 承 澤, lit. names Pei-hai 北 海, T'ui-ku 退 谷 etc., 1593-1675; cf. E. C., page 669), a great scholar, archeologist and collector. He published a catalogue of his collection entitled *Kêng-tzû-hsiao-hsia-chi* 庚 子 銷 夏 記 "Notes written to idle away the summer of 1660" which gives reliable information. He usually marked the items in his collection with a seal reading T'ui-ku 退 谷 or Yen-shan-chai 研 山 齋.

However, both Sun Ch'êng-tsê and Liang Ch'ing-piao are so well known that their colophons and seals were zealously copied by professional forgers. It is worth while, therefore, to make a special study of collectors who, although not very well known, yet were discerning and conscientious connoisseurs. I mention, for instance, the calligrapher and seal engraver Wu Yün (吳 雲, lit. names P'ing-chai 平 齋 and T'ui-lou 退 樓, 1811-1883); he marked most of the scrolls in his collection with the seal *Erh-po-lan-t'ing-chai-shên-ting* 二 百 蘭 亭 齋 審 定. Also the calligrapher Yang Hsien (楊

峴, style Chien-shan 見山, lit. name Yung-chai 庸齋, 1819–1896) had a very select collection; but his name is not known to the average curio dealer.

Since especially in the last decennia of the 19th, and the first of the 20th century Japanese collections were more accessible than those in China, the majority of the antique Chinese scrolls now preserved in Western public and private collections were obtained from Japanese sources.

This being so, Western students will find it useful to have some information on the history of Chinese scrolls in Japan. The quality of the scrolls imported from China varied greatly in different periods, and the standard of Japanese connoisseurship of Chinese pictorial art showed considerable fluctuation. Since the Japanese have always attached great importance to the provenance of antique scrolls while moreover Japanese records of artistic matters are remarkably complete and easily accessible, it is as a rule not too difficult to trace the antecedents of an antique Chinese scroll after its arrival in Japan. It is hoped that the survey given hereunder will assist the reader in evaluating these data.

Since early times the great Japanese centres of the China trade were located on the island of Kyūshū, opposite the coast of central China. In the older period of direct Sino-Japanese intercourse it were places like Karatsu 唐津, Hakata 博多 and Hirado 平戶 that did a flourishing trade with the China ports; since the beginning of the 17th century all China trade was concentrated in Nagasaki, by order of the Tokugawa Shogunate.

Japanese connoisseurs divide imported Chinese antiques into three classes according to the period during which they reached Japan. These are:

ko–watari 古渡 "old arrivals", viz. antiques brought to Japan during the Kamakura and Ashikaga periods. This class comprises Sung and Yüan antiques.

chūko–watari 中古渡 "later arrivals", viz. Chinese antiques that reached Japan during the first half of the Tokugawa period; mainly items of the Ming dynasty.

kinsei–watari 近世渡 "new arrivals", referring to Chinese objects imported during the second half of the Tokugawa and during the Meiji Period. This class comprises Ming and Ch'ing antiques, with occasional items from older periods.

Chinese objects of the Sui and T'ang dynasties are mostly in the collections of the Government or of old temples; they are considered as outside the sphere of the collector and the dealer.

Ko–watari scrolls are without exception valuable, apart from their artistic quality and regardless of whether they were really painted by the masters whose signature appears on them. For we can at least be sure that they date from the 12–14th century and

as such these scrolls provide invaluable material for comparison. It is true that Japanese painters, especially those of the Kanō School, time and again copied these Chinese originals but their copies can as rule easily be recognized and most of them are known as such.

As to the quality of *ko–watari* scrolls, this problem may be reduced to two questions, viz. first, what kind of scrolls the Chinese exported during that period, and second, what was the standard of contemporary Japanese connoisseurship. As regards the first question, at that time the most important Chinese port for the Japan trade was Ningpo, on the mouth of the Yangtse River. As this port was the market of South Kiangsu and North Chekiang where were located such well known centres of artistic life as Hangchow, Nanking etc., Ningpo traders had good opportunities for purchasing superior scrolls. Further, since the crossing to Japan was hazardous, many Chinese junks perishing in storms or being seized by pirates, it was not worth the trader's while to ship to Japan inferior specimens or evident fakes; for the proceeds of such items would hardly have covered their capital outlay. On the other hand the Chinese dealers were well aware of the fact that the Japanese demand was limited to certain classes of scrolls. The nobles in Kyōto wanted Chinese scrolls bearing signatures and seals of Chinese artists who were famous also in Japan; further, scrolls that represented subjects approved by the tea masters and that were of a size suitable for being displayed in the *toko–no–ma*. The Ningpo traders had therefore to concentrate on monochrome landscapes by Hsia Kuei, Ma Yüan, Mu Hsi etc., on still lifes and flower pieces by Chao Ch'ang or Ch'ien Hsüan, autographs by the Emperor Hui–tsung etc. As most of such scrolls were much sought after also by contemporary Chinese collectors it can be readily imagined that not a few copies found their way to Japan. However, such copies must have been very superior ones, produced by the best experts in Hangchow — a fact that did not facilitate the task of the Japanese connoisseur.

Later Japanese art–historians have a high opinion of the connoisseurship of Ashikaga tea masters, such as for instance the Ami trio mentioned on page 243 above. However, if one reads through the notes left by these Ashikaga connoisseurs and compares them with those Chinese scrolls approved by them that are still preserved, one obtains the impression that this favourable opinion is not entirely justified. It is evident that the knowledge of Chinese Sung and Yüan painting as possessed for instance by Sō–ami, was rather limited. His *livre de chevet* was the *T'u–hui–pao–chien* (cf. Appendix I, no. 40), a book that records only the most famous artists and gives but scant information on their work. Further, at that time Chinese antiques in general were comparatively rare in Japan; material for comparison — so important in the judging of old works of art — was practically unavailable. Most Japanese connoisseurs were of the opinion that any scroll if of Chinese origin was *ipso facto* a superior specimen. Moreover, the three Ami were too much inclined to accept seals and signatures as decisive proof of authenticity while they had but a rather vague idea about the individual styles of Chinese painters. Consequently many of their pronouncements regarding quality and authenticity of Chinese scrolls seem given *ex cathedra* and should not be accepted at their face value.

A restraining influence was exercised by learned Chinese immigrant priests, especially those of the *Go–zan* 五 山, the five great Japanese centres of the Ch'an school. Literary sources show that for instance Nō–ami had close relations with some of these Chinese abbots; it may be assumed that in questions of the authenticity of Chinese scrolls he often referred to their opinion. Thus I am inclined to attach much value to Nō–ami's opinion on Chinese scrolls painted by Chinese Ch'an masters like Mu–hsi or Yü–chien. Further, much confidence can be placed in the judgements of Japanese connoisseurs of that time on Chinese scrolls by painters such as the monk Yin–t'o–lo who never acquired fame in China but became very popular in Japan. Later collectors, however, will have to be on their guard against Japanese copies.

From the notes left by the tea master Takeno Shō–ō (see above, page 263) one can see how high the prices were of Chinese scrolls towards the end of the period under discussion. I quote a few items from Shō–ō's book *Bōgetsu–shū* 望 月 集 where he also quotes the prices of a number of other paraphernalia of the tea room.

Picture of Pu–tai 布 袋, by Mu–hsi (牧 溪, S. Sung period): 30.000 *hiki*. [1]
Monochrome ink–painting by Hsia Kuei (夏 珪, flourished about 1200): 15.000 *hiki*.
Picture of apples, by Mu–hsi: 50.000 *hiki*.
Pair of still–lifes by Wang Yüan (王 淵, better known by his literary nam Jo–shui 若
    水, flourished about 1350): 10.000 *hiki*.
Small still–life by Ch'ien Hsüan (錢 選, ± 1250): 40.000 *hiki*.
Still–life by Chao Ch'ang (趙 昌, ± 1000), slightly damaged: 10.000 *hiki*.

As to *chūko–watari* scrolls, these are of mixed value and quality. At that time the China trade had become better organized and the crossing from the continent involved less risks; therefore the Chinese exporters were less particular in their choice of scrolls destined for Japan. Landscape pictures imported during this period almost inevitably bear the signatures of Shên Chou, Wên Chêng–ming etc., while paintings of birds and flowers show the name of Lü Chi, Chou Chih–mien and so on; often these Chinese copies are of poor quality. Moreover, Japanese artists also copied again these copies, so that nowadays one will find scrolls of this kind in nearly every Japanese antique shop.

Although the influx of Chinese copies and mediocre specimens steadily increased, the connoisseurship of the Japanese tea masters remained largely on the same level: they still judged Chinese scrolls mainly on the basis of signatures and seals. Therefore Chinese scrolls belonging to this class should be appraised with great caution.

An exception must be made, however, for scrolls bearing notes written by Chinese Ming refugees and priests who came to Japan in the end of the Ming and the beginning of the Ch'ing period. Among the former I mention the famous loyal Ming scholar Chu

*Chūko–watari scrolls.*

---

[1] One *hiki* 疋 equals ten *mon* 文. The *mon* is a small monetary unit, often translated as "penny". In medieval Japan money was scarce and the purchasing power of one *hiki* must have been roughly that of 25 dollar cents.

Chih-yü (朱 之 瑜, better known by his literary name Shun-shui 舜 水, 1600–1682) who became the teacher of a Japanese Prince and had great influence on Japanese scholarship of that time. The priests belonged mostly to the Ch'an Sect and nearly all of them were good painters and calligraphers. I mention Yin-yüan (隱 元, born 1592, arrived Japan 1654, died 1673), Mu-an (木 菴, born 1611, arrived Japan 1655, died 1684) and Chi-fei (即 非, born 1616, arrived Japan 1657, died 1671), round whom gathered a large number of Japanese priests and laymen as disciples. These men where also often consulted in Chinese artistic matters.

Kinsei-watari scrolls.

Scrolls of the *kinsei-watari* class are still more mixed than those of the *chūko-watari* category. However, by this time Japanese connoisseurs had learned to differentiate among the various Chinese schools and artists, and Chinese books of artistic reference had become more easily obtainable. The Tokugawa government exercised a strict censorship on all Chinese books imported into Japan, but their vigilance regarded chiefly books on Christianity and military matters; they were rather lenient as regards works on fine and applied art. Hence also lesser-known books on these subjects became accessible to Japanese students.

Especially during the Gen-roku period (元 祿, 1688–1703) many of these imported Chinese books were reprinted in Japan. One of the first works on Chinese pictorial art reprinted was the *Hua-chu* 畫 塵 by the Ming scholar Shên Hao 沈 顥. In 1769 a Japanese edition of this book was published by Kimura Sen-sai (木 村 巽 齋, better known by his literary name Kenka-dō 兼 葭 堂, 1736–1802), a famous physician and bibliophile at Osaka. Thereafter followed reprints of the *Ming-hua-lu* (cf. Appendix I, no. 53), *Chiang-ts'un-hsiao-hsia-chi* (ibid, no. 44), and numerous other Chinese books on painting and calligraphy.

Chinese artists at Nagasaki.

Further, during the 17th century many Chinese artists visited Nagasaki. They had scores of Japanese pupils who next to painting also learned from them much about the methods of Chinese connoisseurship. Although on the whole these Chinese visitors — with the possible exception of Shên Ch'üan — were mediocre artists they knew of course much about the antique trade in their homeland and could give their Japanese acquaintances and pupils useful information. It must be remembered that Nagasaki was then the only link between Japan and the rest of the world; all other ports were closed to foreign vessels in accordance with the Seclusion Policy of the Tokugawa Shogunate. Thus the Dutch Factory (蘭 舘 Oranda-yashiki) and the Chinese Factory (唐 人 舘 Tōjin-yashiki) became a kind of Mecca to contemporary Japanese from all over the country who were eager to obtain first-hand information on Western science or Chinese culture. The small Chinese colony of merchants with its sprinkling of mediocre artists and scholars exercised a disproportionately large influence on cultural life in the Japan of the Tokugawa period.

The best artists among the Chinese in Nagasaki were Shên Ch'üan 沈 銓, Fei Lan 費 瀾 and Wang P'êng 汪 鵬, all three of the Ch'ien-lung period.

406

Shên Ch'üan's style was Nan-pin 南蘋, his literary name Hêng-chai 衡齋; he arrived in Nagasaki in 1731. Although a good painter of animals — especially deer and cranes — his landscapes are of indifferent quality. His pupil Chêng P'ei 鄭培 became known as a painter of animals and flowers.

While Shên Ch'üan seems to have been a professional painter, his contemporary Fei Lan (style Han-yüan 漢源) was an accomplished scholar. He was an excellent calligrapher and many of his landscapes are above the average. A painter's handbook compiled by him in three illustrated volumes was published in Japan in 1789 under the title *Fei-shih-shan-shui-hua-shih* 費氏山水畫式.

Wang P'êng, style I-ts'ang 翼蒼, literary name Chu-li-shan-jên 竹里山人 was one of the minor Ch'ing painters and poets. He painted in the traditional literary style, was a fair calligrapher and wrote poetry that has a slight Ming dynasty flavour. Wang P'êng came to Nagasaki for the first time in 1764 and revisited the Chinese Factory several times thereafter, each time purchasing rare Chinese books and manuscripts preserved in Japan. He left a description of the Chinese Factory which draws a vivid picture of the hectic life of the Chinese confined in this small settlement. [1]

Others such as Chang Hsin 張莘, better known by his style Ch'iu-ku 秋谷 (arrived in Nagasaki in 1780), Chiang T'ai-chiao 汪泰交 styled Ta-lai 大來 (better known by his literary name Chia-pu 稼圃; arrived in Nagasaki in 1804) etc. were genre-painters in the traditional styles. Among them there were colourful characters such as I Hai 伊海, styled Fu-chiu 孚九 who was the captain of a Chinese junk that plied between Ningpo and Nagasaki from 1726–1746, and who next to painting rather striking ink-landscapes was also interested in some mild forms of piracy; or Ch'êng Ch'ih-ch'êng 程赤城 who used to pay regular visits to Nagasaki, only because he had conceived an excessive proclivity to Japanese *saké* and salted vegetables!

Shên Ch'üan, Fei Lan and Wang P'êng had much experience in the appraising of Chinese scrolls. But the connoisseurship of the others cannot have been very impressive. I have in my collection a hand scroll where the Ming scholar Wu Wên-hua (吳文華, style Tzû-pin 子彬, *chin-shih* in 1616; cf. *Ming-shih-tsung* 明詩綜, ch. 44) wrote out in a good cursive hand Li T'ai-po's poem *Ts'ao-shu-ko-hsing* 草書歌行 which celebrates the calligraphy of the T'ang monk Huai-su 懷素. Plate **140** is a photograph of the end of the scroll where one sees the last three characters of the poem, viz. *hun-t'o-wu* 渾脫舞, and the writer's signature *Hsiao-chiang-wên-hua-shu* 小江文華書, accompanied by his two seals, the upper one giving his style Tzû-pin, and the lower one reading *ping-chên-chin-shih* 丙辰進士 "*Chin-shih* of the year 1616". This scroll came to Japan in the 17th century. The Japanese owner addressed a request to two Chinese in Nagasaki, Ch'êng Ch'ih-ch'êng mentioned hereabove and a certain Lu Ch'iu-shih, asking them for their expert opinion on the scroll. They sent him a letter in reply,

[1] This treatise, entitled *Hsiu-hai-pien* 袖海編 was published by me in an annotated Japanese translation in *Tôa-ronsô* 東亞論叢, Tokyo 1941.

together with a " testimonial " written on wine–coloured wax–paper; both documents were placed in the box of the scroll and are reproduced on Plate **141**. The letter says:

" I have taken cognizance of your kind inquiry regarding the date and other particulars of Wên Tan, style Tzû–pin, literary name Hsiao–chiang. This man belongs to the Ch'ing period, he became a *chin–shih* in the 15th year of the K'ang–hsi era (1676). He was a descendant of Wên Chêng–ming of Ch'ang–chou and excelled in calligraphy, mastering the hereditary style of his ancestor. At present the people of China still venerate him. This note is presented in reply ".

Thus Ch'êng Ch'ih–ch'êng mistook the character *hua* 華 for *tan* 單, thought that the writer's family name was *Wên* 文, and declared this imaginary person " Wên Tan " to be a descendant of Wên Chêng–ming!

The Chinese artists at Nagasaki are important chiefly because they represented the link between Japanese connoisseurs of Chinese art of that time, and the living Chinese artistic tradition. Their own work obtains additional interest because some 18th century members of the Dutch Factory purchased a few of their pictures and brought them back to Holland. Although these scrolls remained completely unnoticed, they yet can claim to be the first specimens of real Chinese paintings to reach Western shores. As was relevated already in the Preface of the present publication, examples of Chinese " pictorial art " that were introduced into Europe directly from Canton consisted at that time of painted wall paper and " rice paper pictures " made for export.

During this period the judging of Chinese scrolls, heretofore considered as the exclusive right of the tea masters, gradually passed from their hands into those of artists and Sinologues. As a result the later years of the Tokugawa period produced some Japanese connoisseurs of Chinese pictorial art in whose judgement confidence can be placed. Chinese scrolls accompanied by authentic appreciations written by famous Japanese painters like Ikeno Taiga (池野大雅, 1723–1776), Tanomura Chiku–den (田野村竹田, 1777–1835), and by calligraphers such as Ichikawa San–gai (市河三亥, 1777–1854; cf. Appendix I, no. 77) are as a rule superior specimens.

The Meiji Era.

Finally, when after the Meiji Restoration in 1868 Japan's international relations had been placed on a normal basis, the import of Chinese goods assumed enormous proportions. Although the impact of Western culture had somewhat diminished Japanese interest in " things Chinese ", there was still a brisk trade in Chinese antiques, including antique paintings and autographs. Japanese Sinologues and collectors established direct contact with their colleagues on the main land and thus learned the critical methods of Chinese traditional connoisseurship. Since during this period the restrictions on foreign trade were suspended there were imported into Japan a tremendous number of inferior Chinese scrolls. Thus the Japanese connoisseurs had ample opportunity for applying their acumen, and attained to a high standard of art criticism. Unless a Chinese scroll imported after 1868 is accompanied by a testimonial of one of the prominent Japanese connoisseurs, it must be viewed with great caution.

140. – SECTION OF A HAND SCROLL OF THE MING PERIOD
(Author's Collection)
(2/3 of original size)

141. – TESTIMONIALS REGARDING THE SCROLL REPRODUCED ON PLATE 140.
ABOVE: ALLEGED NAME OF THE ARTIST, WRITTEN ON A PIECE OF ORNA-
MENTAL WAX PAPER OF REDDISH–BROWN COLOUR. BELOW: LETTER, WRITTEN
ON YELLOW WAX PAPER

During the Meiji period there were in Kyōto, Tōkyō and Ōsaka some large Japanese trading firms that dealt exclusively in Chinese antiques and had close relations with leading houses in China. One of the best known was the *Hayashiya-yōkō* 林屋洋行. This firm suspended business many years ago but one will at present still find in Japanese curio shops Chinese antiques in boxes that bear the mark of this house. It will nearly always be worth while to examine such antiques carefully, for the wares sold by the Hayashiya-yōkō were generally of superior quality.

The above digression will have proved how necessary it is for a collector to be able The importance of recognizing Chinese and Japanese mountings. to decide at a glance whether the mounting of a scroll is Chinese or Japanese. For pictures and autographs emanating directly from China, and those that became available via Japan must be approached in a entirely different manner. It is therefore that in the First Part of the present publication so much space was devoted to the characteristic features of Chinese and Japanese scroll mountings.

When appraising a Chinese scroll mounted and bought in China that has no colophons or seals of former collectors one has, so to speak, to start from scratch. However, in the case of an antique Chinese scroll mounted and bought in Japan, one begins with the advantage that the item in question has already passed certain initial tests; the value of such tests depends upon the time when they were made, and the person who made the decision.

The history of such a scroll is recorded by the seals on the picture itself and on the box it is kept in, and by the inscriptions on that box; and in the documents that accompany the scroll. These features have been already described in the First Part. Once these data have been sorted out it is comparatively easy to locate information about the former owners. As is well known the Japanese have always had a veritable passion for recording details, and their biographical literature is no exception to the rule. It is but very rarely that one will fail to identify a former owner of a scroll, even if one has only one collector's seal to go by.

Further, in the case of scrolls unaccompanied by any documents and which have no seals or inscriptions by former collectors, the mounting alone will provide a number of clues to follow up. Japanese mountings can be dated with greater precision than Chinese ones; when its date has been established one knows for certain that the scroll was imported into Japan before that date. If the *terminus ante quem* was for instance 1850 one may safely assume that the scroll is at least no mere rubbish, for prior to that date entirely valueless Chinese pictures were not exported to Japan. If the brocade of the mounting has an inwoven heraldic design, such a crest can usually be traced. If it should prove to belong to a feudal lord or official Sinologue (*jukan* 儒官) residing in Kyūshū one may assume that the picture is of fairly good quality; for the feudal lords and the *jukan* of Kyūshū had close relations with the China–trade and would not have a scroll mounted with brocade showing their crest if they did not think it of more than average quality.

The mounting of an antique scroll being of so great importance, I consider it a serious shortcoming of practically all Western illustrated books on Chinese pictorial art

that the mountings of the pictures are not reproduced. It is true that the mounting takes up so much space that in a reproduction of the entire mounted scroll the picture itself is reduced to such a small size that even a folio–size photograph will fail to do justice to it. This problem, however, is easily solved by giving two photographs of every item, viz. one that reproduces the entire mounted scroll, and one giving only the picture itself. Failure to do so means that one witholds from the reader vital data for the judging of the scroll — a task so complicated and hazardous that every scrap of additional information must be utilized. [1]

<span style="float:left; font-variant:small-caps; font-size:small">Historical survey of art–criticism.</span>

This chapter may be concluded with a historical survey of Chinese connoisseurship — necessarily very brief and over–simplified, for this is a field where much research remains to be done.

Viewed from a Western standpoint, the history of Chinese criticism of pictorial art might be divided into four main periods, viz. (1) from early beginnings till the end of the T'ang dynasty, (2) the Sung and Yüan dynasties, (3) the Ming dynasty and the early part of the Ch'ing dynasty, and (4) from ca. 1700 till ca. 1900.

<span style="float:left; font-variant:small-caps; font-size:small">Early period.</span>

In the early phase of art–criticism pictorial art was considered as an expression of certain moral precepts, and art–critics judged scrolls primarily by the degree in which they achieved that aim. Their terminology was a mixture of loans from Confucian pronouncements and the critical vocabulary of calligraphy. Already in the 5th century some critics took note of the fact that especially autographs of famous calligraphers were often copied and faked, but they did not seem greatly perturbed by this. Their chief concern was that the works of the great masters would be preserved for the education and edification of coming generations; whether those works were preserved in originals or in copies was considered of secondary importance. In fact I suspect that the word *chên* in the term *chên–chi* 真蹟 "true specimen" often meant "true to the original" rather than "genuine". It should be noted, however, that with regard to the majority of famous paintings then existing, the problem of authenticity did not arise; for in those days larger pictures were preferably executed as murals in palaces and temples and hence their authorship was common knowledge.

The officials in charge of the various Palace collections, then as later considered to provide the standard for superior pictorial art, adopted the same indifferent attitude to originals and copies. The *kuan–pên* 官本 "government–owned scrolls" of the Liang (502–557) and Sui (590–618) dynasties contained a large number of copies, and we saw in the above that also in the T'ang period Palace officials had copies made on a large scale, artificially ageing them and carefully imitating inscriptions, seals etc. of the antique originals.

---

1) Japanese curio dealers are well aware of the importance of the mounting of a scroll. The illustrated sales catalogues published at regular intervals by the "Tokyo Fine Arts Club" (Tōkyō–bijutsu–kurabu 東京美術倶樂部) reproduce all of the more important scrolls together with their mounting.

In the later half of the T'ang dynasty the evolution of monochrome free–style painting facilitated the process of copying and tracing pictures; just as in the case of autographs the copyist could concentrate on reproducing the brush stroke, there was no need to worry about the artist's colour palette. Next to bona–fide copies there circulated also an enormous number of forgeries. Chang Yen–yüan, the famous art–critic of that period, evaluated paintings on a broader basis, next to grading the artists according to their ability, as done by his predecessors, he also took into account more concrete data such as verisimilitude, historic accuracy, and even the prices their works fetched. But the production of copies he placidly places on record as a matter of course.

This tendency to attach more importance to the transmission of works of art than to their authenticity, characterizes what might be called the " traditional school " of art–criticism.

In the turbulent period of the Five Dynasties (907–960) that intervened before the advent of the Sung dynasty, large numbers of antique scrolls disappeared while the production of copies and forgeries flourished.

Thus in the beginning of the second period copies and forgeries probably outnum- <span style="float:right">Second period.</span>bered originals. Yet the " traditional school " prevailed, art–loving Emperors like Hui–tsung and most Palace officials in charge of artistic matters were rather indifferent to authenticity problems, as witnessed i. a. by the uncritical character of the Hsüan–ho catalogues of autographs and paintings. And we have seen that the *Szü–ling–shu–hua–chi* plainly states that a considerable number of the scrolls in the Palace collection were copies.

At the same time, however, some Sung connoisseurs started to protest against this state of affairs. Alarmed by the increasing number of inferior and pretentious forgeries, they feared that if the current tolerant attitude was not checked, this would jeopardize the faithful transmission of the works of the ancients. Men like Mi Fu, Huang Po–szû, Su Shih and Chao Hsi–ku gave special attention to authenticity problems, and Chao Hsi–ku advises to study later works because dependable material for the older ones was too scarce. Mi fu was most outspoken in voicing his doubts about the authenticity of many well–known antique scrolls circulating in his time and his statements, couched in original and forceful language, had a salutary influence on contemporary collectors. This in the beginning of what might be called the " critical school ".

We should be careful, however, not to ascribe to the founders of this school modern Western ideas. They objected to forgeries and copies, but not because they thought that a work signed by a given master should actually have been painted or written by him; their chief objection, especially to clumsy copies and forgeries was that these were so far removed from the original that if they were not discarded the spirit of the old masters would become lost. Mi Fu's writings prove clearly that he did not object to copies as such; as we have seen on the preceding pages, he himself was a diligent copyist.

During the Yüan period the " traditional " and " critical " schools continued to exist side by side, but the latter was gaining on the former. Great scholar–artists like

<div style="text-align:right">411</div>

Chao Mêng-fu and his son Chao Yung, and literati-painters like K'o Chiu-szû made extensive studies of authenticity problems and investigated the antecedents of antique scrolls in contemporary collections. Although they began to stress the calligraphic brush stroke as the main criterium for paintings, they also paid due attention to historical accuracy and other data, thus continuing and developing the principles laid down by the Sung dynasty art-critics.

Third period.   In the third period, the Ming dynasty and the beginning of the Ch'ing dynasty, these studies were unfortunately set back again several centuries. Partly as a reaction to the alien Mongol rule that had just been overthrown, a large-scale inventory of self-styled pure Chinese culture was undertaken. This implied a general tendency to over-rate antiques, both genuine and faked, everything that was or seemed old was considered part of the national heritage. To cast doubt on the optimistic attributions of pseudo-archeologists, or on the authenticity of the objects in the extensive collections that were now being built up was considered nearly sacrilegious. The veneration of national culture engendered an unprecedented flourishing of fine and applied art, but critical studies languished. Since the "literary painting" in free style predominated, the criticism of all pictorial art was deemed the exclusive privilege of the literati, a man of wide book-learning being *ipso facto* considered as qualified to pronounce authoritative opinions on antique autographs and pictures. Thus a famous scholar-artist like Tung Ch'i-ch'ang could decide authenticity problems *ex cathedra*, although his critical acumen, and even his ability as a calligrapher and painter, nowadays are thought to have been grossly overrated by contemporary and Ch'ing writers. Tung Ch'i-ch'ang and other critics like Ch'ên Chi-ju and Mo Shih-lung devoted in their writings much space to the classification of old painters into various carefully circumscribed schools, often a quite artificial differentiation that at present is no longer thought acceptable. The ancient ethical criteria for appraising scrolls were replaced by a set of mystic concepts, a mixture of Neo-Confucianist and Ch'an thought — an attitude that found much favour with a former generation of Western students but which does not represent that of the older Chinese art-critics. Authenticity problems were neglected or treated in an amateurish manner, the "critical school" was advocated mainly by a few eccentrics whose opinions at that time remained practically unnoticed. Thus this period was marked by a triumphant revival of the "traditional school".

This situation continued unchanged during the early years of the Ch'ing period. The indiscriminate collecting of the preceding dynasty had created additional difficulties for critical research. In the first place, the lack of a really dependable standard of comparison was even more marked than in the Sung and Yüan dynasties. The officially approved standard consisted of a number of antique scrolls designated as *ming-chi* 名蹟. A *ming-chi*, lit. "famous scroll", is a good autograph or painting signed by a well-known old master, preserved in fair condition, and the antecedents of which are placed on record. These *ming-chi* were traditionally considered as representing the highest

achievement in pictorial art of all times. But centuries of various vicissitudes had played havoc with them, a considerable number were copies or forgeries. Obviously a critical re–appraisal of old pictorial art would have to start with the *ming–chi*, but these were not accessible to the average student. Most of them were in the Palace collection, and the rest mainly in the hands of some prominent families. Private collections were open only to close friends of the owner, and reproductions of antique paintings in wood–engravings gave but a very general idea of the brush work of the originals. One had to be either a Court official or a very prominent person in order to be able to see the *ming–chi*. And even if one could see them, to question their authenticity was a risky undertaking. The Manchu rulers were eager admirers of Tung Ch'i–ch'ang and the other Ming critics, they accepted their opinions and even modelled their own calligraphy on theirs; they were hyper–sensitive to direct or implied criticism of their Chinese learning, and especially of their taste. Not a few scholars who wrote indiscreet lines that could be interpreted as questioning these were summarily executed together with their entire families. And also the autographs and pictures in the collections of high Chinese officials and persons of wealth and influence had to be discussed with great circumspection; for they also were extremely jealous of their reputation in artistic matters — a real or supposed knowledge of which was now an indispensable social requirement.

This being so, the *ming–chi* remained a kind of myth, carefully recorded, extensively documented, continually referred to — but actually seen and studied by few. The average connoisseur had to base his critical researches on scrolls of lesser fame which could be seen in the collections of friends and acquaintances, or on the curio market. As a result many collectors began to pay greater attention to the more accessible works by later or unknown artists.

Literati of an independent mind had initiated in the early years of the Ch'ing Fourth period. dynasty already a school of textual criticism, that during the second part of that dynasty had acquired considerable influence in the Chinese scholarly world and encouraged a general tendency to re–appraise national culture on historical principles. Connoisseurship of pictorial art benefitted indirectly from this movement. Eminent archeologists like Wu Jung–kuang (1773–1843), learned bibliophiles like Lu Hsin–yüan (1834–1894) extended their interest to antique scrolls, and critically–minded collectors like Lu Shih–hua (1724–1779) began — however discreetly — to challenge the heretofore unassailable position of the *ming–chi*. Collectors became more discreet with regard to the attributions of their autographs and pictures, they placed on record details also of Ming and Ch'ing masters, and stressed the importance of artists who, although through various reasons not well known, were as good as many an ancient painter. A beginning was made to sift the heterogeneous mass of older art–literature, and although checking of descriptive passages with the actual antique scrolls was in most cases impossible, regarding post–Yüan works much was done to clarify the documentation in

contemporary sources. Thus the second half of the Ch'ing dynasty witnessed a revival of the " critical school " which took up the work where the Sung and Yüan connoisseurs had left off.

As to subsequent developments, after 1900 Western scholars and collectors began to show interest in old Chinese pictorial art. But the great Chinese collectors were loath to show their scrolls to foreigners, and curio dealers could obtain better prices for their choicer items on the Chinese market. Thus Western students had to base their researches on second-rate material, or on data obtained in Japan; and the antique scrolls that found their way to the West were, with a few exceptions, of questionable quality.

In the Twenties the Palace Collection became accessible, Chinese collectors became somewhat more liberal in showing their treasures, the unstable political situation obliged many leading families to bring their collections on the market, and the spread of collotype printing made many *ming-chi* available in reproductions. But this favourable situation was not at once utilized. In the West the study of Chinese pictorial art was still mainly in the hands of art-historians without sinological training, and the Sinologues — with some brilliant exceptions like E. Chavannes and P. Pelliot — showed little interest in the subject. On the Chinese side there was some reluctance to take advantage of the new data that had become available, and a marked hesitation to study the authenticity of well-known antique scrolls in an unbiased manner. Especially among the older connoisseurs reasons of personal prestige still interfered with frank discussions of authenticity problems, and they often ignored unconventional Ming and Ch'ing artists whose work could not be judged by traditional standards.

Thereafter the ever-increasing number of sinologically trained Western art-students raised the standard of Western contributions in this field, while at the same time some modern-minded Chinese connoisseurs started to study Western art-history and published their views in Western languages, thus joining the work done in Chinese art-historical research by Japanese scholars. There is now a growing cooperation between East and West that augurs well for the future. However, there still is the barrier consisting of different art-critical method and different art-terminology; evidently the goal aimed at should be to establish for Chinese pictorial art a new method and a new terminology, that combines the results of Western and Chinese knowledge and experience in the field of art-historical research. If the present publication would help at least to lower that barrier somewhat and thus promote mutual understanding and cooperation between Western and Oriental workers in this field, I would consider my purpose in publishing these notes attained.

Close cooperation is necessary, for present-day critical studies of Chinese old pictorial art are still in the preparatory stage. The modern art-critic finds himself still confronted on the one hand with an enormous mass of antique scrolls of undetermined authenticity, and on the other with an equally enormous mass of largely unsifted art-literature.

The task ahead is a formidable one. As regards art-literature the situation is improving. Qualified scholars are studying the older texts, and the tools for appraising

414

later documentation, including catalogues, are there. Concerning the antique scrolls, however, there is less reason for optimism. It is true that many scrolls are now available for study, but they are scattered over public and private collections all over the world, and their number is still small when compared with that of the total actually preserved but as yet inaccessible or not yet located. We can study what we find within our reach, but it should never be forgotten that the investigation of one scroll, or of one mixed group of scrolls, can only be of limited scope; it is only by comparison on a broad basis that one can eventually arrive at final results. As many as possible of the preserved works ascribed to one given master must be studied together and, more in particular, all known replicas of one and the same famous antique scroll should be examined lying side by side. One cannot arrive at a definitive result by studying, for instance, a Sung picture in a Western museum, comparing it with a photograph of a replica in a Japanese collection, and with a description of what seems a third replica recorded in a Chinese collector's catalogue; one must actually see those three items together, in the same room and on the same table. As a matter of course such a project is not easily achieved, it necessitates international cooperation on government level, and museums and collectors East and West would have to coordinate their efforts. If one thinks of all the difficulties involved, both of a practical nature and those connected with politics and prestige, one greatly doubts whether such ambitious plans can be realized in the foreseeable future.

Yet in my opinion it will be only when there has been brought together a standard collection of authentic antique autographs and paintings that have passed all tests known to traditional Chinese connoisseurship and modern Western science, that we can begin to obtain a real insight in old Chinese pictorial art, and that we can decide authenticity problems with confidence. For only then shall we have obtained a standard of comparison, without which all work in this field must needs bear a provisional character.

# CHAPTER II

# THE CONNOISSEURSHIP OF SEALS

THE CHINESE SEAL, besides supplying secondary clues to authenticity problems, has considerable artistic value in itself. The carving of seal legends is a special aspect of calligraphy, and as such the seal impression has always been considered in China as a specimen of pictorial art.

In China and Japan there are organized at regular times special exhibitions of seal impressions, in exactly the same way as of pictures and autographs, and most painters and calligraphers are at the same time experts in seal carving, the "art of the iron brush".

The ability to judge the artistic merit of a seal and to interpret it correctly, and to determine its relation to the scroll it is impressed on, definitely belongs to the many disciplines a Chinese connoisseur must be thoroughly familiar with. If one aims at seeing an antique scroll through his eyes, one must be able to see also the seals impressed on it as he sees them.

Western literature on Chinese and Japanese seals is not very extensive.

In 1889 R. Masujima published a brief note on seals in the " Transactions of the Asiatic Society of Japan ", entitled *On the Jitsu-in or Japanese legal seal* (cf. vol. XVII, part II). Thereafter, in 1895, F. Hirth discussed in his *Bausteine zu einer Geschichte der Chinesischen Literatur* (T'oung Pao, vol. VI, page 326) the collection of seal impressions *Chi-ku-yin-pu* which is mentioned on page 428 below, and in 1917 Anna Bernhardi published an illustrated article entitled *Chinesische Stempel* in the Baessler Archiv which despite many mistakes is still useful as a general introduction.

The first book on the subject was published in 1937 in Saigon, namely *Sigillographie Sino-Annamite* by Pierre Daudin. It consists for the greater part of translations of old and later Chinese sources chosen at random, and hence must be used with discretion. The book starts with a translation of an essay on seals written by the modern Chinese connoisseur Huang Pin-hung 黃賓虹 which appeared in 1930 in the semi-popular Shanghai monthly *Tung-fang-tsa-chih* (東方雜誌, English subtitle "Eastern Miscellany "); this article does credit to the scholarship of its author but now has become dated through more recent studies by Ma Hêng, Lo Chên-yü e. a. Then follows the translation of an anonymous article in the same monthly, of slight importance. This is followed by several passages culled from the encyclopedia *Ko-chih-ching-yüan* (see above, page 51), and from the *Li-yüan-ts'ung-hua* (see above, page 280, note 2), and a note on the so-called " Seal of the Empire ". Daudin then again translates a number of popular articles on seals from Chinese newspapers, and concludes the Chinese section of his book with a list of literary quotations which are often found on seals. It would have been

417

better if the author instead of translating these heterogeneous notes and articles had tried to write a systematic survey of the subject himself. The last section of the book deals with Annamite seals and to a certain extent makes up for the deficiencies of the first part. Here the reader will find much information on seals and the art of seal carving in Annam, data which heretofore were inaccessible for students living outside Indo–China.

Daudin also published a *yin–pu* of a minor seal engraver of the 18th century, under the title *Recueil de cachets sur la Montagne Jaune*, Saigon 1932.

The most important work on this subject is the comprehensive handbook in Chinese and German by Victoria Contag and Wang Chi–ch'üan 王季銓, entitled *Maler– und Sammler–Stempel aus der Ming– und Ch'ing Zeit* (Chinese title: *Ming–ch'ing–hua–chia–yin–chien* 明清畫家印鑑), published by the Commercial Press in Shanghai, 1940. This is a collection of thousands of seals used by prominent artists and collectors, reproduced photographically from scrolls in Chinese private and public collections, and from *yin–pu*. Each item is headed by a note on names, date, career and works of the owner of the seals; every seal legend is transcribed and the source indicated. Thus this is a most useful manual for the study of Chinese seals in general, and an indispensable reference–book for the collector of scrolls. The seal impressions represent all types and styles one can imagine, and a comparison of the seals on a scroll one is studying with those listed here will often give important clues to authenticity problems. [1]

It is to be regretted, however, that the introductory remarks are very brief. The history of the seal is passed over in silence and the seal script, seal pad etc. are treated but very cursorily. Further there occur not a few wrong readings of seal inscriptions, while some characters that are pronounced undecipherable might have easily been identified by an expert; the painter and seal carver Fu Pao–shih 傅抱石 has listed nearly a hundred emendations in his excellent review of this book, published in the literary supplement of the Chinese newspaper *Shih–shih–hsin–pao* 時事新報, Chungking edition, Jan. 26 and Febr. 2, 1942. As it is, this book is a mine of information, well printed and systematically arranged.

In 1940 Rudolf Kelling published an illustrated article on Chinese seals entitled "Chinesische Stempel", in *Buch und Schrift* (Jahrbuch der Gesellschaft der Freunde des Deutschen Buch– und Schrift–museums, Neue Folge, III, Leipzig 1940). This essay is written in a popular vein, the historical discussions are unsatisfactory. The seals re-

---

1) W. Cohn in his book "Chinese Painting" (cf. Appendix I, no. 3, page 87, note 191) grossly underrates the value of this book. He says: "But the question arises: Is it necessary for Westerners to become familiar with such a large number of seals of, very often, second–class masters? Is it really useful to become familiar with 105 seals of Kao Feng–han (1683–1743), with 149 of Hung Wu (late 18th century), or — most of all — with no less than 193 seals of the painter and collector Ch'ing Kao–tsung, to mention only some oustanding examples?" The answer to these questions is of course in the affirmative, at least if instead of "to become familiar with" one reads "to have access to" — which represents more correctly Dr. Contag's aim in publishing this book. Moreover, the implication that one should study only "first–class masters" reflects the now completely dated view of Western art–historians of the Twenties. That Cohn did not recognize in "the painter and collector Ch'ing Kao–tsung" the Emperor Ch'ien–lung is an awkward mistake that ought not to occur in a serious publication.

produced are of very unequal quality, while moreover there occur numerous mistakes in the interpretation of the legends.

In Chinese and Japanese there exists an extensive literature on the seal, comprising books and treatises dating from the Sung dynasty upwards. Some of the most useful ones are mentioned on the following pages.

Seals were in general use in China well before the beginning of our era. Old literature often refers to them as *hsi* 璽 鈢, a term that after the Ch'in dynasty (221–206 B. C.) is used exclusively for the Imperial seal; in pre–Ch'in times, however, *hsi* was the common term for "seal" in general. Later terms are *yin* 印, *chang* 章, or *yin–chang* 印 章. Less usual are *yin–hsin* 印 信, *yin–chi* 印 記, *chu–chi* 朱 記, *ch'ien–chi* 鈐 記 and *ch'o–chi* 戳 記. Terms like *t'u–chang* 圖 章 and *t'u–shu* 圖 書 though frequently used are said to be less correct and therefore avoided by many connoisseurs. [1]

The early seals were made chiefly of bronze or jade and occasionally of gold and silver. Their tops were modeled in the shape of a dragon, a tortoise, bear or some other animal of auspicious associations. A few of these early seals have been preserved, but whether or not their legends were engraved at a later date is a moot problem; they mostly give official titles.

Thereafter archeology supplies more dependable material. Seals dating from the Han period (206 B. C. – 220 A. D.) have been preserved in sufficient quantity for studying these "classical" examples in detail.

Bronze and jade are still the most common materials. Seals consisted of a plaque of bronze, usually about one inch square — contemporary literature refers to seals as *fang–ts'un* 方 寸 — and less than half an inch high. Since it would be difficult to hold such a flat seal firmly, the plaque was provided with an ornamental knob pierced by a hole. Through the hole was passed a silk band or cord that ensured a firm grip when the seal was being impressed. This band was utilized also for fastening the seal to one's girdle. The technical term for the top of a seal is *niu*, written 鈕 when one wishes to indicate the knob itself, and 紐 when one thinks chiefly of the band attached to it. The knobs had the shape of unicorns, dragons, tigers, three–legged frogs and other fabulous or real animals.

Han seals were made for utilitarian purpose only. They served to authenticate official documents, deeds, and written contracts and were also a symbol of authority. Accordingly the greater part of Han seals preserved have as legend the name of an official function; these seals are called *kuan–yin* 官 印 "official seals". Those bearing a proper name, the so–called *szŭ–yin* 私 印, during this period form a small minority.

1) According to some Chinese sources — for example the *Ku–chin–yin–shih* 古 今 印 史 — the use of the term *t'u–shu* in the sense of "seal" derives from the fact that collector's seals often read *mou–shih–t'u–shu* 某 氏 圖 書 "Pictures and autographs of Mr. So–and–so", and that thus people came to believe that *t'u–shu* meant "seal". This, however, seems a very simplistic explanation; the question is worth a closer examination. Cf. the *Ch'ü–yüan–tsa–tsuan* 曲 園 雜 纂 by the Ch'ing scholar Yü Yüeh (俞 樾, 1821–1907; E. C., page 944), ch. 36, page 13, and also his *Ch'a–hsiang–shih–ts'ung–ch'ao* 茶 香 室 叢 鈔, ch. 9, page 13.

In those early times documents consisted of bamboo tablets bound together with thin ropes; a clot of clay was placed on the knot, and the seal was impressed in it while the clay was still soft; hence the expression *fêng-ni* 封泥 " to seal with clay ". Remains of wooden tablets still showing such clay seals have been discovered in Kansu Province; for although paper became the common writing material during the Chin period (265–420 A. D.), for several centuries afterwards the wooden and bamboo tablets remained in use for official documents, especially in the outlying parts of the Empire. [1] References in Chinese literature to wax seals have led some writers to believe that in olden times seals were occasionally also impressed in clots of wax. This, however, is a mistaken notion; modern Chinese archeologists are agreed that those passages refer to replica in wax of official seals that were buried together with a dead official.

The legends of both *kuan-yin* and *szŭ-yin* usually appear in intaglio, so that in an impression made with an ordinary seal pad the characters show in white on a red ground; hence such seals are referred to as *po-wên* 白文 " white legends ". Some Chinese sources aver that during the Han period all seals were of the *po-wên* type and that seals made according to the reversed technique, later called *chu-wên* 朱文 " red legends " (i. e. that in an impression made with a seal pad the characters appear in red on a white ground) were not used till the Period of the Six Kingdoms (220–557 A. D.). This theory seems reasonable enough if one takes into account that *po-wên* seals make better impressions in clay than those with *chu-wên* legends. But it is not supported by archeological evidence: although most of the Han seals preserved have *po-wên* legends, those with *chu-wên* legends are by no means rare.

*Po-wên* seals are also designated as *yin-wên* 陰文 " negative legends ", and *chu-wên* seals as *yang-wên* 陽文 " positive legends "; this, however, is a later usage that dates from the time when seals were no longer impressed in clay. Originally *po-wên* seals were called *yang*, because in the clay impression the characters would appear in relief, while the term *yin* was applied to seals with *chu-wên* legends. [2]

After silk and paper had come into general use as writing material seals were impressed on it after having been inked with a red pigment. Vermilion was ground with water and the seal moistened with the mixture; such seals are known as *shui-yin* 水印 " water seals ". Since this pigment was too thin to produce a clear impression, some people ground the vermilion with honey; hence the term *mi-yin* 蜜印 " honey seal ". As a further improvement the vermilion was with mixed with oil.

The vermilion seal pad is a comparatively late development, it dates from the Hsüan-ho period (宣和, 1119–1125) of the Sung dynasty. It consists of punk of moxa (*Artemisia moxa*, Chinese *ai* 艾) mixed with oil and vermilion powder till one obtains a thick, plastic substance; placed in an appropriate porcelain vessel it is used much in the same manner

---

1) Cf. Ma Hêng's instructive study " On seal carving " (馬衡, 談刻印), in *Anniversary Volume of Wu Ching-hêng*, Chungking 1944.

2) Cf. also the *Ch'a-hsiang-san-ch'ao* 茶香三鈔

by Yü Yüeh (note 1, p. 419); Benjamin March's statement in his *Some Technical Terms of Chinese Painting*, nos. 284 and 285, stands in need of correction.

420

as our stamp pad. [1]    Red was preferred to other colours because seals inked with this colour could be impressed over signatures etc. written in black ink without obliterating them or giving rise to confusion.

The legends of Ch'in and Han seals show a calligraphic style derived from the writing used in everyday life during the Chou, Ch'in and part of the Han dynasty, and called *chuan-shu* 篆書.    Since it is this style of writing that is used till the present day for seal legends, *chuan-shu* is commonly rendered in English as " seal script ".

There exist several variants of this script, but all are based on three main forms. First, the " great seal script ", *ta-chuan* 大篆, also called *chou-wên* 籀文 after its reputed inventor, the Chou minister Shih Chou 史籀; this style is said to have been in common use during the later half of the Chou dynasty.   Second, the " small seal script ", *hsiao-chuan* 小篆 (also called *ch'in-chuan* 秦篆), which is said to have come into use during during the Ch'in dynasty and remained popular during part of the Han period. And third, the *miu-chuan* 繆篆, a calligraphic style that has extra bends and coils, and is used exclusively for seal legends. [2]

I remark in passing that this classification was established by later Chinese writers and is based on the high lights of Chinese calligraphy; they left out of consideration the Chinese script as it was used in former centuries for practical purposes by average writers. The entire problem of a historical classification of the Chinese script stands in need of a

1) A detailed description of the composition of the seal pad will be found in *The Chemical Arts of Old China* (Appendix I, no. 18).

2) Of Western handbooks on the seal script I mention JOHN CHALMERS, *An account of the structure of Chinese characters under 300 primary forms* (London 1882), and L. WIEGER, *Chinese Characters* (Ho-kien-fu 1915); these books should be used only for identifying seal characters; since they give only the later Chinese explanations — mostly of a secondary character — they should not be used for epigraphical studies.   For the latter Bernhard Karlgren's *Grammata Serica* (Bulletin of the Museum of Far Eastern Antiquities, Stockholm 1940; reprinted Peking 1941) is the best source.

There exists an enormous literature in Chinese on the various kinds of seal script; here are mentioned only a few of the more important works.   As regards *ta-chuan*, most sources dating from before the 19th century are unreliable; they are based on inscriptions in bronze and stone which were largely spurious.   The first scholarly handbook of *ta-chuan* was published by the famous epigraphist Wu Ta-ch'êng (吳大澂 1835-1902; cf. E. C., page 880), under the title of *Shuo-wên-ku-chou-pu* 說文古籀補. Additional material was published by the archeologist Jung Kêng 容庚 in his *Chin-wên-pien* 金文編.   I further mention works by other modern scholars such as the *Ku-hsi-wên-tzû-chêng* 古璽文字徵 by Lo Fu-i 羅福

頤, and the *Ku-chou-wei-pien* 古籀彙編 by Hsü Wên-ching 徐文鏡.   A very comprehensive Japanese publication is the Kochū-hen 古籀篇, published in 1918 by the Japanese epigraphist Takada Chūshū 高田忠周.

The basic manual for *hsiao-chuan* is the *Shuo-wên* 說文, compiled about 100 A. D.; the best edition is that published by the famous Ch'ing epigraphist Tuan Yü-ts'ai (段玉裁, 1735-1815; cf. E. C., page 782) and entitled *Shuo-wên-chieh-tzû-chu* 說文解字注.   There exist numerous older and later editions; all the more important of these are incorporated in the monumental *Shuo-wên-chieh-tzû-ku-lin* 說文解字詁林, published in 1928 in Shanghai by Ting Fu-pao 丁福保.

The best handbook for *miu-chuan* is the *Miu-chuan-fên-yün* 繆篆分韻 by the calligrapher and epigraphist Kuei Fu (桂馥 1736-1805); later scholars published sequels to this work.

On *fêng-ni*, seals impressed in clots of clay, Ma Hêng published a beautifully edited work called *Fêng-ni-ts'un-chên* 封泥存眞 (Commercial Press).

The above-mentioned books should be used for advanced studies in Chinese epigraphy and for solving some exceptionally difficult problems offered by seal inscriptions. In most cases, however, smaller works on the subject such as T'ao Yü's *Chuan-shu-tso-yao* (陶郁, 篆書撮要) will be found sufficient.

thorough revision which takes into account the epigraphical data that came to light in recent years, especially the material discovered in Central Asia and Tun–huang. For our present purpose, however, the traditional classification suffices.

Artistic value of Han seals.

Seal makers of the Han period were just artisans, they do not seem to have made a conscious effort at achieving esthetic effects. Yet the artistic impulse that inspired the Han people made also these seals finished works of art. It would seem that artists and artisans of the Han period simply could not make anything that was not beautiful. To-day still Han seals are considered as the classical example and everyone who aspires at becoming an expert seal carver starts his practice by copying Han seals.

It should not be too much of an effort to learn to appreciate seals. One will soon perceive that the esthetic rules that apply to seal legends are largely the same as those that govern painting and calligraphy. After some study of this subject one will readily understand why Chinese connoisseurs esteem a good seal as highly as a good painting, and one will realize the truth of the much-quoted line: " This space of one square inch naturally comprises hills and dales " 方寸之內自有邱壑.

In the following a few hints are given as to how to judge the artistic merits of Han seals.

Plate **142** (*a*) is an official seal of the Ch'in dynasty, here given only for the purpose of comparison; its legend reads *Tso–chung–chiang–ma* 左中將馬. A cross divides the seal into four separate parts; some scholars consider this as a distinctive feature of seals of that period. Apart from a certain air of " antique rusticity ", this seal has not much artistic appeal.

The seal marked (*b*) is an official seal of the Han period, reading *Pu–ch'ü–chiang–yin* 部曲將印. This is a better seal that is made attractive by its irregularity, stressed by the broken strokes of the characters. Since the characters are evenly spaced — each filling out completely one quarter of the entire surface — the irregularity does not harm the balanced composition; on the contrary, it prevents the seal from becoming lifeless.

The third seal, marked (*c*), is a master piece; it is an official seal that reads *Chün–ssû–ma–yin* 軍司馬印. It immediately gives an impression of great strength because the vertical axis of three of the four characters is heavily stressed, in *chün* by making the central vertical stroke extra broad, in *ssû* by giving the element *k'ou* 口 and the two strokes on top more width than the perpendicular stroke on the right, and in *ma* by linking up the central stroke of the upper part with the third dot from left in the lower part. If also in the character *yin* the vertical axis had been stressed, the seal would have become monotonous; therefore in this character stress is laid on the horizontal lines. Notwithstanding the thick lines and the angular style this seal gives an impression of light grace. This is due to the fact that the legend is, as it were, centrifugal, the strokes near the periphery are appreciably thinner than those near the centre of the seal. The missing left edge is doubtless intentional; it further accentuates the centrifugal tendency and lends this seal a pleasing quality of spaciousness: the characters seem on the point of escaping

A

B

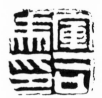

C

D

E

142. – CHINESE SEALS (CH'IN, HAN, T'ANG)

A

B

C

D

E

143. – CHINESE SEALS (SUNG, YÜAN)

from the limits set by this small surface. This is generally considered as one of the greatest Chinese seals that have been preserved.

The fourth, marked (d), is a private seal of the Han period, reading *Ch'ên-tê* 陳德. This is a mediocre seal. No attempt has been made to balance the two characters properly, and white and red are not harmoniously divided; as a result the seal has become rather flat and expressionless. Yet it has a casual air that is not easy to imitate.

It will be noticed that all the four seals described have legends in *po-wên*, and that three of them are " official seals ".

Seals with auspicious legends.

A class by itself is formed by the so-called *chi-yü-yin* 吉 語 印 " seals with auspicious legends "; these served mainly as amulets. Instead of name or rank, their legends consist of some auspicious phrase, for instance *ta-li* 大 利 " great advantage ", *fu-lu* 福 祿 " happiness and riches ", etc. Others bear the name of a Taoist saint or deity, for instance *t'ien-huang-shang-ti* 天 皇 上 帝.

Such seals were carried suspended on one's girdle to bring the owner good luck and to protect him against evil spirits. The philosopher Ko Hung (葛 洪, better known as Pao-p'u-tzû 抱 朴 子, 250-330 A. D.) states that a large seal bearing a long magical inscription was taken along while traveling. He says:

" In olden times people who ventured into the mountains would carry on their girdle the seal ' Huang-shên-yüeh-chang ' (" Excellent seal of the Yellow Emperor " ?), measuring four inches and bearing 120 characters, which they would impress on clots of clay and place on all four sides of their resting place, a hundred feet apart; then tigers and wolves would not dare to come near this area ". [1]

From this passage one would conclude that impressions of such seals were used also as charms, against evil influences in general; probably they were impressed on gates, door posts etc.

Some later connoisseurs impress such seals on the scrolls in their collection as a curiosity, and perhaps also to protect the pictures against insects and other dangers.

T'ang seals.

During the subsequent periods till about the end of the T'ang dynasty the seal underwent few changes. They were usually made of jade or bronze and the Han style was retained for the legends although in the mean time the Chinese script used in daily life had greatly changed.

The artistic quality of the legends declined considerably; T'ang seals lack both the force and the balanced composition of those of the Han dynasty. During this period there was evolved a variation of the seal script known as *chiu-tieh-wên* 九 疊 文 " nine-fold script ". Its distinctive feature is that some perpendicular lines are as it were folded up in three or more folds; the T'ang seal on Plate **142**, and the Sung seal on Plate **143** are

---

1) 古 之 人 入 山 者 佩 黄 神 越 章　封 泥 着 所 住 之 四 方 各 百 步。則 虎 之 印。其 廣 四 寸。其 字 一 百 二 十。以　狼 不 敢 近 其 內 也。

423

specimens of this style. It was used for both private and official seals and re mained popular till well into the Ming period. Thereafter it was retained only for some large official seals.

The T'ang seal reproduced on Plate **142** (*e*), done in *chiu-tieh* style reads *Tung-tu-liu-shou-chih-yin* 東都留守之印, in *chu-wên*. This seal has slight artistic value. The characters are lacking in strength and no attempt is made at proper spacing.

The T'ang seal although in itself devoid of artistic value started to play now a role in the field of fine art. The T'ang collector Chang Yen-yüan observes that till the Sui dynasty none of the scrolls in the Imperial collection was sealed (cf. above, page 153). With the advent of the T'ang dynasty collectors began to add impressions of their seals to the colophons and other notes which they wrote on the antique scrolls that passed through their hands. In ch. III of the *Li-tai-ming-hua-chi* (Appendix I, no. 33), section " On official and private seals of old and modern times ", Chang Yen-yüan places on record a great number of inscriptions on antique scrolls together with the seals he found impressed on them; further particulars have been discussed already on page 153 above.

Sung seals.

During the Sung period the seal gained in importance. By that time the private seal had grown to be much more common than the official seal. It was found that a vermilion seal impression will enliven the black and white of a calligraphic specimen and, besides authenticating the scroll, at the same time serves to embellish it. Thus most autographs by Sung calligraphers show private seals that are tolerably well executed.

It was during this period that also painters started to affix their seal to their pictures. At first they used very small seals giving only their personal name. They impressed these seals in an inconspicuous corner of their painting, concealed in the fold of a rock or among the foliage of a tree; such seals are therefore known as *yin-yin* 隱印 " hidden seals ". The great Sung master Kuo Hsi 郭熙, for instance, used to impress in the corner of his pictures a very small seal reading Hsi 熙. Paintings made on the orders of the Emperor were neither signed nor sealed.

A few specimens of Sung seals are reproduced on Plate **143**. The seal marked (a) is the official seal of the reign-period Hsüan-ho (宣和, 1119-1125), in a fanciful form of the " great seal script ". Here an attempt is made at achieving a balanced composition. Note the graceful curve that links the elements *k'ou* 口 and *ho* 禾 in the lower character. This is quite a good seal for that period; it occurs of many scrolls now preserved in the Old Palace Collection. The legend reproduced here has been redrawn and should not be used for the purpose of verification.

(B) is the official seal of the reign-period Shao-hsing (紹興, 1131-1162); it represents a not very successful attempt at producing an archaic effect. This is also a redrawn impression.

One of the private seals of the connoisseur Mi Fu is reproduced in (c). It is an example of the *chiu-tieh* style, reading *Ch'u-kuo-mi-fu* 楚國米芾. The individual characters lack strength but the composition is good though rather formal.

424

During the Sung period also the "collector's seal", *shou–ts'ang–yin* 收藏印 came into general use. When a connoisseur had added a new scroll to his collection he impressed on it a seal somewhat larger than an ordinary private seal, in order to mark the scroll as his property. Mi Fu, for instance, used several of such seals; one of them bore the legend *Mi–shih–shên–ting* 米氏審定 "judged by Mr. Mi". The famous collector Wang Hsin (see below, page 509) used a seal reading *Pao–hui–t'ang* 寶繪堂, this being the name of the hall where he had stored away his scrolls. These collector's seals were made with special care; being impressed right on the picture or autograph itself they should not interfere with its beauty but substantially increase it. We saw already on page 194 above that Mi Fu states that collector's seals should consist of very thin *chu–wên* lines so as not to obliterate parts of the drawing of the picture they are impressed on.

The spot for impressing the seal was chosen after much consideration. It must be added in such a manner as to harmonize with the spacing of the picture, and in the case of an autograph, so as not to interfere with the rhythm of the calligraphy. Such seals are preferably impressed in one of the lower corners of the picture and, if these places should already be occupied by seals of previous owners, they should be put in a spot beside or under these older seals. If the artist himself has added an inscription with his seals in the upper part of the painting — technically known as *shang–tuan* 上段 — the owner's seal was preferably not impressed on a place above that occupied by the artist's seals. This courtesy extended to scholars and artists of former times applies also to the ex–libris seal that bibliophiles impress on the first page of a book; if possible such a seal is always impressed below the name of the author printed there.

It was the privilege of Emperors and Imperial Princes to impress their large seal near the top edge of a picture or autograph.

Next to its use in pictorial art the seal also continued to be employed as a means for authenticating documents, and as a symbol of authority. No official was deemed to be in possession of executive power before he had during a solemn ceremony taken over the seals of office from his predecessor. This custom has survived till the present day.

In the Yüan period there occurred some new developments in the seal legends. One notices a conscious effort to enhance the artistic quality by giving more graceful forms to the individual characters composing the legend, and by effectuating a better composition. Some Yüan seals adumbrate the artistic evolution that was to come under the Ming dynasty.

Yüan seals.

Also some experiments were made with adapting the new script introduced by Khubilai's religious adviser 'Phags–pa (see note 1 on page 226 above) to seal legends; such seals have, of course, no artistic value but are interesting only as curiosities.

Plate **143** (d) is an official seal of the Yüan period reading *Hai–pin–hsien–yin* 海濱縣印. The right half is excellent, each of the two characters is closely–knit and they harmonize with each other through the horizontal and vertical lines alternately predominating in both; note the slight differences in the *shui* radical, meant to avoid monotony

425

caused by exact duplication. The left half of this seal is less successful; in an effort to balance *hsien* and *yin* the latter character was made more complicated by giving its lower part two extra coils — which makes a forced impression.

Plate **143** (e) is an official seal in 'Phags-pa script, a transliteration of the Chinese characters *Hu–pên–chün–po–hu–yin* 虎賁軍百戶印, with some fanciful extra–coils added. [1]

The "flourish signature".

Here a few words must be inserted about the *hua–ya* 花押 or *ya–tzû* 押字, the "flourish signature" which is often used together with the seal for authenticating pictures, autographs and documents.

The *hua–ya* is a flourish of the brush representing one or more characters of one's name in a highly abbreviated form. Till well into the Ming period documents were first signed with a *hua–ya*, the seal of the writer being subsequently impressed over this flourish.

It would seem that originally only the last character of the name was used as *hua–ya*. The Ch'ing scholar Liang Shao–jên (梁紹壬, flourished ca. 1830) says that the rebellious T'ang minister An Lu–shan 安祿山 used a *hua–ya* consisting of the character *shan* written in three dots, and that the Sung statesman Wang An–shih (王安石, 1021–1086) used an abbreviated form of the character *shih*. [2] The Sung scholar Chou Mi mentions in his *Kuei–hsin–tsa–shih* 癸辛雜識 that Wei Chih (韋陟, 697–761), a son of An Lu–shan, used to write the character *chih* in his name like five cloud–tops (*wu–to–yün* 五朵雲). Later also literary names were used as *hua–ya*; I mention the well–known flourish signature of the Sung Emperor Hui–tsung found on his pictures and which is usually interpreted as consisting of the two characters *t'ien–shui* 天水, the name of the place where his family originated (see Plate **144** a).

The 17th century Japanese Sinologue Arai Hakuseki (新井白石 1656–1726) states that the Chinese *hua–ya* originated from the characters *k'o* 可, *ch'ih* 勅, *i* 宜 etc. meaning "So be it!" and scrawled by the Emperor at the end of drafts submitted to his approval. This theory, however, seems hardly tenable.

Some curious *hua–ya* were employed by Mongol officials during the Yüan dynasty. Since most of them could hardly read or write, they signed official documents with a kind of *hua–ya* composed of Mongol characters. Even this was apparently too much of a literary effort for those fierce warriors, for soon these *hua–ya* were engraved on seals. Many of these have been preserved; those that I had occasion to examine, however, seemed just an intricate scrawl resembling the later Japanese *hua–ya* (see below); I could discover no relation to either Mongol or Chinese characters. [3]

---

[1] For more details about the 'Phags-pa script see my book "Siddham, an Essay on the history of Sanskrit studies in China and Japan", published by the International Academy of Indian Culture, Nagpur 1956, page 98.

[2] Cf. his *Liang–pan–ch'iu–yü–an–sui–pi*, 兩般秋雨庵隨筆.

[3] Such a *hua–ya* occurs on a Mongol seal brought to Japan by the Chinese Ch'an priest Hsin–yüeh (see below), and reproduced in the special edition of my Chinese publication *Tung–kao–ch'an–shih–chi–k'an* 東皋禪師集刊 (Commercial Press, Chungking 1944), page 3.

144. – CHINESE " FLOURISH SIGNATURES "

Here I may be allowed to complete the history of the *hua-ya*, presently to return to the Chinese seal.

During the Ming dynasty the *hua-ya* were very popular. Plate **144** (*b*) shows the *hua-ya* of the Ming Prince Chu Ch'üan (朱權, better known as Ning-wang 寧王, died 1448). It represents the two characters *chung-ho* 中和, the name of his music chamber. *Hua-ya* seem to have been widely used at that time for authenticating documents, as appears from the following note by the Ming scholar Lang Ying 郎瑛:

" Most of the *hua-ya* of our present dynasty show on top and below a horizontal stroke, so as to represent the even surface of the earth and the perfection of Heaven. All those who 'doffed their rough clothes' in order to enter upon an official career had to go to the Board of Civil Office on three different days, each time writing down their signature, so that it could be verified what changes this signature underwent when written at different times. Thus in the capital professional designers of *hua-ya* set up their business, designing flourish signatures with as many curls and stops as their customers desired ". [1]

We shall see below when dealing with the *hua-ya* in Japan that this Ming-style of flourish signatures has been preserved there till the present day.

In China the *hua-ya* seems to have fallen into disuse after the advent of the Ch'ing dynasty. However, the custom survives to some extent in a highly abbreviated way of writing the expression *tun-shou* 頓首 " I bow my head " or some other conventional

1) Cf. his *Ch'i-hsiu-lei-kao* 七修類稿:國 朝押字之製。上下多用一畫。蓋取地平天成之義。凡釋褐入官者。皆 於吏部書字三日。以驗異時文移之真偽。故京師有賣花字者。隨人意欲必有宛轉藏頓。

427

phrase at the end of letters; an example is given on Plate **144** (*c*). To-day still many people are wont to write such expressions in one particular flourish which together with the seal authenticates the letter in the same manner as our Western signature.

The first collection of seal impressions.

It was during the Sung dynasty that the first collection of seal impressions, a so-called *yin-pu* 印 譜 was published. This was the *Hsüan-ho-yin-pu* 宣 和 印 譜, in four parts. This information is given by the Ming poet Shên Ming-ch'ên 沈 明 臣 in his preface (dated 1572) to the famous but now exceedingly rare *Ku-shih-chi-ku-yin-pu* 顧 氏 集 古 印 譜. "In ancient times", he says, "there were no *yin-pu*; the first was published during the Hsüan-ho period of the Sung dynasty. This, however, has not been preserved". [1]

Thus we are in no position to know what this first *yin-pu* looked like. From the Ming dynasty till the present day *yin-pu* have been made by making impressions of the actual seals on good white paper that has been previously cut up in separate sheets, each the size of an ordinary double book page. The production of such a *yin-pu* was thus a laborious process; each seal had to be impressed once in each copy to be published, and one copy usually contains several hundred different seal impressions. Therefore some better-known *yin-pu* were afterwards often published as reprints, each page of the original edition being recut in its entirety on a wooden printing block. When these blocks are struck off the seals are inked red and the explanatory text in black. Such reprints, called *mo-k'o-chu-shua* 摹 刻 朱 刷 "recut seals printed in red" are much cheaper than those containing actual seal impressions; but many characteristics of the original impressions are lost during the process of re-cutting. Nowadays Chinese and Japanese amateurs of seal carving keep a stock of loose leaves with their studio name and page number printed in the margin. Each time when they have carved a seal they impress it on five or six hundred leaves; in due time a few dozen of such imprinted leaves are sewn together with a title page and preface and thus published as a *yin-pu*. These *yin-pu* often include also rubbings of the inscriptions engraved on the sides of the seals, and drawings or rubbings of the ornamental tops of the stones. In the course of the last four centuries a prodigious number of *yin-pu* were published and now these books form a special class of Chinese literature. [2]

Ming seals.

Since official seals have a purely utilitarian purpose, this class of seals underwent no changes during the Ming dynasty. One notices during this period, however, a preference for the *chiu-tieh* style. Plate **148** (*a*) is an official seal dated 1382; its legend reads *Kuang-ning-tso-tun-wei-tso-ch'ien-hu-so-po-hu-yin* 廣 寧 左 屯 衛 左 千 戶 所 百 戶 印.

---

[1] 古 無 印 譜。有 印 譜 自 宋 宣 和 始。宣 和 譜 今 不 傳。

[2] In 1933 Lo Fu-i (see p. 421 note 2 above) published an excellent special bibliography of *yin-pu*, entitled *Yin-pu-k'ao* 印 譜 考, in 4 ch. This book lists several hundred *yin-pu*, beginning with the *Hsüan-ho-yin-pu* and ending with *yin-pu* of the last years of the Ch'ing dynasty. Each item is described in detail, and prefaces and colophons of the more important ones are reprinted in their entirety.

145. — MING IVORY SEAL

Although seals in the *chiu–tieh* style always bear a more or less artificial character, this one shows that much care has been bestowed upon spacing and a certain balance between the characters.

The personal seal, however, developed into a specimen of fine art. The possibilities of artistic expression offered by the seal were fully realized and the seal was raised from the status of a mere utensil. While formerly the manufacturing of seals was left to professional artisans, now most scholar–artists started to carve their own seals. This was the beginning of *t'ieh–pi* 鐵筆 " the art of the iron brush ". From now on this art was considered as one of the approved pastimes of the accomplished scholar and such it has remained till the present day.

Since stone was found to be a more tractable material than bronze or jade, the " seal stone " now came into common use. This change in material brought along a change in shape. As thin stone plaques were easily damaged and difficult to carve, seal stones were cut in the form of square blocks of about one decimeter high; the adding of a handle or ornamental knob was thus no longer necessary. However, in deference to tradition the tops of the seal stones were carved into the shapes of animals and other motifs reminiscent of the *niu* of the antique seals.

Plate **145** reproduces an ivory seal of the Ming Emperor Hsien–tsung 憲宗, from the collection of the great Japanese seal–artist Kawai Senro who kindly gave me this photograph. The top of this seal represents a fabulous animal, beautifully carved in antique style. On the left side of the seal is the inscription " Made in the 9th moon of the year 1467 in the Wu–ying Palace " 成化三年九月武英殿製. The legend, carved in formal style, reads *Chi–chih–shu–shih–chih–pao* 繼志述事之寶.

The technique of seal carving.

Some legends of antique seals were cast in bronze from wax moulds together with the seal itself, others were engraved on the seal after it had been cast. In many cases it is not easy to decide whether the legend found on an antique seal was cast or engraved. After the metal seals had fallen into disuse, however, all legends are of course engraved. Here follow a few words on the technique of seal carving.

For practising this art few instruments are needed, the seal carver's outfit consists of only two or three *yin–tao* 印刀, thin iron knives. Of these several varieties exist, the most common of which are depicted on Plate **146**. Most seal carvers select one type of knife that they find most suited to their hand and use this for all their seals, large and small.

In addition to the knives the carver sometimes uses also a so–called " seal bed ", *yin–chuang* 印床. This is a kind of wooden press for clamping the seal stone firmly while its legend is being carved; Plate **146** shows how the seal stone is held tight by means of a number of wooden wedges. Most carvers, however, despise the use of a " seal bed ", and simply hold the stone in their left hand supported on the desk.

A good seal is " written with the iron brush " in the most literal sense of the word, the characters take shape under the carving knife. While carving the artist will make

146. – SEAL-BED AND SEAL-KNIVES

frequent preliminary impressions of the seal to see how the characters develop under the knife. In this manner the legend will reflect the handwriting of the artist as faithfully as an autograph written with brush and ink. Professional seal carvers will often first write out the legend of the seal in seal-script on a piece of thin paper, then turn the paper over, paste it on the seal stone and engrave the characters according to this design; such a seal will necessarily lack the spontaneous rhythm that gives good seals their artistic value.

Next to a free handling of the knife, due attention must be given also to the peculiarities of the material used; one must choose the appropriate variety of the " seal script " in accordance therewith. Some stones have a tendency to scale off when cut; then the carver must utilize this feature to give the characters a jagged outline, thus lending the seal the worn appearance of antique inscribed stone tablets. If, on the other hand, the stone is soft and of a smooth grain, one may choose more stylized varieties of the seal script whose beauty lies in strong, clear-cut lines of uniform thickness. Further, ivory and horn, various kinds of wood, in short all materials used for making seals have their own properties that should be known to the seal carver.

As a matter of course the seal carver must be an expert in writing the different kinds of seal script with brush and ink. All manuals of seal carving are agreed that the student should first and foremost acquire skill in writing the seal script on paper so as to make him thoroughly familiar with the artistic possibilities of this branch of calligraphy; for only then the seal legend will grow directly under the knife. Hence all great seal carvers were equally famous as calligraphers in the seal script. [1]

Seal stones, seal boxes and seal pads. Ming scholars and artists bestowed great care on the carving of the ornamental tops of their seal stones. They chose suitable motifs from Chou and Han bronzes and had

[1) There exist several good Chinese and Japanese manuals of the art of seal carving. A useful modern Chinese handbook is the *Chuan-k'o-ju-mên* 篆 刻 入 門 by the scholar and painter K'ung Yün-po 孔 雲 白 (Commercial Press, latest edition Shanghai 1936). A very serviceable Japanese manual is the *Tenkoku-hitsu-un* 篆 刻 秘 蘊, one small illustrated volume, published in 1933 in Tokyo by Kususe Hitoshi 楠 瀬 日 年; here the reader will find pictures of the different ways of handling the seal knife and instructions as to how the seal script should be written.

these carved by professional artisans, their own work being confined to the engraving of the legend and the inscriptions added on the sides of the seal stone.

Besides the ordinary square seals there were also used round or oblong ones, or stones, blocks of ivory etc. carved into fanciful shapes. Seal–artists vied with each other to obtain rare and valuable stones. One famous variety, the so–called *t'ien–huang* (田黃; *t'ien* is also written 塡 or 闐), an amber coloured stone found in Fukien Province, was worth its weight in gold. Also good specimens of *chi–hsüeh* 鷄血 "chicken–blood", a grey stone with red and green patches found at Ch'ang–hua 昌化 near Hangchow fetches considerable prices. Less precious is *têng–ming–shih* 燈明石 "lamp–shine stone", a whiteish variety found near Ch'ing–t'ien 青田 in Southern Chekiang. At the same place are found numerous varieties of cheaper material suitable for being used as seal stones; these are generally known as *ch'ing–t'ien–shih* 青田石. The most common variety has a greenish colour.

All these stones can be carved with the ordinary seal knife. There are, however, also others that are so hard that they have to be engraved with a drill; I mention for example *t'ao–hua–shih* 桃花石, a reddish stone from Kwantung, and some green varieties from Shantung. The same applies to jade and crystal. Seal artists design the legends of such stones and leave it to a professional artisan to do the engraving. Since thus this material is unsuitable for a free artistic expression real seal artists rarely use it.

In the Ming period seal stones began to be treated as precious works of art. In order to protect the legends and the ornamental tops, seals were kept in specially–made boxes of some beautifully grained wood containing a number of drawers lined with padded silk and capable of storing a few dozen seals; for by now most scholars and artists had not one or two but often as many as twenty or thirty different seals, giving name, style, literary designations, library names etc. Such seal boxes were often provided with a handle so that the owner could carry them with him when proceeding to a literary or artistic meeting.

Ming literature records numerous recipes for preparing the *yin–ni* 印泥 or *yin–sê* 印色, the vermilion seal pad. For the containers of these pads called *yin–sê–ch'ih* 印色池 rare and delicately coloured ceramics or intricately carved lacquer boxes were chosen. Since seal–engraving had now become recognized as a branch of calligraphy, care nor expense were grudged to make not only the seal stone itself but also everything connected with it into a finished work of art (cf. Plate **147**).

The Ming artists considered as the pioneers of this "art of the iron brush" are two scholar–artists who lived in the later half of the dynasty. One was the famous scholar–official Wên P'êng 文彭 whose style was Shou–ch'êng 壽承; his literary name was San–ch'iao 三橋 and he lived from 1498 to 1573. Like his father, the great Wên Pi, he was a noted poet, painter and calligrapher. The other was Ho Chên 何震, style Chu–ch'ên 主臣, lit., name Hsüeh–yü 雪漁; he lived at approximately the same time as Wên P'êng and is chiefly known as a seal carver.

Wên P'êng and Ho Chên.

431

These two masters took Ch'in and Han seals as their models, striving after "antique rusticity". However, in their time epigraphy was still in its infancy. They often copied characters from inscriptions in stone and bronze that they took to date from the Chou, Ch'in or Han periods but which in reality were falsifications made during the Sung and Yüan dynasties and contained not a few wholly fantastic and spurious characters. But Ming seal carvers were not much interested in epigraphic accuracy, for them the interesting shape of a character counted more than its authenticity. Hence they did not hesitate to use on their seals any unauthorized or fanciful form of a character, provided that it appealed to their — slightly amateurish — antiquarian interest. Therefore Ming seals are nearly always elegant although they are the despair of later epigraphists. [1]

A typical example is the seal reproduced on Plate **148** (*b*). It reads *Yüeh-yin* 越 印 and was carved by the Ming priest Hsin-yüeh (心 越, better known as Tung-kao ch'an-shih 東皋禪師, 1639-1695), a gifted artist who fled to Japan after the Manchus had invaded China, and had great influence on the art of seal carving in the country of his adoption. Neither of the two characters is authorized, they are based on some spurious bronze inscription; Ming scholars called this style *ting-wên* 鼎 文 "bronze-vessel script". The curved lines tapering towards the end are meant to suggest incisions in bronze. This seal has great artistic qualities. Two elegantly curved lines predominate, namely the central stroke of *yüeh* and the lower stroke of *yin*; yet the seal is not lacking in strength. Note the intentional break in the left edge. This is a clever trait, for an unbroken outline would clamp the legend in a frame and neutralize the grace of the two curved vertical lines.

K'uan.

Wên P'êng and Ho Chên started the custom to engrave the date and their signature on the side of the seal stone; such inscriptions are called *k'uan* 款, just like those that the painter adds on his pictures. Besides they added also dedicatory messages, brief essays, poems, etc. so that one often finds seal stones covered on all four sides with inscriptions. Properly, however, only the left side of the seal should be inscribed; that is the side on the left when one impresses the seal.

During the Ming dynasty and the first half of the Ch'ing period the text of such inscriptions was first written with a brush on the stone and then engraved. Thus the inscriptions are copies of the ordinary brush-calligraphy of the writer; Plate **148** (*c*) is a rubbing of the side of a seal carved by Wên P'êng and bearing his dated signature: "Seal script (i. e. seal legend carved) by Wên P'êng, one day before the Summer solstitium of the year 1556" 嘉 靖 丙 辰 立 夏 前 一 日 文 彭 篆, and (*d*) is Ho Chên's signature on the side of a seal carved by him. We shall see below that during the later half of the Ch'ing dynasty the inscriptions on the sides of seals were directly carved in the stone, in the same manner as the legend.

---

1) For deciphering such seals one should refer to fanciful works such as the *Liu-shu-ching-yün* 六 書 精 蘊 by Wei Hsiao (魏 校, 1483-1543) or the *Yün-fu-ku-chuan-wei-hsüan* 韻 府 古 篆 彙 選, published in 1672 by Ch'ên Ts'ê 陳 策; the latter work is rare in China but easily obtainable in Japan where it was reprinted in 1697, in Kyōto.

147. – SEAL STONES; SEAL–KNIVES IN PORCELAIN CONTAINER;
SEAL–PAD IN PORCELAIN BOX ON WOODEN STAND

A

B

C

D

148. – ABOVE: TWO MING SEALS. BELOW: TWO SIGNATURES ON THE SIDE OF MING SEALS

In the Ming dynasty most painters had adopted the fixed custom of adding longer inscriptions on their pictures, duly signed, and authenticated by a number of seals. The latter included not only the artist's name and literary designations, but also seals bearing as legend just a motto or phrase dear to the owner and supplying no clue to his identity. These seals, the so-called *hsien-chang* (閑 章; in Japanese called *yū-in* 游 印 or *ga-in* 雅 印), are generally considered as a typical Ming feature.

The legends of *hsien-chang* vary from simple mottos like for example *wo-yün* 臥 雲 " sleeping on the clouds " to longer quotations like " If you wish to know the essence of streams and rocks you must first understand the meaning of the breeze through the pines " 欲 知 泉 石 心。須 得 松 風 意.

*Hsien-chang* have usually an oblong shape and are impressed on top right of both pictures and autographs. Although it is considered impolite to impress one's name seal on a spot higher than that occupied by the seals of artists, former collectors or persons to whom one dedicates the scroll, this rule does not apply to *hsien-chang*.

It remains to add that during the Ming dynasty many *yin-pu* were published. The seals reproduced in those books reflect the spirit typical for the scholar-artists of that period. Their love for the quaint and unusual, their interest in all that has an antique flavour, their striving after individual expression — all these characteristics are found in the personal seals of the Ming dynasty.

After the advent of the Ch'ing dynasty interest in the art of seal carving declined. During the first half of this period it seemed that the seal that during the preceding dynasty had developed into a work of art, was going to fall back once more to its original position of a mere utensil. However, towards the 18th century the progress made in archeology and epigraphy brought about a revival of the " art of the iron brush ". There arose two schools of seal carving the founders of which aimed at producing seals that combined the artistic qualities of Ming seals with the robust strength and epigraphical accuracy of the antique seals of the Ch'in and Han periods. These two schools are known as the *Hui-p'ai* 徽 派, Anhui School, and the *Chê-p'ai* 浙 派 " Chekiang School ".

The leaders of the Anhui School were the epigraphist, poet and painter Ch'êng Sui (程 邃, style Mu-ch'ien 穆 倩, lit. name Kou-tao-jen 垢 道 人) and the art-collector Pa Wei-tsu (巴 慰 祖, style Yü-chi 予 籍, lit. name Hsi-t'ang 雋 堂, 1744–1793). Since both were natives of Shê-hsien 歙 縣 in Anhui their school was named after that province.

Plate **149** (*a*) and (*b*) are two seals carved by Pa Wei-tsu. The first, reading *Chia-szŭ-ma-yin* 假 司 馬 印 is a magnificent specimen of his work and belongs to the finest Ch'ing seals in existence. Combining the strength and faultless spacing of Han seals with the graceful abandon of the Ming period, it stands as an example of the artistic ideals of this school. Also (*b*), reading *Tung-hsiao-ch'ih* 董 小 池 (this seal was carved for Tung Hsün 董 洵, another noted seal-artist) is noteworthy because of its excellent

433

spacing. The character *tung* fills the entire right half of the seal, the left half is taken up by a diminutive *hsiao*, and a larger *ch'ih*; the balance is effected by giving extra white space to *tung*, and by the sweeping curve of the element *yeh* 也 in the character *ch'ih*.

The Chekiang school was founded in the beautiful Western Lake region near Hangchow by the scholar–artist Ting Ching (丁 敬, style Ching–shên 敬 身, lit. name Lung–hung–shan–jên 龍 泓 山 人, 1695–1765). Ting Ching and his followers based their art also on Ch'in and Han seals but they tried to introduce elegant, curved strokes without losing the strength of the antique seals.

Plate **149** (*c*) and (*d*) are two seals carved by Ting Ching for his own use. The first gives his style Ching–shên. The long, continuous lines of uniform thickness give the seal an elegant air without making it effeminate, while the stress laid on the upper part lends it a certain tension — as of a warrior poised for an attack. A merger of characters and rim is prevented by the intentional break in the left edge, balanced by the missing lower right corner. This is an excellent seal. Seal (*d*), giving Ting Ching's studio name *Lung–hung–kuan–yin* 龍 泓 館 印, comes closer to the Han style: the lines are of unequal thickness and the characters have an atmosphere of "antique rusticity". This is also a very good seal though it lacks the appeal of (*c*).

Ting Ching and seven of his friends, all experts in the art of seal carving, are known as the "Eight great artists of Hsi–ling" 西 泠 八 大 家. During the early years of this century a group of literati of Hangchow founded the *Hsi–ling–yin–shê* 西 泠 印 社 "The Hsi–ling Seal Association" in order to perpetuate the tradition of the Chekiang School. It was still in existence when I visited that region in 1946. The members gather in a old Imperial summer villa on an island in the Western Lake, the main hall of which is called *Szû–chao–ko* 四 照 閣; here are displayed the images of Ting Ching and other famous seal carvers of his school. During the early years of the Republic many Japanese seal artists visited this place and propagated its ideals in Japan. [1]

Since the establishing of the Anhui and Chekiang schools the art of seal carving has enjoyed a period of unprecedented popularity. Three scholars especially earned fame as artists of the iron brush and founded their own schools.

The well known calligrapher Têng Shih–ju (鄧 石 如, lit. name Wan–po 完 白, died 1805; cf. E. C., page 715) elaborated the style of the Chekiang school, giving his characters still rounder curves and elongating the perpendicular strokes; his style represents a combination of elegance and strength that is not easy to achieve.

Plate **149** (*e*) and (*f*) are two *hsien–chang* carved by Têng. The first is a good example of his nearly sophisticated style; it is carved in *chu–wên* and reads *Chiang–liu–yu–shêng, tuan–an–ch'ien–ch'ih* 江 流 有 聲 斷 岸 千 尺. All curved lines are stressed, so

---

1) The seal–association *Hsi–ling–yin–shê* should not be confused with the publishing firm of the same name, established by Wu Yin 吳 隱, a member of the association.

434

A      B      C      D

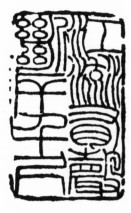  

E        F        G

H        I        J

149. – CHINESE SEALS (CH'ING DYNASTY)

A

B

C

D

E

F

G

150. — ABOVE: THREE SIGNATURES ON THE SIDE OF CH'ING SEALS.
BELOW: FOUR SEALS CARVED BY THE AUTHOR

much so that for *liu* an abnormal form is chosen which has an extra–element *shui* 水, in order to add three more curves. The left edge is purposely reduced to a few dots, for a straight line would have broken the harmony of the flowing lines that predominate in this seal. Seal (*f*) is carved in *po–wên* and reads *Yu–hao–tu–nêng–lei–tz'û–shêng* 有 好 都 能 累 此 生; this sentence has a profound meaning, it might be translated as " All the things you love may prove to be fetters for your entire life ". This seal is still better than the preceding one, mainly because of its superb spacing. If the red dividing line running vertically across the seal were missing, the seal would have made a confused impression. Here an air of quiet stability is achieved by the use of slightly curved horizontal lines and subtle differences in the thickness of the strokes.

The great scholar and painter Chao Chih–ch'ien (趙 之 謙, style Wei–shu 撝 叔, lit. names Mei–an 梅 盦, Pei–an 悲 盦 and Wu–mên 无 悶, 1829–1884; cf. E. C., page 70) went still further in softening the curves of his characters and striving after elegant effects; hence some connoisseurs opine that his work lacks the strength that marks Têng's seals.

Plate **149** (*g*) and (*h*) are specimens of his work. The first reads *Erh–chin–t'ieh–t'ang–shuang–kou–liang–han–k'o–shih–chih–chi* 二 金 蝶 堂 雙 鉤 兩 漢 刻 石 之 記. Here Chao has solved the problem of how to include as many as twelve characters in a comparatively small seal in a masterly manner, specially noteworthy is his balancing of characters of a few strokes with very complicated ones — always a difficult point for both calligraphers and seal carvers. The seal (*h*), giving Chao's lit. name *Pei–an* proves in my opinion that his art certainly does not lack force; note the daring sweep of the lower part of *pei*. The fact that the two characters are as it were suspended on the upper edge also creates a pleasing effect.

Finally, the archeologist and painter Wu Chün–ch'ing (吳 俊 卿, better known by his style Ts'ang–shih 倉 碩 or Ch'ang–shih 昌 碩; lit. name Fou–lu 缶 廬, 1844–1927) acquired national fame as a seal carver. He belonged to the Chekiang school but adhered closely to Han models, having made a careful study of the great number of new Ch'in and Han seals that had come to light. He found many admirers also in Japan where both his pictures and impressions of his seals are treasured by connoisseurs.

Two of Wu Chün–ch'ing's personal seals are reproduced on Plate **149** (*i*) and (*j*). The first, in *chu–wên*, reads *Chün–ch'ing–chih–yin* 俊 卿 之 印 and is a good example of his robust style. The second, in *po–wên*, reads *Ts'ang–shih* 倉 碩; this is a beautiful seal that suggests inscriptions on ancient stone tablets.

Later k'uan.

It should be noted that the artists mentioned above developed a new technique for carving the *k'uan*, the signatures and other inscriptions on the side of a seal stone. They did not engrave these inscriptions after a text previously written on the stone with a brush, as did Wên P'êng, Ho Chên e. a., but cut the characters directly into the stone with a corner of the seal knife. Thus the engraving of *k'uan* became an art in itself. Most later *yin–pu* give next to the seal impressions, rubbings of the inscriptions found on the stones.

Plate **150** (*a*) is a rubbing of a seal stone signed by Hsü San–kêng 徐三庚, a well known seal artist whose literary name was Hsiu–hai 袖海; the inscription reads: " Carved with the iron brush by Hsü San–kêng of Shang–yü (near Shao–hsing) and presented to his old Teacher in the Doctrine Mr. Wan–hsiang, on the 8th day of the 4th moon of the year 1883 " 上虞徐三庚鐵刻詒晚香老道長先生時癸未四月八日也.

(B) is a rubbing of a seal stone bearing Wu Chün–ch'ing's signature: " The third moon of 1885. Ts'ang–shih " 乙酉三月倉碩. The rubbing marked (*c*) has a longer inscription engraved by Wu, namely a quotation from the philosopher Huai–nan–tzû (使但吹竽使氏厭籖雖中節而不可聽). These three seal stones are good examples of this special kind of calligraphy.

Modern seal carvers.
Of present–day seal carvers I mention the famous painter Ch'i Huang (see above page 374), and the aged calligrapher and epigraphist Wang Shou–ch'i (王壽祺, style Wei–chi 維季, lit. name Fu–an 福菴) who designed i. a. the Grand Seal of the Chinese Republic. Also the archeologist Ma Hêng (馬衡, style Shu–p'ing 叔平), until recently Director of the Old Palace Museum in Peking and chairman of the Hsi–ling–yin–shê, is well known for his seals where epigraphical accuracy is combined with a marked individual expression.

How highly the seal is considered in China is proved by the great care that the Government bestows on the seals of its various departments and offices. In 1946 there was still a special Government office, the *Kuo–min–chêng–fu–yin–chu–chü* 國民政府印鑄局 that was charged with the manufacture of all official seals and was responsible for their accuracy and artistic qualities.

For a study of contemporary seal carving the reader is referred to modern *yin–pu* which exist by the hundred. Leafing through these books one will notice that some amateurs of seal carving utilize archaic forms of characters as found on inscribed oracle bones of the Shang and Chou dynasties. Whether it is correct to use characters dating from a period when the seal as such was not yet known is a debatable question.

\* \* \*

The above survey gives only a bare outline of the Chinese seal and its appreciation. A study of the seal impressions reproduced in for instance Dr. Contag's book mentioned in the beginning of this chapter will enable the reader to explore the subject farther and to form his own opinion on the esthetic value of various kinds of seals.

However, as Benjamin March observes: " He who would study a technique without using his hands may be compared to one who would learn to swim without going into the water ". [1] Experiments with the ordinary brush are the best approach to calligraphy and painting, and personal experience in handling the " iron brush " supplies

1) Cf. Appendix I, no. 8, first line of the Preface.

the quickest way to the connoisseurship of seals. A common chisel will do for seal-knife, and any soft stone will provide material for trying one's hand on. Moreover, old Chinese seals are available in Western curio shops at reasonable prices. One and the same seal stone can be used dozens of times for practice, since the carved legend can be obliterated again by polishing the seal's surface on a whetstone. While experimenting with knife and stone one will soon discover that the knife must be held in different ways for certain types of strokes; the hold varies from the traditional manner of holding the writing brush to the Western way of handling a pen or pencil.

On Plate **150** are reproduced four seals which I carved myself. (A) reads " To forget with one smile the hundred sorrows " 一 笑 百 慮 忘 and was carved by me eighteen years ago; it is a clumsy seal, the strokes lack strength and the spacing is unsatisfactory. The next marked (B), reads " The Lute Hall of Middle Harmony " 中 和 琴 室 is a copy of a Ming seal; the copying of good old seals is as essential to the prospective seal carver as the copying of ancient masters is to the calligrapher and the painter. (C) was carved a few years later as an attempt to create an individual style. Chinese connoisseurs approved of the form of the characters and the spacing but found the strokes themselves lacking in strength. This is in fact an " over-worked " seal, I repeatedly corrected the outlines of the strokes with the result that in the end all spontaneous élan was lost. On this seal I worked several days, everytime spending on it half an hour or so. The last seal reading *Li-chai* 立 齋 I carved last year for a Chinese friend. Originally I had envisaged the character *chai* in a rather elaborate form, intending to effect a contrast with the simple construction of the character *li*. However, when I was carving it, the lower part of the seal showed an unexpected tendency to crumble off. I was compelled to give *chai* the most simplified form and to concentrate the main design in the upper part. Therefore I also stressed the upper rim, the aim being to give an impression of stability, as suggested by the legend itself which means " Studio of Standing Firm ". This seal was completed within one hour.

<center>* * *</center>

In the preceding chapter it was pointed out already that the seal does rarely supply conclusive evidence as to the date and authenticity of an antique scroll. In many cases, however, it will supply valuable secondary clues, and nearly always contributes to our knowledge of the artist, and of the scroll's history.

It is therefore that nearly all collector's catalogues give detailed descriptions of the seals found on the scrolls listed. Here we shall briefly review the manner in which seals are used by artists and collectors, together with the technical terms relating to this subject met with in collector's catalogues.

Both painters and calligraphers usually add two seals below their signature. The upper one is as a rule in *po-wên* and gives the style or literary designation; the lower one, usually in *chu-wên*, the real name and surname. Next to these seals often a *hsien-chang* is added, mostly in an upper of lower corner of the scroll, or in any other place where a seal impression would have a desirable effect.

When the scroll passes into the hands of a collector, he will add his seal or seals either on the picture itself, on its mounting, or over the seams where the two are joined. When the scroll is entered into the Palace Collection, the large Imperial seal is impressed on top, and the officers in charge may also add other seals, for instance ones stating the quality of the scroll, or bearing the name of the particular part of the Palace where the picture is stored away.

Plate **151** is a reproduction of a picture by the Ming artist Yüan Shang-t'ung (袁 尙 統, style Shu-ming 叔 明), in the Old Palace Collection. It measures 54 by 106 cm. and represents the celebration of New Year's day in a country villa. On top left the artist added the date (New Years's day 1541) and his signature, with two of his seals underneath. On the New Year's day of the year 1781 (the cyclical signs of which are identical with those of 1541) the Emperor Ch'ien-lung wrote a long poem at the top of the picture. All seals are of that Emperor, except the second one from the right, on top, which belongs to the last Manchu Emperor Hsüan-t'ung. These seals are well placed, they do not interfere with the picture; the square one impressed on the mountain on the right even improves the balance of the drawing. It will be noticed that no seals occur in those places where water is represented; it is an old belief that impressing a seal on such a spot is inauspicious, flowing water suggesting impermanency.

Some connoisseurs and collectors were less discreet in the matter of seals and stamped them all over pictures and autographs. The Ming collector Hsiang Yüan-pien (see above, page 401), for instance, was much addicted to this reprehensible habit. Plate **152** shows the last section of a scroll ascribed to Wang Hsien-chih which is literally plastered with Hsiang Yüan-pien's seals. Except for no. 1 which is the seal of the Sung Emperor Kao-tsung (cf. above, page 208) and two unidentified seals, all others are of Hsiang Yüan-pien. [1]

We saw on page 194 above that the Sung connoisseur Mi Fu protested already against this misuse of collector's seals. Here I translate some remarks on the subject made by the Ch'ing collector Lu Shih-hua:

" Collector's seals should not be stamped arbitrarily on a scroll, for these seals have their fixed places. In some cases one should use large seals, in others small ones; sometimes seals with red legends, at others seals with white legends. If no suitable place is

---

1) The legends of the seals read:

| | | | | | | | | |
|---|---|---|---|---|---|---|---|---|
| 1. | 審 | 思 | 東 | 閣 | | | | |
| 2. | 元 | 汴 | 之 | 印 | | | | |
| 3. | 子 | 京 | 珍 | 秘 | | | | |
| 4. | 項 | 墨 | 林 | 鑑 | 賞 | 章 | | |
| 5. | 墨 | 林 | 堂 | | | | | |
| 6. | 墨 | 林 | 項 | 季 | 子 | 章 | | |
| 7. | 項 | 元 | 汴 | 氏 | 審 | 定 | 眞 | 跡 |
| 8. | 神 | 品 | | | | | | |
| 9. | 天 | 籟 | 閣 | | | | | |
| 10. | 子 | 孫 | 世 | 昌 | | | | |
| 11. | 子 | 孫 | 永 | 保 | | | | |

| | | | | | | | | |
|---|---|---|---|---|---|---|---|---|
| 12. | 項 | 墨 | 林 | 甫 | 秘 | 笈 | 之 | 印 |
| 13. | 墨 | 林 | 外 | 史 | | | | |
| 14. | 遊 | 方 | 之 | 外 | | | | |
| 15. | 項 | 元 | 汴 | 印 | | | | |
| 16. | 平 | 生 | 眞 | 賞 | | | | |
| 17. | 桃 | 花 | 源 | 裡 | 人 | 家 | | |
| 18. | 項 | 叔 | 子 | | | | | |
| 19. | [項 | 墨 | 林] | 鑑 | 賞 | 章 | | |
| 20. | 西 | 疇 | 耕 | 耦 | | | | |
| 21. | 有 | 何 | 不 | 可 | | | | |
| 22. | ?? | | | | | | | |
| 23. | 世 | 外 | 法 | 寶 | | | | |

438

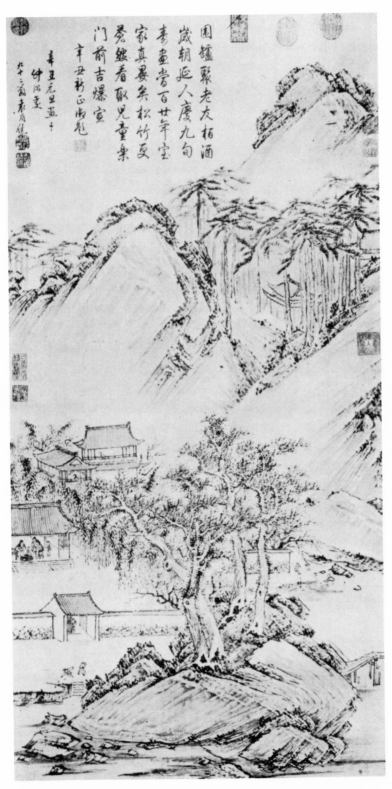

151. — "NEW YEAR'S MORNING" (SUI–CHAO–T'U).
MING PAINTING ON PAPER
(Old Palace Collection)

152. – SECTION OF A SCROLL WITH WANG HSIEN–CHIH'S CALLIGRAPHY,
SHOWING COLLECTOR'S SEALS
(Old Palace Collection)

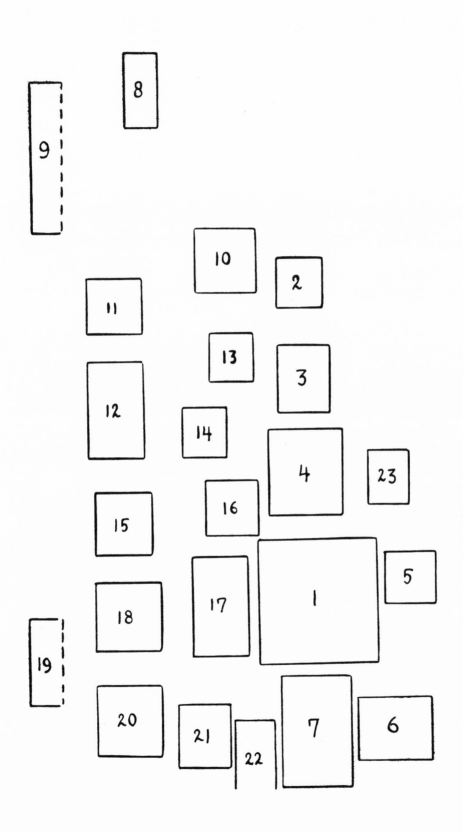

left on a scroll you had better leave it without a seal. Poems and colophons should not be added arbitrarily either. Every poem has its own meaning, every colophon should uncover a special point (connected with the picture). The size of the characters, their style — all such features should be decided upon in accordance with the picture. However, one sees more and more that people just jot down a few sentences on a scroll. Why is this necessary? One should not behave like a first grade student who at the time of the triennial examinations must arrive punctually. Nearly all people of the Ming dynasty indulged continually in this bad habit, not to speak of present-day people. I for one do not presume on my own capacities, when asked to write something (on a scroll for others) I immediately do so — but always on a separate strip of paper so that afterwards people can retain it or throw it away ". [1]

The second part of this quotation does not concern seals but it is translated here in its entirety to show clearly the author's argument.

The description of seals in collector's catalogues.

Most collector's catalogues record of each seal that occurs on the scrolls described the following features: location, shape, whether the legend is in *po-wên* or *chu-wên*, and the text of the legend transcribed in regular characters. Some of the more pretentious catalogues reproduce exact copies of the seals, showing their shape and the style of the characters.

The catalogues first describe the seals on the picture itself, beginning with the seals of the artist. The location of these seals is indicated as follows.

If the seals occur in their usual place, namely directly below the artist's signature, the catalogues print the legends directly below the text of the signature, without further comment. Seals occurring in other spots of the picture are indicated by the following terms.

*Yin-shou* 引首 "at the head"; colloquially called *pien-chang* 邊章 "side seals". Some writers also use the term *kuan-fang* 關防; this is properly the designation of the oblong seal placed at the beginning of official documents, on top right, to prevent spurious additions being written there. Although this term has the same meaning as *yin-shou*, most scholars avoid using it since it is considered inelegant to apply chancery terms to artistic subjects.

In the case of autographs and uninscribed pictures, irrespective of whether they are hanging or hand scrolls, the *yin-shou* is to be found on top right. In the case of paintings that have a longer inscription added to them, the seal appears on top right of this inscription.

---

1) *Shu-hua-shuo-ling* (cf. Appendix I, no. 47):

必明。日別。今於前。又也。況總。必則。到是也。何必筆下可。令皆人在。行勒。敷試。輒其往往員歲者去。往生病量自後。當此如日不犯。恰有非之余紙。收藏大可旨。宜則意容有。位。之一定有。步無可作。文非大小。或草或楷俱。白文妄與字之跋。宜詩發明。印非宜下也。宜小矣。己跋。

*Ya–chüeh* 押 脚 "at the foot"; colloquially called *chui–chüeh–chang* 墜 角 章 "lower corner seals". For all scrolls, regardless the manner of their mounting, these seals occur in one of the lower corners. Some writers, however, use *ya–chüeh* exclusively to designate seals found in the lower *right* corner of the picture.

*Ya–wei* 押 尾 "at the end". These seals are found in the lower left corner of autographs and uninscribed pictures. In the case of paintings that bear a longer inscription, the term refers to the seals at the end of that inscription.

After the seals of the artist, the collector's seals are described.

In the case of hanging scrolls the location of these seals is indicated by the same terms as applied to artist's seals; as a rule they are found in one of the lower corners. If the seal occurs not on the picture itself but on the front mounting, than that part of the mounting is referred to by its technical name; upper and lower *ko–chieh* are differentiated by adding *shang* 上 or *hsia* 下. The title label on the reverse of the scroll is usually discussed separately, and the seals occurring thereon are described under that particular heading.

As regards the seals on hand scrolls, these are discussed under each separate section of the scroll, in the following order: title label, superscriptions, the picture itself, and the colophons. Each of these portions of the mounted scroll is considered as a separate entity, and the seals occurring there are located by the same terms as employed for locating seals on a hanging scroll. For example, *ch'ien–ê–yin–shou* 前 額 引 首 indicates the seal on top right of the superscription, *po–wên–ya–wei* 跋 文 押 尾 refers to the seal in the lower left corner of a colophon, etc.

Seals impressed on the silk of the mounting are generally called *ya–piao–ling* 押 裱 綾, and those stamped over the seams *ch'i–fêng–yin* 騎 縫 印, *ya–fêng* 押 縫 or *fêng–yin* 縫 印.

Terms indicating the form of a seal. Most catalogues briefly describe the form of the seal impression by one of the following terms.

*Fang–yin* 方 印 "square seal".

*Yüan–yin* 圓 印 "round seal".

*Ch'ang–fang–yin* 長 方 印 "oblong square seal".

*Ch'ang–yüan–yin* 長 圓 印 "oval seal"; also called *t'o–yin* 橢 印.

*Pan–yin* 半 印 "half seal". This term refers to both an impression that became accidentally halved — because the scroll was cut down when it was remounted, or half of a "seal astride the seam" disappeared with the silk — and to seals that were intentionally cut in such a way as to present only half of the legend (the part represented giving sufficient indications for identifying the characters).

*Lien–chu* 聯 珠 "double seal". Two seals carved in the same stone and thus always impressed together.

440

1      2

3      4

5      6

7

153. — ABNORMAL FORMS OF SEALS

Besides the above-mentioned more or less regular shapes one may also find seals of fanciful forms.   At present such seals are considered as vulgar, but they were extremely popular during the Ming period.   The most common ones are depicted on Plate **153**; they are indicated in the catalogues by the following terms:

1) *Hu–lu–yin* 葫蘆印 " shaped like a calabash ".
2) *Shu–chuan–yin* 書卷印 " like a book–roll ".
3) *Ch'a–hu–yin* 茶壺印 " like a tea pot ".
4) *Ting–yin* 鼎印 " like a bronze sacrificial vessel ".
5) *Lien–yeh–yin* 蓮葉印 " like a lotus leaf ".
6) *T'ai–chi–yin* 太極印 " like the schematic representation of the interaction of the Yang and Yin elements ".
7) *Ch'ien–yin* 錢印 " like a copper coin ".

The legends of seals. The legends of the seals are usually given transcribed in regular characters.   If there occurs in a legend a character that can not be identified, the editor of the catalogue as a rule replaces it by a blank square, or else reproduces the character in its original form as it is found on the seal.

Thus the editor of the catalogue has already performed for his readers the complicated task of deciphering the seals, a work that requires a thorough knowledge of the seal script and other antiquated styles of writing.   Once the legend has been deciphered, however, there still remains the problem of the correct interpretation; this must be faced not only by the reader of collector's catalogues but also by every one who wishes to study an antique scroll.

As is well known, most Chinese scholars and artists adopt in the course of their life various designations that have a direct or indirect bearing on their identity; for example, literary names derived from the location of their library, the village where their country house stands, the literary school or artistic group they belong to, etc.   Since all such fanciful designations occur on seals, the legends present a bewildering diversity. However, there gradually developed certain rules governing the composition of seal legends.   Based partly on practical, partly on esthetic considerations, these rules diminish the chance that confusion arises regarding the correct interpretation of the legend.   Although these rules are not always strictly adhered to, in most cases they will prove a help in correctly classifying and identifying a seal.

For the reader's convenience I have drawn up a table that gives **22** common types of seal legends, together with their technical names, and a brief explanation of the rules that govern these types.   This table will be found at the end of this chapter.

* * *

Japanese seals. The Japanese at an early date adopted the Chinese " official seal " as a symbol and instrument of government.   For reasons which will be discussed below, it was not until the 16th century that also the " personal seal " began to be used in Japan on a somewhat wider scale.

**442**

Just as in China, in Japan too the seal was in the beginning considered as a utensil rather than as a work of art. It was only as late as the 17th century that Japanese scholars, artists and tea masters started to pay more attention to the artistic possibilities of the seal. Then, in the second half of the Tokugawa period, nearly every Japanese painter, scholar or writer possessed, just like his colleagues in China, quite a collection of personal seals; one or two with his name and surname, others with his literary names, the name of his studio, country villa etc. Thus a knowledge of Japanese seals is indispensable for the student of Chinese scrolls preserved in Japan, and for the connoisseur of Japanese pictorial art.

The outline given below deals only with those features of the Japanese seal that can be considered as peculiarly Japanese. Apart from those, the remarks about the Chinese seal and the art of seal carving apply, *mutatis mutandis*, also to Japan.

The most common Japanese term for " seal " in general is *han* 判 or *han-ko* 判子. Next to these purely Japanese terms, Sino-Japanese words such as *in* 印, *in-shō* 印章 etc. are also used, but these have a distinctly literary flavour.

Early Japanese seals.

Official seals cast in bronze were introduced from China in the beginning of the 8th century; these seals were close copies of those used in China during the T'ang period.

At first seals were employed only by the central government; but soon also the local authorities obtained permission for having their own seals. It took several centuries before the seal spread outside official circles.

This late development of the Japanese personal seal must be ascribed to the fact that the " flourish signature ", introduced from China in the 9th century, appealed more to the Japanese than the seal. Whereas in China the *hua-ya* became to all practical purposes obsolete during the Ch'ing dynasty, in Japan it enjoyed an immense popularity till late in the 19th century. Because of this wide use of the " flourish signature ", the development of the personal seal and the art of seal carving was considerably retarded.

The Japanese *kaki-han*, the " flourish signature ".

Since the 9th century it was customary in Japan to authenticate official and private documents by first signing them with one's family name and surname and then adding therebelow the " flourish signature "; in Japanese this signature is called *kaki-han* (書判, literally " written seal "), *sue-han* 据判, *han-ō* 判押, *ka-ō* 花押 or *ō-ji* 押字.

These *kaki-han* are usually divided into three main categories, depending upon their construction.

The first group, technically called *sō-mei* 草名 " personal name in draft script ", comprises *kaki-han* giving only one's personal name written in a more or less cursive manner, but not so abbreviated as to become illegible. An example is Plate **154**, no. 1; this is the *kaki-han* of the great general Oda Nobunaga (織田信長, 1534-1582) consisting of the two characters *shin* and *chō* of his personal name, written intertwined.

*Kaki-han* of the second class, called *ni-gō* 二合 " two combined ", show two or more characters of the personal name linked together in one and the same flourish of the

443

154. — JAPANESE "FLOURISH SIGNATURES"

brush. Although it is possible to recognize fragments of the characters composing the signature it is difficult to analyze it correctly if one has not identified the owner.    Plate **154**, no. 2, reproduces the signature of Toyotomi Hideyoshi (豐臣秀吉, 1536–1598); the character *hide* can still be recognized in the upper part of the signature, but the lower part is difficult to analyze.    The same applies to no. 5, the signature of the tea master Rikyū 利休, where one can recognize only the cursive form of the character *ri*.

155. – JAPANESE " FLOURISH SIGNATURE "
OF THE MINCHŌ-TYPE

The third class, designated as *betsu-yō* 別用, covers all *kaki-han* where the original strokes of the characters are deliberately distorted to such a degree that the flourisch ceases to bear resemblance to any known character; nos. 3, 4, 6 and 7 all belong to this class.    No. 3 is the signature of Oda Nobunaga in *betsu-yō* style; no character can be identified, the flourish suggests a crouching tiger — as was perhaps Nobunaga's intention.    No. 4 is the *kaki-han* of the feudal lord Takeda Harunobu (武田晴信, better known by his religious name Shin-gen 信玄, 1521–1573).    No. 6 belonged to the famous painter Kanō Motonobu (狩野元信, 1476–1554), and no. 7 to the great general Katō Kiyomasa (加藤清正, 1562–1611).

A sub-division of the *betsu-yō* class is formed by a type which bears the technical name of *minchō-tai* 明朝體 " Ming Dynasty style ", because it was this type that was in vogue during the Ming period.    *Kaki-han* of this group are characterized by a horizontal stroke on top and below, a feature in Japanese called " Heaven and Earth are even " 天平地平.    In between these two lines is inserted a complicated flourish which as a rule would have seem to have no relation to any character at all.    This was the style favoured by the members of the military caste and remained popular throughout the Tokugawa period.

The analysis and explanation of *kaki-han* is a study in itself on which there exists an extensive literature.    The great scholar Arai Hakuseki (see above, page 426) wrote a note on *kaki-han* in his *Dōbun-tsūko* 同文通考 where he tried to trace the origin of Chinese *kaki-han* to characters scrawled by the Emperor at the end of drafts, as described hereabove.    Thereafter the Japanese archeologist Ise Teijō (伊勢貞丈, 1715–1784) wrote a more detailed monograph on this abstruse subject, entitle *Ōji-kō* 押字考, to be found in ch. 9 of his *Teijō-zakki* 貞丈雜記, a collection of antiquarian notes in 16 ch.; this book was published as a blockprint in 1843 and reprinted in 1901 in the *Kojitsu-sōsho* 故實叢書.    Most accounts of the *kaki-han* in later Japanese encyclopedias are based on this study.

445

The theoretical background of this study where form and structure of a *kaki-han* are linked with the destiny of its owner, shows an interesting mixture of Chinese philosophical speculations and purely Japanese beliefs. Plate **155** gives a schematic drawing of a *kaki-han* of the *minchō* type, showing the *shichi-ten* 七點, the "seven points" that have a bearing on the owners condition and fate; these are explained as follows:

1) *unmei-ten* 運命點, the owner's destiny.
2) *jūsho-ten* 住所點, the owner's dwelling place.
3) *kōma-ten* 降魔點, his resistance to evil influences.
4) *kenzoku-ten* 眷屬點, his family and dependants.
5) *fukutoku-ten* 福得點, his good luck.
6) *chie-ten* 智慧點, his wisdom.
7) *aikei-ten* 愛敬點, his love and respect.

Another theory divides the component parts of a *kaki-han* over the five Chinese elements, viz. wood, fire, earth, metal and water. It is chiefly because of these associations with his life and destiny that a Japanese would often adopt a new *kaki-han* after a severe illness, a change in social status, or other important events in his life.

Japanese books reproducing the *kaki-han* of famous people exist by the score. They offer a promising field for graphological research, a subject that is practically untouched.[1]

Tokugawa seals.

In the course of the 16th century personal seals became more popular in Japan. Courtiers, feudal lords, priests and tea masters started to have their own bronze seals made. As a rule these seals gave only the owner's personal name, together with some ornamental design. Among the early Japanese personal seals that have been preserved there is, for example, that belonging to the feudal lord Takeda Nobutora (武田信虎, 1493-1573), reproduced on Plate **156** (*a*). This seal shows the character *nobu*, with two tigers underneath, suggesting *tora*, the second character of Takeda's personal name.

Often these early personal seals gave no name at all but only a literary quotation or just an ornamental design. Plate **156** (*b*) is the seal of the famous general Oda Nobunaga mentioned above; the legend reads *tenka-fubu* 天下布武 "To spread martial prowess all under Heaven".

---

[1] Chinese and Japanese "flourish signatures" are especially important for the graphologist because they allow the writer complete freedom of expression. However, Chinese and Japanese handwriting as a whole provides highly interesting material for graphological research. As far as I know the only attempt at a graphological analysis of Chinese handwriting is the small book by R. JOBEZ, *L'expertise en écriture des documents chinois*, Tientsin 1930. It is hoped that some day a Sinologue schooled in graphology will take up this fascinating study. The field is vast, specimens of the handwriting of nearly every eminent Chinese or Japanese statesman, scholar or artist who lived during the last thousand years are available in original documents or rubbings. Moreover, the Chinese brush is a much more sensitive writing implement than our Western pen and registers minute nuances in pressure etc. which do not appear in Western handwriting.

A

B

C

D

E

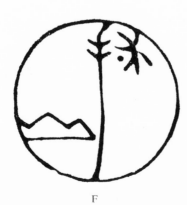

F

156. — JAPANESE SEALS

It was Japanese Sinologues, painters and priests who during the Tokugawa period introduced the custom of sealing their pictures and writings with seals giving their name and surname. In those circles the seal began to compete in popularity with the *kakihan*.

These Tokugawa seals are close copies of those in vogue in China during the later half of the Ming, and the early part of the Ch'ing dynasty. Although occasionally there arose fine Japanese artists of the " iron brush " — for example Hosoi Kōtaku whose work is described in Appendix I, no. 76 — Japanese seal carvers of that time in general showed little originality.

The people who endeavoured to create a peculiarly Japanese style of seal carving were the tea masters and the painters of the Tosa and Kanō schools. Plate **156** (*c*)–(*f*) gives four specimens of their work.

(C) is one of the seals of Sumiyoshi Hironaga (住 吉 廣 長, 1760–1814), a painter of the Tosa school. This seal is an exact reproduction of his signature *Kei–i* 桂 意 — a personal name he used in his youth — written with the ordinary brush in draft script. (D) is another personal seal of this painter that gives his name Hironaga and has a distinct Japanese flavour. He disregarded the general rules for an even spacing of the characters and suspended them as it were on the upper rim of the seal. This seal is rather attractive because of its originality.

(E) is the seal of Watanabe Ryōkei 渡 邊 了 慶, a painter of the Kanō school. The legend shows the two characters *Ryō–kei* in a fanciful archaic style and placed in a frame that represents a porcelain vessel. In the character *kei* 慶 the element 鹿 " deer " is deliberately so deformed as to give an actual picture of this animal; it is lying near a tree or shrub suggested by the character *ryō*.

Very Japanese is also the seal (*f*); it belongs to another painter of the Kanō school called Tsuruzawa Tanzan (鶴 澤 探 山, died 1719) and gives his name Tanzan. The radical 手 in the character 探 is abnormally elongated while the right half is given in its most simple form. The character 山 reproduces the actual shape of a mountain. Thus the seal resembles a diminutive landscape picture, with in the foreground a tree by the waterside and distant mountains in the background.

Chinese connoisseurs are wont to comment unfavourably on such peculiarly Japanese seals. It is quite true that the Chinese are unsurpassed in their own artistic achievements but, in my opinion, one should still keep an open mind for new features developed in those countries which adopted Chinese culture. And some credit must go to those Japanese who tried to impress their individual mark on the art of seal carving while Indo–Chinese and Korean seal carvers remained content with following the Chinese models.

Until recent years *yin–pu* did not enjoy in Japan the same popularity as in China. During the Tokugawa period there appeared only a few collections with reproductions of seals and signatures of famous people. I mention, for instance, the great collection in 51 ch. called *Koga–hikō* 古 畫 備 考 compiled by the painter of the Kanō school

447

Asaoka Sakisada (朝岡興禎, 1800-1856) which gives seals and signatures of Japanese painters, with an appendix on Chinese artists who resided in Japan. Since this and other publications of the same kind are struck off from blocks where seals, signatures and *kaki-han* are re-cut, they are useful only as an aid in identifying a given seal; they can not be used for deciding authenticity problems.

*Yin-pu* became more popular in the Meiji period and after. In recent years there also appeared some collections of photographic reproductions of seals and signatures, taken from the original scrolls. I mention the *Shoga-kantei-impu-rakkan-shū* 書畫鑑定印譜落欵集 which was published in 1912 in 2 foreign volumes by Hirawatari Chosen 平渡緒川; there is a sequel in one volume entitled *Shoga-kantei-hō* 書畫鑑定法 "Methods for judging scrolls". Further the *Shoga-rakkan-impu-taisen* 書畫落欵印譜大全, published in 1932 in 2 vls. by Kanō Kōkichi 狩野亨吉 and Iwakami Hōgai 岩上方外. These books should be on the shelves of every serious student of Japanese pictorial art.

<div style="margin-left:0"><strong>The Meiji period and after.</strong></div>

The modernization of Japanese life that marked the Meiji period, including the compulsory adoption of a surname for all Japanese subjects, brought with it the necessity for a simple method of authenticating receipts, contracts and other documents. Since for such practical purposes the seal was more suitable than the *kaki-han*, the former gained in popularity at the latter's expense. The popularity of the seal was further enhanced by the fact that it proved a boon to clumsy penmen and all those who could never hope to be able to produce a good *kaki-han*. In 1873 the government declared that *kaki-han* would not any longer receive official recognition and that the seal was the only legal means for authenticating documents. Thus the *kaki-han* was relegated to the domain of literary curiosities.

Since then every Japanese householder has at least one seal, the *jitsu-in* 實印 or "legal seal"; this seal takes the place of our Western "authorized signature" and must be duly registered before a witness at the ward office. Next to this *jitsu-in* most people of some standing have one or more *mitome-in* 認印 "private seals" which are used for sealing paintings, books etc. In China there exists no such difference; a Chinese painter may use one and the same seal for authenticating his pictures and for signing a bank cheque. It should further be noted that while in China private letters are mostly signed and sealed, in Japan the seal is not used in private correspondence — except when one wishes to give a letter a distinct Chinese flavour, as some Japanese Sinologues do.

In broader circles the seal is considered as a utensil rather than as a work of art. Professional seal carvers cater for the demand for *jitsu-in*, which are usually made of wood and have no artistic pretensions. Popular belief asserts that the *jitsu-in*, exactly as the *kaki-han*, is closely related to the life and fortunes of the owner. The requirements for a "lucky" seal are fixed on the basis of a complicated Sino-Japanese system of cosmological correspondences. A person born in the year 1884 should for instance only employ seals made of gold, silver or bronze because that year, indicated by the cyclical signs

甲 申 belongs to the element *metal*, and consequently the person concerned has a " metal nature ".   Further there exists a connection between one's disposition and status in life, and the shape, size and material of one's seal; many people consider a seal made of crystal as definitely unlucky.   As far as I know, these theories do not exist in China.

In the first decennia of this century the work of contemporary Chinese seal carvers was eagerly studied in Japan, and several Japanese amateurs of this art paid special visits to China in order to study the new schools that had developed there.   These Japanese seal artists — mostly Sinologues — attained a very high artistic level and gave a new impetus to Japanese interest in this art; I mention great seal carvers such as the late Kawai Senro (河 井 荃 廬, 1871–1945), and the living artists Yamada Seihei 山 田 正 平 and Ishii Sōseki 石 井 雙 石.

In the years 1936–1940 this art  was extremely popular in Japan; clubs and associations devoted to seal carving were organized in all larger cities, many *yin–pu* were published and exhibitions of seals were held all over the country.

At the same time the revival of ancient Japanese customs encouraged by the government in the years directly preceding the Pacific War, brought the *kaki–han* to the lime light again, some writers even maintaining that the " flourish signature " was a genuinely Japanese feature, and as such preferable to the seal.   In the post–war period, however, the art of seal carving was again widely studied, while that of composing and writing *kaki–han* was rapidly falling into oblivion.

# TABLE OF TWENTY-TWO TYPES OF SEAL LEGENDS

**1. – FAMILY NAME ONLY.**

*hsing-yin* 姓印

A. *Li.*

B. *Li-shih.* The family name may be followed by the character *shih* "family, clan", but it is not customary to add to such legends *yin* 印, or any of the other terms for seal.

C. *Yang-chou-li-shih* "Mr. Li, from Yang-chou". If the family name is followed by *shih* 氏, it may be preceded by a geographical designation, usually the place of origin of the family.

**2. – PERSONAL NAME ONLY.**

*ming-yin* 名印

A. *Wên-ta.*

B. *Wên-ta-yin* "Seal of Wên-ta". If one wishes to use four characters as a legend, *yin* may be replaced by other words for "seal" of two characters, such as *yin-hsin* 印信 or *szû-yin* 私印 "personal seal"; it is not customary to expand the legend by inserting *chih* 之 "of" between the name and the character for "seal", for a legend like *Wên-ta-chih-yin* could be read to mean "Seal of Mr. Wên Ta-chih".

C. *Ch'ên-wên-ta.* Formerly only officials added the term *ch'ên* "statesman" before their personal name; now *ch'ên* in such legends usually means "servant", and must be taken as a self-deprecatory term. *Ch'ên* may only precede a *personal name.*

**3. – STYLE ONLY.**

*tzû-yin* 字印

A. *Shih-ch'ing.*

B. *Tzû-shih-ch'ing* "styled: Shih-ch'ing".

C. *Shih-ch'ing-fu* "styled: Shih-ch'ing". Instead of preceding the style by *tzû*, it may also be followed by *fu*, another term for "style"; 甫 may be replaced by the homonym 父.

D. *Tzû-fu-shih-ch'ing* "I style myself Shih-ch'ing". If one wishes to *precede* the style by *fu*, then always the character *tzû* should be added; for *fu* in itself is also a family name, so

that a legend *Fu-shih-ch'ing* might be wrongly read as "Mr. Fu Shih-ch'ing". In such legends 市 may *not* be replaced by 父.

E. *Tzŭ-yüeh-shih-ch'ing* "My style is Shih-ch'ing".

F. *Tzŭ-yü-po-shih-ch'ing* "I report my style as Shih-ch'ing". *Yüeh* may be replaced by *po* 白 "to state, report".

G. *Shih-ch'ing-shih*. To add *shih* after a style is an old custom, the origin of which is not clear to me.

Note: As a rule seals giving the style only, do not show *yin* or any other character meaning "seal".

E

F

G

---

4. – SINGLE FAMILY NAME AND SINGLE PERSONAL NAME.

*tan-hsing-tan-ming* 單姓單名

A. *Wên P'êng.*

B. *Wên-p'êng-yin* "Seal of Wên P'êng". In such cases *chih* 之 "of" is never added, because then the legend could be read wrongly as "Seal of Wên P'êng-chih".

A

B

---

5. – SINGLE FAMILY NAME AND DOUBLE PERSONAL NAME.

*tan-hsing-fu-ming* 單姓複名

A. *Li Wên-ta.*

B. *Li-wên-ta-yin* "Seal of Li Wên-ta". This is the most common type of seal.

C. *Li-yin-wên-ta.* Same legend as B, with *yin* inserted between family and personal name; the technical name of such seals is *hui-wên-yin* 廻文印. It is not customary to apply this change to seals giving styles or literary names.

D. *Wên-ta-li-shih.* "Wên-ta, of the Li family".

A

B

C

D

---

6. – DOUBLE FAMILY NAME AND SINGLE PERSONAL NAME.

*Fu-hsing-tan-ming* 複姓單名

A. *Ou-yang Ch'un.*

B. *Ou-yang-ch'un-yin.* Inclusion of *chih* 之 before *yin* would give the impression that the personal name was Ch'un-chih.

A

B

7. – DOUBLE FAMILY NAME AND DOUBLE PERSONAL NAME.

*fu–hsing–fu–ming* 複姓複名

A. *Ou–yang Wên–chih.*

B. *Ou–yan–wên–chih–chih–yin.* Here *chih* 之 is included, because six characters are easier to divide over the surface of the seal than five.

A

B

---

8. – GEOGRAPHICAL DESIGNATION.

*k'o–ti–ming* 刻地名

A. *Ch'u–kuo–mi–fu* " Mi Fu, from Hupeh Province ".

B. *Ho–lan–wu–li* " Borel, from Holland " Seal of the Netherlands writer and art–collector Henri Borel, deceased 1932.

A

B

---

9. – LITERARY NAME.

*hao–yin* 號印

A. *Szû–ming.*

B. *Szû–ming–tao–jên.* In literary designations *tao–jên* " Who practises Tao ", usually has the general meaning of " unworldly person "; occasionally, however, it may stand for " Taoist " or " Buddhist priest ". The literary name may also be followed by *man–shih* 漫士 " vagrant officer ", *wai–shih* 外史 " petty official ", *chü–shih* 居士 " hermit ", *shan–jên* 山人 " mountain recluse ", *hsien–jên* 閒人 " man of leisure ", *lao–jên* 老人 " old man ", or some other self–deprecatory designation, that at the same time indicates the unworldly disposition of the owner. It is not customary to add to such legends *yin* or other terms for " seal ".

A

B

Note: Terms like *wai–shih, man–shih* etc. may also be preceded by a geographical designation, and thus this group often merges with the preceding.

---

10. – STUDIO NAME.

*chai–yin* 齋印

A. *Liu–ch'in–chai* " Studio of the Six Lutes ".

B. *Wan–yüeh–ko* " Bower where one enjoys looking at the moon ". Instead of *ko* one may find *t'ang* 堂, *shih* 室, *an* 菴, *lou* 樓, *t'ai* 臺 or some other designation of the scholar's abode.

The studio name may be followed by *chu* 主 or *chu–jên* 主人 " master of ... ", or also by *wai–shih, man–shih* etc.; if such an addition occurs, the seal should properly be classified under 9.

A

B

Note: It is not customary to add on these seals *yin* or some other term for " seal ", for then the seal would look like that of a shop or firm. A special mark of shop–seals is the adding of *chi* 記 after the firm name; *Chiu–hua–t'ang–chi* 九華堂記 for instance, is the legend of a seal of a paper shop at Shanghai.

453

## 11. – ELEGANT SEALS.

*hsien-yin* 閒印

*yu-sung-shih* "befriending pines and stones". The choice of literary quotations to be used for such seals is unlimited, some scholars even engraving an entire poetical essay of fifty or more characters on the seal. As a matter of course to such seals there is never added *yin* or some other term for "seal".

If the legend is brief, the *hsien-yin* may be transformed into a *hao-yin* (see 9 above) by adding, for instance, *chü-shih; yu-sung-shih-chü-shih* 友松石居士 "The hermit who befriends pines and stones".

---

## 12. – STATING BIRTH YEAR.

*k'o-shêng-nien* 刻生年

A. *ting-ch'ou-shêng* "born in the year 1817, 1877, etc.".
B. *shêng-yü-ting-ch'ou* "I was born in the year 1817, 1877, etc. ".

Note: As each of the "Twelve branches" (*shih-êrh-chih* 十二支) may be represented by a symbolical animal, Ming literati believed that Han seals, showing instead of a legend the image, of, for instance, a tiger, must be taken as birth year seals, and read: "born in the year of the tiger" (i. e. a year the cyclical designation of which contained the "branch" *yin* 寅). Instead of the seal given above under A, a Ming scholar therefore might simply engrave the image of a cow, meaning "born in 1397, 1409, 1421 etc.". It is, however, by no means certain that Han seals showing the images of animals must be taken as indicating birth years. They may well be a sort of *hsiao-hsing-yin* 肖形印, i. e. seals showing instead of characters a pictorial or geometric design; these were popular during the Han period, but their significance has not yet been satisfactorily explained. A seal showing the image of for instance a tiger, might well be an amulet, protecting the owner against attacks by wild animals (cf. the discussions on page 423 above). Be this as it may, during the Ming period "birth year seals" showing a cyclical animal were very popular, and they were introduced into Japan by Ming emigrants. To-day they are still much used in Japan, while in China they now are comparatively rare.

A.
生丁
丑

B.
丁生
丑於

---

## 13. – STATING AGE.

*k'o-hsing-nien* 刻行年

A. *pa-shih-êrh-wêng* "Senex of 82 years".
B. *Shih-nien-pa-shih-liu* "In my 86th year".

Note: Only persons well advanced beyond the "three-score and ten" are entitled to use such seals. In China a seal reading, for instance: "In my 54th year", would be taken as a joke.

A.
八翁
十
二

B.
八時
十年
六

454

**14. – STATING OFFICIAL TITLE.**

*kuan–yin* 官印

A. *Han–yang–t'ai–shou* " Prefect of Han–yang ".
B. *T'ai–shih* " Compiler attached to the Han–lin Academy ".

Note: It is considered vulgar to use such seals in private life.

太漢
守陽

A

史太

B

---

**15. – STATING LITERARY DEGREE.**

*k'o–chi–ti* 刻及第

*kuei–wei–chin–shih* " Chin–shih in the year 1883, 1823, etc. ".

進癸
士未

---

**16. – STATING OFFICIAL RANK.**

*k'o–p'in–chi* 刻品級

*szŭ–chêng–liu–p'in–chi* " by Imperial Decree promoted to the sixth grade of the principal rank ".

Note: It is considered vulgar to use such seals in private life.

品賜
六
級正

---

**17. – STATING PROFESSION.**

*k'o–shih* 刻職

A. *yin–fang–wei–kuei* " mixing potions according to the correct prescriptions ". Used by doctors.
B. *k'ung–mên–ti–tzŭ* " disciple of the Confucianist school ". Used by literati.

爲因
圭方

A

弟孔
子門

B

---

**18. – SEALS OF BUDDHIST PRIESTS.**

*sêng–yin* 僧印

A. *Shih–yüeh–po* " the priest Yüeh–po ".
B. *Yüeh–po–t'ou–t'o* " the priest Yüeh–po ". Instead of *t'ou–t'o*, other old Chinese transcriptions of the Sanskrit *dhûta* " puri-fied person " may also be used; one often finds 杜多, 頭多.
C. *Yüeh–po–na–tzŭ* " the priest Yüeh–po ". Instead of *na–tzŭ* " man in patched robes ", one also finds other terms desig-nating a priest.
D. *k'ung–mên–ti–tzŭ* " disciple of the school of emptiness "; probably such general terms indicating the creed of the owner of the seal were evolved as a protest against Confu-cianist seals like the one quoted under 17 B.

月釋
波

A

頭月
陀波

B

衲月
子波

C

弟空
子門

D

455

19. – SEALS CUT WHILE TRAVELING.

    A. *Ching–shih–lü–tz'ŭ* " during my visit to the capital ".

    B. *Wu–yüeh–tao–shang* " while traveling through Kiangsu and Chekiang Province ".

Note: Such seals are considered as showing elegant taste, and are often found on antique scrolls.

|  |  |
|---|---|
| 旅京<br>次師 | 道吳<br>上越 |
| A | B |

20. – LADIES' SEALS.

    *kuei–hsiu–yin* 閨秀印

    A. *Kuan–fu–jên–yin* " seal of Mrs. Kuan ".

    B. *Pai–ho–nü–shih* " White lotus lady ". Instead of *shih* 士 in *nü–shih* one also finds *shih* 史. *Fu–jên* is used only with the family name, *nü–shih* only with some literary designation.

|  |  |
|---|---|
| 人關<br>印夫 | 女白<br>士荷 |
| A | B |

21. – CONNOISSEURS' SEALS.

    *chien–shang–yin* 鑑賞印

    A. *Wan–sung–kuo–yen* " seen by Wan-sung ", Wan-sung being the literary name of a connoisseur.

    B. *Liu–fêng–chien–shang* " appraised by Liu-fêng ", Liu-fêng being the literary name of a connoisseur.

    C. *Lan–hsüeh–chien–ting* " judged by Lan Hsüeh ".

    D. *Lan–hsüeh–shên–ting* " judged by Lan-hsüeh ".

    E. *Hsiang–yüan–pien–shih–shên–ting–chên–chi* " Genuine specimen judged by Hsiang Yüan-pien ".

Note: As a rule such seals give only a literary designation of the owner; for exceptions see E above, and Mi Fu's seal mentioned on page 425. Strictly speaking these seals only imply that the scroll bearing them was seen by the owner of the seal; often, however, they may be taken to mean that he actually possessed the scroll. This group, therefore, to a certain extent merges with the next.

|  |  |
|---|---|
| 過晚<br>眼菘 | 鑑六<br>賞峰 |
| A | B |
| 鑑蘭<br>定雪 | 審蘭<br>定雪 |
| C | D |
| 真氏項<br>蹟審元<br> 定汴 |  |
| E |  |

22. – COLLECTORS' SEALS.

    *shou–ts'ang–yin* 收藏印

    A. *Li–wên–ta–ts'ang* " Owned by Li Wên-ta ". This is the most simple and most common form of the collectors' seal; it may be impressed on scrolls, books, and boxes containing other antiques.

|  |  |
|---|---|
| 達李<br>藏文 | 家張<br>藏氏 |
| A | B |

B. *Chang–shih–chia–ts'ang* " Owned by the Chang family ".

C. *Chiang–ts'un–ch'ing–wan* " Appreciated and enjoyed by Chiang–ts'un ".

D. *Lan–pu–chien–ts'ang* " Judged and owned by Lan–pu ".

E. *Jui–ch'ing–kuan–chên–ts'ang* " treasured possession of the Jui–ch'ing Hall ".

F. *San–yü–t'ang–shu–hua–yin* " Seal of scrolls belonging to the San–yü Studio ".

G. *Li–shih–chên–ts'ang–t'u–shu* " scroll treasured by Mr. Li ". May also be read: " Seal of the treasured possessions of Mr. Li "; cf. page 419 footnote 1.

H. *Ming–shan–t'ang–chên–ts'ang–shu–hua–yin–chi* " Seal of scrolls treasured by the Ming–shan Hall ".

I. *Po–yün–shan–fang* " White Cloud mountain retreat ". Possession may also be indicated by impressing a library seal on the scroll. Personal seals may serve the same purpose, but are not often found on antique scrolls.

457

# THE COLLECTING OF SCROLLS

I N THIS FINAL CHAPTER are brought together some data on the collecting of Chinese scrolls — odds and ends chosen from notes that accumulated during two decades of varied experiences in this field.
At first I had some misgivings about the inclusion of these notes in the present publication. Since, however, Chinese connoisseurs from the Sung artist Mi Fu till the Ch'ing collector Lu Shih-hua apparently never hesitated to incorporate their personal views and experiences in the works they wrote, I was finally emboldened by those illustrious precedents to offer these notes for the consideration of fellow-collectors.

The study of lesser-known artists.

While building up a collection of Chinese scrolls one will find it a wise policy not to insist too much on acquiring works by famous artists. This does not only apply to the older masters, but also to the well known artists of the Ming and Ch'ing periods. As pointed out already above, the works of such great men were copied out again and again either for study or for gain, while of those done by lesser known artists hardly any copy exists.

Neither should one despise anonymous pictures. Many masters of former periods did not always sign or seal their work. If one makes it a habit to ignore anonymous pictures one will sooner or later miss the chance of a life time.

It is especially worth while to pay attention to the lesser known Ming and Ch'ing artists. A rather small Chinese collection of painter's biographies that covers only the second half of the Ch'ing period lists more than eight hundred names. It may be safely assumed that among those eight hundred there are scores who although they never achieved nation-wide fame, yet produced works that can be compared to those of the famous masters of the brush of that period. As practically everywhere else, in China too artistic life was to a large extent governed by fashion. During the Ming and Ch'ing periods must have lived numerous talented artists whose works never became famous for the simple reason that they did not catch the fancy of their contemporaries. There must also have been many painters who lived in retirement or in out-of-the-way places so that their artistic activity did not come to the notice of well known connoisseurs and collectors in the big cultural centres. The works of such men are collecting dust on the shelves of antique shops, waiting to be discovered.

Already in the 12th century Chinese connoisseurs warned against concentrating on the works of famous old artists. The Sung writer Chao Hsi-ku observes:

" Remote indeed are the men of olden times. Although Ts'ao Chung-ta [1] and Wu Tao-tzû [2] are men of fairly recent times, not one single painting by them has been pre-

---

[1] The text has Ts'ao Pu-hsing; cf. Pelliot's correction in *T'oung Pao*, vol. XXII (Leiden 1923), p. 226.

[2] Wu Tao-tzû, famous T'ang painter.

served.  How then could one ever hope to see scrolls by Ku K'ai-chih [1] or Lu T'an-wei [2] or others of their period? Therefore, when discussing painting one had better take as standard those pictures one can actually see.  For if one persists in referring to old artists, saying ' This is a Ku K'ai-chih, this is a Lu T'an-wei ', one not only deceives others but in fact also himself ". [3]

Nearly seven centuries later the collector Lu Shih-hua addressed a blunt warning to those among his colleagues who limited their interest to scrolls by old masters.  He says:

" (While collecting scrolls) it is a fundamental mistake to venerate antiquity and think lightly of all that is new.  With each succeeding day antiquity grows more remote, and with each day antique scrolls become more rare.  If one insists on having them, one will in the end have nothing but fakes ". [4]

Most later Chinese collectors subscribe to this view; although attaching due importance to Sung and Yüan works they do not consider scrolls by Ming and Ch'ing artists as *per se* of less value.  Not a few Ch'ing connoisseurs tried to have later paintings represented as well in their collections as those by masters of former dynasties.

Ferguson relates in his " Chinese Painting " (Appendix I, no. 1) that in the Twenties the great collector P'ang Yüan-chi [5] (龐 元 濟, style Lai-ch'ên 萊 臣, lit. name Hsü-chai 虛 齋) at Shanghai sold many of his antique scrolls in order to be able to purchase pictures by early Ch'ing artists.  As a matter of fact it is now more easy to obtain in China scrolls by prominent Ming painters than those of some Ch'ing masters.

Western collectors would do well to bear these facts in mind, lest " in the end they have nothing but fakes ".

Works of contemporary painters and calligraphers.

One often obtains the impression that in the West there is but little interest not only in the work of later Ch'ing artists, but also in that of contemporary Chinese painters.  Collectors of Chinese art do not as a rule make any effort to study them, and to the best of my knowledge there is no Western museum or art-gallery that possesses a representative collection of such pictures.

I would not like to go as far as a modern expert on Western painting who states that " The only art which can teach us to understand art that was ever alive, is the art of living men "; and " Art after all is an aspect of life.  We cannot learn to under-

---

1) Ku K'ai-chih 顧 愷 之, the famous 4th century artist.

2) Lu T'an-wei 陸 探 微, famous painter of the 5th century.

3) *Tung-t'ien-ch'ing-lu* (cf. Appendix I, no. 27):

古 人 遠 矣。曹 不 與 吳 道 子 近 世 人
耳。猶 不 復 見 一 筆。況 顧 陸 之 徒 其
可 得 見 之 哉。是 故 論 畫 當 以 目 見
者 爲 準。若 遠 指 古 人 曰 此 顧 也。此
陸 也。不 獨 欺 人 實 自 欺 耳。

4) *Shu-hua-shuo-ling* (cf. Appendix I, no. 47), ch. 5:

尊 古 而 薄 今 非 也。世 日 遠 而 所 存
日 少。必 欲 致 焉 則 僞 而 已 矣。

5) P'ang Yüan-chi seems to have been the only contemporary collector that H. A. Giles knew; he is mentioned several times in Giles' " Introduction to the History of Chinese Pictorial Art ".  His scrolls are described in the catalogue *Hsü-chai-ming-hua-lu* 虛 齋 名 畫 錄, 16 ch., publ. 1909.

stand life by studying the surviving records of the past ". [1] However, I agree with these statements in so far that a study of modern Chinese painting will appreciably broaden one's understanding of antique scrolls.

It should be born in mind that contemporary Chinese painters who work in the traditional style use the same kind of brush, the same ink and pigments, and paper and silk similar to that of Sung and Yüan artists. Although their technique and their vision will often be very different from those of the old masters, they were confronted with the same problems of artistic expression. Thus their works contain valuable clues to the technique of painters of former times. For example, as was remarked already above, the well known modern painter Ch'i Huang bases his painting technique on the works left by the two great Ming artists Hsü Wei and Chu Ta. An analysis of the artistic growth of Ch'i Huang — whose works are available in hundreds of woodcuts and reproductions — provides an excellent approach to the technique of the two Ming artists he took as his models.

Moreover, among present-day Chinese painters and calligraphers there are not a few who have reached nation-wide fame already during their life time, and many of their works are of outstanding quality.

It must be considered fortunate, therefore, that in recent years modern Chinese painters have become somewhat better known in the West. In 1934 the Chinese Government sent a large collection of their work to Europe, and expositions were organized in The Hague, Paris, Berlin and other places. [2] In 1946 the Musée Cernuschi in Paris held an exhibition especially devoted to the work of modern Chinese painters which included most of the better known contemporary artists. [3] Finally, in the last ten years most Chinese painters do much work for the publishers of colour prints, and specialise in designing illustrated letter paper. Since at present Western art lovers are greatly interested in this subject, the colour print serves as a means for acquainting the general public with modern Chinese art. It is hoped that this will have convinced Western collectors that present-day Chinese pictorial art is well worth their attention, and prove that the great Chinese artistic heritage is still very much alive. [4]

In my opinion no museum of Asiatic art should consider its collection of Chinese scrolls complete without pictures and autographs of modern Chinese artists. Their work not only gives a general impression of the main trends now prevailing in Chinese pictorial art but also presents a review of practically all schools and styles of older Chinese painting and calligraphy.

1) R. H. WILENSKI, *English Painting*, one illustrated vol., London 1947, page 33.

2) Cf. the illustrated booklet *Chinesische Malerei der Gegenwart*, Würfel Verlag, Berlin 1934; here some photographs of the works exhibited are given.

3) The Museum published a catalogue entitled *Exposition de peintures chinoises contemporaines* (Paris 1946), well illustrated and especially useful because it gives photographs of the signatures and seals of 25 prominent modern painters.

4) A good survey of the work of modern Chinese painters and calligraphers is found in the illustrated catalogue of the National Fine Arts Exhibition held in 1929 in Nanking, and published in 1930 by the Yu Chên Book Company in Shanghai under the title *Chiao-yü-pu-ch'üan-kuo-mei-shu-chan-lan-hui-t'ê-k'an* 教育部全國美術展覽會特刊。

I mention here but a few of those artists whose work seems to be of lasting value. In the field of landscapes in formal style Lin Shu (林 紓, style Ch'in-nan 琴 南, lit. name Wei-lu 畏 廬, 1852-1924), and the living painters P'u Ju 溥 儒, Wu Hu-fan 吳 湖 帆 and Huang Chün-pi 黃 君 璧. Fine landscapes in free style were done by the versatile artist Ch'ên Hêng-k'o (陳 衡 恪, style Shih-tsêng 師 曾, 1887-1924), who also excelled in birds, flowers, plants and still-lifes. Further Wang Chên (王 震, better known by his literary name I-t'ing 一 亭, 1867-1909), who was also proficient in monochrome sketches of trees, flowers and stones. The living painter Chang Yüan (張 爰, better known by his lit. name Ta-ch'ien 大 千, born 1899) does excellent landscapes and is well known also for his copies of Tun-huang frescoes. Among those who specialize in flowers, plants and animals I mention Wu Chün-ch'ing (see page 435 above), P'an T'ien-shou (潘 天 授, born 1896), and especially of course the aged artist Ch'i Huang, now perhaps the best known painter in China.

Of particular interest are those artists who are trying to create new styles by combining Chinese and Western techniques. Among those I mention especially the late Hsü P'ei-hung (徐 悲 鴻, Westernized name Ju Péon, 1895-1953); he studied Western painting in France and became a better than average portrait painter in oil. Returned to China he founded a new school in Chinese-style painting with the traditional Chinese media and did very sensitive pictures of animals, plants and flowers. Later he specialized in horses and his reputation among Western collectors rests chiefly on those. Another modern painter who received his elementary training in France is P'ang Hsün-ch'in 龐 薰 琴 who paints Chinese rural scenes in Sino-European style and also made some good purely Chinese pictures inspired by figures on Tun-huang frescoes. In Canton Kao Chien-fu (高 劍 父, born 1887) and his brother Kao Ch'i-fêng 高 奇 峯 did excellent work with Chinese media in Sino-European style; I mention of the latter his fine landscapes which express the dreamy atmosphere of local scenery, and some good pictures of tigers and birds. Plate **157** is a reproduction of a landscape by Kao Ch'i-fêng representing a bridge on a rainy day, done in colours on paper. The washed colours are applied according to Western technique, but brushwork and atmosphere are typically Chinese. The superscription in the *shih-t'ang* is a good specimen of the calligraphy of Yeh Kung-ch'o (see below).

The work of these artists is still in the experimental stage and much of what is done in this new style still bears an unmistakable hybrid character. But there are also not a few pictures where East and West merge harmoniously into a unity of impressive quality and which prove convincingly that this trend in modern Chinese painting has a promising future.

Also in the field of calligraphy there are several writers whose work can be compared to that of the old masters and who have many followers. Among the countless scholars who write in the classical style I mention Ch'ên Pao-ch'ên (陳 寶 琛 1848-1935) for his *kai-shu*, Shên Yin-mo 沈 尹 默 for his cursive script, and Ma Hêng 馬 衡 for archaic styles.

462

157. – LANDSCAPE BY KAO CH'I–FENG, DATED 1932

Colours on paper, cm. 82 by 92

Superscription by Yeh Kung–ch'o

Further there are also some who created an impressive style of their own. Chêng Hsiao-hsü 鄭孝胥 wrote a vigorous, highly original style that is greatly admired; he damaged his reputation by serving as Premier of "Manchukuo" but no one doubts his great artistic talents. Other outstanding calligraphers who founded their own school are Yeh Kung-ch'o 葉恭綽 who writes an expressive semi-cursive style, and Hsieh Wu-liang 謝无量 who developed a forceful cursive calligraphy. The aged scholar-official Yü Yu-jên 于右任 has created an original manner of writing "draft script" that has become known as *piao-chün-ts'ao-shu* 標準草書, and which has set indeed a new standard that is widely practised by present-day scholars and artists.

It is hoped that while a study of modern Chinese painting will broaden the Western student's view of old Chinese pictures, the work of modern Chinese calligraphers will encourage him to include calligraphy in his researches. The late John C. Ferguson has pointed out already that calligraphy has been, and still is the only branch of Chinese fine art that belongs to all Chinese alike, irrespective of their means and position. Not everyone can afford a painter's outfit while painter's manuals and antique models are not easy to come by for the masses. But even the poorest clerk or coolie has access to writing brush, ink and paper, and thereby to all intricacies and possibilities of calligraphic art. Shop signs and placards constitute a gratis supply of writing models — often of surprising quality — and a few coppers will buy a rubbing or copy book that reproduces the writing of Mi Fu, Su Shih and other famous calligraphers. Thus the art of the great old masters is bound up with the daily life of rich and poor, young and old all over China. If one concentrates on painting and neglects calligraphy — the artistic impulse that inspired the entire Chinese nation — one wilfully narrows his perspective of the development and the intrinsic qualities of Chinese pictorial art as a whole.

In the First Part of the present publication mention was made already of the fact that in China and Japan valuable scrolls are as a rule not exposed for a long time on end; they are mostly kept rolled up and stored away.

The exhibition and preservation of scrolls.

This practice is suited to the Chinese and Japanese way of life but it has few attractions for Western private collectors or museums. The former like to see their collection about them while the latter are under the obligation to show their possessions to the public. Doubtless most owners of public and private collections in the West have found adequate solutions for meeting these difficulties. Below I describe only those aspects of the problems involved that happened to come to my notice.

Hand scrolls are meant to be unrolled on one's desk, except in rare cases they can not be used for decorating one's room. This is probably the main reason why hand scrolls are not very popular with Western collectors. Hand scrolls of moderate length, and lacking superscriptions and colophons, can be mounted as horizontal tablets. This is often done in Japan where such long, narrow tablets can be hung against the *ramma* 欄間, the transoms over the sliding doors that connect two rooms in a Japanese house. But it is difficult to adapt such tablets to Western interior decoration. Private

collectors will have to resign themselves to the fact that hand scrolls can only be observed while being unrolled on the desk, comforted by the knowledge that this indeed is the proper way to see them.

In Japanese and Chinese museums hand scrolls are often exposed full length, lying flat under glass plates or inside show cases. Since one can look at them section by section while walking along the show case or table, there is much to be said for this method. It is better than showing the hand scrolls attached to the wall or in vertical show cases, for pictures and calligraphic specimens of this type are meant to be seen while lying flat. If covered by glass plates the scrolls should not be left in this way for longer than one month or so; else the scroll will lose its elasticity and when rolled up again its surface may develop bursts. It would seem that they can be left for a long time inside showcases provided there is some mechanical device that keeps slightly humid air circulating in the case.

In the case of hanging scrolls the problem is more complicated. If one just suspends a hanging scroll on the wall and leaves it there it will certainly deteriorate. The weight of the lower roller will cause a hanging scroll to lose its elasticity much sooner than a hand scroll, its surface will collect dust and it may be soiled by insects. There seems to be no objection, however, to private collectors leaving their hanging scrolls on the wall for several months on end, provided they have the time and opportunity to inspect them regularly and test their condition. The room should be heated by ordinary stoves and not by central heating, for the latter will cause even the most expertly mounted scrolls to warp. It is better not to hang them inside a show case; the constant circulation of the air in a room where people live and go in and out goes a long way to keep a scroll supple, and prevents mould from forming on its surface. This fact is probably the basis of the Chinese view quoted on page 126 above, namely that " scrolls should be near the human breath ".

In China one will see often hanging scrolls framed behind glass, similar to our pictures. The simplest way to transform a mounted hanging scroll into such a framed picture is to cut off all parts of the front mounting except the " frame " (cf. Plate **30** A, 5). Then the picture is stretched over a solid wooden board and placed in a carved wooden frame in such a way that it is pressed flat against the inside of the glass. This is a rather perfunctory method that is not applied by collectors who value their scrolls. It is difficult to prevent dust and moisture from penetrating between the glass and the surface of the scroll and moreover the mounting will become stiff. Further, when the owner changes his abode he will take the picture out of its wooden frame and roll it up to facilitate transport. Then the scroll will develop bursts, and patches of the surface will peel off, especially in the case of pictures on silk. Therefore one will rarely see in China superior scrolls mounted in this way. Although the wooden frames are often beautifully carved and suspended by large, ornamental copper hooks, the Chinese will mount in this way preferably scrolls that have a decorative rather than artistic value.

The real tablet–mounting described on page 101 above is much better, provided that such tablets are not subjected to abrupt changes in climate or temperature. The wooden

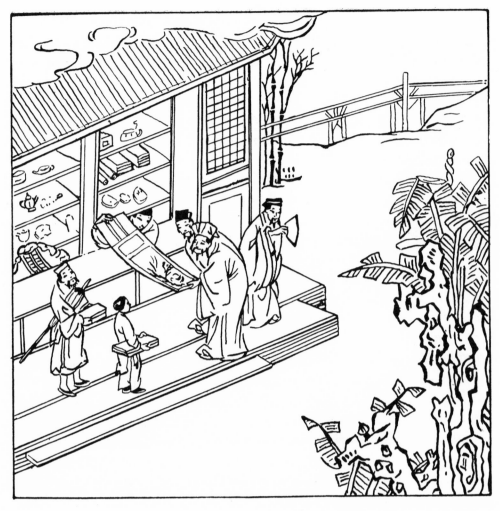

158. – ANTIQUE SHOP (MING PRINT)

frame the picture is mounted on reacts differently to such changes as the silk or paper of the picture itself, and thus the picture may develop bursts or tears, especially in its four corners.

The safest method to expose hand scrolls, hanging scrolls, tablet mountings and screens for longer periods is to place them in show cases where humid air is kept circulating by some mechanical device, as indicated above.

Plate **158** gives a view of a Chinese curio shop of the Ming period, an illustration of the play *I–chung–yüan* 意 中 緣 written by Li Yü, the famous Ming author discussed on page 2 5 7 above.

Curio dealers in China and Japan.

The shop is separated from the street by a high counter.   Behind this counter one sees the large armchair where the owner of the shop is usually sitting.   On the picture he is standing and shows a hanging scroll to two customers; their servants are waiting on the left, carrying purchases made by their masters while one is holding in addition a

large sun shade. The scroll is a landscape picture, provided with a *shih–t'ang*. On the shelves behind the counter are books, bronzes, inkstones and other smaller antiques.

Old–fashioned antique shops in the cities of Central and South China to–day are still arranged in this manner. The open front is closed during the night with wooden shutters. Larger curio shops in the North have as a rule no open front but are built in the same way as an ordinary dwelling house, distinguishable only by the signboard on the gate; the main hall and the side rooms are used as show rooms, and larger stone statues etc. are displayed in the courtyard.

A point often discussed among collectors is how one should assess the connoisseurship of Chinese and Japanese antique dealers in general. It is true that the great Chinese collectors of former times made but part of their acquisitions in antique shops. Often they obtained their most valuable items from fellow collectors by exchange. A collector of bronzes would barter a scroll owned by him for a bronze vessel belonging to a friend who specializes in paintings, and so on. Thus one will often find in colophons attached to antique scrolls such remarks as for instance: " Exchanged with Mr. So–and–so for a jade cup " or " Obtained from Secretary N. N. in exchange for a Ming lute ". Even at present Chinese collectors often make exchanges amongst each other, while some items are sold directly from one connoisseur to another, although questions of " face " make the latter transaction in China even more delicate than it is in the West. However, the curio dealer is now the main source of supply for Western collectors; a few remarks regarding their connoisseurship will therefore not be out of place — even though at the time of writing (1954) the market in China proper is practically closed to foreigners.

Connoisseurship of Chinese antique dealers.

With regard to the average dealer in places like Peking, Shanghai, Canton, Chengtu etc. it may be said that they are neither as omniscient as some collectors would have, nor as ignorant as others declare them to be. As a rule they have grown up in the trade and learned much of what lives on in a centuries–old oral tradition. Moreover years of actually handling all kinds of antiques have given them a rich fund of practical experience. They gather a great amount of information from talking with their regular patrons: they will show their bronzes to an expert in Chou and Han archeology, their old autographs to an authority on calligraphy, their coins to a specialist in numismatics, and so on. Thus they have not only the best chances for disposing of their wares but at the same time pick up a good many items of scholarly information that will come in useful while buying themselves or when recommending their wares to other customers.

However, as far as my experience goes, but few of the ordinary Chinese dealers are capable of doing independent research work in the antiquarian field. One will find on their shelves only some very elementary reference works, as for instance the *Li–tai–hua–shih–hui–chuan* (cf. Appendix I, no. 55), the *Po–ku–t'u–lu* 博古圖錄 etc. If a collector has taken the trouble to familiarize himself with lesser–known Ming and Ch'ing literary sources and has browsed much in local histories, he may occasionally buy real bargains. One need have no illusions that a dealer who possesses a genuine scroll by

466

159. — PORTRAIT OF HO MING-CHIH

for instance Tung Ch'i-ch'ang is not perfectly aware of the fact; but he may well fail to recognize the value of a work by a Ming artist of local fame who is known only to collectors who specialize in Ming painting.

The above does, of course, not apply to connoisseurs who on occasion deal in antiques or some dealers who at the same time are scholars. I mention the late Lo Chên-yü 羅振玉 formerly of Tientsin; at Peking the late Yüan Li-chun 袁勵準 and Huang Pin-hung 黃賓虹, Tung K'ang 董康, Jung Kêng 容庚 and Po Chien 白堅; further the well known Kuo-min-tang Party Elder Chang Ching-chiang 張靜江, formerly of Shanghai; Chiang Mêng-p'in 蔣孟蘋 and his son Chiang Ku-sun 蔣穀蓀 etc.

Ordinary antique dealers, although in conversations with their customers they love to refer to *ta-sung* 大宋 " of the Sung period " etc. are in reality the most sceptical persons in the world. In order to find this out one need only once make the painful experiment of trying to sell them an antique scroll from one's own collection; then it will become manifest that they are indeed men with few illusions left.

It must be considered fortunate for the peace of mind of many collectors that the ordinary Chinese curio dealer, although talkative enough when recommending his scrolls, will suddenly fall silent if questioned about fakes. The only professional dealer who placed on record his candid opinion on problems of authenticity is the late Ho Ming-chih (霍明志, style Tsung-chieh 宗傑), one time owner of a large curio shop in Peking, the Ta-ku-chai 達古齋. His photograph appears on Plate **159**.

Ho Ming-chih was in many respects a unique character. He started by being an ardent Christian and adopted the name of Paul Houo. In 1914, when he was thirty-three years old, he published his first book on connoisseurship; details about this work will be found in Appendix I, no. 25. Speaking about antique scrolls he observes:

" Antique paintings that have survived till the present are exceedingly few. This applies not only to works from the Chin and T'ang periods, also Sung and Yüan scrolls hardly exist. Present-day lovers of curios, however, immediately declare every old and damaged painting they see to date from the Sung or Yüan Dynasty; is this not most perfunctory? I find that paper and silk, no matter how carefully it is preserved, will prove never to last longer than one thousand years. The Sung connoisseur Su Tung-p'o says the following regarding Mai-kuang paper (this is the name of a paper produced during the Sung period; it is also called *Hai-tung-lo-wên*): ' This paper is extraordinarily strong and tough, it will last for five or six hundred years ' (cf. *Superscriptions and Colophons by Su Tung-p'o*, reprinted in the *Chin-tai-mi-shu*). [1] Since this is the case with paper, I need not say much about silk (which is much more perishable). I have in my shop a few paintings from the early Ming period which are thus only five hundred years old. Yet their silk is so decayed as not to withstand the touch of the hand. What then about paintings allegedly older than Ming? It is clear that all those are forgeries ". [2]

1) This collection was printed between 1628-1644 by the great bibliophile Mao Chin (毛晉 1599-1659); the book mentioned here is found in ch. 75.

2) 古書至今存者絕少。不獨晉
唐然也。即宋元之物。而絕無而僅
有矣。乃近今好文玩者。每遇殘破

Twenty years later when Ho Ming–chih published his second book on antiques (cf. Appendix I, no. 26) he had modified his extreme scepticism to a certain extent. On page 79 (Chinese edition) he says:

" The oldest scrolls one sees nowadays date from the beginning of the Sung Dynasty. One will never see a single one that dates from the Sui or T'ang periods ". [1]

It should be noted that in the mean time Ho Ming–chih had become an embittered man. Being concerned in the sales abroad of items recovered from Tun–huang, he got involved into a dispute with Western dealers and conceived a violent aversion to everything foreign. He became a Taoist and time and again denounced the ignorance of Western Sinologues, declaring that most of the Tun–huang scrolls are late forgeries! These astonishing statements will be found in his *Ta–ku–chai–ku–chêng–lu* (cf. Appendix I, no. 26), Chinese edition, page 79.

<p style="margin-left:2em"><b>Japanese antique dealers.</b></p>

In Japan the antique trade is organized in trade associations which have their local branches all over the country. These conduct sales at regular intervals, some of which are open to the public while others are for professional dealers only.

Because of the compact social structure and the highly developed system of communications, Japanese dealers are able to keep in close contact with each other, even those in outlying parts of the country being kept informed of developments in the trade. In this respect the situation is quite different from that in China.

News about an important antique becoming available travels fast. If an extensive private collection is brought on the market it is usually bought up in sections by various groups of dealers after previous consultations; the great houses buy the more expensive items, the rest is divided over those smaller dealers who are interested. The associations have their own periodical publications which often contain learned articles written by leading scholars in the field. As in the past so in the present the masters of the tea ceremony often engage at the same time in the antique trade.

Generally speaking the average Japanese merchant has a wider theoretical knowledge of the antiques he deals in than his Chinese colleague. Old and new scholarly books on antiques are inaccessible to the ordinary Chinese curio–dealer because they are written in the difficult literary style. In Japan, however, there does not exist such a wide gap between the spoken and written language, every dealer who has had the elementary education can consult Japanese handbooks on art and other literary sources written by modern scholars.

舊甚未跋海六書也有麥東百輯按紙逾光羅年以紙千紙文(語元之而(麥紙津呼質不光堅逮之無壞宋韌秘亦論者時異書)何若蘇紙常不何東紙名可且察珍坡又傳如之題名五此絹齋年在宋可有耳明知明其上但隨己初絹即今唐之書廢可見終耐數敗知之未久軸不其字一性距堪皆畫遇不今著偽遠及僅手造遠紙)五況矣不本百遠過

1) 隨己初絹即今唐

On the other hand Japanese dealers usually specialize in one branch; those who deal in ceramics will as a rule know little of pictorial art, and vice-versa. The average Chinese dealer has mostly a wider experience because — with the exception of jade merchants and jewellers — he rarely specializes in only one kind of antiques.

The methods followed by antique dealers in China and Japan for fixing their prices are fundamentally different.

Methods for fixing prices used by Chinese and Japanese dealers.

A Chinese dealer fixes his basic selling price by the logical method of putting this price roughly at the actual market value of the object in question. Taking the value as basis, he will then add a sum that varies greatly according to his estimate of the knowledge and purse of each individual customer. He does not take into account the price he paid himself when purchasing the object. As a consequence the Chinese dealer will in some cases deem it expedient to sell for less than he paid himself.

A Japanese dealer, on the contrary, bases his selling price directly on the amount he paid himself when purchasing, adding a sum of approximately 50 to 100 %. Thus it may happen that in a bona-fide Japanese antique shop one will find objects that are priced too high, and others which are priced below their actual value. Yet especially old-fashioned Japanese dealers have more or less fixed prices and will take badly any attempt at bargaining. If one points out to a dealer whom one knows well that in some particular case his price is really exorbitant, he will say that he cannot help it since for some reason or other he himself had paid too much for it. On the other hand I felt sometimes duty bound to tell a dealer that his price was not one tenth of the actual value of a scroll. I was then answered that he could not well ask more since he had bought the picture from an ignorant person who was selling his family possessions for a trifle, and that the price asked included the dealer's reasonable profit.

Further I noticed a curious difference between Chinese and Japanese dealers as regards their attitude to " bad sellers ". A Chinese dealer takes more or less the general Western view. If an object has been lying in his shop for years without a single customer showing any real interest in it his price will grow lower and lower because he is anxious to get rid of it, even at a loss. The Japanese dealer, however, views such an object as dead capital. Every year he will increase its price by the amount he estimates he has lost by its remaining unsold. If one points out to him that by selling it at a low price he will recover at least part of the sum he paid for it, he will answer that as he has kept it for so long already he may as well keep it for some more years, awaiting the chance that some day there will come a customer who is so keen on purchasing the object that he gladly pays the excessive price, thus refunding the dealer his original outlay plus the interest *in toto*.

It has always struck me that in China the price of antique scrolls shows a remarkable stability while on the Japanese market it is subject to considerable fluctuations.

Comparison between the Chinese and the Japanese market of antique Chinese scrolls.

I found small difference in the price of antique Chinese paintings and autographs of superior quality in Peking and Shanghai between 1935-1946. Yet when I was there

in 1935 the Japanese invasion was in the offing, when I returned in 1937 the Japanese occupation had actually begun; and when I visited North China again in 1946 the war was just over. These events caused enormous social and economic changes but the price of antique scrolls remained unaffected. Even when I stayed in Hongkong as late as 1951 these prices were still approximately the same although one would have expected a slump owing to the fact that not a few Chinese refugees there were selling their scrolls in order to tide over their economic difficulties.

This stability in price proves that in China the buying of a really good antique scroll is considered as a safe and easily transported investment, the intrinsic value of which is not affected by political and economic changes.

In Japan, on the contrary, the curio market reacts sharply to the changing political situation. When in 1935 it was the policy of the Japanese government to seek cooperation with China, Chinese paintings were difficult to obtain and highly priced. Thereafter, when Premier Konoye proclaimed the new policy of " punishment of China " for its unwillingness to cooperate, the market was suddenly flooded with good Chinese scrolls at low prices; many Japanese collectors were selling because they thought it unpatriotic to treasure Chinese pictures and autographs, and there were few buyers. Just before the outbreak of the Pacific War, when occupied China had been declared a partner in the " Coprosperity Sphere ", prices of antique and modern Chinese scrolls suddenly rose again and reached a level far above that of 1935. Finally, when I returned to Japan in 1948, the revival of Japanese interest in Western culture caused for a few years an all-time low in Chinese antiques in general, and more especially in Chinese scrolls.

It follows that while at times it is possible to obtain in Japan a superior Chinese antique scroll signed by a famous master at a moderate price, it is very difficult to do so in China itself. Since Chinese collectors and dealers know that they can any time dispose of a really superior scroll on the Chinese market at a suitable price, there is no incentive to try selling such items to foreigners. Moreover most Chinese collectors — and it is they who as a rule possess antique scrolls of such quality as rarely seen in antique shops — opine that since famous antique scrolls represent the essence of their culture, such items should not leave China. This is a significant proof of the very special place antique scrolls occupy in Chinese life, for Chinese connoisseurs and collectors have no such scruples with regard to ceramic wares, antique pieces of furniture etc.

Sung and Yüan paintings.

A question often discussed by both Chinese and Western collectors is what chance one has nowadays of obtaining a genuine Sung or Yüan painting of good quality at a reasonable price.

Not a few Chinese connoisseurs maintain that all antique scrolls signed by a well known master who lived prior to the Ming dynasty and which do not emanate from one of the better-known collections, are definitely either copies or fakes. They argue that all genuine Sung and Yüan scrolls that have been preserved have been discovered already by connoisseurs or collectors and recorded in artistic literature; and that consequently

470

only those persons who can afford to pay a — by Oriental standard — enormous price can add such a famous work to their collection.

On the basis of my own experience I find it difficult to subscribe to this view. China is so large a country and the output of its artists has always been so prodigious that I believe that there exist not a few good Sung and Yüan pictures that for some reason or other never came to the attention of Chinese collectors. This applies especially to pictures and autographs dedicated to Buddhist and Taoist temples. Most of the old masters were enthusiast travellers. Inspired by the scenery near some lonely temple in an unfrequented corner of the realm they would often on the spur of the moment write or paint, and present their work to the temple. Later, when the temple was deserted — which happened not unfrequently — such a picture might fall into the hands of some ignorant country gentleman of that neighbourhood and be kept in his family for generations. When the fortunes of the family declined it would be sold to a traveling curio dealer who would mistake it for a copy because of its too famous signature. Thus the picture passes from hand to hand and if no connoisseur ever happens to discover its real value a lucky collector with a good eye may purchase it for a neglegible price. Such a picture as a matter of course bears no colophons or collector's seals and is not registered in any literary source.

Such a lucky chance will happen but once or twice in one's lifetime. Yet it is good to keep the possibility in mind, for this will help one to keep his enthusiasm despite all the bitter disappointments that necessarily fall to the lot of every collector.

Another consolation may be found in the knowledge that most of the well known Chinese connoisseurs of former times had to struggle with the same difficulties and often experienced the same disappointments as we.

As an example I here translate a passage from the *Lang-chi-ts'ung-t'an* 浪蹟叢譚, a collection of miscellaneous notes compiled by the Ch'ing scholar Liang Chang-chü (梁章鉅 1775-1849).

"The picture 'Spring Clouds on a Bright Morning' by Kao K'o-kung (ca. 1280), a hanging scroll, is listed in (Kao Shih-ch'i's) *Hsiao-hsia-lu* (cf. Appendix I, no. 44). In the Ch'ien-lung era Wang Yüeh-hsien (unidentified) of Soochow bought it for four hundred taels from the Kao family at P'ing-hu. A mounter called Chang purchased for five silver taels half a sheet of *tsê-li* paper [1] and cut it in two. He paid Chai Ta-k'un [2] ten taels for copying (Kao K'o-kung's painting) on each of the two sheets. Then he paid Chêng Chia [3] ten taels for copying (on these two fakes) the signature and seals

Chinese connoisseurs deceived by fakes.

---

1) *Tsê-li-chih*, lit. "oblique-grain paper"; also written *chih-li* 陟簁. A superior old paper produced in the South, from sea-weed. At present often used for designating good antique paper, rather heavy and resembling the later *yü-pan* 玉版.

2) Chai Ta-k'un 翟大坤, a Soochow painter who flourished ca. 1790; he specialized in landscapes and flowers. The text refers to him by his lit. name Yün-p'ing.

3) Chêng Chia 鄭甲, painter, calligrapher, poet and mathematician. Here referred to by his lit. name Hsüeh-ch'iao.

(of the original). These fakes the mounter moistened thoroughly with clean water and spread them out flat on the lacquered (mounter's) table. When the two pictures had dried he again moistened them and then stuck them again on the table; this he did twenty or thirty times every day. After three months of this treatment he painted the pictures over with a decoction of *po–chi* [1] to give them lustre. Then the ink had sunk deeply into the paper.

"He first mounted one of the two fakes. Because on the silk border (of the front mounting) of the original picture there were impressed the seals of Wang Shih–min [2] and Kao Shih–ch'i [3] he also took an (old) title label bearing Kao Shih–ch'i's seal and added that to the front mounting. When Pi Lung [4] happened to be ill and could not leave his bedroom, he bought this painting at first sight for 800 taels. When after he had recovered he carefully examined the scroll he discovered that it was a fake; but then it was too late to do anything about it.

"The mounter had the second fake mounted also and took that to Kiangsi where Governor Ch'ên purchased it for 500 taels. At present the original is still in Soochow, but no one goes there to ask for it". [5]

A similar occurrence where it was again an unscrupulous mounter who practised the deceit is related by the Ch'ing connoisseur Lu Shih–hua. He says:

"The picture 'Peach Blossoms and Mountain Birds' by Chang Shou–chung [6] is a famous painting which is listed in (Kao Shih–ch'i's) *Hsiao–hsia–lu*. Recently it passed into the hands of a certain person in Soochow who greatly loved it and kept it carefully locked away.

"Now the most cunning and unscrupulous mounter in Soochow happened to know a certain official in the district who when visiting the atelier of this mounter would always expatiate upon the merits of the said scroll. Therefore the mounter went to visit the owner of the picture and remarked that in the course of the years the paste of the mounting had lost its force and that the paper had developed wrinkles, adding that the constant rolling and unrolling was liable to cause damage to the picture; he accordingly advised that it should be remounted with very thin paste, then it could

---

1) *Po–chi*, cf. above, page 294.

2) Wang Shih–min (王時敏 1592–1680), famous painter; the text gives his lit. name Yen–k'o.

3) Kao Shih–ch'i is here referred to by his literary name Chiang–ts'un.

4) Pi Lung 畢瀧 was a well known poet and collector of scrolls; here referred to by his lit. name Chien–fei.

5) 高錄百者而幅用其乾
房所載金以為又清再
山乾得於白二以十水浸
春隆間五金以十浸再
雲蘇湖兩金透實貼
曉州氏側雲橋漆於日二
靄圖王有理雪貼二三
軸立月裱紙半屏摹几上凡三
銷以張張成款俟三

月而止。復光原書江不及裝百無乃
滋其因復臥痾之。又五以門
幅記適金及承吳。

以墨綾村出病第金過而問之者。
白痕邊題房起二購
芨己上籤一諦幅之。今
煎入有嵌於歓雖至其
水肌見視攜眞之。
蒙裡。於先江畢本仍
於裝村潤八已陳在
畫上。一圖飛百無中

6) Chang Shou–chung 張守中, style Tzŭ–chêng 子正 was a painter of the Yüan period. The picture referred to here is the *T'ao–hua–ch'un–niao–t'u* 桃花春鳥 圖 described in ch. 3 of the *Chiang–ts'un–hsiao–hsia–lu*; it was an ink painting on paper, nine inches broad and three feet two inches high.

be preserved without deteriorating further. The owner believed him and entrusted the scroll to him.

" The mounter hired a man to make an exact copy of it. Then, on a day when he expected a visit from the official, he displayed the original (that was being remounted) on a pasting board hung high on the wall. When the official indeed came he asked: 'Why did the owner bring out this scroll?' The mounter answered: 'Having enjoyed it so long, he became tired of it. He wants to have it remounted and then sell it afterwards for the same price he bought it for'. The official then said: 'I know what the original price was, and I am intent on buying this scroll'. The mounter said: 'But must I then go without any profit?' The official reassured him saying: 'I shall certainly give you a suitable reward (for having acted as middleman in the transaction)', and he went home to fetch the money.

" The mounter then put the copy up on the board instead of the original. Shortly afterwards the official came back and gave the mounter the price of the scroll together with an extra reward. The mounter expressly sent some one to fetch a servant of the owner of the scroll. This servant (who was in the plot) pretended to receive the price for the scroll, and pocketed the reward. The mounter took the false scroll down and having nicely mounted it handed it over to the official. The original was returned to the owner and there the matter ended. Later the official realized that he had been deceived, but then nothing more could be done about it ". [1]    Finally, I quote here an amusing anecdote which proves that occasionally the roles were reversed, and artists taken in by the schemes of clever buyers eager to obtain their work. This story is told in ch. 7 of the *Hsin–shih–shuo* 新世說, a collection of notes written by the 19th century scholar I Tsung–k'uei 易宗夔, 8 ch. in 4 vls., Peking 1922.

" Chêng Hsieh [2] was an expert calligrapher who founded his own style. A certain salt–merchant once asked him for an autograph, offering a hundred taels as a mark of his respect. But Chêng was a haughty man who could never be moved by the prospect of gain. He disdainfully refused to consider the offer and thus the merchant had to give up.

" Now Chêng had always been a great lover of dog's meat. One day he left the city for an excursion. While returning home at dusk he suddenly noticed the smell of dog's meat (being cooked). Tracing the smell he found a thatched house behind a bamboo fence the gate of which was half open. So he entered the garden.

1) *Shu–hua–shuo–ling*, chapter 15:

花吳而其說爲恙。一高久
山中居店以害因幅處生
名人者舉本加其官果將
書愛最是日以言者至重
也。之狡書久薄而來曰裝。
銷甚點漿漿付以此照
夏藏同者退直之真物原
守之。有官。一至綢倩貼出而
中近裝每書舒可摹壁曰矣。
桃歸池過家必無成之玩官
錄之郡因紙而即本何價
張載深。一至綢倩貼出而
日點曰偽價僕起者矣。
原者必者及至書仍
價曰有貼酬僕磨還
吾子以於點亦好原
所可酬壁者偽裝所。
知無之之故爲成。後
也。利歸高令受交官
斯而而處人其官。
書空取須喚價。而而
吾行價臾藏而事無
所乎。點官畫存畢可
欲官者至家其矣。如
也者易交之酬。眞何

2) Chêng Hsieh, 1693–1765; cf. above, page 376. Here referred to by his lit. name Pan–ch'iao.

" Before the owner had recovered from his astonishment at the arrival of this unexpected guest Chêng said: 'My name is Chêng Pan–ch'iao. I happened to notice the fragrance of dog's meat, and just entered here on the spur of the moment. I fully realize that there is no excuse for my abrupt behaviour, but still earnestly beg the favour to be granted a taste of this excellent meat'.

" The host was overjoyed and said: 'I have long before already heard your illustrious name, but feared that you would refuse an invitation. Now that you have honoured me with your presence I consider this a great boon'. With a low bow he begged Chêng to enter.

" Chêng sat down at the table and started to eat with great relish, stopping only when he could pat his belly and declare himself completely satisfied. Then the host led him to his library for a cup of tea and a talk. The four walls were covered with scrolls by famous artists and the desk bore piles of rolled–up scrolls and an ample supply of ink and paper.

" Since Chêng thus knew that his host was a connoisseur of calligraphy, he said: ' Having eaten so much of your delicious food, I beg to be allowed to offer some writing in exchange '. The host accepted the offer with a smile. Chêng then took a brush and started to write in an inspired manner, he took his leave only when his arm had become tired.

" Later Chêng once happened to visit the home of the salt merchant. Then he saw that all the scrolls displayed on the walls were those he had formerly written in the house outside the city. Greatly amazed he questioned the merchant. The merchant then told him the entire scheme and calling one of his servants asked: ' Do you recognize this man ? ' Chêng gave him a startled glance and found that it was the man who on that day had treated him to the dog's meat ". [1]

An 18th century Chinese connoisseur on the joys and vexations of the collector.

I here further quote a few passages from the *Shu–hua–shuo–ling*, a brief treatise by the connoisseur and collector Lu Shih–hua.

In a fluent and witty style he relates some of his own experiences as a collector. He contrasts his joyful experiences with the manifold vexations that came his way, first describing a pleasant experience which he calls *chên–i–ta–k'uai–shih* " truly a great joy ", and following it up with the narration of a less fortunate incident which he designates

1) 鄭燮以公募竹入鄭而靈曰。乞可何。薄見主橋足鄭喜曰。某不如游。則焉。板信乞大

橋以動平忽茅訝是唐鼎耳。板願利生歸雜方某入之久。工百者。金唾嗜狗柴速適之我名。書。自爲棄狗肉扉之聞罪。一邀

創壽。不肉。香半客狗自嘗恐。一公顧。一蹤搶至。肉知異不格。性某日其因公香。不味。至。今

商固無城在。入余覺還入乃齪傲。亦出所徑曰。不免。主今光。腹四紙曰之。偶城告。視賜撫話。軸謂頜公在以公也。

幸呼壁墨飮公至外並之己。飽懸橫君撥某某出愕。揖而名陳佳筆商處一然。讓止人知饌。狂處書僕蓋

入主書主請書。見者曰。卽公導案人酬腕所大先當室。人畫人頰懸鶩生曰。據入上精書始條質識狗

案書琳於主去。幅商此肉大齋瑯書人一皆商人主喁茗滿者。笑曰。矗具乎人

as a *ta-shai-fêng-ching* "a tremendous nuisance". His notes throw some interesting side-lights on the relations of Chinese collectors with curio dealers, and with friends of kindred tastes.

"Sometimes you will hear that an old family possesses a famous scroll. Vexed that you do not know that family, after having tried all kinds of approaches at last you succeed in being admitted to their house. Then, if the owner does not raise any objections but gladly takes out his treasured painting to show it to you; if not only the scroll comes up to your expectations but the owner also does not press you to get over with it in a hurry, if he offers tea when you are thirsty, and something to eat when you are hungry; and if when you are about to take your leave after having enjoyed the scroll to the full the owner says: 'I still have other scrolls which you have not yet heard about', and takes out some more specimens all of rare quality, then this is truly a great joy.

"If, on the other hand, when you have heard about a wonderful picture and go to see it it proves to be a patent fake; or if when you visit the owner he raises all kinds of difficulties and invents excuses, saying that he has just lent the picture to a friend, or that he has sold it already, or again that he has has offered it as a present to some high official, then this is truly a tremendous nuisance". [1]

"It may happen that you find in a curio shop a most interesting picture. If because the owner does not realize who painted it, you obtain this scroll for less than half of its real value, then this is truly a great joy. Or, some other time you may think condescendingly that the dealer will certainly not realize the wonderful qualities of a picture. Then when you ask him you find that on the contrary he is perfectly well aware of it. You are full of misgivings and think that since the dealer will be asking a considerable price you will certainly be unable to purchase the scroll. If, however, when casually inquiring again about the price, you find that it is perfectly reasonable and if then and there the transaction is concluded, then this is truly a great joy.

"If, on the other hand, the dealer begins with asking an exorbitant price, calling together a bunch of his friends to corroborate his protestations, and if he makes all kinds of difficulties about consenting to sell the scroll; and if, when finally the deal is agreed upon, he branches off on some other argument, stating that he cannot sell it if you don't buy some other object at the same time, or that you must pay extra for the brocade cover, or the sandal-wood box the scroll is kept in, so that in the end your lips are parched and your tongue dry with arguing till you are full of mortification, then this is indeed a tremendous nuisance". [2]

---

1) *Shu-hua-shuo-ling* (cf. Appendix I, no. 47), chapter 7:

時聞某舊家有名蹟。苦不相識。鑽頭覓縫。百計營求。始得至其家。主人欣然出其所藏以示。既所見果是名品。而主人又不相促。渴則有茶。饑則有食。臨別又云。尚有逸品。君所未聞。更出數種。俱是妙品。此一大快事也。若聞有妙繪往觀之。贋本昭然。或相見多方為難。託辭。或云已送人。或云已售。或云已饋贈當道。此一大煞風景事也。

2) *Shu-hua-shuo-ling*, chapter 9:

偶至市肆。見一妙品。肆主不知為某人真蹟。以半價市之。真是大快事。或自以為肆主必不知畫中妙處。及問之。彼已了了於胸中。此最為快事。

475

"Often you will obtain a famous scroll that lacks its original colophon, or you will find a genuine colophon without the picture it belongs to. You will then be greatly distressed and sigh over a beautiful and complete thing being thus impaired. Then, one day one of your friends comes to visit you and says: ' I happened to obtain this scroll which unfortunately is incomplete. Allow me to offer it to you as a present'. If when he shows it to you it proves the very thing your scroll was lacking, and if thus the sword–pair of Yen–p'ing Ford [1] is re–united, then this is truly a great joy".

"On the other hand a famous scroll, a genuine specimen of great beauty, may have a faked colophon attached to it, while the real colophon has been attached to a faked scroll; both are brought on the market as a clever stratagem of mean persons (who hope thus to make a profit, the genuine scroll keeping its value notwithstanding the faked colophon, and the faked scroll becoming more vendable because of the genuine colophon. Transl.). If when you learn in due course that one scroll has been sold to this person and the other to some one else, and if then both of them insist on keeping what they have and will not allow it to become complete again, then this is truly a tremendous nuisance". [2]

"In the poems or essays written on a famous scroll or in the critical comments added to it there sometimes occurs some expression which you do not understand, or also you may be unable to identify the writer. You search through various books and records, but all without avail. Then friends will recommend to you a person as a man of wide learning, and you pay him a visit to ask his opinion. But then you find either that he too is completely at a loss, or that he persists in making it appear that he knows by prevaricating. Thus you think that you must resign yourself to the problem remaining unsolved forever. Then one day you happen to mention it to some person who says: ' This expression is taken from such–and–such a book', or: ' It is found in such–and– such a literary collection of such–and–such period', and opening the book in question,

余爲之姑頃索不有另匣則
重其價値一一尚檀襟

爲價値。一一尚匣。則又
之姑頃索不有另
躊躇再刻百肯。一要
問成呼飫物。
曰。事所此引交牽敝唇
不索之交朋成要補煞風景。
諸之一類。互而吻焦。塵生滿
矣。彼竟快爲圈別售。或生
必價事圈生
索符。或一節。
適也。又錦囊

from its sheath and into the water. Then two dragons were seen sporting together in the waves; it were the souls of the sword–pair, now happily re–united. The text has *Yen–chin*, short for Yen–p'ing–chin. The full story is found in Chang Hua's biography in ch. 105 of the *Chin–shu*, « History of the Chin Dynasty ».

2) *Shu–hua–shuo–ling*, chapter 11:

蹟中一持逐物。跋所於風
名圖。來以物。名眞之落煞
得而歎。敢之一跋人一大
一失忽缺或僞小此。
圖而或駕惜余快之市落肯。
有離乎事以井於合。
跋之不所
失璧破物。卽眞圖。此一不
而有拾視之美僞偽圖久持。
圖耿。偶而津全以計。
有耿云出延是之巧彼
或心友贈。爲本繫爲彼景。

1) Allusion to a story told about the famous Chin writer Chang Hua (232–300 A.D., author of the *Po–wu–chih*), and his friend Lei Huan. The latter discovered a pair of antique swords, respectively called Lung–ch'üan and T'ai–ngo; one he kept himself, the other he presented to Chang. After Chang's death, the sword Lei had given to him unaccountably disappeared. When Lei had also died, his son once visited Nan–p'ing (in Fukien Province) where Chang had lived and, carrying his father's sword, passed by the Yen–p'ing Ford nearby. Suddenly the sword jumped

476

he shows you that he is correct so that the entire problem becomes perfectly clear to you. If a matter of doubt of several years standing is thus suddenly entirely solved, then this is truly a great joy ". [1]

*  *  *

Thus the study of the means and methods of the Chinese connoisseur has led us on to the collecting of antique scrolls, and its joys and its vicissitudes.

This book may therefore be concluded by translating a Chinese prose-poem on the enjoyment of works of art in general.

The prose-poem, entitled *Pao-hui-t'ang-chi* " Essay on the Hall where Pictures are Treasured " or " Essay on the Hall of Precious Pictures " was written about one thousand years ago by Su Shih, better known by his literary name Tung-p'o, who was perhaps the greatest scholar-artist of the Sung period. He wrote it for his friend Wang Hsin, another noted artist and scholar, when he had added to his mansion a treasure house built especially for storing his collection of antique scrolls. This essay on the enjoyment of works of art, written by a man who was himself an eminent creator of beauty, is presented here below in a free translation. [2]

### *Essay on the Hall where Pictures are Treasured.*

" The wise man possesses things, but he is not possessed by them. He who possesses things in this detached manner shall derive joy even from a trifle, while even great things cannot cause him sorrow. But he who is possessed by what he loves shall sorrow even over a trifle, while great things he shall be unable to enjoy to the full.

" An ancient philosopher has said that the many colours blind the eye, that the many tones deafen the ear, the many flavours dull the taste, and that violent passions confuse man's heart. Yet the Sages of old did not wholly despise the things of this world: but they saw them in the true, detached spirit. Heroes and wise men of former days notwithstanding their aloofness from this world were yet often greatly attached to apparently material things; but in reality these seemingly material things obtained for them a deep significance. It is because of this that they could enjoy them, never tiring of them till the end of their days.

" Now calligraphy and painting are the most excellent of all things that gladden man's heart without leading him astray. If, however, one should become so fond of them as to fall entirely under their spell then great indeed is the calamity that will ensue.

---

1) *Shu-hua-shuo-ling*, chapter 10: 或解。考料道代。中不書。或義群請吾。自然。蹟中有字索造謁而支人。偶集某。名其中姓名。探博覽。知而一。跋。之某爲強案。書。或忽逢於某。題作者。咸推。或疑生畢。賦知不得。殊茫然。詞不敢。詩或而亦此及。曰是出何。取册證之。歷歷在目。積年疑團。一旦冰釋。此眞一大快事。

2) A literal translation needs a number of footnotes explaining the allusions occurring in the text. Since such notes might interfere with the reader's appreciation of the essay, here only a free translation is given; a literal translation accompanied by notes and the Chinese text will be found in Appendix III.

Out of their love for antique autographs people have endangered their health, they have dug up the dead from their graves; and a passion for antique paintings is known to have estranged ruler and subject. Some were so engrossed in their art treasures that they would even take them along on military expeditions in specially made boats, while others stored them away in secret rooms built in their houses. Engaged in such futile undertakings those people endangered the State and brought disaster over themselves.

" When I was young, great was my love for these sister–arts, calligraphy and painting. So great indeed was my passion for them that when I was not fearing to lose the scrolls in my own collection, I was worrying lest I should be unable to acquire those possessed by others.

" Then, one day, I laughed at my own folly and reasoned thus with myself: ' You despise wealth and honours, yet adore old calligraphy; you are not afraid of losing your life, yet greatly fear losing your pictures. This attitude is self-contradictory and utterly mistaken, and if you persist in it you will lose your sane judgement '.

" Since that day I fundamentally changed my attitude towards things of beauty. Occasionally I collected two or three specimens, but after having enjoyed them I again parted with them, giving them away without regret. I have come to look upon these things as if they were clouds that pass before the eye or the songs of birds coming to the ear; one loves these things while one perceives them, but once they are gone one does not long for them. Thus my treasured autographs and paintings are now for me a constant source of joy while they have lost their power to cause me sorrow.

" Now my friend Wang Hsin although he is related to the Imperial Court yet in simple dignity and true love of poetry and painting does not yield to a frugal recluse. In his house there is none of the luxury of high living, he is aloof from all sensual pleasures, living only for his autographs and his pictures. To the east of his mansion he has constructed the Pao–hui Hall, there to house all his art treasures. He asked me to write a commemorative essay for this occasion. I, fearing lest perchance he might become afflicted with the same mistaken passion for antiques as I had when I was young, write this essay for him as a warning, hoping that it will make him understand how to enjoy his treasures to the full and prevent them from causing him sorrow ".

" Written on the 22nd day of the 7th moon of the year 1077 ".

The *Pao–hui–t'ang–chi* does not belong to Su Tung–p'o's better known works. Yet I think that it must be considered as one of the finest essays on the collecting and enjoyment of works of art that has ever been written, in Chinese or any other language. The ideal here set forth in faultless style is high, and probably far beyond our reach. But then this is as ideals should be: to be strived after and struggled for even if one can never really hope to attain them.

478

As the expression of such an ideal the *Pao–hui–t'ang–chi* stands as a guide and example to all lovers of art. For who would not wish to emulate the attitude of Su Tung-p'o: a man who was a passionate lover of beauty but whose passion had been tempered by much experience and relentless self–examination, finally to be ennobled by a deep understanding for real values and a mild resignation to the transitory nature of all earthly things?

# APPENDICES

APPENDIX I

# LITERARY SOURCES

Here are listed only those items which are referred to repeatedly or which are thought to be of special interest to the student of Chinese pictorial art and the collector of Chinese scrolls. All other sources are quoted in the footnotes.

Western and Japanese translations of Chinese texts are listed under the Chinese original.

## *A)* WESTERN LITERATURE

1. *Chinese Painting*, by John C. Ferguson.   One illustrated volume, Chicago 1927.

This is the only Western book on the subject that gives a glimpse of the working methods of the Chinese connoisseur, stressing especially the importance of studying the provenance and past history of an antique scroll.   When reading this thorough and well–written book, it should be remembered, however, that in the field of artistic studies the late John C. Ferguson — through long and intimate association — had come to identify himself with a small, hyper–conservative circle of Chinese artists and collectors in Peking, most of them of Manchu descent.   Their decisions on authenticity problems were often delivered *ex cathedra*, and their interest was limited to works in the approved classical styles.   Hence many readers will find it difficult to agree with all attributions quoted in this book, and one sorely misses the names of such brilliant painters in unconventional style as Hsü Wei, Chu Ta, Chin Nêng e. a.

Despite this bias, however, this is still a most useful book, showing as it does the lines of reasoning followed by Chinese connoisseurs.   It also gives valuable data on the artist's media and other technical matters, i. a. regarding the tips of some common types of Chinese brushes.

2. *An Introduction to the Study of Chinese Painting*, by Arthur Waley.   One illustrated vol., London 1923.

A most informative series of essays on the highlights of Chinese pictorial art, as all the works of this distinguished Sinologue rich in new material and new thoughts.   Students of Chinese pictorial art and collectors will find this book an excellent introduction to the subject.   One only regrets that the Ming and Ch'ing dynasties have been treated very perfunctorily, and many students will disagree with the author's low opinion on the pictorial art produced during those periods.

3. *Chinese Painting*, by William Cohn.   One illustrated vol., London & New York 1948.

A conscientious effort to record the state of Western knowledge of Chinese painting ca. 1945, as seen by a competent art–historian.   Particularly valuable are the footnotes which give detailed reference material to Western books and articles on the subject.   Although some of the author's statements reflect an attitude that is now dated (e. g. p. 9 where he speaks of Western incapacity for appreciating Chinese pictorial art in the Chinese manner; p. 19 where he states that in many cases it is not worth while to read what is written on scrolls, because one can judge their date without knowing the content), and although his lack of sinological training caused mistakes, especially in the Chinese bibliography, this book is still a most useful introduction to the subject, illustrated with plates which on the whole are well–chosen.   The fact that of each item owner and size are indicated — data missing in many other Western books on Chinese painting — deserves special commendation.

483

4. *The Chinese on the Art of Painting*, by Oswald Sirén. One illustrated vol., Peking 1936.

A survey of Chinese artistic theory based on copious quotations from older and later Chinese art literature. Useful for general orientation but unsuitable for detail–study, since numerans passages translated stand in need of correction, and quotations are often mistaken for original texts.

5. *The Pictorial Art of Japan*, by W. Anderson. Two illustrated vols., London 1885.

This beautifully edited publication is still a standard work, notwithstanding its date. Part II, pp. 116–129 give a good survey of the most common types of Japanese scroll mountings, illustrated with diagrams and sketches.

6. *Chinese Free–hand Flower Painting*, by Fang–chuen Wang. One illustrated vol., publ. Peking 1937.

This book, written by a well–known painter in Peking, is divided into two parts, " History of free–hand flower painting " and " Methods for free–hand flower painting ". The first is a detailed historical account of the art of painting flowers, birds and insects in monochrome, free style. Ch. IV, entitled " Contemporary artists " is especially useful for the collector since it lists scores of artists of the last years of the 19th and the beginning of the 20th century, together with their literary names, and biographical data; information about artists of that particular period is difficult to find.

The second part is of importance to the connoisseur, it is a serious attempt at explaining the underlying principles and the technique of ink–painting. Although the author evidently had difficulty in formulating his thoughts in English, his discussions are original and well worth careful study. The subject matter is divided into six chapters, viz.: V " Calligraphy and its relation to free–hand painting "; VI " How to paint the three principal parts of a plant "; VII " How to paint birds and insects "; VIII " Colouring and composition " (with a survey of Chinese pigments); IX " Principles involved in judging paintings of the free–hand style "; and X " The value of reproduced prints of paintings by famous artists ".

The collotype reproductions are well chosen, they include a few excellent lesser known old pictures from private collections in Peking. I mention Plate 10, an impressive Ming painting of a crab in a rice field, by Ch'ên Ch'un (1483–1544), and Plate 17, a bird on a bough by Pa–ta–shan–jên.

7. *Brush–strokes in Far Eastern Painting*, by Kōjirō Tomita. Article in " Eastern Art ", vol. III (1931), publ. for the College Art Association, Memorial Hall, Philadelphia.

One of the few sources in Western language where the brush stroke is considered in more detail, especially with regard to its plastic possibilities. Illustrated with some instructive detail–photographs.

8. *Some Technical Terms of Chinese Painting*, by Benjamin March. One illustrated vol., Baltimore 1935. American Council of Learned Societies, Studies in Chinese and related civilizations, no. 2.

This brief, unassuming treatise of about 50 pages is one of the important Western contributions to our knowledge of Chinese painting. It is a list of 302 technical terms, illustrated with drawings and photographs. Although these terms mainly represent present–day usage in Peking, the greater part is commonly used also in older Chinese artistic literature. The explanations are brief and to the point, they represent the result of much careful research.

The terms are classified under twelve headings which together constitute a cross–cut through the entire domain of Chinese pictorial art. Beginning with the media and the canvas the artist has at his disposal (I. Materials: silk, paper, brush, pigments, etc.; II. Forms of painting: murals, banners, scrolls, etc.) the author proceeds to III.: Subjects: landscapes, men and objects etc. Section IV and V are devoted to the various brush techniques and their classification, and Section VI (trees),

VII (rocks and mountains), VIII (water), IX (clouds) and X (figures) discuss these techniques in greater detail. Section XI deals with seals and signatures, and XII with the art of mounting. It should be noted that the " diagram of a typical scroll mounting " on page 56 represents a *Japanese* hanging scroll; this is one of the few major errors in this useful book.

9. *Linear Perspective in Chinese Painting*, by Benjamin March. Illustrated article in " Eastern Art " vol. III (1931).

Another excellent study by the author of the preceding item whose promising career was cut short by an untimely death. Some of his concluding remarks on the much-debated problem of Chinese perspective are worth quoting: " So, in recapitulation, we note that Chinese perspective is characterized, in contrast with the Renaissance perspective of the West, by two distinctly typical features — a station-point movable without restriction, or numerous station-points within a single picture; and the drawing of parallel lines as true, rather than apparent, parallels. And we have seen that these features are due to choice rather than ignorance, and that the choice was conditioned by the fact that Chinese painting has been the studio-painting of scholar-artists whose pictures were visual poems rather than prose records, translations rather than transcriptions, and who had no taste for the mathematical theorizing necessary to produce a single geometrical formula for the universal solution of the general problem, even had such a solution be desirable, which according to the psychology of the artists, it was not ... Also we have noted that any system of perspective is a compromise, and that if the system be rigid, compromises must be made with the system itself in the interests of pictorial effectiveness. Further, for practical purposes the acceptance of the compromise is more important than its theoretical accuracy. Whether one system is superior to the other or not depends upon so many debatable criteria that it would be silly to attempt such an evaluation " (page 139).

10. *The Problem of Hui Tsung*, by Benjamin Rowland. Illustrated article in " Archives of the Chinese Art Society of America ", vol. V (1951).

A study on the authenticity of some pictures ascribed to the Sung Emperor Hui-tsung. This essay, based on a careful analysis of brush technique and historical data, proves that it is not impossible for a Western art-historian to make valuable contributions to the solution of Chinese authenticity problems, provided he combines a sound sinological background with a sensitive eye.

11. *Sinology or Art History*, Notes on method in the study of Chinese art, article by John A. Pope in " Harvard Journal of Asiatic Studies ", vol. X, 1947.

A lucid exposition of the qualifications necessary for the present-day Western student of Chinese art, and a timely warning that the days when anyone with a general knowledge of art history but lacking sinological training could materially contribute to our knowledge of the subject, are definitely past.

12. *Imitation and forgery in ancient Chinese painting and calligraphy*, article by E. Zürcher, in " Oriental Art " New Series, vol. I, no. 4, London 1955.

This brief essay gives much reliable information on the many vicissitudes antique scrolls were subjected to, translated from original Chinese sources from the 5th to the 12th century. Since the author had to select especially those passages that deal with copies and forgeries, the dark side of the picture is here and there over-stressed. For example, the passage on forgeries in Yü Ho's " Memorial on Calligraphy " translated on p. 142 is in the original followed directly by a reference to fine and genuine specimens; and although Chang Yen-yüan is correctly quoted where he draws attention to the enormous losses suffered by contemporary collections, one should not

overlook his statement that the scrolls selected in 818 by his grandfather for — forced! — presentation to the Palace, counted some excellent specimens about the authenticity of which Chang himself felt not the slightest doubt; cf. *Acker*, p. 139. One readily agrees, however, with the author's conclusion where he says: "Whatever later and more credulous critics may have said, whatever quantities of T'ang and pre–T'ang works may adorn the pages of Ming and Ch'ing ' handbooks', they are plainly contradicted by our earliest sources".

13. *Die Beiden Steine* (Beitrag zum Verständnis des Wesens chinesischer Landschaftsmalerei), by Victoria Contag. One illustrated vol., Braunschweig 1950.

A well–written special study of the two monk–painters Tao-chi (道 濟, lit. name Shih–t'ao 石 濤, ca. 1612–1697) and K'un–ts'an (髡 殘, lit. name Shih–hsi 石 溪, 1630–1707); commonly referred to together as *Erh–shih* 二 石 "The Two Stones", because the literary names of both contain the character " stone ".

After a brief introduction, the author discusses at some length the meaning of *ch'i–yün–shên–tung*, one of the Six Canons of Hsieh Ho. Then follows the main part of the book, viz. a complete translation of Tao-chi's *Hua–yü–lu* 書 語 錄. The 32 reproductions are well–chosen and accompanied by a full description. Such detail studies on individual painters are useful both for art students and collectors.

It may be added that Tao-chi's work became very popular in Japan; some fine pictures by him are now in Japanese collections. In 1926 the well known Japanese painter Hashimoto Kansetsu 橋 本 關 雪 published an interesting study entitled *Sekitō* 石 濤, with good reproductions.

14. *Die Sechs Berühmten Maler der Ch'ing Dynastie*, by Victoria Contag. One vol. accompanied by a set of lithographed plates. Leipzig 1940.

This book gives an on the whole well–documented evaluation of the work of six famous early–Ch'ing masters, namely Wang Shih–min (王 時 敏 1592–1680), Wang Chien (王 鑑 1598–1677), Wu Li (吳 歷 1632–1715), Wang Hui (王 翬 1632–1717), Yün Shou–p'ing (惲 壽 平 1633–1690) and Wang Yüan–ch'i (王 原 祁 1642–1715).

There is also a brief explanation of the painter's media (page 12: Tuschlinie und Maltechnique), but here the peculiar features of brush, paper, etc. are not done full justice. Yet this book is a valuable contribution to the study of a group of Chinese painters that was practically ignored by the former generation of Western students of Chinese art.

15. *Meisterwerke Chinesischer Malerei* (aus der Sammlung der Japanischen Reichsmarschälie Yoshimitsu und Yoshimasa), by Werner Speiser. One illustrated vol., Berlin 1947.

A carefully documented study of Chinese paintings in the collection of the two shōguns mentioned, with detailed Western and Japanese bibliographical data. More than 60 paintings are given in excellent reproductions, with some good detail-photos. Of each picture size, material and owner are listed, together with references to pertaining literature. Professor Speiser shows great discretion in authenticity problems, he concentrates on the intrinsic artistic quality of the paintings, leaving it open whether they were actually painted by the men whose seals and signatures they bear. This is all the more commendable since in the case of these pictures where the *terminus ante quem* is so clearly established, the temptation is great to accept the attributions of the old Japanese critics who supervised the collection.

16. *Paper, a historical account of its making by hand from the earliest times down to the present day*, by R. H. Clapperton. One illustrated vol., Oxford 1934.

486

This book contains a brief but sound description of paper–making in China.  Of special interest are some microscopic photographs of various papers discovered in Tun–huang.

17. *A papermaking pilgrimage to Japan, Korea and China*, by Dard Hunter.  One illustrated vol., New York 1936.
    This book, written by a well known expert on paper–making, contains excellent technical studies of Chinese and Japanese papers, illustrated with numerous actual samples.

18. *The Chemical Arts of Old China*, by Li Ch'iao-p'ing 李 喬 苹.  One illustrated vol., publ. by the " Journal of Chemical Education ", Easton, Pa. 1948.
    A collection of concise but informative essays on subjects on which heretofore little was found in Western sources.  Of special interest to the student of Chinese pictorial art are Chapter 8: " Colours and Dyes ", which treats of the manufacture of Chinese ink, pigments and the seal pad, and Chapter 12 which gives some elementary information on paper manufacture.

19. *L'Encre de Chine*, son histoire et sa fabrication d'après des documents chinois, by Maurice Jametel.  One illustrated vol., Paris 1882.
    A detailed account of the manufacture of Chinese ink cakes.

20. *Chinese Calligraphy*, by Chiang Yee.  One illustrated vol., London 1938.
    An ably written introduction to the esthetic value of Chinese calligraphy, intended for the general reader.  Collectors unfamiliar with the Chinese language will find this a useful book for acquiring a general understanding of the principles of calligraphy and the role of the brush stroke in pictorial art.

21. *Some Chinese brushes*, by Laurence Sickman.  Article in " Technical Studies in the Field of the Fine Arts ", vol. VIII (1939), published by the William Hayes Fogg Art Museum,  Boston.
    A brief but sound description of 29 modern brushes manufactured in Peking, illustrated with photographs.  The author promises a more extensive monograph on the subject " with historical notes and a discussion of regional differences of manufacture ".

22. *A study of Chinese paintings in the collection of Ada Small Moore*, by L. W. Hackney and C. F. Yau.  One illustrated folio vol., New York 1940.
    The pictures reproduced are of unequal quality, but the descriptions are excellent and include mounting and seals.

## *B)* CHINESE LITERATURE

23. *Shu–hua–shu–lu–chieh–t'i* 書 畫 書 錄 解 題, 12 ch. in 6 vls., published in 1931 by the National      General.
    Library of Peking.
    An extensive bibliography of over 800 old and modern Chinese books and treatises on the arts of painting and calligraphy, compiled by the modern scholar and painter Yü Shao–sung (余 紹 宋, style Yüeh–yüan 越 園).  Most items are described *in extenso*, including details about editions, authors and contents, while prefaces, colophons, etc. are often quoted in full.  Yü Shao–sung added critical remarks of his own which do great credit to his scholarship.  The books are classified according to their content, the items of each class being again arranged in chronological order.  This system of classification evolved by the compiler represents a satisfactory combination of tra-

ditional Chinese bibliographical methods and modern scientific requirements. The guiding principles are explained in the introductory remarks which are well worth a closer study; they give a lucid discussion of the problems of Chinese artistic bibliography. An index of authors and titles has been added. This work is an indispensable handbook for all students of Chinese pictorial art.

Yü Shao-sung also published a good compendium of painter's manuals that is described below under no. 43.

24. *Cho-kêng-lu* 輟 耕 錦, 30 ch.; Chi-ku-ko 汲 古 閣 edition, collated by Mao Chin (毛 晉 1599-1659). In 1923 there was published in Wu-chin 武 進 a magnificent folio reprint of the original Yüan edition. Movable type reprint in *Ts'ung-shu-chi-ch'êng* 叢 書 集 成, nos. 0218-0220, Shanghai 1936. In 1652 there appeared a Japanese reprint of the Chi-ku-ko ed.; a curious feature is that the date of publication is printed on the last page of ch. 29 instead of at the end of the book, as is customary.

This book is a collection of miscellaneous notes covering a wide range of subjects. The compiler was T'ao Tsung-i 陶 宗 儀; his preface is dated 1366. Ch. 11 contains a reprint of the *Hsieh-hsiang-pi-chüeh* 寫 像 秘 訣, a treatise on portrait painting by the 14th century artist Wang I 王 繹, with a note on the use of colours; translated by Herbert Franke in his article "Two Yüan treatises of the technique of portrait painting", in: "Oriental Art", vol. III, no. 1, London 1950. Ch. 18 contains general observations on painting, mostly extracts from earlier works. Ch. 23 gives a very extensive list of the material used in mounting scrolls.

25. *Ta-ku-chai-po-wu-hui-chih* 達 古 齋 博 物 彙 誌, 2 vls., illustrated; publ. Peking 1914.

This is a survey of Chinese antiques compiled by the late Ho Ming-chih 霍 明 志, owner of the Ta-ku-chai, a large curio shop in Peking; details are given on page 467 above. Most editions are interleaved throughout with a French translation by a Mr. X; the title reads: Paul Houo, *Comment éventer les faux?*, Pékin, Imprimerie des Lazaristes du Pei-t'ang, 1919. The anonymous French translator added a list of technical terms.

Ho Ming-chih was not a scholar but his experience in the antique trade had given him a comprehensive practical knowledge while he was also familiar with the tricks practised by old and modern forgers. Although this first publication of his is written in faulty style and contains not a few errors, and although the illustrations are poorly executed, it is still a useful book since the author ungrudgingly imparts to the reader the fruits of his close association with the antique trade. This book is now rare but the two other publications by Ho Ming-chih listed below used to be easily obtainable in Peking.

26. *Ta-ku-chai-ku-chêng-lu* 達 古 齋 古 證 錄, in French. Subtitle: "Preuves des Antiquités de Chine". One foreign folio volume, profusely illustrated. Publ. Peking 1930.

After Ho Ming-chih had published the book listed above he set to work on a revised and enlarged edition. While this book was still in manuscript he had it translated into French and published in Peking. Although this work too must be used with much care — not a few statements are quite erroneous and the French translation is faulty — it is useful in so far that it practically covers the entire field of Chinese curios and antiques and contains a wealth of information on Chinese folklore and popular manners and customs; I mention the description of the Sa-mo ritual (薩 魔; the second character is also written 嫫 or 瑪), a secret exorcising ceremony held in the Imperial Palace during the Manchu dynasty, with good photographs of the female exorciser, Sa-mo-t'ai-t'ai 薩 嫫 太 太 who presided over this ritual (page 365 sq.).

In 1935 the author finally published the original Chinese version, in one foreign volume, with the same Chinese title but a slightly enlarged text. It contains less illustrations than the French

488

edition, but under the heading "Antique Scrolls" the author pasted into each copy a series of actual samples of silk used by artists of former dynasties. The survey of antiques forms the first part of the book (pp. 1–97). Then follows an edition of the *Tao-tê-ching* 道 德 經 with the famous commentary by Wang Pi (王 弼 226–249), and explanatory notes written by Ho Ming-chih himself. The third part is an edition of the *I-ching* 易 經, also with Wang Pi's commentary, and a second commentary by Ho Ming-chih (pp. 165–448). The book closes with chronological tables and some notes on earthenware vessels.

27. *Tung-t'ien-ch'ing-lu(-chi)* 洞 天 清 祿 (集), 10 ch.; earliest version printed in the *Shuo-fu* 說 郛, later reprinted in various other *ts'ung-shu*. In 1810 reprinted in Japan as an "official edition", *kam-pan* 官 版.

This is the oldest "guide for the scholar of elegant taste", the class of books discussed on page 51. It was written by the Sung scholar Chao Hsi-ku 趙 希 鵠, a member of the Imperial clan; he worked ca. 1230 and is known chiefly as the author of this manual. The best edition of this text (reprinted in the *Tu-hua-chai-ts'ung-shu* 讀 畫 齋 叢 書 and the *Hai-shan-hsien-kuan-ts'ung-shu* 海 山 仙 舘 叢 書) was collated by the eminent classical scholar Ho Ch'o (何 焯, lit. name I-mên 義 門, 1661–1722; cf. E. C., page 283), on the basis of a manuscript copy in the collection of Lu Yüeh 陸 燿, style Lang-fu 郎 夫 who lived 1723–1785. This manuscript came originally from the library of the famous bibliophile Ch'i Ch'êng-yeh 祁 承 爍 who flourished ca. 1600; cf. the article "Seven intimate library owners" by Nancy Lee Swann, in: Harvard Journal of Asiatic Studies, vol. I, 1936.

The contents are as follows: I. Antique lutes; II. Antique inkstones; III. Antique bronze vessels; IV. Quaintly shaped stones; V. Miniature screens (for preventing the ink on the inkslab from drying by protecting it against currents of air); VI. Brush stands; VII. Water reservoirs (for moistening the inkstone); VIII. Old manuscripts and autographs; IX. Ancient and modern rubbings; X. Antique paintings. The last three chapters are often quoted in the present publication.

This book enjoys a high reputation notwithstanding its brevity; it is warmly praised in the Imperial Catalogue, ch. 123, page 1, and it is much quoted by later writers.

In 1926 the Japanese connoisseur Ōmura Seigai 大 村 西 崖 published a Japanese translation, published as no. 2 of his *Bungansōyaku* 文 玩 叢 譯, by the School of Fine Arts, Tōkyō.

28. *Tsun-shêng-pa-chien* 遵 生 八 牋, 19 ch.; cf. *The Lore of the Chinese Lute*, page 168. Next to the original edition of 1591 described there I should have mentioned a second one corrected by Kao Lien himself where the title is preceded by the phrase *Hsien-hsüeh-chü-ch'ung-ting* 弦 雪 居 重 訂, "Corrected again in the Hsien-hsüeh Studio". In 1905 there appeared in Shanghai a fairly good reprint.

This is a collection of essays on the daily life and the manifold interests of the refined scholar, much attention being given to various Taoist disciplines aiming at a healthy and long life. For our present subject the sixth section, comprising ch. 14–16 and entitled *Yen-hsien-ch'ing-shang* 燕 閒 清 賞 "Refined enjoyment of elegant leisure", is of importance. After an extensive discussion of antique bronze vessels — including tests for recognizing forged specimens — the author treats ceramics, books, rubbings, and lacquer wares. Then there follows a fairly detailed essay on antique scrolls including some observations on falsifications and copies. Thereafter the author discusses inkstones (illustrated), ink, paper, brushes and various other objects that should not be missing in the scholar's library, such as seals, paper weights, incense, lutes, swords, etc. The last section is devoted entirely to plants and flowers and how they should be cultivated.

29. *K'ao-p'an-yü-shih* 考 槃 餘 事, 4 ch., compiled by the Ming scholar T'u Lung 屠 隆 who became a *chin-shih* in 1577; cf. my remarks in *The Lore of the Chinese Lute*, page 167.

A detailed description of all the objects that belong to the traditional outfit of the refined scholar. Contents: First Chapter I. Books – II. Autographs (chiefly antique rubbings); Second Chapter I. Paintings – II. Paper – III. Ink – IV. Brushes – V. Inkstones – VI. Lutes; Third Chapter I. Incense – II. Tea – III. Potted plants – IV. Fishes and cranes – V. The Mountain retreat; Fourth Chapter I. The necessities of daily life – II. The outfit of the library – III. The outfit for picnics and excursions (with an illustrated description of portable tea– and wine stoves).

30. *Chang-wu-chih* 長物志, 12 ch.; circulated apparently for a long time in manuscript. Printed in the *Yüeh-ya-t'ang-ts'ung-shu* 粤雅堂叢書 with a colophon by the editor Wu Shao-t'ang 伍紹棠 dated 1874, and a preface by Shên Ch'un-tsê 沈春澤. Reprinted in the *Shuo-k'u* 說庫 and the *Mei-shu-ts'ung-shu* (see page 286).

This is as far as I know the most complete work on all objects dear to the cultured scholar. It was compiled by the scholar–artist Wên Chên-hêng (文震亨, style Ch'i-mei 啓美, 1585-1645). Since the author belonged to one of the leading literary families of Changchow — the Wên clan that produced such famous artists as Wên Pi, Wên Chia, Wên P'êng, etc. — he was in an excellent position for gathering material on his subject. The contents are as follows.

Ch. 1 on houses and interior decoration, ch. 2 on plants, trees and flowers (including a description of flower arrangement, tray landscapes, etc.), ch. 3 on ponds, rocks and precious stones, ch. 4 on birds and fishes, ch. 5 on painting and calligraphy, ch. 6 on furniture, ch. 7 on inkstones, writing brushes, paper, lutes, etc., ch. 8 on clothing, ch. 9 on boats and carriages, ch. 10 on the arrangement of the interior, ch. 11 on fruit, ch. 12 on incense.

31. *Ch'ing-pi-tsang* 清秘藏, 30 sections in two parts, compiled by the Ming connoisseur and collector Chang Ying-wên 張應文; edited by his son, the well known connoisseur Chang Ch'ou (張丑; in this text referred to by his earlier name Ch'ien-tê 謙德). Preface by Wang Chih-têng (王稚登 1535-1612). Nineteenth century blockprint.

The first part of this book deals with jade, bronzes, autographs, paintings, rubbings, porcelain, seals, inkstones, stones of quaint shape and beautiful grain, precious stones, lutes and swords, incense, crystal, agate and amber, ink, paper, Sung albums with rubbings, Sung *k'o-szû*, carved lacquer and other carved objects, the features of antique paper and silk, the remounting, repairing and preservation of antique scrolls.

The second part discusses famous connoisseurs, the seals and colophons of scrolls, the history of famous rubbings, well–known copyists, rare curiosities, famous lute builders, T'ang and Sung brocade, famous ink manufacturers, books on artistic subjects, and antiques the author possessed himself or saw in other collections.

This book covers a wide range of subjects and the explanations are brief and to the point; although much is borrowed from earlier sources, in many cases the author took pains to formulate his own views.

In 1879 the Japanese Sinologue Sugiyama Keiji 杉山鷄兒 published a carefully edited reprint under the title of *Kantei-shinsho* 鑑定新書, in 3 vls.; here the text is provided with Japanese reading marks.

32. *Yüan-yeh* 園冶, also called *To-t'ien-kung* 奪天工 "Stealing the work of Heaven", 3 ch. Illustrated Ming blockprint. Compiled by the Ming scholar Chi Ch'êng 計成, style Wu-p'i 無否, author's preface dated 1631. Preface by Chêng Yüan-hsün 鄭元勳 dated 1635, and preface by the notorious corrupt politician Yüan Ta-ch'êng (阮大鋮 ca. 1587-1646; cf. E. C., page 398), dated 1634. The original Ming print is now of great rarity, but Japanese manuscript copies are easily obtainable. The Society for the Study of Chinese Architecture published a reprint, Peking 1933.

The first part begins with rules for selecting the site for a house and garden and laying the foundations, and then gives a detailed description of housebuilding including designs for doors and windows. The second part is devoted entirely to the various designs for balustrades, hundred patterns in all. The third part gives designs for doors, fences, ponds, rockeries, etc.

It would seem that this book never became very popular in China, probably because of Yüan Ta-ch'êng's preface; Yüan betrayed many of his compatriots to the Manchu conquerors and was responsible for the destruction of a Chinese city. The book is well known in Japan, however, and exercised great influence on Japanese garden architecture.

33. *Li–tai–ming–hua–chi* 歷 代 名 畫 記 " Records of famous paintings of the succeeding dynasties ", 10 ch. written in 847 by the T'ang connoisseur Chang Yen–yüan 張 彥 遠, a member of a family of well known collectors. This work is doubtless the most important early Chinese source on ancient painters and painting. Reprinted in various *ts'ung–shu*. Traditional " histories " of pictorial art.

In 1938 the Japanese Sinologue Ono Katsutoshi 小 野 勝 年 published an annotated Japanese translation of this text, in the *Iwanami Bunko* 岩 波 文 庫. Although this translation leaves many problems unsolved and contains not a few errors and ambiguities, it is still a laudable effort to make this difficult text more accessible.

Dr. W. R. B. Acker, formerly of the Freer Gallery of Art in Washington, has published the first three chapters of this text in annotated translation in his book " Some T'ang and Pre-T'ang texts on Chinese Painting " (*Sinica Leidensia*, vol. VII, Leiden 1954). The result of more than twenty years study, this book is one of the important contributions made by Western scholars to the study of Chinese painting. It opens with an extensive Introduction which contains i. a. a penetrating analysis of the significance and historical background of Chinese pictorial art. These prolegomena testify to the deep understanding and broad knowledge of the author, himself a calligrapher in the Chinese regular script. Then follows a translation of the *Ku–hua–p'in–lu* by Hsieh Ho, and the *Hsü–hua–p'in*, prefaced by Yao Tsui. Thereafter comes the translation of the *Li–tai–ming–hua–chi*, which forms the bulk of the book. This text poses numerous problems, and one will not always agree with Acker's translation. I quote, however, Max Müller's words written regarding a translation of ancient Sanskrit texts: " Scholars should never forget how easy it is to weed a field which has once been ploughed, and how difficult to plough unbroken soil " (Preface to R. E. Hume, " The Thirteen Principal Upanishads ", Oxford 1921).

Here I only relevate my different interpretation of the opening passage of Ch. III, section I; the Chinese text and my translation are found on p. 156 of the present publication. Acker translates the last line: " They bore only the ornamental signatures of the connoisseurs and art experts of the time, ranged in rows " (p. 216). I think that *pei–lieh* can not be translated as " bore ... ranged in rows ", but that it means " provide in sequence (i. e. enumerate) ". This different translation changes the interpretation of the rest of that section.

Chang Yen–yüan was also a student of calligraphy; he compiled the *Fa–shu–yao–lu* 法 書 要 錄, a collection of 38 treatises on calligraphy written by various authors from the Han period upwards.

34. *T'ang–ch'ao–ming–hua–lu* 唐 朝 名 畫 錄 " Records of Famous Paintings of the T'ang Dynasty ". Printed in *Wang–shih–hua–yüan* 王 氏 畫 苑 and *Mei–shu–ts'ung–shu*.

A brief treatise on T'ang painting in 1 ch., by Chu Ching–hsüan 朱 景 玄.

Translated by A. C. Soper under the title " The Famous Painters of the T'ang Dynasty ", in: " Archives of the Chinese Art Society of America ", vol. IV, 1950. In the foreword added to the translation Soper points out that Chu Ching–hsüan probably wrote this book in the early 840's.

491

35. *Hua-p'in* 畫 品 " Critical Appraisal of Paintings "; reprinted i. a. in *Wang-shih-shu-hua-yüan.*

A brief treatise by the Sung scholar Li Chai (Chih) 李 廌, describing in some detail 21 T'ang and Sung pictures.

Annotated translation by A. C. Soper in his article " A Northern Sung descriptive catalogue of paintings ", in: " Journal of the American Oriental Society ", vol. 69 (1949); the name of the writer is wrongly transcribed *ch'ih.*

Strictly speaking this work does not belong to the category of books listed here; it is included because it is one of the rare old texts which gives detailed descriptions of ancient pictures.

36. *T'u-hua-chien-wên-chih* 圖 書 見 聞 誌 " Records of what was seen and heard about painting ", 6 ch.; Chi-ku-ko edition.

Next to the *Li-tai-ming-hua-chi* the most important old history of painting, compiled by the 11th century collector Kuo Jo-hsü 郭 若 虛 and running from the end of the T'ang dynasty to the author's own time. Next to a wealth of data on life and work of the painters of that time this book contains also notes on scroll mounting and connoisseurship.

A. C. Soper has published an annotated translation under the title " Kuo Jo-hsü's Experiences in Painting " (American Council of Learned Societies, Studies in Chinese and Related Civilisations, no. 6; Washington 1951).

37. *Hua-shih* 畫 史 " Notes on Painting ", not divided into chapters; compiled by the Sung artist and connoisseur Mi fu (米 芾 1051-1107).

38. *Shu-shih* 書 史 " Notes on Calligraphy ", not divided into chapters; same author as preceding item.

39. *Pao-chang-tai-fang-lu* 寶 章 待 訪 錄 " Records of Searches for Precious Scrolls "; same author, dated 1086.

The above-mentioned three works by Mi Fu consist of miscellaneous notes, greatly varying in length, style and content. They deal with pictures and autographs, artists and collectors, materials for painting and writing, mountings of scrolls, etc. All three belong to the small number of basic early texts on the history of Chinese pictorial art.

Unfortunately none of them has ever been properly edited. Although they were reprinted in a number of *ts'ung-shu,* no editor made a serious attempt at identifying or restoring corrupt passages, tracing the numerous repetitions, or establishing the division into paragraphs, while also the punctuation leaves much to be desired. Until these texts have been re-edited and provided with indexes of proper names, titles of scrolls and technical terms it would be idle to attempt a complete translation of any of them. I am working on such an edition but it will take some time before this is ready for the press; the punctuation alone poses numerous difficult problems.

40. *T'u-hui-pao-chien* 圖 繪 寶 鑑 " Precious Mirror of Pictures ", 5 ch. and a sequel in 1 ch.; Chi-ku-ko edition.

A general history of painting from early beginnings till the end of the Yüan dynasty, compiled by the scholar and collector Hsia Wên-yen 夏 文 彥; his preface is dated 1365. He was a close friend of T'ao Tsung-i (cf. no. 24 above) but he lacked the latter's wide knowledge. The sequel, treating painters from the beginning of the Ming period till ca. 1500 was added by the Ming scholar Han Ang 韓 昂.

Painter's Hand-books.

41. *Chieh-tzû-yüan-hua-chuan* 芥 子 園 畫 傳 " Handbook of Painting of the Mustard-seed Garden ", 5 ch.

492

This is the most popular painter's handbook, edited in 1679 by Wang Kai 王槩. The original edition is a fine blockprint with many illustrations executed as colour prints. Reprinted several times in both China and Japan.

The complicated history of this book and its sequels has been thoroughly discussed by Ch'iu K'ai-ming 裘 開 明 in his article " The Chieh-tzû-yüan-hua-chuan ", in: " Archives of the Chinese Art Society of America ", vol. V (1951). The weak point in this otherwise excellent study is Mr. Ch'iu's discussion of the date when this book was introduced into Japan. He dismisses the theory that it was first brought over by Chinese immigrant monks of the Huang-po Sect 黃 蘗 because " the monks arrived in 1654 while the painting manual was not published until 1679 " (page 62). Although it is true that the first Huang-po monks arrived in 1654 and 1655, new monks kept coming from China till long after that date; this statement must therefore be reconsidered.

In 1918 Raphael Petrucci published a French translation of this book, entitled " Encyclopédie de la Peinture chinoise " (Kiai-tseu-yuan Houa-tchouan, Les Enseignements de la Peinture du Jardin grand comme un Grain de Moutarde), one illustrated volume. The greater part of the illustrations are reproduced in black and white, and the translation is on the whole well done; Petrucci's notes do credit to his wide knowledge and his understanding of Chinese art. See the detailed review by E. Chavannes, in " Journal Asiatique ", vol. XI (1918), pp. 321-339; the bibliographical data must now be checked with Ch'iu K'ai-ming's article cited above.

42. *Wu-ju-yu-hua-pao* 吳 如 友 畫 寶 34 vls. of pictures, published Shanghai 1909 in lithograph reproductions.

A collection of paintings by Wu Yu (吳 猷, style Chia-yu 嘉 猷, later Ju-yu 如 友) who during the late Eighties enjoyed considerable fame in Shanghai. The collection is divided into twelve sections, each comprising two volumes and depicting respectively: I. Famous people of ancient times; II. Beautiful women, ancient and modern; III. Life of contemporary Shanghai beauties; IV. Chinese and foreign animals; V. Chinese and foreign birds; VI. Strange stories from foreign lands; VII. Strange Chinese stories; VIII-IX. Stories old and new; X-XI. Customs and manners; XII. Famous localities, and still-life pictures.

From an artistic point of view this collection is not very important but it is widely used as a copy book, especially by Chinese professional painters. Section III is a valuable source for our knowledge of Chinese domestic life, costumes and customs in the end of the 19th century and the beginning of the 20th century, and the infiltration of Western culture in the Chinese port cities; I mention the pictures of ladies in foreign dress, Chinese ladies playing billiards, etc. Many modern Western books on China of a popular character borrow their illustrations from this collection — usually without mentioning the source.

Section VI is intended to acquaint the Chinese general reader with foreign countries, more especially Japan. This section reflects the influence of Wang T'ao (王 韜 1828-1897; cf. E. C., page 836), one of the pioneers of Chinese journalism and well known to Sinologues because of his long association with the great James Legge. Next to being a consummate classical scholar Wang T'ao was a far-sighted politician who wished to awaken among his countrymen an interest in Western civilization; he realized that China would be able to maintain her position as a great independent nation only if she adopted Western scientific methods and modernized her national defense. He tried to whet the reader's appetite for such studies by publishing interesting stories and news items from foreign newspapers, which he had illustrated by Wu Yu. Originally these stories and pictures were published periodically in Wang T'ao's *Tien-shih-chai-hua-pao* 點 石 齋 畫 報, but Section VI of the collection described here contains a great number of them. The selection proves how well Wang T'ao knew his countrymen's predilection for the quaint and supernatural.

493

43. *Hua-fa-yao-lu* 畫 法 要 錄 " Important texts on the art of painting ", first part (6 ch.) published Peking 1926, second part (10 ch.) publ. Shanghai 1934.

A most comprehensive collection of extracts from older manuals on the art of painting, compiled by Yü Shao-sung (cf. no. 23 above). He showed great discretion in the selection of the passages, including discussions of both the practical and theoretical aspects of painting. To each item are added critical and bibliographical comments. The latter are especially valuable because the compiler has gone to great trouble to trace the quoted passages to their original source, thus saving the student much laborious searching. This work should be on the shelves of every student who wishes to acquaint himself with theory and technique of Chinese painting.

44. *Chiang-ts'un-hsiao-hsia-lu* 江 村 銷 夏 錄, 4 ch., published 1693; there exist several later Chinese editions, and one Japanese reprint, dated 1800.

A descriptive catalogue of scrolls, compiled by the scholar–artist Kao Shih-ch'i (高 士 奇, 1645-1703; cf. E. C., page 413), who was Court painter under the Emperor K'ang-hsi. This may be called the standard collectors' catalogue; it is frequently quoted by later connoisseurs, who took this book as the example after which they modeled their own catalogues. Although not without errors, it is still the best catalogue to begin with when studying this special branch of Chinese literature.

The items are arranged in chronological order, beginning with a scroll by Wang Hsi-chih, and ending with artists of the Ming period. Material, form, seals, measurements, superscriptions, colophons and other data are recorded in detail, together with critical remarks by Kao Shih-ch'i himself.

Kao Shih-ch'i left several other works. Of special interest for antiquarian studies is a small collection of notes entitled *T'ien-lu-shih-yü* 天 祿 識 餘 in 2 ch.

45. *Ai-jih-yin-lu-shu-hua-lu* 愛 日 吟 廬 書 畫 錄, 4 ch.; supplement 2 ch., sequel 8 ch., appendix 4 ch.; published 1913.

This is a descriptive catalogue of selected scrolls in the collection of the connoisseur Ko Chin-lang 葛 金 椋, whose preface is dated 1881. The four chapters that form the body of the work contain items selected by Ko Chin-lang himself; only a small number of scrolls is treated, but the critical remarks added by the compiler show that he was a learned and discerning connoisseur. The rest of the work was written by his son. Here a great number of scrolls is treated, but not a few of those would seem to be forgeries; the additional chapters do not come up to the high standard of the main body of the work.

46. *Mo-yüan-hui-kuan* 墨 緣 彙 觀, 4 ch.; completed 1742, published 1909.

Descriptive catalogue of the collection of An Ch'i (安 岐, style I-chou 儀 周, literary name Lu-ts'un 麓 村), a wealthy salt merchant at Tientsin. An Ch'i succeeded in obtaining numerous important scrolls emanating from famous late–Ming collections (e. g. that of Hsiang Yüan-pien), that were scattered during the turbulent years that marked the change of dynasty. Some of these scrolls collected by An Ch'i later passed into the hands of the famous scholar–official and collector Tuan Fang (端 方, 1861-1911; cf. E. C., page 780), while others ultimately were entered into the Ch'ing Palace Collection. It was Tuan Fang who had this catalogue printed, and who added a preface to it.

A brief account of the contents of this catalogue is given by John C. Ferguson, in his article *Ink remains, by An I-chou*, in: " Journal of the North China Branch of the Royal Asiatic Society ", vol. XLV, 1914.

Contemporary literature gives conflicting statements about An Ch'i's identity. Some sources say that he was a Korean official who, having come to Peking as a member of a Korean government mission, stayed on in China; others aver that he was a curio dealer in Tientsin, of Korean descent. An Ch'i's biographical sketch in E. C. (page 11), explains the reason why older sources are so vague in their references to An Ch'i. An Ch'i was the son of a Korean servant in the family of Ming-chu (明珠, 1635–1708; cf. E. C., page 577), the well known Manchu minister. Both An Ch'i and his father secretly managed various lucrative salt monopolies on behalf of Ming-chu, and thus greatly contributed to the latter's fabulous wealth. Since Ming-chu was closely related to the Imperial family, contemporary writers were reluctant to place on record details about his manifold legal and illegal enterprises.

An Ch'i used part of his own fortune for assembling a large collection of antique scrolls. Since nearly every scroll in his collection was a choice item, paintings and autographs bearing his seals are eagerly sought after, and fetch high prices. For reproductions of his seals, see Viktoria Contag's publication, mentioned on page 418, pp. 536–37. At the end of the excellent biography in E. C., the reader will find the Chinese sources where the An Ch'i problem is discussed; to these, however, there should be added a reference to the discussion of An Ch'i's identity, by the modern scholar Yeh Tê-hui (葉德輝, 1864–1927), to be found in his *Hsi-yüan-tu-shu-chih* 郋園讀書志.

47. *Wu-yüeh-so-chien-shu-hua-lu* 吳越所見書畫錄, 6 ch., published 1776.

This is a descriptive catalogue of scrolls collected or seen by the great connoisseur Lu Shih-hua (陸時化, 1714–1779), mainly in Kiangsu and Chekiang Province. The scrolls listed offer a rich variety, especially Ming artists being well represented.

As a kind of introduction, Lu Shih-hua added a short treatise or scrolls and connoisseurship, entitled *Shu-hua-shuo-ling* 書畫說鈴, in 29 chapters.

About one fifth of this treatise has been translated in the present publication; consult the General Index, s. v. *Shu-hua-shuo-ling*. Since it contains data on the connoisseurship of antique scrolls in the 18th century which are not found in other sources, I have published the complete translation as a separate book, under the title " Scrapbook for Chinese Collectors " (Catholic University, Beyrouth 1958). There the reader will find more details about Lu Shih-hua's life and work, also on his remarks on forgeries embodied in the appendix *Wei-tso-jih-ch'i-lun*.

48. *Hsin-ch'ou-hsiao-hsia-chi* 辛丑銷夏記, 5 ch., published 1905; title page written by Tuan Fang (see above, under no. 46).

Descriptive catalogue of the collection of the famous archeologist Wu Jung-kuang (吳榮光, 1773–1843; cf. E. C., page 872). Although the number of scrolls treated is limited, they are all representative specimens, while the lengthy critical remarks which the compiler added to nearly every one of them testify to his wide learning and sharp eye. He had a number of the antique autographs in his collection engraved in stone; a collection of rubbings of these stones, entitled *Yün-ch'ing-kuan-fa-t'ieh* 筠清館法帖 was published in 1909, by one of his grandsons.

How rich the contents of a collector's catalogue are also from a purely literary point of view, is shown, for instance, by the item *Chiang-nan-ch'un-fu-chuan* 江南春副卷, described in ch. 5, pp. 59–70. This is a hand scroll containing scores of autograph poems written by famous Ming literati, and depicting the pleasures and miseries of night life in the gay centers of Chiang-nan; these poems, written in a polished literary style, form an apt illustration of the discussions on page 256 and 279 above.

49. *I–chüeh–pien* — 角 編, 2 ch.; published in the *Sung–lin–ts'ung–shu* (see above, page 318).

Descriptive catalogue of a small collection of scrolls, assembled by Chou Êrh–hsüeh (see above, page 315); his preface is dated 1734. A distinguishing feature of this catalogue is that the items are arranged according to the dates on which they were entered in the collection, during the years 1712–1728. The compiler added to each scroll a detailed description of the way it was mounted, recording even the material of the roller knobs.

None of the scrolls listed is of great importance, but it is this very fact which makes this catalogue a very useful one for present–day collectors: many of the items listed are of a kind that one may well meet some day on the market.

50. *Jang–li–kuan–kuo–yen–lu* 穰 梨 館 過 眼 錄, 40 ch., sequel 16 ch.; published 1891.

Descriptive catalogue of the extensive collection of scrolls assembled by the famous scholar–official Lu Hsin–yüan (陸 心 源, 1834–1894; cf. E. C., page 545). The compiler is best known as a collector of rare books and manuscripts; his celebrated library, containing i. a. more than one hundred Sung impressions, was sold in 1907 to the Japanese financier Baron Iwasaki and now forms the nucleus of the Seikadō Library, near Tōkyō. This catalogue shows that also in the field of pictorial art he must be considered as no mean connoisseur.

The value of this catalogue, however, lies chiefly in the great number of scrolls discussed, and the accurate descriptions, quoting *in extenso* critical remarks which former collectors added to the scrolls. A number of the scrolls listed were not in the compiler's possession, but studied by him in the collections of friends, or in curio shops; cf. remarks such as the one found in ch. 9, page 12: " Seen in a curio shop in Yangchow " 見 於 楊 州 市.

For his own comments Lu Hsin–yüan often refers to his *I–ku–t'ang–t'i–pa* (儀 顧 堂 題 跋, 16 ch., sequel 16 ch., published 1890), an extensive collection of colophons added by him to the books, manuscripts, paintings and autographs that he had acquired in the course of the years.

51. *Shu–hua–chien–ying* 書 畫 鑑 影, 24 ch., published 1871.

Descriptive catalogue of scrolls collected and seen by Li Tso–hsien (李 佐 賢, lit. name Chu–p'êng 竹 朋), a scholar–official who flourished round 1830. Next to the book described here, he left several minor works relating to antique scrolls, and on numismatics.

The greater part of the scrolls described are listed in catalogues of former collectors; to these the author adds little new information. Those items, however, which were collected by Li Tso–hsien himself, are accompanied by his own critical comments; and these prove that he was capable of independent judgement. Since the choice of scrolls is fairly comprehensive, while the number of items discussed is yet not so vast as to bewilder the beginner, this book is a good introduction to the study of collectors' catalogues in general.

52. *Hai–wang–ts'un–so–chien–shu–hua–lu–ts'an–kao* 海 王 村 所 見 書 畫 錄 殘 稿, 1 ch., published 1916.

Description of 17 remarkable antique scrolls that Li Pao–hsün (李 葆 恂, 1859–1915), a connoisseur who enjoyed the protection of Tuan Fang (see above, under no. 46), saw in curio shops in the Hai–wang–ts'un quarter. This belongs to the antique dealers center Liu–li–ch'ang 琉 璃 廠 in Peking, well known to collectors of Chinese antiques all over the world; it is in Hai–wang–ts'un that there is also found the *Chiao–yeh–shan–fang* 蕉 葉 山 房, one of the oldest Peking shops dealing in antique lutes and other musical instruments. In recent years Hai–wang–ts'un has much declined, but in the beginning of this century it was still the favourite haunt of Chinese collectors of antiques, and its gates saw a continuous *va–et–vient* of high officials and wealthy amateurs.

496

Originally this catalogue was a most comprehensive study, but during the Boxer troubles in 1900, the greater part of the manuscript was destroyed; hence the term *ts'an-kao* "incomplete draft" in the title. Yet what has been preserved is of great interest. It shows, for instance, what important scrolls were apparently on the market in Peking at the end of the 19th century; I mention the "Picture of the Lo River Fairy", by Ku K'ai-chih.

53. *Ming-hua-lu* 明 畫 錄, 8 ch.; reprinted in various *ts'ung-shu.*

A list of biographies of painters of the Ming dynasty compiled by Hsü Ch'in 徐 沁. Though the life of each painter is but briefly described, this book enjoys a reputation for supplying accurate information.

In 1817 there appeared a well-printed Japanese edition, with a preface by the well known Tokugawa Sinologue Ichikawa Kansai (市 河 寬 齋 1749–1820), and a colophon by the painter Kanō Ekisai 狩 野 掖 齋.

54. *Kuo-ch'ao-hua-chêng-lu* 國 朝 畫 徵 錄, 3 ch., sequel 2 ch.; first published in 1735.

A collection of painter's biographies covering the Ch'ing dynasty till the beginning of the Ch'ien-lung era, compiled by the painter and scholar Chang Kêng (張 庚 1685–1760). The Imperial Catalogue criticizes this book rather severely (cf. ch. 114, page 7) pointing out a number of mistakes; still it is a handy book of reference for early-Ch'ing artists. In 1798 there appeared a good Japanese reprint.

55. *Li-tai-hua-shih-hui-chuan* 歷 代 畫 史 彙 傳, 72 ch., appendix 2 ch., published 1796–1820; lithographed reprint publ. 1920 by the Sao-yeh-shan-fang 掃 葉 山 房 at Shanghai.

More than 7000 biographies of painters of all the dynasties assembled by P'êng Yün-ts'an (彭 蘊 璨 1780–1840). This is the book commonly used by Chinese collectors and curio dealers for quick reference. Its value lies in the great number of painters included, but the information given is scanty and sources are not indicated. Many readers will find it inconvenient that the items are arranged according to the rhymes of the family names.

In 1878 a certain Ōno Masaemon 大 野 政 右 衛 門 published an index of the names of Yüan, Ming and Ch'ing painters included in this book, under the title of *Gashi-iden-jimmeifu* 畫 史 彙 傳 人 名 譜, a blockprint in 4 vls.; the names are arranged according to the *iroha*.

56. *Tung-yin-lun-hua* 桐 陰 論 畫, first part 3 ch. (publ. 1846), second part 2 ch., third part 2 ch., sequel 1 ch. (publ. 1882).

Selected biographies of 128 painters of the end of the Ming, and the beginning of the Ch'ing period, written by Ch'in Tsu-yung (秦 祖 永 1825–1884). He was a well known scholar and collector of scrolls who had made a careful study of the work of each artist listed. Each item begins with a poetical description of the style and special features of the artist, followed by a biographical note. This work will be found a useful guide to the appreciation of the pictures of the artists studied.

In 1914 there appeared a good Japanese translation by Honda Nariyuki 本 田 成 之, published by the Ibun-dō 彙 文 堂 in Kyōto, with a preface by the eminent Japanese Sinologue and connoisseur Naitō Kojirō 內 藤 虎 次 郎. This book is printed in 4 Chinese-style volumes, and contains some reproductions of pictures by the artists listed. There is an index arranged according to the Japanese pronunciation of the family names.

57. *Chung-kuo-hua-chia-jên-ming-ta-tz'ŭ-tien* 中 國 畫 家 人 名 大 辭 典, one foreign volume, pp. 725; first edition 1934, second edition 1940.

A comprehensive biographical dictionary of Chinese painters, from the earliest times till the end of the Ch'ing period. Compiled by Sun Ta-kung 孫重公, whose preface is dated 1931.

The author remarks in his colophon (dated 1932) that part of the book had to be hurried through the press because of the Japanese invasion; yet there occur comparatively few mistakes. The items are arranged according to the number of strokes of the family names, each group being again divided chronologically. Of each painter are given style and literary names, a brief biographical account, and a few remarks on style and influence. At the end of each item the sources used are mentioned. A useful book for quick reference.

Special subjects. 58. *Shu-hua-yü-chuang-huang* 書畫與裝潢 " On scrolls and their mounting ", article by Chiang Yin-ch'iu 蔣吟秋, published in *Chung-kuo-i-shu-lun-ts'ung* 中國藝術論叢, one volume with essays on Chinese art, edited by T'êng Ku 滕固 and published by the Commercial Press, Shanghai 1938.

A succinct but lucid account of the art of scroll mounting.

59. *Chung-kuo ku-hui-hua-ti-ts'ai-liao-chi-pien-sê-hou-huan-chih-yen-chiu* 中國古繪畫的材料及變色後還原之研究 " A study of the material of antique Chinese paintings and the restoring of the original colours of those that have changed ", article in: Anniversary Volume of Wu Ching-hêng, Chungking 1933.

This article is signed by Chiang Hsüan-i 蔣玄詒, perhaps the same author as of the preceding item. This is a survey of modern scientific methods applied to the restoration of antique Chinese scrolls. For removing dirty spots and brightening up darkened colours the writer recommends a treatment with bleaching powder and hydrochloric acid, or with oxygen. He adds, however, that such a treatment should be based upon a careful study of the material and pigments of each individual specimen. In the first place the old traditional methods should be analyzed, only when this preliminary work has been done can one decide how these methods might be improved with aids provided by modern science.

60. *Yü-shih* 語石, 10 ch., blockprint published 1909; in 1936 reprinted with movable type in 2 foreign vls. in the series *Kuo-hsüeh-chi-pên-ts'ung-shu* 國學基本叢書, Commercial Press, Shanghai.

This is a circumstantial account of rubbings, viewed from an archeological and epigraphical standpoint, written by the scholar-official Yeh Ch'ang-shih (葉昌熾 1847-1917). The author was a well known collector of rubbings at Peking who, next to scouring the local market, also acquired many rare items on his official journeys in the provinces. In 1900 the work on this book was broken off when he had to leave the capital on account of the Boxer troubles; returned to Peking he resumed his studies and rewrote his book in the present enlarged form.

The contents are arranged systematically and constitute an excellent survey of this complicated branch of Chinese studies. Chapter I gives a historical review, starting with stone tablets from pre-Han times and ending with the Ming period. Chapter II is a geographical survey describing the most important stone tablets from every province, and in addition giving some examples from Korea, Annam and Japan. Chapter III then gives a detailed account of the distinctive features of stone tablets, their origin, decoration, etc., while Chapters IX-X go into various special questions such as styles of writing, damaged and censored tablets, forgeries, etc., each problem being illustrated by the description of one actual specimen. The 13th heading of Chapter X deals with the mounting of rubbings and has been frequently quoted in the present publication. This is doubtless the best handbook for the study of rubbings that does great credit to the zeal and erudition of the author.

In 1929 the Japanese connoisseur of Chinese art Fujiwara Sossui 藤原楚水 published a Japanese translation of this work under the title *Shina-kinseki-sho-dan* 支那金石書談, in

498

one foreign volume, pp. 540 + 140. This book is a useful supplement to the Chinese original. It is profusely illustrated with photographs of the rubbings discussed (the Chinese original has no illustrations), and it is also printed in a more surveyable manner. Moreover the translator has added an index of all rubbings treated in the book, giving under each item the name of the author of the text engraved on the tablet, its date, and the locality where the tablet is found. A number of literary allusions, names of persons, and technical terms are explained in marginal notes.

61. *Szŭ–hsiu–pi–chi* 絲 繡 筆 記, 1 ch., publ. 1931.

A detailed account of various kinds of antique Chinese silk and brocade, compiled by Chu Ch'i-ch'ien (朱 啓 鈐, born 1871). After a chequered political career the author devoted himself after 1920 to literary and artistic pursuits, and earned merit in the field of preserving ancient monuments. The present work consists mainly of extracts from older sources, systematically arranged, and constitutes a useful book of reference when studying the mounting–material of antique scrolls.

This book is part of the *Szŭ–hsiu–ts'ung–k'an* 絲 繡 叢 刊 edited by the author, which includes also treatises on *k'o–ssŭ* and embroidery.

## *C)* JAPANESE LITERATURE

62. *Shina–gagakusho–kaidai* 支 那 畫 學 書 解 題, one foreign vol., pp. 475, with indexes of proper names and book titles; published Tōkyō 1938.

A bibliography of Chinese works on pictorial art, compiled by the Japanese art–historian Harada Bizan 原 田 眉 山. Although this book is much more restricted in scope than Yü Shao-sung's bibliography listed under no. 23, the 300 items discussed are useful for quick orientation; the contents are critically described, and representative passages quoted in Japanese translation. It is to be regretted that the bibliographical data leave much to be desired. To quote only one example, Harada mentions of the *Tsun–shêng–pa–chien* (see no. 28 above) only the reprint in the *Ku–chin–t'u–shu–chi–ch'êng* 古 今 圖 書 集 成 while he omits the two original Ming editions and the modern Chinese reprint.

63. *Nihon–genzai–shina–meiga–mokuroku* 日 本 現 在 支 那 名 畫 目 錄, one foreign volume, pp. 462, published Tokyō 1938.

This is a catalogue of antique Chinese paintings now preserved in Japanese museums, temples and private collections, compiled by Harada Bizan. Recording ca. two thousand Chinese paintings this book is an important source for the study of Chinese art in Japan. Each item is briefly described, including its measurements and seals, and a short biographical note on the artist is added; the institution or person who owned the scroll at the time the catalogue was compiled are mentioned by name. The items are arranged in chronological order, beginning with the T'ang period and ending with the last years of the Ch'ing dynasty.

64. *Kundaikan–sayū–chōki* 君 臺 觀 左 右 帳 記.

In 1511 this treatise was published as a blockprint, engraved after Sō-ami's own handwriting and with his illustrations. The blocks are preserved in the Imperial Household Museum (now National Museum) in Tōkyō. In 1884 a limited number of copies were struck off, followed by a second imprint in 1932, issued on the orders of the then Director-General, Mr. Sugi Eisaburō 杉 榮 三 郎. In 1904 the book had been reprinted in Part XII of the *Gunsho–ruijū* 群 書 類 從, and the Japanese art–historian Imaizumi Yūsaku (今 泉 雄 作 1850-1931) published a critical edition (*kōshō* 考 證) in nos. 20-44 of the periodical " Kokka ".

A collection of notes on the art treasures of the Ashikaga shōgun Yoshimasa, written by the tea master Sō-ami; special attention is given to the implements used for the tea ceremony.

The Chinese pictures mentioned in this book have been treated by O. Kümmel in his article *Die chinesische Malerei im Kundaikwan Sayūchōki*, in " Ostasiatische Zeitschrift ", vol. I, 1912–13. Excellent reproductions are found in Werner Speiser, *Meisterwerke Chinesischer Malerei aus der Sammlung der Japanischen Reichsmarschälle Yoshimitsu und Yoshimasa*, see no. 15 above.

65. *Go-shoku-ki* 御 飾 記.

Notes on the interior decoration of the shōgunal mansion, recorded during 1521–1528 by Sō-ami. Published as blockprint in 1660.

Reprinted in Part XII of the *Gunsho-ruijū*.

66. *Kissa-nambō-roku* 喫 茶 南 坊 錄.

A book on the tea ceremony, completed in 1593 by Nambō Sōkei (cf. page 263 above), one of the most famous disciples of Ri-kyū. This text first circulated in manuscript only, as a kind of secret handbook to be used only by the initiated; in 1690, however, it was published as a block print.

67. *Sadō-zentei* 茶 道 筌 蹄, 5 vls., published 1816.

An illustrated account of the tea ceremony, with extracts from older sources, compiled by a tea master who calls himself Mokumoku-sai shujin 默 默 齋 主 人.

Ch. 2 contains a section entitled *Kakemono-hyōgu-meisho* 懸 物 表 具 名 所 " Technical names of the various parts of mounted hanging scrolls "; here there is given a fairly extensive description of the Japanese art of mounting.

68. *Kasei-hyōsō-zu* 華 製 裱 裝 圖 " Illustrated account of Chinese-made mountings "; one Japanese-style volume, pp. 18, illustrated. No date. Manuscript in the author's collection.

Compiled by the Ryūrin-dō 龍 鱗 堂, a mounter's shop at Edo that flourished round 1850. This manuscript contains a detailed description, in Sino-Japanese, of some representative Chinese-mounted scrolls that passed through the hands of the writer. Models for mounting hanging scrolls, hand scrolls, albums and screens, and for the making of card board boxes for scrolls and books are neatly drawn in full colours, with measurements and technical names added. Apparently written for the compiler's own reference.

69. *Hyōgu-byōbu-shitate-moyō-den* 表 具 屏 風 仕 立 模 樣 傳 " Account of the various types of mounted scrolls and screens "; one Japanese-style volume, pp. 23, illustrated. No date. Manuscript in the author's collection.

Anonymous, but judging by style and content about contemporary with the preceding item. A description in Japanese of the various styles of Japanese mountings, chiefly copied from the works left by Tokugawa tea masters. Illustrated with rough sketches and coloured drawings. Apparently written by a mounter for his own reference.

70. *Hyōgu-no-shiori* 裱 具 の し を り " Guide to the art of mounting ". First edition Kyōto 1922, second revised edition Kyōto 1927. One foreign volume, pp. 312. Illustrated.

By Yamamoto Gen 山 本 元, an art-historian. This is the most complete modern account of the art of mounting as practised in Japan, treated in a scholarly way, with constant reference to older sources. For the present publication I utilized only parts of this excellent work; it fully deserves, however, to be translated in its entirety.

The First Part commences with a short historical outline (ch. 1), and thereafter gives a detailed description of hanging scrolls (ch. 2), and of the various styles of mounting them (ch. 3); then the

materials used for the mounting process are discussed (ch. 4), and finally the actual process of mounting is described stage by stage (ch. 5). The Second Part starts with a brief historical survey of the *karakami-shi* 唐紙師 the mounter of sliding doors (ch. 1); then the sliding doors themselves are described (ch. 2), and thereafter the process of making them (ch. 3). Chapters 4–5 in the same way treat folding screens, *byō-bu*, while ch. 6 is entirely devoted to single standing screens, *tsui-tate*. Chapter 7 describes the history of horizontal tablets, *gaku*, and the methods for mounting them; chapter 8 gives the same data with regard to hand scrolls, and chapter 9 with regard to albums. Chapter 10 is a detailed account of how gold foil, *kimpaku* 金箔 and gold powder *sunago* 砂子 are applied, while finally ch. 11 contains some miscellaneous notes on the restoration of antique scrolls.

71. *Hyōsō-hikō* 表装備考 " Documentated account of the art of mounting ". One Japanese-style volume, pp. 58, illustrated, published Tōkyō 1936.

By Okamura Tatsuo 岡村辰雄, a mounter at Tōkyō. A more popular account of the art of mounting in Japan, chiefly with regard to hanging scrolls; the historical discussions bear a superficial character. To be read as a supplement to the preceding item, especially for some additional material on the types and measurements of hanging scrolls.

72. *Kakemono-to-nihon-seikatsu* 掛物の日本生活 " The hanging scroll in Japanese life ". One foreign volume, pp. 236 + 58, illustrated, published Tōkyō 1941.

By Nishibori Ichizō 西窟一三. An account of the history of the Japanese hanging scroll, and its place in Japanese culture. Written in a rather popular vein, but containing some interesting theories about the beginning of hanging scroll mounting in Japan, and on artistic life during the Kamakura and Ashikaga periods; special attention is given to Chinese scrolls preserved in Japan. The second part consists of *verbatim* reprints of extracts from old Japanese books and manuscripts, treating of the art of mounting, and the displaying of scrolls; unfortunately only the titles of the sources are given, without any indication of author and date.

73. *Tokonoma-no-kōsei* 床の間の構成 " Construction of the toko-no-ma ". One foreign style volume, pp. 280; profusely illustrated with photographs and sketches, published Tōkyō 1933, second impression Tōkyō 1936.

By Kitao Shundō 北尾春道. A rather popular description of the role played by the *toko-no-ma* in the Japanese interior; only recent times are treated, historical problems being passed over in silence. The art of mounting hanging scrolls is treated on pp. 123 sq.; this description is chiefly based on Yamamoto's book (see sub 70 above), but the author adds some interesting details about modern Japanese scrolls, and Westernized Japanese interiors. Moreover he gives a full description of the various objects that are displayed in the toko-no-ma together with hanging scrolls.

74. *Hyōsō* 表装, periodical publication of the Japanese Mounters Association; appeared at irregular intervals from 1940–1943.

No. 3 (April 1941) contains a detailed study of the wooden boxes scrolls are kept in, No. 4 (February 1942) an essay on Chinese and Japanese papers, and an article by me on the history of hanging scroll mounting, No. 5 a brief but interesting study on the development of Japanese interior decoration, by the mounter Okamura Tatsuo (cf. no. 71 above).

75. *Tōhō-zenshoku-bunka-no-kenkyū* 東方染色文化の研究, one foreign volume, pp. 311, illustrated by paper samples dyed with the actual pigments described. Published Tōky. 1933.

A detailed study on the pigments used by ancient Chinese and Japanese artists, by Uemura Rokurō 上村六郎. An English extract appeared in *Eastern Art*, vol. III, Philadelphia 1931, under the title " Studies on the ancient pigments of Japan ".

76. *Kanjō-nifu* 管城二譜 "Two Books on the Brush"; illustrated blockprint, one vol., Edo 1834.

This small book, now of great rarity, was written by the Japanese calligrapher and seal engraver Hosoi Kōtaku (細井廣澤 1658–1735); his literary names were Gyoku-sen 玉川, Shi-i-sai 思貽齋, Shōrindō 蕉林堂 and Kishō-dō 奇勝堂. His father was a samurai of Saga who came to Edo when his son was ten years old. He started practising calligraphy under the Sinologue Kitajima Setsuzan (北島雪山 1636–1697), at the same time studying the Chinese Classics and perfecting himself in the martial arts. Kōtaku soon became known as a calligrapher in the Chinese style, especially that of the Ming artist Wên Chêng-ming, and he published several books on the subject. He also distinguished himself as a seal engraver; here also he took Ming carvers as model. He was a loyal supporter of the Imperial cause and hence was granted a posthumous title by the Meiji Emperor.

Kōtaku completed the *Kanjō-nifu* in 1715 but it was not published, probably because it contained some laudatory references to the Emperor which might have attracted the attention of the Tokugawa censors. In 1767, thirty years after Kōtaku's death, his pupil the calligrapher Nagane Bumpō 永根文峯 made a carefully traced copy of Kōtaku's manuscript together with the illustrations; there were only a few lacunae that could not be completed. This traced copy was published as a blockprint in 1834 by a certain Watanabe Shō 渡部璋.

The first half of the book gives a detailed description of the construction of the Chinese brush, based upon an examination of antique Chinese specimens, and experiments made by Kōtaku himself. The second half is devoted to the *chin-pi* 槿筆, a peculiar kind of brush made not of hair but of the bark of the hibiscus tree; Kōtaku states that this type was favoured by the famous Chinese statesman and philosopher Wang Shou-jên (王守仁, better known by his literary name Yang-ming 陽明, 1472–1529). Many Chinese calligraphers at present still use such brushes, the most famous being the variety known as *lung-hsü* 龍鬚 "Dragon's Whiskers", produced in Kuangtung Province.

The book also contains an interesting portrait of the author, and the text of his biography as engraved on the tablet that marks his grave.

77. *Zōhitsu-fu* 藏筆譜, 2 vls. with pictures of brushes in colour print. Published in 1834 by the Daigaku-dō 大學堂 in Owari 尾張.

A *catalogue raisonné* of selected Chinese brushes in the collection of the famous Japanese Sinologue and calligrapher Ichikawa Sangai (市河三亥, 1777–1854); he was a great admirer of the Sung artist Mi Fu, and hence adopted the literary name Bei-an 米菴 "Hermitage where Mi Fu is studied". The plates give coloured pictures of more than 200 old Chinese brushes, including inscriptions, seals and labels on the shafts. Bei-an added to each specimen some remarks on its quality, and references to Chinese sources.

Prefaces by the Sinologues Shibano Ritsuzan (柴野栗山 1735–1808) dated 1803, Minagawa Ki-en (皆川淇園 1724–1807) dated 1804, Satō Issai (佐藤一齋 1772–1859) dated 1802; superscription by Ichikawa Kansai (市河寬齋, 1749–1820), dated 1804. Colophon written by Bei-an himself dated 1802, and a colophon by the publisher dated 1834.

78. *Tōboku-waboku-zusetsu* 唐墨和墨圖説, one foreign volume, pp. 1–192 plates, 1–130 Japanese text. Published in a limited edition of 500 copies, Tōkyō 1953.

A study of Chinese, Korean and Japanese ink cakes, by the late Togari Soshin-an 外狩素心菴. Unfortunately the author died before he could complete the manuscript, but his extensive collection of antique ink cakes is reproduced on the Plates, many of which are in full colours. For a detailed description of this book including a brief historical account of the Chinese ink cake, see my review in "Monumenta Nipponica", vol. X (1954).

# APPENDIX II

# TIBETAN AND NEPALESE MOUNTINGS

The history and significance of Tibetan scrolls have been aptly described by Giuseppe Tucci in his magnificent publication " Tibetan Painted Scrolls " (3 vls., Rome 1950), in vol. I, pp. 267–327. There Tucci has demonstrated that although Tibetan pictures are produced more or less mechanically and leave little scope for individual expression, their artistic qualities should not be underrated; " Tibetan painting ", Tucci says, " is imbued with a spirit of serene simplicity and a devout and naive grace which not infrequently suggest a natural affinity with the Italian primitives " (op. cit., Preface page 1).

Students of Tibetan pictorial art will readily agree with this view. It is true that especially as regards Tibetan pictures dating from the last two hundred years, they are in nine out of ten cases the work of artisans rather than of artists. A rigid tradition prescribes how each individual deity should be represented; since deviations from these rules are considered sacrilegious, most monk–painters use calques and schablones (Tibetan: *ts'ags–par*). Smaller models are enlarged in a purely mechanical · way by dividing them in squares, in the same manner as we enlarge geographical maps. It is often by observing the landscape background rather than the figures of the deities that the artistic qualities of such a painting can be assessed.

The landscape background, especially of later *tangka*, shows a marked Chinese influence, not only in the painting technique — preponderance of mineral green and blue, often combined with gold filigree work — but also in perspective and conventionalized patterns; one notices especially the stylized Chinese mountains. [1]

Tibetan and Sino–Tibetan pictures are painted according to the same traditional method of Indian origin. Just like the ancient *pata* they are done on a sheet of cloth or coarse silk previously covered with a coat of flour, glue and incense powder. The working methods of the monk–artists have been vividly described by Marco Pallis in his charming book *Peaks and Lamas* (London 1946), pp. 336–339; this description includes an excellent picture of a painting lama, facing page 334. Another useful book on this subject is *Tibetan Paintings* by G. de Roerich (Paris 1925). The reader is referred to these two books for further details on the painting technique.

As to the identification of the deities represented on *tangka* pictures, next to Tucci's work mentioned above the reader is referred to Eugen Pander, *Das Pantheon des Tschangtscha Hutuktu* (ein Beitrag zur Iconographie des Lamaismus), Berlin 1890, which notwithstanding its early date is still a useful hand-

---

1) The Chinese stylized mountains traveled an amazingly far way; they are found not only in Tibetan painting but also farther West in 14th century Iranian pictures, and down in the South Seas in temple reliefs on the island of Java. An interesting study on this subject is *L'influence chinoise sur le paysage dans la peinture de l'Orient et dans la sculpture de l'Insulinde* by J. AUBOYER, an article in *Revue des Arts Asiatiques*, vol. IX, no. 4, Paris 1935. The author mentions the visits of Chinese travelers to Java but is rather diffident in fixing the intermediary through which the Javanese came to know the Chinese style of painting landscapes. In my opinion there can be no doubt that this was *Chinese porcelain and pottery*. In the 15th century the Chinese tra-

veler Ma Huan noticed the preference of the Javanese for these Chinese products; " the natives (of Java) ", he says, " are exceedingly fond of Chinese porcelain wares painted with blue designs " (same source as quoted on page 168 above, note: 國 人 最 喜 中 國 青 花 磁 器). The mountains and trees on the Javanese relief reproduced on plate 8 of Miss Auboyer's article seem copied directly from a Chinese white–and–blue plate or bowl. I mention also the old Javanese custom of inserting small Chinese plates among the sculpture decorating temple gates — to–day still observed on the island of Bali — which proves that they were familiar with these wares.

book for quick reference. Further *Das Lamaistische Pantheon*, edited by S. F. Oldenburg in *Biblio-theca Buddhica*, V, St. Petersburg 1903; *Two Lamaistic Pantheons*, edited with introduction and indices by Walter E. Clark (Harvard–Yenching Institute Monograph Series, vol. III, Cambridge 1937), and F. D. Lessing, *Yung–ho–kung, an Iconography of the Lamaist Cathedral in Peking* (Cambridge 1942).

The mountings of Tibetan scroll pictures have been briefly described by Tucci, op. cit., vol. I, pp. 267–268. Since a study of *tangka* mountings throws some interesting sidelights on the history of Indian and Chinese scroll mounting, I here give some additional technical details. These data are based on conversations with lamas in Peking and Kalimpong, and on information kindly supplied to me by Mr. Ch'ên Ts'un–chih 陳 存 志, former interpreter of the Chinese *amban* in Lhasa during the last years of the Manchu Empire, and now retired in Calcutta.

Tibetan scroll mountings can be divided into two categories, representing the Indo–Tibetan and the Sino–Tibetan type. The Indo–Tibetan type is the *tangka* mounting that derives directly from the Indian " banner "; this type we shall discuss first.

Indo–Tibetan moun-
ting.

*Tangka*, correctly spelled *t'ang–ka* and meaning " surface " [1] refers to picture and mounting together. The mounting alone is called *t'ang–kaḥi–gos–sam* (Chinese translation *hua–p'ao* 畫 袍), lite-rally " the silk apron of the surface ". A more popular designation is *t'ang–kaḥi–mt'aḥ–c'ags* (Chinese translation *hua–pien* 畫 邊), " the borders of the picture ".

First a double border of seamed silk is sewn along all four sides of the picture; on Plate **160** these borders are marked (1). The border is called *ḥzaḥ* " rainbow ", evidently because its strips having dif-ferent colours it reminds one of the spectrum of a rainbow. Then there is stitched on the left and the right a strip of coarse cloth, mostly dyed blue or black; these strips are called respectively *gyon–pa* " the left " (2) and *gyas–pa* " the right " (3). Thereafter there is sewn along the top of the picture a horizontal strip of the same material, called *gnam* " heaven " (4), and at the bottom a strip called *sa* " earth " (5); these two terms are apparently derived from the Chinese mounter's jargon. It should be noted that in the case of Indo–Tibetan mountings " earth " is broader than " heaven ", just the opposite of the proportion of *t'ien* and *ti* of Chinese mountings. I also draw attention to the fact that the bottom of a *tangka* is often slightly broader than the top so that there is an outward slope in its left and right side; Chinese hanging scroll mountings are always rectangular.

The " root ".

In the center of *sa* there is sewn a rectangular piece of gold brocade or embroidered silk that links the bottom edge of the picture with the lower roller (6); this patch is known as *rtsa–ba* " the root ".

The meaning of this particular feature of Indo–Tibetan mountings is doubtful. Lamas in Peking told me that this " root " represents the root of the " Life tree ", *srog–śing*, of Buddhist statues. This is a small piece of wood shaped like a truncated pyramid and inscribed with magic formulas, which is inserted in a cavity inside a newly–made wooden, clay or bronze image of a deity, together with some rolled up paper strips inscribed with prayers, three coloured cotton threads, incense, tea and some other small objects. The ritual name of these objects together is *shê–li* 舍 利, the Sanskrit *çarīra* used in its special sense of " mystic body of the Buddha "; when properly consecrated it is supposed to give mystic life to the statue by making it part of the transcendental body of the Buddha. The theory that the " root " of a *tangka* has the same significance as the " Life tree " of a statue would seem to be confirmed by information given to me by lamas at Kalimpong to the effect that folded strips of thin paper bearing magic formulas are often inserted into the lining of the patch. This would ex-plain why Tibetan mounters often choose as material for the " root " a patch of brocade with the Chinese character *shou* 壽 " long life " — the meaning of which is well known among Tibetans because

---

1) Tucci states that *t'ang–ka* means literally " volumen "; the Tibetan dictionaries at my disposal, however, do not give this meaning s. v. *t'ang*.

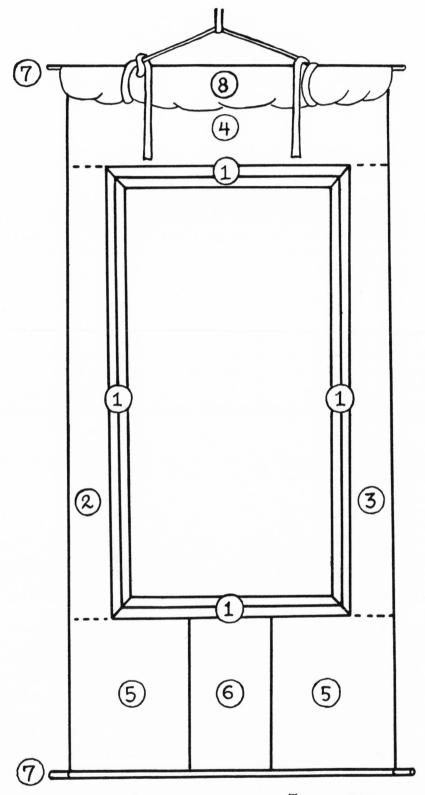

160. – Schematic drawing of a Tibetan scroll

505

of its prominent place in decorative art. Thus the addition of the root would consecrate the picture in the same way as the magic formulas inscribed on its reverse. [1]

Tucci, on the other hand, gives an entirely different explanation of the "root". He states op. cit. page 268 that this patch is called *t'ang-sgo* "door of the tangka", and draws attention to the fact that it often shows a pattern of dragons. He adds: "This may seem simply a decorative pattern, but it answers to an exact symbolism: it represents the sphere of cosmic waters, of the endless and inexhaustible possibilities which are latent in the world of *māyā*, the "becoming" contrasted with the planes of spiritual purity represented in the painting: on one side intellect, on the other nature and matter". As a matter of fact the "roots" are often made from a patch of silk cut from an embroidered Mandarin robe, showing dragons, and cloud and water symbols. On the other hand, however, I have also seen numerous *tangka* where the "root" had a pattern of birds and flowers or other well known Chinese decorative motifs which have no connection with dragons or water.

It is clear, therefore, that this feature was differently explained according to time and locality; which explanation is the original one will require a special study. For the sake of completeness I may add that some *tangka* have above the picture a continuation of the "root", stretching across the *gnam* from the upper edge of the picture till the upper stave. Others again have only a kind of miniature "root" in the shape of a small, square patch of brocade sewn on in the center of the *sa*.

Rollers and veil.

Both *gnam* and *sa* have a seam for inserting upper stave and lower roller. In Tibetan these sticks are called *t'ang-rgyugs* "ends of the tangka", or *t'ang-śing* "sticks of the tangka" (7). The ends of the lower roller are often provided with brass knobs.

Finally a veil of thin silk (8) is stitched along the upper stave; when hanging down it covers the picture together with its borders. This veil is called *t'ang-k'ebs* "picture cover". When the picture is suspended on the altar this veil protects it against profane eyes, and prevents it from becoming soiled by the oily smoke of temple lamps, or by insects. It is kept hanging straight by two ribbons of lined brocade, called *t'ang-ḥdzar*, that are attached to the upper stave; their tips are weighted

1) The ceremony of consecrating a picture is described in detail by TUCCI, op. cit., vol. I. The sequel to the *Tsao-hsiang-liang-tu-ching* (cf. page 226 above, note 3) gives some practical directions as to how an image should be consecrated by inscribing it with the proper magic formulas; this ritual is called in Chinese *chuang-ts'ang* 裝藏 or *k'ai-kuang* 開光. The text says: "These germ-letters of the five roots (i. e. eyes, ears, forehead, tongue and navel) should be written on their appropriate places as soon as the sketch of the image has been completed, so that afterwards they are covered when the colours have been applied. Images on banner paintings must also be treated in this way. If such pictures are already completed (without the magic syllables having been added) one may also write them on the back of the scroll" 此五根種字。皆書於草創之素底各處。以被彩粉塗蓋。其幢像之藏。亦應作如是。若已成者則書於背面亦可。

The "germ letters", Sanskrit *bijākṣara*, are magic syllables which represent the essence of a certain deity; cf. my book *Hayagrīva, the Mantrayānic aspect of horse-cult in China and Japan*, page 48. In later times the magic syllables and other formulas were written on the reverse of the picture only. I quote a pertaining passage from the article *On mak-ing earthen images, repairing old images and drawing scroll pictures in Tibet*, in "Journal of the Indian Society of Oriental Art", vol. I, no. 2, Calcutta 1933, which is an English translation by Dr. J. van Manen of a Tibetan treatise written by the Tibetan scholar Gegen Lungtok Puntsok; this passage reads as follows. "Then on the back the spell of whatever God it is must be written. Whilst writing the spell on the back of the scroll the three spots forehead, throat and heart must be accurately marked from behind, and the formula *auṁ-āḥ-hūṁ* written against them. On the spot marked against the heart the spell of whatever God it is must be written horizontally. Against the navel the 'hundred syllables' must be written. Against the lotus seat (on which the deity is enthroned) the 'Ye dharma etc.' must be written. Any picture not so inscribed is not a ritually correct image. No image, earthen image, picture or the like will be the dwelling of a God if it is without the magic syllables. I myself have heard lamas say that demons and evil spirits will dwell there". I may add that "the hundred syllables" are those representing the hundred benevolent and fierce gods that are supposed to dwell in the human body; the hundred spells can be rendered in one abbreviated formula. Further, "Ye dharma" are the first words of the well known Buddhist profession of creed.

by filling them with a small quantity of sand. When the veil is rolled up so as to expose the picture, these two ribbons are passed through slits near the upper edge of the veil and wound round it so as to keep it in place; their ends hang down across the *gnam* (see the accompanying plate) and constitute an ornament closely resembling the *futai* of Japanese hanging scroll mountings. When the *tangka* is rolled up to be stored away the bands are wound round it. Other types of *tangkas*, however, have bands that serve only as decoration; the scroll is kept rolled up tight by winding round it the suspension loop, as is done in the case of Chinese scrolls.

The adding of veil and ribbons completes the front mounting, in Tibetan called *mdun*. As regards the back of the scroll, called *rgyab*, no lining is attached to the picture itself. Only the strips that constitute the front mounting are backed by sewing on some coarse cotton or silk. The suspension loop, consisting of a cord or a narrow silk band, is fastened to the protruding ends of the upper stave, or to copper eyes screwed into the stave; the latter manner, however, is more common in the case of Sino–Tibetan mountings.

This cursory description may suffice to show that the *tangka* mounting has faithfully preserved the essential features of the ancient Indian " banner " mounting. The two bands used for fastening the rolled up scroll appear already on the Borobudur relief discussed above (page 164), while the " rainbow border " surviving in the Japanese *butsu–jitate* type of mounted hanging scrolls would also seem to point to an Indian prototype.

Tibetan pictures mounted in lamaseries in China usually show a different type of mounting that corresponds to the Chinese " bag style " popular during the Ming dynasty. The picture is surrounded by a " frame " of silk or brocade, there is no veil, ribbons or " root ", and the upper and lower part of the " frame " show the classical Chinese proportion of 2 : 1.

This type of mounting corresponds to the *tangka* in so far that its component parts are sewn together, no paste entering the process. However, whereas in the case of Indo–Tibetan mountings the picture itself has no lining, Sino–Tibetan ones have a loose backing of silk that covers the entire reverse of the scroll.

Nepalese painted scrolls are known as *prabhā*. These pictures are very different in style from the Tibetan ones, they are close copies of East-Indian prototypes. The drawing is more realistic, it lacks the stylized, flowing delineation of Tibetan paintings; the deities have large eyes, with the white painted in. In the colouring red, brown and blue predominate, the mineral blue and green and the gold outlines that appear in most later Tibetan pictures are absent. Style and colouring often remind one of pictorial representations in Javanese art; this is only to be expected since this art also is derived from East Indian (Pāla) examples. For further details the reader is referred to *Nepalese Paintings*, an illustrated article by Stella Kramrisch published in the " Journal of the Indian Society of Oriental Art ", Dec. 1933.

The *prabhā* mounting is much simpler than that of the *tangka*. There are no triple seams round the picture, and no borders on left and right; there is only a horizontal strip of mounting sewn along the upper edge of the painting, and a broader one along its bottom. The material is usually dark blue cotton. Tucci found that *tangka* is Western Tibet (Guge) also showed this archaic type of mounting; the reader will remember that till the Yüan dynasty Chinese hanging scroll mountings also lacked left and right borders, and the same applies to the " banners " found in Central Asia. Thus it may be assumed that the ancient Indian " banners " had only strips of mounting on top and bottom, the left and right side of the painting being protected by the narrow " rainbow " seams.

# ESSAY ON THE PAO-HUI-T'ANG

(Literal translation).

The Superior Man may in his thoughts momentarily dwell [1] with things, but he may not let his thoughts be detained [1] by them. If one lets one's thoughts dwell with things, even a trifle will suffice to give joy, while even a great thing will not be enough to cause sorrow. If one lets one's thoughts be detained by things, even a trifle will suffice to cause sorrow, while even a great thing will not be enough to give joy.

Lao-tzû has said: " The five colours blind man's eye, the five tones deafen his ear, the five flavours dull his taste, wild courses and country hunts confuse his heart ". [2] Now the Holy Man does not abolish all these four, indeed he lets his thoughts dwell with them, but only temporarily. Liu Pei was a man of egregious talents, yet he loved to plait hair; [3] Hsi K'ang was a man of great perspicacity, yet he loved to forge iron; [4] Yüan Fu was a man of detached spirit, yet he loved to wax sandals. [5] All these lack even sound, colour, flavour and taste, yet these men till the end of their days never wearied of them.

Of all gladdening things that can make a man happy without changing him (for the worse), nothing equals autographs and paintings. But if one lets one's thoughts be detained by them, so that one cannot do without them, then the calamity that will ensue is too great for words. Because of this (over-fondness of antiques) Chung Yu spat blood and violated a grave; [6] because of this the Emperor Hsiao-wu and Wang-sêng Ch'ien came to hate each other; [7] Huan Hsüan because of this made special boats, [8] and because of this Wang Ai constructed a secret

---

1) The contrast lies in *yü* 寓 " to dwell temporarily ", and *liu* 留 " to stay ".

2) Cf. *Tao-tê-ching* 道 德 經, ch. 12.

3) Liu Pei (劉 備, 162-223, B. D. no. 1338), the famous hero of the San-kuo period. The commentary on the *Shu-chih* 蜀 志, chapter V, 5th paragraph, describes one of the earlier meetings of Liu Pei and the great general Chu-ko Liang (181-234, B. D. no. 459); after an important military conference both stayed behind. " Now Liu Pei by nature was fond of plaiting hair. Just then someone happened to give him a cow's tail, and Liu Pei immediately started to plait it. Then Chu-ko Liang remarked: ' An illustrious general in his mind must dwell on far-reaching plans, how can he be content with plaiting hair? '. Liu Pei knew that Chu-ko Liang was not an ordinary man, so he threw away the hair and said: ' What are you talking about? I just do this for a moment to forget my sorrow ' " 備 性 好 結 毦。時 適 有 人 以 髦 牛 尾 與 備 者。備 因 手 結 之。亮 乃 進 曰 明 將 軍 當 復 有 遠 志。但 結 毦 而 已 耶。備 知 亮 非 常 人 也。乃 投 毦 而 言 曰 是 何 言 與。我 聊 以 忘 憂 耳。 Cf. also *Shih-shuo-hsin-yü* 世 說 新 語, A 35.

4) Hsi K'ang (稽 康, 223-262) was said to be fond of forging iron; cf. my book *Hsi K'ang and his Poetical Essay on the Lute*, Monumenta Nipponica Monograph, Tōkyō 1941, page 17, and the Errata.

5) Yüan Fu 阮 孚 was a scholar of the Chin 晉

period, who is said to have been fond of waxing wooden sandals.

6) Chung Yu (鍾 繇, 151-230), scholar-official of the San-kuo period, famous as a calligrapher, especially in the " Chancery script ". The incident referred to is related in the *Shu-tuan* 書 斷, a brief treatise in 4 ch., compiled during the T'ang period by Chang Huai-kuan 張 懷 瓘 and containing miscellaneous notes on famous calligraphers. Chapter I, near the end, says: " Then Chung Yu asked from Wei T'an (another celebrated calligrapher of that time) the treatise on calligraphy left by Ts'ai Yung (蔡 邕, 133-192), but Wei T'an greatly treasured this, and did not give it. Then Chung Yu (in mortification) struck his own breast till he gave up blood. When Wei T'an had died, Chung Yu had his grave violated, and thus obtained it (viz. the treatise by Ts'ai Yung, that Wei T'an had caused to be buried together with him); after that Chung Yu's calligraphy became still more wonderful ". 繇 乃 問 蔡 伯 喈 筆 法 於 韋 誕。誕 惜 不 與。乃 自 搥 胷 嘔 血。及 誕 死。繇 令 人 盜 掘 其 墓。逐 得。由 是 繇 筆 更 妙。

7) Hsiao-wu reigned from 454-464; his relations with Wang-sêng Ch'ien (426-485) are related in the History of the Northern Sung Dynasty, chapter 138.

8) Huan Hsüan (桓 玄, 369-404, B. D. no. 837) was a statesman of the Chin period; in his biography in the *Chin-shu* (晉 書, ch. 99, i. e. 69 of the biographical section) it is said: " He had light boats made, and loaded them with

room; [1]) through such futilities these men endangered the state and brought harm to themselves. Such are the calamities caused by letting one's thoughts be detained by things.

Formerly, when I was a youngster, I loved these two (viz. autographs and paintings): I was always fearing lest I might lose those in my collection, and always fearing lest I might not obtain those possessed by others. Finally I laughed at myself, saying: " I despise wealth and honour, yet venerate autographs. I consider life and death lightly, yet greatly value paintings. Is this not a contradictory and wholly mistaken attitude, which will make me lose my true nature? ".

Since that day I controlled my passion. When seeing beautiful things, although occasionally, as before, I try to add them to my collection, I do not sorrow when others take them away. I compare them with clouds that pass before my eyes, [2]) or the songs of birds that are heard by my ear. Such things are enjoyed when met with, but one hardly thinks of them when they are gone. Therefore these two (viz. autographs and paintings) always gladden me, and they cannot cause me sorrow.

Now my friend the Imperial Son–in–law Wang Hsin, [3]) although married in the Imperial Family, closely adheres to Rites and Propriety, and in learning, composing poetry and calligraphy is wont to emulate a poor recluse. In his daily life he has renounced all luxuries, and he has discarded all sensual pleasures, living only for his autographs and paintings. To the east of his mansion he now has built the Pao–hui–t'ang, there to house his collection. On this occasion he asked me for a commemorative essay. Now I, fearing lest perchance he might come to have the same passion as I had when young, wrote this essay for him as a warning, hoping that it may enable him to enjoy his collection to the full, while preventing it from causing him sorrow.

Written on the 22nd day of the 7th moon, of the year 1077. [4])

his cherished antiques, old scrolls, and other suchlike objects. When someone reproved him, Huan Hsüan answered ' Scrolls and antiques I must always have with me. Moreover, in this dangerous time of war, one must be able to escape in an emergency, and pack these things lightly, so as to be easily transported '. All laughed at him " 使 作 輕 舸。載 服 玩 及 畫 書 等 物。或 諫 之。玄 曰 書 畫 服 玩。旣 宜 恆 在 左 右。且 兵 凶 戰 危。脫 有 不 意。當 使 輕 而 易 運。 衆 咸 笑 之。

In 403 Huan Hsüan occupied Nanking, ousted the Emperor, and pronounced himself Emperor of Ch'u. In 404, however, his troops were beaten by the loyalist army and he himself was killed; his biography relates that during this last battle he still had his boats with antiques with him. Su Tung–p'o writes *tsou–ko* 走 舸 " running boats "; these were swift boats, used during the famous battle near the Red Wall (cf. *Wu–chih* 吳 志, the biography of Chou Yü 周 瑜). In the text of course the *ch'ing–ko* 輕 舸 of Huan Hsüan are meant; such slight changes in quotations, provided they do not lead to ambiguity, are quite permissible and lend vigour to the style.

1) For Wang Ai, cf. above, page 224. His biography in the *Chiu–t'ang–shu* 舊 唐 書 says that he made a secret wall–safe (*fu–pi*), in order to store away his treasured scrolls; but after his execution all these carefully preserved antiques were scattered.

2) Cf. above, page 201, note 1.

3) Wang Hsin 王 詵, style Chin–ch'ing 晉 卿, was well known as a painter, poet and chess player. An ardent collector of antique scrolls, he was a boon compa-

nion of Mi Fu, who mentions him very often on the pages of his *Hua–shih* and *Shu–shih*. Being married to an Imperial princess, he occupied several high official posts but afterwards became involved in political strife, and died in disgrace. In Chinese literature his romance with the beautiful courtesan Chuan–ch'un–ying 轉 春 鶯 is often referred to. The use of the term *yu–wu* 尤 物 in connection with *i–jên* 移 人 in the opening lines of the *Pao–hui–t'ang–chi*, would make one suspect that Su Tung–p'o intended to convey to Wang Hsin also a subtle warning not to become too much engrossed in this girl. For *yu–wu* is used with special reference to women in general in a famous passage of the *Tso–chuan* 左 傳; there it is said, under the 28th year of Chao–kung: " Shu–hsiang wished to marry a daughter of Wu–ch'ên, Prince of Shên. His mother … said to him: ' Why should you do this? Those *strange beings* (yu–wu, i. e. women) are capable of *changing the heart of men* (i–jên); if you are not virtuous and just, this (marriage) will certainly bring a calamity over you ' " (昭 公 二 十 八 年 初 叔 向 欲 取 申 公 巫 臣 氏。其 母 ○○○ 曰 女 何 以 爲 哉。夫 有 尤 物 足 以 移 人。苟 非 德 義 則 必 有 禍).

Lang Yeh (郎 曄, 12th century), writer of an extensive commentary on Su Tung–p'o's works, adduces this *Tso–chuan* passage for explaining the meaning of *yu–wu* in the *Pao–hui–t'ang–chi*, so apparently he also suspected some connection with Wang Hsin's love affair. This problem can not be settled, however, as long as the dates of Wang Hsin's relations with Chuan–ch'un–ying have not been ascertained — which as yet I have been unable to do.

4) It is of interest to note that it appears from Su

(Chinese text).

君子可以寓意於物。而不可以留意於物。寓意於物。雖微物足以為樂。雖尤物不足以為病。留意於物。雖微物足以為病。雖尤物不足以為樂。

老子曰[五色令人目肓。五音令人耳聾。五味令人口爽。馳騁田獵。令人心發狂]然聖人未嘗廢此四者。亦聊以寓意焉耳。劉備之雄才也。而好結髦。嵇康之達也。而好鍛錬。阮孚之放也。而好蠟屐。此豈有聲色臭味也哉。而樂之終身不厭。

凡物之可喜。足以悅人。而不足以移人者。莫若書與畫。然至其留意而不釋。則其禍有不可勝言者。鍾繇至以此嘔血發冢。宋孝武王僧虔至以此相忌。桓玄之走舸。王涯之復壁。皆以兒戲害其國。凶其身。此留意之禍也。

始吾少時。嘗好此二者。家之所有。惟恐其失之。人之所有。惟恐其不吾子也。既而自笑曰[吾薄富貴而厚於書。輕死生而重畫。豈不顛倒錯繆。失其本心也哉]。

自是不復好。見可喜者。雖時復蓄之。然為人取去。亦不復惜也。譬之煙雲之過眼。百鳥之感耳。豈不欣然接之。去而不復念也。於是乎二物者。常為吾樂。而不能為吾病。

駙馬都尉王君晉卿。雖在戚里。而其被服禮義。學問詩書。常與寒士角。平居攘去膏粱。屏遠聲色。而從事於書畫。作寶繪堂於私第之東。以蓄其所有。而求文以為記。恐其不幸而類吾少時之所好。故以是告之。庶幾全其樂。而遠其病也。

熙寧十年七月二十二日記。

Tung-p'o's biography that he must have written this essay at Hsü-chou 徐州, only a few days after a disastrous flood had ravaged the district; the flood reached Hsü-chou on the 21st day of the 8th moon, and was brought under control on the 5th day of the 10th moon of that year. Was it the sight of this general destruction that made Su Tung-p'o all the more conscious of the transitoriness of all earthly goods? However this may be, he did not let his philosophical speculations interfere with his official duties: he was commended by the Throne for his efficient measures taken to control the flood.

# INDEX OF TECHNICAL TERMS[1]

## A) INDEX OF CHINESE TECHNICAL TERMS[2]

*ch'an-i-chih* 蟬 翼 紙 "cicada-wing paper", a thin sized paper, sprinkled with mica, 89.

*ch'an-i-t'a* 蟬 翼 搨 rubbings made with this paper, 89.

\**chang-tzŭ* 障 子, stiff screen, 33, 160.

\**chê-pien* 折 邊 "folded borders", narrow seams along the sides of a mounted scroll, 68, 76.

*chê-shan* 摺 扇 folding fan, 37.

\**ch'ên-ch'ing-lü* 襯 青 綠 blue and green pigments added on the reverse of a painting, to deepen the corresponding colours on the obverse, 73.

*ch'ên-hu* 陳 糊 old paste, used by mounters, 60.

\**ch'ên-pien* 襯 邊 "lined borders", a style of mounting where one or more seams separate original and "frame"; used especially for remounting antique scrolls, 106.

*chêng* 幢 "banner mounting", 168.

\**chêng-chuang* 整 裝 "uncut mounting", rubbing mounted in its entirety, usually as a hanging scroll, 94.

*chêng-mien* 正 面 obverse of a sheet of paper, 74.

\**chêng-wa-piao* 正 挖 裱 "bag style" mounting, 248.

*ch'i-fêng-chang* 騎 縫 章 "seals astride the seams", seams impressed over the seams of a mounted scroll, 68, 133.

\**chia-chien-tzŭ* 挾 簽 子 paper title label stuck between the pages of a book, 219.

*chia-chih* 夾 紙 laminated paper, 72.

*chia-chu* 夾 注 commentary printed inside the text, 178.

*chiang-hu*, v. *hu*.

*chieh* 揭 to take off the old backing of a scroll, 107.

*chieh-hua* 界 畫 "ruled painting", 342.

\**chieh-chih-po* 接 紙 跋 colophons directly attached to the picture they belong to, 68.

\**chieh-ling* 界 綾 strip of front mounting. In the case of hanging scrolls the strips that separate "frame" and *t'ien*, and "frame" and *ti*, 64; in the case of hand scrolls the vertical strips that separate its component parts, 68.

*chien* 簽, 檢, v. *t'i-chien*.

\**chien-chuang* 翦 裝 "cut mounting", mounting a rubbing in album form, after having cut it up in strips, 94.

*ch'ien* 籤, v. *t'i-chien*.

\**ch'ien-cha* 嵌 札 title slip included in the front mounting of a hanging scroll, 125.

\**ch'ien-chieh-ling* 前 界 綾 vertical strip of mounting separating superscription and original of a hand scroll, 68.

\**ch'ien-ê* 前 額 space at the beginning of a hand scroll, for writing the superscription, 68.

\**ch'ien-pien* 嵌 邊 "incrusted borders", v. *wa-ch'ien-pien*.

*ch'ien-ko* 鉛 格 paper ruled with lead, 173.

---

1) The terms given in this Index are not again listed in the General Index.

2) Those terms not found in Chinese standard dictionaries like the *Tz'ŭ-yüan* or the *Tz'ŭ-hai* are marked with an asterisk.

*chih* 帙 book cover, 139, 216–217.

*chih-fu* 直 幅 vertical hanging scroll, 18.

*chih-pên* 紙 本 scroll done on paper, 63.

*chih-piao* 紙 裱 scroll mounted entirely with paper, 63.

*chih-shu* 治 書 to "cure" book rolls, 136.

*chin* 進 one section of a Chinese house, 16.

*chin-chê-piao* 巾 摺 裱 albums showing a continuous text, uninterrupted by vertical strips of mounting, 97.

*chin-su-chih* 金 粟 紙 a rare variety of ornamental paper, 301.

*ching-chuang* 經 幢 rubbings from Buddhist texts engraved for instance on the socles of steles, 97.

*ching-tai* 經 帶 two narrow strips of paper or silk, vertically crossing the *t'ien* of a mounted hanging scroll, 66, 77, 198, 246.

*ching-t'ung* 經 筒 tubular scroll-containers, 126.

*ching-yen* 驚 燕, v. *ching-tai*.

*ch'ing-lü-hua* 青 綠 畫 style of painting where much use is made of mineral blue and green, 63.

*cho-sê-hua* 著 色 畫, v. *shê-sê-hua*.

*chou* 軸: 1) knobs on both ends of the roller of a mounted scroll; 2) roller of a scroll; 3) numerative of scrolls, 65.

*chou-hsin* 軸 心, v. *chou* 2.

*chou-t'ou* 軸 頭, v. *chou* 1.

*chou-shou* 軸 首, v. *chou* 1.

*chu-ko* 朱 格 paper ruled with red, 173.

*chu-t'a* 朱 搨 rubbing made with red ink, 88.

*chu-wên* 朱 文 seal-legends in red, 420.

*chuan-ê* 篆 額 heading of an inscription on a stone tablet in seal characters, 95.

*chuang-ch'ih* 裝 池: 1) to mount a scroll, mounting, 70; 2) a mounter's shop, 58.

*chuang-ch'ih* 裝 褫 mounting; mounting and remounting, 177.

*chuang-huang* 裝 潢 to mount a scroll, 52, 136.

*chuang-huang-shih* 裝 潢 師 a mounter, 58.

*chuang-pan* 裝 板 boards used by the mounter for drying scrolls, 59, 251.

*chuang-pei* 裝 褙 to mount, 176.

*chuang-piao-tien* 裝 裱 店 a mounter's shop, 58.

*chuang-t'ang-hua* 裝 堂 花 a kind of wall-hangings, 179.

*chuang-ting* 裝 釘 book-binding, 52.

*ch'uang* 幢, literally "flag", also: banner mounting, 168.

*chui-chüeh-chang* 墜 角 章, v. *ya-chüeh*.

*ch'ui-tai* 垂 帶, v. *ching-tai*.

*ch'un-kung-hua* 春 宮 畫 erotic pictures, 304.

*chung-t'ang* 中 堂, v. *t'ang-hua*.

*chung-t'iao* 中 條 medium-sized hanging scroll, 22.

*chung-tuan* 中 段, v. *shang-tuan*.

*chüan* 卷: 1) hand scroll, v. *shou-chüan*; 2) book roll, 135; 3) chapter of a book, 223.

*chüan-chou* 卷 軸, v. *shou-chüan*.

*chüan-pên* 絹 本 picture done on silk, 63.

*chüan-piao* 絹 裱 picture mounted with silk, 62.

*chüan-tzǔ* 卷 子, v. *shou-chüan*.

*ch'üan* 全 to retouch, 117.

*ch'üan* 圈 the "frame" of a mounted hanging scroll, 65.

*jan-huang* 染潢 to treat book rolls with yellow sap, 136.

*kan* 桿, 杆, v. *chou* 2.
*kang-lien* 扛連 a Chinese paper, 297.
*ko-chieh* 隔界, v. *chieh-ling*.
*ko-shui-ling* 隔水綾, v. *chieh-ling*.
*k'o-pên* 刻本, v. *t'a-pên*.
*ku-chou* 孤軸, v. *tan-t'iao*.
*ku-pên* 孤本 unicum, 93.
*kua-fu* 掛幅 vertical hanging scroll, 18.
*kuan-pên* 官本 government-owned scrolls, 410.
*k'uan* 欵 signature on a scroll, or on one of the sides of a seal stone, 432.
*kuo-t'ou* 裹頭 ends of the roller of a hanging scroll, cut off even with the scroll, and covered with
    paper or silk, 81.
*kung-pi* 工筆 elaborate and realistic style of painting, 63.
*kung-tan* 供單 a Chinese paper, 297.
*k'ung-ko* 空格 space left open in a column of writing to indicate respect for the name or title follow-
    ing directly below, 95.

*lan-chieh*, v. *lan-tao*.
*lan-ko* 藍格 paper ruled in blue, 173.
*lan-tao* 闌道 ruled space for writing, 173.
*li* 裏, v. *pei* 1; also inside of flap of hand scroll, 69.
*li-fu* 立幅 vertical hanging scroll, 18.
*lien-ch'i* 連七 a Chinese paper, 296.
*lien-chü* 聯句 antithetical couplets, 19.
*lien-shih* 連史 a Chinese paper, 228, 296, 329.
*lien-ssû* 連四 a Chinese paper, 296.
*lin* 臨 to copy, 397.
*ling-chih-po* 另紙跋 colophons written on separate pieces of paper or silk, and later mounted toge-
    ther with the picture they refer to, 68.
*ling-pên* 綾本 picture done on fine silk, 63.
*ling-piao* 綾裱 picture mounted with fine silk, 62.
*lo-ti-chao* 落地罩 wooden open work screens and arches connecting the pillars in the hall of a
    Chinese house, 23.

*mi-yin* 蜜印 "honey seal", 420.
*mien-lien* 棉連, a paper, 74, 123.
*ming-hsiang* 冥像 ancestral portrait, 18.
*mo-chih* 墨紙 rubbing, or paper used in making a rubbing, 305.
*mo-pên* 墨本, v. *t'a-pên*.
*mo-pi* 墨筆, v. *shui-mo-hua*.
*mu-ku* 沒骨 a style of painting in colours only, without outlines in ink, 63, 115.
*mu-pên* 摹本 a copy, 397.

*nien-yeh* 黏葉, v. *hu-t'ieh-chuang*.

*pao-pei-chuang* 包背裝 "protected spine binding", a style of bookbinding where the leaves are
    glued along their spines in a cover of stiff paper, 221.

*pao-shou 包首 protecting flap of a mounted scroll, 66.

pei 背, 褙: 1) the back or reverse of a mounted scroll, 66; 2) to provide a scroll with a backing, 72; 3) the backing of a scroll (substantive), 136.

*p'ei-chou 配軸, v. shuang-fu.

*p'ei-fu 配幅, v. shuang-fu.

*pên-ch'ên 本襯, v. chih-piao.

*pên-shên 本身, v. hua-hsin.

*pi 壁 "the wall", i. e. the drying boards hung against the wall of a mounter's work shop, 59.

piao 表, 裱, 褾 the front mounting of a hanging scroll, 64; outside of the flap of a hand scroll, 69.

piao 標, v. t'i-chien.

piao-chuang 裱莊, v. chuang-piao-tien.

piao-hua-shih 裱畫師 mounter, 58.

piao-li 褾裏 frontside mounting and backing of a scroll, 177, 204.

*piao-ling-t'i-po 裱綾題跋 superscriptions and colophons written on the front mounting of a scroll, 126.

piao-pei 表背, 裱褙 mounting, to mount, 52.

pien-chang 邊章, v. yin-shou 3.

pien-ê 匾額, v. ê.

p'ing-chang 屏障, v. p'ing-fêng.

p'ing-chou 平軸, v. kuo-t'ou.

p'ing-fang, v. t'ou-fang.

p'ing-fêng 屏風 folding screen, 33.

*p'ing-fu 軿幅, v. p'ing-lien.

*p'ing-lien 軿聯 a set of hanging scrolls of identical size and mounting, and representing kindred subjects, 20.

*p'ing-mên 屏門, v. p'ing-fêng.

*p'ing-t'iao 軿條, v. p'ing-lien.

po 跋 colophon, 68, 223.

*po-chih 跋紙 space at the end of a hand scroll reserved for writing colophons, 68.

po-wên 白文 seal-legends in white, 420.

*po-wên 跋文, v. po, 68, 132.

*pu 補 patching up a damaged scroll, 116.

*pu-cho 補綴, v. pu.

pu-t'ien-hua 鋪殿花, v. chuang-t'ang-hua.

shan-mien 扇面 an unmounted or dismounted fan, 23.

*shan-mien-chi-ts'ê 扇面集冊 album containing a collection of dismounted fans, 41.

shan-tai 扇袋 fan case, 37.

shan-t'ao 扇套, v. shan-tai.

*shang-pi 上壁 to put a scroll on the drying board, 77.

*shang-piao 上褾, v. t'ien.

*shang-tuan 上段 upper part of a painting; the middle part is called chung-tuan, and the lower hsia-tuan. In the case of a landscape painting these parts comprise roughly distance, middle distance, and foreground, 174.

*shê-sê-hua 設色畫 painting in colours, 63.

shêng-chih 生紙 unsized paper, 72.

*shih-t'ang 詩堂 a sheet of ornamental paper or silk, mounted directly above a hanging scroll, and used for writing comments, superscriptions, etc., 66, 125, 198, 277, 298, 329, 462.

*shou-chih 首 紙 extra length of paper at beginning of hand scroll, 138.

shou-chüan 手 卷 hand scroll, 38.

*shou-k'ai 首 開 the first four pages of an album, 95.

*shou-tai 壽 帶, v. ching-tai.

shu-chih 熟 紙 sized paper, 72.

shu-chüan 熟 絹 sized silk, 72.

shu-hua 書 畫 literally "autographs and paintings", in the present treatise usually rendered as "scrolls", passim.

shu-hua-chi-chin 書 畫 集 錦, v. shu-hua-shuang-pi.

*shu-hua-shuang-pi 書 畫 雙 璧, v. shu-hua-tui-yeh.

*shu-hua-tui-yeh 書 畫 對 頁 album the leaves of which contain alternately a picture and a poem, 41.

shu-t'ieh 書 帖 album containing autographs, 40.

*shua-pên 刷 本, v. t'a-pên.

*shuang-fu 雙 幅: 1) two hanging scrolls belonging together, 20; 2) sheet of paper the size of two ordinary sheets, 214.

shuang-kou 雙 鈎 tracing, 100.

*shuang-p'ing-kua-fu 雙 軿 掛 幅, v. shuang-fu 1.

shui-mo-hua 水 墨 畫 monochrome ink painting, 63.

shui-shua 水 刷 water brush, 74.

shui-yin 水 印 "water seal", 420.

*so-i-piao 蓑 衣 裱 a style of cut mounting, applied to rubbings of inscribed tablets in order to make them suitable for being mounted in album form, 97.

*szû-hsiang 四 鑲, v. ch'üan.

*szû-pien 四 邊, v. ch'üan.

*ta-an 大 案 large mounter's table, 58.

*ta-pên 打 本, v. t'a-pên.

*ta-ya-chu 打 壓 竹, v. t'ieh-chu.

t'a-pên 搨 本 a rubbing, 86.

tai 繃 silk cord or band for winding round a rolled up scroll, 66, 69.

*t'ai-t'ou-tzû 擡 頭 字 characters elevated above the top margin as a sign of respect, 95.

tan 賺 strip of silk used in the front mounting of a scroll, 69, 70.

*tan-chih 單 紙 single paper, 72.

tan-ch'ih 賺 池, 70.

*tan-sê 淡 色 ink painting with light touches of colour, 63.

*tan-t'iao 單 條 a single hanging scroll, 24.

*t'ang-hua 堂 畫 principal hanging scroll displayed in the main hall of the house, 17, 41.

*t'ang-i 堂 翼, v. tui-lien.

t'ao 套 book cover, 217.

*ti 地 "earth", strip of silk or paper at the bottom of a mounted hanging scroll, 64.

*ti-kan 地 杆 lower roller, v. chou 2.

t'i 題 superscription, 67.

*t'i-chien 題 簽 title label, 66.

t'i-ê 題 額 heading of an inscribed stone tablet, written in chancery script, 95.

tiao 縧 suspension loop, 66.

*t'ieh-chu 貼 竹 upper stave of a mounted hanging scroll, 65.

*t'ieh-lo 貼 落 small paintings or calligraphie specimens inserted in the lo-ti-chao, 23.

*t'ien 天 "heaven", strip of mounting at the top of a mounted hanging scroll, 64.

516

*t'ien-kan 天 杆, v. t'ieh-chu.

*t'ien-ti 天 地: 1) t'ien and ti of a mounted hanging scroll, or upper and lower border of a hand scroll, 68;
2) upper and lower margin of a book page, 174.

*t'o-chih 拖 紙 a long strip of blank paper at the end of a hand scroll, 68.

*t'o-hsin 托 心 first backing of a scroll, 73.

*t'o-pei 托 背, 祂 稍 last backing of a scroll, 78.

*t'o-wei-chih 拖 尾 紙, v. t'o-chih.

*t'ou-fang 斗 方 small square picture, 41.

*tsai-pien 裁 邊 to cut the borders for the mounting of a scroll, 76.

tsao-ching 藻 井 painted ceiling, 145.

*ts'ao-hsien 槽 線, v. ch'ên-pien.

ts'ê 册 album, 40, 218.

ts'ê-yeh 册 葉, v. ts'ê.

*tsung-p'i-shua 棕 皮 刷 coir brush, 74.

*tu-chou 獨 軸, v. tan-t'iao.

*t'uan-fang 團 方 small round picture, 41.

*tuan-pên 緞 本, scroll on satin, 63.

t'uan-shan 團 扇 stiff fan, 35.

*tui-fu 對 幅, v. shuang-fu.

*tui-lien 對 聯 a pair of hanging scrolls, 19, 247 sq.

*tui-tzû 對 子, v. tui-lien.

*t'ui-p'êng-shih 推 篷 式 a style of mounting rubbings of texts consisting of excessively large characters, 97.

*t'ung-ching 同 景 a set of two or more scrolls, together showing one continuous representation, 20.

*tzû-chou 字 軸 calligraphic specimen mounted as a hanging scroll, 62.

*tzû-chüan 字 卷 calligraphic specimen mounted as a hand scroll, 67.

tzû-hua 字 畫 "autographs and paintings", scrolls, passim.

*tzû-t'ieh 字 帖, v. shu-t'ieh.

*tzû-ts'ê 字 册, v. shu-t'ieh.

*wa-ch'ien-pien 挖 嵌 邊 "frame" of a mounted hanging scroll, cut from one piece of silk, 65, 297, 329.

*wên-ch'ên 文 襯 scroll mounted with figured silk, 62.

wu-chin-t'a 烏 金 搨 "black gold rubbing", white characters on a shining black ground, 87.

wu-szû-lan 烏 絲 闌 ruled space for writing, 173.

*ya-chüeh 押 角 "at the foot", seals impressed in one of the lower corners of a scroll, 440.

ya-fêng 押 縫, v. ch'i-fêng-chang.

ya-lo 砑 螺 polishing shell, 79.

*ya-piao-ling 押 裱 綾 seals impressed on the silk of the front mounting of a scroll, 440.

*ya-tzû 牙 子 narrow strips directly above and below a picture mounted as hanging scroll, 65.

ya-tzû 押 字, v. hua-ya.

ya-wei 押 尾 "at the end", seals impressed at the end of an inscription, 440.

*yang-chü 養 局, v. ya-tzû.

yang-wên 陽 文, v. chu-wên.

yen-chang 掩 障 stiff screen, 33.

*yen-wei 燕 尾 title-tag, 216.

yin-sê 印 色 vermilion seal pad, 431.

yin-ni 印 泥, v. yin-sê.

*yin-shou 引首: 1) strips of mounting directly above and below the original of a hanging scroll, 64; 2) space for writing the superscription of a hand scroll, 68; 3) seal impressed at the beginning of an inscription, 439.

yin-wên 陰文, v. po-wên.

*yin-yin 隱印 "hidden seal", small seal impressed in an inconspicuous place of a painting, 424.

ying-huang 硬黃 hardened yellow paper, 137.

ying-lien 楹聯 a pair of narrow vertical hanging scrolls, 22.

*ying-t'ieh 楹帖, v. ying-lien.

yü-ch'ih 玉池 strip of silk used in the front mounting of a scroll, 69.

*yüan-t'a 原搨 original rubbing, 99.

*yün-ch'ên 雲襯 scroll mounted with cloud-pattern silk, 62.

# B) INDEX OF JAPANESE TECHNICAL TERMS

atama-giri 頭切 a type of knob, 83.

batsu 跋 colophon, 68.

bi-shi 尾紙: 1) space at the end of a hand scroll for writing colophons, 68; 2) long strip of blank paper at the end of a hand scroll, 68.

bunjin-hyōgu 文人表具 a style of mounting hanging scrolls, 271.

butsu-jitate 佛仕立 a style of mounting hanging scrolls, used chiefly for Buddhist representations, 106.

byō-bu 屏風 folding screen, 34.

cha-gake 茶掛 scroll displayed in the cha-shitsu, 33.

cha-jin 茶人 tea master, 32.

cha-shitsu 茶室 special room for performing the tea ceremony, 32.

chi 地, v. ti in the Chinese Index.

chōsen-bachi 朝鮮鉢 a type of knob, 83.

chū-beri 中緣, v. chū-mawashi.

chū-futai 中風帶 fū-tai made of the same material as the "frame", 66.

chūgire-rendai-hyōgu 中切連臺表具 a style of mounting hanging scrolls, 272.

chu-mawashi 中廻 "frame" of a mounted hanging scroll, 65.

dai-bari 臺張 a style of mounting small or irregularly shaped pictures, 271.

dai-ji 題字 superscription; also used to designate the shih-t'ang, 66.

dō-hoè 幢褙 a style of hanging scroll mounting, 243.

dō-hyō 幢裱 "banner mounting", 172, 238.

don-su 緞子 multi-coloured silk, 264.

e-maki-mono 繪卷物 illustrated hand scroll, 39.

fu-chin 風鎮 "wind guards" of hanging scrolls, 84.

fude-maki 筆卷 square bamboo mats used for wrapping up writing brushes, 218.

fukuro-hyōgu 袋表具 "bag style" hanging scroll mounting, 272.

fukuro-shitate 袋仕立, v. fukuro-hyōgu.

futokoro 懷 inside of the protecting flap of a hand scroll, 69.

518

*futo-minchō-shitate* 太明朝仕立 a style of mounting hanging scrolls, 272.
*fu-tai* 風帶 two narrow bands of silk hanging down over the *ten* of a hanging scroll, 66.

*ga-chō* 畫帖 album with pictures, 41.
*gaku* 額 tablet mounting, 34.
*gara-awase* 柄合 harmonization of design (of original and front mounting), 273.
*ge* 下, v. *chi*.
*ge-dai* 外題 title label, 66.
*ge-jidai* 下地題, v. *chi*.
*ge-jiku* 牙軸 ivory knobs of scrolls, 82.
*goku-zaishiki* 極彩色 a style of painting with much colouring, 63.
*gyoku-chi* 玉池 upper and lower border of a hand scroll, 70.

*hachi* 鉢 a type of knob, 83.
*hada-ura* 肌裏 first backing of a scroll, 74.
*hagasu* 剝 taking off the old backing of a scroll, 107.
*hako-gaki* 箱書 inscriptions on the box of a scroll, 128.
*hanada* 縹 a fabric made from yellow hemp, 235.
*hari-komi* 張込 putting a scroll on the drying board, 77.
*haritsuke-fūtai* 張附風帶 *fu-tai* pasted down on the *ten*, 66.
*hashira* 柱 vertical strips of the " frame ", 65.
*hassō* 八相, 八宗, 發宗 upper stave of a hanging scroll, 65.
*heri* 緣 border of a scroll mounting, 68.
*himo* 紐 band for winding round a rolled up scroll, 66.
*hō-chō* 法帖 album with calligraphic specimens, 41.
*hok-ken* 黃絹, 北絹 a brownish silk, imported from China, 264.
*hon-shi* 本紙 the picture itself, as differentiated from its mounting, 63.
*hon-zon* 本尊: 1) v. *hon-shi*; 2) central scroll of a set of three, 241.
*honzon-hyōgu* 本尊表具 a style of mounting hanging scrolls, 270.
*hyō-dai* 表題 title label, 66.
*hyōgu-shi* 表具師 a mounter, 60.
*hyōgu-zairyō-ten* 表具材料店 shop where mounting materials are sold, 276.
*hyō-hoè* 裱褙 a style of mounting hanging scrolls, 243.
*hyō-hoè-shi* 裱褙師, 表補衣師, 表補繪師 old term for mounter, 244.
*hyō-hō-shi* 裱褙師, v. *hyō-hoè-shi*.
*hyō-moku* 標木, v. *hassō*.
*hyō-shi* 標紙 protecting flap, 69.
*hyōshi-take* 標紙竹, v. *hassō*.

*ichi-monji* 一文字, v. *ya-tzŭ* in the Chinese Index.
*ichimonji-futai* 一文字風帶 *fu-tai* of the same material and size as the lower *ichi-monji*, 66.
*in-ka* 印可 a type of knob, 83.
*in-shu* 引首 space at the beginning of a hand scroll, for writing superscriptions, 68.
*iro-awase* 色合 harmonization of colour (of original and front mounting), 273.
*iro-sashi* 色差 retouching, 117.
*ishi-zuri* 石搨, v. *taku-hon*.

*jiku* 軸 knobs of a mounted scroll, 65.

*jiku-gi* 軸木 roller of a scroll, 65.

*jiku-tasuke* 軸助, v. *chüeh* in Chinese Index.

*ji-su* 帙簀 old Japanese term for "book cover", 216.

*jō* 上, v. *ten*.

*jō-jidai* 上地題, v. *ten*.

*kake-ji* 縣字, v. *kake-mono*.

*kake-jiku* 縣軸, v. *kake-mono*.

*kake-mono* 縣物 vertical hanging scroll, 30.

*kaki-hyōgu* 畫表具 "painted mounting", 275.

*kakusui-ryō* 隔水綾 vertical strips of silk that separate the component parts of a hand scroll, 68.

*kambata* 綺 brocade, 86, 235.

*kan* 鈛 metal eyes in the upper stave of a hanging scroll mounting, for attaching the suspension loop, 66.

*kantei-fuda* 鑑定札 connoisseur's certificate, 130.

*kari-bari* 借張 drying boards, 60.

*kasuga-jiku* 春日軸 knobs of deerhorn, 82.

*kin-ran* 金襴 gold brocade, 264.

*kiri-jiku* 切軸 a type of knob, 83.

*kiri-tsugi* 切次 to cut the borders for a scroll, 76.

*kura* 倉 storehouse of a Japanese mansion, 30.

*kyō-ji* 經師 "sûtra master", old term for mounter, 60.

*kyō-kan* 經卷 Buddhist text mounted in roll form, 39.

*kuri-nuki-hyōgu* 刳拔表具 a style of mounting hanging scrolls, 272.

*kurumi-jiku*, v. *kuo-t'ou* in Chinese Index.

*kusari-nori* 腐糊 old paste, used by mounters, 307.

*maki-ginu* 卷絹 protecting flap of a hand scroll, 66.

*maki-ita* 卷板, v. *hassō*.

*maki-mono* 卷物 hand scroll, 39.

*maru-byōsō* 丸裱裝, v. *fukuro-hyōgu*.

*mashi-ura* 增裏 second backing, 75.

*men-tori* 面取 type of knob, 83.

*mi-kaeshi* 見返し: 1) inside of the protecting flap of a hand scroll, 69 (also the reverse of the title page of a printed book).

*mi-kiri* 見切 a type of hanging scroll mounting, a variety of Yamato, Plate 100 B.

*minchō-shitate* 明朝仕立 "bag style" hanging scroll mounting, 272.

*misu-gami* 美栖紙 a Japanese paper, 74.

*mō-sen* 毛氈 felt pad, 49, 161.

*murasaki-usumono* 紫羅 purple silk, 235.

*naga-bachi* 長鉢 a type of knob, 83.

*nagara-chō* a type of knob, 83.

*naka-no-suji* 中の肋 strips of mounting separating *ten* and *chi* from the "frame", 64; Chinese *ko-chieh*.

*nidan-hyōgu* 二段表具 a style of mounting hanging scrolls, 272.

*nori-bake* 糊刷毛 paste brush, 76.

*nori-ita* pasting board, 61.

520

*usu-mino-gami* 薄美濃紙 a Japanese paper, 116.
*uzu-maki* 渦 a type of knob, 83.

*waki-e* 脇繪 the left and right scroll of a set of three, 242.

*yamato-hyōgu* 大和表具 most common style of hanging scroll mounting, 270.
*yamato-ichimonji-mawashi* 大和一文字廻 a type of mounting hanging scrolls, 270.
*yoko-mono* 横物 horizontal hanging scroll, 30.
*yotsuban-shi* 四判紙 a Japanese paper, 74.

*za-gane* 座金, v. *kan.*

522

# GENERAL INDEX

# GENERAL INDEX

(Titles of books are printed in italics, names of scrolls are marked with an asterisk).

Hsü Tsêng 318.

Hsü Wei 374, 376, 461, 483.

Hsü Wên–ching 421.

Hsü Yüan 139.

hsüan–chih (paper) 74, 108, 123, 155, 229, 297.

*Hsüan–ho–hua–pu* 180, 202.

*Hsüan–ho–shu–pu* 180.

*Hsüan–ho–yin–pu* 428.

Hsüan–wu 4.

Hsüeh Chi 157.

*Hsüeh–hai–lei–pien* 285.

Hu Chêng–yên 286.

Hu Chi–ch'ên 314.

Hu Ch'i–i 286, 289, 314.

Hu Huai 202.

Hu K'ai–wên (ink–maker) 365.

human breath (ch'i), scrolls should be kept near to, 126, 184, 187, 307, 464.

Hu–szû–hui 233.

*Hua–chi* 166, 193.

hua–chiao (Xanthoxylum piperitum) 306–308.

*Hua–chu* 131, 406.

*Hua–fa–yao–lu* 494.

*Hua–p'in* 69, 492.

*Hua–shih* 8, 50, 85, 183, 191, 324, 325, 492, 509.

Hua T'o 295.

*Hua–yü–lu* 486.

Hua–yüan " Academy of Painting " 193.

Huai–nan–tzû 350.

Huai Su 407.

Huan Hsüan 46, 141, 185, 327, 508, 509.

Huan Wên 184, 189.

Huan–wu ch'an–shih (monk) 265.

Huang Chün–pi 462.

Huang Jên–hêng 286.

Huang Kung–wang 156, 280.

Huang Mien 205.

Huang Pin–hung 286, 417, 467.

Huang Po–szû 361, 411.

Huang Tao–chou 387.

Huang T'ing–chien 208.

*Huang–t'ing–ching* 193, 220.

Huang Tzû–ching 137.

Hui–nêng (monk) 354.

Hui–p'ai (Anhui school of seal–carving) 433.

*Hui–shih–hsiao–yen* 73.

Hummel, A.W. 219.

Hung–wên–kuan 153.

Hunter, D. 297, 487.

*Hyōgu–no–shiori* 268, 500.

*Hyōsō* 501.

*Hyōsō–hikō* 501.

*I–ching* 274, 489.

Ichikawa Bei–an (San–gai) 361, 362, 408, 502.

Ichikawa Kan–sai 497, 502.

*I–chüeh–pien* 315, 496.

I Hai 407.

Ikeno Taiga 408.

Ikkyū 244, 265.

*I–ku–t'ang–t'i–po* 496.

Imaizumi Yūsaku 499.

*Imperial Catalogue* 201, 489.

Inn, Henry 12.

I P'ei–chi 396.

ironing, of mounted scrolls, 79, 137.

Ise Teijō 445.

Ishii Sōseki 449.

Itō Chūta 12.

Itsukushima rolls 236.

I Tsung–k'uei 473.

Iwakami Hōgai 448.

I–yüan–chên–shang–shê (publisher) 216.

Jagaddala 167.

*Jang–li–kuan–kuo–yen–lu* 496.

Jametel, M. 487.

Java, scroll paintings on, 167; Chinese porcelain on, 503.

Jên Hsün 393.

Jên Kuei 393.

Jên Yüan 205.

*Jinsha–ki* 238.

Jobez, R. 446.

*Jou–pu–t'uan* 304.

Ju–ching (monk) 196.

*Ju–shu–chi* 220.

Jung Kêng 421, 467.

*Kakemono–to–nihon–seikatsu* 501.

Kan–chieh (monk) 196.

*K'ang–hsi–tzû–tien* 69, 70.

K'ang Sêng–kuei 301.

*Kanjō–nifu* 348, 349, 502.

Kanō Akinobu 269.

Kanō Ekisai 497.

536